Hollywood Cartoons

Hollywood Cartoons

American Animation in Its Golden Age

Michael Barrier

New York Oxford
Oxford University Press
1999

Oxford University Press

Oxford New York
Athens Auckland Bangkok Bogotá Buenos Aires
Calcutta Cape Town Chennai Dar es Salaam Delhi Florence
Hong Kong Istanbul Karachi Kuala Lumpur Madrid
Melbourne Mexico City Mumbai Nairobi Paris São Paulo
Singapore Taipei Tokyo Toronto Warsaw

and associated companies in
Berlin Ibadan

Published by Oxford University Press, Inc.
198 Madison Avenue, New York, New York 10016

Oxford is a registered trademark of Oxford University Press

Library of Congress Cataloging-in-Publication Data

Barrier, J. Michael.
Hollywood Cartoons:
American animation in its golden age
/ Michael Barrier.
p. cm. Includes bibliographical references.
ISBN 0-19-503759-6.
1. Animated films—United States. I. Title.
NC1766.U5B37 1999 791.4'33—DC21 98-7471

1 3 5 7 9 8 6 4 2

Printed in the United States of America
on acid-free paper

To Phyllis

Contents

Preface

This is a book about American studio animation in its "golden age"—the cartoons, most of them only seven or eight minutes long, that were commonly part of theater programs in the thirties, forties, and fifties. When I was a child in the late forties and early fifties, I usually saw such a film once a week as part of a Saturday matinee at a neighborhood theater. On rare occasions, short cartoons might make up a whole matinee, and—great event—every year or two my parents took me in the evening to a new Walt Disney animated feature. I knew many cartoon characters only from their comic-book appearances, and it was in comic books that even so familiar a character as Bugs Bunny seemed most "real" because I saw him there so much more often.

Today it is a rare American child who is not exposed to thousands of hours of cartoons—including many made fifty and sixty years ago—before reaching puberty. Millions of Americans know cartoon characters and even individual cartoons from the golden age in a way that was all but impossible in the days before television. That latter-day intimacy has been a mixed blessing. Television, while making cartoons more accessible, has made them seem more a children's medium than ever before, by presenting them at times and in formats best suited to children's viewing. Cartoons have always been popular with children, but so were the great silent comedians; just as Charlie Chaplin could not be dismissed as a children's entertainer, neither could the Walt

Disney of the thirties be patronized as a children's filmmaker. It was adult admissions that lifted *Three Little Pigs* and *Snow White and the Seven Dwarfs* to enormous success, and it was adult audiences, and especially men in uniform, who responded enthusiastically to the Warner Bros. and MGM cartoons a few years later.

The greatest pleasures to be found in the best Hollywood cartoons are far more accessible to adults than to children. What I've tried to do in this book is identify those pleasures and go some distance toward explaining them, the latter a task that requires above all describing how the people who made the cartoons worked together. The Hollywood cartoons, like many another industrial product, were made by specialized workers in organized settings, but specialization at the animation studios often encouraged not assembly-line rigidity but a pooling of strengths. The rigorous schedule was not a prison but a school; lessons learned in one film could be applied immediately in another. The Hollywood cartoon at its best was a wonderful collaborative medium, and I write in this book about the nature of that collaboration, as well as its fruits.

Most of the time, of course, the Hollywood cartoon was not at its best. What makes the whole of the Hollywood cartoon's history, and not just the best of the films, worthy of attention? One answer, as always in such cases, is that the ideas at work in the best films shaped many lesser efforts, too. Devoting some time to the successful films' context—that is, to the relative failures—can yield greater understanding of those successes. What makes the whole body of the Hollywood cartoons most appealing to me as a subject, though, is the nature of the ideas that governed so many cartoons, strong ones and weak ones alike.

Consider, for example, the violent comedy that was characteristic of the Warner Bros. cartoons in the forties and fifties. Consider specifically a run-of-the-mill Bugs Bunny cartoon called *Southern Fried Rabbit* (1953), directed by Friz Freleng. Bugs has taken refuge inside a hollow tree, and his recurring adversary Yosemite Sam (a Confederate soldier this time) vows to blast him. Sam lights a bomb, but Bugs pops his head out of the tree long enough to blow the fuse out. Sam moves away from the tree and lights the fuse again, but a tube emerges from the tree and extends to the bomb, and Bugs uses the tube to extinguish the fuse again. Sam moves even further away from the tree and lights the fuse yet again, but this time, the bomb blows up as he rushes back toward the tree with it.

A real actor in the same situation in a live-action film would have to appear to be hurt or else the film would proclaim itself a fraud, but in the cartoon, because pain and injury have been made plausibly absent, comedy can go where human physical limitations prevented it from going before. Sam is not hurt, only a little singed—and, especially, foot-stamping mad. The world of such cartoons is one in which anger, greed, and even murderous impulses do not lead to suffering and death for the innocent, as they so often do in our own world, but to mild discomfort and temporary inconvenience for the wicked. It is a world where one could quite reasonably wish to spend more than seven minutes at a time.

Because the Hollywood cartoons were popular, there were lots of them—several thousand sound cartoons were released between 1928 and 1966, my cutoff date—and most of them have survived. I've tried in conducting research for this book to see the bulk of each studio's output, a strategy that has become much easier to implement in recent years thanks to the release of many hundreds of cartoons on videototape and laserdisc, usually in their original form or something very close to it. Other cartoons remain accessible only in archives or private collections, but even the black-and-white cartoons released in the thirties are finding their way onto videotape.

During work on this book I was able to see almost all the short sound cartoons produced for theatrical release by the Disney, Harman-Ising, Schlesinger, Warner Bros., MGM, UPA, and Iwerks studios. I also watched a very high percentage of the Fleischer, Lantz, Terrytoons, Columbia, Famous Studios, and Van Beuren cartoons released between 1930 and 1950, as well as a substantial number of the later releases from the Lantz, Famous, and Terrytoons studios. I watched hundreds of silent cartoons as well, and many peripheral films like those made for the military during World War II. My general statements are based on actually seeing thousands of films, rather than extrapolating from a small sample.

My documentary sources are reflected in the endnotes. The Walt Disney Archives in Burbank is the central resource of this kind; no other film studio has done nearly so good a job of preserving its history. Even though large parts of the Disney studio's

records are not available to most researchers because of their continuing legal significance or their continuing use in production, what is available is overwhelming in its abundance.

Interviews are the most problematic area in film research. Memories can fail, and an interview may serve as a vehicle for rehabilitating a reputation or settling an old score. There is another hazard associated with interviewing people who work in a collaborative medium, and that is that they will be like the blind men describing the elephant—each mistaking a part for the whole, each mistaking the significance of what he did and saw and heard.

Such hazards are not an argument against interviews, though— much of animation's history has simply not been accessible in any other way—but rather an argument for conducting as many of them as possible, as thoroughly as possible; and that is what I have tried to do, with the invaluable assistance of the animator Milton Gray. Not only did Gray and I interview more than two hundred people, some of them repeatedly, but we measured their memories against one another's and against the films and all the other evidence. That interviewing began in 1969, and most of it took place in the seventies, when relatively little had been published about Hollywood animation; most of the people that Gray and I interviewed were clearly relying on their own memories. It's possible, through that sort of interviewing, to be reasonably certain about the accuracy of both particular statements and an interviewee's memories in general. For example, the late Wilfred Jackson emerged as an exceptionally reliable source on the Disney studio in the early thirties, a critically important period that is not well documented. The late Richard Huemer was a comparably reliable guide to the silent period.

My standard procedure was to make a transcript, or in some cases summary notes, of each interview and to give the interviewee the opportunity to revise that transcript; usually, but not always, the interviewee took that opportunity. (A few people died before an interview was transcribed or before they returned a transcript.) I have quoted from the revised transcript whenever there is one. Inevitably, in some cases interviewees excised "good stuff"—most often, colorful comments about former co-workers— but I found that the gains in accuracy, and in openness during the interview itself, far outweighed that cost. I have quoted deleted remarks in a very few instances, when the interviewees deleted those remarks only so that they would not bruise a former col-

league's feelings and all the parties involved have since died.

Although a few people who worked on the Hollywood cartoons have published memoirs in recent years, I have chosen to rely on those books as little as possible. Often, the interviews that Gray and I recorded—perhaps twenty years before the publication of an interviewee's book—are simply more trustworthy.

A few housekeeping matters:

For some release dates, I have given both month and year, but in other cases only the year, depending on what was needed to anchor a particular cartoon firmly in its studio's chronology.

In keeping with industry practice, I have referred to as "scenes" what most likely would be called "shots" in live action.

You will find references here not to Warner Brothers, but to Warner Bros., which was the way the company always identified itself. Throughout I've referred to the major film companies by the sort of shorthand in which "Paramount," for instance, embraces a tangle of related corporations bearing a variety of names.

Because the animation industry is willfully informal (as witness the requirement that Walt Disney's employees address him as "Walt"), once past a first reference—and sometimes even then, especially for secondary figures in my story—I have used the nicknames that were common currency. To refer to Charles M. Jones as anything other than "Chuck" would be silly once he was introduced; similarly, I have referred to Bob Clampett and Bill Tytla by those names on first reference, saving "Robert" and "Vladimir" for later, for their formal introduction, because everyone knew them as "Bob" and "Bill." When in doubt, I've come down on the side of clarity rather than consistency, which is truly a hobgoblin in this area.

Alexandria, Virginia M. B.
June 1998

Acknowledgments

Milton Gray is largely responsible for this book's existence. He and I began corresponding in 1966, shortly after he started work at the Walt Disney studio as an inbetweener (he has since become a highly respected animator), and very early he communicated to me his enthusiasm for the best Hollywood cartoons. Milt's enthusiasm was contagious, and thanks to him, I began watching those cartoons more regularly and more observantly than I had before.

If Milt had done no more than pique my curiosity about the cartoons and the people who made them, he would have a large claim on my gratitude. But he has, as well, continued to help me at every turn—recording interviews, reading the manuscript with a sharp critical eye, and generally providing the kind of assistance that most authors can only dream of.

I am especially grateful, too, to Mark Kausler, another Hollywood animator, whose knowledge of animators' styles and of the films themselves is unequaled; he has always been very generous with that knowledge.

I have also received valuable help from a number of other historians of Hollywood animation, including Joe Adamson, Robin Allan, Jerry Beck, John Canemaker, J. B. Kaufman, Mark Langer, and Steve Schneider.

As indicated in the notes, I have had access to the personal papers of a number of people who worked on the cartoons. In many cases I am indebted to others for that access: to Bill

Blackbeard for items from Tack Knight's papers; to Nick and Tee Bosustow for items from the papers of their late father, Stephen Bosustow; to David Butler for items from Robert McKimson's papers; to John Canemaker for items from Sylvia Holland's papers; to Bob Clampett for items from Joe Dougherty's papers; to Sody Clampett and her son, Rob, for items from Bob Clampett's papers, in addition to the many items that their late husband and father provided himself; to Mrs. David Hand for items from her late husband's papers; to Mrs. Richard Huemer and Dr. Richard P. Huemer for items from their late husband and father's papers, in addition to those that Dick Huemer himself permitted me to copy; to Mark Kausler for items from Hugh Harman's papers; to Patricia Leahy for items from the papers of her late father, Paul Terry; to Steve Schneider for access to documents from the papers of a number of Warner Bros. cartoonists; and to Martha Werler for items from the papers of her late husband, Maurice Day.

I've enjoyed assistance from dedicated people at many libraries and archives, but especially the following:

David R. Smith, Robert Tieman, Rebecca Cline, Collette Espino, Adina Lerner, Rose Motzko, and Jennifer Hendrickson of the Walt Disney Archives; Pat Sheehan, Paul Spehr, Barbara Humphrys, Joe Balian, Madeline Matz, Emily Sieger, and David Parker of the Motion Picture, Broadcasting and Recorded Sound Division of the Library of Congress; Charles Silver, Ron Magliozzi, and Mary Corliss of the Film Study Center of the Museum of Modern Art; Ned Comstock, Stuart Ng, and Leith Adams of the Archives of Performing Arts at the University of Southern California; Jere Guldin of the Film and Television Archives, University of California at Los Angeles; Howard Prouty of the Margaret Herrick Library, Academy of Motion Picture Arts and Sciences; and Maxime La Fantasie of the Fales Library/Special Collections in the Elmer Holmes Bobst Library, New York University.

Well over two hundred people who worked on the Hollywood cartoons sat for interviews with me and Milton Gray, mostly in person but sometimes by telephone; others provided full tape-recorded responses to my written questions. Many of the people who sat for interviews also answered my questions in letters and provided me with documents and publications of various kinds. It's a source of deep regret that so many of the people on the following list are no longer here to read this book. I regret, too, that not everyone on the list is represented in the text, but they all

contributed to my understanding of what the animation industry was like in its heyday. I am grateful to them all:

Edwin Aardal, Ray Abrams, Robert Allen, Peter Alvarado, Kenneth Anderson, Michael Arens, Roger Armstrong, Gus Arriola, Tex Avery, Arthur Babbitt, Ralph Bakshi, Ed Barge, Carl Barks, Tom Baron, Aurelius Battaglia, Xenia Beckwith, Bob Bemiller, Ed Benedict, Richard Bickenbach, Lee Blair, Mary Blair, Preston Blair, Mel Blanc, Billy Bletcher, Ray Bloss, James Bodrero, Stephen Bosustow, Jack Boyd, Jack Bradbury, Scott Bradley, Robert Bransford, J. R. Bray, Jameson Brewer (known in the thirties as Jerry), Homer Brightman, Bob Broughton, Bernard Brown, Treg Brown, Robert C. Bruce, Jack Brunner, Daws Butler.

Mary Cain, John Carey, Robert Carlson, Jim Carmichael, Don Caulfield, Marge Champion, Donald Christensen, Ivy Carol Christensen, Bob Clampett, Sody Clampett, Les Clark, Claude Coats, Corny Cole, William Cottrell, Chuck Couch, Jack Cutting, Arthur Davis, Marc Davis, Robert De Grasse, Eldon Dedini, Nelson Demorest, David DePatie, Philip Dike, Eyvind Earle, Mary Eastman, Phil Eastman, Isadore Ellis, Jules Engel, Al Eugster.

Carl Fallberg, Paul Fennell, Marceil Clark Ferguson, Owen Fitzgerald, John Fitzsimmons, Dave Fleischer, Lou Fleischer, Bernyce Polifka Fleury, Eugene Fleury, June Foray, Hugh Fraser, John Freeman, Friz Freleng, John Gentilella, Gerry Geronimi, Arnold Gillespie, Merle Gilson, Robert Givens, George Goepper, Mo Gollub, George Gordon, Campbell Grant, Joe Grant, Lu Guarnier.

Richard Hall (known in the thirties as Dick Marion), David Hand, Bill Hanna, Jack Hannah, Hugh Harman, Jerry Hathcock, Gene Hazelton, Thornton Hee, John Hench, Stod Herbert, David Hilberman, Cal Howard, John Hubley, Richard Huemer, William Hurtz, Rudolph Ising, Willie Ito, Wilfred Jackson, Ollie Johnston, Chuck Jones, Volus Jones, George Jorgensen (known in the thirties as George Dane), Paul Julian, Don Jurwich.

Milt Kahl, Milton Kahn (known in the thirties as Dave Mitchell), Lynn Karp, Millard Kaufman, Van Kaufman, Lew Keller, Hank Ketcham, Betty Kimball, Ward Kimball, Jack Kinney, Earl Klein, Phil Klein, Herb Klynn, Ruth Kneitel, Fred Kopietz, Michael Lah, Walter Lantz, Rudy Larriva, Eric Larson, Gordon Legg, Irv Levine, Fini Rudiger Littlejohn, William Littlejohn, Hicks Lokey, Ed Love, Harry Love, Alex Lovy, Richard Lundy, Eustace Lycett.

Fred MacAlpin, Norman McCabe, James Macdonald, John

McGrew, Helen Nerbovig McIntosh, Robert McIntosh, Robert McKimson, Daniel MacManus, Michael Maltese, Sid Marcus, Carman G. Maxwell, J. C. "Bill" Melendez, Jack Mercer, Otto Messmer, John P. Miller, Phil Monroe, Manuel Moreno, Kenneth Muse, Clarence Nash, Grim Natwick, Maurice Noble, Dan Noonan, Cliff Nordberg, Les Novros.

James Pabian, Tony Pabian, Edwin Parks, Don Patterson, Ray Patterson, Bill Peet, Hawley Pratt, Alice Provensen, Martin Provensen, Thor Putnam, Willis Pyle, David Raksin, Ed Rehberg, John Rose, Virgil Ross, George Rowley, Herb Ryman.

Leo Salkin, Paul Satterfield, Milt Schaffer, Zack Schwartz, Don Selders, Ben Sharpsteen, Mel Shaw (known in the thirties as Mel Schwartzman), Gordon Sheehan, Charlie Shows, Martha Goldman Sigall, Larry Silverman, Joe Smith, Margaret Smith, Paul Smith (the Lantz director, not the Disney composer), Paul Sommer, Irven Spence, Carl Stalling, Jack Stevens, McLaren Stewart, Robert Stokes, John Sutherland, Howard Swift.

Frank Tashlin, David Tendlar, Frank Thomas, Richard Thomas, Richard Thompson, Lloyd Turner, Carl Urbano, Lloyd Vaughan, Edith Vernick, Myron Waldman, John Walworth, Ben Washam, Clair Weeks, Tiger West, Ross Wetzel, Don Williams, Bern Wolf, Tyrus Wong, Cornett Wood, Adrian Woolery, Ralph Wright, Irene Wyman, Rudy Zamora, Jack Zander, and Alan Zaslove.

In addition, Gene Deitch, Theodor Geisel, Jerry Hausner, Al Kouzel, Thomas McKimson, Michael Sasanoff, Bill Scott, and Claude Smith provided helpful information through letters.

Milt Gray, Mark Kausler, Phyllis Barrier, John Canemaker, J. B. Kaufman, Mark Mayerson, Howard Prouty, David R. Smith, and Robert Tieman read all or part of the manuscript and offered many helpful suggestions.

I'm also grateful, for help of many kinds, to John Benson, Larry Estes, Maxine Fisher, Eddie Fitzgerald, Howard Green, John Kricfalusi, Eric Kulberg, Mrs. Abe Levitow, Scott MacQueen, Mrs. Michael Maltese, Mark Newgarden, Marilyn Wood Roosevelt, Michael Sporn, Bhob Stewart, Karl Thiede, Adrienne Tytla, Tim Walker, Hames Ware, Phyllis Williams, and the late Martin Williams; and to Sheldon Meyer, the world's most patient editor.

About the "Flip Books"

At three places in this book you will find a series of animation drawings. Each of these series illustrates a different style of animation—"rubber hose" animation, "stretch and squash," and "smear" animation—that is discussed in the text. Flip these drawings at a uniform speed and an illusion of movement will result. The drawings were made for this book by Milton Gray.

Character animation as practiced in the Hollywood cartoons embraced many other styles and techniques, but these three are particularly important to an understanding of the evolution of the art of animation.

Hollywood Cartoons

Introduction

Walter Kerr, in *The Silent Clowns*, refers to silent comedy—the films of Buster Keaton, Charlie Chaplin, Harold Lloyd, and their lesser contemporaries—as a "fantasy of fact": the camera confirms the reality of what is happening, but the special properties of silent film—silence itself, and a slight acceleration that weakens gravity's pull—transform that fact into fantasy.[1]

With animated cartoons, very nearly the reverse happened. In silent cartoons, fantasy in the form of blatant impossibilities was the stock in trade, so that, for example, Felix the Cat could detach his tail and use it as anything from a spyglass to a grappling hook. What was missing was a foundation in fact that would permit audiences, with a single suspension of disbelief, to accept the reality of what was happening in the cartoon they were watching. Even the most distinctive characters in silent cartoons were like playing cards in a magician's trick; they made no claim on the imagination outside the bits of cleverness in which they were used.

Sound filled part of the gap, but ultimately it was the improvement in drawing and animation that mattered most, because human beings are influenced much more by what they see than by what they hear. By the end of the thirties, cartoon makers could animate characters that all but dared their audiences not to believe in their existence, even when those characters were humanized animals or very peculiar-looking people. Such anima-

tion provided the missing ingredient, the plausibility—Kerr's "fact"—needed to bring the fantasy to life.

Most of this dramatic improvement in animated cartoons took place at the Walt Disney studio; the line of progress can be traced clearly through Disney's short cartoons and his first feature cartoon, *Snow White and the Seven Dwarfs*. The animation that Disney cultivated in those films shared with the best performances of living actors an emotional truthfulness, even though it differed fundamentally from live-action film in other respects. In the features that followed, though, Disney restricted "fantasy" increasingly to the subject matter. Once it had been established that a story was a fairy tale or an animal fable, "fact" dominated, in the form of very subtle but ultimately parasitic animation, separated from live action by only a leavening of caricature.

Throughout the thirties, while the Disney studio was moving steadily forward, cartoonists at other studios were simply figuring out what they were *not* doing, and as it turned out, they were definitely not making Disney cartoons. Since the Disney cartoons had defined the terms of animation's progress, that could have meant that other studios' cartoons were doomed to perpetual inferiority—except for one thing: by the early forties, it was becoming clear that, in animation, fantasy and fact can be combined in many different proportions.

Even though animated cartoons can be believable, they can probably never be *as* believable as live-action film. No matter how caught up in a cartoon an audience may be, it must be aware that it is watching photographs of drawings rather than photographs of real people. By way of compensation, the range of permissible fantasy in animated cartoons is much broader. Cartoon makers whose characters suggest a three-dimensional reality—that is, have some footing in fact—can do just about anything they want, as long as they respect the need for consistency within a film. A cartoon can be in some sense successful even if, at one extreme, it verges on an imitation of live action or, at the other, only a thin veneer of plausibility holds together a clump of ridiculous gags.

When animated cartoons are at their best, though, fantasy and fact do not merely coexist: they reinforce each other continuously. In the strongest short cartoons of the forties and early fifties, as in the Disney cartoons of the thirties, the most creative cartoon makers demonstrated repeatedly that what makes a cartoon character exactly that, a cartoon, can also make that character seem more real.

Their work did not pass unchallenged. Over several decades, and in radically different ways, other cartoon makers argued in effect that what made cartoon characters seem more real inevitably diminished them as drawings. Better to offer drawings that were unequivocally drawings, they said—even when those drawings were wholly derivative—than drawings that tempted audiences to think of them as something else. It was an argument echoing those that have swirled around painting and music and theater—and more recently, live-action motion pictures—for a century and more. The disagreements among cartoon makers were on a smaller scale, and rarely as well articulated, but they were at bottom just as serious. At issue ultimately was whether animated cartoons were by their nature ancillary to other arts, painting especially, or had some claim to existence as a unique art form—a claim rooted not in graphics, but in the animation of their characters.

Such a conflict could not have been imagined in the late twenties, at the dawn of the sound era, when not just the characters in cartoons but also the films themselves, and the tiny studios that made them, hardly seemed real at all.

Part I: Cartoon Acting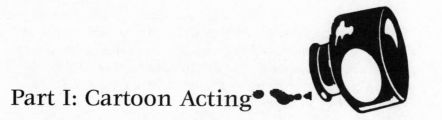

The staff of the Paramount cartoon studio in New York City in 1921. Earl Hurd, the pioneer animator who ran the studio, is seated at the rear. The two mustachioed men at rear center are Frank Moser (left) and Ben Sharpsteen; the younger man at the far left is Bill Tytla. Courtesy of Ben Sharpsteen.

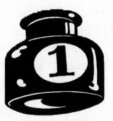

Beginnings,
1911–1930

The photographs, filled as they are with solemn young men (not many women) dressed in vests and ties, and working at desks in spartan settings, could have been taken in almost any New York office building in the twenties; they do not suggest an artistic undertaking. It's only because the papers in front of these earnest toilers are drawings that their workplaces are recognizable as animated-cartoon studios rather than insurance companies.

Such people numbered a few hundred at most, a tiny fraction of the thousands who made up the rest of the film industry. Almost all cartoon studios were still in New York in the twenties, even though live-action filmmaking had largely moved to California years before. Animated cartoons had always been a cinematic afterthought: when regular production of cartoon shorts began in the middle teens, the industry's weight was rapidly shifting away from such one-reel (or less) films and toward multiple-reel shorts and features. Cartoons appealed at first as novelties, particularly when they added movement to familiar comic strips. By the twenties, though, animation had long since lost its novelty value, and many cartoon studios that had never offered much else were either out of the business or on the way there. In 1922, fewer than 23 percent of the nation's theaters offered cartoons on their programs (as opposed to the almost 73 percent that offered two-reel comedies).[1]

Early on, filmmakers tried to bring efficiency to the manufacture of what was, after all, a complex and expensive industrial product, without destroying what made people want to see the films in the first place. It was an inherently difficult balancing act, especially where cartoons were concerned. An animated cartoon could easily require thousands of drawings, each differing a little from the next, and making those drawings could take a long time; finding some way to generate drawings faster could seem all-important. As the photos of cartoon studios from the twenties suggest, with their businesslike atmosphere, cartoon producers did find ways to achieve a sort of efficiency, but what made regular production possible also robbed many of the films of interest. There is nothing so inefficient as the efficient production of a product that hardly anyone wants.

Winsor McCay, the New York newspaper cartoonist who was also the first American animator of consequence, made films that people wanted to see. But as if anticipating the dilemma his successors would face, he sidestepped the production problems more than addressed them.When McCay animated characters from his Sunday comics page, "Little Nemo in Slumberland," in 1911, he made his cartoon not primarily for movie theaters but as an addition to his vaudeville act.[2] Although a one-reel film incorporating the roughly two minutes of Nemo animation also appeared in movie theaters, simultaneously with McCay's own use of it,[3] he withheld two subsequent films, *How a Mosquito Operates* (1912) and *Gertie* (1914) (for which he animated a dinosaur) until he had exploited their stage appeal.[4] Another popular newspaper cartoonist, Bud Fisher, followed McCay's example by having a young cartoonist named Paul Terry (they had worked together at the *San Francisco Chronicle* a few years earlier) make an animated film based on Fisher's comic strip "Mutt and Jeff"; Fisher, like McCay, had his own vaudeville act.[5]

Terry's film has not survived. McCay's have, likewise accounts by his assistant John Fitzsimmons of how two of them were made. McCay's methods were radically at odds with rapid production on a regular schedule. For instance, his third film, *Gertie*, was the first to require much of a background. Fitzsimmons provided it by tracing a McCay drawing of the background onto each of the many hundreds of McCay's detailed drawings of the dinosaur herself.[6] Even the most talented cartoonist would have found it extraordinarily difficult to produce a regularly appearing series of short animated cartoons by working as McCay and

Fitzsimmons did; the question was whether there was any other way to do it.

The first attempt at such a series was, like McCay's Little Nemo cartoon, based on a comic strip. The French cartoonist Emile Cohl, who in the preceding four years had made dozens of short films—some containing animated drawings—for Gaumont and Pathé, came to the Eclair studios in Fort Lee, New Jersey, in the fall of 1912 to make a series based on George McManus's comic strip, "The Newlyweds." It began appearing in theaters in March 1913, by which time McCay had made only his first two films.

All but one of the Newlyweds films have disappeared, so it's not possible to say with any assurance how Cohl—whose French films were in many ways more innovative than contemporaneous American films—solved the production problems that such a series posed. He was able to make only one cartoon a month, though, as opposed to the planned release of one every two weeks, so it seems likely that the series' demands were not particularly easy for him to meet.[7] To judge from the sole surviving example, *He Poses for His Portrait*, released in July 1913, Cohl did not even attempt character animation like that in McCay's films. His characters—shown as negatives, white lines on black—are instead frozen in a tableau, each one highlighted in turn as their dialogue appears on the screen; movement comes mostly in bursts of free-flowing metamorphosis animation of the kind Cohl had employed in his French films (a whale becomes a meat grinder, into which a cat disappears; the cat emerges as white balls, which change into a goat, and so on). When characters do move, it is as cutouts. Cohl returned to France after eighteen months, leaving behind neither a continuing series nor trained assistants; shortly after he left, a fire destroyed almost all of his work for Eclair.

Cohl's biographer Donald Crafton cites an incident when Cohl was ordered by his superiors at Eclair to admit to his studio two visitors who showed an intense curiosity in his methods.[8] Crafton speculates that one of the visitors was Raoul Barré, a French Canadian cartoonist who had moved to New York in 1912, but that visitor more likely was John Randolph Bray, a cartoonist who had worked since the early years of the century for humor magazines like *Judge*. By 1913, when the visit to Cohl's studio probably took place, Bray was deeply involved in making films on a different model from either McCay or Cohl, and he was making them for Pathé, like Eclair, a French firm, whose American studio was just down the road from Eclair's, in Jersey City.[9]

Bray sold *The Artist's Dream*, his first film—in which animation
and live action alternate, the two never combined in the same
scene—to Pathé in 1913. Before he completed *The Artist's Dream,*
Bray said a dozen years later, he learned that McCay "had been
experimenting along the same lines,"[10] and that is likely enough,
since Pathé scheduled the release of *The Artist's Dream* for 12
June 1913.[11] By that time, only the first two McCay films had been
exhibited, the second in 1912, when Bray supposedly was already
at work on his own film. (The climax of Bray's film, in which an
animated dog explodes after eating too many cartoon sausages,
suggests strongly that Bray had seen *How A Mosquito Operates*, in
which the title character suffers a similar fate.) Bray distinguished
himself from McCay, saying, "I wanted to simplify and perfect the
process, so that the cartoons could be supplied as a regular
motion-picture feature—as *many* of them as the public might
want."[12] When Bray's second cartoon, *Colonel Heeza Liar in Africa*,
was released in December 1913, it was not as a novelty, but as the
first in a series with that character.[13]

Bray had, in fact, merely begun to simplify and perfect the
process by addressing the early animators' largest problem, the
one that McCay simply ignored and that Cohl circumvented
through his use of cutout figures: how to combine characters
(which had to move) with backgrounds (which ordinarily would-
n't). Bray's solution, which he reduced to a patent application on
9 January 1914, was to print multiple copies of the background
for each scene, draw the characters on those printed sheets, and
scrape away those parts of the background that the characters dis-
turbed. (Alternatively, when the animator knew that part of the
background would be disturbed for more than a few frames of
film, he could have some of the sheets printed with part of the
background blanked out. Then, when he had drawn the charac-
ters, the missing part of the background could be traced from one
of the complete sheets.) Bray's method did not really differ much
from McCay's, except that it mechanized the reproduction of the
backgrounds; even at that, it called for assistants' tracing some
parts of both characters and backgrounds.

Bray's initial patent application was rejected on 27 February
1914 by a patent examiner who had seen McCay's Nemo cartoon
and who believed, correctly, that what Bray was trying to patent
was not sufficiently different from the means used to produce
McCay's film.[14] Bray's attorney labored successfully to distinguish
Bray's methods from McCay's, and the patent was ultimately

granted on 11 August 1914. Under the pressure of actual production, Bray's methods did not live up to his patent's claims for them: he made only seven cartoons in all of 1914. Bray apparently animated his own limited output in 1914 with the help of a few assistants; it was probably not until late in that year that he hired other cartoonists as animators and set up a New York studio capable of systematic production. [15]

Competitors were close behind. By early in 1915, Raoul Barré had formed a studio of some kind to make cartoons for the Edison company in a series called Animated Grouch Chasers; the first was released in March.[16] By the end of 1915, he was making cartoons based on Tom Powers's "Phables" newspaper comics for release as part of the Hearst newsreel.[17] Barré did not use printed backgrounds like Bray's, but neither did his films require tracing nearly as extensive as McCay's. He was from all appearances the first cartoon maker to realize that it didn't matter whether what was put under the camera was a single drawing, as with the McCay and Bray methods. All that mattered was what the camera saw, and it could see as a single image what was actually a composite of several pieces of paper, pressed together under a piece of glass.

As one result, Barré could employ what came to be called the rip-and-slash system. It entailed tearing holes in the paper drawings so that, for instance, the moving part of a character's body was visible on one sheet while the stationary part was visible through the hole, on another sheet under it. When the two sheets were laid together, the camera saw them as one (at least if the torn paper's edges were feathered adequately), eliminating the need to redraw the stationary part.

Such a system could have embraced torn background drawings as well as torn drawings of characters, but Barré evidently chose to use translucent sheets, probably of celluloid, on which the backgrounds were drawn or pasted. Putting such a sheet over the animation drawings separated the characters from the backgrounds more effectively than Bray's invention did; but since the backgrounds were actually on top of the characters that were supposed to be in front of them, Barré's solution created problems of its own. Background drawings had to be high on the screen or otherwise placed so that the characters wouldn't disturb them; when such a disturbance was unavoidable, the animator had no choice but to trace the background drawing onto the animation drawing for however long the disturbance lasted.

Barré is generally credited with inventing not just rip-and-slash animation, but also what very quickly became the universally adopted method for keeping animation drawings in register, that is, each drawing in proper relation to the next. It involved installing two or more pegs at the top or bottom of the animator's drawing board and using drawing paper with holes punched to fit over the pegs.[18] Bray's method for registration, which involved aligning the "guide marks" on each printed sheet, was clumsy by comparison. Animators began very quickly to draw on boards equipped not just with pegs but with panes of glass illuminated from below—lightboards, as they were called—so that the animator could more easily see previous drawings as he made a new one. That need would have grown more pressing as drawings began to be broken up into several layers.

Earl Hurd, who had been a newspaper cartoonist in Chicago and New York,[19] came up with a method for separating characters from backgrounds that surpassed both Bray's and Barré's. Unlike Barré, who never patented anything, Hurd reduced his idea to a patent application on 19 December 1914. Hurd's patent called for drawing the animated figures on translucent sheets of paper and celluloid, painting them, and then placing them over a single background drawing when they were to be photographed. Bray's earlier patent had called for exploiting translucent paper's advantages in the actual animating—the idea was that an animator would be able to see the previous drawing as he made the next one—but he had not realized, as Hurd did, that translucence could be exploited in the photographing of the drawings as well.

By the time Hurd applied for his patent, Bray's method had already proved to be unworkable. Bray used printed backgrounds for a few early cartoons, like *Colonel Heeza Liar in Africa* and *The Grafters*, but they were hopelessly inflexible. In *The Grafters*, probably the first cartoon with cat and mouse antagonists, the staging is often dictated not by the comedy's requirements but by the backgrounds, so that, for instance, all the action in one scene takes place on the far left side of the screen, in a long shot. Bray cartoons from later in 1914 and 1915 show him trying to wriggle out from under his method's inadequacies, mainly through the use of cutouts for both backgrounds and characters.

Hurd received his patent in June 1915.[20] At some point during that year, he went to work for Bray, bringing his patent—and thus a solution to Bray's problem—with him. (He also brought along his character Bobby Bumps, who had appeared in a couple of car-

toons released by Universal.) Bray probably used translucent sheets of paper in producing a few cartoons at most before all the animation drawings for his cartoons began to be traced in ink onto sheets of celluloid—"cels," as they came universally to be called.

Bray himself received two more patents, one each in 1915 and 1916.[21] Through his own patents, and Hurd's, he was trying to stake out all of animation as his preserve, in effect emulating the Motion Picture Patents Company's efforts to license all film production and exhibition (efforts that had ended in January 1915 with an adverse court decision). Bray's patents gave birth not only to litigation, beginning with his 1915 suit against a short-lived series called Keeping Up with the Joneses, but to a continuing campaign by Bray and his formidable wife to persuade aspiring animators that they had to accept Bray's yoke.

Even though Bray was trying to establish his suzerainty over theatrical animation, his and Hurd's patents never completely stymied his potential rivals. He even gave one of them a back-handed boost. When Bud Fisher approached Paul Terry about undertaking a Mutt and Jeff series, Terry declined because he had already agreed to make cartoons for Bray; he recommended that Fisher talk to Barré instead.[22] The publicity for the new series mentioned only Fisher, but Barré was apparently involved with it from the start.[23] The first of the new Mutt and Jeff cartoons was shown in New York in March 1916.[24]

It was only through his use of celluloid that Barré came within hailing distance of the Bray-Hurd patents, and in later years he claimed that he had used celluloid as long ago as the summer of 1913, early enough to sink Hurd's critically important patent (Barré may have been making novelty films of some kind for Edison then).[25] As Barré and other cartoon makers used celluloid more extensively, they did so in ways that owed little or nothing to Bray's films. For example, it was not anyone associated with Bray, but rather William C. Nolan, an animator at Barré's studio in 1915, who came up with the idea of making wider background drawings and then moving them under the camera, a little in one direction or the other, each time a frame of film was exposed. Such movement encouraged the illusion that the camera was moving on a track parallel to moving characters.[26] Animators very quickly realized that they could combine celluloid overlays of foreground elements with Nolan's innovation: foreground shrubbery that moved on and off the screen more rapidly than the

background drawing, as if it were closer to the camera, enhanced the illusion of depth.[27]

As in Barré's case, there was enough ambiguity surrounding the Bray-Hurd patents—and enough that they did not address—to encourage other cartoonists to disregard them or work around them. In December 1916, Bray defeated a conflicting claim by Carl Lederer, another animator at Barré's studio. Lederer evidently made a renewed effort to nullify Bray's patents, only to drop it in January 1918, not because he had been defeated again, he said, but because "I found that the subject matter covered by the Bray patents is in universal use today."[28] Bray himself vowed to pursue infringers vigorously—and he sometimes did—but he may have been deterred by awareness of how fragile was his patents' validity. In any event, by 1918 his patents had become mostly a nuisance. Other cartoon makers had surpassed him technically; they had found ways to make cartoons on a regular schedule, not only by exploiting the flexibility that separating characters from backgrounds gave them, but also by adopting shortcuts of other kinds. They used cycles, for instance, in which a few drawings representing a single movement, like a stride in a run, were seen over and over again.

Their much larger problem was how to make their cartoons appealing to audiences.

The pioneer animators were not green cartoonists. Emile Cohl was in his fifties when he made the Newlyweds cartoons; Winsor McCay was in his early forties when he made his first animated film; Raoul Barré turned forty in 1914; John Randolph Bray was thirty-five in that year. All these men were accustomed to drawing for publication, that is, to doing work that required speed and proficiency. When Bray and Barré began setting up real studios, they attracted other cartoonists of the same kind. By the end of 1915, Bray had assembled a group of former newspaper cartoonists—Paul Terry and Earl Hurd were two of a larger number—who made the films for him, each specializing in his own characters.[29] The cartoonists at Barré's studio likewise included men who had come to animation after years as newspaper cartoonists or as contributors to humor magazines.

Late in 1915, Bray switched distributors, leaving Pathé for Paramount; he was now obligated to produce one cartoon a week.

By September 1916, when he was deep into the Paramount release, his staff included nine cartoonists, as well as four camera operators and thirty assistant artists.[30] Such assistants, at his studio and others, shouldered the more nearly mechanical tasks involved in production, much as Fitzsimmons did for McCay. When the animation was on celluloid, as at Bray's studio, an assistant might trace the characters in ink from the animators' pencil drawings. When the animators' own inked drawings were photographed, as at Barré's studio, an assistant might fill in the solid black areas or even erase the pencil lines. A talented newcomer need not remain in such a job long, however: when Richard Huemer started at Barré's studio in July 1916, he was animating after three weeks.[31]

The more seasoned cartoonists, including Bray and Barré themselves, had made the transition to animation with apparent ease, because animating was for them not all that different from simple cartooning. Although Bray showed himself in *The Artist's Dream* to be capable of depicting a dog's movements with surprising subtlety, other Bray studio films that survive from the teens tend to be fairly elaborate in drawing, like the nineteenth-century magazine cartoons they evoke, but barely serviceable as animation. Instead, a drawing may be held for many seconds on the screen or animation repeated throughout a film; likewise, rather than make, say, ten individual drawings to represent a rapid action, an animator might make only five drawings, or three, and have each drawing shot for two or three successive frames ("on twos" or "on threes").

Even Winsor McCay had resorted to such expedients as cycles and repeated animation, but only within the context of animation that was otherwise painstakingly realistic. In *How a Mosquito Operates*, McCay's animation of the mosquito as it attacks a sleeping man is startling—and even painful to watch—because the mosquito is so very large in relation to the man and plunges its huge beak so deep into the man's face. But McCay animated the swelling of the enormous insect's body, as it gorges itself on blood, with disarming subtlety: the mosquito fills out gradually and persuasively—not simply increasing in size, like a balloon filling with water, but as if its body had a certain structure, now distended. McCay animated his dinosaur, Gertie, with the same combination of grand scale and surprising delicacy; she is like a mischievous and unpredictable trained animal, suggesting variously an elephant, horse, or big cat. In the Bray cartoons, by contrast,

there is nothing resembling real movement; everything is stiff and mechanical, in keeping with the industrial model that Bray had embraced so confidently.

Barré had embraced it, too, but he may have been looking back over his shoulder at McCay's example with some wistfulness. Even in 1916 at the Barré studio, Dick Huemer said, "there was some attempt to improve animation," as well as evening art classes with a model: "We would come back at night to study the human form."[32] George Stallings, who animated for Barré, wrote to Huemer in 1963 about aspirations Barré had expressed even earlier, probably in 1915 during the Edison release: "Barré's one ambition...was to raise the quality...of animation so high that the others could not compete with him. He had a planned program for this all outlined and threw all of his profits back into it, whenever he had any, but he couldn't get far on twelve hundred dollars a picture."[33] Nothing speaks of such ambition in a Grouch Chaser like *Cartoons at the Beach*, which is primitive in both drawing and movement; the occasional heavily rendered drawing invites comparisons with an overripe tomato. *Never Again!* (1916) is comparably crude: only a police chief's mouth and arm move— in cycles—as he gives orders to Si Keeler, a seedy old traffic cop, in the first scene, while one held drawing suffices for Keeler himself.

Generalizing about the animated cartoons of the teens is treacherous because so many of the films have not survived and not all the surviving films are accessible, but the overwhelming impression is of films poorly animated, populated by highly artificial characters, and offering mostly jokes of the lamest kind— often in dialogue balloons, enhancing a resemblance to filmed comic strips. Cartoons never ran more than ten minutes or so, and they often shared a reel with a newsreel or a nature film. They were, in sum, films of a highly marginal kind, and there's some evidence, in trade-paper reviews and personal recollections from the time, that by late in the teens audiences were growing impatient with cartoons' weaknesses.

There's evidence, too—more often in accounts from the period than in the surviving films—that some people working in animation tried to respond by improving their product. One of them was Gregory La Cava, a New York newspaper cartoonist who, according to Nat Falk's early history, worked first in animation for Barré and then made animated cartoons for Rube Goldberg, by 1916 a famous newspaper cartoonist. It's not clear when La Cava

took charge of the cartoon studio that William Randolph Hearst established within his International Film Service to make films based on his comic strips; the first Hearst cartoons, from early in 1916, which included Barré's Phables and Krazy Kat cartoons animated by Bill Nolan, were probably farmed out. La Cava was certainly running the studio by sometime in the fall of 1916, when the first Katzenjammer Kids cartoons appeared. La Cava made improved cartoons, in Falk's account, by increasing the average number of drawings from 2,000 to 3,500, by introducing what Falk called a "more natural animation" as opposed to "stiff angular movements," and by substituting titles for balloons—in short, by moving the cartoons away from their comic-strip origins.[34]

Someone had to make those additional drawings, of course, and so the animator who could draw quickly took on added value. Frank Moser was the exemplar. He was yet another newspaper cartoonist; he had worked as one in Des Moines, Iowa, before finding a job of some kind in New York. He evidently did not get into animation until he went to work for the Hearst studio, most likely in its earliest days in 1916.[35] By 1918, when the Hearst operation briefly shared space with Barré's studio in the Bronx (it subsequently moved to Hearst's live-action studio in Harlem), Moser had become famous among animators as a "speed wizard," Dick Huemer said. "He was then considered the best animator in the world—and the highest paid, too—because he could turn out these fantastic amounts of footage; he just slashed the stuff out. Worked on paper, pen and ink...batted it out."[36]

The early animators had inherited, from newspaper comics and magazine cartoons, characters that were drawn and animated as relatively rigid vertical forms. What Falk called "more natural animation" involved not just more drawings—and thus more movement—but also character design with a greater reliance on curves. (The use of curves may even have grown in response to the increased number of drawings, curves being easier and faster to draw.) Vertical forms tend to stutter when they're moving across the screen, whereas curving forms tend to flow. It was, in various accounts, Bill Nolan who first demonstrated the potential in a more curving and pliable kind of animation, but he was certainly not alone. Another cartoonist who later won some credit for such an innovation was Charles Bowers.

Like so many others in the field, Bowers was a newspaper cartoonist until the middle teens, when he entered animation; he was by 1918 a partner in Barré's studio. Bowers's contributions

are hard to assess in the absence of so many films, but there is this praise in an unsigned obituary in a 1947 newsletter of the cartoonists' union (clearly written by some former colleague, possibly Ted Sears, who began working at the Barré studio around 1917): "He was one of the first to eliminate angular stiffness from animation and substitute smooth action based upon the movement of curved forms. He also added perspective and solidity of figure construction to an art that had long been two-dimensional."[37] Such terms could be applied without strain to parts of a surviving Bowers film called *A.W.O.L.*; it appears to have been made not long after the armistice, probably in 1919, as a cautionary tale for restless soldiers.

The small budgets and tight schedules that were so confining to Barré in the middle teens were no less confining later in the decade. When several animators worked on a film, as was increasingly the case, there was typically only the most limited effort to pull their disparate contributions together. While he was with Barré, Dick Huemer said in 1973,

> Barré would hand out the idea of the story. He'd say, "We're making a picture about Egypt this week; have pyramids in it, and sphinxes, and camels."... So, we'd go back to our boards. We would animate for a week—just about a week—cut it off, and then soon it would be spliced together.[38]

The process may not always have been quite that stark, but the animators unquestionably worked with only the most limited kind of guidance—on another occasion, Huemer recalled "a very rough scenario.... Probably on a single sheet of paper, without any models, sketches or anything."[39]

The Barré-Bowers partnership had broken up by the fall of 1918, after Barré suffered some sort of mental collapse.[40] The Mutt and Jeff series itself ended by early in 1923, from all appearances a victim, like other cartoons, of the postwar recession that overtook the American economy in the early twenties. The film industry as a whole was hit hard, but cartoon studios—making a product few people cared about—especially suffered.

A few studios in addition to the Mutt and Jeff operation had enjoyed at least mild prosperity in the years just after World War I. In September 1919, Bray broke with Paramount and began distributing his Pictographs—potpourris that mixed travelogues and nature studies with animated films of various kinds—through Samuel Goldwyn, on a schedule that called for three reels a week,

three times as many as before.[41] In October, the Bray studio announced a deal under which it would make cartoons with such Hearst characters as Krazy Kat and Happy Hooligan; in fact, it planned to package some of the Hearst studio's cartoons with those it made itself.[42] Paramount responded immediately to the loss of Bray's cartoons with cartoons of its own, as part of a weekly Paramount Magazine. Earl Hurd took his character Bobby Bumps from Bray to Paramount after the break, and Frank Moser left the Hearst studio to produce another series for Paramount, Bud and Susie.

Within two years, though, Paramount had first dropped the Magazine, then withdrawn from animation entirely, and the Hearst studio had closed. The Bray studio's role in the film industry—and in animation in particular—was declining rapidly. Goldwyn had acquired what was billed as a "controlling interest" in Bray Pictures Corporation early in 1920,[43] but the Goldwyn-Bray Pictograph ended in 1921, and Bray's alliance with the Goldwyn company apparently ended around the same time. In 1922, Bray began distributing what was now called the Bray Magazine on a "states-rights basis," that is, selling the exhibition rights to regional distributors, a definite step down from his earlier arrangements.[44]

New Bray cartoons starring the revived character Colonel Heeza Liar—a preternaturally vigorous old man who had no comedy in him—were made by George Stallings with the help of two younger animators, Walter Lantz and Clyde "Gerry" Geronimi, who had worked with him at the Hearst studio. As if in testimony to animation's declining popularity, the new films combined animation with live action; the combination work involved blowing up frames of the live-action film so they could be reshot with the character animation on celluloid over them.[45] Bray fired Stallings, Geronimi said, because he "had a habit of coming in late," and put Lantz in charge of the studio's animated films, with Geronimi as his assistant. In 1924, Lantz—who also acted in the live action—laid Heeza Liar aside in favor of a series built around a boy protagonist, Dinky Doodle.[46]

Bray himself had abandoned any active role in production of his cartoons. His interest had shifted away from theatrical films of all kinds and toward films for schools, filmstrips in particular (his company began offering a filmstrip projector in 1924).[47] He was observing the logic of the industrial model he had always followed. For a small studio like his, that logic pointed toward films

that served markets less volatile than theatrical audiences. Otherwise, his ambitions for animation were exactly as limited as they had always been: to hold the number of drawings to a minimum. For a 600-foot cartoon, he told a magazine interviewer, "we manage to get along with only 2,000 to 2,500 drawings"[48]—fewer than La Cava was putting into the Hearst cartoons a half-decade earlier. Bray had no larger ideas for organizing the production of his animated films. There was, however, a predictable concern with the most minor costs. "Walter had charge of the drawing supplies," the animator David Hand said, "and if a pencil wore out, you went to Walter and he gave you one more."[49]

Animation in the early twenties was guttering out much as might have been predicted; the yearning for greater efficiency, exemplified by Bray's pride in the poverty of his product even as his studio slid out of the cartoon business, had triumphed too often. A few cartoon studios did manage to thrive in the twenties, though, even if on a small scale. Their films invited audiences to find novelty not in the medium itself, but in what the cartoonists were doing with it.

J. R. Bray and Max Fleischer met around 1901 at the *Brooklyn Daily Eagle*. Bray was working in the art department and the eighteen-year-old Fleischer was, as Bray wrote in a third-person "History" many years later, a "cub artist, retouching photographs."[50] Fleischer moved to Boston to work for an advertising agency (Bray may have gotten him the job) and later became the art editor of *Popular Science* magazine. He and Bray met again, probably in 1917, at Paramount's offices, where Fleischer was waiting to show a sample cartoon he had produced. According to the "History," "Bray told Fleischer that he had an exclusive contract with Paramount and suggested he show it to him.... Bray agreed to try the cartoon on the public. It immediately was a success, so Bray engaged Fleischer and his brother to make a series at Bray Studios for regular release."

Fleischer had come up with a method that yielded animation that was, like McCay's, far more lifelike than Bray's or that of the other animators of the teens, but Fleischer's method was much closer in spirit to Bray's than to McCay's, because its animation was not really animation at all. It was instead a tracing from live-action film that was projected from below, frame by frame, onto

a glass surface the size of the animation paper. Like Bray, Fleischer sought patent protection: he filed an application for a patent on his method, called rotoscoping, on 6 December 1915. (Like Bray's, Fleischer's application was rejected at first but eventually approved, in Fleischer's case on 9 October 1917.)[51]

Fleischer and his younger brother Dave had tested the new method by filming Dave in a black-and-white clown suit—the distinct patterns made for easier tracing—and it was that same clown who became a continuing character in the Fleischers' cartoons for Bray. Fleischer cartoons began appearing in Paramount-Bray Pictographs by June 1918. The rotoscoping made the desired impression. One early review, of what was probably the clown's first appearance in a Pictograph, described him as "a wonderful little figure that moves with the sinuous grace of an Oriental dancer."[52]

When the Bray studio's production of both entertainment films and industrial subjects picked up after World War I, the two were sometimes combined, as in an animated Pictograph segment that demonstrated how a gasoline engine worked.[53] Max Fleischer's involvement in such films was surely substantial, given not only his background—especially his association with *Popular Science*—but also the infrequent appearances of his clown cartoons; they were subordinate to his other work. It was not until September 1919, when Bray moved his Pictographs from Paramount to Goldwyn, that the clown cartoons, now dubbed Out of the Inkwell, became a series within the Pictographs.[54]

In mid-1921, when Bray's entertainment films were of declining importance both within the studio and in the industry as a whole, the Fleischers set up their own studio.[55] Their timing, and the move itself, may have been dictated by the general slump in animation and the concurrent termination of the Pictograph. The Fleischers first distributed their new Out of the Inkwell series themselves, on a states-rights basis; by sometime in 1922, though, they had signed with a distributor—not one of the major film companies, but Margaret Winkler, a young woman who had just gone into business for herself after seven years with Warner Bros. as a secretary.[56]

The Inkwell films relied heavily on live action, even though the rotoscoping of Dave Fleischer diminished rapidly as the foundation for the clown's actions; rotoscoping is detectable only at the beginning of *Modeling* (1921), for example. Instead, the films presented the clown as a creature who emerged from a live-action

inkwell and played against a live-action cartoonist, Max Fleischer himself. The animation was mostly on paper.

Dick Huemer started animating for the Fleischers, probably in early 1923, when the total staff was, he said, "ten at the most"[57] (it had grown to nineteen by late in the year, when the studio moved to larger quarters at 1600 Broadway).[58] Roland Crandall was the only animator apart from Burton Gillett, who preceded Huemer by only a little and, Huemer said, "got me in there." Before long, Huemer told Joe Adamson, the Fleischers were paying him the impressive sum of $125 a week: "They would get crushes on people, a boss would, and say, 'Oh, this is the best animator in the business, he's a wizard! Can't lose him!' So they would pay him a good salary."[59] It was to make Huemer even more productive that the Fleischers proposed to him, probably in 1924, that Arthur Davis become his assistant.

Davis was to be an assistant in a new sense of the term. By the early twenties, there was wide acceptance of the idea that there was a sort of hierarchy of animation drawings. Winsor McCay himself advocated a "split system" in a correspondence course that Federal Schools published in 1923, telling the students that they should break movement down to single drawings by making a new drawing midway between two others, starting with the two at the beginning and end of a movement.[60] Many other animators were already working in a more sophisticated fashion, by making the most important drawings first and anchoring the rest of their animation in them. The poses that defined a movement came to be called "extremes," the others, "inbetweens," because they were literally in between: they smoothed the transition from one extreme to another.

An alternative adopted by some animators was to work "straight ahead," that is, to start at the beginning of a scene and make one drawing after another. That method could produce animation of a particularly fluid kind, but it also entailed risks—a character could easily grow or shrink over the course of a scene— and it was by no means the norm in the twenties; as Dick Huemer said, "We worked from pose to pose with inbetweens." The animators themselves drew the inbetweens, though, and it was that procedure that the Fleischers proposed to change in Huemer's case by making Davis a sort of subanimator who would draw the inbetweens for Huemer's scenes. "It was their idea.... They talked me into it," Huemer said in 1973. The Fleischer animators inked their own drawings, on paper ("You wouldn't dare

let anybody else touch your precious stuff," Huemer said), and so Davis, as Huemer's inbetweener, inked the inbetweens, adhering to Huemer's style.[61]

Huemer worked very little with Max Fleischer. "Max and Dave went off by themselves and thought up the stories," Huemer said, "some basic idea of the clown, say, getting involved with a masquerade party.... They would also then go off by themselves and shoot the live action." Once it was shot, Max was no longer involved. Dave Fleischer, on the other hand, "would come sit next to an animator, and they would talk.... Not writing anything down, just talk—a private gag meeting. That was the only preparation for the animation."

The Fleischer studio was in that respect much like Barré's Mutt and Jeff studio, where Huemer had worked not long before. What distinguished the Fleischer cartoons from Barré's, and from most other studios' cartoons, was their reflexive nature; whatever their ostensible subject, they were always cartoons about what it was like to be a cartoon. That self-awareness sometimes extended beyond the characters—the clown, called variously KoKo or Ko-Ko, knew he was made of pen and ink—to the filmmakers themselves. *Cartoon Factory* (1925), for instance, is built around the idea of mechanization, which embraces even the production of multiple Maxes (cutout photos of Max in a tin-soldier suit). Max appears in stop motion at the start, pressing levers to stir up all his drawing tools.

Max Fleischer had, of course, worked at J. R. Bray's side for several years, and he may have taken the industrial model all too seriously. He set up his own distributing organization, Red Seal Pictures Corporation, in 1923, and by 1925, Red Seal was releasing monthly "featurettes" that included not only the Fleischer Inkwell cartoons and Song Cartunes (the latter were film versions of the song slides that had been part of theater programs for decades), but also a variety of live-action shorts. Red Seal released 141 shorts in 1925, as opposed to only 26 in 1924.[62]

It was clearly too much. In October 1926, Max Fleischer asked for appointment of a receiver in bankruptcy, contending that, despite Inkwell Films' solvency, "the action of a film laboratory has forced it to seek the protection of the courts to work out its problems."[63] In November, Alfred Weiss, a film-industry veteran, bailed out Red Seal and Inkwell Films, paying $218,000 of the firms' liabilities and becoming president of both.[64] Paramount announced in May 1927 that it would begin releasing the Inkwell

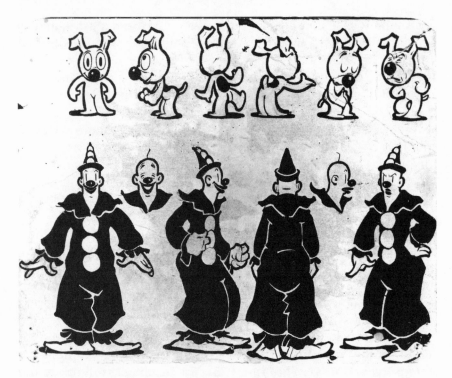

A model sheet of KoKo the clown and his canine sidekick Fitz, drawn sometime in the late twenties by Dick Huemer. © *Fleischer Studios; courtesy of Dick Huemer.*

cartoons, which were to be "presented" by Weiss but "produced" by Fleischer.[65] The Red Seal episode ended, as Dick Huemer told Joe Adamson, "in the backer [Weiss] taking over the whole thing, and Max being ousted.... However, they weren't able to get the clown away from Max. So he set himself up over [in Long Island City], opened a little studio and continued making song cartoons."[66] That apparently happened around the beginning of 1929 and was the occasion for the formation of a new corporation, Fleischer Studios, in May 1929.[67] When the Fleischers moved back to Manhattan in October 1929, a *Film Daily* announcement said that their studio had "no connection whatsoever with Out-of-the-Inkwell Films, [*sic*] Inc."[68]

Despite such distractions, at least some of the Fleischer cartoons had passed beyond mere self-awareness to become as knowing in their handling of animation's properties as Buster Keaton's live-action comedies were in their examination of film itself. They employed metamorphosis—a device integral to ani-

mation since the earliest animated films—with an unprecedented relish. In *KoKo the Kop* (1927), Fitz the dog, fleeing after he has stolen a bone that Max has drawn, "hides" by becoming a window with a girl hanging out of it (he turns back into himself as KoKo kisses the girl). But, more striking, objects repeatedly change their nature without changing their appearance. The characters lift up and rearrange seemingly solid and immovable background elements, as if they were stage props. Thus rearranged, the background elements again appear to be fixed in place—as in fact they are. In the same manner, Fitz picks up the front half of a large rock; the remaining half appears to be a hole—and thus, it is one, which Fitz escapes into. Appearances are simultaneously true and false.

Cartoons like *KoKo the Kop* seem not to have emerged from any systematic exploration of the medium, but to have grown out of the contradictions built into the way the Fleischers made cartoons. For all that they adhered to a Bray-like model in so many ways, they did not follow through; at crucial points there was an abrupt transition from industrial efficiency to a much looser and more eccentric sort of filmmaking.

A few animation drawings from the Inkwell films have survived,[69] and on the evidence of those drawings—and the films, too—the Fleischers manipulated paper far more intricately than did other animators who put the paper animation drawings under the camera, as opposed to tracings of those drawings on celluloid. Working with paper drawings alone was much more restrictive than working with cels. Animators could, by tearing the paper, achieve only some of the flexibility that cel animation offered. Putting the characters on cels eliminated the need to worry about the characters' disturbing the backgrounds (at least as long as the drawings on the cels were opaqued, or painted, as they almost always were). Animators who worked with paper could never shed that worry. On the other hand, cel animation could match some of paper animation's virtues, since animators could divide individual drawings among more than one level of celluloid; a moving character or part of a character could be on one sheet and a stationary character or body part on another. Stacking sheets of celluloid in that manner produced noticeable differences in paint color—a white or gray seen through three sheets of celluloid was darker than a white or gray on top of the pile—but that was a minor annoyance compared with the time saved by not having to trace drawings that did not change from one exposure to the next.

Cartoon makers who stuck with paper because of its lower cost or more handsome appearance (the inked lines on cels tended to be crude-looking compared with the inked drawings on paper) still used cels to some extent, particularly for background overlays. But although the Fleischers put KoKo on cels over rear-projected frames from live-action film whenever the clown left the drawing board (the Rotograph, a device of Max's invention, yielded results similar to those in the Bray films made by Walter Lantz), they resorted to cels seldom if ever in the pure cartoon sections. There, the Fleischer staff tore and cut the paper animation with an ingenuity that probably became an end in itself. "Some of it was like lacework," said Al Eugster, who started work at Fleischers' in 1929. "I don't know how the cameraman ever handled that."[70] It is impossible to believe that the other studios' methods were not more efficient.

The Fleischers also worked without exposure sheets, a tool in use at some studios since the middle teens;[71] such sheets told the cameraman how many exposures, or frames of film, should be devoted to each drawing. Instead, as Roland Crandall wrote a few years later, "most of the planning, matching and timing was done under the camera"[72]—a practice no doubt mandated by the paper animation's complexity, and one at war with anything like efficient production. Similarly with their assigning Art Davis to Huemer to draw his inbetweens: however sensible such a move might have been, considered in isolation, as a way to increase Huemer's production, it probably would have made more sense, in those terms, had it been combined with careful planning of what Huemer was animating.

There is in the Inkwell cartoons continual friction between a rigorously mechanical approach to animated filmmaking, on the one hand, and an utterly whimsical, not to say careless, attitude toward stories and animation, on the other. As in Huemer's recollection, it seems in the films that Max Fleischer is in charge up to a point and then Dave Fleischer takes over, their radically different temperaments governing different aspects of each film. Thus it is that KoKo—clearly more Dave's creature than Max's—is constantly testing and poking at the mechanical apparatus that is Max's preserve and that (as the film is at pains to show) makes the clown's very existence possible.

In only one other series of cartoons in the twenties was there the same sort of examination of the medium, with the difference that in the other case a single sensibility was in charge. It is Otto

Messmer's Felix the Cat cartoons that reveal most clearly just how much—and how little—a creative animator might accomplish within the confines of the silent cartoon of the twenties.

Pat Sullivan, an Australian-born newspaper cartoonist, was making animated cartoons with the character Sammie Johnsin, a black child, by early in 1916, working with at least two assistants.[73] Sullivan's career over the next few years was erratic, like himself (he was imprisoned for nine months in 1917–18 on a rape conviction),[74] but by the fall of 1919, he was making cartoons for the weekly Paramount Magazine. Like Earl Hurd and Frank Moser, he helped fill the gap left in Paramount's program after Bray decamped with his Pictographs. When Sullivan signed a contract with Paramount in March 1920, one of the specified subjects of his cartoons was a black cat, Felix, who had been introduced (as "Master Tom") in a Paramount Magazine cartoon called *Feline Follies*.[75]

Sullivan was hit hard by the 1921 slump that brought an end to the Paramount Magazine and then to all of Paramount's cartoons. He emerged from the wreckage with ownership of his character, but at first he had no place to go with Felix. By late in 1921, though, he had become Margaret Winkler's client, even before the Fleischers signed with her. *Felix Saves the Day* was released in February 1922 as the first free-standing Felix cartoon.[76]

Sullivan was an animator—he learned the trade at Barré's studio in the middle teens—but he was, to judge from such surviving evidence as his 1919 Bray cartoon called *Origin of the Shimmie*, never a very good one. He was, besides, an alcoholic. By the early twenties, he had abandoned even a supervisory role to Otto Messmer, a younger man who had worked with him as a subordinate since the Sammie Johnsin days. The Sullivan studio moved around Manhattan in the twenties, from Forty-second Street to Sixty-fifth Street near Lincoln Square, and finally, for most of the decade, to Sixty-third Street near Broadway.[77] Although Sullivan had a small office off the large second-floor workroom that made up most of the Sixty-third Street studio, he rarely came there.[78] As Messmer said, "Once he had the studio going, that was it. He just owned it."[79]

Throughout the twenties, Messmer said, "there was never more than one animator helping me," plus assistants (some of

whom probably did some animation as well) and the cameraman.
Messmer made layouts—rough sketches showing the other car-
toonists what the backgrounds should look like—and he animat-
ed, he said, "at least 70 percent" of each cartoon. He was also the
series' de facto writer: he made up enough titles for a year's out-
put, and those titles dictated the general shape of the stories.
"Since you had given the titles," he said, "it was easy to concen-
trate." Al Eugster, who traced the pencil animation drawings in
ink, said he "never did see a script. Otto used to have maybe some
small notes—small pieces of paper—and the rest of it in his head.
When an animator finished a sequence he'd come over to Otto
and pick up some more work, and then ad-libbed.... They'd sort
of gag it up as they went along."[80]

The Felix cartoons were Messmer's creations far more than
Sullivan's, but it was only Sullivan's name that appeared on the
cartoons and in publicity for them. Messmer admitted that he was
frustrated "a little bit" at not getting screen credit for the Felix car-
toons. "But, you see, it was kind of a contented feeling that what
we're doing is going; it's a nice feeling. A feeling of security."[81]
Such passivity was extraordinarily convenient for Sullivan, who
reaped not only all the glory but also, of course, most of the
money that the cartoons generated.

There was soon plenty of both. Like the Fleischers' Inkwell car-
toons, the Felix cartoons met the requirements of the more
demanding theatrical environment of the middle twenties. There
is abundant evidence—in everything from warm trade-paper
reviews to licensed toys to Buster Keaton's unmistakable parody
in *Go West* of Felix's ruminative pacing—that critics and audi-
ences recognized the cartoons' superiority to most of what had
gone before. As the Fleischers did in 1923 when they set up Red
Seal, Sullivan left Margaret Winkler for what promised to be a
more lucrative distribution arrangement, in Sullivan's case with
Educational Film Exchanges: for the 1925–26 season, he commit-
ted himself—and Messmer, of course—to producing a new car-
toon every two weeks.[82]

So popular had Felix become that Winkler, after losing the Felix
series, started a competing series with a feline star: she got the
rights to Krazy Kat, absent from films since the teens. After the
demise of the Hearst studio, Bill Nolan had worked for two or
more years as what Messmer called his "guest animator"; Nolan
began making the Krazy Kat cartoons for Winkler at a studio in
Long Branch, New Jersey, in the summer of 1925.[83]

A healthy percentage of the Felix cartoons have survived, and it's not readily apparent from many of them, particularly those from early in the decade, what aroused so much enthusiasm. Cartoons like *Felix Goes Hungry* (1924) are basically a stream of loosely related incidents, resembling in that respect short comedies like Keaton's *The Goat*; Felix occasionally mugs at the camera in closeup, taking his audience into his confidence as if he were a second-rate comedian in live action. Broaden the sample, though, and the basis of Felix's appeal becomes clearer.

In *Oceantics* (date uncertain, but probably 1925), Felix wants a round of Swiss cheese in the window of a grocery store. He reaches with his prehensile tail toward what appears to be a distant house, but when he lifts the front door off the house, it remains the same tiny size as Felix brings it toward the grocery. He places the door, still tiny, under the grocery's window, opens the door, reaches through the doorway up into the display space, and removes the cheese. He then takes the round of Swiss to a billboard that advertises player pianos, cuts the cheese into a thin strip, like a piano roll, and runs it through the piano on the billboard, producing music. By seizing the door, Felix collapses the illusion that the screen is a three-dimensional space; but he then insists that his audience accept the illusion represented by the billboard. He does both quite elegantly, without any hesitation or awkward transitions.

It was thanks mainly to Felix himself that Messmer's cartoons surpassed the Fleischers' Inkwell cartoons, which they otherwise so much resembled, in the piquancy of their continual scrutiny of the peculiar characteristics of the animated screen. More so than KoKo, Felix had the rudiments of a personality; the cartoons focused not entirely on sly transformations, but also on Felix himself—he was curious and rather hard-boiled—as he instigated and responded to them. Because Felix was wholly Messmer's creature, he could act as a surrogate for both his creator and the audience, exploring on their behalf a strange and treacherous place. Given the sharply different interests that Max and Dave Fleischer brought to their cartoons, there was no way that KoKo could play a comparable role.

Felix was rather square and angular in his early appearances, differing from earlier cartoon characters mainly in the simplicity of his black body. Here Messmer had a stroke of luck: Bill Nolan, when he was Messmer's guest animator, brought with him the drawing and animating style he had adopted at Hearst, the style

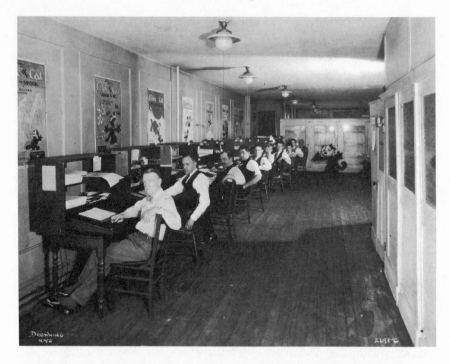

Pat Sullivan's Felix the Cat studio in the middle twenties. Sullivan himself is seated at the far left, in what was normally Otto Messmer's place; Messmer is to Sullivan's right, and to Messmer's right is Raoul Barré, once the co-owner of the Mutt and Jeff studio but by then Messmer's "guest animator." Courtesy of Al Eugster.

that emphasized curves rather than straight lines. Felix reflected Nolan's presence by becoming a more rounded, and thus more immediately appealing, character. In his circular construction, as well as in the general simplicity of his design, the revised Felix was a character who facilitated animation in a way that most earlier characters had not; KoKo's design, with its floppy clown suit, was fussy by comparison.

Through Felix, Messmer led the eye away from the many elements that his cartoons shared with the failed series of the early twenties. As it so often did—because the background drawings, on torn paper or celluloid overlays, framed the action—the use of paper animation in the Felix cartoons encouraged dull, uniform staging, in medium to long shots, with few closeups. The Felix cartoons also looked rather stark in their lack of grays, another by-product of paper animation; almost everything was pure black or white, except for celluloid overlays with gray areas. It was in

their animation, though, that the Felix cartoons were most reveal-
ing about the circumstances in which animated cartoons were
being made in the twenties.

Despite the speed and regularity that the Sullivan studio's out-
put required, it remained at its heart a one-man operation.
Messmer differed greatly as an artist from Winsor McCay—
Messmer was wholly a cartoonist, whereas McCay drew in an
elaborate illustration style—but as filmmakers they worked much
alike. They did as much of the work themselves as they could,
delegating and taking shortcuts as little as possible. In Messmer's
case, though, the schedule's pressure meant that he had to dele-
gate and take shortcuts much more often than McCay did.
Besides having people like Eugster trace the pencil drawings in
ink, he met some of the pressure for production by animating fre-
quently on twos (although "if it was running, or falling," he said,
"you had to have it on ones") and relying heavily on what were by
then the customary devices for economizing on animation: held
drawings, cycles, repeats.

Such expedients, useful enough in individual cases, were dam-
aging in their cumulative effect: the animation in the Felix car-
toons is almost never more than functional, and the cartoons sag
badly when what is actually on the screen counts for more than
the thought behind it. That is why Messmer's fantastic transfor-
mations are most effective when they emerge incongruously in
an otherwise "normal" setting, as with the grocery store in
Oceantics. In a full-blown fantasy sequence where everything is of
a piece, like the hallucinations the drunken Felix endures in *Woos
Whoopee* (1928?), the films' limitations loom larger. As ingenious
as he was, Messmer could make cartoons only by compromising
right up to edge of mediocrity.

Messmer enjoyed as much freedom as he did only because he
worked inside the cocoon of Sullivan's indifference; for all the
apparent injustice of their arrangement, Messmer may have
known that there were no other circumstances under which he
could be so fully immersed in what really interested him. His
speed and efficiency were the price he paid for that privilege.

Other cartoonists viewed speed and efficiency very differently:
they were what cartoonists had to provide if they were to be taken
seriously by the larger film industry. The cartoon producer in the
twenties who most successfully accommodated himself to the
industry's demands was not Pat Sullivan or Max Fleischer, but
Paul Terry.

Terry had left Bray's studio by early in 1917, when he sold a cartoon with his character Farmer Al Falfa to the Edison company; then he made a few parodies of feature films before entering the army. After he was discharged in 1919, he supervised Paramount's cartoons until he struck a deal the next year to make an Aesop's Fables series. Terry's first contract was with an actor and screenwriter named Howard Estabrook, who actually came up with the idea for the series; Terry made only a few cartoons, though, before Estabrook sold his contract to Fables Pictures, Inc., a company formed late in 1920 to produce the cartoons.[84] Terry said many years later that he owned only 10 percent of Fables Pictures; ownership was mostly in the hands of the Keith-Albee vaudeville circuit, which could guarantee playing dates in its theaters.[85] Pathé scheduled the release of the first of Terry's Fables for 19 June 1921.[86]

Theater owners still wanted short subjects for the sake of a "balanced program," but the industry's economics, centered now on features, dictated that those short subjects be made quickly and cheaply. Accordingly, the Fables moved through the new studio on a rigorous schedule that saw one cartoon completed every week. Terry's account book for 1923–25 indicates that during the first week of a three-week schedule, John Foster, a veteran of the Barré studio, worked on the story for a new cartoon; the second week, Frank Moser and other experienced men animated; the third week, less experienced men finished up. This torrent of work came from a staff that usually totaled only seventeen or so.[87] Terry put the character animation on cels, over background drawings on paper, as Bray had since the midteens—a far from automatic choice in the early twenties, when studios like Sullivan's were doing exactly the opposite. Although using cels for the animation was initially more expensive than using paper, cels could be washed and used again, and turnover would have been rapid on a once-a-week schedule.

The Felix cartoons were surely more popular than the Fables, but popularity is always fragile, as the short-lived careers of live-action movie stars had already demonstrated many times. Moreover, Sullivan's indifference, however useful it was to Messmer in some ways, held its hazards, too: Messmer recalled that Sullivan resisted making changes in the studio—using cels for more than overlays, for instance—by saying, "You don't change when you're making money." Terry had a much firmer grasp of the industry's realities.

It was Terry, far more than Bray, who established cartoon production on an industrial basis. The key to his achievement did not lie in how efficient he was at producing the cartoons, although in some ways he clearly was efficient: Terry's characters, most of them animals, were usually so brutally simple in design that they could be drawn and traced onto cels swiftly even by inexperienced help. Neither Terry nor any other cartoon producer of the teens or twenties ever devised a sophisticated division of labor, though; in that respect, the cartoon studios lagged far behind the live-action producers. Instead, Terry achieved efficiency on the screen itself by using shortcuts of all kinds, and with unprecedented vigor.

Every other cartoon maker had used shortcuts, to be sure, starting in the teens, but a filmmaker like Bray had used shortcuts without regard to what the results would look like. It was because he leaned so heavily on held drawings, in particular, that his cartoons were unappealingly stiff. It took Terry only a year or so to shake off such influences. After that, he relied much more than his predecessors had on those shortcuts, like cycles and repeat animation, that put his characters into motion. Like so many makers of live-action slapstick comedies before him, he attacked his audiences with the equivalent of brute force: furious activity, unmotivated violence. Such cartoons commanded an audience's attention, if not necessarily its admiration; they were plausible ingredients in a theater's program, as cartoons of the old Bray kind no longer were. There was visible in Terry's Fables a future of the kind that Bray had aspired to but never really achieved: one in which cartoons were a fungible product, appearing with great frequency and on a regular schedule.

As raw as the individual Fables inevitably were, the weight of the series as a whole—a new one every week!—could not but impress aspiring producers of animated films. One young cartoonist who admired Terry's work first saw the Fables in Kansas City, Missouri, in the early twenties. "Even as late as 1930," Walt Disney said, "my ambition was to be able to make cartoons as good as the Aesop's Fables series."[88]

In 1921, when Walter Elias Disney was only nineteen years old (he was born in Chicago on 5 December 1901) he was working as a cartoonist at the Kansas City Film Ad Company, which

produced advertisements that were shown at local theaters. He was the fourth son of a frustrated striver who had moved his family around the Midwest, from Chicago to Marceline, Missouri, to Kansas City and back to Chicago again, trying to succeed at one business after another. Walt had by his middle teens settled on cartooning as the career he wanted; his only formal art instruction was a cartooning course at the Art Institute of Chicago. He drove an ambulance in France after World War I and then returned to Kansas City, where the family still owned a house.[89] At Kansas City Film Ad, Disney and other cartoonists made cutout figures, riveted at the joints, that were manipulated under the camera in a primitive form of stop-motion animation.[90]

Even then, Disney wanted to be in business for himself. Fred Harman, another Film Ad cartoonist, later wrote that he and Disney "secretly rented a studio, bought a used Universal movie camera and tripod and a second-hand Model T Ford coupe," and tried to shoot film for the Pathé newsreel of the third American Legion convention, held in Kansas City from 31 October to 2 November 1921.[91]

Animation was also part of their plans. "They were determined they were going to quit as employees and become their own Paul Terrys," Fred's younger brother Hugh said. Like Bray and the Fleischers before them, Disney and Fred Harman based their first animated film on a drawing that came to life. That cartoon—they may never have finished it—was called *The Little Artist*, Hugh Harman said, "and it was nothing more than an artist, a cute little fellow, standing at his easel, and he was making a picture, and as I recall it came to life on his easel."[92]

Fred Harman had given up on the fledgling studio by the time that Rudolph Ising answered a newspaper ad for an artist, probably early in 1922. The studio was still called Kaysee Studios, the name Harman and Disney had given to their unsuccessful business; the staff consisted of Disney and a camera operator, Red Lyons. "When I started at Kaysee Studios, they weren't making anything I can remember," Ising said fifty years later, "except probably a sort of news thing for the Newman theater."[93]

The "news thing" was a recurring reel called Newman Laugh-O-grams—in effect, a filmed editorial cartoon, the Newman name taken from the small local theater chain that showed it. In the one surviving example—the first such reel, made in February or March 1921 and the earliest extant animation by Disney himself—Disney appears as a "lightning sketch" artist, drawing commen-

taries on local events; there is a little animation only at the end, in a bit about a scandal in the Kansas City police department. Policemen walk in simple, identical cycles (only their heads differ), and as they're thrown out of the station house, they're cutouts of the kind Disney was familiar with.[94]

Learning how to produce even such crude animation was not easy in Kansas City. Disney himself wrote in 1937 that his first source of information on animation was a book by Edwin G. Lutz, *Animated Cartoons: How They Are Made, Their Origin and Development*, "which I procured from the Kansas City Public Library."[95] That book, published in 1920, is essentially a compendium of labor-saving techniques of the kind Terry started using so aggressively in his Fables the next year. Hugh Harman, who began working for Disney in the summer of 1922, confirmed that "our only study was the Lutz book; that, plus Paul Terry's films.... We used to get them at the exchange, through a girl who worked there...and take scissors and clip out maybe fifty or seventy-five feet.... We learned a lot from Terry."[96]

Disney incorporated as Laugh-O-gram Films—and may have quit his Film Ad job—in May 1922, around the time he moved his studio to the second floor of the new McConahy Building at Thirty-first and Forest and began expanding his staff. By his own account, he had already spent six months or so making a version of *Little Red Riding Hood* at night with the help of several unpaid "students" who were learning animation from their unlettered instructor (work that evidently took place before Ising was hired).[97] Now he planned to move ahead with a series of such short cartoons.

As he launched his new company, Disney put up a brave front in the trade press. He announced Laugh-O-gram's formation in June 1922 with the promise that "the plan of distribution" would be revealed "shortly."[98] In August, Leslie Mace, Laugh-O-gram's sales manager, and Dr. J. V. Cowles, its treasurer (and principal financial backer), were in New York, where Mace was "arranging for distribution of a series of twelve Laugh-O-grams to be released every other week."[99] In fact, distributors were not much interested—hardly surprising, given the chilly climate then, even for established cartoon producers. The films themselves, however many Disney was able to show to potential distributors, could not have been much of an inducement. As Terry used Aesop as the loose frame for his series, so Disney used fairy tales. What his cartoons lacked, though, to judge from three that survive, was Terry's

economy of both means and narrative. For example, in *Puss in Boots*, a modernized version of the original story is laboriously worked out, and the animation has much the same quality: earnest and careful, much of it on ones.

In September 1922, Mace finally sold a series to a Tennessee company called Pictorial Clubs, for distribution to schools and churches. The Pictorial Clubs contract was bizarrely one-sided, probably reflecting Disney's eagerness to make some kind of national distribution deal: Pictorial Clubs made only a hundred-dollar down payment, with the balance of eleven thousand dollars not due until 1 January 1924. As it turned out, Disney delivered the six contractually required cartoons by late in the fall of 1922, but Pictorial Clubs, in its Tennessee incarnation, went out of business soon after, long before the eleven thousand dollars was due. It transferred its assets, including the cartoons—but not its liabilities—to a New York company bearing the same name.

The Laugh-O-gram staff scattered after the company ran out of money to pay them, but in the spring of 1923, with bankruptcy looming, Disney pulled some of them back together to make a new film, *Alice's Wonderland.* He emulated the Fleischers' combination of animation and live action in the first part of the film, introducing cartoon characters into the real world as the Inkwell films did (the setting is the Laugh-O-gram studio, with Disney on screen in a Max Fleischer-like role), but then he added a reverse twist: he inserted a real girl, four-year-old Virginia Davis, into "Cartoonland." Of Disney's surviving Kansas City cartoons, it is *Alice's Wonderland* that most closely resembles an Aesop's Fable. When Alice arrives in Cartoonland, there is a welcoming parade with a great variety of animals, all moving in cycles and repeats; they instantly evoke Terry's films.

Disney began trying to interest distributors in an Alice series in the spring, but he had not succeeded by the time *Alice's Wonderland* was finally completed in the summer of 1923. He left late in July for Los Angeles, drawn there by the presence in California of his older brother Roy (a World War I veteran who was recuperating from tuberculosis at a government hospital) and an uncle. He took with him *Alice's Wonderland* as a sample reel, but left behind Laugh-O-gram's camera stand and other equipment in the back room of a hardware store whose owner, Fred Schmeltz, had taken the equipment as collateral for his loans to the company. Hugh Harman, Rudy Ising, and another veteran of Laugh-O-gram, Carman G. "Max" Maxwell, presenting themselves

as Arabian Nights Cartoons, used that equipment to make a cartoon of their own, *Sinbad the Sailor*.[100] Their film was eventually shown for three nights in October 1924 at the Isis theater, as a test, but that was the extent of its theatrical exhibition.[101]

Disney had better luck. While he prowled the movie studios, looking for a job of some kind in live action (all the cartoon studios of consequence were still in the East), he sent *Alice's Wonderland* to New York, where a film-storage company screened it for any distributors who showed interest. In October 1923 he struck a deal with Margaret Winkler, who as the distributor of the Felix and Inkwell series already had almost two years' experience handling cartoons. She was about to lose the Inkwell series to Red Seal, though, and she was, moreover, in the midst of an acrimonious dispute with Pat Sullivan, who already wanted to take the Felix cartoons elsewhere for more money; signing with Disney was a sort of insurance policy. Winkler offered to pay him fifteen hundred dollars for each film, the first to be delivered by 15 December 1923.[102] Disney had rented a tiny studio space two blocks from his uncle's house and had bought a used camera for two hundred dollars. He immediately began work on the animation for a new film, and he offered a contract to the parents of Virginia Davis, his *Alice's Wonderland* star; the Davis family moved to Los Angeles quickly enough that Disney missed his very tight delivery deadline by only eleven days.[103]

If the other animation studios of the early twenties were mostly pocket-sized, the new Disney Brothers Studio was the tiniest of the lot, consisting at first only of Walt and Roy (who shot the live action that Walt directed). The Alice Comedies, as they were called, were not really cartoons at all, but rather live-action comedies with animated inserts. They strongly resembled Hal Roach's Our Gang series, with certain children, like a fat boy, turning up in one film after another; Virginia Davis herself, with her blonde curls, suggested a miniature Mary Pickford. The animation in the earliest Alice Comedies, by Disney himself, was equally derivative: it recalled the Fables, only it was even more oppressively loaded with shortcuts (so that, for example, a character's body is noticeably rigid while its head or perhaps just its eyes move).

Disney slowly expanded his staff as the Alice Comedies established themselves. In February 1924, he hired Rollin Hamilton as the first cartoonist on his California staff; and in July, he lured west Ubbe Iwwerks (or, more frequently, Ub Iwerks), an

From Walt Disney's Alice's Wonderland (1923), the last film he made in Kansas City, with Virginia Davis as Alice.

animator whom he had known since they worked together briefly in a Kansas City commercial-art studio in 1919. Iwerks and Disney had been colleagues at Kansas City Film Ad after that, and Iwerks had then worked for Laugh-O-gram. He was back at Kansas City Film Ad when Disney persuaded him to move to California.[104]

Alice the Peacemaker—the first Alice on which Iwerks animated, immediately after his arrival in California—showed some improvement in drawing and animation, especially of the human characters; it was with *Alice the Peacemaker*, too, that the live action became a true framing device, and the animation the clear center of interest. Now that he at last had a strong animator on his staff, Disney moved swiftly into making real cartoons. By the time the tenth film in the series, *Alice the Piper*, was released in December 1924, there was no live-action framing story, only live action combined with the animation (more smoothly than before).

The comic thinking in these films was still at a sub-Fables level;

Disney was so far from mastering his medium that he was vulnerable to jarring accidents. In *Alice the Piper*, rats pour out of a king's nightshirt in cycle animation, but there are too many of them, and their regular flow suggests bodily emissions. Slowly but surely, though, Disney was mastering lessons from the cartoons made by more experienced producers and sometimes improving on their work. *Alice Solves the Puzzle*, released early in 1925, offers an enhanced version of what was already a stock cartoon gag: a character doesn't fall until he realizes he has lost his support. Julius, Alice's feline sidekick, pauses as he climbs a pulley rope, puffing and wiping his brow until he sees that he has pulled the rope completely over the pulley; he gestures down for the rope to come up and then grasps at the pulley above him, before he finally falls. Julius owed his presence in the Disney films to Felix, and he finally gets to the top by using his tail as a spring, very much as Felix might have done, but it is the general purposefulness of the comic business that most clearly invites comparisons with the Felix cartoons.

In June 1925, Hugh Harman and Rudy Ising—their hopes for a cartoon series of their own in abeyance—moved west to join Disney's staff. With more animators on his staff, Disney began putting more animation into the films, and Alice disappeared from each Alice Comedy for long stretches. In *Alice's Orphan*, made late in 1925, Alice (now played by Margie Gay) was present in only two scenes, making awkward and meaningless gestures that could have been combined with animation of almost any kind.

By now Disney really was the director of his films; that title fit him more snugly than it did any of the other cartoon makers who might have claimed it in the twenties. Disney no longer acted in his films (as Lantz did) or animated for them (as Messmer did); free of such distractions, he could devote more time to controlling those things that a director most needed to control, in particular, the shape of the stories and the pacing of the films. Rudy Ising said that Disney "was the one who really sort of put the story together" and assigned sequences to the animators; once those sequences had been animated, Disney made out the exposure sheets that guided the cameraman—specifying, for example, how many times a cycle was to be repeated (the cameraman himself might have made such a decision in the Laugh-O-gram days).[105]

"He was always thinking and acting pictures," Ising observed. "The cartoon medium, I think, was an expedient back then.... I

think he really would have liked to have been in live pictures, but cartoons sort of overwhelmed him."[106] By 1925 Disney was beginning to sense in animation opportunities of a kind that he might have thought existed only in live action. To seize those opportunities was, however, a forbidding task for a filmmaker not yet twenty-four years old. Moreover, Disney was surrounded by people who were concerned with opportunities of other kinds.

After Harman and Ising moved to Los Angeles, they and Disney "were together practically every night of the week," Ising said.[107] Harman remembered the same sort of camaraderie, rooted in everyone's intense interest in the cartoons: "We would do nothing after dinner but start thinking of stories and acting them out."[108] The three men shared not only youthful enthusiasm (both Harman and Ising were born in August 1903, not quite two years after Disney) but also youthful ambition. Harman and Ising were just as determined as Disney had been to go into business for themselves. In August 1925, barely six weeks after they joined Disney's staff, Ising wrote to their friend Ray Friedman in Kansas City: "We think that in a year we will be able to begin production on our own pictures with the experience and information we are gaining here."[109]

Disney's staff was thus a fragile asset; so was his relationship with Winkler Pictures. Margaret Winkler had married Charles Mintz in November 1923, shortly after making her deal with Disney, and within a few months, it was Mintz, rather than Winkler, who was corresponding with Disney, usually in a harsh, hectoring tone. Disney was increasingly important to Winkler Pictures in the middle twenties, when it lost first the Inkwell cartoons and then Felix, and that may have been why Mintz browbeat him so mercilessly. From the start, the final editing of the Alice Comedies was not by Disney but by Winkler Pictures; it was as an editor that Margaret's brother George spent at least part of 1924 at the Disney studio, and Mintz told Disney in October 1925 that it was to George Winkler that he owed his studio's survival.[110]

By then, though, the balance of power had started to shift. In a 17 November 1925 letter, Mintz lectured Disney about how single-reel subjects were failing. A week later, he took exactly the opposite tack: he was trying to talk Disney into waiting for his share of

the proceeds from the Alice Comedies until Winkler Pictures had received fifteen hundred dollars on top of its costs, and he told Disney that substantial grosses were assured. Disney—his backbone stiffening—persisted until Mintz finally agreed to give him more money.

Disney could now afford to move to larger quarters—and did, on a rainy day in mid-February 1926, to a building at 2719 Hyperion Boulevard, on the eastern edge of Hollywood.[111] The furnishings of the new studio reflected the Disneys' tentative new prosperity. "Walt's office looks like a bank president's loafing room," Ising wrote to his family two months after the move.[112]

Disney had started giving his animators a bonus for finishing a cartoon in two and a half weeks, but when they earned the bonus on six films in a row, he wanted to put them on a two-week schedule.[113] Such irritants did nothing to discourage Harman and Ising from pursuing their own ambitions. By the summer of 1926, they were approaching distributors about getting their own release. They expected to hire away Disney's other two animators, Iwerks and Rollin Hamilton. "This will leave Walt in a mellavahess [sic]," Ising wrote to Max Maxwell, "but business is business."[114] When the Disney studio closed for vacation in September 1926, Harman and Ising, working with Iwerks and Hamilton, made a second Arabian Nights cartoon, *Aladdin's Vamp*, in offices they had rented for two weeks.[115] (The cartoon, which miraculously still exists, has a cast made up of cats.) They were no more successful than before in finding a release.

Harman and Ising were going to pay Iwerks seventy-five dollars a week, or twenty-five dollars more than they planned to pay themselves. Iwerks had become a sort of West Coast equivalent of Frank Moser, the fabulously fast New York animator, but he was not merely fast, he also created patterns of movement that less dexterous animators could follow. Ising did not animate on his own at Disney's but instead followed Iwerks's layouts, which indicated how a character should move across the screen by means of circles for the head and a line for the tail "and maybe some of the feet," plus an occasional drawing of the full figure, all on a single sheet of paper. Ising used that sheet as his guide as he made multiple animation drawings: "You just followed the lines that he had already put in."[116]

Iwerks's influence is clearly visible in a film like *Alice the Fire Fighter*, released in October 1926. Its cycle animation is strikingly proficient, if just as strikingly obvious. Here, though,

Walt Disney and the three principal members of his staff pose around 1926 at the outdoor set where the live action for the Alice Comedies was filmed. From left: Walt Disney, Rudy Ising, Hugh Harman, and Ub Iwerks. ©Disney Enterprises, Inc.; courtesy of Rudy Ising.

Disney used that mechanical quality to advantage. Julius—or one of a large number of identical fireman cats—takes a puppy from the window of a burning building; he hurls the "rescued" dog four stories to the ground, then does it again and again, with two more unfortunate mutts. The rhythm the cycle animation establishes— its very matter-of-factness—actually enhances the comedy.

The comedy in the Alice Comedies continued to be more often rough and even cruel, based on physical damage rather than witty transformations of the Felix kind. There was growing evidence within the films themselves, though, that what was involved was less a failure to comprehend what Messmer was doing than a rejection of it. Disney was groping toward some alternative kind of animated comedy. Rudy Ising recalled that the Winklers encouraged Disney "to study Felix and get some of that funny stuff. You know, he would take the top of his head off, and an idea would come out, or his tail would go up and form a question mark. We all thought that was kind of corny."[117]

For all the traces of personality that Felix showed, Otto

Messmer never let his audience forget that Felix was as artificial as his environment. Felix's appeal was always based not on disguising that artificiality but on how cleverly Messmer manipulated it, in particular, by turning Felix's body into a sort of infinitely versatile Swiss army knife. Since the turn of the century, though, live-action filmmakers had shown an ever stronger desire to create an illusion of reality, and Disney—who could very well have gone into live action after he moved to Los Angeles—was at heart a member of their camp. Thus he treated his characters not as assemblages of detachable parts, in the Felix manner, but as organic wholes, even when the results were unfortunate. In *Alice's Brown Derby*, released in December 1926, a dog groom kneads a horse's stomach exactly as if it were dough, finally knotting the flab and snipping off the excess; such a "gag" invites a kinesthetic response, and not a pleasant one.

Clumsy gags of that kind were common in the Alice Comedies of 1926, but the clumsiness was starting to vanish by the next year. Only about half of the fifty-six Alice Comedies have survived, and many of the missing titles are concentrated in 1927, but *Alice's Circus Daze* (released in April of that year) shows that by then Disney and his animators could bring off even relatively complex gags and animation. When the cartoon first reveals the three rings of the circus (after some gags outside the tent), they are aswarm with activity—in cycles, yes, but *elaborate* cycles.

By the time that cartoon appeared, Disney had already shifted to production of a new series, this time for distribution not by a small-time states-rights operation but by Universal, which was, if by no means as grand as Paramount or Metro-Goldwyn-Mayer, nonetheless a full-fledged Hollywood studio. Winkler Pictures was still the middleman, however: it was not Walt Disney but Charles Mintz who signed a contract with Universal on 4 March 1927, for twenty-six cartoons with a new character to be called Oswald the Lucky Rabbit.[118]

Rudy Ising was involved only briefly with the Oswald series: Disney fired him late in March 1927. "I'd go to sleep on the camera," Ising said, "and a couple of times I went to sleep with my hand on the button, and Walt got mad about it." But, he said, he planned to leave soon anyway.[119] Harman and Ising had continued to pursue a release of their own. In January 1927, they had written to Maxwell that they felt "quite confident of securing a contract, as we are corresponding with Metro Goldwyn, Fox, Universal and Paramount."[120] Ising wrote to his sister that month

that he and Harman had "a secret shop all equipped and can start immediate production on our own pictures."[121]

There's a clue to his colleagues' disdain for Disney in a letter Ising wrote in June 1927, three months after Ising himself had left the studio's staff, but while Harman and another Kansas Citian, Isadore "Friz" Freleng, were still there: "He is still trying to make us [sic] think he is overpaying us and that we have a lot to learn."[122] Freleng, who had worked with Harman at Kansas City Film Ad, had joined Disney's staff in January 1927, taking Rollin Hamilton's place. Hamilton had left, Freleng said, "because he couldn't bear the abuse that Walt heaped upon him."[123] (Hamilton returned to the staff in May 1927, though, to work with Harman on the Oswalds.) Freleng, in his account, became the target of the abuse that Hamilton had once received. "I made mistakes," Freleng said almost fifty years later, his resentment still very much alive, "and Walt—even though he expressed patience in his letters prior to my joining him—didn't show any. He became abusive and harassed me."[124]

The Disney studio in the late twenties was from all appearances not a particularly pleasant place to work. Harman spoke in 1973 of pressure to turn out animation and concomitant pressure from Walt Disney to simplify the drawings. Iwerks increased that pressure, he suggested, through his great facility: "Before you knew it, within a half hour, he would have maybe twenty or thirty drawings of Oswald, running off into perspective. All he had drawn [beforehand] was perhaps a guideline like this and another one like that—careless sweeps."[125] Iwerks was that great rarity, an animator who could work straight ahead without losing control of his animation (perhaps thanks in part to guidelines of the kind Harman mentioned). His resistance to working like most other animators, with extremes and inbetweens, was a source of continuing friction between him and Walt Disney, who, like the Fleischers with Dick Huemer, wanted his strongest animator to spread his work thinner. Ben Clopton, who started at the studio in February 1927, began working under Iwerks around the time that production of the new Oswald series began, and it was then, or soon thereafter, that Iwerks started leaving inbetweens for an assistant to draw.[126]

Only nine of Disney's twenty-seven Oswald cartoons have survived, and not all of those are accessible, but seven of the extant films are, in their general contours, very much like the surviving Alice Comedies from 1926 and 1927. There is more dismember-

ment, sometimes the same sort exactly from one cartoon to the next. In *Trolley Troubles*—the second Oswald that Disney produced, but the first to be released—Oswald takes off his own foot, kisses it, and rubs it on his head for luck. In *Oh Teacher*, the third Oswald that Disney produced, a cat, Oswald's romantic rival, literally knocks his block (that is, his head) off. In *Great Guns*, Disney's fourth Oswald, Oswald himself knocks a mouse's head off in a fistfight.

There were, however, glimpses of a different kind of comedy. In *Bright Lights*, the sixteenth Oswald, released in March 1928 (and animated by Harman and Hamilton), Oswald is jumping with joy at getting past a stage door when his hand touches the beard of a guard who is looming over him. Oswald looks puzzled as he feels the beard, and he then examines the hand that touched it before he finally sees the guard. The comedy is not particularly strong, but it is almost entirely psychological, evoking Chaplin more than it recalls any other cartoon.

In their execution, the Disney cartoons were by now quite polished, enough so to impress animators on the East Coast. Disney's "first Oswalds were, at least by our standards, very fine," Dick Huemer said. "We used to seek them out and study them."[127] Disney's cartoons had by 1928 achieved a certain equilibrium: after five years, and dozens of cartoons, he and his colleagues had, on the evidence of the surviving Oswalds, learned how to smooth over gaucheries of the kind that popped up in the Alice Comedies, so that audiences need not feel the physical damage to the characters. In some of the Oswald cartoons, machines and animals are all but interchangeable. In *Great Guns*, for instance, Oswald turns an elephant into a cannon, whereas the villain's cannon "eats" cannonballs. With the distinction between animal and machine thus blurred, there's scant cause for distress when the elephant gets blown up, leaving only its feet behind.

By putting distance between his characters and his audience, though, Disney was defeating the purposes he was revealing in other parts of his cartoons. He may have become aware of that during work on the Oswald series. In November 1927, Rudy Ising wrote to Friz Freleng (who had retreated to Kansas City) that Iwerks was "trying to handle the one shift himself at the Messrs. Disneys"—Iwerks had been animating in tandem with Freleng, the two of them completing a cartoon together, as Harman was doing with Hamilton—"but his pictures lack character action."[128] Turning characters into machines was the sort of thing that came

easily to an animator with Iwerks's facility; "character action," or
animation that aroused interest in the characters themselves, was
another matter.

To move forward, Disney would have to be jarred out of the
contradictions he had locked himself into. Circumstances would
oblige him in 1928 with not just one but two such jolts.

When George Winkler approached him in the summer of 1927
about replacing Walt Disney as the maker of the Oswald cartoons,
"I was interested right away," Hugh Harman said, "because I was
very disappointed in Walt and wanted to get away from him."[129]
Rudy Ising wrote to Ray Friedman in Kansas City then, telling
him that "Winklers have made us a definite offer for a next years
[*sic*] release." Ub Iwerks was also planning to leave, Ising said, "to
engage in a private enterprise."[130]

Iwerks said many years later that he warned Disney in January
1928 that "renegades" on his staff were planning to leave, but that
Disney wouldn't believe him.[131] Disney went to New York in mid-
February to renew his contract with Winkler Pictures; he learned
then that Iwerks was right. Mintz had not yet signed contracts
with the defectors, though. What he really wanted was to control
the Oswald operation as he did his Krazy Kat studio. By 1928, that
studio was in Manhattan and under the supervision of Ben
Harrison and Manny Gould; Paramount was distributing the car-
toons, alternating them with the Fleischers' cartoons.[132]

Mintz wanted to make Walt Disney his employee, in fact if not
in name. He dangled the lure of what Disney called, in a telegram
to Roy on 28 February, "substantial salaries for all plus fifty per-
cent" (of the proceeds from Universal, presumably). Disney did
not reject Mintz's offer out of hand; he spoke in his telegram of
trying to get Mintz to offer a "larger cash advance and percent-
age." While he dickered with Mintz, Disney canvassed the New
York offices of some of the same distributors that Harman and
Ising had already approached in Hollywood; he had no better
luck than they did. He was, however, feeling the self-confidence
he had earned in several years as a modestly successful producer.
Even though he was losing his release, Disney talked while he
was in New York with Bill Nolan, Mintz's former chief animator
on the Krazy Kat series, about Nolan's joining the Disney staff at
$150 a week. (Since leaving Mintz in 1927, Nolan had been mak-

ing topical shorts called "Newslaffs.")[133] In a 7 March letter to Roy, Disney also spoke of several other New York animators as candidates for the staff.[134]

If Disney ever seriously contemplated yielding control over his studio to Mintz, he had abandoned that idea by the time he left for Los Angeles on 13 March after three weeks in New York. The rupture with Mintz was now irreparable; Mintz signed contracts with the breakaway Disney animators within days of Disney's departure. Disney had no character, since Oswald was Universal's property, and no release.

As soon as he returned to his studio, Disney set to work on a cartoon featuring Mickey Mouse, a character whose name he later claimed that his wife, Lillian, had suggested on their return train trip. Ub Iwerks—who had evidently laid aside his plans for a "private enterprise"—animated the first Mickey Mouse cartoon, *Plane Crazy*, while he was in some way isolated from other members of the staff. "They curtained off part of the studio with a great black drop, black scrim of some kind," Hugh Harman said, "so that I and a few others who were leaving couldn't see the great secret that was going on."[135] Paul Smith, who had begun working at the Disney studio in August 1926 as a cel painter—then the bottom rung on the ladder for young men who wanted to work their way up into animation—remembered Iwerks's working not behind a curtain, but in a back room.[136] The animators who were leaving were not supposed to know what Iwerks was doing, in any case.

The departing animators and assistants stayed around long enough to complete their work on the remaining Oswald cartoons on Disney's schedule. Both Disney and Mintz had every reason to want them to stay until then, however uncomfortable the situation may have been. (Harman said that Roy Disney stopped speaking to him.) Harman, Hamilton, and Smith all left the payroll on 5 May 1928; Ben Clopton followed them a week later. By then, Disney had completed *Plane Crazy* and shipped it to the same New York film-storage company that had cared for *Alice's Wonderland* five years earlier. At least one major-studio executive, from MGM, saw the film, but no offer was forthcoming.

There was nothing particularly innovative about *Plane Crazy* or its mouse star. He was a formulaic mouse of a kind that had long been plentiful in competitors' cartoons, and in some of Disney's own, too—*Alice's Circus Daze*, for instance. Like many of the mice in Paul Terry's Fables, the earlier Disney mice had simple faces—

essentially white masks composed of eyes and muzzle—on otherwise black bodies, a characteristic that they shared with Felix and Oswald and many other animal characters of the twenties. Mickey was larger than most cartoon mice—he appeared to be two or three feet tall, or about the same size as Felix—but the mouse couple that Terry used as occasional partners in adventure in such Fables as *The Big Tent*, released in October 1927, and *The Good Ship Nellie*, released in February 1928, looked to be about the same size. Typically, though, the mice in Terry's Fables had pointed and downturned noses, fried-egg eyes, and long, skinny ears; in Mickey's design, the snout turned up, not down, and the ears were emphatic circles, rather than blown back. Mickey was a much more positive-looking character than the earlier mice, and although Ub Iwerks surely deserves most of the credit for Mickey's design, the cast of the character's features was very much in keeping with the emphatically optimistic tone that Disney himself adopted.

Disney plunged ahead with work on a second Mickey Mouse cartoon. It was at a gag meeting on *The Gallopin' Gaucho* at Walt's or Roy's house, Wilfred Jackson said—he had joined the staff as an assistant in April, just before the animators' exodus—that "Walt brought up the idea that it might be possible to make cartoons with sound."[137] That gag meeting almost certainly took place on 29 May 1928, just a few weeks after MGM, Paramount, and United Artists committed themselves to producing features in sound.[138] Disney saw in the new sound technology a way to distinguish himself from other cartoon producers, through what he later called "the extreme novelty" of sound cartoons.[139] He had probably decided to go with sound by 27 June 1928, when he wrote to Powers Cinephone Equipment Corporation in New York to ask about the costs that would be involved in synchronizing sound with cartoons. Patrick A. Powers, the company's owner—an industry veteran who had warred with Carl Laemmle in the teens for control of Universal—had advertised in the trade press earlier that month, offering both sound-on-film and sound-on-disc recording.[140] Disney told Powers that he expected to be in New York in September.[141] He was giving himself two months to complete a cartoon planned around sound.

Such planning entailed increased attention to the writing and staging of the cartoon. For the Alice Comedies, particularly once the live-action girl's role shrank drastically, the writing was loose; it consisted of brief scenarios that, like surviving scenarios from contemporaneous East Coast studios, left a great deal to the ani-

mators. By the time of the Oswald series, though, cartoon planning had expanded beyond scenarios—more detailed now—to rough sketches, six to a page, that established the general appearance of each scene. Iwerks drew such sketches for the Oswald cartoons that he animated and for the first two Mickey Mouse cartoons. For the sound cartoon, *Steamboat Willie* (a title inspired by Keaton's *Steamboat Bill, Jr.*, released earlier in 1928), Iwerks made more polished sketches, with a synopsis of each scene typewritten beside them.

The critical task was to find some way to synchronize the music with what was happening on the screen. There were few precedents; scores written especially for theater musicians to use in accompanying silent cartoons were rare or nonexistent (although in 1923 Pathé was furnishing "musical effect sheets" to distributors booking Aesop's Fables).[142] A theater organist or pianist usually improvised while a cartoon was on the screen. Disney wound up using what came to be called a "bar sheet," a chart that paired each measure of music with a description of the corresponding screen action. During work on *Steamboat Willie*, Jackson, who had some limited knowledge of music (more than Disney), prepared "a little rudimentary bar sheet for the entire picture, and in the places where we had definite pieces of music in mind, the name of the music was there, and the melody was crudely indicated, not with a staff, but just with a little note that would go higher and lower...so that I could follow it, in my mind."[143]

Disney had always prepared the exposure sheets, the frame-by-frame instructions for the cameraman, after the animators did their work; now, for the first time, the "ex-sheets," as they were called, had to be prepared in advance, as instructions for the animators themselves. As Les Clark, then an assistant animator, said, "it was the only way we could control synchronization."[144] Disney and Jackson prepared the bar sheets and exposure sheets for *Steamboat Willie* "almost simultaneously," Jackson said. Using a metronome, Jackson roughed out a bar sheet for each tune Disney wanted to use; Disney next made exposure sheets, indicating exactly on which frames the musical beats were to fall.[145] Together, bar sheets and exposure sheets gave Disney, as director, unprecedented control over the animation's timing.

There was still the question of whether the illusion could be persuasive, even with perfect synchronization. "Walt wanted it to seem real, as if the noise was coming right from what the character was doing," Jackson said.

So...when a few scenes had been animated—enough to make a little sequence that could be run—they set up this test. I was able to play a few simple tunes on a harmonica; that was the most of a musician anybody was at the studio, at that time. One of my favorite tunes was "Turkey in the Straw"; that's why it got used there. And "Steamboat Bill" was a tune that Walt had in mind, in connection with the making of the picture. So those two melodies were planned.

The first little sequence where the steamboat comes down the river, around the bend, and Mickey's up there, and toots the whistle—that first little sequence of scenes was what we had made. While work was being done on the rest of the picture, Walt had these scenes inked and painted and photographed and put together. We came back one night to try this thing out, and Ub Iwerks rigged up a little microphone and speaker.... Walt's office had a glass window in the door, so we could close the door, and look through it, and see the back of the screen. The screen was a bedsheet that was hung up in this long room where the backgrounds were painted. Roy Disney got outside the building with the projector, and projected through a window, so the sound of the projector wouldn't be too loud.

When Roy started the projector up, I furnished the music, with my mouth organ...and the other fellows hit things and made sound effects. We had spittoons everywhere then, and they made a wonderful gong if you hit them with a pencil. We practiced with it several times, and we got so we were hitting it off pretty well. We took turns going out there ourselves, and looking at the thing, and when I went out, there wasn't any music, but the noises and the voices seemed to come from it just fine. It was really pretty exciting, and it did prove to us that the sound coming from the drawing could be a convincing thing.[146]

Disney had completed *Steamboat Willie*, in silent form, by late in August. Iwerks had animated most of it, with a few scenes by Jackson. Disney took the train to New York and passed through Kansas City on the way. There he left prints of *Plane Crazy* and *The Gallopin' Gaucho* with Carl Stalling, an organist for the Isis theater and an acquaintance from the Laugh-O-gram days. The Isis ran the cartoons, and Stalling doubtless improvised music to accompany them, as he had for so many cartoons shown at that

theater before; this time, though, the idea was that he would put his ideas into writing by composing scores for both cartoons, scores that would be recorded in New York, after *Steamboat Willie*'s score.[147] Disney's commitment to sound was by now complete.

Disney had gone to New York without a recording agreement in hand. In his first two days in the city, he visited not just Powers Cinephone but three other sound-on-film companies. He was stepping into a tumultuous arena, one that recalled the battles over the Edison patents fifteen years earlier, when Powers had been a leader in the successful assault on the Motion Picture Patents Company. From the start, Disney leaned toward Cinephone, finding Powers himself to be "a fine fellow" who knew motion pictures, in contrast to the smug engineers he encountered elsewhere.[148] By 7 September he had "made up my mind to score it with Powers."[149] To insure proper synchronization, Disney had a theatrical-trailer company make up a piece of film that showed a ball bouncing in the musical tempo, rising and falling to the beat, for the guidance of the conductor, Carl Edouarde.

The first recording session did not take place until late on a Saturday night, 15 September. The recording of the sound effects didn't satisfy Disney, though, and there were problems with the synchronization, too, evidently because Edouarde didn't want to follow the bouncing ball. There would have to be a second session, and it could not take place for another two weeks. Roy's side of the correspondence has not survived, but it's clear from Walt's letters that his older brother was alarmed by the costs a second session would entail; getting their bank to lend them the necessary funds was proving to be difficult. Walt brushed aside such concerns: "Why should we let a few little dollars jeapodarzize [sic] our chances.... We can lick them all with Quality."[150] Roy Disney was the studio's business manager, but his role was really just to come up with the money that Walt needed; he had no control over how the money was spent, or even how much of it was spent. When the company changed its name from Disney Brothers Studio to Walt Disney Productions in 1926, that change simply ratified the supremacy that Walt was exercising fully by 1928.

The second recording session was finally held on the morning of 30 September—successfully. Disney had had a new print of *Steamboat Willie* made with the bouncing ball superimposed alongside the picture in the space for the soundtrack; Edouarde

followed the bouncing ball as he conducted (the orchestra had its back to the screen), and this time sound and image were synchronized. Disney was still not happy with some of the effects, but, he wrote that evening, "as a whole I would say that it was Damn near perfect."[151] By using the bar sheet, Disney had made possible an airtight fit between music and animation, and even though the bar sheet could not assure the same sort of perfection in the actual recording, the bouncing ball could. As Disney was well aware, he was now far ahead of any other cartoon producer in his mastery of sound.

When he wrote to Roy and Iwerks on the day after the recording session, Disney was already thinking in rather grandiose terms of making fifty-two Mickey Mouse cartoons a year.[152] In his subsequent letters from New York, he was unfailingly cheerful, writing enthusiastically about their chances for a major release even though the apparent warmth of various distributors when they saw *Steamboat Willie* in private screenings never led to an acceptable offer. Only in letters to his wife did Disney confess to doubt and weariness. His optimism in his letters to Roy and Iwerks was not false, exactly, but like many another small businessman in dire circumstances, Disney willed it into being.

Carl Stalling joined Disney in New York on 26 October 1928 to record the scores for the two silent cartoons; they worked together on the music for not just *Plane Crazy* and *The Gallopin' Gaucho*, but also *The Barn Dance*, a fourth Mickey Mouse cartoon that Disney had written in New York and that Iwerks had animated in California in his absence. Money was turning into a severe problem, especially now that Disney had to bear Stalling's expenses as well as his own; on 27 October he told his wife to "have Roy look into the matter of selling my car."[153]

Disney had been dickering with Universal, his old Oswald distributor, but evidently Universal's contract with Mintz imposed an obstacle to its making a deal with another cartoon producer. By 11 November, though, when Disney wrote to Ub Iwerks, he had agreed to let Universal run *Steamboat Willie* at the Colony, the Broadway showcase theater it had been leasing for about two years[154]—and where it had been showing Disney's Oswald cartoons. Disney claimed many years later that he was paid five hundred dollars a week as rental for *Steamboat Willie*,[155] but it seems at least as likely that he let the Colony run it free of charge, as Universal was insisting in October. He wanted desperately to get his cartoon before the public.

Steamboat Willie premiered at the Colony on Sunday, 18 November 1928. Stalling was with Disney at the first showing. "We sat on almost the last row," Stalling said more than forty years later, "and heard laughs and snickers all around us."[156] The Colony held *Steamboat Willie* over for a second week.[157]

Film reviewers responded to *Steamboat Willie* as enthusiastically as the audiences at the Colony did. "It's a peach of a synchronization job all the way," *Variety* wrote, "bright, snappy, and fitting the situation perfectly."[158] Such praise, and the visibility the film gained through it, were exactly what Universal's executives had predicted when they insisted on a free Colony run.

Steamboat Willie is indeed "a peach of a synchronization job"— Mickey, his girlfriend Minnie, a cat captain, and a boatload of domestic animals make a tremendous variety of musical and non-musical noises—but not much else. The heart of the cartoon is a prolonged episode in which a goat eats Minnie's sheet music. She then turns the goat's tail as if she were a barrel organ-grinder and the goat her instrument; "Turkey in the Straw" emerges from the goat's mouth, as visible notes, and Mickey picks up and "plays" the tune by, among other things, beating on pots and pans and pressing a sow's teats to produce squeals of the appropriate pitch and duration. Disney's insistence on marrying sound and image as tightly as possible paid off in what was instantly recognizable as a real sound cartoon, rather than a silent cartoon with an added soundtrack.

Excluding a few cartoons the Fleischers made with the unsuccessful De Forest sound-recording process earlier in the decade, other producers had made hardly any sound cartoons by the time *Steamboat Willie* premiered. Disney saw one of them, an Aesop's Fable—evidently the one called *Dinner Time*, although he didn't mention its title—in September, and he dismissed it scornfully as a "lot of racket and nothing else.... It merely had an orchestra playing and adding some noises."[159] In October, though, Disney saw a sound cartoon he liked, *The Sidewalks of New York*, which was showing at the Rivoli on a program with a Paramount feature, Erich von Stroheim's *The Wedding March*. It was a Fleischer cartoon, a song cartoon of the kind the Fleischers had been making since 1924 along with their Inkwell cartoons. Animation was a relatively minor part of the silent Song Cartunes, since they con-

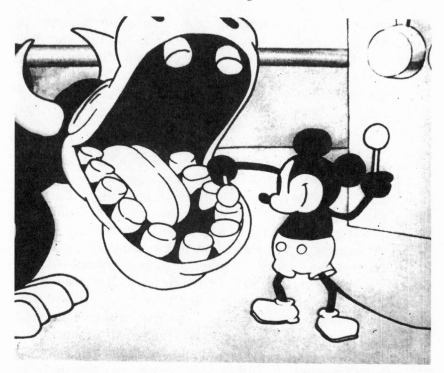

Mickey Mouse, as animated by Ub Iwerks for Disney's Steamboat Willie (1928). It was the union of music and image in scenes like this one that made the film what one reviewer called "a peach of a synchronization job." © Disney Enterprises, Inc.

sisted largely of a song's lyrics, shown with a bouncing ball that guided the audience's singing. Neither lyrics nor ball was animated: the lyrics were filmed as they came into view on a rotating drum, while the animator Art Davis moved the "ball," a cut-out white circle on a black stick, from word to word.[160]

The new sound cartoon—the first in a series called Screen Songs—was much the same for most of its length. "Most of it was just synchronized with [the] Orchestra playing the tune," Walt Disney wrote to Roy Disney and Ub Iwerks—the bouncing ball on the screen would have made synchronization relatively easy—but he singled out for praise the last part of the film, where "they had the letters and characters doing all kinds of funny things in time to the music that got lots of laughs." What had been added was metamorphosis animation of a kind that had become a Fleischer specialty and that Disney rarely if ever used; he noted that the Fleischer cartoon "is an entirely different sort of thing than ours." What the Fleischers were doing, he wrote, was more along the

lines of the novelties that Carl Stalling had proposed that Disney make.[161]

Stalling had broached that idea when Disney saw him in Kansas City, or perhaps even in earlier correspondence; he had specifically proposed a cartoon based on a "skeleton dance."[162] There was in Disney's mind a clear distinction between the Mickey Mouse series, on the one hand, and the Fleischer song cartoons and Stalling's novelties, on the other—a distinction that he did not articulate, but that was rooted in what he told his wife in a letter on 26 October, when he had just seen *Steamboat Willie* again: "It sure seems like [Mickey] whistles...[Disney's ellipsis] also the Parrot seems like he talks."[163]

For all that it is musically organized, *Steamboat Willie* is also thick with sound effects of various kinds, from Mickey's whistling at the start (provided by a piccolo) to the parrot's squawks. The very abundance of the effects caused problems ("We have so many effects in this picture that it scares them all," Disney wrote after the first, failed recording session),[164] but it was through the sound effects, more than through the music, that Disney made what was happening on the screen seem a little more real than anything in his silent cartoons. From the first, Disney grasped sound's potential for involving his audience in what was happening on the screen. Musical fantasies of the kind Stalling envisioned could delight an audience, just as the Fleischers' song cartoon did, but a full and free use of sound could help draw them toward the characters and into the story.

Having proved that point—through a tremendous expenditure of energy and by overriding his colleagues' misgivings—Disney pulled back from it. In his letters after the second recording session for *Willie*, he spoke as a small businessman not just through his willed optimism but also through a burgeoning anxiety about costs: what he had accomplished with *Steamboat Willie* would count for nothing if his company foundered. He wrote of the need to integrate the sound effects with the musical score; that way, the musicians could provide the necessary noises (as opposed to the three-man team of specialists he hired for *Willie*), with much less of the expensive rehearsal time that *Willie* required.[165]

Disney likewise encouraged Iwerks to cut corners in his animation of *The Barn Dance* ("cut down the number of drawings.... Try and devote most of your time to action instead of detail in the drawings") so that it could reach New York in time for Disney and Stalling to record its score along with the scores for the two silent

cartoons. Iwerks met that deadline for *The Barn Dance*, but Disney disregarded his own admonitions when the first half of the film reached him on 22 October. He filled most of a page with sharply worded criticisms: "Listen—Please try and make all action definate [*sic*] and pointed and don't be afraid to exagerate [*sic*] things plenty...[Disney's ellipsis] It never looks as strong on the screen as it appears on the drawing board. Always work to bring the GAGS out above any other action."[166] Iwerks surely felt wounded by such criticism; he had, after all, worked as rapidly as Disney wanted, and there's nothing in his animation for *The Barn Dance* that is notably inferior to the animation in the Oswald cartoons. That may have been Disney's point: his animators were going to have to meet new demands as they worked on sound cartoons.

The Barn Dance at one point employs the same sort of violation of the body that the Alice Comedies did—Mickey steps on Minnie's leg, stretching it; she ties her leg in a knot, then cuts off the excess loop—but sound had already made such a gag obsolete. Other gags in *The Barn Dance* have a much stronger grounding in reality. When Mickey dances clumsily with Minnie, his feet grow enormously: what is on the screen mirrors what is in Mickey's mind. It was comedy of the latter kind, glimpsed occasionally in his silent cartoons, that Disney now had to develop; his chosen use of sound pointed firmly in that direction.

At the time of *Steamboat Willie's* run at the Colony, though, Disney had other strong claims on his attention besides the course his cartoons might take. It had become clear before then that no important distributor was going to sign up for a series of Mickey Mouse cartoons. Of the major distributors in 1928, only Paramount included cartoons in its program (and, as Disney heard during his New York visit, it was about to drop Mintz's Krazy Kat cartoons); of the second-tier distributors, only Universal did. Cartoons, never more than a film backwater, had remained emphatically such since the early twenties, despite Felix's burst of popularity.

Disney had become increasingly intrigued by the idea of Pat Powers's distributing his cartoons, although he wrote to California that he thought Powers was too big a man in the industry to be interested in a small-time cartoon producer. Powers undoubtedly saw advantages in keeping Disney overawed, but he didn't go too far: he and Disney signed a two-year letter agreement on 15 October 1928, under which Powers was to help sell the Disney

cartoons. On 16 November, two days before *Steamboat Willie*'s premiere, Disney granted Powers's associate Charles J. Giegerich power of attorney to negotiate distribution agreements for the cartoons.[167] Shortly after the premiere, Disney was finally on the train back to California—he had been in New York almost three months—and Powers was offering his cartoons on the states-rights market, using the favorable reviews for *Steamboat Willie* as a selling tool.

Disney and Stalling returned to New York less than three months later, in February 1929, to record the soundtracks for *The Opry House*, the fifth Mickey Mouse cartoon, and *The Skeleton Dance*, the first of the musical novelties that Stalling had proposed and the first Disney cartoon in whose planning Stalling was involved from the start. There is evident already in *The Opry House* a little more sophistication than Disney brought to the first couple of Mickey Mouse cartoons made for sound. It's not just that Mickey plays the piano (with Stalling at the keyboard in the recording session)—the piano and its stool become Mickey's adversaries. The piano kicks him as if it were a mule; then the piano plays itself (using two of its legs to reach the keys) while the stool dances. Mickey returns to play some more, ultimately jumping up and down on the keys; then he, the piano, and the stool take bows. This is not real fighting but the stylized, make-believe conflict of a vaudeville act; music does not accompany the comedy but is instead integral to it.

This integration of the visual and the musical was exactly what Disney had in mind when he wrote, shortly after the second recording session for *Steamboat Willie*, of what could be gained from working with a musician who was "thoroughly familiar with all the GAGS and situations" and was besides "capable of understanding the production angle of things."[168] Disney and Stalling worked together on the story and the music; then, Wilfred Jackson said, "Walt, the animator [Jackson, for one], and Carl would review the actions Walt had in mind and how these actions would fit with the music for each scene. And together they would write out the exposure sheet."[169] What such a collaboration did not yield immediately, however, was the lower costs that Disney also wanted. *The Opry House* was the most expensive of the early Disney sound cartoons, at a "negative cost"—that is, the cost before any prints of the film were made—of almost $7,500, or $2,500 more than *Steamboat Willie*.[170] *The Skeleton Dance* cost almost as much.

Disney recorded the soundtracks for later cartoons in both the Mickey Mouse series and the new novelty series, called Silly Symphonies, with Powers equipment in Los Angeles; costs settled into a pattern that was correspondingly lower, saving more than a thousand dollars per cartoon. By then, though, Disney's willingness to spend money that would make his cartoons in some way better had begun to assert itself again, through the hiring of animators who had worked in the New York studios. Ben Sharpsteen became the first such animator to join the Disney staff, in March 1929; he was, in fact, the first animator Disney had hired since the Harman-led exodus of almost a year before. Disney paid him $125 a week—more than Iwerks ($90 a week) or Disney himself ($50). Working at Disney's "was just a complete reversal" of his New York experience, Sharpsteen said. "This business of planning, and having exposure sheets that spelled out to the very drawing, that was entirely new. And the synchronization of sound."[171]

Other New York animators followed over the next few months—Burt Gillett in April, Jack King in June, Norman Ferguson in August—and the tiny studio experienced its first growing pains. Since Ub Iwerks had been doing most of the animation (Jackson, Les Clark, and John Cannon were handling a few scenes), his drawing style dominated the Disney cartoons; all the new animators struggled to match it. [172] That struggle is evident in the films, which in the course of 1929 began to look less and less like the products of a single hand.

With the staff larger and, after the advent of the Silly Symphonies, the release schedule heavier, Disney moved Iwerks toward something like a supervisory position. After the first few sound Mickey Mouse cartoons, Wilfred Jackson said, Iwerks devoted less time to animation and more to the sketches that showed the animators how to stage each scene; he worked with Disney and Stalling in what came to be called "the music room" (because Stalling's piano was there). "Walt still handed out the scenes to the animators for the most part," Jackson said, "but I believe Ub occasionally did this for him at this time."[173] Burt Gillett, who had already supervised two studios in New York, also began to help Disney prepare work for the animators soon after he joined the studio's staff.[174]

Gillett and Iwerks were both directing in fact if not in name— they prepared bar sheets and exposure sheets—by the late summer of 1929, around the time that *Mickey's Choo Choo* and

Springtime, the third Silly Symphony, went into production.[175] Gillett's was the Mickey Mouse unit, whereas Disney put Iwerks together with Jackson and Les Clark specifically to make Silly Symphonies based on the seasons.[176] The two units divided to some extent along East Coast–West Coast lines—Sharpsteen, King, and Ferguson all worked with Gillett on the Mickeys—but the division was more profound than that.

Iwerks had animated most of *The Skeleton Dance* by himself, in only four weeks (Les Clark animated a little of it, his first such assignment),[177] and a musical novelty of that kind had turned out to be a very comfortable environment for someone who animated as Iwerks did, very rapidly in essentially mechanical patterns. The animation was planned so carefully to fit Stalling's score that Iwerks was animating *The Skeleton Dance* in Los Angeles even as Disney and Stalling recorded the score in New York. (The seven-page continuity for the cartoon, written—almost certainly by Disney himself—in advance of the animation, concludes with the admonition that "every frame of this is timed to music and all action must be made as per [exposure] Sheets.")[178] Even more than in *Steamboat Willie*, there is in *The Skeleton Dance* no narrative to speak of, and there are no characters at all: skeletons rise from their graves at night and take part in simple, repetitive dances.

The earlier Disney cartoons' cavalier attitude toward the body is present in *The Skeleton Dance*, too, but there is in Iwerks's manipulation of the skeletons—their bony limbs are surprisingly rubbery—none of the visceral impact of some of the earlier animation. Far from being gruesome (an objection supposedly raised by nervous theater managers when Disney was first seeking a release for the new series), the skeletons are in Iwerks's animation more like toys come to life. The animation makes abundant and ingenious use of such familiar devices as repeats, cycles, and reverses (which involve turning drawings over so that a character moving in one direction moves in the other, in exactly the same drawings), and because those devices have been synchronized very precisely with music, they take on a stylized grace, most evident when several identical skeletons are dancing identically. So snugly does Iwerks's animation fit the music in *The Skeleton Dance* that it conforms not just to the beat but to the melody as well, with the

characters mimicking in their actions the movements of the notes.

Iwerks and Stalling brought a tidiness to the production of the Silly Symphonies that had no counterpart in the way that Walt Disney was running the studio as a whole. Even though Disney was sympathetic from the start to the idea of musical novelties, his interests did not lend themselves as readily to the production of musical cartoons as Iwerks's and Stalling's did; his skepticism, mild though it presumably was, surfaced in quarrels with both men. Stalling found Disney dismayingly inarticulate: "He couldn't explain just what he wanted, at times. We'd go crazy trying to figure out what he wanted."[179] Disney himself was trying to figure out the same thing.

Disney,
1930-1933

On 17 January 1930, Walt Disney, his wife, and his attorney, Gunther Lessing, caught a train to New York, on the way to a showdown with Pat Powers.[1] Walt and Roy Disney apparently suspected that Powers was not accounting honestly for their share of the profits; for his part, Powers refused to open his books until the Disneys signed a distribution contract stronger than the simple letter agreements they had signed in 1928 and 1929. The match had never been a good one: even as the popularity of the Disney cartoons grew, Powers told Roy Disney that Walt should scale back his negative costs, rather than increase them.[2]

Powers held what he must have thought was a trump card: he had just signed a contract with Ub Iwerks. If the Disneys would not capitulate, Powers—through his Celebrity Productions—would pay Iwerks three hundred dollars a week to make a new series of sound cartoons.[3]

On 21 January, Walt Disney met with Powers and learned from him what Iwerks had done. The same day, in Los Angeles, Iwerks told Roy Disney that he wanted to leave the studio as soon as possible, citing not his contract with Powers but rather his quarrels with Walt. It was not until Roy received a telegram from Walt the next day that he learned that

Powers and Iwerks had made a deal.[4] That day, Roy signed an agreement with Iwerks that called for the Disneys to pay him $2,920—the amount withheld from his salary over the previous two years toward the purchase of a 20 percent interest in the Disney brothers' partnership.[5]

In New York, Walt Disney continued to negotiate with Powers for a couple of weeks, stringing him along while Lessing and another lawyer approached Warner Bros. and Metro-Goldwyn-Mayer.[6] Walt shared little with Roy of what he was doing, communicating with him mainly through letters from Lillian. ("What is going on," an anxious Roy wired Walt on 28 January. "Hope you are not dealing for next years with Powers.")[7] Even though, in Lillian's letters, distributors and rival cartoon producers sometimes seem to be circling her husband like curious birds of prey, New York's atmosphere was clearly heady for Walt. In early 1930, New York was still the center of the animation industry, with Disney's the only significant West Coast studio; but since his last visit to the East Coast, almost a year before, the New York animators had started looking to him as the leader. As Disney himself put it, in a postscript to a letter from Lillian on 30 January, "Our pictures are the center of attention back here. All the New York artists are trying to compete with them."

On 7 February, Walt wired Roy that they would deliver no more films to Powers—the break was final.[8] Soon after, he moved from the Algonquin Hotel to the Hotel Piccadilly and registered under the name "Walter E. Call"—using his mother's maiden name—presumably the better to elude Powers and any process servers. Powers's threat of legal action apparently derailed a deal with MGM at the last minute.[9] On 19 February, Disney signed a distribution agreement with Columbia Pictures, which was already distributing the Silly Symphonies under a subcontract with Powers. He left immediately after that for Los Angeles.

Columbia agreed to lend the Disney brothers as much as $25,000 to fend off a challenge by Powers, and Walt and Roy spent $10,000 on legal fees before Roy went to New York and settled with Powers in late April. The settlement's cost to the Disneys, in abandoned claims and outright payments, was around $112,000,[10] a huge sum for a small studio that in the months before the break with Powers had been spending less than $5,000 each to make most of its shorts.[11] The Disneys had to borrow $50,000 of the settlement money from Columbia; they would see nothing of their share of the profits from their films until that debt was repaid. But

for Walt Disney, the costly change from Powers to Columbia was worthwhile because, paradoxically, he could now spend more: Columbia would advance him $7,000 upon delivery of each cartoon.[12]

The loss of Iwerks may have looked like an even more serious setback to the Disneys than the high cost of the settlement—certainly Pat Powers thought it would be—but in fact it roiled the studio much less than the 1928 departure of Hugh Harman did. For one thing, Iwerks could not take Disney's most important character with him; Pat Powers never owned Mickey Mouse. Neither did Iwerks spark an exodus of other members of the staff. Carl Stalling did leave as soon as he learned Iwerks was going; he walked out of the studio on 24 January, the day before Iwerks left the payroll, after telling Roy Disney that he would never be able to get along with Walt.[13]

There were no other defections. Iwerks apparently offered a job to at least one other animator, Ben Sharpsteen, but this time Disney's staff stuck with him.[14] In fact, as Roy Disney was quick to realize, the Disneys stood to suffer very little damage, and to gain a great deal, from losing Iwerks and Stalling. As he told Walt, "If we had deliberately planned to use [Iwerks] and Carl over the period of time [when] we really needed them, and when they were essential to the success of the pictures, and had planned and plotted to throw them over at the first opportunity for selfish motives,...the whole affair could not have worked out prettier."[15]

By the time Iwerks and Stalling quit, the Disney studio had been making sound cartoons for a year and a half, and other animators and musicians had mastered the new technology's requirements. Some were already on the Disney staff, and others could be hired; Roy immediately summoned Bert Lewis, a former theater organist who had been directing the orchestra in the recording sessions for the cartoons, to fill in for Stalling. Further, the Disneys no longer had to share with Iwerks the ownership of what promised to be a highly successful small business.

Walt no doubt agreed with Roy's assessment, but he may have found it more difficult than Roy to shed his feelings of disappointment and resentment toward Iwerks. David Hand, who started work as an animator on the Monday after Iwerks left, observed that when he finally met Walt four weeks later, after his

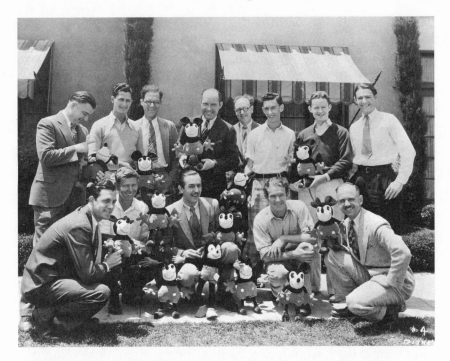

*By 1930, the staff that made Disney's two silent series had under-
gone an almost complete turnover. Standing, from left: animators
Jack King, Les Clark, and Tom Palmer; director Burt Gillett; com-
poser Bert Lewis; animators Dick Lundy and Norman Ferguson;
Floyd Gottfredson, artist for the Mickey Mouse comic strip. Kneeling:
animator David Hand; director Wilfred Jackson; Walt Disney; ani-
mators John Cannon and Ben Sharpsteen. © Disney Enterprises,
Inc.; courtesy of Mrs. David Hand.*

new employer returned to the studio from New York, "Walt was
awful mad at Ub, because he didn't talk about anything else to
me."[16]

However bitterly Disney may have resented Iwerks's depar-
ture, he was actually liberated by it, in ways barely suggested by
his brother's cool analysis. Iwerks's dealings with the Disneys
were necessarily colored by his memories of Walt as a green
Kansas City animator, inferior to Iwerks in ability and experience.
In Los Angeles, Iwerks had contributed more heavily than any-
one else to the way the cartoons actually looked on the screen.
He could have made a strong claim to stand on an equal footing
with Walt as a creator of cartoons, and any such claim would have
had a legal dimension because Iwerks was a part owner of the stu-

dio. Stalling, too, could have made claims that came with owner-ship—he had invested two thousand dollars in a separate Disney Film Recording Company—and, like Iwerks, he had resisted accommodating himself completely to Walt's demands.

After Iwerks and Stalling left, Walt Disney was for the first time working only with collaborators who were unequivocally subor-dinate to him. Some were very young men who had been hired in California, like Wilfred Jackson and Les Clark, and some were older men (that is, in their thirties) who had worked in the New York studios, like Burt Gillett and Ben Sharpsteen. Even though the New York cartoonists were older than Disney himself—David Hand, for example, was almost two years Disney's senior—and far more experienced as animators, they had never known him as anything but a boss. If in the twenties Disney aroused so much exasperation and dislike that Rudy Ising characterized the studio as a "den of strife and vexation,"[17] he was by 1930 inspiring much warmer feelings. Like other people with very strong egos, he became a far more appealing figure when his authority was free of even the subtlest challenge.

Cannibal Capers, delivered to Columbia in March 1930, was the first Silly Symphony the studio completed without Iwerks; work on it had barely begun when he left. Burt Gillett took charge of it, at least until Walt Disney returned from his negotiations with Columbia in New York. Iwerks's shadow did fall over much of the film, since the cannibals are basically stick figures that contort their bodies rhythmically—legs and torsos bend and stretch in rubbery animation that recalls the skeletons in *Skeleton Dance.*

The film departs from the Iwerks structure only toward its close, when a lion corners a cannibal in a cooking pot and lifts him out in a huge spoon. The lion removes the spoon from his mouth apparently empty; but as the lion chews, the cannibal rises slowly into view from the bowl of the spoon. The lion tries again, but the cannibal clings stubbornly to the spoon, refusing to be swallowed. In again, out again—then the lion snaps at the cannibal, bit-ing down on the spoon, and the cannibal flies into the air and lands on the lion's nose, with a honking sound effect. There is just a hint, in

the way the musical beat regulates the timing of this comedy, that synchronization could be put to more sophisticated uses than in the Iwerks-directed cartoons, that it could, when combined with gags as abundant as those in the Oswalds, make comedy more pointed and organized.

In other respects, though, *Cannibal Capers* is a mess. The Disney studio no longer has any record of who that film's animators were, but their styles differ so radically that the lion looks and moves like an altogether different creature from one scene to the next. If such anomalies were common enough in the cartoons made before Iwerks left, they multiplied after his departure. Not only had the studio added the New York animators—who mostly drew in what was, by Iwerks's standards, an eccentric style—but with Iwerks gone, there was no single strong animator whose work could be held up as an approved alternative.

Iwerks's influence persisted in other ways, though, long after his departure; the Silly Symphony *Winter*, from the end of 1930, is very much in the Iwerks vein, all pattern and repetition, as bears and deer and other animals dance in the snow. Throughout 1930 and into 1931, not only did the Silly Symphonies fall back onto the Iwerks prototype, but, often as not, the Mickey Mouse cartoons did, too. *The Birthday Party*, a Mickey delivered to Columbia in January 1931, offers little more than singing and dancing by Mickey, Minnie, and a small crowd of other animals.

Disney delivered twenty cartoons to Columbia in the first twelve months after Iwerks left the studio. When one of them moved forward in some way, another cartoon matched it by lurching in the wrong direction. *The Cactus Kid,* a Mickey delivered in May 1930, was more smoothly drawn than its immediate predecessors; but in *The Chain Gang*, delivered three months later, some of the animators attempted more detailed drawings, and the results were strikingly ugly. Only rarely, as with *The Fire Fighters*, a Mickey delivered in June 1930, was there any sense that a whole fast-moving cartoon, and not just an occasional scene like the one in *Cannibal Capers*, had recaptured some of the comic spirit of Disney's best silent cartoons.

In the months after Iwerks left, Disney must have realized that he had to find new ways to control his cartoons. By mid-1930, two years had passed since the last of his silent Oswalds, and those two years had made a world of difference: his 1930 staff was much larger—the total passed thirty in April of that year[18]—and more diverse in its talents than his 1928 staff, and the animation

required more of his attention than it did in the days when he could rely on Iwerks to shape the other animators' work. Making sound cartoons was far more complicated and expensive than making silent cartoons; now there were whole new phases of production—working with a composer, overseeing recording sessions—that had not existed before.

Early in 1931, Disney hired as his gag man Ted Sears, a veteran animator who had already spent a year on the West Coast in the midtwenties when he worked as a writer with Charles Bowers— his old boss at the Mutt and Jeff studio—on a half-dozen live-action shorts.[19] Sears was that great rarity in the early thirties, an animator who was esteemed for his ideas rather than his drawings; before he left New York for Disney's, he was listed in the 1931 *Film Daily Year Book* as the Fleischer studio's scenario editor. Disney also hired, as Sears' assistant, Webb Smith, a newspaper cartoonist.[20] Sears and Smith, in Wilfred Jackson's words, "came into the music room for the first couple of weeks to help out with gags and cartoon business each time a director began to work on a new short."[21] (Jackson himself had begun directing around the time Sears joined the staff. Like Iwerks and Gillett before him, he worked at first without a title of any kind, but by mid-1931 Disney was calling Gillett and Jackson his "story men.")[22] The gag men provided very little help through drawings: Sears drew little if at all after he came to Disney's, and Smith's idiosyncratic drawings did not translate easily into animation. The gag men functioned only as writers and were thus truly specialized, in a way that no one on the Disney staff had been before.

The first fruits of Disney's increasing concern with the writing for his cartoons showed up even before Sears arrived, in two cartoons delivered to Columbia in September 1930. These cartoons were not reprises of the Oswalds, with their flow of fantastic gags; instead, they told stories—slight ones, pocket narratives. *Monkey Melodies*, a Silly Symphony, begins very much like an Iwerks-period cartoon, with rhythmic movement in the jungle, mainly by a monkey couple. The resemblance to Iwerks's cartoons diminishes sharply, though, when a crocodile begins to menace the monkeys. *The Gorilla Mystery*, a Mickey Mouse cartoon, offers another menace, a ferocious gorilla that threatens Minnie. The hero and heroine of *Monkey Melodies* escape from the crocodile, but Mickey and

Minnie go them one better by using the vanquished gorilla as a Maypole.

From the first, Disney had understood that sound could make what was on the screen seem more real. That stronger sense of reality was now opening up a tantalizing new possibility: that cartoon makers need not rely on rapid-fire gags, but could instead tell stories that held an audience's attention at least as firmly as the average two-reel comedy did. Such cartoons would, however, require characters that invited a willing suspension of disbelief, and characters of that kind did not exist in 1930. No one knew how to animate them.

Wilfred Jackson, remembering his earliest days as a director, thought of Walt Disney as a constant presence: "He was right there all day, every day, to talk with us about whatever we were doing, each step of the way."[23] So, too, for the animators. "He was right in the next room," said Richard Lundy, who began animating early in 1930 after a few months as an assistant to Norm Ferguson. "Whenever we'd go to the can, we'd see him.... He would drop by and just start talking."[24]

He dropped by, too, when the animators weren't there. He prowled the studio at night, stopping at the animators' desks to see what they were doing. Those nocturnal visits were regarded as "a little sneaky," Dave Hand recalled—at one Christmas party in those years, when members of the staff drew names and exchanged inexpensive gifts, Disney got a pair of rubber heels[25]— but most animators seem to have been invigorated by the tension that Disney's constant presence imposed. "I think the outstanding thing about Walt," Jackson said, "was his ability to make people feel that what he wanted done was a terribly important thing to get done."[26]

Disney noticed, Jackson said, "little things that would make a big difference," like what could be done by "varying the spacing of the inbetweens," that is, by having each successive drawing differ from its predecessor not always in the same proportion, with stair-step regularity, but sometimes sharply and sometimes very little. By "spreading out, then condensing the spacing," as Jackson said, the animator could "get an accent in the action." Most animators would have appreciated the advantages of such a change once Disney had pointed them out. Sometimes, though, in anec-

dotes from those early years, there is a sense of a much wider gulf of understanding.

Hand recalled animating a "Mickey Mouse taxicab scene," almost certainly for *Traffic Troubles*, delivered to Columbia in March 1931. The Disney studio's records show that in January of that year Hand was animating a scene in which Mickey's anthropomorphic taxicab suffers a blown-out tire. "I did my very best with it...and got it on the Moviola with Walt," he said, "and he squinted and squirmed and grunted, and said, no, it didn't have enough exaggerated action to it. I said O.K., and back I went to my desk.... I made it more exaggerated, and...he turned it down. I thought, 'What does this crazy man want?'"

Hand had reached his limit:

> I said to myself, "I'm going to show that fellow a trick or two." So I went back to my desk to redo this scene...and I said, I'm going to make this thing so extreme, so outlandish, so crazy, that he'll say, "Well, Dave, I didn't mean to exaggerate it *that* much."...I brought the new test in very self-righteously and put it on for Walt and said, "All right, Walt, I did this thing over again. I hope it's O.K.," while slyly watching for him to explode—fly off the handle. He put his foot on the pedal, and he started the loop [of film] around and around and around, looking at it and looking at it. Then he stopped the loop and looked up at me with a big smile and said, "There! You've got it! Why didn't you do it that way in the first place?"[27]

As Hand's anecdote indicates, by early in 1931 Disney and his animators were often looking not just at drawings on paper, but at drawings on film—"pencil tests," as they were called. For such a test, the Disney cameraman photographed the animator's pencil drawings on thirty-five-millimeter film, as if he were shooting inked and painted cels. To save money, Disney and the animators looked at the negative film, instead of a positive print; they watched it on a machine called a Moviola, which back-projected the image onto a tiny screen. The Disney studio's animators were making pencil tests by the late twenties, not to show to Walt but to see for themselves how a scene was turning out. Gradually, the tests assumed more importance—by the time Ben Sharpsteen joined the staff as an

animator, in mid-1929, pencil tests were already in common use[28]—and Disney himself began to watch them.

Disney seems to have lagged a little behind his animators, though, in appreciating how helpful pencil tests could be. It took a few years, Dick Lundy said, before animators began shooting tests of complete scenes as a matter of routine. In Lundy's account, Tom Palmer had shot a complete forty-nine-foot scene in pencil test—this was probably early in 1931—and Disney happened by when Lundy was helping Palmer feed the film into a Moviola. Disney looked at Lundy, holding the film out straight some distance away from the Moviola, "and he said, 'Jesus Christ, what's this?'... But he thought that was a good idea. From that time on, we shot the complete scene."[29] To envision a completed scene on the screen required a considerable stretch of the imagination when only the paper animation was available for part of the scene; the stretch required was much less when all of the scene was in pencil test.

At the beginning of the thirties, Disney and the animators looked at pencil tests only on a Moviola.[30] For all its usefulness, the Moviola had severe limitations: not only was the image very small, but since the Moviola had been designed for use in editing silent films (the first sound model did not appear until 1930), the pencil tests moved through it not at the constant sound speed but at a variable speed controlled by a foot pedal.[31] "If you had a heavy foot," Dick Lundy said, "you could run it fast; if you had a light foot, it was slow."[32] And the Moviola was noisy.

Between February and July 1931, the Disney premises expanded significantly, through the construction of a two-story, L-shaped addition to the rear of the studio, and an adjacent sound stage. The animators and directors moved into the L-shaped addition, leaving the inkers and painters as the only members of the animation staff in the building that had once housed everybody.[33] The studio probably had only a single Moviola before the move, but in the new building there were at least two, one in an alcove on each floor.[34]

The addition gave Disney and the animators the opportunity to watch tests in another setting as well. The two music rooms, for Gillett and Jackson, occupied bays at the angle of the "L"; Jackson was on the ground floor, Gillett on the floor above (Walt Disney's office was a few steps away from Gillett's). Opening on the hall outside Jackson's music room was what he described as a small,

roughly triangular room, originally designed as a closet. Within a year, by sometime in the spring of 1932, that closet had been converted into a cramped projection room, soon dubbed the "sweatbox."[35] In that sweatbox—the name seems to have been inspired by the jitters that the screenings inspired, as much as by the close quarters—"the group of us stood huddled close together, between the projection machine and the screen, but off to one side, so as not to cut off the image on the screen," Jackson said. "One after another of the animators' tests would be threaded up and run over and over again while it was viewed and thoroughly discussed before being taken off the projector."[36]

Disney criticized those pencil tests "in a general way," Ben Sharpsteen said. "Walt was never much at being specific.... He just figured if there was something wrong with it, it was up to the responsible people to get out and do something about it."[37] By the time pencil tests came into common use in the studio, Disney was years removed from his own work as an animator, and by 1931, with Jackson in a second music room, he had finally left behind his involvement in the details of production. Because he rarely made technical criticisms of the animators' work, much less suggested solutions, some animators, like Sharpsteen, found his comments of limited value.

But as Hand's anecdote indicates, what Disney was starting to do was potentially far more valuable. From his new, relatively detached perspective, Disney was responding to the animation not as one technician might respond to another's work. He was concentrating instead on the effect the animator's work would make when it appeared on a theater screen: Was it "exaggerated" enough? That is, was it simple and clear and funny? Was it strong enough to get across the point of the scene? He had long thought in such terms—as witnessed by his criticisms of Iwerks's animation for *The Barn Dance*—but now that he was not writing stories or preparing exposure sheets, he could more consistently evaluate his animators' work as if he were a particularly knowledgeable and discriminating member of a theater audience.

By 1931, Disney had begun cleansing his cartoons of an arbitrariness that animators had

long taken for granted. That arbitrariness had attracted some of them to the business in the first place. Jackson was one:

> The kind of gags I used to like in pictures were the things that they could do because they were drawings—the impossible things. You feel like you could do it: I feel like if I stretched hard enough I could reach out there and get my hand on those things [he was reaching toward some sandwiches six feet away]; well, a [cartoon character] could shoot his hand out, and pick one of those up, and eat it.[38]

A cartoon character reaches for something and stretches his arm several times its normal length while his body remains stationary; nothing could be more arbitrary than that. By the early thirties, too, many animators were relying on curving forms so heavily that they were sacrificing any sense of a body's structure for the sake of smooth, flowing movement. Like arbitrary distortion of other kinds, such "rubber hose" animation could not be reconciled with Disney's emerging emphasis on telling coherent cartoon stories that would engage an audience. "As Walt began to bear down a little bit on making his characters believable," Jackson said, "all this had to go."[39]

Disney was absent from his studio on an extended vacation for much of the fall of 1931, responding to what Diane Disney Miller, in her biography of her father, describes as a nervous breakdown brought on by overwork. "I was expecting more from my artists than they were giving me," he told her, "and all I did all day long was pound, pound, pound."[40] He was back at work by December 1931,[41] and by then his efforts were bearing fruit: he had banished from his cartoons intriguing strangeness of the kind that had flourished in the silent Felix and Out of the Inkwell cartoons.

He had also not replaced it with much else. Take *Mickey's Orphans*, delivered to Columbia in December 1931: even though the animation was surely pencil-tested at least in part, the timing is consistently slow, to the point that the characters—Mickey and a horde of destructive kittens—sometimes seem to float. In *Mickey's Orphans*, and many other Disney cartoons made around the same time, there is not much that is arbitrary on the screen, but there is not much that is believable either. As Disney sweated the old formula excesses out of his cartoons, and shot more and more pencil tests, many of his animators did not, or could not, respond. But one of them did.

Norm Ferguson had worked for Paul Terry on the Aesop's

Fables series as a cameraman until Terry discovered his talents as an animator. He first caused a stir at the Disney studio when he animated a trio of dancing fish for an undersea Silly Symphony called *Frolicking Fish*; it was delivered to Columbia in May 1930. Ferguson's animation was, as Jackson recalled, the first Disney animation with "moving holds," that is, poses that were not rigid and sharply defined, in the Iwerks manner, but were instead softened by movement. "He slowed in, moved through," Jackson said. "If one part held, some other thing moved. Before that time, we'd get into a pose and hold it; we'd move into another pose, and we'd hold it. Gee, this was something [when] we saw this: 'What did Fergy do?'"[42]

Shortly after animating the trio in *Frolicking Fish*, Ferguson animated two identical bloodhounds who pursued Mickey in *The Chain Gang*. The dogs were among the very first Disney characters whose design broke with the prevailing formula that put white masks on virtually interchangeable black bodies. The bloodhounds, in their single scene, snuffle along the ground, then sniff and howl into the camera; their jowls hang loosely, their nostrils wrinkle and flare, their movements echo those of real dogs. When the dogs appear, there is a sense, however faint and fleeting, of solid flesh on a screen otherwise occupied by phantoms. (Shortly after the dogs appear on screen, Mickey encounters two black-and-white horses, animated by Sharpsteen, that might as well be jointed paper cutouts.)

Two months later, in October 1930, Disney delivered *The Picnic*, the first Mickey Mouse cartoon with the dog that was then called Rover but soon became known as Pluto. Ferguson shared the animation of Pluto in that cartoon with Lundy and Charles Byrne, but the dog was far more his character than theirs. If Pluto was in no sense "realistic" in design—his drooping black ears and his pencil-thin black tail were particularly fanciful—he was nevertheless, like the bloodhounds, something more than an abstract idea of a dog. He was closer to a caricature of an ungainly hound, his face and body heavy with flesh.

It was through his animation of the bloodhounds, and then of Pluto, that Ferguson directly challenged the gravest deficiencies of the Disney animation of the early thirties. That animation's rigid look, as Jackson said, derived mostly "from the way all the different

parts of the cartoon character's figure and drapery—all the secondary parts of the drawing—moved in between one extreme drawing and the next. It was these details...that moved precisely and rigidly."[43] Ferguson softened that rigidity by expanding upon the animation principle he had just uncovered in *Frolicking Fish*. He had proved in that film that movement could enliven, not weaken, a pose. From there it was but a short step to animating a character the parts of whose body moved at slightly different and constantly varying speeds.

Such movement—animators call it "overlapping action"—looks loose and natural on the screen because it corresponds to how real bodies and clothes move against the opposition of gravity and air. In Pluto's case, since he wore no clothes, overlapping entered through shifts in the dog's flesh as he moved. Because Ferguson animated that shifting flesh as if it bore some relationship to gravity, Pluto became the first Disney character whose body seemed to have any real weight.

Dick Lundy recalled the time that he tried to animate a dance: "I analyzed it, and I animated it the way I thought it was, but it wasn't the dance. And Fergy says, 'You want to give the *illusion* that this is happening; regardless of whether it does or not, give the illusion.'"[44] Here was what was so important about Ferguson's animation: it showed animators how they could create a more lifelike illusion without copying life. There was, after all, no way Ferguson could have observed how fish move when they dance; from the start, in *Frolicking Fish*, the principles behind Ferguson's animation existed apart from what he was animating. Overlapping action lent itself to the animation of all kinds of characters: it could be modified and refined, endlessly, to produce the most lifelike result in every case. What would matter was not how carefully the animator observed nature, but how cleverly he manipulated the tool Ferguson had given him.

Gradually, some of the other Disney animators did begin to follow Ferguson's lead. In *Mickey Steps Out*, delivered to Columbia in July 1931, Mickey dances while Minnie plays the piano, and the routine animation that has filled most of the cartoon's earlier minutes gives way to something more sophisticated. Mickey moves with none of the monotonous rhythmic twitching so typical of the early Disney sound cartoons; instead, Mickey's movements have some of the variety, within the rhythmic framework of the music, that a human dancer's would have. This animation

could be Ferguson's, but according to the Disney studio's records, it is Lundy's.

Lundy was an exception. For all the admiration that Ferguson's animation was exciting within the studio by 1931—and it seems to have excited a lot—very little of what he did rubbed off on his fellow animators. There was, to be sure, gradual improvement in almost every category, and sometimes whole cartoons stepped forward in surprising ways. *Egyptian Melodies*, a Silly Symphony delivered to Columbia in August 1931, opens with palm trees swaying in the wind—remarkably, the trees (animated by Charles Byrne) move not just rhythmically but irregularly, as if struck by a breeze that picks up and dies down. Inside a Sphinx, in a scene by David Hand, animated backgrounds move in constantly changing perspective, as a spider wanders along hallways.

However impressive such isolated achievements, they could not close the gap between Ferguson's animation of the characters themselves and that of most of his fellow animators. By early 1932, as Ferguson's own work grew more assured, the gap could sometimes be disturbingly wide. In, for example, *The Mad Dog*, delivered to Columbia in February 1932, Ferguson animated the early scenes in which Mickey washes Pluto. After Pluto swallows a bar of soap that fills his mouth with suds (thus the cartoon's title), Ferguson's animation gives way to animation by Hand. Pluto dashes past the camera in animation that echoes Ferguson's, and in that animation there is evidence of what Hand himself described as a continuing process: "Seeing the stuff the other guy's doing, and liking it, and thinking, I'll get some of that into my dog, or whatever, when I'm animating it."[45] But then Mickey, likewise animated by Hand, floats by in weightless animation, his footfalls marked by hollow-sounding "tocks."

When Disney and his animators watched pencil tests in 1931, they saw drawings that were, except for the lack of ink and paint, very similar to what would wind up on theater screens. The animators' drawings were clean and finished, with all the inbetweens in place. Ordering changes in those scenes was a serious matter because of the cost involved, especially

since for each of an animator's tests it was often the animator himself who, as Dave Hand said, made "all the inbetweens, and the drawings cleaned up nicely."[46] When Hand spoke in 1973 of the changes he had to make in his scene for *Traffic Troubles*, he said that he had to make six pencil tests; the true total was probably more like three,[47] but whatever the figure, such multiple tests of a single scene must have been a bizarre anomaly.

At some point, most likely by early in 1932, Disney set in motion a major change in how his animators tested their work. Jackson thought that the change got under way when Ferguson was animating for Gillett on a Mickey Mouse cartoon. Ferguson "made rough drawings of the dog, and pencil tests were shot of the rough drawings. The great discovery was made that you could read the action perfectly well from the rough drawings."[48] That "rough test" may have been Disney's idea. Lundy remembered that once the animators began shooting tests of complete scenes, Disney did not want to wait until a scene was cleaned up to see it in a test: "It got so that it took too much time to clean up, so [Disney] said, 'Rough it.'"[49]

Ferguson had never been admired for his draftsmanship—in his animation of the early thirties, the characters' proportions tend to shift—and even if, as Les Clark suggested, "he animated as clean as he could, in the beginning,"[50] rough sketching came more easily to him. In early 1930, when Lundy assisted him, Ferguson made rough drawings for his scenes, then traced them cleanly on new pieces of paper.[51] By 1931, Larry Silverman, one of Ferguson's three assistants then, said, his work was "very rough, real sketchy."[52] In any case, Disney valued Ferguson not for the way he drew, but for the way his characters moved, and Ferguson's pencil test of his rough animation made clear how tenuously the two were related. Disney seized the opportunity: from then on, Ferguson would animate roughly, relying on an assistant to clean up most of his drawings after his rough pencil tests had been approved.

Assistants had already been improving Disney animators' drawings, Ferguson's included, for some time, and in later years some studio veterans spoke as if "cleaning up roughs" began in 1930 or even earlier. But there was a difference. Typically, in those earlier cases, as Jackson said, "all of the detail was drawn, but not very well." The assistant improved the appearance of details that the animator had already drawn. But now Ferguson's assistant provided details that Ferguson himself did not draw. As

a practical matter, the procedure may not have changed all that much—most of the characters were still so simply designed that there couldn't be a lot of details to add—but, conceptually, the change was significant. As Jackson said, Ferguson's job had become, in a first for a Disney animator, to draw "the action without really drawing the character."[53]

Disney expected his other animators to switch to tests of rough animation, too, but the transition did not occur abruptly; Jackson remembered it as being "spread out over maybe a two- or three-year period."[54] Disney may have forced the change on only a few animators at first, concentrating on those whose work seemed most in need of loosening up. For certain, some animators found the change extremely taxing, none more so than Jack King, who in Jackson's account "resisted Walt's order for all preliminary animation to be roughed out.... When it finally became necessary for him to shoot a rough test, Jack would have his assistant add rough lines to Jack's clean animation drawings to make them look like roughs for the test." After the rough test had been approved, the drawings went back to King's assistant, who made a new set of drawings that looked pretty much like King's originals. Finally, though, "Walt caught [King] doing it and made a big fuss about it."[55]

The source of King's discomfort was far more profound than a simple disruption of long-established working habits. Before the advent of rough pencil tests, a Disney animator's drawings of, say, a dog had to meet little more than one broad, simple test: Could an audience accept this animation as in some way representing a dog? But as soon as Disney began requiring rough pencil tests, and thus opened the door for extensive changes in an animator's work, he could make more rigorous comparisons. In effect, Disney asked King and his other animators to recapitulate overnight the transition from the art of the Middle Ages to the art of the Renaissance—a transition marked in part by a shift from hard, precise, formulaic drawing to loose, exploratory sketching. "The hallmark of the medieval artist," E. H. Gombrich has written, "is the firm line that testifies to the mastery of his craft. That of the postmedieval artist is not facility, which he avoids, but constant alertness. Its symptom is the sketch, or rather the many sketches which precede the finished work."[56] At the Disney studio, the animator's

rough pencil test served as a "sketch," to be modified repeatedly until the animator completed the "work," the finished scene.

There's scant evidence of such a change in the seven Disney cartoons—only one of them a Silly Symphony—released in the first half of 1932, when Disney filled out the schedule with routine musical Mickeys like *Mickey's Revue* and *Musical Farmer*; the animation for those films, and others, is in many ways as weak as any from a year or two earlier. But major change was on the way. In June 1932, Disney and United Artists announced a new distribution contract, one that gave Disney an advance of fifteen thousand dollars per cartoon.[57] That was more than double what he received from Columbia—and this time Disney had no settlement costs to work off before he got his share of the profits.

Disney had actually signed his contract with United Artists in December 1930,[58] less than a year after making his deal with Columbia. The hard bargaining that surrounded the Disneys' settlement with Pat Powers had left in them a residue of ill feelings toward Columbia—in a letter to Walt during the negotiations, Roy complained that "Columbia hasn't shown a very square attitude"[59]—and, in any case, Columbia was too small and financially scrawny to offer the Disneys enough money. It took until July 1932, more than a year and a half after they signed with United Artists, for the Disneys to deliver to Columbia *Mickey in Arabia*, the last cartoon under their contract.

The Disneys had delivered their last Silly Symphony to Columbia six months earlier. When United Artists released its first three Sillys in July, the change in budgets could be felt right away—most dramatically in *Flowers and Trees*, the first Disney Technicolor cartoon, a Silly Symphony in which two young trees find their romance threatened by a malicious stump. *Flowers and Trees* was the first film anyone made in three-color Technicolor, although Disney had begun making it as a black-and-white cartoon; he ordered the change to color after the cartoon had already been shot. William Cottrell, Disney's cameraman at the time, remembered that "they took all the [black-and-white] cels and carefully washed all the reverse side," removing the white and gray paint there and leaving the ink and the black paint on the top side, "then repainted them in color on the back." Using a camera at Technicolor's own facilities, Cottrell reshot the film in color.[60] In its drawing and animation *Flowers and Trees* very much resembles the black-and-white cartoons that preceded it by a year or more, but the sheer novelty of its color was enough to win it

excited approval. *Flowers and Trees* opened at Grauman's Chinese Theater in Hollywood as part of a prestigious bill—the feature was MGM's *Strange Interlude*—and it received, according to *Motion Picture Herald*, a welcome "little short of sensational."[61]

The Disneys and United Artists had approached color gingerly, wary of the added cost of Technicolor prints when the Depression was ravaging theater admissions. Roy had broached the idea of releasing *Flowers and Trees* in color to only a few first-run theaters, with a general release in black and white,[62] and it remained an open question for some months after the cartoon's premiere as to whether all future Silly Symphonies would be made in color. By the fall, though, audiences' enthusiasm—and the Disneys' own enthusiasm—had carried the day. "The reaction on every hand to the addition of color in the Symphonies has been so outstanding and personally we feel that color has added so much to the Symphonies that we are convinced it would be wrong to consider any other course," Roy Disney wrote to a United Artists executive.[63]

It was, however, *Just Dogs*, a black-and-white Silly Symphony released the same day (30 July) as *Flowers and Trees*, that offered an even more tantalizing glimpse of where the Disney cartoons might be headed. In *Just Dogs*, Pluto for the first time played a starring role apart from Mickey Mouse. The cartoon is set in a dog pound, populated by dogs of breeds depicted so precisely that they can be caricatured (a Russian wolfhound all but disappears when it turns its narrow body to face the camera). Not only are the dogs more precisely drawn than their predecessors, but there is also a new assurance in the way they move—in the way a Boston bull terrier's head turns in three-dimensional space, for instance. *Just Dogs* was the first Disney cartoon to benefit from advances in animation and drawing of exactly the kind that could be expected to flow from the use of rough pencil tests. Predictably, Norm Ferguson animated much of it—his are the key scenes in which the Boston bull tries to win Pluto's friendship and finally succeeds—but the animation in *Just Dogs* was not simply a more refined version of what Ferguson had already done. Ferguson's earlier animation, although more lifelike than the animation that preceded it, did not invite direct comparison with real life; the animation in *Just Dogs* did.

When work on *Just Dogs* was getting under

way early in 1932, a notice for a 14 January gag meeting circulated in the studio, bearing this admonition, in capital letters: "All scenes will depend on the characters acting as natural as possible without any exaggerated tricks."[64] In *Just Dogs*, for the first time, a Disney cartoon was not just free of "exaggerated tricks"—the arbitrariness that Disney had begun banishing from his films soon after Iwerks's departure—but offered for its entire length something to take the place of those tricks: plausible characters who moved in a "natural" way.

As far back as the Laugh-O-gram days in Kansas City, Walt Disney had fastened on the idea that drawing from life could lead to improved animation. Rudy Ising remembered that Disney advertised for models and held one life class at the Laugh-O-grams studio: "Walt had the idea that maybe we should learn to draw a little better."[65] That was not a popular notion in the animation studios of the twenties. Shamus Culhane told John Canemaker that when he was working as an apprentice in Charles Mintz's Krazy Kat studio late in that decade, "I decided to go to the Art Students' League at night, and one of the animators told me very solemnly, 'Don't go to art school. It'll stiffen you up.' "[66] So long as rigid formulas dominated animation, many animators regarded suspiciously anything that might make an animator hesitate to use those formulas—anything that might "stiffen you up."

Even at Disney's, in the early thirties animators took for granted a rather low level of simple drawing skills. As in Kansas City, though, Walt Disney himself wanted his animators to meet a higher standard. Late in 1929, he began sending members of his staff to a Friday-evening class at the Chouinard School of Art in downtown Los Angeles, with tuition paid by the studio.[67] "He'd drive us down and drop us off," Les Clark said. "None of us had cars then. He'd go back to the studio and work, and then pick us up."[68] Disney probably had no specific goal in mind—Ed Benedict, who attended the classes around 1931 as an assistant animator, said the idea was "just to get a feeling for drawing, generally"[69]— and many of the Disney animators seem to have regarded the classes skeptically. By mid-1932, though, life classes were becoming more attractive. Not only was the center of gravity in Disney animation shifting away from formulas, but the staff itself was

changing, infiltrated now by animators who did not find life classes disturbingly alien.

One of those animators, Arthur Babbitt, had come to Los Angeles from New York late in the spring of 1932, determined to work for Disney. Babbitt had spent almost three years on Paul Terry's staff, but, he said, the Disney studio "was the only place I wanted to work." By then, Disney himself was no longer as accessible as he once had been ("No matter how many times you phoned, you just didn't get to the master," Babbitt said). So Babbitt resorted to "an old trick I'd learned from an advertising man. I wrote a big letter to his secretary—and by 'big letter,' I mean it was approximately twenty by twenty-four feet. I had to get down on the ground to paint it. I sent it special delivery, registered, and all those things that would make her take notice." Babbitt got his interview with Disney and, a day or two later, a call to start work. After two days as an inbetweener he began animating, at first under the wing of Ben Sharpsteen.[70]

The animators were not attending the night classes when Babbitt started work in late July, but Babbitt himself took up the slack a few weeks after he joined the staff:

> One night, I invited the guys who worked in my room—there were eight of us—to come to an art class because I very foolishly thought that artists, animators, should know how to draw. I got hold of a model, and we were very serious about just drawing. We had no teacher. I invited eight guys, but fourteen showed up. The next week, I invited those fourteen, and twenty-two guys showed up.[71]

After three weeks of classes, Walt Disney called Babbitt to his office. As Babbitt recalled their conversation in 1941, Disney said he had "tried to stimulate interest in art studies among the artists and even had arranged for scholarships at Chouinard's, but the interest lagged and gradually all the students dropped away. However, he noticed that there was a great deal of enthusiasm for this class and he was willing to supply materials and pay for instructors or anything else I desired if I could get the class going out there at the studio."[72] For six weeks or more, Babbitt was the closest the classes had to a teacher. Then Hardie Gramatky, a Disney animator and a Chouinard

graduate, suggested to Babbitt that "there was an art teacher at Chouinard's that we ought to get, name of Don Graham."

Donald W. Graham already knew some of the animators; since 1930, he had taught the Friday-evening classes to which Walt Disney would, as Les Clark put it, "drag us down." Graham began teaching life classes on the Disney sound stage on 15 November 1932. "First it was just two evenings a week," he wrote in 1972, "with some twenty or thirty men in attendance each evening. In a matter of three or four weeks it became necessary to divide these classes [and] Phil Dike was called in."[73] Because he and Dike had no knowledge of animation and "most of the Studio artists had no understanding of the human figure," Graham continued, "it was a brutal battle."

However brutal the "battle," it was over quickly. Graham was by all accounts an exceptional teacher, one whose pragmatic turn of mind—he had originally studied to be an engineer[74]—fitted him for teaching in an animation studio. In addition, Graham was, like many of his youthful Disney students, an athlete—"a fantastic water polo player and a great swimmer," in Phil Dike's words—and he brought to his classes a sensitivity to movement. "I learned more about animation from Don Graham than I ever learned from any animator," Babbitt said, "because he taught me to analyze.... You realize that only the slightest little offbeat element in a person's movement makes him a distinctly different character."[75]

For many of Graham's students at the Disney studio, the simple fact they were drawing from life may have been even more significant than the identity of the teacher. By the time the classes got under way, Disney animation had, thanks mostly to Norm Ferguson, torn loose from its old moorings; the life classes, by forcing the animators to look outward and consider the life that some of their animation now resembled, made it more difficult for them to drift back into bad habits.

Although Mickey Mouse was immutably a formula character, by late 1932 Disney had introduced many characters in both the Mickey series and the Silly Symphonies that departed from strict formula; it was in the drawing and animating of such characters that the animators and their instructors could find common ground. Both Graham and Dike swiftly adapted their classes to make them more useful. As Dick Lundy said, "Graham didn't just come in and say, 'Now I'm going to teach you the human figure.' He tried to combine his teachings with animation.... He would

actually have the model...fall down on his hands and roll over....
And then we would try to copy it."[76] In such ways did the classes
serve Walt Disney's purposes. Certainly he did not start the class-
es out of any interest in art as such; he seems to have regarded
much fine art with a provincial's narrow suspicion. Art Babbitt
told this story in 1971:

> Shortly after I came there, I spent my last eighteen dollars
> on a Cézanne still life, *The Green Jug*. I couldn't afford a
> decent frame for it, so I had a frame made out of door mold-
> ing. I kept it up on top of my animation desk. [Disney] came
> in and he looked up at this print on my desk, and he said, "I
> don't like it.".... I said, "Why not?" "Well, the top of that god-
> damned jug is crooked." I tried to find some common
> ground; I don't know whether I was successful or not. I tried
> to relate the crookedness of the top of the jug somehow hav-
> ing a little to do with Mickey Mouse's arm being twice as
> long as it should be, under certain conditions. He had the
> last word: "Anyhow, I don't like it." And he went stomping
> out. I got mad, and I picked up my print, and I stomped out
> and went home.

A few months later, probably in the early fall of 1933, Babbitt
"was working on something completely unrelated to this inci-
dent"—apparently a scene near the beginning of *The China Shop*
(1934)—"and again, he was breathing over my shoulder. He said,
'You know what I'd like to see you get in this character here?' I
said, 'What?' 'You know, some of that exaggeration, some of that
sensitivity and stuff, you know, like Cézanne gets in his still
lifes.'"[77]

Babbitt told that story again after 1971, but in such a way that
Disney emerged as nothing more than a philistine—crudely hos-
tile to modern art on the one occasion, crudely accepting it on the
other. In Babbitt's 1971 account, the meaning is somewhat differ-
ent: however much Disney's own history may
have predisposed him to scorn art that he did
not understand, he would be drawn back to it
if he saw in it something that might help him
improve what he *did* understand—his own ani-
mated films. His desire to improve those films
encouraged in him an openness that almost
everything else in his makeup discouraged.

"Walt was one to say no to something," Les

Clark said, "then pick it up again and say, 'Hey, that's a good idea.'"[78]

"Our studio had become more like a school than a business," Walt Disney later said of this period. "As a result, our characters were beginning to act and behave in general like real persons. Because of this we could begin to put real feeling and charm in our characterization. After all, you can't expect charm from animated sticks, and that's about what Mickey Mouse was in his first pictures."[79]

Some of the animals in the Silly Symphony *Father Noah's Ark* do, in fact, reflect a new sharpness of observation on the animators' part; the elephants, animated a few months after *Just Dogs*, move with a heaviness that is unmistakably authentic, even more so than the three-dimensional movements of the dogs in the earlier film. (Griffith Park, site of the Los Angeles city zoo, was near the Disney studio.) But the most striking of the Disney cartoons from late 1932 and early 1933, the ones completed in the months when Graham's classes were getting under way, still contained little in the way of "feeling and charm in our characterization." Their charm was of another kind. In *Father Noah's Ark* and other Silly Symphonies, like *Santa's Workshop*, Disney's larger budgets under the United Artists contract showed up in a new abundance and intricacy of movement—in crowds of animals boarding the ark in the one film, in dozens of Christmas toys on the march in the other. There was finally enough money to plan and animate scenes teeming with characters without relying too obviously on such cost-saving devices as cycles and repeats.

With the change in distributors and the increase in budgets came a rush of new human characters, too. Before 1932, human characters had turned up rarely in the Silly Symphonies (and never in the Mickey Mouse series) and usually in so eccentric a form that they hardly seemed human at all. Human characters assumed new importance in the second Silly Symphony made in color, *King Neptune*, released in September 1932, and this shift in emphasis continued over the next few months in *Babes in the Woods*, *Santa's Workshop*, and *Father Noah's Ark*. Disney clearly hoped to bring his principal human characters to life in key scenes early in each film in a way that would sustain interest in those characters through to the film's conclusion. In *Santa's*

Workshop, Norm Ferguson animated the key scenes of Santa himself as he reads and chuckles over a little girl's letter. In *Father Noah's Ark*, Ferguson animated only two scenes, but those are the scenes in which Noah and his wife address the camera directly, singing as they identify themselves. In neither case were the results particularly encouraging. Movement that was impressively lifelike in a formula character like Mickey Mouse seemed much less so when the characters were cartoon humans.

In the Silly Symphony that followed *Father Noah's Ark,* a newly promoted animator finally provided some of the charm that Disney was seeking—not in human characters, though, but in animals. The animator was Fred Moore, and the cartoon was *Three Little Pigs*, released in May 1933.

Moore started work at Disney's in August 1930, less than a month before his nineteenth birthday. His hiring was in some sense accidental. Les Clark, the animator whom Moore assisted in his early months at the studio, remembered that someone else was supposed to get the job but decided not to take it and sent Moore in his place.[80] Chuck Couch, who had known Moore "since we were kids together," offered a slightly different version: Couch encouraged a friend to apply for a job at Disney's, but that friend suggested Moore as a substitute. "I took some of Freddy's drawings over to the studio," Couch said, "and Walt flipped right away."[81] (In one elaboration on this studio legend, Moore himself showed Disney some drawings he had made on cardboards from laundered shirts.)[82]

Moore seems always to have been a supremely natural draftsman, one whose animation, in Art Babbitt's wryly admiring words, "came out of the tip of his pencil without circulating through his brain."[83] Les Clark, who had the first opportunity to assess Moore's work, said, "Animation came too easily to him; he didn't have to exert any real effort."[84] Despite his facility—or perhaps because of it, if Clark's comment is any guide—Moore did not advance at the Disney studio with exceptional speed. He was still an assistant animator in October 1932, more than two years after he started.[85] Around that time, though, the Disney studio's records show him beginning to animate minor bits and pieces under Ben Sharpsteen's tutelage; he got credit with Sharpsteen for a couple of scenes in *Santa's Workshop*. His first major assignment, which

he picked up in February 1933, was a group of scenes in *Three Little Pigs*.

In later years, Walt Disney spoke of *Three Little Pigs* as simply one more cartoon in the studio's pipeline: "It was just another story to us," he told *Time* in 1937, "and we were in there gagging it just like any other picture."[86] Other members of the staff later echoed that thought: *Three Little Pigs*, Dave Hand said in 1973, was regarded at the studio as "normal development," not as any sort of breakthrough film.[87] This is curious because there is good reason to believe that Disney saw *Three Little Pigs* as a special film. In making it, he departed from patterns he had set in making his earlier films, not least in how he deployed his animators. The bulk of the film was animated by only two men: Ferguson and Lundy, the strongest of the studio's veteran animators. Of the remaining footage, most was animated by Fred Moore and Art Babbitt, two of the brightest of the newer animators.

Such a concentration of talent was highly unusual, as was the small size of the crew. Many more animators had usually worked on each of the earlier cartoons, animating a scene here and a scene there; Disney had little choice but to parcel out work that way, if he wished to keep his staff busy and his costs down. By early 1932, though, with his United Artists contract about to take effect, Disney had begun to assign work differently. On *Barnyard Olympics,* for example, a Mickey Mouse cartoon delivered to Columbia in April 1932, most of the animators handled short sequences, blocks of scenes, instead of bits and pieces. By the time Disney made the first color Silly Symphonies, he had gone even further and begun to "cast" his animators by character, in an embryonic fashion, most often by tossing difficult characters to Norm Ferguson.[88]

For *Three Little Pigs*, Disney divided the animation among his exceptionally small and talented crew with a precision that had no precedent. Ferguson animated most of the wolf scenes, and Lundy most of the pigs. Babbitt filled in behind both men, animating wolf scenes and a few related scenes with the pigs. In addition to a sprinkling of pig scenes in which the pigs do not dance—Lundy was a dance specialist, so the dance scenes were assigned to him—Moore animated the crucial first three scenes in the film, the ones in which the pigs introduce themselves to the audience. The two foolish pigs sing cheerfully about their houses of straw and sticks, and the dour practical pig endorses the virtues of brick. It was in these scenes, for the first time, that

a cartoon delivered Disney's "charm in our characterization," thanks to Moore.

In Moore's hands, "charm" did not mean subtlety or acuteness; his pigs scarcely exist as personalities. Moore did not so much characterize the pigs as present them in drawing and animation that were uniquely ingratiating. Moore based his drawing style on soft, rounded forms with immediately pleasurable associations (he was famous at the studio for his sketches of ripe young women), but his curving forms, unlike those of rubber-hose animation, suggested skin and flesh over bone. Those forms suited the pigs, which had been designed in a more realistic style—partially clothed, but pink and hairless, with beady eyes—than had been the norm only a year or so before. Moore did not draw and animate the pigs as real animals, however; even though he articulated parts of their bodies (their trotters, for instance) more distinctly than the other animators did, there is no hint that he measured his pigs against real ones. Instead, like some Renaissance artist filling his canvas with centaurs, Moore drew fabulous animals that seemed to be made of flesh and blood.

The pigs would have caught an audience's eye for that reason alone, but Moore went further: he animated these seemingly solid little creatures with a plasticity that was new to Disney animation. The pigs do not simply bob in time with the music, as earlier cartoon characters did; instead, they seem to compress and extend their bodies rhythmically. Lundy's pigs in the succeeding scenes move stiffly by comparison, even though they are actually far more active than Moore's; their bodies are like steel balls that rise and fall without ever changing shape.

Moore observed a simple rule: even though the shape of each pig's body changes as it stretches and squashes in time with the music, the volume that each body represents stays the same. In that way, he showed how to make up for part of what was lost as Disney suppressed what Wilfred Jackson called "the impossible things." When, to use Jackson's example, an earlier cartoon character's arm stretched out several times its normal length to grasp something, what most damaged the plausibility of the action, and of the character, was not the stretching alone. As Jackson suggested, the stretching could have had some psychological validity, by giving visual shape to the way it feels to strain toward an object just out of

reach. But if the volume of a character's body expanded to accommodate the longer arm, there could be no sense of attenuation, or any other sympathetic response to the character's actions. By preserving a constant volume, Moore avoided just such a trap.

In this way in his few scenes at the beginning of *Three Little Pigs*, Moore significantly expanded Disney animation's vocabulary, much as Ferguson had before him. Like Ferguson's innovation, Moore's was not rooted in the observation of real life that Graham's classes had spawned. (Nothing indicates that Graham influenced his animation, any more than Graham influenced Ferguson's.)[89] The principle behind Moore's animation of the pigs could be applied to the animation of just about anything. "Stretch and squash," as it came to be called, was most directly applicable to solid, rounded forms of the kind Moore drew so well—certainly the charm that Disney sought was most easily obtained by animating such characters—but nothing limited the combination of elasticity and a constant volume to characters like the pigs.

Once Moore's animation reached the screen in *Three Little Pigs*, other Disney animators seem to have recognized its importance immediately. Claude Smith, who began assisting Moore around the time *Pigs* was released, remembered that important people from around the studio, including Walt Disney himself, dropped by Moore's room frequently.[90] Thanks largely to Moore and Norm Ferguson, any reasonably alert Disney animator could start work with a handful of trustworthy rules and techniques. The new gospel also began to spread to other studios, sometimes borne by unlikely messengers. Jack King, exemplar of the old hard-edged Eastern style, animated a few undemanding scenes in *Three Little Pigs* and left soon afterward to become head animator at the new Leon Schlesinger studio in Hollywood. When he talked about the animation of the pigs with Bob Clampett, a young assistant, King "told me much about the Disney style of distortion in the characters," Clampett recalled in 1975, "the looser treatment on the pigs."[91]

Three Little Pigs was a straightforward adaptation of a classic children's story. As Disney and his writers turned again to such material—to fairy tales, legends, animal fables, and nursery rhymes—they would find that many of those stories required plausible human characters at their core. The Disney animators had not brought human characters to life in the cartoons that preceded *Three Little Pigs*; the question now was whether, armed

with new techniques and fortified by Graham's classes, they could do so in the cartoons that followed it.

Although Walt Disney had first turned to fairy tales for inspiration when he made the Laugh-O-grams of 1922, he did not take much from stories like "Puss in Boots" besides their titles and general situations. In Hollywood in the twenties, he did not make any more fairy-tale cartoons of even that marginal kind. When he returned to rudimentary narratives, in the 1930 cartoons *Monkey Melodies, The Gorilla Mystery,* and *Playful Pan,* he set up simple conflicts between small, vulnerable characters and oversized menaces. He recycled that embryonic plot repeatedly over the next year or so, typically opening a cartoon with two or three minutes of musical scene setting as animal characters jigged and twittered until the plot proper got under way.

In most other Disney cartoons from 1931 and early 1932, musical scene setting was all there ever was, just as when Ub Iwerks was still on the staff. The animation looked less and less like Iwerks's, but the biggest difference between the Disney cartoons of 1929 and those of 1931 lay in what might be called the cartoons' density—the accumulation of comic incidents. Usually, a lot more was going on in the 1931 cartoons. For instance, *The Delivery Boy,* delivered to Columbia in June 1931, overflows with inventive gags. Mickey is delivering a piano and other musical instruments to Minnie's house in a mule-drawn wagon; after the mule kicks the instruments out of the wagon, a horde of farm animals somehow master the instruments instantly and plunge into a rousing performance of "Stars and Stripes Forever," each one playing in some ingenious way.

It's easy to see in these cartoons the value that Ted Sears, Webb Smith, and the gag men who followed them brought to the studio, through the help they gave Disney and his directors in fleshing out cartoons that otherwise could have been thin and hackneyed (as, indeed, a fair number of Disney cartoons still were). Just as Disney had to parcel out work to his animators scene by scene, so it made sense for him to think about gags scene by scene, too. That way, difficulties with a particular

scene or a particular gag need not jeopardize the film as a whole. When Wilfred Jackson spoke a few years later to a studio audience about stories for musical cartoons, he emphasized the importance of building them out of short, simple gags that could be moved around easily: "Then when you get in trouble with your timing you can play checkers with your gags. The music will give you the flow of continuity that you need."[92] Such considerations must have been especially persuasive in the early thirties.

Something else may have played a part: Disney's innate conservatism. He said in a 1931 interview that it was a mistake to think "that American audiences always want brand-new gags— surprises and cute turns.... They easily forget the original turns, but if a picture has given them a good laugh, whether by old gags or new, they always remember it."[93]

In the very early thirties, Disney did not depend heavily on anyone else to come up with ideas or even to give them visual shape; as Jackson said, "the picture Walt was after was in his head, not on pieces of paper."[94] Preliminary drawings of some kind were always a part of the process, of course. In 1931, as Jackson worked out the detailed continuity of his first cartoons, making "very rough thumbnail sketches of the business," Disney came to his music room "every day or two" for a short meeting; Jackson laid his sketches on a table and pointed to them while his musician, Frank Churchill, played the piano score that the two of them had worked out.[95] Sometimes the sheer volume of drawings forced a slight change in this procedure. Jackson recalled that in early 1931, during work on his second Silly Symphony, *The China Plate*, "quite a large stack of story sketches began to accumulate.... We arranged and rearranged them in long rows on the floor until they told the story.... [Disney] had to walk back and forth along the lines of sketches to see what we had in mind."[96]

In such ways did the preliminary drawings gradually assume greater importance. Likewise, as the studio grew, the search for gag ideas took on a more formal shape. Early in 1931, Disney was passing out simple typed outlines for planned cartoons at the evening gag meetings that had been part of the studio's routine since the midtwenties; the staff had grown too large to meet in Disney's office or the music room, but the meetings continued on the new sound stage. "We'd sit around in chairs, in a great big circle, and suggest gags," Dick Lundy said.[97] By the summer, the outlines were circulating in advance of the gag meetings,[98] and by the fall, an outline might fill the better part of two legal-size

pages, as the one for *Mickey's Orphans* did.[99] Disney had hired his first few gag men by then, and increasingly he was asking the rest of his staff to add finishing touches to a package of gags that was already substantially complete.

In 1932, with the advent of the United Artists release, Disney was coming under the same sort of strain that had earlier led the great silent comedians to change course. Those comedians had discovered that though the gag might be supreme, it was not sufficient. The silent comedians started out, like Disney, chained to a one-reel format, but the best of them escaped from it as quickly as possible, first into two or more reels and finally into features. It was only for longer films that they could devise gags that grew out of one another, building and evolving and telling a story. It is difficult to imagine the gags in Lloyd's *The Freshman* or *Safety Last* or in Chaplin's *The Gold Rush* transposed into a much shorter film; too much of the comedy arises from the context. In even the most inventive of the early thirties Disney cartoons, the gags are far more self-contained.

Now everything was changing. Disney had fostered animation in his cartoons that was threatening to outrun the gags by offering on the screen characters who were obviously capable of doing more interesting things than what Disney was giving them to do. The United Artists contract would give Disney more money to develop stories that would put those characters to work. The challenge was to come up with stories that made sense in seven minutes, yet still provided enough room for the indispensable gags.

By the early fall of 1932, Disney's staff had grown to 107 people—more than triple the total of two years earlier.[100] David Hand had just become the third director. Although Disney was less involved in the day-to-day work on each cartoon, his voice was still clearly audible in the mimeographed story outlines that circulated in his studio then. Disney may well have written some of the early outlines himself—the January 1932 outline for *Just Dogs,* in its repeated emphasis on "not resorting to unreal or human actions," clearly reflects his concerns. Typically, though, the outlines opened with functional summaries that were probably written by

someone in the story department, even if based largely on
Disney's own ideas.[101] Then came short addenda in Disney's own
voice, probably dictated to a secretary after he had read and
revised the outline itself, and a deadline for submitting gags to
the story department. By December 1932, the month when the
writing of *Three Little Pigs* got under way, gag meetings were tak-
ing place every two weeks. Those who attended—animators and
many other members of the staff—read and discussed the current
outline, and for the next two weeks submitted gags to what had
become a full-fledged story department.[102]

Although Ted Sears and Webb Smith had worked at first almost
as assistants to the two directors, by late 1932 that relationship
had changed significantly. The gag men, who had previously
moved like gypsies from one music room to another, now had an
office of their own. "After the preliminary gag meeting with the
whole studio crew to kick the story off," Jackson said, "they would
work there instead of in the music room on...getting the rough
story line into shape. Now the director had to go to *their* room to
take part in the earliest stage of the story work...and now *they*
took the initiative in seeing that a story came out of the sugges-
tions from the gag meeting."[103]

As the director, though, Jackson remained in late 1932 what
Disney had until recently called him: a story man. "When Walt
okayed the general story line and moved the picture into my
music room," Jackson said, "the continuity was only very loosely
worked out and a considerable part of it consisted of suggestions
that 'maybe this might work here'...or 'we need a better way to
get into this part of it.'" Several gag men joined the director in his
music room for a couple of weeks to pull the story into final
shape. (To Bill Cottrell, who joined the story department late in
1932 after several years as the studio's cameraman, it seemed that
"the director did all the work.")[104]

Other gag men passed through the studio in the months after
the hiring of Sears and Smith, but without leaving much of a
trace. Early in 1932, though, Disney added to his story depart-
ment Albert Hurter, a Swiss immigrant who had been an anima-
tor off and on since 1916. Hurter, a facile and highly inventive
artist with a style rooted in nineteenth-century book illustration,
joined the Disney staff as an animator in mid-1931, but after a few
months Disney created a unique job for him. As Ted Sears wrote
in his introduction to *He Drew As He Pleased,* a collection of
Hurter's sketches published after his death:

Since Albert's outstanding ability lay in humorous exaggeration and the humanizing of inanimate objects, he was soon released from animating and set to work drawing inspirational sketches. Each time a new subject was planned, Albert was consulted and given free rein to let his imagination wander, creating strange animals, plants, scenery, or costumes that might serve as models for the forthcoming production.[105]

Hurter had begun to draw such sketches by the time work was under way on the last of the Columbia Mickeys, *Mickey in Arabia*, in the spring of 1932. Disney may have decided that the higher budgets for his United Artists cartoons would permit him the indulgence—as it would have seemed to other producers—of using Hurter in that way and not as an animator. Hurter's new role bore fruit immediately in the way the Disney characters looked. Until 1932, character design was an incidental part of Disney animation because almost all of the characters owed so much to formulas that were common currency—thus Mickey Mouse's fundamental resemblance to the mice that populated the Aesop's Fables. Those formulas made it much easier to give a character a consistent appearance over the course of a film. Silly Symphony characters frequently appeared only in single scenes made up of self-contained gags, and as the Disney animators gained in skill, they sometimes drew those incidental characters in a more realistic design; such is true, for instance, of some of the birds in *Birds of a Feather*, delivered to Columbia in January 1931.

Mickey Mouse's dog Pluto was the first recurring Disney character to depart from strict formula, and so he had to be scrutinized in a new way: as a character and not as a piece of rather primitive machinery. An early model sheet for Pluto—dated 14 September 1931 and almost certainly drawn by Norm Ferguson—provided animators with such practical guidance as a "sniff cycle," four drawings that show Pluto snuffling along the ground, but the sheet is most notable for its wide range of canine attitudes, as Pluto cringes and scowls and barks exuberantly.

With the increased budgets that the United Artists contract brought, there was time for the animators to master characters of greater

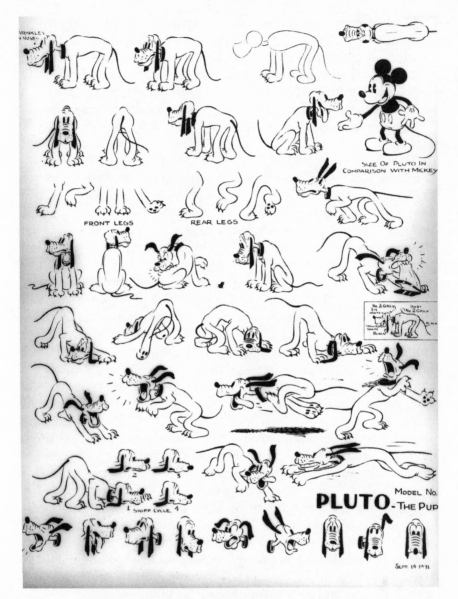

The 1931 Pluto model sheet drawn by Norm Ferguson, the animator who specialized in the character. © Disney Enterprises, Inc.; courtesy of Rudy Ising.

complexity, a task of growing urgency, now that they were increasingly animating not just individual scenes but sequences. Hurter provided such characters through his inspirational sketches; among the drawings reproduced in *He Drew As He Pleased* can

be found the germ of such characters in the early color Silly Symphonies as King Neptune, Hansel and Gretel, and Noah. Hurter's Noah, in the few glimpses of him in *He Drew As He Pleased,* looks superficially similar to Ferguson's unsuccessful version, but Hurter's Noah is a lively cartoon figure, with large, expressive eyes—they have a mischievous glint—and not Ferguson's pop-eyed puppet. The vivacity of Hurter's drawings clearly could have been captured in animation like Fred Moore's. Ted Sears credited Hurter for the design of the three pigs; one unpublished sheet filled with sketches of leaping, dancing musical pigs is surely his, and it proclaims its close kinship with Moore's animation.

Preliminary drawings of all kinds were becoming steadily more important as the studio grew larger and Disney was forced to rely more on "pieces of paper." Increasingly, those drawings originated in the story department, and it was there that the idea took hold that drawings need not be spread out haphazardly on a table or the floor, but could be pinned up on a sort of large bulletin board, in chronological order. It's not clear how quickly such storyboards came into regular use or how long it took before the boards embraced a cartoon's complete continuity. Wilfred Jackson remembered a sort of storyboard for *Father Noah's Ark,* which he directed, but even then, that board did not tell the story from beginning to end.

Jackson thought that storyboards were used at first as a convenience—it was easier for a large group to look at the sketches on a board than to pass them around "from hand to hand as we had been doing in our smaller story meetings."[106] But the storyboard was also an efficient device for presenting a story that would, after all, be told by overwhelmingly visual means. A writer could take an audience through a storyboard, telling the story of the cartoon as he pointed to one drawing after another.

However useful Hurter's drawings and the storyboards, they could not in themselves meet Disney's need for more substantial narratives. As a practical matter, he had to find existing narrative formulas that he could adapt to his seven-minute format. Starting with *Mickey in Arabia,* the Mickey Mouse cartoons took a decisive turn toward compact adventures, with an occasional story making a basically sentimental appeal. The Mickey cartoons now bore a strong

three little Pigs

A sheet of inspirational sketches by Albert Hurter for Three Little Pigs (1933). © Disney Enterprises, Inc.; courtesy of Dr. Richard P. Huemer.

resemblance, in their mixture of comedy, adventure, and sentiment, to the "Mickey Mouse" comic strip that Floyd Gottfredson had drawn for newspaper syndication since 1930; that strip, in turn, owed a great deal to the "Wash Tubbs" comic strip by Roy Crane. In those comic strips—and, at a greater remove, in some of the films of Chaplin, Keaton, and Lloyd—the comedy owed less to gags than to the very idea of depositing a small, sympathetic, but fundamentally comic figure in circumstances usually assigned to far more heroic characters. Only rarely now did a Mickey cartoon rely mainly on gags of the kind that filled *The Delivery Boy.* Far more typical was *The Mail Pilot,* released in May 1933, two weeks before *Three Little Pigs.* Mickey, the pilot, tries to elude his nemesis Pegleg Pete, here an air pirate. Gags play no very important part and are often forced (when Mickey squirts oil at a wanted poster of Pete, the oil runs down to form bars over his picture).

Although the Mickeys settled into their comfortable groove in mid-1932, it took Disney a few months longer to find an equally suitable format for the Silly Symphonies. In their first three years,

from 1929 to 1932, the Symphonies had glanced occasionally toward children's stories—as with *Mother Goose Melodies* or *The Ugly Duckling,* a cartoon that owed nothing but its title to Hans Christian Andersen—but it was not until Disney made *Babes in the Woods* that he used a fairy tale as the basis for a Silly Symphony. Even then, he modified "Hansel and Gretel" heavily, most notably by giving the cannibalistic witch a host of new enemies in the dwarfs who befriend the two children.

Fairy tales, animal fables, and other stories of that kind held obvious advantages; for one thing, many of them were so pithy and direct that they could easily be told on the screen in seven minutes. But they suffered from disadvantages, too: they might seem overly familiar, they might bore adults, and many of them were simply too serious to permit filling them with gags. And there was, at least until Fred Moore emerged as an animator, the nagging question of whether fairy-tale characters could be animated in a way that made them appealing to audiences. Only after circling around fairy tales for a while, by making *Babes in the Woods* and *Father Noah's Ark*—the one based very loosely on a fairy tale, the other on a biblical story with a fairy tale's contours—did Disney finally take the plunge with *Three Little Pigs.*[107]

By the time he started work on *Three Little Pigs,* Disney had shed any reluctance to bring such a well-known story to the screen. Attached to a three-page outline for *Three Little Pigs* that circulated in the studio in mid-December 1932 was a copy of the story as it appeared in Andrew Lang's *Green Fairy Book.*[108] The outline itself hewed to the story as it had become familiar to generations, simplifying and compressing it but not compromising its fundamental character, as Disney had done with "Hansel and Gretel." The outline did rule out some standard elements in earlier versions ("it will be impossible for us to have the wolf eat [two of] the little pig[s] or the [third] little pig eat the wolf"), but those changes did not soften the story fatally. In the outline, and in the film, the wolf remains eager and determined to kill and eat the pigs.

The mimeographed outline for *Three Little Pigs* concluded with an addendum in Disney's voice that filled the better part of a legal-size page—extraordinarily long and further evidence that he did not regard *Three Little Pigs* as a routine cartoon. "These little pig characters look as if they would work up very cute," he

wrote, "and we should be able to develop quite a bit of personality in them." He prescribed an operetta style for the dialogue ("Anything they would say would be handled either in singing or rhyme") and dwelled at length on the musical possibilities. As always, he returned time and again to the need for gags ("It is not our intention to make a straight story out of this, we want to gag it in every way we can and make it as funny as possible"), but this time, his addendum closed on a somewhat different note: "These little pigs will be dressed in clothes. They will also have household implements, props, etc., to work with, and not be kept in the natural state. They will be more like human characters."

Disney's distinctive addenda disappeared from the story outlines in March 1933, around the time work on *Three Little Pigs* was ending; the outlines' closing notes, when there were any, took on a more diffident tone, with no trace of Disney's intensity and enthusiasm. It no longer made sense for Disney himself to bear down so heavily on the need for gags. The gathering of gag ideas had become one part of a much more comprehensive process. True, *Three Little Pigs* has plenty of gags—for instance, as the wolf grabs the two fleeing pigs' tails, they run on either side of a tree and pull the wolf into it; then, as he looks up in disgust, an apple plops onto his face. *Pigs* is, in fact, as dense with gags as just about any of its predecessors. But the gags—unlike those in, say, *The Delivery Boy* of two years before—do not define the film; no single element does.

None of the cartoons released on either side of *Three Little Pigs* in the spring and summer of 1933 come close to matching it in that regard. For example, in *Mickey's Mechanical Man*, released just after *Pigs*, the animators and the story department seem almost to be running on separate tracks, with the animators well ahead and clearly worthy of better material. However convenient it may have been as a narrative framework, the miniature-adventure format for the Mickeys did not inspire strong writing. Fairy tales and animal fables were sturdier raw material, and now that they were open to the Disney writers, there was reason to hope that more cartoons would capture what most distinguished *Three Little Pigs* from any cartoon that had come before: its sense of balance and completeness.

Leigh Harline joined the Disney staff late in 1932; he became the studio's third composer, to match what had become, with Dave

Hand's promotion, its three directors. Unlike Bert Lewis and Frank Churchill, the composers who preceded him onto the Disney staff, Harline had not learned his craft in the days of silent pictures. Lewis had been a theater organist, and Churchill, a largely self-taught musician, had played piano and portable organ on the sets of films as they were being made, to get the actors into the right mood. Harline, a younger man than either of his colleagues, was college-educated and had worked not in the movies but in radio, as composer, conductor, arranger, and even singer and announcer, before Disney hired him.[109] When he joined the Disney staff, Harline began working regularly with Wilfred Jackson, displacing Churchill.

Harline's first score, for the Silly Symphony *Father Noah's Ark*, proclaimed the difference that his education and experience made. In that cartoon, both music and action are divided into miniature movements, or acts; each of those units advances the story, but there is also an abundance of elaborate synchronization within each one. In the first few minutes of the cartoon, for example, Noah's family and the animals carry out the construction of the ark to a theme adapted from the first of Beethoven's contredanses. Jackson had already made one other Silly Symphony of this general kind—*Santa's Workshop*, released in December 1932, four months before *Father Noah's Ark*—with a Churchill score. Harline's ability to work on two levels, picking up details of the action while maintaining longer musical lines, made for a richer score and a more cohesive film; Churchill's score for *Santa's Workshop*, is, by comparison, fragmented and repetitive.

It was, however, Churchill who scored *Three Little Pigs*, as one of his first collaborations with Burt Gillett. In his hands, it was not a relatively sophisticated score of the kind Harline was composing for Jackson, but in effect the apotheosis of the tightly synchronized music making that had dominated the Disney cartoons since 1928. (As if to give his blessing to this crowning achievement in a genre he helped to originate, Carl Stalling returned briefly to the Disney studio as a freelance arranger and pianist around the time the score for *Three Little Pigs* was recorded; it is Stalling who strikes the keys when the Practical Pig plays his piano.)[110]

The pigs themselves are instrumentalists—playing fiddle, flute, and piano—and they sing throughout the film; in fact, music permeates every detail of *Three Little Pigs*. As Ross Care

has written, "The plot unfolds purely through music, singing and rhythmically timed and spoken dialogue.... Song, rhymed speech, and traditional background scoring [are] seamlessly wedded to musical gags." As Care points out, so faithfully does the music follow the twists and turns of the story that "Who's Afraid of the Big Bad Wolf," Churchill's song, "is never rendered intact during the entire film, being fragmented, forestalled or interrupted by the narrative."[111] Eric Larson, who as an assistant animator worked near Gillett's music room in 1933, a few months after *Three Little Pigs* was made, remembered vividly how Gillett instructed his animators in what he expected in their scenes:

> You could hear Gillett in there, putting his heart into it—and the fellow at the piano would be playing right along with him, just like the old silent-movie days, where they'd catch all the action on the screen. Gillett would roar, he'd holler, he'd scream, he'd jump on the desk, and onto the floor. And he'd say, "Now let's do it again."... Even an eye blink would be acted out, to a musical beat.[112]

Jackson and Harline were the superior team, making the more complex and sophisticated cartoons, but for that reason it could be more difficult for Jackson's animators to develop the characters on their own. Jackson left very little to chance. Gillett's direction was so broad that an animator who wanted to do something more with a scene could easily find room to do it, as long as he met the minimal requirements Gillett laid down, fidelity to the musical beat in particular. Unlike so many other Silly Symphonies, *Three Little Pigs* had a small cast of only four characters. All four had to appeal strongly to the audience if the cartoon was to succeed. Not just by picking four of his strongest animators but also by assigning them to the director who was least likely to get in their way, Disney improved the odds that his animators would, as he said in the outline for *Three Little Pigs*, "develop quite a bit of personality" in the pigs and make them "more like human characters."

It was in such ways that Disney began reaping the benefits of greater specialization on his staff, even when the numbers involved were still very small, as with his three directors and three musicians (Bert Lewis, the senior composer, worked with David Hand). Elsewhere in the studio, in categories whose larger numbers made far more extensive specialization feasible, the benefits were even greater.

Eric Larson, an aspiring radio writer who needed some kind of job, started work as a Disney inbetweener on 1 June 1933, four days after the release of *Three Little Pigs*. He was working in a pool with other inbetweeners, and after two days he was ready to quit. Only the fatherly counsel of Dick Creedon, a radio writer who had joined the Disney story department three months earlier, prevented him from leaving. About five weeks later, Larson said, the animator Hamilton Luske "saw what I was doing, and said, 'I want him for an assistant.' "[113] As it turned out, Luske wanted Larson not just to work for him directly, but also to do work that was significantly different from what assistants had been doing for other animators.

"When I came with Ham," Larson recalled, "the animators were doing all their own key clean-up drawings for final production." Many Disney animators, if not all, were working in the rough by 1933 and making pencil tests of their rough animation. Once their tests had been approved, it fell to their assistants to clean up the animators' rough drawings, to get them ready for tracing in ink onto cels. But the animators themselves still made some finished drawings; these were the "key clean-ups," the drawings that defined how a scene looked. "I moved in with Ham," Larson said, "and the first word I got was, 'We are now going to let the assistants be responsible for all the clean-up work.'" From then on, no drawing that went to the inkers for tracing onto cels would be Luske's unaltered original; in the normal course, all of Luske's animation would be clothed in lines actually drawn by Larson.

It had been less than two years since Walt Disney began pushing his animators to animate in the rough and shoot pencil tests of their rough animation. By doing that, Disney had, in effect, declared that drawing and animation were distinct activities; putting an assistant in charge of key clean-ups was the final, logical extension of that idea. More than that, it was the final step in a highly compressed evolution that had radically changed the roles of both animators and assistants in a very short time.

At the Disney studio in the twenties, the use of inbetweeners had taken root only slowly. When Wilfred Jackson began animating in 1929, he had no assistant, and so he drew his

own inbetweens on those rare occasions when his scenes required them (usually they did not since he tended to animate straight ahead).[114] Although new hires like Dick Lundy and Jack Cutting worked as inbetweeners for a time in 1929 and 1930, David Hand recalled that when he started at Disney's in January 1930, "we were not using [inbetweeners] to any extent."[115] As the studio's staff filled out with veteran New York animators, though, the use of inbetweeners spread, almost certainly with the usual purpose in mind: that is, to increase the animator's output. By 1931, a three-tier system—composed of animator, assistant, and inbetweener—had developed, even though it was probably not in use throughout the studio. The terminology remained imprecise for some time: when William Garity, Disney's technical chief, described this division of labor in a paper written late in 1932, he said that each Disney animator had "an 'inbetween' man or an assistant, and generally two apprentices."[116]

The assistants and inbetweeners did, in fact, play roles analogous to those of artists' apprentices in Renaissance Italy: like the apprentice painter, the apprentice animator assumed increasingly important duties, under a master's supervision, as he became more skilled. In 1931, Disney carried such arrangements one step further by putting Dave Hand and Ben Sharpsteen in charge of two small groups of green animators. When Disney ordered the switch to rough animation, somewhere around the beginning of 1932, that procedure made it possible to pass down much more work to the lowest—and lowest-paying—rungs, and so greatly increase the animators' output.

In fact, though, everything indicates that the animators' footage actually declined sharply as they delegated more work.[117] Although the Disney studio's staff more than tripled between 1930 and 1932, the number of its films changed hardly at all. In 1930, the studio completed nineteen cartoons; in 1931, twenty-two; and in 1932, twenty-two again. The studio's increased income under the United Artists contract paid for a still larger staff, but not for more cartoons—United Artists released nineteen in 1933—even taking into account the few films the studio made apart from its theatrical releases. As Disney pursued an ever more refined division of labor, breaking the work into smaller and smaller components, each worker's output did not rise—as could be expected in a normal manufacturing operation—but fell.

The paradox was double. At the beginning of the decade, a Disney animator began work on a scene with limited guidance

from the director as to what his animation was supposed to look like on the screen. Usually, he got only a single thumbnail sketch for a scene; the animator was responsible for translating that sketch into the full-size layout drawing of the characters that would serve as a starting point for his animation. He also sketched the backgrounds for his scenes, so that they could be rendered by a background painter (who might himself fill other jobs). In June 1931, Disney hired his first two specialized layout artists: Charles Philippi, formerly a cartoonist for the *Los Angeles Examiner,* and Earl Duvall. Working with Burt Gillett, Philippi designed the backgrounds and made sketches of the characters—typically several poses for each scene—of the proper size and in the proper positions. Duvall held the same job briefly with Jackson, before going into story work. Animators like Albert Hurter and Ben Sharpsteen filled in as Jackson's layout man[118] until, in March 1932, Disney hired Hugh Hennesy, another former *Examiner* cartoonist.

The animators might depart from the layout men's sketches, but they no longer had to start almost from scratch. Quite the contrary—by 1933, Disney's animators enjoyed far more support from other people in the studio than any animators had ever had before. The Disney directors and their musicians had governed the cartoons' timing since the earliest days of sound. Now the directors and their layout men worked out the detailed staging of a scene, including the movements of both camera and characters, before an animator ever came into the music room to pick up his assignment. On 2 May of that year, when Dick Huemer picked up his first scenes as a Disney animator, for a Silly Symphony called *Lullaby Land,* he was "simply amazed," he said forty years later, by "the exquisite preparation."[119]

Work done at other studios by the animator himself or by the animator and his assistant was at Disney's spread across a corps of specialized workers, ranging from the director down to the most junior of inbetweeners. Disney aimed not for greater efficiency and higher output from such specialization, but for a concentration of effort, by his animators in particular. As David Hand said, Disney allowed his people "the time to develop. Up to that time—and I had worked ten or eleven years before then—you couldn't have time to develop anything."[120]

That time to develop was costly: by 1933, when Disney made *Three Little Pigs,* he was already spending beyond the limits of his advances from United Artists for most of his cartoons. The studio's books showed that *Pigs* cost $15,719.62; *Old King Cole,* the Silly Symphony that followed it, cost more than $21,000.[121] By spending so much, Disney was gambling that he could stimulate public demand for his cartoons and that the cartoons' popularity in the theaters would in turn generate greater demand for licensed merchandise like books and toys.

In 1933, with the release of *Three Little Pigs,* Disney's gamble paid off spectacularly. Not only was *Three Little Pigs* a stronger film than any of its predecessors, but it was also highly successful at the box office, returning rentals to Disney and United Artists of $125,000 in its first year.[122] Mickey Mouse had been a favorite for years, the earlier color Silly Symphonies had stirred some interest, and *Flowers and Trees* had won the first Academy Award ever given to an animated cartoon, but the popularity of *Three Little Pigs* was of an altogether different order. "It nailed our prestige way up there," Disney wrote a few years later. "It brought us honors and recognition all over the world and turned the attention of young artists and distinguished older artists to our medium as a worthwhile outlet for their talents.... The income from all our pictures and from merchandising royalties took a sharp upswing."[123]

Even though the Disney cartoons commanded higher rentals than competitors' films, Disney could not advance much further, financially or artistically, unless he could escape from his seven-minute straitjacket. He had seized on the animation of his cartoons as the key: if longer films were to be feasible, his animators would have to provide him with the drawn equivalents of strong human actors. In 1933, despite the vitality in Ferguson's and Moore's best work, the Disney animators were still far from being able to meet this precondition for a successful animated feature; as Disney himself said, their characters resembled real people only "in general." Because those characters could not engage an audience fully in the way a living actor could, there was no way yet that Disney could bring to his films an element that he knew was essential to their growth—what he called "real feeling."

The Disney cartoons actually flirted with pathos a couple of times in 1931—once in *The Moose Hunt,* when Mickey sobs over what he thinks is a dead Pluto, and again, a few months later, in *The Ugly Duckling*—but the results were tortured in the first case,

flat in the second. Over the next few years, Disney avoided characters who were supposed to be experiencing grief or loss. And yet there was every reason to believe that his animators would have to be able to depict the full range of human emotions if an audience's interest was to be held throughout an animated film of feature length.

Disney,
1933-1936

In the months just after he made *Three Little Pigs*, Walt Disney took up the challenge of human characters again and made five Silly Symphonies with them. The third of those cartoons, *The Pied Piper,* was being animated when *Three Little Pigs* was released in May; it was easily the most ambitious of the new cartoons because its central figures, the Piper and Hamelin's Mayor, most resembled real human beings in how they were drawn. In 1933 the production schedule, and the need to give work to animators, made the thoughtful casting behind *Three Little Pigs* impractical on every film; on *Lullaby Land*, the Silly Symphony that came just before *The Pied Piper*, the animators handled sequences rather than characters, and the infant protagonist looks like a different character from one animator's scenes to the next. For *The Pied Piper*, though, Disney cast by character again, even more rigorously than he had for *Three Little Pigs*. All the most important scenes with the Mayor—the closeup scenes in which he speaks—were assigned to Art Babbitt, and the comparable scenes with the Piper to Ham Luske.

More than any of the other Disney animators, Babbitt and Luske showed in their work an intense interest in how people really moved. If other Disney animators, under the

influence of Don Graham's life classes, measured their animation against the real world and adjusted it to get a closer fit, Babbitt and Luske went much further: they looked long and hard at the real world before they ever started animating. It was Babbitt whose work first grew out of scrutiny of that kind, in a scene toward the end of *Three Little Pigs*. As the Practical Pig lifts the lid off a pot and then carries a can of turpentine, Babbitt's animation reflects careful observation, quite likely of some other staff member whom he loaded down with comparable burdens; the lid and the can have real weight, and the pig struggles a bit. There's no trace in this animation of Fred Moore's charm, but there is by way of compensation a striking verisimilitude.

In his colleagues' memories, though, it was not Babbitt but Luske who worked hardest at observing the real world and analyzing what he saw there. Eric Larson, who became Luske's assistant soon after *The Pied Piper* was animated, remembered that Luske called on him to perform the actions of the characters he was animating. Larson remembered a boat trip to Catalina Island:

> [Luske] took his tie and let the wind carry it, and he said, "Look at the movement of that tie as the wind hits it." On the golf course, you'd go to putt, and after you'd putted, he'd act it out for you...there wasn't a damned thing that came up that wasn't animation.[1]

A newspaper cartoonist in Oakland, California, in the twenties, Luske joined the Disney staff in April 1931,[2] and he was animating by the fall of 1932. After a few months on Mickey Mouse cartoons, he was assigned to human characters: first the Sandman in *Lullaby Land*, then the Piper.

In Babbitt's animation in *Three Little Pigs*, the Practical Pig's movements—impressively realistic though they are—still seem a little fussy, as if the details of what the pig is doing have assumed too much importance in the animator's mind. What was a troubling but minor flaw in that animation turned out to be crippling in Luske's and Babbitt's animation for *The Pied Piper*. The Mayor and the Piper have almost nothing to do in Luske's and Babbitt's scenes, apart from speaking to each other (the pig, by contrast, has concrete tasks to perform), and the two characters address each other with what are, particularly in Luske's animation, empty theatrical gestures. Their movements—no doubt the products of scrutiny of the real world—seem false in a way that the movements of Ferguson's Noah, say, do not.

The techniques pioneered by Ferguson and especially Moore may have yielded more general results than did the methods that Luske and Babbitt adopted, but they had a crucial advantage. "At that time," Larson said, "we were talking about cute things—cute poses, cute this, cute that. You never had anybody stand up straight; they were always bent at the waist, leaning forward, leaning backward, sideways—attitudes that would give a rhythm and movement to the [individual] drawing and throughout the picture. This was Freddy's big influence; he never did anything that didn't move, that didn't flow." There is no flow in Luske's animation in *The Pied Piper*. However lifelike the Piper's individual movements, Luske's analytical animation isolates each of them in a way that makes them seem shallow and counterfeit.

Larson recalled that "Ham tried so hard to be like Freddy," but Luske's painstaking methods contrasted sharply with Moore's. "Freddy Moore just wrote it off," Larson said, "but Ham had to work his fool head off to make a drawing." By talent and temperament, Luske was suited to a kind of animation that differed from Moore's, and as of his work on *The Pied Piper*, he had not yet found it. Ted Sears probably expressed a general sentiment within the studio when he wrote in November 1933 to the animator Isadore Klein in New York: "Having just completed *The Pied Piper*, we've come to the conclusion that our best screen values are in cute animal characters. We haven't advanced far enough to handle humans properly and make them perform well enough to compete with real actors."[3]

In fact, two more Silly Symphonies with human characters followed *The Pied Piper* into animation in the summer and fall of 1933, but both were special cases: Santa Claus was the star of *The Night Before Christmas* and the relatively stilted movements of the figurines-come-to-life in *The China Shop* were acceptable in characters made of porcelain. Once past those two cartoons, though, Disney returned to animal characters in a familiar story, an Aesop's fable this time. For *The Grasshopper and the Ants*, the Disney writers used *Three Little Pigs* as a template: they softened the fable's harshness, offering in exchange an operetta-like cheerfulness. The grasshopper is such a genial, harmless fellow that the ant queen can grant him a reprieve, under the pretext of letting him fiddle for his supper, without undermining the ants' work ethic.

The transformation of the fable occurs almost entirely in the writing. The animation—much of it, in the last half of the film, by Babbitt and Luske—is stiff and cautious, all too obviously the product of labored thought. The grasshopper, whose design owes a great deal to Albert Hurter's drawings,[4] looks and moves more like a real insect than the formula-bound ants do, and this authenticity leads to some odd results, in particular an unmistakable emphasis on the lower portion of the 'hopper's torso (which he uses as a stool, among other things). In *The Grasshopper and the Ants*, as in *The Pied Piper*, the animation is at once more advanced and more ungainly than in *Three Little Pigs*, and this time there was no blaming that awkwardness on the use of human characters. In the wake of *The Pied Piper*, not even "cute animal characters" were a safe haven.

"It is often the case," Don Graham wrote many years later, in words that may have owed something to his experience at Disney's in the midthirties, "that a person who is too analytical has difficulty adjusting to the attitude of the artist. In addition to thinking with his brain an artist positively must learn through his eyes, ears, body, and especially his hands."[5] What the Disney animators needed, at this point in their development, was not more tools—analytical tools least of all—but rather the sort of intuitive breakthrough that might inspire them to use all their tools with a new assurance.

Diane Disney Miller, in her biography of her father, writes of a time, probably in the summer of 1933, when Walt Disney tossed out a mild challenge to the gag man Webb Smith:

> One day Father said to him, "Our dog, Pluto, is always sniffing along the ground. He never looks where he's going. What would happen if Pluto was sniffing along and ran into some flypaper?" He left Smith to ponder that suggestion and walked away. Two days later Smith had a wall covered with sketches of things that could happen to Pluto under those circumstances.[6]

By the time *Playful Pluto* reached theaters in March 1934, Smith's story sketches had grown into more than a minute of animation by Norm Ferguson. Ferguson's sequence is, indeed, full of "things that could happen to Pluto." After Pluto gets his snout

stuck to the flypaper, he holds the paper down and pulls his snout loose—but then he realizes that both of his paws are stuck. He pulls one paw loose, then the other paw—but both times, of course, his other paw stays stuck. His ear gets stuck to the flypaper; then the paper gets stuck to both a front and a rear leg. He succeeds in kicking the paper away—but then he unwittingly sits down on the paper, as it settles on the floor behind him. The comic business spirals onward from there.

It's no longer possible to say just how much of this sequence originated with Smith and how much with Ferguson. Smith's sketches almost certainly no longer exist: the "story sketches" on file at the Walt Disney Archives are, typically for cartoons of *Playful Pluto*'s vintage, thumbnail layout drawings, probably by Charles Philippi, rather than true story sketches. When an outline for *Playful Pluto* (then called *Spring Cleaning*) circulated in the studio in July 1933, the flypaper sequence was already envisioned as what the outline called "a build-up gag.... We'll carry this business thru, showing the various ways in which Pluto gets twisted up with the fly-paper."[7] Even so, Ferguson certainly added footage to what the exposure sheets called for; he said as much in a "Pluto Analysis" that he wrote at the end of 1935 for use by other animators.[8]

Regardless of how much Smith put into the sequence, there's no question but that Ferguson's contribution was the more significant—to the sequence, to the cartoon, and to the evolution of Disney animation. That was true even though Ferguson's work was in some ways already a little backward compared with the animation by some of his colleagues. Art Babbitt animated part of *Playful Pluto*, too, and in his animation the frustrated dog is pushed backward by water from a hose as he struggles to move forward. Most animators at that time did well to present simple movements clearly, but Babbitt successfully combined movements that were contradictory. Pluto's movements are strikingly lifelike, more so than any comparable passages in Ferguson's animation. Serviceable though Ferguson's animation is, there is no sense that he analyzed carefully how a dog might move when it was trying to rid itself of a piece of flypaper.

Ferguson's sequence as a whole seems more true to life than Babbitt's, though, because Ferguson emphasizes not what Pluto does, but

how he feels about it. It was this shift of emphasis, at a time when other Disney animators were preoccupied with reproducing the mechanics of movement accurately, that made the flypaper sequence so unusual. Throughout the sequence, Pluto's state of mind is always visible, in his expressive face and body. The gags are well constructed—everything that happens to Pluto seems possible, in a physical sense, with none of the gags forced—but it is the trajectory of the dog's emotions that makes the sequence so vivid. Ferguson's animation makes clear how Pluto's increasingly frantic irritation and impatience (punctuated by his moment of blissful happiness just before he sits down on the flypaper) grow out of each gag in turn. Pluto is not just expressive, but expressive in a seemingly spontaneous and yet logical way.

Just before animating on *Playful Pluto*, Ferguson had animated most of a Mickey Mouse cartoon, *Shanghaied*, released in January 1934, and it is full of forced gags and stock gestures; like *Playful Pluto*, it was directed by Burt Gillett, so the director almost certainly made no difference. Ferguson had become a specialist in animating Pluto by the time *Playful Pluto* was made, and it may be that his familiarity with the character had opened his eyes to possibilities in Pluto that no one else had seen. More than a year earlier, in *Mickey's Pal Pluto*, released in February 1933, he had already given Pluto some of the same fluid expressiveness that the dog shows in *Playful Pluto*. The big difference is that the later animation sustains that expressiveness over many more feet of film, and so the cumulative effect is much stronger.

There are suggestions, too, in Ferguson's "Pluto Analysis," that his animation in *Playful Pluto* was born of the same impulses as the rough animation he pioneered. "In the laying out of Pluto's action on exposure sheets before animating," he wrote, "it is hard to anticipate the necessary feeling [in] certain spots where expressions will be used. This sometimes means it will be necessary to add footage when such spots are reached in animation." The animator should go ahead and add footage on his own, without checking with the director first, Ferguson continued:

> It has been found easier to cut down stalling in the rough test than to build up undertimed situations later on. The reason for this is that the animator works spontaneously when he feels the situation, and trying to crowd things into a given footage handicaps him to the extent of breaking the spontaneity of his work.

Ferguson was an exemplar of the kind of artist Don Graham later wrote about: the artist who learns with his hands. Through his rough animation, and then through his animation of Pluto, Ferguson let his hands take him where more self-consciously analytical methods could not.

Wilfred Jackson singled out Ferguson's animation in *Playful Pluto* as "the one big one" among "the milestones in our learning process" because "it was an outstanding example in its time of how to picture to the audience what the character was thinking, how it felt about what was happening, and the motivation of its action." Animation, "no matter how crudely done," that conveyed such inner life would be far more effective than comparatively sophisticated animation that did not. "Of course," Jackson continued, "knowing how to make a cartoon character move in a convincing, believable way will greatly assist an animator to put across these things, but skill in drawing the movements, or action, in itself is only a means to *this* end."[9]

Well before the end of 1933, Disney's three directors—Gillett, Jackson, and Hand—had ceased to be story men, a title that migrated to the members of the story department. The directors no longer constructed stories out of a mass of raw material provided by the writers; there was instead a clear distinction between "story," what the writers did, and "production," what the directors did. By the time *The Grasshopper and the Ants* was being written in the early fall of 1933, Jackson recalled, the story department was responsible for "developing a complete story line and almost the entire continuity of gags and business," with the director involved only sporadically—"*if* one had been assigned to the film."[10] Jackson directed that cartoon, but a typewritten continuity dated 3 October 1933 indicates that Bill Cottrell was largely responsible for writing it, and hand-printed notes by another story man, Pinto Colvig (who also provided the Grasshopper's voice in the film), suggest that he contributed heavily to the dialogue and lyrics.[11] Each of those people played a role that would not have been nearly so clear-cut if the cartoon had been made a year earlier.

After several years of evolution, the story-

board also assumed a distinct shape, around the time that the story department did. Walt Disney wrote about the storyboard early in 1934 in a memorandum offering employees outside the story department fifty dollars for usable story ideas. He wrote as if the storyboard were a brand-new device that would be unfamiliar to most of the staff—as it probably was. "Instead of writing your story," he said, "you could present the entire idea with sketches, with a few notes below each sketch (when necessary), to explain the action. This would be an ideal way to present your story because it then shows the visualized possibilities, rather than a lot of words, explaining things that...turn out to be impossible to put over in action."[12]

The emergence of the storyboard led to yet more specialization later in 1934, when "story sketch men" began to assist the writers; Bob Kuwahara, who had joined the staff in January 1933, most likely as an inbetweener, was probably the first. The sketch men were not the first cartoonists to work in the story department—by 1934 Albert Hurter had been a part of it for two years—but the sketch men were not expected to come up with ideas on their own; they were there instead to give visual shape to the story men's ideas.[13] The presence of the sketch men tilted the writing of the cartoons more toward "visualized possibilities"—and, increasingly, toward giving animators opportunities of the kind Ferguson exploited in *Playful Pluto*. In his memo soliciting story ideas, Disney said he wanted more than just a title or a setting; he wanted a plot or a situation, and of a particular kind: "Your story should deal mostly with personalities." Disney had invoked "personality" before, as in the outline for *Three Little Pigs*, but in early 1934 Ferguson had just animated his scenes for *Playful Pluto* and shown how personality could transform otherwise routine comic business.

It was in 1934, too, that dialogue first entered the Disney cartoons in quantity, a development that affected the animators even more than it affected the writers. From very early in sound cartoons' history, it had been possible to record dialogue in advance on film and animate a character's mouth movements to match the words. The dialogue could then be "dubbed"—combined with music recorded after the cartoon was animated—to form a complete soundtrack. Until 1934, though, such "prerecorded" dialogue rarely turned up in the Disney cartoons, except as a few words spoken by Mickey and Minnie Mouse (Walt Disney himself spoke in a falsetto for Mickey, after unsuccessful efforts

in 1929 to find someone else who could provide a satisfactory voice). There was no dialogue worth mentioning in the Silly Symphonies until the United Artists release began in 1932. Even then, that dialogue was typically tied to the music, so that, as Wilfred Jackson said, "the principal voice accents were matched to music accents."[14]

The Silly Symphonies had begun as musical cartoons, and in *Father Noah's Ark*, *Three Little Pigs*, *The Pied Piper*, and other cartoons like them, the operetta-like dialogue—usually rhymed, and all but indistinguishable from song—extended the musical emphasis. Some of the Mickey Mouse cartoons, notably *Ye Olden Days*, an April 1933 release, mimicked operetta in the same way. Because the dialogue in such cartoons was musical, or at least rhythmical, it could be planned in advance, to the frame, and then recorded at the same time as the music, after the film was otherwise complete. In such cases, the animators worked with exposure sheets that broke the dialogue down into frames, permitting them to animate the mouth movements accurately even though they could not hear the voices.[15]

Disney also used the alternative procedure, recording both music and voices in advance of the animation, at least for some songs; for example, the studio's records show that two songs in *Pioneer Days*, a 1930 Mickey Mouse cartoon, were "prescored" or prerecorded. But working with a wholly prerecorded soundtrack would have been hopelessly rigid from Disney's point of view since he or his directors might order major changes in a cartoon even when it was virtually finished. There survives in a private collection, for instance, a silent Technicolor print for the 1934 Silly Symphony *The Wise Little Hen* whose scenes are ordered differently than in the released version, and which contains animation that was subsequently cut.

The Disney studio no longer has any records from its thirties recording sessions, so it's impossible to say with certainty that any given piece of rhythmical or musical dialogue was postrecorded, that is, recorded after the animation. But much of it was, and postrecording was probably to blame for some awkward results on the screen. In Ham Luske's animation for *Lullaby Land*, the Sandman's voice seems oddly disconnected from his body: his rich baritone doesn't fit his aged appearance. The new emphasis on

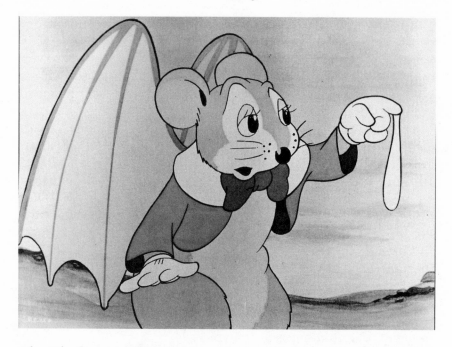

The title character sheds a large tear in a scene animated by Fred Moore for Disney's The Flying Mouse (1934). © Disney Enterprises, Inc.; courtesy of J. B. Kaufman.

personality reflected in Walt Disney's memo pointed irresistibly toward recording more of the dialogue before animation, so that the animators could be guided by what they heard the characters say, and toward weaning the Silly Symphonies away from their reliance on music. "Personality more or less came when they opened up on the dialogue," Dick Lundy said. "It was the dialogue that had the personality that you tried to portray."[16]

The first Silly Symphony with a significant amount of prerecorded dialogue was *The Flying Mouse*, released in July 1934. It was animated early in the year, in the months just after Norm Ferguson worked on *Playful Pluto*, and the title character is highly expressive in the two extended dialogue sequences. In the first, he asks a fairy, a female figure drawn with a fair amount of realism, for wings; in the second, he begs to be rid of them. But unlike Pluto—and in a striking departure for a Disney cartoon—the mouse is expressive not for comic purposes, but to give the story an emotional dimension. He is, as an outline for the film said, "a very cute and sympathetic character."[17] And although the fairy speaks rhythmically, the mouse's speech sounds natural; it is free

of any obvious ties to the musical score. Formula-derived characters—a menacing spider, for one—linger in the cast, but the mouse himself, like the pigs and the grasshopper in earlier Silly Symphonies, resembles a real animal: when the fairy gives him wings they are leathery, like a bat's. A wide range of expression fits his face much more easily than it would Mickey Mouse's rigid mask.

Ham Luske animated a large part of *The Flying Mouse*, but not the two dialogue sequences. They were animated by Fred Moore, in his most important animation since his work on *Three Little Pigs* more than a year before. For the most part, Moore's animation conveys the mouse's emotional states vividly, but not with the same precision that Ferguson brought to his animation of Pluto. When, for example, the mouse tells the fairy of the suffering he has endured because of his wings—he has been shunned by birds, bats, and his own mother—his face and gestures convey agitation, but not any specific feelings. Dialogue was a two-edged sword: it gave the animator more to work with, but it also imposed new demands.

Dialogue, or simply the distinctive sound of a voice, could serve other purposes, though, besides stimulating the animators to more penetrating work. It could define a character and attract an audience to him. Donald Duck, introduced in March 1934 in *The Wise Little Hen*, was an indifferently designed fowl, a good example of how the shift toward greater realism could miscarry: his head and eyes were small, and his beak indistinct, so that his design shortchanged his most expressive features. The blue of his costume—a sailor hat and middy blouse—over his white feathers gave him a visual identity; it was, however, nothing visual but rather his quacking voice by Clarence Nash, heard in only a few scraps of prerecorded dialogue, that made him worthy of a second look. All three of the characters with speaking roles in the film— the others were the eponymous hen and a pig—had voices dominated by animal sounds. The hen's clucking voice was like a hiccup, though, and the pig, for whom Nash also provided the voice,[18] seemed to have gone through throat surgery. Donald, by contrast, sounded just the way a talking animal should, with a duck's normal noises shaped into barely intelligible words.

A voice as distinctive as Donald Duck's was extremely rare in the cartoons of 1934, with

their limited use of dialogue, and it was almost certainly for the voice, more than the character, that Disney put Donald into a Mickey Mouse cartoon, *Orphan's Benefit*, that came out only five months after *The Wise Little Hen*. Sound had sharply restricted the comedians of the great silent films, in large part because their voices could too easily undermine the fiction that, say, the deep-voiced Buster Keaton was a college freshman (as he was in *College*, in 1927, just before sound came in). But as Nash's voice for Donald Duck showed, sound could work powerfully in animal characters' favor, reinforcing their identities without limiting the roles they could play. Donald Duck could be a child or an adult, whatever the story required.

Orphan's Benefit made the greatest impression within the studio not because of Nash's voice, though, but because of Lundy's animation: specifically, the fighting pose Donald assumes, bouncing around with one arm outstretched, when the audience of orphans (all of them identical little Mickey-like mice) refuses to let him complete his recitation of "Little Boy Blue." When Donald made his third appearance, in *The Dognapper*, a Mickey Mouse cartoon released in November, just three months after *Orphan's Benefit*, Lundy had animated only one scene—but it was the fourth scene in the cartoon, a solo turn by Donald in which he reacts excitedly when Mickey takes off on a motorcycle, leaving Donald behind in the sidecar. The scene, from all appearances, was added to give the cartoon a little more of the flavor of the *Orphan's Benefit* Donald.

Within the Disney scheme of things, animators like Lundy had become stars. "When I first went to Disney's," Milt Schaffer recalled—he started in 1934—"all of the young fellows wanted to animate.... As young people trying to animate, we were not terribly aware of scripts and stories and gags, although they were coming from somewhere. Our whole focus was on animation, and if you couldn't animate, you might as well commit suicide."[19]

At Disney's, as in the film industry in general, there was a sound financial reason for attaching great importance to the people who actually put the movies on the screen. As the screenwriter Nat Perrin has said, "If you waste your money on the script, that's comparative small potatoes. If the picture's shot and it won't go together, you have a fiasco on your hands."[20] Here, though, there was more to it than that. For one thing, Walt Disney himself was still so heavily involved with the writers and directors that their work could seem more his than their own. Beyond

that, giving the seven-minute sound cartoon some of the texture and richness of real life was turning out to be so demanding a task that when an animator made a leap forward—when Ferguson's Pluto tried to think his dull-witted way out of a predicament, or Moore's flying mouse expressed anguish that seemed almost real—it was like a flash of lightning that illuminated an otherwise clouded landscape.

●•⁘•●

Late in the spring of 1934, Walt Disney expounded on film comedy in an interview with a *New York Times* reporter. As so often in interviews from around this time, some of Disney's ideas about comedy sound backward looking, as if he yearned for a sure laugh as passionately as his most pedestrian rivals. "Portrayal of human sensations by inanimate objects such as steam shovels and rocking-chairs never fails to provoke laughter," he said. "Human distress exemplified by animals is sure-fire. A bird that jumps after swallowing a grasshopper is a 'natural.' We try to create as many laughs with gags as possible in a sequence and then give the situation a quick twist."[21]

That interview appeared just weeks before the release of *The Flying Mouse*, a cartoon with very little comedy in it; for that matter, obvious comedy of the kind Disney invoked had been fading slowly from his cartoons for several years. Some of what Disney said may have been disingenuous. For the most part, though, he was probably not playing the naïf but was simply reflecting the unsettled state of his studio and his films. His release schedule—United Artists released seventeen Disney cartoons in 1934—worked against his having time to pause and think about where his cartoons were going. He could not do what the silent comedians did and work his way gradually into longer films that appeared at less frequent intervals. The market for two-reel short subjects was shrinking in the early thirties, the victim of double-feature bills in many theaters and, ironically, the success of cartoons like Disney's.

The Disney cartoons from 1934 that embodied real advances popped up from among more routine films, and it seems to have been difficult to incorporate those advances in subsequent releases. Although a trickle of Silly

*Pluto and Persephone, as animated by Dick Huemer for Disney's
The Goddess of Spring (1934).* © *Disney Enterprises, Inc.; courtesy of
J. B. Kaufman.*

Symphonies based on fairy tales and animal fables followed *Three
Little Pigs*, fully half the Silly Symphonies continued to be based
on much flimsier material, some of it originating with Disney
himself.

Despite his pleas for stories with "personality," Disney may not
have recognized the extent to which "personality" might collide
with the kinds of gags that had been common in earlier cartoons.
Dave Hand, who directed *The Flying Mouse*, recalled "an argu-
ment Walt and I had about a specific action.... The mouse was
being blown backward through the air, out of control. He was a
sympathetic character in a sad plight. The 'laugh' gag was that his
rear end would make a 'bull's-eye' into a large thorn sticking out
of a rosebush stem." Hand had opposed that gag during work on
the story, but Disney had overruled him, "so when the picture got
to me, I decided to play the impaling idea down as much as pos-
sible." Disney caught up with Hand, though, and overruled him
again: "Walt insisted that I make the thorn long, dark, and sharp—
and that the mouse's rear end get buried clear up to the hilt. And
further to this, that I have the music build up to a 'screech' accent.

That poor mouse!"[22] The scene as it appears on screen, animated by Bob Wickersham, is more bland than painful, laying claim neither to laughs nor to sympathy.

Even as animation of the characters moved forward in fits and starts, animation of another, less conspicuous kind was advancing steadily. This new specialty embraced "effects"—everything from raindrops to tornadoes. In the early thirties, effects animators did not exist as a separate category; each animator drew the effects in his own scenes. Some scenes required more effects work than others, of course, and those scenes began to find their way into the hands of second-string animators who, as Wilfred Jackson said, "seemed to have a genuine interest in picturing the movement of natural phenomena."[23]

By early 1934, Cy Young and Ugo D'Orsi had gone one step further, to become true specialists. In *The Wise Little Hen*, for example, D'Orsi animated corn, and nothing but corn—growing corn in one scene, cooked corn and cornbread in another—in scenes that he shared with Ben Sharpsteen, who animated the characters. This new specialization was in keeping with the more refined division of labor that had entered the work of all the animators earlier in the decade; when the effects work went to specialists, the character animators no longer had any distractions to speak of. For their part, the effects animators had what was, by comparison with the character animators, a narrowly focused responsibility, and so they progressed rapidly. By late in 1934, effects animation could make a Disney cartoon look remarkably rich. *The Goddess of Spring*, a November release based on the Greek myth of Persephone, abounds in lush details: flashes of lightning as the goddess is carried off to Hades by the god Pluto, dramatic shadows as Pluto's minions dance. Those details were expensive; in 1934, the cost of a typical Disney cartoon rose almost 50 percent from the previous year to around $25,000, and for *The Goddess of Spring*, with its sumptuous effects, the total was $37,605.02.

The effects in *Goddess* were animated with far more sophistication and assurance than the characters, the first important human characters in a Disney cartoon since *The Pied Piper*. Wilfred Jackson, who directed both films, spoke of *Goddess* to a studio audience in 1939. "The main mistake we made," he said, "was that we didn't let the audience in on

something—we kept it a secret that we were kidding grand opera."[24] When an outline for *The Goddess of Spring* circulated in the studio in April 1934, it included a request for "any gags burlesquing grand opera."[25] The principals, Persephone and Pluto, sing in a pseudo-operatic style—Leigh Harline assigned the labels "aria" and "recitative" to much of what they sing[26]—and there are indeed traces of an intended parody: the devils' dance in Hades has a Cotton Club flavor, and Pluto himself slips into a Cab Calloway imitation, singing "Hi de Hades."

The character animation never encourages the belief that its peculiarities are intentional, though. Persephone, when she dances in animation by Ham Luske, looks rubbery; she swoops down and throws her head back in curves that are too strong, and there is none of the comedy that could have come from a dance that was at once graceful and silly. Pluto, in animation by Dick Huemer, is not appropriately angular and muscular; he is mushy instead, his torso like a balloon full of hot air. The character animation's weaknesses would no doubt be less glaring if the parodic intent were clearer—if, as Jackson said, "we had done the same thing, with better business, on a stage, where the audience felt we were kidding"—but it would remain weak.

The principal animators for *The Goddess of Spring* were Luske, Huemer, and Les Clark; there was no sign of Moore or Ferguson. Luske and Huemer had worked frequently with Jackson on other cartoons, so their assignment to this cartoon had no significance, and although Clark had acquired a modest specialty as an animator of female characters, he was not really a first-rank animator. In other words, there's not much reason to believe that Walt Disney was using *The Goddess of Spring* as a sort of training camp for a larger project; Clark, for one, never heard Disney connect *Goddess* to some future film.[27]

And yet, considering that *Goddess*'s leads were human characters of the sort that Disney had been avoiding, it's tempting to find such a connection. By the time the outline for *Goddess* circulated in the spring of 1934, Disney had begun preparing for his first feature, whose cast would include several realistically drawn humans.

Disney had decided to make a feature by sometime in the fall of 1933.[28] No doubt the great success of *Three Little Pigs* had encouraged him. *Three Pigs'* success proved that audiences could

respond enthusiastically not just to familiar animated characters, but to an individual film with a totally new cast—at least as long as the story itself was familiar, and the story Disney had in mind for his first feature was indeed familiar. The *New York Times* reported on 3 June 1934 that he "contemplates spending $250,000 on a full-length feature based upon 'Snow White and the Seven Dwarfs.' If, after it is made, he thinks it will disappoint the public, he will destroy it."

Disney could not have taken seriously that lofty vow to destroy the finished film, but he was probably serious about its projected cost. That figure, $250,000, was roughly ten times the cost of the average Silly Symphony in early 1934, and it must have seemed a reasonable target since a feature would be roughly ten times as long as a Symphony. Disney may even have expected a feature to cost a little less per minute than a Symphony because so many of the same characters and settings would carry through the film. Disney spoke later in 1934 of a production schedule stretching over a year and a half, with release coming late in 1935 or early in 1936.[29] That schedule, like the budget, sounded reasonable when measured against the time required (typically four to six months) for a Silly Symphony or Mickey Mouse cartoon to move through the Disney plant and into theaters; Disney would not be tying up staff and money for an inordinate amount of time.

A Snow White feature thus looked financially feasible—and financially attractive, too, because it promised to end what Disney later called "a chronic headache for us": extracting premium rentals from reluctant exhibitors. "Our only solution," as he said in 1941, was "to build our prestige through quality to the point where public demand forced the exhibitor to pay more for our product."[30] That he had done— *Fortune* estimated in 1934 that Disney cartoons rented for half again as much as competitors' cartoons[31]—but there was no way the shorts could win payments commensurate with their real value to theaters.

If the potential benefits from a $250,000 feature were enormous, the risks must have seemed manageable. Disney by 1934 was in much better shape financially than he had ever been. Even though he spent far more on each cartoon than he received as an advance from United Artists, he typically recouped his costs in little more than a year, and then moved solidly into the black; and revenues from licensing the rights to use the Disney characters in toys, books, and games provided a financial cushion of several hundred thousand dollars a year.

As attractive as a feature may have been to him in the spring

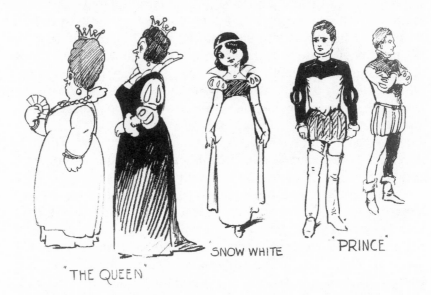

"THE QUEEN" SNOW WHITE "PRINCE"

An early sheet of suggested models for three of the principal charac-ters in Snow White and the Seven Dwarfs *(1937), by Albert Hurter.* © *Disney Enterprises, Inc.*

of 1934, Disney did not rush into work on it. There's nothing in the Disney studio's files to indicate that any real work was done on *Snow White* until 9 August 1934, and even then, it was work of the most preliminary kind. The twenty-one pages of "Snowwhite Suggestions" that bear that date are not an outline or a treatment, but rather a mass of suggested characters, situations, and songs. That material was probably assembled at Disney's request by the staff writer Dick Creedon, whose initials indicate that he dictated it to a stenographer. Disney's annotations on his copy of the sug-gestions show that he liked the idea of giving Snow White a song to be titled "Someday My Prince Will Come," and he marked "OK" beside a few of the many suggested names and characteristics for the dwarfs: Sleepy, Hoppy-Jumpy, Bashful, Sneezy-Wheezy. He also marked "OK": "The dwarfs put their beds together to make one for Snow White. They sleep on shelves, in the stove, etc. Awful [Creedon's suggested name for one of the dwarfs] finds sev-eral comfortable spots, but is ousted from each one. Finally, they put a coat hanger in his jacket and hang Awful up in a closet overnight."

Disney said of *Snow White and the Seven Dwarfs* in 1941 that "I

picked that story because it was well known and I knew we could do something with seven 'screwy' dwarfs."[32] By 1934, too, Disney knew how readily a fairy tale—that most malleable of literary forms, thanks to its oral origins—could be adapted for animation; the Grimms' "Snow-White," as short as it was in print, was sufficiently rich in plot and incident that it could expand comfortably to feature length on the screen. But, as Disney himself said, the dwarfs were the strongest lure. Indistinct in the Grimms' original, they could be made "screwy" in the film—assigned names like "Awful" and hung in closets. From the start, the idea was to distinguish the dwarfs from one another through names and corresponding characteristics as clear-cut as the four humors or the seven deadly sins.

Disney met three times in October with Creedon and the lyricist Larry Morey; three other senior members of the story department—Ted Sears, Albert Hurter, and Pinto Colvig—also attended one meeting. (Harry Bailey, a veteran of the Aesop's Fables studio in New York, served as a sort of stenographer for all these meetings, making handwritten notes that were later typed.) The dwarfs—their names, their voices, what they were to do—dominated all the October meetings. After the last meeting was held, on 15 October, Creedon prepared an eighteen-page tentative outline; around fifty copies of the outline, dated 22 October, circulated in the studio.[33] The outline skipped over such preliminaries as the Queen's jealous orders to kill the girl; "Walt prefers," it said, "to start actual work at the point where Snow White finds the cottage of the Seven Dwarfs." Names had been chosen for all the dwarfs: Happy, Sleepy, Doc, Bashful, Grumpy, Jumpy, and a dwarf named only "Seventh," who was "Deaf, Always Listening Intently—Happy—Quick Movements—Spry."

However sensible its attention to the dwarfs, the outline in other respects did not reflect well on Walt Disney's judgment. It was cluttered with episodes that would add to the film's length without strengthening the story. For example, in partial and misguided faithfulness to the Grimms, who tell of three attempts on Snow White's life while she is living with the dwarfs, the outline called for the Queen to make two such attempts, poisoning both a comb and an apple. It stooped to crude Halloween scare: the Queen was to use the skeletons of other imprisoned young men as marionettes, dangling them sadistically in front of the Prince in her castle's dungeon. The outline took for granted—and here it surely reflected Disney's own thinking—that the film would have

to offer a constant flow of gags if it was to hold an audience's interest, that it could never be allowed to go wholly serious. Even the Queen's fall to her death was to have a comic flavor: the outline referred to the "Laurel and Hardy vultures" who were to witness it and to the need to kill the Queen with a "clever piece of business." Disney envisaged something like an animated Marx Brothers comedy, with straight young leads providing a frame for the comedians.

An evening meeting on the studio's sound stage followed on 30 October. A fragmentary note from that meeting indicates that Disney approved the idea of working with two versions of the Queen: "a fat, cartoon type; sort of vain—batty—self-satisfied... and also as a high collar stately beautiful type."[34] (A Hurter-drawn model sheet of Snow White, the Prince, and a fat Queen probably dates from this time.) It was already turning out to be difficult to reconcile Disney's desire for gags with the fundamentally serious nature of the story: a "fat, cartoon" Queen could not be plausible as a threat to Snow White, but neither could a "stately beautiful type" be plausible as a comic figure.

When a revised outline circulated in the studio on 6 November, it implicitly recognized that conflict. "For the time being," it said, "we will concentrate entirely upon scenes in which only Snow-White, the Dwarfs, and their bird and animal friends appear," specifically, the scenes in which the dwarfs were to discover Snow White asleep in their cottage. The dwarf named Seventh had been supplanted by one named Deafy, but the outline emphasized that all the dwarfs "are open to change."[35] Another large meeting took place on a Friday evening, 16 November, to air ideas stimulated by the 6 November outline.[36] It must have been productive: by the following Monday, Disney himself had dictated a new gag outline, far more detailed than the 6 November outline, titled "Dwarfs Discover Snowwhite."[37] It circulated in the studio two days later. The dwarf named Jumpy in the earlier outline had been supplanted by a new character named Dopey, and the sequence was clearly taking shape to Disney's liking; by circulating a new outline, he was really asking only for comic embellishments. On 19 November, the date of "Dwarfs Discover Snowwhite," he also dictated a detailed chronology for the entire film, specifying when most of the action occurred over a three-day period.[38]

The Disney studio's files show no more meetings on *Snow White* during the rest of 1934; Disney apparently was wrestling

with the story on his own. In December he made several Dictaphone recordings of a "skeleton continuity," or plot summary; the final version, dated the day after Christmas, suffered from weaknesses that were, despite the intervening work, not all that different from those in the 22 October outline. At bottom, Disney still did not trust his story. The Grand Guignol episodes with the Queen, even riper in the 26 December continuity than in the earlier version, were his way of trying to get around the dilemma he had recognized at the 30 October meeting. If the Queen could not be a comic figure—if, in fact, she could fill her role in the story only as a stately beautiful type—Disney would overcome his staff's difficulty in dealing with such characters by presenting her as a grotesque menace. Likewise, the Prince, another figure with no comic potential, would break out of the Queen's dungeon and ride to rescue Snow White in melodramatic scenes that in Disney's continuity read like a parody of D. W. Griffith's *Orphans of the Storm*.[39]

There was still plenty of room for gags in Disney's continuity, though. He had the dwarfs eating soup noisily during their first evening with Snow White; the next day, the dwarfs were to hold a "lodge meeting" to decide what to do about a bed for Snow White; then they would build the bed. These three sequences, tacked onto others that provided plenty of time to introduce the dwarfs and establish their rapport with Snow White, made sense only as opportunities to load up *Snow White* with a comedy that was far more self-contained than anything else in the film.

Work on *Snow White* slowed to a virtual halt around the end of 1934. The Disney writers continued to turn out pages of suggested dialogue for a few more weeks, but in the early months of 1935 there were no more meetings, at least none important enough to be memorialized in notes, and no more outlines. It's possible that the weak animation in *The Goddess of Spring* planted some doubts in Disney's mind about whether any of his animators were ready to animate a girl like Snow White. Certainly he was not happy with the animation of Persephone; as Dick Huemer put it, "Nobody ever got off the griddle on that one."[40] But Disney's doubts may have run less to the animators' readiness than to his own.

A year earlier, in February 1934, when the outline for *The Golden Touch*, a new Silly Symphony, circulated in the studio, it bore as usual the name of the man who was expected to direct the film. This time, though, the director's name was Walt Disney.[41]

Upon completion of the writing of the story, he began directing *The Golden Touch* in May 1934, and soon he was shepherding the studio's two strongest animators, Fred Moore and Norm Ferguson, through a retelling of the King Midas story.[42] Only those two animators worked on the film, Ferguson animating almost all of the king and his cat, and Moore doing Goldie, the elf who grants his wish. *The Golden Touch* was one of the first Silly Symphonies to make extensive use of prerecorded dialogue, and Disney had Billy Bletcher, the actor who provided King Midas's deep voice, filmed with what Bletcher called "white on my lips" while he recorded his lines, so that Ferguson could use the film as a guide.[43] The animation stretched over an unusually long period, from June to December 1934, with a lull only in late summer, coinciding with the first serious work on *Snow White*. *The Golden Touch* finally reached theaters in March 1935. Ben Sharpsteen recalled Disney's saying "that he was kind of getting his hand in at directing on this picture, and that he was going to continue over into *Snow White*.... But as it turned out, *The Golden Touch* was a stinker."[44]

In later years Disney himself dismissed *The Golden Touch* contemptuously ("a tremendous flop").[45] It looks back even in the design of its characters: King Midas is all but identical to Old King Cole, whom Ferguson animated three years earlier in *Mother Goose Melodies*, and the king's cat is the Ferguson-animated Boston terrier of *Just Dogs*, from 1932, in a slightly different skin. Given especially Disney's emerging emphasis on personality, the cast of *The Golden Touch* is notably lacking in that respect. Midas's greed is not one element in a personality that has more attractive aspects, but is instead all-defining. Neither is Goldie particularly ingratiating; he is at bottom a spiteful tempter. Ferguson and Moore could not find a handhold on either of these stony characters, and they clearly got no help from their director.

By 1934, Disney was primarily a highly demanding critic and editor of what his employees did. *The Golden Touch*, with its hollow, repellent characters, suggested that when he got more directly involved in the making of a cartoon, he could not stand outside his own work and judge it with the same severity—at least, not until it was too late. For him to direct *Snow White* himself could invite disaster.

The Golden Touch's shortcomings may have been made all the more obvious to Disney by the contrast with some of the other cartoons that were emerging from his studio around the same time. In the closing months of 1934—when Disney's attention

must have been distracted from normal releases by his work on *Snow White* and *The Golden Touch*—his animators and directors began weaving together the threads of character, story, and animation that had until then resisted their looms.

In the fall of 1934, Disney was still working with three directors, but Burt Gillett was gone, and Ben Sharpsteen had taken his place. Gillett had left the staff and returned to New York after his contract ran out at the end of March.[46] Gillett was, Wilfred Jackson recalled, "a bit more stubborn in trying to have his own way" when he disagreed with Disney than the other directors were.[47] Just as Ub Iwerks's departure four years earlier helped Disney, in a roundabout way, so too did Gillett's because now Disney was working only with directors—Jackson, Sharpsteen, and Dave Hand—who might try to change his mind, as Hand did about that painful gag in *The Flying Mouse*, but would never go behind his back, as Gillett sometimes did. It was under Disney's tutelage that Jackson had learned everything he knew about animation; Hand and Sharpsteen had found at Disney's the success that eluded them in New York in the twenties.

The directors' loyalty was important because Disney's involvement in day-to-day production was still receding. Not only did he concentrate on both *Snow White and the Seven Dwarfs* and *The Golden Touch* in the last half of 1934, but he had become a celebrity of sorts, and it's clear that much more of his time was devoted to welcoming famous guests to the studio and sitting for press interviews than had been the case a few years earlier. By way of compensation, he had acquired in what was called the "running reel"—a complete pencil-test reel for each cartoon—a tool that gave him and the directors a much stronger grasp of each cartoon as a whole, well before it was completed.

Pencil tests of each scene were spliced into the running reel as they were shot, and the reel was shown with a temporary sound track, made up of a piano score, any prerecorded dialogue, and the more important sound effects. (At first, blank film represented the scenes that had not yet been shot in pencil test, but film of story sketches, timed to the soundtrack, soon replaced it.)[48] The running reel is surely one reason that several of the Disney cartoons released in the early months of 1935 have much more vigorous and assured storytelling rhythms than most of their

predecessors. That is true especially of *The Tortoise and the Hare*, a Silly Symphony that Jackson directed in the summer and fall of 1934; it was released in January 1935.

Speaking to a studio audience in 1939, Jackson singled out *The Tortoise and the Hare* as the first cartoon in which "we depicted speed on the screen. Before that time nobody had dared to move a character clear across the screen in five frames," or less than one-fourth of a second; the Hare crosses the screen that fast several times.[49] The Hare when running is usually blurred, sometimes literally a blue streak. With the Hare's running visible so briefly, what came before and after assumed greater importance.

For all the growing emphasis on observation in the midthirties—the idea that, as Dave Hand said a few years later, animators should be "constantly storing up experiences and notes for future use"[50]—the Disney animators continued to hone useful techniques comparable to those that Ferguson and Moore introduced. Dick Huemer talked about one such technique: "When a man put his hand in his pocket, it didn't ooze right into his pocket, he pulled his hand back first, sort of aimed for his pocket and then thrust in. Walt called it 'anticipation.'"[51] Artists have for a long time exploited the human tendency to see movement in the anticipation of it. Its mirror image is follow-through, which Huemer described as "when a person ran, for instance, and then suddenly stopped, his coat kept going, ahead of him, independently, and then flopped back again."

As Disney and his animators had probably realized by the late twenties,[52] anticipation and follow-through can clarify what a character is doing by pointing forward to it and back at it. In the early thirties, though, they began using those tools to serve a larger purpose: by compressing a character's actions and emphasizing anticipation and follow-through instead, a director and his animators could not just clarify those actions, they could also enlarge their scope.

Ham Luske, who animated the bulk of the Hare's scenes—everything except the start of the race and the rush to the finish line—was the first to demonstrate fully the potential of this kind of animation. The awkwardness of so much of his earlier animation, of the Pied Piper and the Grasshopper, is nowhere evident in his animation of the Hare. What Luske shows the Hare doing is clearly impossible, but Luske makes it *seem* possible by bringing to his animation what he had observed of athletic action (he drew illustrations for the sports section when he worked at the

Oakland Post-Inquirer)[53] and what he knew from his own experience on the playing field. As the Hare prepares to run, or skids to a halt, or plays tennis with himself, he moves with the authority of realistic movement; but the exaggerated pattern of anticipation and follow-through, and the Hare's speed itself, are not realistic at all. Luske's analytical bent, his concern with how things really moved, thus eased audience acceptance of what might otherwise have seemed as tiresomely farfetched as the old "impossible things" that Disney had banished.

The Hare was solidly characterized in Bill Cottrell's writing: he was a star athlete, tremendously talented, and just as vain and cocksure. As Dick Huemer told Joe Adamson: "If [any other studio] had done *The Tortoise and the Hare* it would have been a series of assorted gags about running, one after another. Not all this clever, boastful stuff like stopping with the little girls and bragging and being admired, and showing off how he could play tennis with himself."[54] This time, though, the writing did not have to carry most of the load. Luske depicted the Hare's boastfulness through gestures, poses, and expressions that were markedly more pointed and precise than those in Fred Moore's animation for *The Flying Mouse*, just a few months earlier.

In another 1939 lecture, Jackson spoke of how he fitted music to the climactic rush to the finish line, in a way that built excitement. As he cut back and forth from Tortoise to Hare, he switched from an accelerated version of the Tortoise's theme, "Slow but Sure," to a siren sound effect for the Hare that was itself musically phrased: "We tried to phrase it so the peaks of the siren would fall naturally on the peaks of the music, and still give us time to cut back and forth." To make the phrasing come out right as he shortened the intercut scenes of the two racers, he inserted shots of the excited crowd.[55]

Jackson delighted in such aural puzzles; that was why he was a natural for the Silly Symphonies and directed more of them than anyone else. Yet it was not in a Silly Symphony but in his next cartoon, *The Band Concert*, a Mickey Mouse that was animated late in 1934 and released in February 1935, that Jackson's inclinations found the most congenial task. A conspicuous cartoon, as the first Mickey Mouse in Technicolor, it was in some ways an anomaly: departing from the pattern set in the Mickeys of the previous three years, *The Band Concert* was a musical cartoon; one made, moreover, just as the Silly Symphonies were starting to slip out of their musical leash.

In its basic structure a throwback to the plotless, musical Mickey cartoons of the very early thirties, *The Band Concert* is virtually a remake of one such cartoon, *The Barnyard Concert* (1930). The climactic action, in which Mickey Mouse's band is scooped up by a tornado but continues to play Rossini's overture to *William Tell* as it spins through the air, originated in an even ruder source: a 1930 Max Fleischer cartoon, *Tree Saps*, one of the last on which Ted Sears received credit (as an animator) before he joined the Disney staff. *The Band Concert* surpassed its predecessors many times over, especially in the final sequence, where music and action are far more wittily and intricately intertwined than in the Fleischer cartoon. It was in the marshaling of such details that Jackson was visible as a director, as in no other cartoon before it. "The more details there were to be worked out," he wrote in 1978, "the more fun it was for me."[56]

David Hand, by contrast, delegated. Lacking Jackson's lapidary instincts, he approached the director's job in the spirit of a business executive, farming out detail work—the kind Jackson thrived on—to subordinates and concentrating instead on broader issues, which at the Disney studio entailed primarily an intensive reading of Walt Disney himself. Hand's first really strong cartoons, *Who Killed Cock Robin?* and *Pluto's Judgement Day*, followed Jackson's by a few months. Both cartoons shared many of the virtues of *The Tortoise and the Hare* and had besides a more sophisticated tone than was typical of Jackson's work. That was especially true of *Who Killed Cock Robin?* By the time that cartoon was written, late in 1934,[57] the Disney story men, like everyone else in the studio, had become more specialized. Bill Cottrell was by then unquestionably the lead writer for the Silly Symphonies; he had been working for about a year with Joe Grant, a newspaper cartoonist who came to the studio to provide caricatures of Hollywood actors for a cartoon called *Mickey's Gala Premiere* and stayed on to work in story. Cottrell and Grant were probably the first Disney story men to work together regularly as a team.[58] Cottrell wrote but did not draw; Grant drew story sketches and, from all appearances, contributed less to the writing of the stories than Cottrell did. (Bob Kuwahara worked with them, too, strictly as a sketch man.)

More than most of its predecessors, *Who Killed Cock Robin?* has the air of being "written," that is, based on a real script (one of Cottrell's continuities runs seventeen pages, much longer than usual). But it also shows how the writing could benefit from the

new emphasis on visualized possibilities. *Cock Robin*'s all-bird cast includes, for example, a character named Jenny Wren, a caricature of Mae West. She is plainly in the film because of her "visualized possibilities," first as a caricature by Joe Grant and then as animation by Ham Luske. Even her tail proclaims her curviness: concave, it swings back and forth in a way that emphasizes its contours. (Luske worked from a three-dimensional model of the tail: "We could not conceive how the tail would go around until we made a tail and turned it," he said in 1938.)[59] The tail's movement serves to bring out the pivoting of Jenny's hips, and that, in turn, brings out the countermotion of her shoulders—the movement in each of three parts of her body emphasizes the movement in the other two. The total effect is less to make Jenny seem like an intricate automaton, although there is some of that, than to make her comically voluptuous.

Jenny is, however, more than an animator's bosomy delight. Cottrell gave her parodic dialogue, too, and the cartoon is organized around her "testimony" at the trial, where she sings, "Somebody rubbed out my robin." *Who Killed Cock Robin?* is, for Disney, uncharacteristically satirical. At one point, a bird jury, confronted with three potential murderers of Cock Robin (all of them innocent, as it turns out), sings merrily, "We don't know who is guilty, so we're going to hang them all." The operetta style of earlier Silly Symphonies returns to soften the satire's sting; the resemblance to Gilbert and Sullivan is unmistakable.

Cottrell and Grant probably wrote *Pluto's Judgement Day*, although there is no contemporaneous record of that.[60] It is a courtroom cartoon, too, with Pluto dreaming that vengeful cats have put him on trial in a hellish cavern; the feline jurors deliver their "guilty" verdict after passing through a revolving door. There is no satirical undertone but rather a deft blending of horror and comedy; again, cheerful, witty music, combined with rhyming and rhythmical dialogue, serves as an emollient.

Both cartoons required their director to respect the balance the stories struck between competing elements, a task of a kind that had not been imposed on a Disney director before, and Hand met that requirement fully in both cases. He may have been most advanced as a Disney director, though, not in what he put on the screen but in how he put it there. The "drafts," the scene-by-scene records of who animated what, for both *Cock Robin* and *Pluto's Judgement Day* suggest that he found ways to exercise a great deal of control over who worked on his cartoons. *Cock Robin* is cast

very carefully by character: Luske animated Cock Robin and his paramour Jenny Wren, Norm Ferguson the owl judge, and Bill Roberts, another skillful animator, the parrot prosecutor. For *Pluto's Judgement Day*—a cartoon most of whose characters are, unlike *Cock Robin's*, intentionally shallow—the animators were cast by sequence. The crew was again a strong one, including Moore, Luske, Roberts, and Dick Lundy.

The directors by no means had the final say on who worked on their cartoons ("It wasn't too infrequent that somebody would just be dumped in on me, all of a sudden," Jackson said),[61] and Hand was not very illuminating when he talked about casting. "There was a sort of working back and forth," he said, "until you got a crew that could pretty much handle the kind of picture that you were working on."[62] That "working back and forth" was the special province of Hand the delegater and organizer; rather than devote himself to the kind of painstaking labor that Jackson thrived on, Hand spent his time assembling teams of strong animators and organizing their assignments so that he would not have to submerge himself in details.

In working as he did, Hand was acting upon his knowledge of Walt Disney; he had seen the value that his boss attached to a more systematic kind of filmmaking than Disney was usually able to practice. When Disney directed *The Golden Touch*, with only Moore and Ferguson as his animators, he cast that cartoon with a thoroughness that no other director had ever approached. Hand followed his boss's lead—and gave Disney better films than Disney had been able to make himself.

By 1935, the Disney studio had grown not only much larger—the number of employees passed three hundred that year, up from fewer than two hundred in 1934—but also much more complex. A few years later, Walt Disney said of the studio as it existed then: "I think I was learning a great deal about handling men; or perhaps the men were learning how to handle me."[63] The learning was slow and tortuous on both sides.

As early as 1933, the growth in the studio's staff had opened up considerable distance between Disney and most of the people who worked for him. Both Walt and Roy Disney still lived just a few blocks from the studio, but the cozy familiarity of the early thirties was rapidly vanishing. Eric Larson, for one, did not meet

Walt until several months after he was hired in May 1933.[64] Increasingly over the next few years, the new employee who wanted to catch the boss's eye had to be alert for the slightest opportunity. The writers, in particular, more than the animators, whose work typically came before Disney free of any confusion about authorship, believed they had to find ways to capture Disney's attention, not just for what they had done but for themselves. Thus Joe Grant broke with the prevailing pattern by using color in his story sketches (he worked with pastels).[65]

The growing number of writers and sketch artists in the story department (fifteen men and one woman, Bianca Majolie, were working on stories for the shorts alone by late in 1935)[66] probably contributed to a certain insecurity in the people who worked there. The work of any one person could easily be swallowed up in a group effort—or simply appropriated by someone else. Homer Brightman, who began working as a Disney story man in March 1935, recalled with some bitterness how isolated he was in his early months. Only one other writer, Harry Reeves, shared ideas with Brightman, and even Reeves "turned his storyboard to the wall when I came in."[67] Brightman escaped purgatory by pleasing Walt Disney with a gag he suggested during a meeting on a Mickey Mouse cartoon, *Alpine Climbers*.

By the spring of 1935, stenographers had begun transcribing the story meetings that Disney attended; when the transcripts became available a day or two after the meeting, the writers and directors had a concrete guide to what Disney wanted. The value of such transcripts is evident from one of the earliest surviving examples, from an October 1935 meeting on a cartoon called *Mickey's Circus*; Mickey Mouse was to be the ringmaster and Donald Duck, the impresario of a troupe of seals. Disney steered the writers toward a presentation of the seals that would permit the animators to introduce personality. He said, in the stenographer's abbreviated version: "Only way to work those seals is as whole bunch of comics—they applaud themselves.... [No tricky way that] they juggle balls is important unless it is part of some business you are building."[68] Disney was concerned not just with personality, but with the danger of making a personality one-dimensional; of Donald Duck, he said: "You are depending too much on the idea of the Duck getting mad." (The film itself, released the following year, suggests that the story men heeded Disney's wishes. In it, Donald resembles an exasperated schoolmaster, the seals, a mob of high-spirited, anarchic schoolboys.

There are tongue-in-cheek echoes of the bitter labor disputes of the thirties, too: at one point, Donald addresses the seals as "You radicals!")

The transcripts were by no means an infallible guide. As Jackson said, "The big trick was to know when Walt was just thinking out loud and when he was telling you what he wanted, because he'd say it the same way."[69] The studio retained an intensely personal flavor—everyone had to call Disney "Walt"— even as it became a much larger and more formal organization. Employees who might once have seen Disney on a daily basis, and even socially, now saw him much less often, and as a result, an encounter with him in a sweatbox session or in front of a storyboard could be much more daunting than before. Disney had always been quick to criticize and slow to praise, but now, for many employees, there was no buffer, built up over day after day of casual exchanges, when his criticism turned harsh.

By 1935, Disney himself said a few years later, "a greater degree of specialization was setting in. The plant was becoming more like a Ford factory."[70] For example, sometime in 1934 Disney set up a two-man sound-effects department. Sound effects had been scarce in most of the Disney cartoons; like voices, they were recorded along with the music for the earliest sound cartoons, in one take, and they usually had a makeshift, pit-drummer quality—the sort of thing (whistles, bells, ratchet wheels, noisemakers) that might have accompanied a knockabout comic's appearance on a burlesque stage. By the early thirties, some sound effects were being recorded separately, but even as late as *Mickey's Fire Brigade*, released in August 1935, the sound effects were overwhelmingly of the pit-drummer variety. Wthin two years, though, according to James Macdonald, one of the first two sound-effects men on the payroll, "we had five sound-effects fellows."[71] Adding sound effects to the cartoons became a matter not just of inventing or finding appropriate effects (for example, when the Hare screeches to a halt in *The Tortoise and the Hare*, the sound is of brakes recorded at an intersection outside the Disney studio),[72] but of analyzing the films and editing the effects to the frame.

Even though the studio's ever more refined division of labor actually bore only a superficial resemblance to Henry Ford's mass-production methods, by the midthirties the atmosphere in some parts of the studio did smack of a factory. Inking and painting the cels, for example, which in the late twenties had been the first rung on the ladder for aspiring animators, had become in the

early thirties a women's preserve, populated by low-paid person-
nel. Their work, unavoidably mechanical at its core, could be
measured and evaluated almost as easily as any assembly-line
worker's.

It was as inbetweeners that most young men now broke into
animation, and it was in Disney's inbetweening department that
the resemblance to a Ford factory may have been strongest. In
the very early thirties, the inbetweener typically worked in the
same room with an animator and the animator's assistant. By
early 1933, though, many and perhaps most of the inbetweeners
were working in a separate inbetween department. It's not clear
when or why this separate department came into existence, but
it quickly became a sort of boot camp. In the depths of the
Depression, the Disney studio had its pick of hundreds of trained
artists who needed work; putting artists into the inbetween
department was a way to weed out not the untalented—they
never got in—but those without the necessary stamina and dedi-
cation. When he started at Disney's in the spring of 1933, George
Goepper recalled, "we all worked our little fannies off because
you never knew when you were going to be fired."[73]

What was known at the studio as "the bungalow" was built for
the inbetween department in the closing months of 1932, in the
courtyard formed by the original Disney building, the L-shaped
addition to it, and the sound stage.[74] Claude Smith, who started
working there early in 1933, recalled that the inbetweeners
worked in "a large room...with desks lined up all facing a glassed-
in office, which was Drake's."[75] "Drake" was George Drake, who
had been Dick Lundy's assistant earlier in the decade—and who
was, Lundy recalled, "not very capable at all." Lundy was "quite
surprised" when Drake was put in charge of the inbetweeners.[76]
(Studio gossip had it that Drake got his job because he was Ben
Sharpsteen's brother-in-law, but, in fact, Sharpsteen said, Drake
was only "a remote cousin-in-law from my mother's side of the
family.")[77]

Gradually, the hiring and training of inbetweeners became
entwined with Don Graham's classes, even as Graham himself,
and his fellow teacher Phil Dike, were getting more deeply
involved in the studio's work. In 1934, Dike became the studio's
color coordinator, and Graham began working there three days a
week, as well as teaching two evening classes.[78] In addition, Dike
said, he and Graham "knew what was going on in the art schools,
and saw the smart young kids coming up and captured them

because we knew how to reach them."[79] Those "smart young kids" might still go through George Drake's meat grinder, but they had to be offered something else besides. As early as the fall of 1934, McLaren Stewart recalled—he started as an inbetweener then—it had become standard practice to interrupt production work for an hour or so in the morning while all the inbetweeners drew from a model.[80] Of Graham's three days a week at the studio, he spent one with Walt Disney and the directors in sweatboxes, but he spent two days taking junior members of the staff on sketching expeditions to the Los Angeles zoo.

By 1935, the inbetween department had metamorphosed into a full-fledged training department, with George Drake still in charge, and life drawing now swallowed up the two weeks of a prospective employee's tryout period. As Graham described the process many years later, each "class" of a dozen or so new hires got six to eight weeks of instruction in drawing and animation before settling into production work; they were encouraged to attend the evening classes, which by then were held five nights a week.[81] By that fall, when the Disney studio built an annex across Hyperion Avenue that provided new quarters for both the evening classes and the inbetween department,[82] Drake's department had been scrubbed clean of its harshest attributes. With a feature film ahead, Disney had shifted the department's attention away from culling the unworthy and toward preparing new employees for more creative work. But even though the studio had reverted somewhat to being the "school" it once was, it now had an underlying industrial character that could not be changed.

Walt and Lillian Disney spent almost three months in Europe in the spring and summer of 1935; they returned to the United States in early August. That trip apparently dispelled any doubts about *Snow White and the Seven Dwarfs* that Walt may have taken with him: by October he had resumed work on his first feature in earnest. Skeletal transcripts survive from only a few of what were probably many meetings. Disney and his writers were concentrating now on the sequences extending from Snow White's discovery of the dwarfs' cottage through the dwarfs' first meal with her. These were the sequences that would, in effect, reveal Snow White and the dwarfs to the audience, and then to each other. The first attempts at animation lay just ahead.

By 1935, animation—and through it, the animators—had assumed an overwhelming importance within the Disney scheme of things, sometimes to an almost comical extent. In April, George Drake circulated a memorandum titled "Notes and Suggestions for Animators and Assistants," with the aim of eliminating what must have been increasingly nettlesome interruptions in the flow of work. Drake was at pains to say that he was not ordering the animators to do anything; "at Walt's suggestion," he said—and with lots of diplomatic hedging—he recommended to the animators that they do such things as draw the characters in the correct proportions and try not to lose drawings.[83]

The subtext of Drake's memo was that by 1935 some of the animators had become sloppy prima donnas. By then, though, everyone knew that animators could do wonderful things, and no one wanted to get in the way of their doing them. Disney said in a memorandum late in 1935 that animators should not be asked to come up with gags; instead, whatever time they spent in story meetings should be devoted "to find[ing] out what possibilities the scene presents to the animator, stirring up his imagination, stirring up his vision, stimulating his thought regarding what can be done in the scene."[84]

The Disney cartoon characters of 1935 existed in a motion-picture environment that was vastly different from the one at the time Disney made his first sound cartoons. In many live-action sound films of the late twenties and early thirties, stage and silent-film conventions dominate the acting—what the actors do seems externally imposed and disconnected from anything the actor might be thinking or feeling himself. Such acting could not survive: the camera, especially in combination with sound, exposed too much for the artifices of stage technique to go unnoticed. By the midthirties, much screen acting seemed far more natural; and it was acting of that kind that audiences would measure the animation in Disney's feature against. By late in the year, he was girding himself for what was going to be a much more demanding task than he had once anticipated.

In December 1935, Disney's leading animators began to codify their techniques in a self-examination unprecedented at a cartoon studio. The idea plainly was to spread their knowledge to the less-experienced crews that would make the shorts while the studio's strongest talents worked on the feature. Four animators—Fred Moore, Fred Spencer, Art Babbitt, and Norm Ferguson—talked to studio audiences about how to animate continuing

characters in the Mickey Mouse series; the substance of those talks was embodied in a memorandum by each man, all written at the end of the year or very early in 1936. On 31 December 1935, Ham Luske contributed a primer on general animation principles.[85]

Disney himself went much further. In an eight-page memorandum titled "Production Notes—Shorts," he sorted the studio's 1935 releases into successes and failures, obviously expecting that his preferences would guide work on future cartoons. Another memorandum he wrote around the same time, dated 23 December 1935 and addressed to Don Graham, laid the groundwork for what Disney called "a very systematic training course," differing in scale and intensity from the training the studio already provided new hires. This training, Disney wrote, would not be for "older animators," who were "lacking in many things," but for "young animators." Rather than hire experienced animators and try to break them of their bad habits—and those older animators would have been, in many cases, men only in their thirties—Disney wanted to train unspoiled young men in the principles that had taken shape at his studio over the previous few years. The training should be based, Disney said, on the idea that "the first duty of the cartoon is not to picture or duplicate real action or things as they actually happen—but to give a caricature of life and action...to bring to life dream fantasies and imaginative fantasies that we have all thought of," fantasies that would be erected on "a foundation of fact."[86]

In other memoranda addressed directly to animators, Disney pounded home the idea that caricature was "the thing we are striving for," with "caricature" conceived in terms that fit animation like Ham Luske's of the Hare and Jenny Wren. In a memo evaluating animation for *Cock o' the Walk* and dated just three days before the memo to Graham, Disney said: "On any future stuff where we use human action, first, study it for the mechanics, then look at it from the angle of what these humans could do if they weren't held down by the limitations of the human body and gravity."[87]

This flurry of activity—getting the studio as a whole lined up for the new day ahead—accompanied a comparable rush of work on *Snow White* itself. On 25 November 1935, Disney wrote a six-page memorandum laying out likely assignments for everyone who would be working on the film.[88] A few days later, he dictated a "description of the seven Dwarfs as I see them at the present

time." He sketched in each dwarf's characteristics at greater length than anyone had before; traits that had once floated from dwarf to dwarf, like a tendency to talk in spoonerisms, had now attached themselves firmly to one dwarf or another. He invoked Hollywood personalities: of Doc, the leader of the dwarfs, he said, "At times when he is doing things he mutters to himself and stammers around like W. C. Fields." And he spoke of how the dwarfs felt about one another: "Grumpy's remarks are a great source of irritation to Doc. Doc can be in the happiest mood, but one look at Grumpy brings a complete change over him and a sort of determination to show his authority."

It was through Dopey, "the under-developed of the Dwarfs—mentally and physically," with "the mind of about a two-year-old baby," that Disney hoped to make a connection with the comic triumphs of the shorts: "He has a sort of dumb personality—in a way, like Pluto," and like Pluto, Dopey would not speak. "While there are chances for personality gags on all the Dwarfs, Dopey is the one that we are depending upon to carry most of the belly laughs."[89]

The Disney writers pruned and polished the sequences on which animation would begin; their work survives in detailed scripts and continuities bearing dates clustered around Christmas. They were no doubt under the gun: one animator, Bill Tytla, came onto *Snow White* on 23 December, a Monday—the same day Disney addressed his memo to Don Graham—and Fred Moore probably started at the same time. They were to animate the dwarfs; Luske, who followed them a little more than a week later, was to be in charge of Snow White herself.[90]

Tytla had started at Disney's barely a year earlier, in November 1934. Whereas both Luske and Moore started at the bottom at Disney's, Tytla was hired as a full-fledged animator; he was an "older animator," born on 25 October 1904, of exactly the kind Disney disparaged. Not only had he already been in the business for almost a dozen years, but his experience was of a kind that by 1934 must have seemed of dubious value to many people at Disney's. He had gone on the payroll of Paul Terry's Aesop's Fables studio in New York in March 1923,[91] and he had worked for Terry until he left for Disney's, except for eighteen months in 1929–30 when he traveled in Europe, studying painting and sculpture.[92] He had returned to New York when Terry offered him a job at his new Terrytoons studio.

Tytla had also had extensive formal art training as a teenager

in New York, and his animation in the Terrytoons of the early thirties is impressively solid and three-dimensional.[93] Terry's studio, the most nakedly commercial of all the cartoon studios, was a curious setting for someone like Tytla, but he and Terry evidently got along well, and Tytla was not the only animator in the early thirties who was slow to leave New York for California. It was his friend Art Babbitt's presence at Disney's that was ultimately decisive.

Once at Disney's, Tytla worked on only a few cartoons before Walt Disney tapped him to work on *Snow White*. That assignment may have been in part fortuitous; Tytla broke his pelvis playing polo in October 1935, and he may have been put onto *Snow White* because the animation would still be experimental for the first few months and thus free of the deadline pressures that accompanied work on the shorts. Tytla was not chosen because he had established any particular rapport with Disney. "I first became aware of Walt on *Snow White*," he said many years later. "I never saw much of him before that."[94]

Tytla was, however, a natural choice for work on the feature. Despite his years at Terry's, he responded with enthusiasm to what he found at Disney's. Sweatbox sessions, he told a studio audience in 1937, were "a revelation. After all, if you do a piece of animation and run it over enough times, you must see what is wrong with it."[95] The Disney studio rewarded animators who turned out good footage in less time than allowed, and it was probably Tytla's enthusiasm for reworking his animation that put his "account" $625 in the red before he went to work on *Snow White*.[96] (Another problem may have been what Walt Disney criticized as his "lack of system.")[97]

Tytla's draftsmanship may have been a little overwhelming for the work he was given: his scenes of the formula character Clarabelle Cow in *Mickey's Fire Brigade* are a little *too* solid, her muzzle a little too real. There would, however, be plenty of opportunities for Tytla to animate solid forms in his work on the dwarfs, and making them seem too real would be the least of his worries.

In the early months of 1936, Moore, Tytla, Luske, and some junior animators who worked under Luske felt their way through their first assignments on *Snow White*. Luske and his crew handled

sequences 3C and 3D, showing Snow White and the animals who have befriended her as they enter the dwarfs' cottage and clean it to song. (Larry Morey and Frank Churchill had written "Whistle While You Work," the housecleaning song, sometime before story work resumed the previous fall.) Moore was animating sequence 5A, the bedroom sequence in which the dwarfs and Snow White meet, and Tytla sequence 6A, the dwarfs as they wash up for dinner.

In keeping with the plan he had outlined to Don Graham, Disney began hiring on an accelerated schedule. By February the studio was running ads for artists in what the Hollywood trade paper *Daily Variety* called "eastern dailies."[98] Graham and George Drake left for New York on 19 March 1936 to spend two months reviewing the portfolios of several thousand applicants for jobs with the studio.[99]

In the weeks preceding his departure, Graham taught a series of "action analysis" classes on Thursday nights. Those classes, which had begun the previous October,[100] differed from the life classes; in them, Graham and his students studied live-action film and critiqued the Disney studio's own cartoons. On 5 March 1936, the class viewed the Silly Symphony *Elmer Elephant*, scheduled for release later that month, and *Building a Building*, a black-and-white Mickey Mouse cartoon made in late 1932. The members of the class came down heavily in favor of the earlier film. Something, they said, had leached away the "spirit" that enlivened *Building a Building*, even though, when both films were measured against the standards Walt Disney had embraced, *Elmer Elephant* should have made the stronger impression. Ham Luske, in one of his last assignments before going onto *Snow White*, had animated most of the two principal characters in *Elmer Elephant*, Elmer and his tiger girlfriend, Tillie, with even more assurance than he had brought to the Hare and Jenny Wren a few months before.

And yet the grumblers in Don Graham's class had a point: there was a disturbing hollowness at the center of *Elmer Elephant* that had no business being there, given the promise of such predecessors as *The Tortoise and the Hare* and *Who Killed Cock Robin?* The problem was larger than the story, trite as that was: a little elephant is mocked by other jungle children for his trunk, but then becomes a hero by using it as a hose to save Tillie Tiger from the flames attacking her house. Disney had based many other

Silly Symphonies on fairy tales and fables that smacked no less of the nursery, and yet *Elmer Elephant* was a *juvenile* film, as its predecessors somehow were not.

Elmer Elephant was one of the first Silly Symphonies with no real musical foundation. In the early thirties, the rigorous musicality of the Silly Symphonies had contrasted sharply with the virtually music-free soundtracks of most live-action features; now the two kinds of film were much closer in their use of music. Although some of the action in *Elmer Elephant* is conspicuously timed to music, and there are a couple of bursts of song, music for the most part plays a supporting role, similar to the one it had come to play in live-action features. The characters speak almost entirely in naturally paced, prerecorded dialogue, and there is, compared with the earlier Sillys, lots of it. Disney had attempted only one cartoon of this kind before—*The Robber Kitten*, released in April 1935—and it had won a place on his list of 1935's failures, but a year was an eternity as far as the progress of Disney animation in the midthirties was concerned. There was no reason to expect *Elmer Elephant* to share *The Robber Kitten*'s weaknesses, and yet it did.

In the best of the early Silly Symphonies, music had with increasing subtlety served as a matrix for all the other elements of the cartoon; there was a balletic synthesis of music and action. Now that music's role had shrunk, the audience's attention was directed at the characters and what they were doing, not at how ingeniously they were doing it. The weight of the cartoon fell mostly on the animation—and the animation still could not bear it. For all the skill that the Disney animators had applied to developing animation principles and then to analyzing and caricaturing movement—and for all the assurance that Luske, in particular, now brought to his animation—the results of their efforts, when embodied in characters like Elmer Elephant and Tillie Tiger, still fell well short of bringing those characters fully to life on the screen.

If the Disney studio's characters around the time of *Three Little Pigs* resembled real persons only in general, as Disney said, that was still true three years later. Such animation principles as overlapping action and stretch and squash were, of course, general by their very nature, but so was the kind of analytical animation that Ham Luske pioneered. The analytical style necessarily focused attention on how real human and animal bodies moved in general or on average; the animators might pay attention to how cer-

tain types of people moved—how fat men or old ladies walked, say—but it was impossible to subdivide a general type enough times so that eventually a truly individual character emerged.

By early in 1936, two years after *Playful Pluto*, it was still only in Norm Ferguson's Pluto that a character had emerged as a distinct individual through the animation alone; and Ferguson, it was increasingly clear, was a special case. Don Graham, speaking of Ferguson in his last action-analysis lecture before he left for New York, said: "Fergy...can get away with less anticipation in his work than almost any animator in the studio...his timing is so exact that he depends on very slight anticipations."[101] Ferguson's timing was so exact, in turn, because it was related so closely to the mental processes, such as they were, of his chosen character. When an animator could make a character's state of mind as clearly visible as Ferguson could Pluto's, anticipation became superfluous: it was the movement of Pluto's thought, rather than the movement of his body, that told the story. And, remarkable though it was, Ferguson's animation of Pluto had its limits: when he animated Pluto for *On Ice*, more than a year after his animation for *Playful Pluto*, the dog scrambled around on skates instead of on flypaper; but in their structure, and even in Churchill's music, the two episodes were highly similar.

On Ice was the second in a string of cartoons, most of them directed by Ben Sharpsteen, that pulled together three or four of the major Disney characters, usually including Mickey Mouse, Donald Duck, and the lanky, dim-witted dog character called Goofy. First recognizable in a grandstand in *Mickey's Revue* in 1932, Goofy stood out in the beginning only because of his buffoon's laugh. As "The Goof," he filled minor roles for three years in the Mickey Mouse series before assuming his definitive form— buck-toothed and chinless, like a vaguely canine rendering of the comic-strip character Andy Gump—in *Mickey's Service Station*. That was one of the last black-and-white Mickey Mouse cartoons, and the first in which Mickey, Donald, and Goofy were co-stars. The three characters, under threat from the villainous Pegleg Pete, work furiously to eliminate a squeak from Pete's car; in a single fifty-four-foot scene (about forty seconds of screen time), Goofy gropes through the engine, gooses himself, and smacks his own hand with a wrench. Art Babbitt animated that scene, adding significantly to the planned footage, as Ferguson had on *Playful Pluto*.[102] This time, too, the added footage went into the film, and Babbitt became the studio's authority on the character.

Babbitt animated Goofy again in *On Ice* and for a third time in *Moving Day*, which had gone through animation under Sharpsteen's direction by February 1936. In this Depression-flavored cartoon, Pete is the sheriff, threatening to auction off Mickey and Donald's furniture because they have not paid their rent. They pack frantically, trying to escape from the house with their belongings, and they enlist Goofy's aid when he shows up to make a delivery of ice. Babbitt's *Moving Day* animation was by far his most ambitious; he brought to Goofy an analytical concentration that exceeded even Luske's. Babbitt used his own sixteen-millimeter camera to film Pinto Colvig, the gag man who provided Goofy's voice, as he pantomimed Goofy's movements. Babbitt then studied the film on a viewer of his own, which provided, he said a few years later, a picture "so small you couldn't even make out any details."[103]

If Babbitt, who had started roughly on a par with Luske three years earlier on *The Pied Piper*, had since fallen behind, here he made a heroic effort to catch up and even pass his colleague, and he succeeded. The analytical subtlety of Babbitt's animation in *Moving Day* invites comparison not so much with Luske's best work as with Ferguson's. Like Pluto in *Playful Pluto* and *On Ice*, Goofy must struggle with a troublesome prop, but in *Moving Day* the prop is not really an inanimate object: an upright piano stubbornly resists Goofy's efforts to load it onto his ice truck. Goofy's struggle to overcome his own stupidity is, however, the real center of interest. As Babbitt makes clear through the shades of expression in his character's face and body, Goofy is no mental match even for a piano.

Babbitt's Goofy was the first Disney character after Ferguson's Pluto to have a visible inner life, and Goofy, stupid though he was, was clearly more complex than Pluto. For the most part, Pluto simply reacted; Goofy schemed and planned, however dimly. Babbitt's animation was, however, sweat stained when compared with Ferguson's. Making Goofy even a plausible simpleton required labor that showed in the animation, especially in the underlying sense that each drawing was a distinct unit. Babbitt's animation was constructed—expertly, but still constructed; it lacked the spontaneity and flow of Ferguson's animation.

Goofy remains a far more plausible character in *Moving Day* than Mickey or Donald, who are supposed to be more intelligent than he. They are furiously active, and hideously inefficient, as

they try to gather their things together, but the animation in neither case conveys a sense of panic that would make these intelligent characters' stupid actions credible. As work began on *Snow White*, the Disney animators had succeeded in bringing fully to life only characters that they depicted as either lacking in human intelligence or having very little of it. Moreover, those characters revealed themselves through pantomime, just as the silent comedians did: Pluto did not speak at all, and Goofy said nothing of consequence in Babbitt's landmark sequences with the character. The liberating influence of dialogue, so important to other animators and other characters, was not at all critical to Ferguson's and Babbitt's successes.

However satisfactory characters like Goofy and Pluto might be in a short cartoon, there was no way that they could sustain an audience's interest over the length of a feature. A Pluto-like character might provide welcome comic relief—the role planned for the pantomime character Dopey—but the weight of the film would have to fall on more complex characters. Disney needed something more than characters whose movements on the screen permitted a willing suspension of disbelief; many of his characters had already passed that threshold test. Feature animation required real animated acting—the sort of thing that Babbitt had accomplished with Goofy, but on a higher level and done without such obvious effort. That, in turn, required a close identification between animator and character.

There could be no better way to encourage identification between animator and character than to have one animator handle all of a character's scenes throughout a film. Spreading the same character among several different animators made real animated acting vastly more difficult: it encouraged defining that character through easily grasped mannerisms. In some Disney cartoons made before *Moving Day*—starting with *The Golden Touch, The Goddess of Spring*, and *The Tortoise and the Hare*—not only had animators been attached firmly to characters, for all or part of a cartoon, but the animators sometimes shared scenes. In *The Golden Touch*, for instance, Moore and Ferguson share those scenes when Goldie and King Midas are on the screen together. In *The Tortoise and the Hare*, three animators—Luske, Dick Lundy, and Les Clark—share one scene. Casting by character thus involved pinning the animators down; what they did had to be governed by the layouts and by what the animators who shared their scenes were doing with *their* characters. Restraints of that

kind were at odds with the idea—so well developed at Disney's by 1936—that strong animators should be allowed lots of elbow room, an idea that encouraged giving them long sequences.

In February 1936, Dave Hand told Don Graham's action-analysis class that many cartoons were being broken down "by sequence, more or less. We try to spot about four master animators, giving them about one sequence each."[104] Casting by character hadn't vanished from the cartoons Hand directed. For *Three Little Wolves*, which had gone through animation just a few weeks before he spoke, he had put Moore and Ferguson back to work on the Three Little Pigs and the Big Bad Wolf, assigning them to their characters in the original film; they animated almost all of *Three Little Wolves*, sharing some scenes. Hand was, however, the director most alert to Walt Disney's preferences, and for his next two cartoons—*Thru the Mirror*, which was being animated when he spoke to Graham's class, and *Alpine Climbers*—he divided the work by sequences.

Both of those cartoons were part of the Mickey Mouse series, and it was in that series that a sort of compromise between the two approaches had already been struck by the time Hand spoke. In *Mickey's Service Station*, and then again in *On Ice* and *Moving Day*, Mickey, Donald, and Goofy (and Pluto, in *On Ice*) were rarely on the screen at the same time; instead, two or three of those characters were alone for extended sequences, each by a different animator. One result was, as John Hubley, a Disney layout man in the thirties, put it a few years later, "the tendency to reduce plot and the telling of a whole story to a single action situation."[105] Each animator was, in effect, encouraged to think only of what was happening within his own sequence. Babbitt, perhaps the most advanced of the Disney animators by 1936, apparently carried this tendency furthest. He sometimes occupied himself so intensely with what went on in a scene that he showed no concern about consistency from one scene to the next.[106]

This, then, was what Disney animation had come to early in 1936: one of the strongest animators did his best work in a sort of isolation, depicting a single character for a minute or so and paying little or no attention to what was happening in the rest of the film—and not really needing to. Moreover, the way he did his work was a natural outgrowth of the way Disney animation had been developing over the previous few years. It would have been hard to find a stranger starting point for work on *Snow White and the Seven Dwarfs*, a feature film whose large cast would be domi-

nated by the dwarfs, who would usually be on the screen together, and who would frequently share the screen with a female character who would differ radically from them in the way she looked and moved. Nevertheless, that was where things stood on 19 February 1936, when Walt Disney began watching the first pencil tests for *Snow White* of which there is a record.

Disney's Rivals,
1928–1937

In February 1928, just before Walt Disney's confrontation with
Charles Mintz in New York, Hugh Harman and Rudy Ising
finally agreed to sign one-year employment contracts with Mintz.
Harman was to be production manager, with broad authority (that
would not, however, extend to salaries).[1] Ising and George
Winkler began equipping a studio at 1154 North Western Avenue
in Hollywood, in the same space that Harman and Ising rented
briefly in 1926 when they made *Aladdin's Vamp.*[2] Even after they
agreed orally to work for Winkler Pictures, though, Harman and
Ising did not give up trying to win their own release: late in
February they unsuccessfully approached Paramount.[3] Since
Mintz was still trying to bring Disney to heel, he as well as
Harman and Ising had good reason to put off signing a contract
until mid-March, after Mintz had finally broken with Disney.[4]
Friz Freleng returned from Kansas City to join the new studio's
staff, and production got under way in early May, after Harman
and Rollin Hamilton left the Disney payroll.

The atmosphere soon turned sour. George Winkler "became so
much like a grandma that all of us resented it very much,"
Harman said.[5] By November, not just Harman but also Ising,
Hamilton, and Max Maxwell were so much at odds with Winkler
that they addressed a complaint directly to Mintz in New York.
He sent them a soothing reply,[6] but on the day after Christmas,

Hugh Harman submitted these drawings of his character Bosko to the U.S. Copyright Office on 3 January 1928, four months before he left Walt Disney's staff. Library of Congress photo.

Winkler fired Ising, ostensibly because he was coming in late.[7]

The Winkler studio made the Oswalds for only a year. Within a few months of its opening, animators from New York—chief among them Walter Lantz, who had already come west to work on the Sennett comedies—had begun trickling onto the staff, animating sequences at first and then whole cartoons. Universal announced in April 1929 that it would make its own cartoons, with Lantz and Bill Nolan in charge;[8] it was the first of the big Hollywood studios to establish its own cartoon department after sound came in, a clear sign of how cartoons' status had been elevated by Disney's success.

Three surviving Winkler Oswalds, *Homeless Homer*, *Sick Cylinders*, and *Weary Willies*—all made by the former Disney hands, with little or no animation by the New Yorkers—are reminiscent of the Disney Oswalds, with the same relatively high level of inventiveness and narrative coherence. By mid-1929, though, such silent cartoons were obsolete. Walt Disney had been making sound cartoons for almost a year. Audiences were moving rapidly: through their response not just to the Disney cartoons but, more importantly, to such early feature talkies as *The Broadway Melody*, they had already tipped the balance decisively in sound's favor.

Harman later claimed he had been interested in making a sound cartoon for almost two years, since Rollin Hamilton came to his apartment one evening in 1927 and told him about an article on sound film he had read in *Literary Digest*. "I got to thinking about that," Harman said, "and I thought that if the images of the person could just be replaced with the images of a cartoon, you've got the same thing."[9] Around that time, Harman "invented," as he said, a cartoon character called Bosko. A sheet of his drawings of the character, with Bosko identified in the application papers as a "Negro boy," was registered for copyright on 3 January 1928, in the name of Harman's Kansas City friend Ray Friedman.[10] Harman claimed he soon began thinking about a Bosko sound cartoon, perhaps even before he left Disney.[11] By the spring of 1929, he said, he had been working on a Bosko story "for over a year."[12]

In any event, it was no more than a few weeks after they left the Winkler studio that Rudy Ising and Max Maxwell went before sound cameras at a Hollywood recording studio, performing in live action for a Bosko film.[13] (Harman and Ising had prepared a detailed script, with a sketch each for eight of the nine scenes.)[14] Animation was under way soon after that—Friz Freleng and Rollin Hamilton were among Bosko's first animators—and by the beginning of August the animation had been shot at 1558 North Vine Street, in the Hollywood structure known as the Otto K. Olesen Building, on the camera that Harman and Ising had stored there since bringing it with them from Kansas City.

What emerged from this intense effort was not a cartoon that could be exhibited commercially, but rather a five-minute sample reel that Harman and Ising could use (or so they hoped) to persuade a distributor to hire them to make a series. That reel set them apart from the early Disney sound cartoons because it emphasized not music but dialogue. The soundtrack for *Bosko the Talkink Kid* (as the 1929 sample reel is known, although there seems never to have been a title on the film itself) is filled with dialogue, all of it recorded in advance of the animation, and there is no instrumental music except for a few notes on a piano. It invites comparison less with the Disney cartoons than with the Max Fleischer cartoons with KoKo the clown, since the cartoon character on the drawing board engages in byplay with a live cartoonist (Ising) and then disappears into an ink bottle.

Bosko himself is just another white, masklike face on a black body, very much of the same cartoon family as Mickey Mouse

and Felix the Cat; he wears a derby and has a little black nose instead of an animal's snout. Only his voice, by Max Maxwell, identifies him as a stereotypical black. Maxwell delivered his lines in front of a second camera while Ising was being filmed, so that his mouth movements could guide the animation of Bosko's dialogue.[15] Harman remembered clipping together, "with little brads, the film [of Maxwell] and the soundtrack, so we could see one frame opposite the other. We began to see there that this soundtrack was an easily readable thing."[16]

Harman and Ising did succeed in synchronizing Bosko's dialogue with the animation, but in other respects their film was less impressive. Although the live cartoonist and the drawn character are sometimes on the screen at the same time, they are in contact with each other only once, when Ising uses his pen to stick Bosko to the drawing board by his pants. Moreover, the sound recording is not balanced. Because Maxwell spoke his lines offscreen when Ising was in front of the camera, both their voices could be recorded on the same piece of film, but Maxwell can be heard much more clearly than Ising can. In 1929, though, no one else, including Disney, was making sound cartoons that were any more technically sophisticated, and the comedy in *Bosko the Talkink Kid*—having Bosko's head pop up from his body on a spring, for instance—was no more foolish than most cartoon comedy.

Harman and Ising had begun writing to potential distributors of a new cartoon series by 2 August 1929, when Harman addressed a letter to, of all people, Charles Mintz.[17] No one was interested. Harman remembered "carrying that film can through what seemed to me hundreds of interviews, and everybody saying, 'It's a great thing, and sound is coming, but you're a little early.'"[18] In fact, their timing should have been just about perfect. Although sound had triumphed by the summer of 1929, many of the "sound" cartoons being released then were—to judge from surviving examples—really just silent cartoons with music and sound effects tacked on. Since such cartoons were not planned for sound, there could be none of the Bosko reel's tight synchronization. Disney had, however, already set the pattern for what a sound cartoon should be like, that is, dominated by music, and the other studios' cartoons fit that pattern, however imperfectly. The Bosko sample reel's music-free soundtrack, its strongest claim on distributors' attention, may have worked against it—as may have Mintz, who as late as January 1930 wanted Harman and Ising to sign with him not as independent producers, but as his employees.[19]

In that same month, though, Harman and Ising were freelancing for producers named Gilliam and Reed, who in Ising's account were making stop-motion puppet films for Eastman Kodak. "Gilliam wanted more of a cartoon slant in them," Ising said in 1971. "So we wrote some stories, and then drew big sketches," in effect, character layouts.[20] In timing the film, Harman and Ising worked with Bert Lewis, the musician who directed the orchestra at the Disney recording sessions and who was shortly to take Carl Stalling's place at that studio.[21] From Lewis they learned how Disney used bar sheets to synchronize music and image.[22]

Gilliam and Reed arranged for Harman and Ising to meet at their offices with a man named Leon Schlesinger; that meeting led very quickly to a three-year contract with Schlesinger that Harman and Ising signed on 28 January 1930. It stipulated that Schlesinger would buy from them a series of cartoons called Looney Tunes, a title imitative of Disney's Silly Symphonies. Harman and Ising agreed to deliver the negative for one cartoon a month; Schlesinger would pay production costs as they were incurred, up to a maximum of $4,500 per cartoon. That ceiling would rise to at least $6,000 in the second and third years.[23]

Schlesinger had already signed a two-year contract with Warner Bros. on 24 January that would give him $5,000 for the first cartoon. Warners had an option to buy eleven more cartoons at $6,000 each, and twelve more after that at $7,500 each.[24] Schlesinger's brother Gus was a Warner Bros. executive, head of its foreign department, and it was probably through that connection that Leon knew of Warners' interest in a cartoon series; he said in 1945 that Warner Bros. had been trying unsuccessfully to make cartoons in Brooklyn (probably at the old Vitagraph studio that Warners owned there) before he made his deal.[25]

Schlesinger, a Philadelphia native in his midforties, had worked in show business for many years, as a press agent and a salesman for film companies, among other things. By 1925 he had acquired Pacific Title and Art Studio, a company that made titles for silent features.[26] He used animation in some of those titles; the Disney studio animated at least two sets of titles for Schlesinger in 1926,[27] and Ising, after he left Disney, animated the titles of a Universal feature for him.[28]

Harman and Ising quickly rented a three-room suite of offices on Western Avenue, a block south of Santa Monica Boulevard in Hollywood.[29] They moved their camera, camera stand, and animation tables there and built some more tables to accommodate

their rapidly expanding staff.[30] That staff was heavy with people—
Freleng, Maxwell, Hamilton, Ben Clopton, Paul Smith, Norman
Blackburn—who had worked with Harman and Ising at the
Disney and Winkler studios. Schlesinger's brother-in-law,
Raymond Katz, was to be their business manager and the conduit
for Schlesinger's money. The young staff worked furiously on the
first Looney Tune, *Sinkin' in the Bathtub*. In Friz Freleng's account,
"we'd come there at nine o'clock in the morning and work on
through, go out to dinner, come back and work till maybe twelve
or one o'clock [in the morning], and then go out and play minia-
ture golf."[31]

Harman and Ising finished that first cartoon just a few weeks
after signing their contract with Schlesinger, which called for
delivery by 1 April. "Halfway through the showing" of *Sinkin' in
the Bathtub*, Schlesinger said a few years later, "Jack Warner
ordered twelve more."[32] More prosaically, on 17 April 1930
Warners exercised its option for eleven more cartoons; at the
same time, Schlesinger gave Warners an option on a third year of
Looney Tunes.[33] A series theirs at last, Harman and Ising moved
their studio to larger quarters at 5653 Hollywood Boulevard.

For all that their budgets lagged behind what Disney was
spending—by early in 1930, Disney's production costs for some of
his shorts were edging above ten thousand dollars—Harman and
Ising were blessed with a major release and an experienced staff.
Moreover, Warner Bros. was picking up the tab for the sound
recording and for the musicians who played the cartoon scores,
expenses that Disney had to bear. Harman and Ising were, in
short, about as well prepared to compete with Disney as any
Hollywood cartoon studio could hope to be in 1930.

Sinkin' in the Bathtub, the first Looney Tune, premiered in April
1930 (probably on the nineteenth) at the Warner Bros. Theatre in
Hollywood; it played on the same bill as an early talkie called
Song of the Flame, a film version of a 1925 Broadway musical.[34] As
the cartoon begins, Bosko is seated in a bathtub—singing the title
tune, playing streams of water from the shower head as if they
were a harp, and stretching his nose and plucking it. The tub then
comes to life and dances gaily, strewing pieces of toilet paper in
its path as if they were flowers. The rest of the cartoon is very
much in the same vein.

Bosko's dialogue in *Sinkin'* has a minstrel-show ring, but there are only a few lines of it. An early script for the second Looney Tune, *Congo Jazz,* shows Bosko speaking a lot more such darkie dialogue,[35] but by the time Warner Bros. released *Congo Jazz* in September, he was saying much less than that script called for, and in a high-pitched voice. Bosko had become an imitation of Mickey Mouse, whose popularity had risen sharply in the months between the making of *Bosko the Talkink Kid* and production of the first few Looney Tunes.

If there had been "no real directors at the Winkler studio," as Rudy Ising said,[36] at first no one filled that role completely at the new Harman-Ising Productions, either. Both Ising and Hugh Harman continued to animate for some time after they began making Looney Tunes.[37] As he had been at Winkler's, though, Harman was more nearly the director than anyone else. "We operated much the same as at Disney's," Friz Freleng said, "but with Hugh as the mastermind [in place of Walt Disney], and the rest of us offering gags and suggestions."[38] Bosko was Harman's character, and now the Looney Tunes with Bosko were largely Harman's films—but they strongly resembled the Disney cartoons.

The resemblance was most pronounced in the Looney Tunes' emphasis on music, as evidenced by the title of the series and by Schlesinger's contract with Warner Bros., which referred to the Looney Tunes as "animated musical cartoons." Warners, as the owner of several music publishers, had a particularly strong reason to be interested in the Looney Tunes as musical vehicles. The cartoons could be vehicles for plugging songs that Warners hoped to turn into hits; popular songs could in turn make the cartoons more attractive. The titles of four of the first six Looney Tunes burlesqued the titles of Warner-controlled songs.

The Looney Tunes' resemblance to the Disney cartoons extended to much more than their heavily musical soundtracks. From the start, Bosko had a girlfriend, Honey, to match Mickey's Minnie, and sequences and sometimes whole cartoons echoed what Disney had done a short time before (*Congo Jazz* bears a suspicious resemblance to *Jungle Rhythm,* a Mickey Mouse cartoon released in November 1929). Like the early Disney sound cartoons, but even more so, Harman's Looney Tunes based much of their comedy on breaches of decorum—the cartoons abound in gargling, spitting, outhouses (Bosko's anthropomorphic car emerges from one in *Sinkin' in the Bathtub*), bare bottoms, and

cuspidors and, especially, on arbitrary distortion of the characters' bodies. Their audiences responded warmly to such comedy, Rudy Ising recalled. When he saw *Sinkin' in the Bathtub* in a neighborhood theater, and a cow in the cartoon flipped its huge udder over its back, "you never heard such a reaction in the theater...they howled at it."[39]

There was stronger evidence of the cartoons' success: by the middle of the first season of Looney Tunes, Warner Bros. had asked Schlesinger to double his output. He signed a contract for a second series on 13 January 1931.[40] Although from the beginning Harman-Ising's resident musician, Frank Marsales, was able to use as much Warner-controlled music as he wished (Schlesinger's original contract provided that he was to "have complete access to [Warners'] musical libraries"),[41] it was only with the advent of the new series called Merrie Melodies that everyone involved began to exploit the musical connection vigorously. There was in April 1931 a busy exchange of letters and telegrams between Warner Bros. in California and its music publishers in New York, evidencing a lively interest on both sides—and by Schlesinger and Ray Katz, his man at Harman-Ising—in getting Warner-controlled songs into the Merrie Melodies.[42]

By then, the first two cartoons in the new series were finished or close to it. They did not burlesque song titles but instead bore the titles of their featured songs: *Lady, Play Your Mandolin!*, the first Merrie Melodie, appeared sometime in the summer of 1931, and the series got under way on a monthly schedule in September 1931 with the release of *Smile, Darn Ya, Smile!* Harman and Ising now split up the directorial duties, Harman taking the Looney Tunes and Ising the Merrie Melodies (although they occasionally switched off). Harman claimed in later years that he "shunned" the Merrie Melodies because he thought the music ill-adapted to use in cartoons; he most likely shrank not from the music itself but from the role that it played in the new series. "I just didn't like to be compelled to use the certain songs available to us," he said in 1973.[43] Music remained central to the Looney Tunes in their second season, and Bosko and Honey never walked when they could dance.

Once past the first five Merrie Melodies—three with fox characters and two with pigs—Ising began using new characters in almost every cartoon, so that the Merrie Melodies resembled Disney's Silly Symphonies as much as the Looney Tunes with Bosko resembled Disney's Mickey Mouse cartoons. Usually, the

cartoon characters sang one or two choruses of a Merrie Melodie's title song; the rest of the cartoon's score was an instrumental mixture of the title song and other tunes, including some from other Merrie Melodies. The settings for the Merrie Melodies were sometimes plausible—the characters in *Pagan Moon*, released in January 1932, are South Seas islanders—and sometimes comically incongruous, as in *One Step Ahead of My Shadow*, a February 1933 release whose action takes place in China. (A reference to "Chinatown" was added to the song, which in its original form has not the slightest connection with China.)

Members of the Harman-Ising staff occasionally came back for night meetings on gags for a cartoon, and the announcement seeking gags for *One Step Ahead of My Shadow* included these specifications: "We want as many gags as possible and funny situations pertaining to rick-sha, pergodas [sic], Chinese bridges, junks, Chinese boats, sam pans, volcanoes, Chinese musical instruments, queues, and pigtails, rice eating with chop sticks, mandarins, geisha girls and any other things that present themselves to you, except that we do not want anything about a Chinese laundry."[44] There are no Chinese-laundry jokes in *One Step Ahead of My Shadow*, but there is, among other things, a sedan chair with a portable outhouse. As that gag suggests, the Merrie Melodies were at heart not much different from the Looney Tunes; they just had more varied surfaces. Starting with *Pagan Moon*, Ising used a human cast in some of them, in a break with the practice, rooted in the Disney silent cartoons, of working with mostly animal characters.

Like those early Disney cartoons, the Harman-Ising cartoons were conceived largely in verbal terms: as members of the staff discussed possible gags, the directors took notes, and then refined them into a typewritten script and a bar sheet. They thus worked out the timing of gags without devoting much effort to visualizing them. The notion of telling the story through a sequence of sketches took hold very slowly, as in Harman's decision to begin "using full-sized background layouts...pinning those up."[45] Before then, the animators drew such layouts themselves, working from sheets of small sketches like those that Ub Iwerks had made for the Disney cartoons (and that Harman had made for the Winkler cartoons).

When Harman, and later Ising, handed out a scene in the first year or two of the Warner Bros. release, the animator got exposure sheets prescribing the timing to the frame and perhaps a

model sheet for a new character, "and that was about it," Ising said in 1971.[46] Bob Clampett, who joined the Harman-Ising staff as an assistant animator early in 1931, recalled that Ising's timing "was so precise that even if it was a blink, [the exposure sheet] would have a circular line for [the eyelid] to close, and if it was to be held three frames, or four frames, there would be a little line for that, and then open again.... It wasn't left at all to the animator."[47] That skimping of attention to how the cartoons would look on the screen, combined with the tight control of timing, meant in practice that the character design and the animation remained heavily formulaic. Although the animators turned out a lot of footage—Ising estimated that the average may have been as high as thirty-five or forty feet a week[48]—they could do so without a great deal of strain.

The animators who joined the staff with the greatest fanfare were the McKimson brothers, Robert and Thomas; from the summer of 1930 until sometime early in 1931, they had run a tiny studio set up by Romer Grey, the son of Zane Grey, the author of cowboy novels. When they came to Harman-Ising later in 1931, Clampett told Jim Korkis, "They marched right in as if in perfect step, went to their desks, took off their coats, and sat down exactly at eight o'clock and started to work. This was all very spectacular, like a Busby Berkeley routine."[49] The McKimsons took a comparably cool and systematic approach to their animation. Tom McKimson "animated by charts," Rudy Ising said, "and he would make maybe every twentieth drawing," relying on two or three assistants to fill in the rest by following his diagrammatic instructions.[50]

The Harman-Ising studio had at least one animator whose work resembled Norman Ferguson's more than it resembled the McKimsons', but that animator did not assume the same exemplary role within the studio that Ferguson did at Disney's. "Rollin Hamilton was a very bad artist," Ising said, "but he was one of the great animators. He was thinking of the acting part of it.... What I used to do with Hamilton was give him the character that no one else had to draw.... You had to watch what a man could draw."[51] There was no equivalent at Harman-Ising of Disney's move away from what Clampett called "a swell finish line" on the animators' drawings and toward freer sketching. Likewise, Harman and Ising were slow to appreciate the usefulness of pencil-testing animation; they might test cycles, because they would be seen over and over again, but not much else.[52]

When developments at the Harman-Ising studio did mirror what was happening at Disney's, the effect was oddly different. As at Disney's, work on stories occupied a lot of time. "Practically nobody was married," Ising said, "and we all lived right around the studio.... We used to sit there half the night sometimes, working on stories."[53] Both Harman and Ising worked on stories in so loose-jointed a fashion, though, that, as the animator Larry Silverman recalled, "sometimes they'd get near the end of the picture and they wouldn't even know how to end it.... If somebody came in for a scene...you'd have to sit and wait for [Ising] until he timed it."[54]

As the cartoons' stories grew a little more complex, and their casts larger, both Harman and Ising began drawing character layouts for their animators; Friz Freleng then assumed that task for Ising's Merrie Melodies, working sometimes from Ising's rough sketches.[55] With the advent of less formulaic characters in the second season (1932–33) of his Merrie Melodies, Ising said, "you had to give [the animator] more sketches, progressive through the scene, because he would begin to get off."[56] But character layouts, in many ways so liberating as the Disney animators used them, more often imprisoned the Harman-Ising animators, who had no encouragement to use them as springboards to more effective movement. "So often," Bob Clampett said, "you saw animators struggling to just trace Friz's layout sketches."[57]

Even as Disney scrutinized the stories for his cartoons ever more closely while cultivating animation that seemed more spontaneous, Harman and Ising did the reverse: they held the animation under tight rein, but the writing got away from them. Between 1930 and 1933, the Disney cartoons changed markedly; the Harman-Ising cartoons, which started on roughly the same level as the Disneys, did not, except for a gradual improvement in the drawing and to a lesser extent in the animation—improvements that were all but inevitable, given the animators' greater experience.

Improvement was visible more in Ising's Merrie Melodies than in Harman's Looney Tunes, but it was Harman's personality, far more than Ising's, that shaped the studio even after both men began directing. Harman wanted to surpass Disney, but because that ambition was rooted in a personal rivalry, rather than in convictions about what cartoons should be like, he could not harness it in the actual making of his films. "He seemed to have...a great philosophy of making animated cartoons," Freleng told Joe

Adamson, "but when he put it down on paper, it wouldn't work."[58]

Walt Disney was not immune to the nepotism and cronyism that were endemic in the movie industry, but the practice was more widespread at Harman-Ising—Harman, Ising, Maxwell, and Hamilton all had relatives on the staff in the early thirties—and its effects there were more pernicious, since no constantly rising standards held them in check. Eventually, Clampett said, "things had kind of settled into a pattern where Hugh and Rudy had their close friends, maybe some of the animators' wives became social with Hugh's wife, and you'd say, 'By God, no matter what I do here, I'm not going to get a chance to get around this guy.'"[59]

Harman's arrogance expressed itself most directly in a disdain for money and for Schlesinger and Katz, the men who provided it. Ising and Schlesinger maintained a cordial relationship; Harman and Schlesinger did not, and Harman's hostility was decisive: he and Ising broke with Schlesinger early in 1933. They said in later years that Schlesinger resisted increasing the amount of money he would have paid them per cartoon under a new contract, and that is more than likely. As Warner Bros. and most of the other big Hollywood studios sank into deep financial trouble in the early thirties, Schlesinger and Warners amended their contract twice to reduce the amount Schlesinger got per cartoon in the 1932–33 season of Looney Tunes and Merrie Melodies.[60] He wound up getting $7,300 per cartoon instead of $10,000, and when he signed a new contract with Warners on 1 March 1933, he took another cut, to $6,000 per cartoon.[61] Had he continued with Harman and Ising and raised their payments, he would actually have lost money on each cartoon.

In 1933, Disney was spending close to $20,000 for some of his Mickey Mouse cartoons; he spent nothing less than $13,000 on any of his cartoons released in that year. For Schlesinger, even making allowance for the soundtrack costs that he did not pay, his 1933 contract with Warner Bros. set a precedent that he would have to follow when he began making cartoons without Harman and Ising: there would not be nearly enough money to compete with the Disney cartoons on their own terms.

For Harman and Ising, finding a new distributor did not come easily. In Harman's recollection, they delivered their last cartoon to Schlesinger in August 1933.[62] After that, they picked up a little outside work—the studio made two cartoons with a character called Cubby Bear for release as part of the Aesop's Fables series—and started making, on speculation, a film version of *The*

Nutcracker; perhaps a thousand feet was animated.[63] The drug-store on the ground floor of the building that housed the studio "practically supported the whole bunch of us," Ising said.[64] William Hanna, the head of the Harman-Ising inking and paint-ing department, remembered "six months without pay.... That was a very tough time; I ran up a lot of bills."[65]

Competing with Disney would have to wait.

Ub Iwerks had begun hiring a small staff for his new studio by March 1930,[66] and by April, trade-paper ads were announcing the imminent arrival of Iwerks's series with his new character, Flip the Frog.[67] By June, Pat Powers's Celebrity Productions had struck a distribution deal with Metro-Goldwyn-Mayer, which advertised Flip then as part of its lineup.[68] MGM released Iwerks's first Flip the Frog cartoon, *Fiddlesticks*, in August 1930.

That cartoon was, ominously, a compendium of what had already become early sound-cartoon clichés. *Fiddlesticks* lacks both plot and gags, offering in their place lots of dancing, so to speak, and other synchronized action. There is casual vulgarity (a bird's tobacco juice drips onto Flip's piano keys), the characters squawk instead of speak (Flip quacks like a duck), the cast includes a Mickey-like mouse (he plays the violin, as Mickey did in *Just Mickey*, released barely a month after Iwerks left Disney), and so on.

Iwerks was locked in time. His first few cartoons presented synchronization as if it were entertaining in itself—as it had been, briefly, in his Silly Symphonies—rather than a way to strengthen already promising material. Flip the Frog was no help. Vague as a personality, made up of stock gestures and expressions like all of his animated contemporaries, Flip was awkward and unstable graphically, too. A frog, it turned out, could not be reduced to a crisp pattern as readily as a mouse or a cat. When translated into the sharp contrasts of cartoon formula, what made a frog a frog emerged as, for one thing, the conspicuous lack of a nose.

However unsettled his anatomy in any given cartoon, Flip was being pulled steadily toward Hollywood animation's center of gravity. By the time of *The Village Barber* (1931), the third cartoon in the series, he had begun wearing gloves, pants, and shoes in addition to the bow tie he wore in the first cartoon, and he was also losing the lanky, and more froglike, physique of the earliest

cartoons. By 1932, Flip had become, like Harman-Ising's Bosko, a creature of indeterminate species and variable habits, firmly anchored only in his makers' awareness of Mickey Mouse's popularity.

Flip's evolution took place in cartoons whose dominant comedy was cheerfully rude, to an extent rarely approached in the Disney or Harman-Ising cartoons. Even when the comedy was not off-color, the Iwerks cartoons still had a strikingly eccentric texture. At the beginning of *The New Car* (1931), on a used-car lot, the anthropomorphic cars move rhythmically in their puppylike eagerness as Flip looks them over. One car powders itself and applies lipstick, trying to attract Flip's attention; it slinks toward him on its hind wheels; it blows a smoke ring and jumps back and forth through it; it licks Flip's hand like a dog.

Such arresting episodes existed only as bits and pieces. There was never any sense in a Flip the Frog cartoon—as there already was in some of the contemporaneous Disney cartoons—that Iwerks was trying to construct a film with a distinct comic or narrative shape. Plausibility of any kind was the least of his concerns, thus, the chronic weightlessness of his characters, among other things, and the painfully slow timing.

In his first couple of years, Iwerks relied on a small staff dominated by the marginal (like the animator Ben Clopton) and the inexperienced (the first two inbetweeners he hired, Fred Kopietz and James Pabian, had never worked in animation before). The notoriously taciturn Iwerks never talked for the record about how he went about making the Flip the Frog cartoons, but it's safe to assume that he not only directed the cartoons but did much of the writing and the animating as well. According to Jim Pabian, Iwerks animated one entire cartoon in a week, with the assistance of two inbetweeners, Pabian and Merle Gilson, "because we were a little bit behind schedule."[69] It was not until late in 1931 or early in 1932, perhaps at Pat Powers's instigation, that Iwerks began hiring the sort of experienced New York animators that Disney had been adding to his staff since 1929.[70] Even then, only Myron "Grim" Natwick, hired from the Fleischer studio, had been in the business as long as a Gillett or a Sharpsteen.

Shamus Culhane (known in the thirties as James), also from the Fleischer studio, described Iwerks to John Canemaker as "the most quiet man and the most uncommunicative," a peculiar cartoon maker who "really didn't have much of a sense of humor, and...didn't know how to handle his people."[71] Iwerks asserted

himself most forcefully in his dealings with his animators by insisting on a sort of mechanical perfection. There are glimpses throughout the Flip series of Iwerks's technical facility, as mechanical objects move with a verisimilitude often lacking in the animation of the characters. That facility extended beyond the drawings themselves: Iwerks's animation camera could truck into and out of a scene very early in the thirties, almost certainly earlier than anyone else's. Natwick eventually wound up running the studio day-to-day, while Iwerks worked on mechanical improvements in the studio's basement.

The Flip the Frog series sputtered to a halt in 1933. Flip was replaced for a year by Willie Whopper, a boastful boy whose fabrications the cartoons illustrated, until finally Iwerks lost his MGM release. The last of his MGM cartoons appeared in September 1934, at the tag end of the 1933–34 release season. Almost a year earlier, perhaps already aware that the MGM contract would not be renewed, Powers and Iwerks had launched a series of fairy-tale cartoons. The success of Disney's Technicolor cartoons had spurred interest in color among other cartoon producers, but since Disney had exclusive rights to three-color Technicolor until 31 August 1935, those producers had to make do with inferior processes; Iwerks's "Comicolor" cartoons were made in two-color Cinecolor. The new Iwerks cartoons did not have a major distributor behind them, but were instead rented by Powers's Celebrity Productions on a states-rights basis, as Disney's early Mickey Mouse cartoons had been.

Just as Flip the Frog's two-year odyssey from one design to another had testified to Mickey Mouse's growing popularity, so now the Comicolor cartoons bowed to the Silly Symphonies. But only in general; in their particulars they were indebted to models of a very different kind. *Jack and the Beanstalk*, the first of Iwerks's fairy tales, appeared in December 1933. As it opens, its characters sing pseudo-operatically, joined by an empty purse that becomes a mouth for the occasion. The many stray incidents are there not to contribute to the telling of the story, much less to parody it, they're just whatever the story men or animators or director felt like tossing in.

Iwerks, far from establishing himself as an alternative to Disney, had for a second time surrendered his studio's claim to artistic autonomy. Even before the end of the Flip the Frog series, after Natwick took charge, the Iwerks cartoons had begun to resemble the cartoons being made in New York; now, with *Jack*

and the Beanstalk, the transition was complete. Iwerks had become a rival not to Disney, but to Paul Terry.

● ⋰ . ●

Walt Disney's former collaborators, it was turning out, could bring to their own ventures only bits and pieces of what had made Disney and his films successful. Hugh Harman's ambition and Ub Iwerks's narrow technical skills were not enough to pull their cartoon studios abreast of Disney's. But, after all, the Disney cartoons of 1928 or 1930 were primitive compared with the Disney cartoons of 1933. Someone who had worked closely with Disney in the early thirties would surely be better qualified than Harman or Iwerks to build a successful rival studio. So it must have seemed to the proprietors of the New York studio that made the Aesop's Fables cartoons.

Amedee J. Van Beuren, one of the incorporators of Fables Pictures in 1920 and its president after that, formed the Van Beuren Corporation in 1928 and bought the Fables studio[72] (the impetus coming from the absorption of Fables' principal owner, the Keith-Albee-Orpheum theater chain, into a new movie studio called Radio-Keith-Orpheum, or RKO). Within a few months of his taking control, during the turmoil that accompanied the film industry's conversion to sound, Van Beuren fired his two most expensive employees. First Paul Terry and then Frank Moser, Fables' principal animator, were cut from the payroll, and others along with them.[73] With sound added and production thus complicated, the Fables no longer appeared once a week, but half as often. (Terry and Moser formed a partnership, found another backer in a company called Audio Cinema, and by the fall of 1929 had begun making "Paul Terry-toons" for release on a similar schedule.)[74] The senior member of Van Beuren's remaining staff was John Foster, who had been in the business as long as Terry and Moser. Despite a torrent of dancing and music making by the Fables characters in the early thirties, the Van Beuren sound cartoons retained many of the habits of their silent predecessors; much of what the characters did was as arbitrary and unmotivated as what Terry's characters had done in his Fables.

By 1933, though, when the Van Beuren studio was gearing up for its most ambitious series—one based on the enormously popular radio program *Amos 'n' Andy*—change was in the air. The studio began using inbetweeners for the first time,[75] and one anima-

tor, Carl Urbano, remembered that it even adopted pencil tests, still a revolutionary tool.[76] RKO had bought a 50 percent interest in the Van Beuren Corporation in October 1930,[77] and by late in 1933, RKO's executives had good reason to be unhappy with their investment. The studio's new animated series were foundering: Freeman Gosden and Charles Correll, the radio voices of Amos and Andy, refused to live up to their agreement to provide material for thirteen cartoons, and a Little King series, based on a newspaper cartoon, was so poorly received that it was cut short at ten, instead of thirteen. "Since Van Beuren apparently does not know how to make cartoons that have box-office appeal," Ned Depinet, an RKO vice president, wrote to another RKO executive in November 1933, "I think we should find someone who knows what it is all about and put him in charge of the Van Beuren cartoon production department."[78] (Amedee Van Beuren seems not to have figured in such decisions. His office was in another building—he made live-action shorts as well as cartoons—and he rarely even visited the cartoon studio.)

It was not until June 1934 that RKO came up with what appeared to be the answer to its problems: Burt Gillett, who had directed Disney's *Three Little Pigs*.[79] Once again, one of Disney's rivals had hired away one of his employees in the hope of duplicating his success. When Gillett took charge, the studio moved from what John Gentilella, then a Van Beuren inbetweener, called a "loft building" on West Forty-eighth Street to 729 Seventh Avenue, a building that housed many other film-related offices. "We had beautiful quarters," Gentilella said of the new studio. "Tile floors in those days was a big item."[80] Gillett was both director-in-chief and general manager, his position roughly analogous to Walt Disney's at the Disney studio.[81] Gillett's hiring was nothing if not a declaration that Van Beuren was now serious about making cartoons. That new seriousness may have accounted for what the animator Isadore Klein recalled as "the concentrated stillness" of the studio when he began working there in 1934.[82]

Even if the first pencil tests preceded Gillett's arrival, he was probably the first to use them as Disney did: he "really criticized the work and told us where we were making mistakes," the animator Jack Zander said.[83] As he had at Disney's, Gillett acted out scenes with what Shamus Culhane (who had left Iwerks to return to New York and work at Van Beuren) described as "excessive energy."[84] Gillett's energy was not directed entirely to the making of films. Klein recalled what seems to have been a tense

atmosphere in the studio when Gillett was running it: "People were hired and quickly fired before they could prove themselves."[85] Gillett himself said early in 1935 that he went to work for Van Beuren with the understanding that he could fire the entire staff if he wished. After a few months he fired fifty people, mostly for "incompetence or inability to meet my requirements."[86]

Soon after Gillett took charge, he invited the Disney animator Dick Lundy to visit him in New York and, Lundy said, "give a lecture to his animators"; this was probably when the Disney staff was taking its summer vacation. "I felt foolish," Lundy recalled, "because here I had been in the business five years, and I was talking to men who had been in the business fifteen or twenty years. Who the hell was I to tell these guys what to do?" Lundy's reservations had an even more solid basis: "In the first place, they couldn't do it, because it wasn't Disney's."[87] That was the problem: Gillett had taken charge of a studio steeped in a casual, not to say cynical, kind of cartoon making. Walt Disney himself could not have transformed such a place without great difficulty, and Gillett, however much he might ape Disney's methods, could not match his single-mindedness. "Gillett seemed more taken up with supervising the building of partitions between floor areas and having dreams of doing live action films" than with making cartoons, Klein later wrote.[88]

When cartoons made under Gillett's supervision began to emerge from the Van Beuren studio, by early in 1935,[89] they did look different from their predecessors: they were now all in color, for one thing, and the drawing quality was a little better. But the writing was, when not as muddled as before, hopelessly thin. The characters—one was Molly Moo Cow, a real cow (in cartoon terms) who was a sort of bovine Pluto—were simply hopeless. It would have taken years to redeem the Van Beuren cartoons, and as it turned out, Gillett had nothing like that much time. After RKO signed a distribution agreement with Walt Disney, it had no further use for the inferior cartoons being made by the studio of which it was part owner. The Van Beuren Corporation announced in March 1936 that it was dropping its cartoons.[90]

If a close association with Walt Disney had proved to be more a handicap than a blessing in competing with his films, the open question in the early thirties was whether distance from Disney,

both physical and artistic, could be liberating, that is, whether other cartoon makers could offer a vision that was distinct from Disney's but as attractive to theater audiences. The candidates for such a role all had their roots in the New York animation of the twenties; by the early thirties, though, many such individuals had transplanted themselves to California. One whole New York studio made the move: Charles Mintz rented a private railroad car "to accommodate the staff," as *Film Daily* put it, and shifted his Krazy Kat studio to Hollywood in February 1930.[91] Mintz moved his animators into the space on Western Avenue that Hugh Harman and Rudy Ising had occupied when they were making the Oswald cartoons.

Mintz signed a one-year contract with RKO in May 1930 to make a series featuring a new character called Toby the Pup, in addition to his Krazy Kat cartoons for Columbia.[92] By then, though, work on the Toby series had evidently been under way for several months.[93] To make the series, Mintz had hired two Fleischer animators, Dick Huemer and Sid Marcus, and brought them with the rest of his staff to California. *The Museum* (1930), the first Toby cartoon, is one of only three known survivors from the series, and predictably, it bears a strong resemblance to the Fleischer cartoons that Huemer and Marcus had just left behind.

The Toby the Pup series ended in 1931, its demise probably tied to RKO's purchase of half-ownership of the Van Beuren studio. By the time the series ended, though, Mintz had made a deal with Columbia for a new series with a small boy called Scrappy. Huemer, Marcus, and a third animator, Art Davis—Huemer's former assistant at the Fleischer studio—continued to work much as animators had in the twenties, each man taking a sequence, developing the story, animating it, "except that we...would talk it over more," Huemer said. "We would agree what each one would do, and give each other ideas."[94]

On the Scrappy series, "we used to tag our animation," Marcus said. "Dick Huemer's animation was cute; Artie Davis's animation was smooth; and my animation was funny.... I would always do the last part."[95] Huemer's animation in the earliest Scrappies, from 1931 and 1932, is, however, not so much "cute" as astonishing: he drew the characters with proportions that could not be more extreme unless some parts of their bodies simply vanished (in the first cartoon in the series, *Yelp Wanted*, released in July 1931, Scrappy's head and feet dwarf his torso). It was Huemer, too, who shaped his scenes' backgrounds, often designing them as if they were being seen from an arresting angle. There was in

Huemer's writing some of the same sort of risk taking, so that his peculiar characters seemed to be living in a deranged universe, rather than taking part in routine gags of the kind that dominated the other Mintz animators' work.

In his animation, Huemer used lots of held drawings, cycles, and repeats—as he had in the silent Fleischer cartoons—but the strength of his drawings and his choices of what to emphasize through stillness and repetition more than compensated for what might otherwise have been shortcomings. This was animation of a different kind from what Disney had begun cultivating: Huemer's animation persuaded not through its resemblance to reality, but through its elegant and surprising patterns.

By the time *The Bad Genius* was released in December 1932, though, Huemer's animation was becoming much more conventional. Someone at Columbia may have noticed how much his work differed from that of his colleagues ("they complained at Columbia they were getting three different pictures," Sid Marcus said),[96] but Huemer never spoke as if he had felt discouraged from pursuing the course he chose in the early Scrappies; he never spoke as if he took his work on those cartoons very seriously, either. However much Charles Mintz may have criticized Disney's Alice Comedies in the twenties, he had by the early thirties become largely indifferent to what was in his films. "He didn't know what was going on," Huemer said.[97] The boss's attitude encouraged a relaxed cynicism on the part of his staff. "We were up on the second floor [on Western Avenue]," said Don Patterson, who worked there as an inbetweener, "and downstairs they had a pool hall. Some of the animators, and Dick Huemer with them, would go down and play pool while we did their work for them."[98]

Huemer, as the only distinctive animator in a crew otherwise dominated by hacks and novices, played a role at Mintz that was comparable to Bill Nolan's at the cartoon department on the Universal lot, the other Hollywood cartoon studio that was, in the early thirties, strongly New York-flavored. Unlike Huemer, Nolan was in some sense a boss at Universal. He and Walter Lantz often shared equal billing on the screen or Nolan got solo billing with no mention of Lantz, even though, Lantz said, "Bill [Nolan] came out here from New York to work for me. I made him a director. I was in charge of the entire studio."[99] (The animator Ed Benedict recalled that Lantz "looked formal next to Bill Nolan," who usually wore a gray sweatshirt at work.)[100]

Lantz animated very little at the start, and then none at all.

Nolan, on the other hand, was in the eyes of other members of the staff the head animator.[101] He brought to the studio the authority that came not just from having worked in the business since the teens, but also from preparing a correspondence school course in animation. When he found himself working for Nolan at Universal, Manuel Moreno said, "I couldn't believe it. I just stopped short of dusting his chair before he sat on it."[102]

Moreno, who assisted Nolan in the Universal cartoon studio's earliest days, remembered that Nolan would "keep on going, one [drawing] after another. Then he'd go back and clean up just a few key drawings, leaving most of the rough drawings for me and [another assistant] to clean up." Other Universal animators from the East, like Gerry Geronimi and Rudy Zamora, adhered to Nolan's straight-ahead method, which permitted them to turn out a lot of animation quickly.[103] Understandably, Ed Benedict (who began assisting Nolan around 1932) found Nolan more concerned with "filling up that paper...than what it was being filled with."[104] Much of the animation that can be identified with some confidence as Nolan's, or as strongly influenced by him, is just as crude and slapdash, especially in the drawing, as one might expect; but the careless surfaces of the earliest Universal cartoons sometimes obscured a radical conception of what animators could do with their characters—a conception that expressed itself most naturally through rubbery, ever-changing animation like Nolan's.

There is, for instance, *The Hash Shop*, an Oswald the Lucky Rabbit cartoon released in April 1930 and animated largely by Nolan. Its utterly cavalier attitude toward the body goes well beyond the very free handling of the characters in silent cartoons like the Felix series. In *The Hash Shop*, Nolan says in effect that in his cartoon world the body can do *anything*, it can assume any shape. The emblematic image comes at the very end of the film, when a peg-legged bear villain carried over from Disney's Oswald cartoons has declared himself hungry enough to eat a horse. Oswald sassily produces one, which the bear immediately shoves down Oswald's throat, tail first, leaving Oswald himself shaped like the horse now inside him.

Music does not dominate *The Hash Shop*'s soundtrack; instead, dialogue and sound effects do, just as they dominate the soundtracks of many early live-action sound features. Because such a use of sound conferred a certain authenticity on otherwise bizarre proceedings, it paradoxically unleashed Nolan to plunge

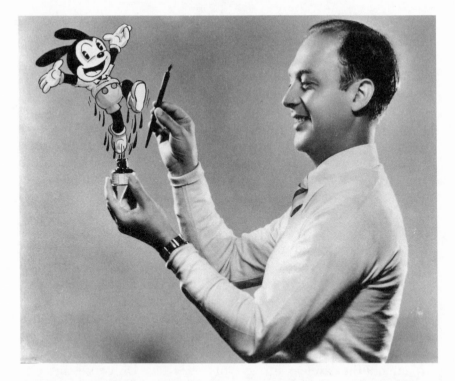

Walter Lantz and his adopted character Oswald the Lucky Rabbit in
a publicity photo from the first half of the thirties.

further into anarchic fantasy than anyone had before. Music the
way Disney used it, by contrast, governed whatever fantasy was
already there; *Cannibal Capers*, released a few weeks before *The
Hash Shop*, includes distortion of the body that approaches *The
Hash Shop*'s, but the effect in that Silly Symphony is more ballet-
ic than anarchic.

Traces of *The Hash Shop*'s attitude toward the body continued
to surface for the next few years, but rarely with its nihilistic
intensity. By late in 1930, the trend was toward organizing the
Universal cartoons musically, more like the Disney cartoons.
(Nolan's animated insert for the 1930 live-action feature *The King
of Jazz*, of a caricatured Paul Whiteman, was planned from the
start as a musical number, with Whiteman's band recording the
music in advance of the animation.)[105] The Universal cartoons
didn't move in a straight line toward a stronger musical-fantasy
emphasis: *The Barber Shop*, an Oswald cartoon released in 1932,
bears some resemblance to *The Hash Shop*, even though it suc-
ceeded heavily musical cartoons like *Alaska* (1930) and *The*

Farmer (1931). Increasingly, the scenes that Nolan himself animated became islands of engaging eccentricity in cartoons that were otherwise the deformed product of a struggle to depict movement that more nearly resembled real life. On the evidence of his animation, Nolan never embraced such an aim; like Huemer's animation on the early Scrappy cartoons, Nolan's animation was not based on observation of the real world, but was fundamentally abstract.

Shaping a whole film around such animation was inherently difficult. Preston Blair—an art school alumnus who went into animation at Universal and later Mintz because "it was an art business, and they were paying pretty good money to artists"—remembered that Nolan's animation "was most impressive when... flipped by hand," and that the "charm of line and style" were diminished by the time the animation reached the screen. By contrast, the work of an animator like Manuel Moreno looked better on the screen than on paper; despite his youthful admiration for Nolan, Moreno animated in a more Disney-like manner, using extremes and inbetweens.[106] Animation of that kind, because its structure was so much easier to grasp, and thus amenable to control by both animator and director, could more readily be fitted together with dialogue and story, and with the work of other animators.

Nolan, like Huemer, worked in an environment where no one, including the animator himself, was at all likely to understand the value of his unique kind of animation, however much his colleagues might appreciate Nolan's speed and inventiveness or Huemer's draftsmanship. As Leo Salkin, a Universal inbetweener in the early thirties, said of his co-workers: "You would have to say that they were very unsophisticated, immature people."[107]

The possibility that some sort of alternative animation style might develop at either studio was always remote; at the end of 1933, after the enormous success of Disney's *Three Little Pigs*, it had evaporated entirely. By then, the Disney cartoons had simply overwhelmed the Mintz directors and animators, to the point that they had lost all power of independent motion. Their characters skipped and danced and whistled and grinned only because such behavior evoked, at however great a remove, the atmosphere of the Disney cartoons. Huemer himself had undergone a complete conversion, joining the Disney staff as an animator in May 1933.[108] The surrender at Universal was slower and more grudging, probably because both Lantz and Nolan felt so little

sympathy for the Disney kind of film, but when Lantz told
Moreno to redesign Oswald, he said, in Moreno's recollection:
"Make him cute, and let's get rid of so much black on him." Lantz
"wanted to get away from" the earlier version, Moreno said,
"because Disney was also changing his characters."[109] By early in
1934, one Universal cartoon after another was, like the contem-
poraneous Mintz cartoons, inviting comparison with the Disney
films.

Physical distance did make a difference: it was another studio,
one that remained in New York, that offered the clearest alterna-
tive to the Disney films in the early thirties.

Max and Dave Fleischer's staff shrank from several dozen in Red
Seal's heyday almost to the vanishing point by the time Red Seal
collapsed.[110] After the Fleischers moved from Long Island City
back to 1600 Broadway in the fall of 1929, the staff expanded
again, in the newly prosperous environment for sound cartoons,
sometimes through the rehiring of animators who had worked for
the Fleischers in the twenties. By October 1930 the staff totaled
around ninety.[111] The Fleischer studio was as thick with relatives
as Harman-Ising: four Fleischer brothers—Max, Dave, Lou, and
Joe—worked there in 1930, Lou as the staff composer, Joe as a
general handyman.[112]

Within a few months of moving to Manhattan, the Fleischers
lost four of their most experienced animators—not to a single
rival, as Walt Disney had, but to two of them. Not only did Dick
Huemer and Sid Marcus go to work for Charles Mintz, but George
Stallings and George Rufle moved to Van Beuren, plugging the
holes that Paul Terry and Frank Moser had left. To take the place
of those veterans, the Fleischers over the course of a few months
made animators of a half dozen or so inbetweeners—Al Eugster,
Rudy Zamora, and Shamus Culhane among them.[113] So raw were
these new animators, Eugster said, that "our exposure sheets—
our timing" were checked by two staff members who were more
experienced, even though not as animators: Nelly Sanborn, Dave
Fleischer's secretary, and Bill Turner, a cameraman. Both
Sanborn and Turner had worked at the studio since the midtwen-
ties, Sanborn originally as a "planner" whose job was to make it
feasible to shoot the rip-and-slash paper animation the Fleischers
used then.[114]

Not long after the 1930 shakeup, the Fleischers made Sanborn head of what became known as the timing department. As such, she made decisions that at other studios would have been in the hands of the animator and his director. Sanborn and Alice Morgan, the other charter member of the timing department, "decided that we should never animate a drawing which did not overlap the preceding figure," Culhane wrote many years later.[115] The idea was to make the animation flow more smoothly by having one drawing lead naturally to another; but the effect was to strengthen what was already a strong tendency toward very even, monotonous timing.

The Fleischer animators of the early thirties appear to have drawn extremes that progressed from one to the next in a predictable pattern, with inbetweens of the same kind. Animators at other studios worked in much the same way, as witness Rudy Ising's recollection of how Tom McKimson handled his scenes. Animating in that metronomic fashion probably gave birth to most of the slow, mechanical timing that was so prevalent in the early thirties (and that Walt Disney was trying to get rid of when he encouraged his animators to vary the spacing of their inbetweens). It was, however, only at the Fleischer studio, thanks to the timing department, that so sterile a method became in effect the officially sanctioned way to animate.

By the time the Fleischers made a Talkartoon called *Fire Bugs*, released in May 1930, they had finally begun to put animation on cels; all studios of any importance had finally ended their reliance on paper animation. (The Pat Sullivan studio, hopelessly laggard in adapting to sound, was by 1930 defunct as a producer of animated cartoons, although Otto Messmer continued to draw a "Felix the Cat" comic strip.) *Fire Bugs*—in which Fitz, the white dog from the silent cartoons, and a nameless horse are firefighters—was also one of the first cartoons on which the Fleischers awarded animation credits, in that case to Grim Natwick and Ted Sears. Natwick had remained as the studio's principal animator when the other veterans left. "Besides the young fellows," Eugster said, "we had Grim Natwick; he was the experienced animator."[116] In scenes in *Fire Bugs* that can be attributed with some confidence to Natwick, the timing is highly eccentric, and thus at odds with what was becoming the Fleischer norm. He used what the animator and critic Mark Kausler has called "stretch inbetweens," exaggerated drawings that Natwick probably roughed in himself. "He took more care to indicate the way he wanted the inbetweens

to go," Kausler says—and Natwick wanted them to go all over the place.

There's more such unpredictable movement, almost certainly animated by Natwick, in *Wise Flies*, a Talkartoon released in July 1930: as a spider sits down at a table, to an empty bowl, his hat takes on a life of its own. In *Dizzy Dishes*, released in August 1930, a canine chanteuse animated by Natwick sings with grotesquely exaggerated mouth movements—exaggerated not just to synchronize with the singer's voice but also, it would seem, for the sheer pleasure of seeing how far a character can be stretched before she snaps. There is in Natwick's animation some of the same freedom in manipulating the body that there is in Bill Nolan's animation for the contemporaneous Universal cartoons, but Natwick, like Nolan a veteran of silent cartoons, was unlike Nolan an accomplished draftsman besides.

Even though Natwick slipped the leash in his animation—thanks probably to the weight of his experience—other animators did not: toward the end of *Dizzy Dishes*, during what passes for a climactic chase, the animation is sluggish and evenly timed. The contrast makes Natwick's animation seem even odder than it is. This was the curious pattern that began asserting itself in the Fleischer cartoons in 1930: the cartoons were in their fundamentals belligerently mundane, but they could be in their total effect very strange indeed.

It was in 1930 releases that the props in the Fleischer cartoons started springing to life and taking part in peculiar bits of incidental business that were related barely if at all to the main thread of the action. In *Accordion Joe*, copyrighted in December 1930, a quickened cactus, with an alarmed look on its newly acquired face, pulls an Indian girl's skirt back down over her exposed rump; a suddenly animate accordion makes itself into a stairway up a rock; a button pops off the dog Bimbo's pants and a living safety pin immediately takes its place.

The Fleischers began paying some attention to story as early as Disney did, so that Ted Sears was by 1930 recognized as a writer as well as an animator—thus his title as the Fleischers' scenario editor. In 1931, after Sears left for Disney's, Bill Turner became the unlikely head of a new story department. Turner apparently had no background as a writer and was from all appearances a man of very basic tastes; his story department probably served at first largely as a supplement to the work of the animators. Al Eugster recalled that stories were "sort of worked out as we went

along.... Dave would make the rounds almost every day and suggest gags."[117] That was how Dave Fleischer worked in the twenties, too, but now the context was different—he was dealing with a crew of mostly green animators, for one thing—and so were the results on the screen. Dave Tendlar (who began animating for the Fleischers in the early thirties) explained how Fleischer contributed directly to the cartoons' unusual texture:

> Dave Fleischer's theory was that every scene should have a gag; nobody should animate a scene without a gag. He would come around, every other day perhaps, and speak to the guys. He'd pick up your scene and flip it, and he'd say, "Where's the gag in this?"... If you couldn't think of something in a scene, you would confer with him, and you would come up with something, what they considered a gag. Whether it was a chair moving across the room, or an apple in a bowl of fruit animating up and saying something, and then going back in the bowl—this was a gag, a surprising piece of business.[118]

As Tendlar's remarks indicate, it was by bringing the inanimate to life that such gags could most easily be introduced. For instance, in *The Male Man*, released in April 1931, a stamp on a letter is rolling up at one of its corners; the wigged figure on the stamp licks it so that it will stay down. By 1932, such tiny throwaways were simply everywhere in the Fleischer cartoons. In *Admission Free*, released in June 1932, an arcade slot stretches outward and swallows Bimbo's penny for a peep show called "Sahara Sadie," then a stool comes running up to provide him with a seat.

Not only did Dave Fleischer want a sight gag in every scene "as much as possible," the animator Myron Waldman said,[119] but he also wanted the characters to appear to respond to the music on the soundtrack; this was apparently his makeshift substitute for the tight synchronization of music and image that Disney and some of his Hollywood rivals were seeking. Fleischer "did not want any characters 'held' on the screen," Tendlar wrote many years later, "so he told the animators to bounce them up and down to a beat"[120]—an arduous requirement, as Waldman explained: "That up-and-down bit, with that bouncing...drove us crazy. It made an awful lot more drawings, and it made it very difficult—every beat of the music, no matter what they were doing."[121] By mid-1931, in cartoons like *Bimbo's Express*, the

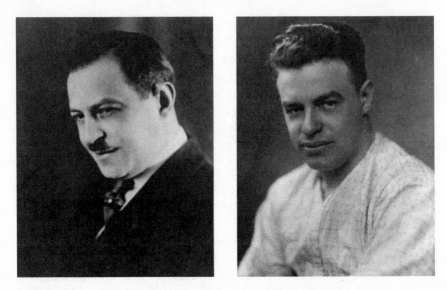

Max Fleischer and his brother Dave, in undated portraits probably taken in the late teens or early twenties. Quigley Collection, Georgetown University.

Fleischer cartoons were full of such arbitrary movement; the characters moved constantly, as did their settings.

Even more clearly than in the days of the silent Inkwell cartoons, the Fleischer cartoons owed their odd combination of stolidity and eccentricity to the sharply different personalities of the two brothers who ran the studio. As a boss, Max Fleischer was, if by no means forbidding, largely removed from the day-to-day work. Like Ub Iwerks, he was engaged by the technical side of studio animation, not by the demands it imposed for collaborative effort. Dave Tendlar described him as "a very quiet, retiring fellow...who liked to go into his own laboratory or his own machine shop, and putter with his inventions."[122] Said Myron Waldman: "Personally, he was a very nice guy, but there were a lot of things he didn't think about."[123]

Max had gone through the bankruptcy of Red Seal in 1926 and with it the virtual destruction of his studio; then the studio had grown rapidly, but in an economic climate, after 1929, that was proving fatal to many other businesses. Such experiences have driven many a small businessman to seek greater control over his business—and thus, presumably, over its fate—and it was no different with Max Fleischer. As the Fleischer studio grew, it became much more thoroughly, not to say rigidly, organized than before.

The kind of animation fostered by the timing department, so safe and predictable in its general contours and thus easily produced, fit perfectly in what was, especially in the studio's lower reaches, a dour new atmosphere.

According to an unsigned biography in the first issue of the Fleischers' studio newsletter, *Fleischer's Animated News*, in 1934, Dave Fleischer had theatrical ambitions as a youth, performing in amateur nights and later joining a theatrical company.[124] "Dave was always a wild kind of thinker, and actor, and everything else," said Max's daughter Ruth Kneitel, who ran the studio's cel-painting department in the early thirties. "My father was more from the old school: settle down, and work has got to be turned out."[125] Dave played the active role in production that Max eschewed, but not as a director, even though that was the credit that each cartoon assigned to him. That title more reasonably belonged to the studio's head animators. By early in 1932 there were three such animators—Willard Bowsky, Seymour Kneitel, and Al Eugster—all of them supervising groups of other animators.[126] It was the head animators who laid out the cartoons, made out the exposure sheets, and handed out work to the other animators in their units. They were doing much of the work of a director at Disney's and other studios, except that they animated parts of their cartoons, too.

Dave Fleischer's role was, like Walt Disney's, to be his studio's dramaturge, scrutinizing and revising the work of others, but Fleischer did not wrestle earnestly with stories and animation in countless meetings, as Disney did. Instead, he exercised his control in a glancing, all but random way, as through his insistence on gags and constant movement. Fleischer's casual contributions to the cartoons left untouched their essentially mechanical, unimaginative core. Interpolating bizarre gags and rhythmic twitching into cartoons otherwise dominated by smooth, unaccented animation meant that those cartoons took on a hallucinatory quality: they were, in their zombielike pacing, their aimlessness, and their arbitrary transformations, literally dreamlike.

The Fleischers' use of sound enriched the cartoons' otherwordly atmosphere. Apparently they recorded the soundtracks of some of their early sound cartoons in advance or, in a few cases, used existing commercial recordings, but by 1932 at the latest, they had settled into a normal pattern of recording everything after the cartoon was animated. Not just the music but the voices and sound effects, too, were postrecorded, and all at once. Such

postrecording, in contrast to a Disney-like procedure that entailed recording dialogue in advance of animation, and music and sound effects afterward, held the cost and complications of sound recording to a minimum. Once that larger goal had been achieved, Dave Fleischer, who was in charge at recording sessions, was free to tinker around the edges as much as he wished; again, the results were often very odd, compared with those at other studios. Typically, in a postrecorded Fleischer cartoon of the early thirties, most of the dialogue is muttered, with no attempt at synchronization; mouth movements have been animated for only a few lines of dialogue, emphatically voiced. The Fleischer cartoons sound just as random and accidental as they look.

As haphazardly assembled as were the elements in the Fleischer cartoons of the early thirties, there was in the best of them a sort of discipline at work. In a cartoon like *Betty Boop's Ker-choo*, released in January 1933, the Fleischers went beyond the usual accumulation of oddities—the anthropomorphic automobiles include one that speaks with a Yiddish accent—and all but endorsed an aesthetic credo directly opposed to the one emerging in the Disney cartoons. In *Betty Boop's Ker-choo*, nothing important is happening at the center of the cartoon; the audience is clearly not supposed to care who wins the auto race in which Betty, Bimbo, and KoKo take part, whereas it would be expected to care if the race were between Mickey Mouse and Pegleg Pete. Everything of interest happens around the edges, typically in gags presented in such an offhand way that they pass almost without notice, as in the opening scene, when the letters "RACE" on a pennant have feet and literally run off the pennant (which has to reach out and pull them back). The pennant and the overeager letters are in the upper left-hand corner of the screen, in a scene that at first appears to be devoted to animals that are rushing into a stadium.

Stronger yet is *Snow-White*, a Betty Boop cartoon released in March 1933. Here the fairy tale that provides the film's narrative thread is even more obviously of no interest. The incidental gags in *Snow-White* are instead both so plentiful and so flagrantly irrelevant to the plot that they banish any thought of taking this retelling of the familiar story at all seriously. Early in the film, for instance, the Queen's face arbitrarily transforms itself into two eggs (for her eyes) in a pan (the handle is her nose). More than in any previous Fleischer cartoon, the incongruous elements that

had worked together accidentally seem in *Snow-White* to be working together according to plan; the animation's steady flow is not so much mechanical as deadpan, deliberately robbing potentially dramatic moments, like the threatened execution of Snow-White, of any such impact.

The animation for *Snow-White* was done entirely by the Fleischer veteran Roland Crandall over a six-month period.[127] There's no reason to believe that "Doc" Crandall's accomplishment was, in the eyes of the Fleischers or their lieutenants, a breakthrough that put their cartoons on a more solid aesthetic footing. The Fleischer cartoons remained fundamentally dependent on happy accidents, and the Fleischers were consequently vulnerable to comparisons (by themselves and others) with more purposeful filmmakers. Walt Disney was, of course, one such filmmaker; and his own retelling of a children's story, *Three Little Pigs*, entered theaters just two months after the Fleischers' *Snow-White*.

In November 1932, Fleischer Studios, Inc., and King Features Syndicate signed a five-year licensing agreement that let the Fleischers use Popeye, the prognathous, one-eyed sailor who had been appearing for three years in Elzie Segar's comic strip, "Thimble Theatre."[128] Popeye made his animation debut in July 1933 in *Popeye the Sailor*, a cartoon that was technically not a Popeye cartoon at all, but an entry in the Betty Boop series (the contract with King provided for such a "test cartoon").

Betty Boop was till then the only Fleischer character of any consequence. She had evolved, in fits and starts, from the dog-like singer in *Dizzy Dishes*, until eventually, in *Any Rags*, released in January 1932, she had shed her floppy ears and become a wholly human character—so to speak. Betty was not so much a character as a travesty of compliant femininity, with a very large head (its features babylike) atop a mature woman's body; she spoke and sang in a childlike voice. It was thanks mainly to Betty that ribald humor surfaced occasionally in the Fleischer cartoons, as in *Mask-a-Raid*, released in November 1931: when Bimbo the dog and an old man duel over Betty, Bimbo with a short sword and the old man with a long one, the phallic symbolism is inescapable. Other male characters approached Betty with obviously lascivious interest, but she remained virginal herself, and

the Fleischer cartoons never deployed blue material as freely as Ub Iwerks's did.

Even as a travesty, Betty was not at all original. Her vocal and visual similarity to the singer Helen Kane provoked a lawsuit by Kane against Max Fleischer, Fleischer Studios, and Paramount Pictures in April 1932; after a trial in April 1934, her suit was dismissed, mostly because the defense had demonstrated that Kane herself had appropriated some of her mannerisms from other performers.[129] But Betty's similarity to Kane was no accident: Grim Natwick, who animated on some of her early films, wrote many years later that he had drawn Betty's spit curls to match those in a photograph of Kane that Dave Fleischer gave him.[130]

Because neither Dave's nor Max's inclinations led them to give sustained attention to the writing and the animation for their films, the Fleischer cartoons were poor soil for the growth of strong characters. In the early thirties, the Fleischers all but ridiculed the idea of continuing characters: the dog character identified in the titles as Bimbo might be in one cartoon a white dog resembling the Fitz of the silent cartoons and in another a black dog with a white mask. KoKo, always a vehicle more than a real character in the Fleischers' silent cartoons, turned up occasionally in the sound cartoons, but only as a supporting player for Betty Boop. The importance of popular characters to a studio had been clear since the early twenties, though, and in the early thirties, with the rise of Mickey Mouse, the evidence of their value was overwhelming. That such a character might emerge from the Fleischer cartoons was doubtful at best; so the Fleischers went out and bought one, even though that meant forgoing the revenues from licensing the character's image.

By the time the first Popeye cartoon appeared, Disney had raised the stakes again: *Three Little Pigs* had become wildly popular. If Mickey Mouse in 1933 was still an iconic character, Disney in the Silly Symphonies was beginning to make cartoons whose characters engaged an audience's interest in much the way that real actors did. The Fleischers were pulled along with the tide. Their cartoons began to reflect a Disney influence, both in how they were made and in what appeared on the screen.

As the Popeye series was getting under way around the end of 1933, "the stories were worked out more carefully, in much more detail," Dave Tendlar said,[131] and such preparation discouraged off-the-cuff gags of the kind that had been so plentiful before. By 1934, some Fleischer cartoons were starting to look like imitation

Disney: in *Keeps Rainin' All the Time*, a Screen Song released in January 1934, a bear cub runs away from home and goes through trials that echo recent Disney cartoons like *The Bears and Bees* (1932). In *Lazybones*, a Screen Song set at a racetrack and released in April 1934, there's evidence of a cautious effort to achieve more realistic drawing and animation. The eponymous horse is, however, very simply and crudely drawn, with rubbery legs that have no joints; it is utterly lacking in definition. What might have been amusing crudeness in an earlier Fleischer cartoon—because skillful drawing and animation were usually so much beside the point—now loomed, in this changing context, as a disastrous flaw.

The distinction between character animators and effects animators, as it emerged at Disney's in the early thirties, did not take hold at the Fleischer studio, where there was no separate effects department. The Fleischer animators not only did both kinds of animation but were more nearly effects animators who also handled characters than the other way around; the cartoons come most alive when large mechanical props are on the screen. The animators thus echoed Max Fleischer's own technical bent, and it was as a technician—as the applicant for a new patent—that he mounted his most serious response to the Disney cartoons' growing popularity. On 2 November 1933, he filed for a patent on a system of miniature sets that the Fleischer animators called "setbacks." The system involved mounting the cels for each scene between two vertical sheets of glass that were themselves positioned between the camera and a setback; the idea was that the animated characters on the cels would seem to be performing on a three-dimensional stage.[132]

The Fleischers first used setbacks in *Poor Cinderella*, their first Color Classic (in the two-color Cinecolor process); it was released in August 1934. That cartoon is far more painstaking than the Fleischer norm, in every respect—drawing, animation, backgrounds—to the point that the screen is filled with ornament. The coach in particular is extraordinarily elaborate in drawing, with every bridle and harness rendered carefully. All of the energy poured into the cartoon has gone into such details, however: *Poor Cinderella* is almost entirely a straight retelling of the Cinderella story, with Betty Boop in the Cinderella role.

There's no sign in most Fleischer cartoons from the middle thirties, and in the Color Classics in particular, of any real interest in the characters; they're usually dull or unsympathetic. The Popeye series, with its ready-made characters, was the closest

thing to an exception. In his early appearances in the Fleischer cartoons, Popeye seemed close kin to the newspaper original: roughhewn but chivalrous. Similarly distinct were Olive Oyl, modeled in vocal delivery and to some extent in actions on the fluttery actress ZaSu Pitts, and Bluto, a hulking bully from one of the comic-strip adventures.

"Dave and I chose the peculiar voice of a fellow named [William "Red Pepper Sam" Costello] for Popeye the Sailor," Lou Fleischer later wrote, "but he became entirely incorrigible.... I was asked to find a voice to replace him." As he was walking through the animation department, he heard Jack Mercer, an inbetween-er, singing the Popeye theme song and decided that Mercer's was the voice he wanted.[133] The first Popeye cartoon with Mercer's voice was evidently *King of the Mardi Gras*, released in September 1935.[134] Mercer's Popeye voice, although as gravelly and quirky as Costello's, was considerably warmer and more flexible, giving the character a dimension he lacked in the earlier films.

The more that interest gravitated to such characters, though, the more conspicuous became some of the Fleischer cartoons' other characteristics, and not to their advantage. In *A Clean Shaven Man*, released in February 1936, Popeye pulls a barber chair out of the floor and spins the chair's seat off its base, so that it whirls through the air and forces Bluto against a wall. Then the seat, with Bluto in it, bounces back onto the base of the chair, which Popeye is holding. There is no sense that this might some-how be physically possible; the seat simply floats. The slow and even Fleischer timing, sometimes so effective in earlier films at contributing to a dreamlike atmosphere, was much more prob-lematic in cartoons organized around coherent narratives and dependent on audience interest in their protagonist.

Conceivably, such gaucheries might have been reduced through the use of pencil tests like those that were standard pro-cedure at Disney's and other Hollywood studios by 1936, but pen-cil tests were not part of the Fleischer routine. For all that the Fleischers emphasized a sort of cartoon engineering on the screen, they were reluctant to embrace advances that were more than just mechanical. For instance, they did not allow animating on twos until sometime after 1935, even though Disney's and other studios had long since realized that the uniform projection speed that came with sound meant that many scenes could be animated on twos without risking jerkiness on the screen.[135]

Gordon Sheehan, who began animating in Willard Bowsky's

unit in 1936, recalled that "new animators didn't have assistants. They had to clean up their own drawings...and get them ready for inbetweening." All the animators worked without the kind of support that animators at the Hollywood studios were beginning to take for granted. The head animator supplied a few key poses, "enough to give you an idea of how the staging should be," Sheehan said, but the animators made their own detailed background sketches, to be rendered in watercolor by the background department.[136]

For all of Max's geniality, the Fleischer studio was, in fact, a not entirely benign sweatshop. When John Gentilella started work there after the Van Beuren studio closed, he found "regimentation. They had everything down to how many [drawings] you could do and what you should do."[137] Sheehan recalled the footage quotas as thirty feet a week for animators with assistants, twenty-two feet a week for animators without assistants—higher than comparable figures at the Hollywood studios. "It was a very, very good thing if you were fast at Fleischer's," Sheehan said. "...Of course, the management always said that quality was very important, but it was quite obvious that quantity was the big item."[138] As at Disney's, it was in the inbetween department that life at the Fleischer studio was at its harshest; former Fleischer inbetweeners described Edith Vernick, the department's head in the middle thirties, in terms comparable to those that Disney veterans applied to George Drake. "When you went to the men's room," said Irv Levine, who started as a cel painter in 1934, "she looked at her watch and wanted to know if you had diarrhea."[139]

By 1937, the Fleischer studio had become, like the Disney studio, very much of a closed system: no outside animators had been hired in the previous two years. Of the seven inbetweeners promoted to the animation department since 1935, all but one had started as a cel painter.[140] Unlike Disney, though, the Fleischer studio was rigid and bureaucratic. There was no hiring and training with an eye toward making a superior kind of film; the rigidity—the control—was an end in itself. Almost everything amusingly peculiar had disappeared from the cartoons, leaving behind labored, badly drawn imitations of the Disney films.

The Fleischer studio, its management fundamentally cold and arrogant, was fertile soil for labor unrest, especially given a national political environment that was newly hospitable to unions after passage of the Wagner Act. Union organizers could point to pay disparities, too. As of April 1937, the Fleischers'

twenty-three animators made an average salary of $90.80 a week. The gap between them and other classifications was large—inbetweeners and cel painters averaged $24.45.[141] Given the rigidity of the Fleischer system, no assistant or inbetweener could hope to rise to an animator's pay level until years had passed.

The Fleischers provoked a strike by firing thirteen union members early in May 1937. About a hundred members of the staff (half the total) went out on 7 May.[142] The strikers were overwhelmingly from the studio's lower ranks; only one animator, Eli Brucker, refused to cross the picket line for the duration of the strike. The strike, reinforced by a successful boycott of Fleischer cartoons, ended on 12 October in a victory for the Commercial Artists and Designers Union.[143] Max Fleischer, as paternalistic in his own way as a George Pullman or a Henry Ford, was profoundly offended by the strike. "My father just didn't believe in unions," Ruth Kneitel said. "It was an unbelievable thing because just as close as these people were, all of a sudden...it was like a civil war."[144]

On Valentine's Day 1934, Hugh Harman got another chance to go head to head with Walt Disney: he signed a contract with Metro-Goldwyn-Mayer, the largest and most powerful of the Hollywood studios. MGM agreed to pay $12,500 for each cartoon that Harman-Ising Pictures made, a total of thirteen a year for five years. MGM would, moreover, reimburse Harman-Ising weekly for its production costs up to that cap, starting in May. MGM would own the cartoons outright, but Harman-Ising would keep the characters, that is, the Bosko troupe, it brought with it from the Warner Bros. release.[145]

This deal was in a number of respects clearly superior to Harman and Ising's contract with Schlesinger: they would make only a single series of cartoons, but their payment for each cartoon would be more than twice as large as their payments under the old contract. In effect, their staff would have twice as much time as before to make each film. Those films would be all in color—two-color Technicolor, to be sure, because of Disney's temporary monopoly of three-color Technicolor, but not even Disney had yet broken completely free of black and white.

Harman recalled that the negotiations did not go smoothly, even so, because the MGM executives wanted him and Ising to

become MGM employees. He had gone to New York with Gordon Wilson, Harman-Ising's business manager, while Ising stayed on the West Coast. "We had an awful time," Harman said of the negotiations. "They were just trying to browbeat us."[146] Harman's contentious nature no doubt contributed a great deal to the friction, but there may have been on MGM's side misgivings about entering into the direct competition with Disney that an all-color schedule implied. MGM had, after all, just ended its association with Ub Iwerks, who had his own strong credentials as a Disney alumnus.[147] MGM may have shown its concern even after the contract was signed by dragging its feet on *The Nutcracker*, the ambitious cartoon on which Harman-Ising had begun work after the break with Schlesinger. In May 1934, MGM announced the film as a two-reeler,[148] but, Harman said, "we never did get a contract, so we stopped work on it."[149]

Ising had completed Harman-Ising's first cartoon for MGM, *The Discontented Canary*, by June 1934,[150] but the film did not reach theaters until September, just before the release of the last of Iwerks's cartoons for MGM. Starting with *The Old Pioneer*, the second in the series, the new Harman-Ising cartoons bore the name Happy Harmonies. They were, far more than Ising's Merrie Melodies, imitative of Disney's Silly Symphonies, telling real stories, and drawn and animated far more carefully than before. Disney seemed always to be at Harman and Ising's elbow: early in the MGM release, they moved from Hollywood Boulevard into a building at 861 North Seward Street that had previously housed a film laboratory, one where, Ising recalled, Disney brought his film to be developed in the twenties.[151]

Harman spoke in 1973 not of imitating Disney but of "a desire to make refined stuff...a desire to get away from common gags. They became so repetitive, within the industry, and everything had a certain tone to it...it became tiring. I just thought how good it would be to make some cartoons that had no humor in them, unless it was very mild, restrained stuff."[152] The early months of the MGM release coincided, too, with a new rigor in enforcement of the film industry's Production Code, which could only have strengthened Harman and Ising's inclination to follow Disney's lead. (Few records survive to indicate how the cartoon studios felt that change, but by the time of the crackdown, cartoons had already shed most of the sexual innuendo and barnyard grossness that might have earned them censure.)[153]

The early Happy Harmonies still bore traces of the animation

shortcuts that had been so common in the Harman-Ising cartoons for Schlesinger—conspicuous holds, for instance, and equally conspicuous cycles. A few of them even reused animation from the earlier cartoons. Mainly, though, the new cartoons were strikingly ugly, directly comparable in their plentiful but labored drawing to the color cartoons that Max and Dave Fleischer were making at the same time. The crude formulas of the Looney Tunes had hidden many sins; when the animators were asked to draw in something more like an illustration style, the shortcomings in their draftsmanship were made visible. The animators knew it, and they resented it.

In Ising's third Happy Harmony, *Tale of the Vienna Woods*, released in October 1934, the principal characters are a faun—a statue come to life—and a deer, characters of a kind that still taxed even the Disney animators; the result is a clumsy combination of failed prettiness and low clowning. Mel Shaw (known then as Mel Schwartzman), who worked on the story and then drew character layouts for the film, had something else in mind. "Animated storybook-illustration style is more what I've always been interested in," he said. "I tried it on *Tale of the Vienna Woods*, but the guys wanted to murder me. They didn't want to draw a deer like that [that is, a deer that resembled a real animal]; a pop-eyed deer with rubber legs is what they could handle."[154]

Harman, despite his ambitious talk, put Bosko and Honey into the first two Happy Harmonies that he directed. Bosko had become wholly parasitic: in *Hey-Hey Fever*, released in January 1935, he and his dog Bruno instantly summon up Mickey and Pluto. In that cartoon, though, the Happy Harmonies' larger budgets were finally visible in such things as multilevel panning shots and reflections in a polished palace floor. There were elaborate touches in Ising's cartoons, too, but it was Harman who staked out production values of that kind as the turf on which he would compete directly with Disney, starting with his third Happy Harmony, *The Lost Chick*.

Although the first few Harman-Ising cartoons for MGM "cost just about" the contract figure, Harman said, he never intended to be bound by that $12,500 cap: "On our succeeding pictures, it was my plan to jump them up, whether MGM liked it or not. I thought, well, we'll just show them." (He cited as justification MGM's "early breaches of contract," specifically in regard to sharing the profits on the cartoons, but it seems unlikely that such a motive could have been at work as early as production of *The Lost Chick*.) "When [spending on *The Lost Chick*] reached twenty thou-

sand dollars, they *really* screamed, and came over and talked to us," Harman said. "It didn't mean a thing; we just went ahead and finished the picture."[155]

Harman was vague about what raised the cost of his cartoons, apart from a decline in his animators' weekly output, but in Ising's view, Harman ran up costs by choosing to do things that took more time, like scenes animated in perspective. "Hugh was a nut on perspective," Ising said, "and he had a layout man, John Niendorff, who was a bigger nut on perspective."[156]

Over the course of 1935, Harman's predilection for the elaborate and expensive continued to shape his films, but the additional spending began to pay off in more substantive ways as well. By the time three-color Technicolor became available to him— Harman-Ising's first three-color cartoon was Harman's *The Old Plantation*, released in September 1935—he was in a good position to take advantage of its possibilities, because the level of his employees' skills had risen so rapidly. Harman-Ising was benefiting from the Depression by hiring people who had been trained in the fine arts, like the watercolorist Lee Blair, Preston Blair's brother. As more and more of the work of such artists reached the screen—in Lee Blair's case, both directly as animation and then, after the advent of three-color Technicolor, indirectly as color styling sketches that other artists translated into finished backgrounds—it smoothed away the crudeness that afflicted the early Happy Harmonies.

Bosko himself reflected the change most clearly: for the character's third MGM appearance (in *Run Sheep, Run!*, released in December 1935) Harman transformed him into a small black boy, drawn and animated in a highly realistic style. That cartoon's general richness embraces elaborate shadows and lots of movement in depth, as well as highly detailed effects animation; when Bosko and Bruno, fleeing from a bear, slam the door of their house, all the boards fall off the sides and the shingles fall off the roof. That extravagance goes to waste, though: when the bear gets inside Bosko's house, it turns out—altogether unbelievably—to be four lambs disguised in a bear suit. Everyone immediately begins dancing and singing. Such a failure was the rule.

As had been the case during the Warner Bros. release, the films' weak stories were apparently the product of much effort. "He'd spend a lot of time on story," Ising said, speaking of what made Harman's cartoons so expensive, "and he had a much bigger story staff than I did."[157] Harman himself spoke of taking film more seriously when he began to make cartoons for MGM release: "I

read Pudovkin, and I read Eisenstein.... I began to study the craft more, especially the craft of story."[158] Harman had an "intense desire" to rival Disney, the animator Robert Stokes said: "I got to know Hugh very well, on a personal basis—we'd go out together, to night clubs and so forth—and he'd talk and talk about it. After the Metro deal, he began talking features," specifically one on King Arthur.[159] As during the Warner Bros. release, though, Harman never deigned to make the necessary connection between his grand ambitions and what was needed, besides money, to realize them.

For all the rapid improvement in the work of its animators, in particular, the Harman-Ising studio never rose above a relatively inchoate state, as measured against what it would have to be to compete seriously with Disney. Storyboards of the Disney kind never took hold at Harman-Ising; both directors continued to work out their cartoons less through story sketches than on their bar sheets. Lee Blair recalled that, as in the Looney Tunes days, "they'd be working on the [bar sheets] as we were animating, right behind them, on their backs."[160] Although some Harman-Ising animators sketched roughly, that Disney-like pattern did not become the rule on Seward Street. Most of the animators cleaned up their own extremes; likewise, the animator Carl Urbano said, even though the pressure for footage was not severe, "they tried to keep you up to around twenty-five feet a week."[161]

Money that at Disney's paid for more painstaking animation and more thoughtful writing did not pay for the same things at Harman-Ising, especially where Harman's cartoons were concerned; it disappeared instead into frills—and into unnecessary length (Harman's *Poor Little Me* runs just short of eleven minutes) that increased MGM's print costs.[162] MGM was famous in the thirties for its free spending on its features, but its patience with extravagance did not extend to Harman's on his cartoons. MGM's contract permitted it to terminate its agreement with Harman-Ising at the end of any of the annual cycles, with sixty days' notice, and in February 1937 it did so.[163] By March it was recruiting animators for a new studio of its own.[164]

Hugh Harman's efforts to compete successfully with the Disney films had finally ended—but only in part because Harman-Ising had lost its release. What was happening at the Disney studio itself had terminated the rivalry far more emphatically.

Disney,
1936-1938

In the earliest sweatbox sessions for *Snow White and the Seven Dwarfs*, in the late winter and early spring of 1936, Walt Disney reviewed a lot of animation of animals—the ones that help Snow White clean the dwarfs' cottage—as well as some animation by Ham Luske of Snow White herself. By late spring, though, the greatest responsibility for animating Snow White had passed into the hands of Grim Natwick. He had joined the Disney staff on 12 November 1934, an event significant enough to be noted in Walt Disney's desk diary, as few such staff developments were.[1]

"Down underneath it all," Natwick said in 1976, "I think—because of Betty Boop—that Walt had an idea all the time that maybe I would be able to draw Snow White."[2] That was surely true. Not only did Disney hire Natwick away from the Iwerks studio just as serious work on *Snow White* was getting under way, but when Natwick got his first assignment, on 30 November 1934, it was for the Silly Symphony *Cookie Carnival*. Ben Sharpsteen, the director, gave to Natwick a long scene (lasting almost a minute on the screen) in which a cookie boy dresses a cookie girl in marzipan finery so that she will be chosen queen of the carnival. Natwick drew and animated the girl, cookie though she was, with real feminine grace—the quality that was so painfully lacking in *The Goddess of Spring*, which began playing in theaters just before Natwick joined the Disney staff. In the cookie girl, the Disney

cartoons had for the first time an appealing heroine—not a neuter
to which a few crude symbols of femininity had been attached, as
with Minnie Mouse's skirt and eyelashes, but a character that was
female at her core. Over the next year, Natwick handled almost
nothing but female characters. His progress was not smooth, but
Walt Disney, although he complained to Natwick that he was slop-
py and disorganized, nursed him along.[3]

Natwick apparently began working on *Snow White* sometime
late in the spring of 1936. He soon was surrounded by talented
artists whose presence testified to the importance of his assign-
ment. His principal assistant was Marc Davis, a very strong drafts-
man who had joined the Disney staff as an inbetweener in
December 1935.[4] Another assistant was Les Novros, one of the
first artists hired by Don Graham and George Drake in New York;
Novros, who joined the Disney staff in June 1936, had studied for
two years under George Bridgeman, the famed author of
Constructive Anatomy.[5] Three inbetweeners, all skilled draftsmen,
also began working under Natwick by early in the summer, com-
pleting a self-contained unit devoted to a single character.[6] "Walt
gave us two months to practice the character," Natwick said:

> Scenes were being planned, and we'd try them out.... When
> we'd arrived at something we thought was good, we really
> waded through and animated a few scenes and tested them
> and ran them and re-ran them.... Actually, we went ahead
> and animated twenty-six scenes before the first showing of
> anything. Fortunately, Walt OKed, for ink and paint, twenty-
> four out of the twenty-six.[7]

Natwick was probably exaggerating only a little. He was almost
certainly referring to two long sweatbox sessions on 20 and 21
August 1936 when Walt Disney, in the company of Natwick,
Luske, Dave Hand, and a few others, viewed a total of thirty-eight
scenes from sequence 3C, the one in which Snow White and the
animals enter the dwarfs' house. Remarkably, it might seem,
Disney was most concerned with the animation of the animals;
his instructions for changes in Snow White herself dealt only with
how the character was drawn. For Natwick's scene 9, for instance,
there was this comment: "Check the drawings to see what is
wrong with Snow White's arms as she goes to the fireplace; they
are much too large."[8] There was not a trace of concern about how
the character's personality emerged through the animation. That
was because such acting issues had been settled months earlier
when a sixteen-year-old dancer named Marjorie Belcher, the

daughter of the owner of a Hollywood dance studio, was filmed going through Snow White's actions, under Luske's direction.

There is no hint in the outlines and meeting notes that survive from 1934 and 1935 that Disney ever conceived of Snow White as anything other than a conventional heroine, necessarily pretty, and old enough to be carried off to marriage by her Prince. Here again, Disney had painted himself into a corner through his choice of a story: most of his animators had shown no affinity for the kind of character who was at the center of that story. At first, Disney seems to have thought only in terms of live-action filming as a guide for the animation of dances, but by the fall he had decided to rely on live action far more extensively; the filming of Marjorie Belcher (later known as the dancer Marge Champion) probably began in November.[9] In explaining that decision a few years later, Disney singled out his animators' shortcomings not as draftsmen but as actors: "One reason I did it was because the artists looking at themselves in the mirror sometimes were not so successful because they were bad actors and they would do things in a stiff way."[10] It was only by using live action as a guide, or so Disney must have thought, that he could give to Snow White the consistency—what Marc Davis called the "unity of acting"[11]—that was possible in a short cartoon when a single animator handled a character all the way through. Ham Luske, by directing the live action for Snow White, thus assumed control over the character greater than any he might have enjoyed if he had been only the lead animator.

As Marge Champion recalled, she missed a day of high school every few weeks so she could devote that day to filming at the Disney studio:

> The method we used all the way through [was that] they would show me the storyboards, and they would play the voice, if there was a vocal track of any kind.... I would rehearse a few times, mostly improvisationally.... I would do it over and over again for the camera until they felt they had all the pieces they needed for her to be drawn.[12]

For scenes with dialogue, she acted in synchronization with the soundtrack, so that the timing of her action would match the timing of the dialogue. Sometimes there were props, including "a little set constructed with hanging twine or ropes or something," to suggest the tree branches that grasp at Snow White as she flees after learning of the Queen's designs on her life.

In other words, Luske tried to make the staging and the timing

of the live action as close as possible to the result desired on the screen. That way, the animators could concentrate on the details that live action might reveal, that is, how Snow White's dress moved and how the figure itself turned in three dimensions. The multiple filmings of each action became, in effect, pencil tests from which Luske and possibly Walt Disney himself could choose what they liked best.

Disney did not want his animators to use this live action as diffidently as Art Babbitt did when he studied but did not copy sixteen-millimeter film of Pinto Colvig for his animation of Goofy in *Moving Day*, but Disney still approached the film of Marjorie Belcher as if he did not wholly trust it. Although he had members of his staff make tracings from the frames of live-action film—just as Max Fleischer did for his rotoscoped cartoons of the twenties— Disney did not want the tracings themselves presented as animation. Instead, the animators used them as guides for their own drawings of Snow White, altering proportions and revising not just the girl's appearance but also her actions, as needed.

Natwick's assistant Les Novros recalled that "Grim would get a sheaf of these tracings, and he would just flip them, and throw out every other one, or every ten of them, or something, retime it all, analyze it, study it, and then put it away."[13] Natwick may have used the tracings gingerly, as Novros said, but Natwick recalled that he used them willingly. Sometimes they "really did help," he said in 1976, "because you needed a basis to work on— but you always had to carry it further, and you always had to be very careful that you didn't depend on the rotoscope."[14]

Rotoscoping was tricky because no tracing of live-action film could do what good animation always did: distinguish the important from the unimportant. Lines in an animator's drawing could evoke a figure's shifting center of gravity, giving that figure weight and mass; in a tracing, they could do no more than locate body parts. But for Ham Luske in particular, live-action film held revelations that far outweighed such risks. He found in it subtleties that an animator might never think to introduce on his own. For him, live-action film was a way to extend the analytical interest in movement he had shown since his work on *The Pied Piper* in 1933. "Live action does much more than any animator in the place does," he said at a studio meeting on 8 December 1936, after working with the film of Marjorie Belcher for almost a year.[15]

Disney's virtual silence in the sweatbox sessions on the anima-

tion of Snow White testified to how well he thought this use of live action worked out in practice. As far as he was concerned, live action had permitted his animators to surmount the fundamental challenge, which was to create a reasonable facsimile of a human being on the screen; nothing remained but to tidy up around the edges. In fact, though, the idea of a different kind of Snow White—one that owed more to drawing and less to photography—did not die quite as easily as that.

When Grim Natwick spoke in later years of how his animation of Snow White fit together with Ham Luske's, he seemed to say that his work on the character was so independent of Luske's that he did not even know what Luske was doing: "I suppose Ham gradually dropped out, but I don't know."[16] As far as Walt Disney himself was concerned, though, Natwick was working under Luske's supervision. Disney's November 1935 memorandum said that Natwick and an animator named Eddie Strickland would "act in a way as assistants to Ham, handling [action] scenes under his direction, with Ham concentrating on personality entirely."[17] Many animators' assignments diverged very quickly from those that Disney envisioned in his memorandum, but Natwick's fundamental subordination to Luske remained: an animation cost analysis, prepared at the end of work on the film, showed him as one of seven animators in Luske's unit, four of whom animated the animals and three of whom animated Snow White.[18]

The other two Snow White animators were Jack Campbell, who worked with Natwick at first, as a sort of junior animator, before he started reporting to Luske, and Bob Stokes, who joined the Disney staff in January 1936. Because Stokes had such strong credentials as an animator of the human figure—he taught life drawing at the Chouinard School of Art in the early thirties[19]—he was hired as an animator (the same job he had with Harman-Ising) and not put through the preliminary hazing of inbetweening and assistant work. Stokes, unlike Natwick, had no difficulty recalling that Luske supervised the animation of Snow White, overseeing several animators, including himself, who in turn distributed work to as many as eight assistants and inbetweeners.[20]

Stokes did not remember Luske's animating any scenes of the girl himself, and it's clear that many scenes credited to "Ham" in the sweatbox notes were not his own work. At the beginning,

though, Luske was drawing Snow White as well as supervising the live-action filming. Dick Huemer, who shared a room with Luske and their assistants, recalled in 1979 that Luske "*did* determine and animate the first stuff by himself" and reworked the live-action Snow White "to make her figure conform to cartoon proportions," giving her a much larger head and thus a more youthful appearance.[21] It was apparently Snow White's "cartoon proportions" that precipitated conflict between Natwick and Luske. Natwick, even though he had originated the macrocephalic Betty Boop, resisted Luske's design in favor of more realistic proportions. That conflict "was not a friendly thing, really," Marc Davis said, because it was a proxy for disagreement of a more profound kind—one rooted, Davis believed, in the suspicion that westerners like Luske felt toward "the people who came from the East," Natwick in particular.[22]

Natwick was not only much older than many of the Disney animators (he turned forty-five in 1936) but he was a sophisticate compared with many of his colleagues. "If he saw something that was good," Davis said, "he wanted you to be a part of it.... I found out [from him] that wine could be white, and come in nice bottles, and be chilled." Natwick was at home not just in the world but in almost any studio; Luske, who had risen through the ranks at the Disney studio and had shaped its prevailing ideas as much as anyone had, could only have recoiled from the idea of transplanting himself as freely as Natwick did.

"Grim felt very strongly about corrections he was taking on the drawing of Snow White," Davis said in 1993, "and I kind of went along with that because I was working for Grim, I wasn't working for Ham. I wasn't about to make a little bubblehead out of her, as they were doing in the other unit." As Davis became aware of the hostility between Luske and Natwick, though, he gradually took it upon himself to make the necessary changes in Natwick's drawings. Those changes went beyond the character's proportions to what Davis called a "kind of feeling of the character"; Natwick, he said, wanted the girl to have "a vitality," more than simple cuteness, and it was that vitality that Davis had to tame.

What Natwick had in mind can be guessed from the handful of Natwick's drawings of Snow White that Marc Davis saved. In them, Snow White seems strikingly self-possessed, a sister to such actresses of the thirties as Myrna Loy and Carole Lombard. She is not the innocent fourteen-year-old that Disney specified in the earliest outlines, but older, and far more sexually mature. She

carries herself in one drawing (from a deleted scene) with shoulders up, chin raised, and eyes down, like a girl who knows she is being watched with an admiration that she doesn't want to encourage too much.[23] "Those were all things I had to take care of," Davis said. (Natwick was appreciative: having Davis as his assistant, he said in 1980, "was like having two right arms.")[24]

Natwick had shown himself to be highly adaptable in almost twenty years at other studios; once he had learned that his version of Snow White was not the one that was wanted, he surely could have drawn a girl that met Luske's specifications. Snow White was, however, the first character that offered Natwick the opportunity to exploit fully not just his draftsmanship but his other great asset as an animator. In the animation in the early Fleischer sound cartoons that can be identified with some confidence as Natwick's, on stylistic grounds (with some minimal help from the screen credits), the characters have a strong physical presence, far more so than in the work of animators of adjacent scenes. In the 1930 Screen Song *Mariutch*, for instance, when a very heavy Italian girl dances—she is a sort of elephantine Betty Boop—her belly rolls as if gravity were clutching at it. The Fleischer characters were, however, such peculiar creatures that the existence Natwick gave to them tended to be of an unsettling kind. Snow White was, potentially at least, a far more realistic figure in both drawing and movement. It is that kind of Snow White that can be glimpsed in the sketches that Marc Davis saved; and it was that kind of Snow White that Ham Luske rejected.

"How can anyone say what can be done with a human figure until someone tries?" Don Graham asked one of his classes in 1937. "Grim is the only one that has seriously tried it around here, and he hasn't had a chance to show it in a picture yet. But he has the knowledge."[25] Graham—who had no use for rotoscoping—may have been thinking of what happened to Natwick's Snow White. As Natwick's animation passed from his hands through countless others in 1936, on its way to the screen, only traces of his original conception survived. During the song "Whistle While You Work," for instance, as Snow White and the animals clean the dwarfs' cottage, the girl loads down a deer's antlers with clothes, and she looks for just a moment a little older and more knowing—less a happy child than a worldly young woman.

Luske had good reasons for fighting Natwick's vision of the character. Snow White, even drawn with "cartoon proportions," was inherently slippery; as Natwick said, she was difficult to draw

"because her eyes are floating.... When you've got a cartoon character, you've got bulges and bumps and circles, and you can tie things together, but with Snow White, if her eye got a little out of balance, the thing would immediately show on the screen."[26] So difficult was the character to draw that Marc Davis made a plasticine model of Snow White's head, a few inches high, "as a way to understand this thing in three dimensions."[27] To have made the character more realistic in design would have compounded the difficulties, if not for Natwick or Davis, then for all the assistants and inbetweeners and inkers who also had to draw Snow White but were not as talented as they were.

Beyond that, Natwick's conception of Snow White was at odds with the film as it was evolving. For one thing, by late in 1935 Disney had chosen a naive, childlike voice for Snow White. The voice was that of Adriana Caselotti, the nineteen-year-old daughter of a Hollywood vocal coach. Her voice was so tiny that sometimes, the sound editor Sam Slyfield said in 1939, she "could scarcely be heard at a distance of three feet,"[28] creating severe problems during recording sessions. A sweet child's voice would have made an odd fit with the girl in Natwick's drawings.

More fundamentally, Natwick's Snow White could not have helped knowing how much power her beauty gave her. It was that awareness—sexual at its core, and certainly consistent with the Grimms' story—that made her so dangerous. By the summer of 1936, when the friction between Luske and Natwick was apparently at its worst, Disney was well into constructing a story that required a charming innocent at its center; she had to be able to enchant not just a Prince but also gentle animals and grubby little men who had scarcely ever seen a woman. Introducing into this story a sophisticated young temptress, however interesting she might be, would tear it apart. The girl that Luske had designed and was nursing into existence through live-action filming and his own animation met Disney's requirements, even though she revealed at every turn—in awkward animation and uncertain drawing—how little experience Luske and his animators had in drawing such a character. With Snow White confined in such a way, her appeal would depend in large part not on what she did herself, but on how other characters responded to her. The triumph of Luske's version of Snow White, however much sense it made for the film as a whole, meant also that the animators of the dwarfs had a heavier load to carry: Snow White could shine most brightly only as she was reflected in the dwarfs' love.

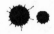

By early in January 1936, the dwarfs had undergone a significant casting change. Deafy had departed, replaced by a new dwarf, Sneezy.[29] With Deafy gone, none of the dwarfs had a name that suggested a serious physical affliction, and five of them—Doc, Happy, Bashful, Dopey, and Grumpy—had names that spoke more of personality traits than physical tics. The dwarfs were at last ready for development by Fred Moore and Bill Tytla.

In the first two months of 1936, Moore and Tytla worked on the dwarfs by themselves, without assistants of any kind. It's not clear exactly how they spent their time, but—with Walt Disney close at hand—they must have devoted much of it to feeling their way with the characters and refining them out of the sketches on the storyboards.[30] By 21 February, the dwarfs had emerged in a set of model sheets drawn by Moore. In his designs, the knobby, bony dwarfs of many of the earliest sketches had given way to dwarfs with button noses and comfortable bellies—little Santa Clauses, miniature men whose proportions barely echoed those of real dwarfs. Their cuteness was unmistakable, but also still a little generalized: the dwarfs were not yet so distinct that an audience could easily tell them apart.

With designs in hand, however tentative they were, Moore and Tytla could at last begin animating. They both started with scenes from what was known as sequence 6A, the washing sequence. That was going to be Tytla's sequence, but with Moore's bedroom sequence 5A evidently not quite ready, Walt Disney "wanted to get Fred started on something," Ollie Johnston recalled, and so Moore animated a scene in which Dopey struggles with a slippery bar of soap and finally swallows it.[31] Johnston began assisting Moore on 23 March, and even then, Johnston was only drawing inbetweens—as opposed to cleaning up Moore's rough drawings— in what was in effect a reversion to the work pattern of the early thirties.[32] Tytla apparently began working with a single assistant, William Shull, at around the same time.

Disney no doubt expected both Tytla and Moore to contribute to the final versions of the dwarfs. In the 16 April sweatbox session, when he saw their first animation of the dwarfs, he told them to get together and iron out the differences between their versions of Grumpy,[33] and in an August sweatbox he told Moore to "check with Bill Tytla for size and drawing of Doc's hands."[34]

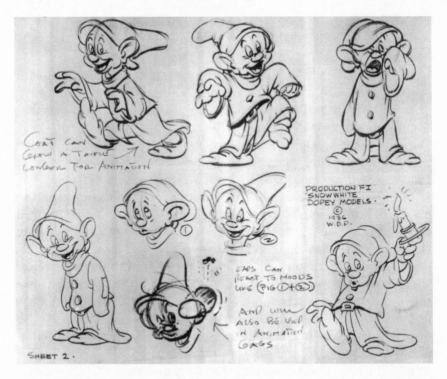

A 28 September 1936 model sheet of Dopey by Fred Moore, for Snow White and the Seven Dwarfs. *It was in a set of such model sheets by Moore that the dwarfs' appearances were at last fixed, after six months of experiment.* © *Disney Enterprises, Inc.*

There could never have been any question, though, but that Moore would take the leading role. The dwarfs were prime material for an animator like Moore, whose work made its strongest impression through charm and cuteness.

In his animation during the spring and summer of 1936, Moore transformed the little men in his February model sheets, much as he had transformed Hurter's sketches of the Three Little Pigs. The dwarfs went through a neotenic evolution, growing younger (despite their white beards and jowls), cuddlier, and more immediately appealing. Dwarfs who had looked dangerously similar grew apart as Moore found ways to distinguish them in both appearance and movement. As he explained later in 1936, he made Happy distinct from Doc, the dwarfs' officious leader—who was, like Happy, a stocky figure with a fringe of white beard—by treating Happy as "a cartoon of Otis Harlan," the jovial comedian who was providing his voice.[35] The changes that Moore wrought

were most noticeable in Dopey, the mute Dwarf. In Moore's 21 February model sheet, and in his earliest animation of the character,[36] Dopey was a bucktoothed imp, but subsequently Moore made of Dopey a far more babyish character, with a vacant grin and heavily lashed blue eyes.

Early in the fall of 1936, Moore produced a new set of model sheets of the dwarfs; none (the sheet for Dopey excepted) were radically different from the February sheets, but they were all more precise and detailed than those earlier versions. The new model sheets were dated 28 September—coincidentally or not, the day when Walt Disney approved the first dwarf animation (from Tytla's sequence 6A) for cleanup. It was at that point that definitive model sheets of the dwarfs were needed, since the assistant animators required such guidance when they were transforming an animator's rough sketches into drawings that an inker could trace onto celluloid.

The character who bore the lightest traces of Moore's influence was Grumpy, the only dwarf to resist Snow White's appeal. He was the irreducibly adult dwarf, the one who (in Moore's sequence in the bedroom) sourly pointed to the hazards in giving shelter to a girl whose death the Queen sought and then (in Tytla's sequence) refused to honor her wishes and wash for the dinner she was preparing. The September model sheet for Grumpy, although clearly from Moore's hand, was harder-edged than those for the other dwarfs because Moore used drawings from some of Tytla's scenes; he softened those drawings ("some of [Tytla's] Grumpy things Walt felt were not appealing enough," Ollie Johnston said, "and the drawing too wormy around the face"),[37] but not enough to erase Grumpy's wiriness. Most of the other dwarfs conformed so snugly to Moore's style that only Grumpy was an obvious vehicle for Tytla's animation; and it was through his animation of Grumpy that Tytla was giving shape to his distinctive ideas about cartoon acting.

By 1936, actors of many kinds were beginning to feel the influence of Constantin Stanislavski, whose Moscow Art Theater was a beacon for actors in the first few decades of the century. Stanislavski's "method," in its barest form, called for an actor to strive for emotional identification between himself and the character he was playing. That identification would be strongest at the actor's psychological core, in effect diminishing as it moved outward through the actor's physical actions—necessarily so, since the punch an actor threw, for instance, could not be a real blow.

Stanislavskian ideas about acting first achieved wide currency in America through Richard Boleslavsky's *Acting: The First Six Lessons*, published in 1933. Bill Tytla owned a copy of that book, which he probably bought in Hollywood sometime early in his work on the dwarfs (his copy bears the stamp of a Hollywood theatrical bookstore, and it's from the third printing, in October 1935).[38] He may have sought there answers to the troubling questions that Disney animation had begun raising, in cartoons like *Elmer Elephant* and *Moving Day*, just as production of *Snow White* got under way.

It was then, early in 1936, that Ward Kimball, who had been Ham Luske's assistant, began working on his first scenes as a full-fledged Disney animator, for a Silly Symphony called *Toby Tortoise Returns*. More than forty years later, he spoke of the difficulties that animated acting poses:

> Animation is very slow. When you're an actor, you depend on spontaneity in a scene, and it's hard to work up spontaneity when you're doing separate drawings.... The faster you can work, the more spontaneity, and that was one of the secrets of the early Ferguson animation drawing. He could draw almost as fast as he could think.[39]

Not many animators could draw that fast, though; the question was whether they could bring a Ferguson-like spark of life to their work in some other way. The teachings of Boleslavsky (and, behind him, Stanislavski) suggested that they could. Logically, the *repetition* that an actor's work entails—on the stage, certainly, and to a lesser extent in films—would seem to be just as deadening as turning out one drawing after another, each slightly different than the one before. But Boleslavsky argued that repetition was not at all alien to bringing real feeling into a part, but was in fact essential to it: "Gradually, it will take you less and less time. It will be just like recalling a tune.... All you will need is to have perfect bodily technique [for an animator, read drawing skills] in order to project whatever emotion you are prompted to express."[40]

By extension, analytical animation did not have to be a barrier to real feeling, but could instead be the means of concentrating and distilling it. Careful analysis, and the painstaking drawing it required, were potentially the threshold of a much greater subtlety of emotional expression than Ferguson, so limited in technique, could bring to his animation. What Ferguson achieved

through rough, rapid sketching, other animators might surpass by first mastering a character's actions and then moving through them, to the character's emotional life.[41] Tytla was not in thrall to an analytical style of the kind practiced by his closest friend, Art Babbitt, neither was he limited as a draftsman in the way that Ferguson was. There was no one better suited to explore the potential of a new kind of cartoon acting.

●ᐧᐧᐧᐧ ● ●

It was, however, Fred Moore who faced the most conspicuous acting challenge. Moore's bedroom sequence was by far the most dialogue-heavy stretch of film that any Disney animator had ever tackled. It was to run around 650 feet, or more than seven minutes, with most of that time taken up by dialogue. Although the surviving meeting notes reflect no such discussion, Walt Disney later told Bob Thomas that his rationale was that "we've got to take the time to have her meet each dwarf individually, so the audience will get acquainted with them. Even if we bore the audience a little, they'll forget it later because they'll be interested in each individual dwarf."[42]

For this strategy to work, the dwarfs had to emerge clearly as individuals through Moore's animation, and here the abundance of dialogue offered him advantages. There's scant evidence of how the dwarfs' voices were chosen, or when, but the recording of dialogue began by early in 1936, and the dwarfs' voices were almost all strong ones. Most of the voices were to be those of veteran character actors: besides Otis Harlan's Happy, there was Roy Atwell as Doc, Billy Gilbert as Sneezy, and Scotty Mattraw as Bashful. Their voices were distinct and yet not sharp in contour; Disney could reasonably hope that they would wear well over the length of a feature. The only nonactor among the voices for the six speaking dwarfs was Pinto Colvig, the story man who delivered Grumpy's and Sleepy's lines. His voice for Grumpy sounded a little forced when set beside the work of the real actors, but at least it bore scant resemblance to the brutally simple hayseed voices he had provided for *The Grasshopper and the Ants* and Goofy.

As Moore began his exploration of the dwarfs, he thus had a wealth of material to work with in the actors' voices and physical mannerisms. Tytla faced a different sort of challenge because his was a *musical* sequence—he had to work with timing dictated not

The dwarfs as they appear near the start of the washing sequence in Snow White and the Seven Dwarfs, the first sequence that Bill Tytla animated for the film. © Disney Enterprises, Inc.

by dialogue, but by a song, "Bluddle-Uddle-Um-Dum," to which the dwarfs were to wash themselves.

All the surviving evidence indicates that from the beginning Walt Disney conceived of *Snow White and the Seven Dwarfs* as a film spotted with musical numbers. It is easy to understand why he planned to give music so prominent a role in the film—not only had music been an organic part of the Disney cartoons since 1928, but work on *Snow White* began in the wake of *Three Little Pigs*, whose success was fueled by a tremendously popular song. Moreover, songs could deflect the audience's attention away from any shortcomings in the animation of the characters themselves.

Still, the Disney animators had been peeling characters and music apart, and now Tytla had to put them together again, under far more demanding circumstances: in a feature film, with seven characters who were supposed to be clearly different from one another. His work on *Cock o' the Walk* in the summer of 1935 had probably won him this assignment. In a January 1936 meeting on *Snow White*'s evening musicale (called the entertainment sequence), Walt Disney said in a stenographer's summary that

Tytla "is good on things that have a definite pattern"[43]—a remark that Disney could have based only on Tytla's animation of dancing chickens.

As Don Graham told one of his classes on 7 June 1937, Tytla's *Snow White* sequence entailed "taking the toughest kind of a problem—seven characters all working at the same time—and giving each one personality, yet keeping each one composed, and on top of that, giving a definite feeling of life to the whole scene."[44] That the sequence was musical simply compounded the difficulty. Three weeks later, Tytla spoke to the class about the pains he had taken to preserve the sense that the dwarfs were individuals, in scenes showing six of them gathered around a trough to wash:

> There were six characters, and every one was drawn on a different piece of paper because I wanted to get a different type of reaction and spacing for each character, each reacting according to what I considered his mental reflexes; Sleepy very slowly—when everyone in position was taking in the dialogue, Sleepy would just be going into it. This handling gave the scene a soft kind of feeling and not a mechanical one as if a company of infantry were present and on the order, "Eyes right" all eyes went right.[45]

In effect, Tytla relied on the music—and the rhythmic structure it imposed on the dwarfs' movements—to strengthen the sense that the dwarfs were a cohesive group, while his animation of each dwarf suggested their differences.

Graham devoted most of three of his weekly classes in June 1937 to analyzing and praising Tytla's animation. He spoke with particular enthusiasm of the scenes at the beginning of the sequence when Grumpy, angry with Snow White, leaves the dwarfs' cottage and seats himself on a barrel. Tytla's drawings did not have a "cut-out feeling," Graham said, but instead "one of life and caricature in three dimensions." As Graham pointed out to his class, Tytla used his strong drawing to enhance subtly constructed action: "the way movements are used to oppose each other—the way the hands cup—the way the feet play in and out of each other—the way the heels are used—the way the head is tucked down low and how the straight lines of the eyebrow enhance the whole drawing."[46] The effect on the screen is, however, anything but studied. Above all, Grumpy is highly elastic: his face and body change shape freely, his features move about his face, one expression flows effortlessly into another. As Tytla's

principal assistant, Bill Shull, told the class: "I get a kick out of the way Tytla will distort something—the forefinger on a hand, per- haps—stretch it out so that it looks almost silly. When you see it on the drawing you would swear it meant nothing, but on the screen these things seem to hold the scene together."[47]

Tytla's distortions succeed in that way because there is nothing arbitrary about them. Instead, every change in Grumpy's physi- cal appearance mirrors what is going on inside his head: his indig- nation at Snow White's orders to wash, his determination not to obey, his astonishment at the others' compliance, his contempt for it. The most extreme distortions, concealed in single drawings that an audience can feel but not really see, mark the strongest emotional transitions. Likewise, gestures that could have seemed hackneyed—that pointing forefinger, for example—are instead nothing of the kind, because it is so clear that Grumpy would express himself in that way.

This was acting of a kind that could be expected to flow from applying Boleslavsky's principles to animation. Tytla had com- pletely mastered the physical demands of his "role"—he made masterly use of all the animation principles that his Disney col- leagues had adopted earlier in the decade—but rather than stop there, he had used that mastery to make Grumpy not just physi- cally but emotionally three-dimensional. This acting was, howev- er, *cartoon* acting, and, as Tytla demonstrated, such acting could go well beyond what Boleslavsky and Stanislavski had in mind, and not just in the circumstances of its production.

A method actor was supposed to make visible to his audience, through his face and body, the movement of his character's thoughts and emotions; the actor could not reveal his character through dialogue alone. In his posthumously published writings, Stanislavski said: "The more immediate, spontaneous, vivid, pre- cise the reflection you produce from inner to outer form, the bet- ter, broader, fuller will be your public's sense of the inner life of the character you are portraying on the stage."[48] In Tytla's anima- tion of Grumpy, that gap between "inner" and "outer"—the gap that Stanislavski called upon the human actor to bridge—simply did not exist. Whatever passed through Grumpy's mind, it seemed, was simultaneously visible in his face and body, through acting of a kind that was possible only with a cartoon character.

Tytla and Moore had given Grumpy exaggerated and simplified features; like the other dwarfs, Grumpy wore a face that sum- moned his name. The two animators had gone much further,

though, by giving all the dwarfs what Frank Thomas and Ollie Johnston have called, in a general statement about character design, the "potential for movement in all parts of the body."[49] When Fred Moore described some of the dwarfs, he talked not just about how their features differed, but about how those features moved:

> Doc has medium large eyes with glasses, and has heavy jowls. Happy's eyes and nose are much smaller and flatter. His jowls spread out when he rolls his body around.... When he smiles, his cheeks will relax and jowls spread right out. Doc's fit his face. Happy's [are] more flexible than Doc's.[50]

In the dwarfs' faces and bodies, expression did not have to strain against an antique design like Mickey Mouse's, but neither did it have to strain against a design that was particularly elaborate.

"I've always felt that characters should be uncomplicated," Grim Natwick said many years later. "Then put the complicated things into the animation."[51] No Disney characters had ever been better vehicles for "complicated things" than the dwarfs. When Tytla had worked his way through an analytical kind of animation of Grumpy to an emotional comprehension of his character, there were no barriers in that character's design to revealing the full measure of Grumpy's feelings. Grumpy thus seemed to behave as naturally as the best human actors, but in a far more direct way, because his features and his body lent themselves so completely to expression. By exploiting the opportunity that Grumpy's design offered him, Tytla caricatured not just what Walt Disney in his 1935 memo to Don Graham called "life and action," but a much more profound and elusive subject: thought and emotion.

Moore in his bedroom sequence did not reach quite the same high level, in either his drawing or his animation. Natwick's comment on Moore was surely too harsh: "He never seemed to get the hang of drawing the Seven Dwarfs. He made real dummies out of them, kind of like feed sacks or something."[52] But it had some truth in it. Even though the dwarfs were, in their design, largely Moore's creatures, his work suffered when set beside Tytla's versions of the same characters. The nature of Tytla's sequence allowed him to present no more than two of the dwarfs—Grumpy and perhaps Doc—as fully as Moore did, but whenever Tytla had the opportunity, his dwarfs emerged more distinctly than Moore's. Tytla gave to Doc a physical bulk and a genial

condescension toward the other dwarfs that made him immediately plausible as their leader, in a way that Moore's cuddly fuddy-duddy was not. All of Moore's dwarfs lacked the vivid directness of Tytla's Grumpy; as personalities, they were more of a patchwork, cobbled together from voices and actors' mannerisms. Dwarfs who were infinitely pliable in Tytla's hands could seem soft and doughy—"feed sacks"—in Moore's.

Moore's animation was, nevertheless, an impressive advance over what most of his colleagues had done. There was the rub: if Tytla had pulled so far ahead of Moore, one of the studio's strongest animators, how would the dwarfs fare when they were delivered into the hands of animators who lacked Moore's gifts?

When Tytla spoke to Graham's class in June 1937, he described the filming of a scene for a D. W. Griffith feature (almost certainly *The Struggle*, Griffith's last film) as he had witnessed it in New York a few years earlier. He remembered how sharply a stand-in's performance differed from the actor's performance that followed it. The stand-in's performance had "no intensity, no feeling of emotion in it," Tytla said.

> The same thing can happen in animation—it just means the character comes over, picks up a chair—there is no feeling of weight, nothing to it.... There is all the difference in the world when an actor does the same piece of business. There is a certain phrasing—a certain sense of movement....
>
> In running over all the [pencil] tests, that is what amazes me most—after all the effort which is very obvious and broad, the action is nothing because the fellow is not an actor and conveys nothing.[53]

To judge from the length of the transcript, Graham's class lasted two to three hours that evening, but Tytla spoke about acting at no other point. Instead, he and Graham bore down repeatedly on what might have seemed like a given at that point in the Disney studio's history: the need for good drawing. Tytla addressed what he saw as a certain disdain felt by the "average man" at the studio for all the opportunities to learn and improve: "The tendency of the average man here is to take these opportunities with a sneer because he feels they are going to a terrific amount of trouble for 'ducks.'"

Tytla and Graham had read their audience—made up mostly of assistants and lower-ranking animators—correctly. The class members' questions, on 28 June as at meetings earlier in the month, revealed a stubborn bias toward a conventional, mechanical kind of animation. When, for example, Graham spoke on 21 June of eliminating "trick methods of doing certain things—stock actions," a couple of class members resisted. What was needed, said one, was simply *better* stock actions.

That such attitudes were still widespread in the studio in mid-1937—a year and a half after Tytla, Moore, and Luske began work on *Snow White*—suggests how large a challenge Walt Disney faced in the fall of 1936 when the dwarfs, and the story, had finally jelled to the point that he could expand the number of animators working on the film. Tytla's kind of animation in particular demanded strong draftsmanship, not just by the animator but by his assistant as well. As Tytla told Graham's class, he relied heavily on Bill Shull to produce the drawings that actually went to the inkers: "If you have faith in your first assistant and you *know* he will draw in the rest for you, and will give it the roundness and solidity and everything else it needs, you feel free to concentrate on trying to convey a certain sensation."

By the fall of 1936, strong draftsmen were at least more numerous on the studio's staff than they were early in the year, when Shull began assisting Tytla on the dwarfs. Some of those artists had come to Disney's as a result of the trip that Graham and George Drake made to New York in the spring. Graham and Drake had set up a "school" for promising recruits on the eighth floor of the RKO Building in Rockefeller Center; they were looking, they told the *New York Times*, not for geniuses but for "adaptable" artists.[54] Les Novros and David Hilberman, who were among the artists they chose, remembered attending classes in New York for six weeks or so, drawing from a model and doing what Novros called "elementary animation tests"[55]—for no pay.

In July, after Graham and Drake returned to Los Angeles, *Daily Variety* reported that thirty-five hundred artists had applied for jobs through the New York screening program. Only twenty-nine applicants had been chosen to work at the studio; nineteen were already there, with the remaining ten soon to arrive.[56] Within weeks, some of those new artists, like Novros and Hilberman (who became Tytla's second assistant), were assisting *Snow White* animators.

By 1936, Disney also had his first few post-Graham animators:

well-educated young artists who had learned to animate after
Graham began teaching his evening classes. When measured
against the demands of the feature, though, the reservoir of draw-
ing talent was still disturbingly small. Draftsmanship was, in addi-
tion, only part of the challenge—and probably not the largest
part—that was emerging as Disney and his writers wrapped up
work on sequence 4D, called "spooks," in October 1936. This was
another sequence devoted almost entirely to the dwarfs: return-
ing from their mine to find their cottage clean, they conclude,
amid a string of comic mishaps, that some monster has invaded
their home. This sequence would give the audience its first good
look at the dwarfs and would lead directly into the bedroom
sequence. It was yet another sequence in which the dwarfs had
to emerge clearly as individuals, clearly enough that the audi-
ence, as well as Snow White, could guess each one's name by the
time she saw the row of dwarfs at the foot of her bed.

Tytla and Moore were both still working on their pilot
sequences—still showing rough animation for many scenes, in
fact. Their work might go a little faster now that it had been set-
tled what the dwarfs would look like (so that there was no need
to go back and redraw animation based on earlier versions of the
characters), but it could not go fast enough. Other animators
would have to take up the slack.

The process of bringing other animators onto the film began no
later than 26 October, when someone—perhaps Walt Disney him-
self, although no one's name is on the document—dictated "sup-
plementary action notes" for Moore's bedroom sequence; those
notes specified that Frank Thomas would animate several scenes
at the beginning of the sequence, when the dwarfs tiptoe into the
bedroom, still thinking that Snow White is a monster.[57] Because
Thomas had preceded Ollie Johnston as Moore's assistant (and
then animated almost a year on shorts), he was probably the best
prepared of the animators who were waiting in the wings.
Integrating the work of the other animators—Art Babbitt and Dick
Lundy among them—threatened to be more difficult, especially
since there was no way that Disney could spend as much time
with them as he had with Moore and Tytla.

Starting on 3 November, Dave Hand led a series of Tuesday-
night meetings intended to acquaint the new animators who were
coming onto *Snow White* with the film's characters. Even though
Disney had started the year planning to direct *Snow White* him-
self while the other three directors continued to make shorts, he

was by the fall of 1936 delegating to Hand a supervisory role over the whole of *Snow White*. Hand had, in effect, been grooming himself for that role for several years, and probably Disney had settled on him as his second in command long before Hand directed his last short cartoon, *Little Hiawatha*, that fall; Hand attended far more *Snow White* meetings in 1936 than Wilfred Jackson and Ben Sharpsteen, the other shorts directors.

Disney was not present at the earliest of the Tuesday-night meetings, but his name was invoked constantly. Here was Ham Luske in the first meeting, for instance: "These characters are the way Walt sees them. There is no need to find a way to change them; this is the way he wants them. This is a pattern." Likewise, the writer and director Perce Pearce, as he described the dwarfs, used Disney's name in a way that brooked no argument: "Walt feels very strongly...that we have got to keep these little fellows cute—mustn't get grotesque."[58]

Pearce's emergence as a director was another signal of the change the studio was going through as the *Snow White* staff expanded. Pearce had joined the staff as an inbetweener only a couple of years earlier;[59] he was involved in the writing of *Snow White* by the end of 1935, and when story work on the spooks sequence ended in October 1936, it was he—and not one of the shorts directors—who was tapped to direct it. What won him that assignment was not any expertise as an animator, but rather his ability to bring out the personalities of the dwarfs as he acted out a scene. As a sequence director, Pearce would play a role with his animators similar to the one that Walt Disney had played through-out 1936 with Tytla and Moore: not providing technical help so much as guiding their interpretations of the characters.

As Pearce acknowledged in the 3 November meeting, though, translating the dwarfs' personalities into animation was "a hard thing to catch. Take Dopey for example—Dopey has been an awfully tough problem. He is not an imbecile. He is full of fun and life.... It is more that he is a little guy that hasn't grown up."[60] On an even more fundamental level, there was still worry that the audience wouldn't be able to tell some of the dwarfs apart. By the third meeting, on 17 November, Hand was baiting the anima-tors: "We are going to lose them [the audience] because I haven't enough confidence in you animators to tell the difference between these dwarfs." He did not exempt Moore and Tytla from his criticism: "I say that I have looked at the reel many times, and I don't know what characters are being presented to me."[61]

Hand spoke on this and other occasions like a classic straw boss—goading his men, ruffling their pride—but here it is easy to believe that he felt the first stirrings of real fear. Walt Disney had entrusted the dwarfs to him, and now he could see them slipping into mushiness. He pushed for giving each dwarf obvious mannerisms, so that they would be recognizable even in the least accomplished animation: "We must have each one doing something so that you just couldn't miss." In that 17 November meeting, even more than in the first two, the members of the group, with Pearce in the lead, rummaged through the dwarfs' personalities, trying to isolate critical elements in each one. Hand invoked Babbitt's animation of Goofy as an example of what he was striving for, but Babbitt himself objected, speaking in terms strikingly evocative of Stanislavski: "The feeling that I get tonight is that everybody has found some superficial mannerism that is supposed to describe the character. You have to go deeper than that. You have to go inside—how he feels." No one else echoed his concern.

It was in the next Tuesday-night meeting, on 24 November, that Hand began to fasten on what looked like a solution to his problem. It was the tool that Ham Luske had already used extensively and that none other than Bill Tytla had used in his groundbreaking animation of Grumpy: live-action film.

Live action had been lurking around the edges of the dwarf animation almost since Tytla and Moore first put pencil to paper. The studio shot film of real dwarfs named Tom, Erny, and Major George—the assembled animators watched such film at the second of the Tuesday-evening meetings, on 10 November 1936, and again on 15 December—but it had little or no effect on the animation. Walt Disney cast about for a long time for characteristics in those real dwarfs that the animators could adapt for one or more of the Seven Dwarfs, Dopey in particular ("One of these characters has to look like a dwarf," he said at the 15 December meeting),[62] but real physical deformity was at odds with cuteness.

The more significant live-action filming, which probably began early in 1936, was of a burlesque comedian named Eddie Collins;[63] he became the model for many of Dopey's actions, fleshing out a conception that was otherwise, as Disney himself said, a mixture of traits borrowed from film comedians like Harry

Langdon and Harpo Marx.[64] Dopey was, like Langdon, a full-grown baby, but he had a sense of mischief and an almost lecherous enthusiasm for Snow White that owed more to Harpo. (Disney rejected the idea of filming Langdon himself: "He is not sober half of the time and not dependable.")[65] From all appearances, Collins was filmed more as a source of ideas than as a guide for the actual animation.

Sometime early in 1936, though, Tytla and Disney directed Pinto Colvig—Grumpy's voice—in live-action filming that was not far removed from what Ham Luske was doing with Marjorie Belcher. They shot Colvig performing Grumpy's actions at the beginning of sequence 6A, the washing sequence, as Grumpy, fuming, takes a seat on a barrel. When Dave Hand showed that film to the animators at the 24 November meeting, he pointed out the similarities between what Colvig did and what Tytla drew: "Notice how Bill Tytla got the same thing in his animation."[66]

Hand spoke as if he saw real promise in such use of live action but hesitated to plunge into it: "It's a lot of work, but if it's going to help you animators to get personalities of the dwarfs, we will be glad to do it for you." Hand expected that he and other members of the staff would play the parts of the dwarfs. Pearce might not pass muster as an actor on a stage, but he could, presumably, put across what he wanted in a scene, and live action could thus serve as a highly specific handout when an animator began work. As Hand put it: "The value of live action is the working agreement between the animator and the director."

Some live action with studio "actors" had already been shot for scenes that Dick Lundy was animating for the spooks sequence. After seeing that film in the 24 November meeting, both Babbitt and Tytla, the two animators present who had already used live action, spoke enthusiastically about the possibilities. Babbitt offered a caveat, though: "I would like to repeat once again the objections that Walt has [to the use of live action]; heretofore there has always been the tendency to take the idea, file and copy it." What made that "tendency" so alluring was its promise of efficiency: the more closely the animators hewed to live action, the more quickly and smoothly their work might make its way to the screen, and Ham Luske and Grim Natwick had already shown in their work on Snow White that skilled animators could buff away the most obvious evidence of live-action origins.

When the animators and directors assembled for another discussion of the dwarfs on 8 December 1936, Luske was with them,

praising live action as a resource. Lundy, the animator who was already using live action for his part of the spooks sequence, found himself under a cloud for not using it enthusiastically enough. Lundy had looked at the film, animated in his usual manner, then "checked [the live action] over and saw what I missed, and redrew the whole thing." Hand was clearly concerned that if other animators followed Lundy's lead, live action would not speed up production. To show the animators what he wanted them to do, Hand pointed not to the likeliest exemplars, the animators of Snow White, but to the way Tytla had used his film of Pinto Colvig. Tytla's animation of Grumpy was run simultaneously with the film of Colvig to, in Hand's words, "show you animators how to use the live action properly." That live-action film has not survived, so there is no way to compare it with Tytla's animation. Tytla spoke that night, though, as if he had simply exaggerated Colvig's actions. Even the timing of his animation was very close to the timing of the live action, he said, "a couple of frames one way or the other."[67]

The live action and the animation must have been very different, though, even if Colvig performed Grumpy's actions with the abandon of the circus clown he once was. There is not the slightest whiff of rotoscoping in Tytla's animation, and it's inconceivable that so implacable a foe of rotoscoping as Don Graham could have praised Tytla's animation so highly if he saw in it any traces of a dependence on live action. Rotoscoping was, Graham said in mid-1937, "a crutch" for animators who had not learned to draw well enough.

Tytla evidently took for granted certain things about his use of live action that made all the difference. Presumably, for instance, the timing of his animation was so close to Colvig's because Tytla directed Colvig's performance and got from Colvig the same timing he envisioned for his animated character. There are hints, too, in what Tytla said, that he used live action to solve what were essentially mechanical problems ("It saves trying to figure out exactly how a certain character would do a certain thing") and to strengthen his animation more than shape it. "Sometimes after I rough out a thing," he said, "I run a black and white [the live-action film] through [on a Moviola]; then suddenly I see something that would help me improve on my sketches." Used in that way, live action could be the servant of animation, helping the animator to enhance what remained a fundamentally animated conception. That conception had to be, like Tytla's, rooted in an

understanding of the *acting* that successful animation required; if it was, then the use of live action could be, like the endless drawing and redrawing that animation involved, a way of working through to the heart of the character—and no more confining than an easel painter's use of a live model.

There were, then, no shortcuts to be found in live action the way Bill Tytla used it. But that was surely not obvious to Dave Hand that evening, since he envisioned far more live-action shooting. Walt Disney first attended one of the Tuesday-evening meetings a week later, on 15 December 1936, and mostly he talked at length about what he saw in each of the dwarfs. Early in the meeting, though, out of the blue, he started talking about Hand's planned use of live action: "I am afraid of this live-action stuff.... There are so many people starting in on this, and they might go haywire if they don't know how to use this live action in animating." Hand made the obvious defense: "We feel that we are getting towards a consistency in each animator's drawing of these characters by using live action." There was no hint that Disney was ordering Hand to pull back from his use of live action; Disney certainly retained ultimate control, but Hand was the one who would decide how to get the dwarfs onto the screen.

In early February 1937, Hand met with a group of assistant directors on *Snow White*, the people whose job was to keep track of everything that was going on in the directors' units. He told them that live action was going to be used "on all important action of the dwarfs.... We make the animator direct the stuff so he gets it in his head." Studio personnel were playing parts: Colvig was Grumpy ("Put a big nose on him and he'll act all day for you"), and Pearce was "good on some of the dwarfs." The studio was paying Eddie Collins to perform as Dopey: "He comes down for twenty dollars a morning, up till 11:30."[68] A couple of weeks later, at a luncheon meeting with Walt Disney and eight other directors and writers, Hand spoke expansively of how live action was speeding up work. "Live action is what is going to lick the picture," he said.[69]

More live action was shot in the weeks ahead, but probably not nearly as much as Hand anticipated, judging by the scanty references to such film in the voluminous notes from studio meetings. By July 1937, Don Graham was speaking to his action-analysis

class as if the use of live action had turned out to be a failure: "When the dwarfs were rotoscoped and it was found that this was not satisfactory, the animators went right ahead and got what they wanted."[70] The dwarfs were far more cartoon characters than Snow White was; they did things that simply could not be adequately encompassed in live action. When Perce Pearce spoke about Dopey on 3 November 1936, in the first of the evening meetings on the dwarfs, his most telling comparison was not with a live-action comedian but with one of Disney's own stars: "At times there is great violence done him—just like [Donald Duck].... Whether he gets socked on the head or whatever it is, it never hurts him."[71]

There was a larger problem: over the previous few years, Disney and his directors had cultivated an atmosphere in which animators felt encouraged to experiment and develop characters; now, on *Snow White*, they were expected to hew closely to designs and characterizations that other people imposed on them. The contradiction between the old and the new showed itself as soon as Art Babbitt began turning in his scenes for the spooks sequence.

Babbitt was animating scenes with Dopey, a natural enough assignment, given his success with Goofy, and Walt Disney spoke optimistically about Babbitt at that February 1937 lunch meeting. Just two weeks later, though, on 3 March, Hand and Pearce confronted Babbitt in the room known as Sweatbox 4. Hand was blunt, accusing Babbitt of "going off in your corner" and presenting animation that was "entirely out of line" with what the directors wanted. Although Babbitt took the blame, he also said, in effect, that he had done nothing more than what he had done before.[72] That was true; in the years before he began work on *Snow White*, Babbitt had won esteem in the studio by taking liberties of just the kind (adding footage to his scenes, for example) that were now being charged against him. The kind of "exploring" of characters that Babbitt had done in the past, and that he defended now, was at war with the need to present the dwarfs consistently throughout the feature.

Babbitt was the extreme case, but what was happening to him was also happening to some extent to other animators. By the early spring of 1937, it was becoming clear that there was going to be no simple way to achieve consistent and satisfying characterizations of the Dwarfs; instead, Disney and his animators and directors would have to fight their way there, scene by scene. It

was this struggle that Disney referred to when he told his daughter and biographer Diane: "We had trouble with the Dwarfs...only you don't know it. That was a studio secret. I had to use different artists on various scenes involving the same dwarfs. Doing it that way made it hard to prevent variations in the personality of each dwarf."[73]

Disney seems not ever to have contemplated assigning particular animators to particular dwarfs, so that, for example, Tytla would animate Grumpy every time he appeared. Probably the sheer number of dwarfs made such a choice seem unrealistic; as Dave Hand said a few years later, "There were so many of the damn little guys running around, and you couldn't always cut from one to the other.... We had to cut to groups of three and four, so it became a terrific problem of staging."[74] Even though animators had been sharing scenes for several years—and would continue to do so in *Snow White*, so that, for instance, Snow White as animated by Luske is on the screen at the same time as a dwarf animated by Moore—the idea of several animators sharing a scene that showed several dwarfs (not to mention a scene that showed all seven) must have seemed wildly impractical.

By the spring of 1937, though, it was clear that the course that Disney did choose—having Tytla and Moore develop all the dwarfs in their two pilot sequences—had its own, equally severe disadvantages. Not only was their work not entirely compatible with each other's, but it was going to be very difficult for other animators to produce animation that resembled theirs. And yet there was no alternative: there was no way that Tytla and Moore could handle all the remaining dwarf animation. Reconciling the different versions of the dwarfs thus promised to be at least as grueling a task as dividing up the Seven Dwarfs among seven different animators would have been. Art Babbitt, who might have come up with a perfectly satisfactory Dopey if he had animated that character from the start, was instead banished from the dwarfs after he finished his work on spooks. He was sentenced to animate the Queen—a cold and unappealing figure, even closer to live action than Snow White herself—in the film's opening scenes.[75]

As if aware of such problems, Disney spoke at the February 1937 lunch meeting of pairing animators with particular dwarfs as much as possible: "It will be good to keep certain guys on certain characters.... I think Tytla is better on Doc and Grumpy." (At the same meeting, he decided to put one man—it turned out to be

Moore's assistant, Ollie Johnston—over the other dwarf anima-
tors' assistants, to bring some uniformity to their cleaned-up
drawings.) Tytla and Moore came on the spooks sequence months
after Babbitt and the other animators and animated only a hand-
ful of scenes—Moore's were not seen in sweatbox until May. After
that the two animators were hoarded for use on a few critical
scenes in other sequences.

However effectively Disney might deploy his best animators,
he couldn't spread them thin enough. In the early months of
1937, two long sequences with the dwarfs went into animation
with neither Moore nor Tytla involved. In one, the dwarfs
scrounged for places to sleep after sending Snow White upstairs
to their bedroom; in the other, more elaborate sequence, which
was to follow the washing sequence, the dwarfs were to slurp
soup as Happy sang "There's Music in Your Soup."

The soup sequence was the subject of one of the last of the
Tuesday-evening meetings devoted to the dwarfs, on 29
December 1936. More than two dozen animators gathered to hear
the recorded dialogue. They weren't being asked to pick at the
story; as Perce Pearce said, "This sequence is set as far as Walt is
concerned." But the animators revealed a lot of discomfort with
the sequence, and they voiced reservations that went, signifi-
cantly, to characterization. Did it make sense for Happy, and not
Doc, to take the lead at the table? Would Doc really be so uncouth
as to dunk his roll and squeeze the soup into his mouth? Those
were odd questions to raise about a sequence that was ready to go
into animation, and Dave Hand moved in to beat out the fire: "We
have got to trust in one man's judgment or we won't have a good
picture."[76] In this case, though, there was good reason to fear that
Walt Disney's judgment was faulty—that, in fact, long stretches of
the story as it then stood would work against the very characteri-
zation that was the subject of such intense scrutiny at the
Tuesday-evening meetings.

When Disney attended two Tuesday-evening meetings with the
animators in December 1936, he was almost like an emissary
from the story department, which had absorbed a great deal of his
time in the preceding weeks. On 22 December, he urged upon the
animators the importance of the spooks sequence: "Our effort is
to plant these characters very definite as we move this sequence

through." But even the elite animators seem to have been ignorant of just how the spooks sequence fit into the story as a whole; it was Fred Moore who asked Disney, "How much is there of the picture before this sequence?" Disney replied by summarizing the Grimms' version of the fairy tale and explaining how his version would differ from it: "We put in certain twists to make it more logical, more convincing and easy to swallow.... We have developed a personality in the mirror and comic personalities of the Seven Dwarfs." Then he plunged into an extraordinarily detailed telling of the entire film story.[77]

That "general continuity as talked by Walt" was extracted from the transcript a few days later and distributed within the studio in hectographed copies. It confirmed a significant evolution in the story in the two and a half years since the writing got under way. For example, the 22 October 1934 outline had Doc delivering a "tear-jerker" of a prayer over the seemingly dead Snow White, but now Disney expressed a new trust in restraint: "We show very little action as we show these different dwarfs around there in their sad attitudes." (In a meeting two days later, on 24 December, he made his decision explicit: "We aren't going to have a prayer at the end for these guys to say at all.")[78]

In other respects, though, the story as Disney told it was alarmingly weak. It was still cluttered with episodes that had been part of the plan from the beginning and were superfluous at best; the soup sequence was one, as was the lodge meeting the dwarfs were to hold after they left Snow White to go work in their mine and the bed-building sequence that was to follow. Most dangerous of all, perhaps, was a dream sequence that would show Snow White and her Prince dancing in the sky, just before she sang "Someday My Prince Will Come" to the dwarfs.

The gravest threat to *Snow White and the Seven Dwarfs* always was that Disney would fall back on the sort of crude comedy and sentimentality that would amount to a confession that he lacked confidence in his story. By the end of 1936, that threat had diminished so far as the handling of any given sequence was concerned, although it still bobbed up occasionally. (At the meeting on Christmas Eve, for example, Disney talked about whether the Queen's body should be heard hitting the ground when she fell to her death: "I thought we might get a comic effect out of the boom; to relieve the tension.") The larger threat now was from whole sequences that by their very triviality would diminish the rest of the film. The comedy in the soup sequence, for instance, was to

be mostly mechanical, with the dwarfs little more than inter-changeable parts—thus the animators' unease at the 29 December meeting.

The bizarre dream sequence, as described in a five-page outline in November 1936, called for Snow White and the Prince to meet in the clouds beneath a "love tree" bearing "heart-shaped fruit"; the fruit would "begin to pit-a-pat very fast" when Snow White heard the Prince's voice. It was in talking about this sequence in an 8 December 1936 meeting that Disney made his motives clear: "A lot of people haven't liked the idea of getting too obvious, with a swan boat with heart-shaped sails, but...remember this thing is built for Oshkosh and places all over. If the audience sat down and tried to imagine something, they'd imagine [heart-shaped] sails, and when you do it, you please them. I think we should be obvious with the thing and at the same time clever.... I felt this sequence would be for the women."[79]

The writing of all these sequences proceeded slowly late in 1936 and early in 1937. There is always the sense in the meeting transcripts of a general lack of enthusiasm, even on Disney's part, but scarcely a hint that the sequences should be scrapped. It was not until 9 February 1937 that Ham Luske suggested dropping the soup sequence entirely: "It's not funny enough to go with it." Disney was defensive, but even he sounded doubtful; "I definitely felt from this track [they had heard the dialogue but seen no animation] it was very long."[80] At a 23 February meeting on the lodge-meeting and bed-building sequences, the words "monotonous" and "monotony" turned up with an ominous frequency.

The momentum was, however, all in the other direction. The urgency that Dave Hand felt as he tried to find some way to control the animation of the dwarfs was everywhere evident in the studio in the early weeks of 1937. So intent was Disney on completing the writing of his film that he devoted dozens of hours to story meetings; on 5 January, for instance, he attended meetings from 10 A.M. to 9:45 P.M., with breaks only for meals. Now that the story as a whole had acquired so definite a shape that large chunks of it could move into the hands of the animators, nothing could have been less welcome to Disney than suggestions that it was still seriously flawed.

Within a few weeks, though, the furious activity that had consumed the studio since the beginning of the year had taken on a subtly different character. Not only had Disney begun his arduous sculpting of the dwarfs in the sweatbox sessions on the spooks

sequence, but he was approaching the rest of the film in a similarly determined spirit. By early spring, the sequences that were occupying the largest part of his time in story meetings were those with the Queen, both as herself and as transformed into a hideous crone. Even though the horrific excesses of the original outlines had disappeared by 1937, these were still treacherous sequences. Perhaps for that reason there is evident in the meeting transcripts no rush to get the sequences to the animators.

In the few remaining sequences with the dwarfs, too, Disney relentlessly honed and polished. The entertainment sequence, in which the dwarfs play, sing, and dance for Snow White, turned out to be tricky not only because it required combining music and action in intricate patterns—this was a sequence that Wilfred Jackson would direct—but because Disney did not want to compromise the characterization of the dwarfs.

Characterization was even more crucial for sequence 10A, in which each dwarf was to get a kiss on the head from Snow White as he left for the mine; it was here that Grumpy's harsh facade would begin to crumble. The work on this sequence resembled a Stanislavski-style rehearsal, as Disney and his writers tried to get the action right, leaving the exact words till last. (In these transcripts, especially, story work on *Snow White* resembles the staging of a play more than the writing of one.) Disney was consistently sensitive to his characters in work on sequence 10A, realizing, for instance, that Dopey—here at his most Harpo-like, puckered up for a big smack on the mouth—should try to get *three* kisses from Snow White, and not just two. She gives him the second, tilting his head down by the ears to kiss him on his crown, but not the third, gently shooing him on his way instead. As a result, Snow White seems sweetly indulgent, but not *too* soft; having her deny Dopey a second kiss—the original plan—would have made her seem a little cold.

Two critical meetings on sequence 10A took place on 7 and 12 January 1937, in the midst of meetings on the much weaker sequences devoted to the dream, the lodge meeting, and the building of the bed. Disney himself must have been aware at some level of how much sequence 10A, with its finely tuned character relationships, differed from the others. By 16 March, when a final story meeting on 10A took place, Disney was just three days away from watching pencil tests for the whole of the soup sequence. By 2 July 1937—when Disney watched pencil tests for most of sequence 10A, including scenes animated by Bill Tytla,

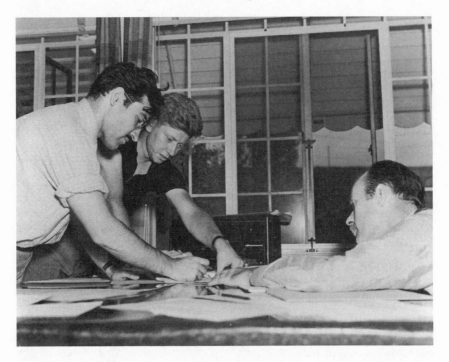

Bill Tytla, Wilfred Jackson, and Frank Churchill—animator, director, and musician, respectively—work out the timing of a scene for Snow White and the Seven Dwarfs, sometime in 1937. © Disney Enterprises, Inc.; courtesy of Wilfred Jackson.

Fred Moore, Ham Luske, and Frank Thomas—he had pulled the soup sequence and all the other weak sequences from the film.

The dream sequence apparently went first; it seems never to have got as far as the animators, and it may have been easier to drop because of the demands it would have imposed, both financially and in animators' time (it would have been heavy with effects). The soup sequence was the next to go, even though it was completely animated. The lodge-meeting and bed-building sequences, on which some animation had been done, were still in the film as of 17 June,[81] but they too were gone by 12 July, when Al Eugster noted in his journal that most of his animation had been cut from the film.[82]

Discarding those three sequences with the dwarfs could not have been easy. The soup sequence in particular had absorbed not only dollars but the talents of several animators who should have been working on better things (Bill Tytla animated three scenes of Grumpy). Disney did save money and time by not finishing those sequences, but that could not have been a major con-

sideration; it was after he dropped the other three sequences that he restored to the film two minutes showing the dwarfs at work in their mine, their first appearance in the film.[83]

However difficult it may have been for Disney to shed the superfluous sequences, there was simply no way that they could survive in the atmosphere that had grown up in his studio by the summer of 1937 and that found some of its purest expression in sequence 10A. In that sequence, Grumpy is, if anything, even more fully developed than he is in his earlier appearances in Tytla's animation. His attraction to Snow White, a sort of subtext earlier under his stubborn refusal to wash for dinner, is here in open warfare with his hostility to women in general; one side and then the other gains the upper hand in a fluid display of emotions. Grumpy warns Snow White against the Queen, showing his concern even as he tries to maintain his gruff manner, and she kisses him, over his vigorous objections. He stalks away, but finds himself overcome with delight in spite of himself—and as he tries to regain control, he jams his nose into a knothole in a tree and then falls into a creek. What could have been slapstick in another animator's hands was here the occasion for Grumpy to reveal himself.

Disney responded to Tytla's cartoon acting as if he were a sympathetic stage director, asking for adjustments in timing and staging that would sharpen an already strong performance. It's easy to see in such sweatbox notes what Art Babbitt called Disney's "sensible criticisms": "From a technical standpoint, he couldn't tell you a damned thing. But he could say,...'That guy isn't looking left long enough.' Or 'That fellow in the background is too active, he's taking your eye off the guy in front.'"[84] There was by this point a profound harmony between what Tytla was doing in his animation and what Disney was trying to do in the entire film. They had the same goal: to make the fantastic seem utterly simple and natural. If there was one obstacle to the realization of this goal, it lay in a short sequence that was, if not the most important in the film, certainly the most vulnerable—and probably the most dangerous.

In the fall of 1938, with the pressures of *Snow White* almost a year behind him, Dave Hand talked to a studio audience about a short sequence that he thought was "one of the most perfectly put over" in the film.[85] That sequence, 15A, showed the grieving dwarfs

gathered around Snow White's bier. Once Walt Disney had decid-
ed, at the end of 1936, that there would be no "tear-jerker," or
prayer of any kind, he still had to decide how the dwarfs would
express their grief. "You who were in on the story meetings
remember how frightened we were that the audience would not
react as we hoped they would," Hand said.

When serious work on sequence 15A got under way in the
spring of 1937, Disney brushed aside temptations to deal with
such fears by italicizing the sequence. "All this stuff will have very
little animation—just good sad poses, and we can get their eyes
watery and a slow tear running down," he said on 6 May. "Just
maybe never see the tear drop, or in one place it might drop, but
not feature it."[86] In the final meeting on the sequence, on 27 July,
Disney let himself be tugged toward overstating the dwarfs' grief,
putting them on their knees and assigning Dopey a high-pitched
sob. By purging all the superfluous sequences, though, he had in
effect decided on simplicity for the film as a whole, and so he now
came down firmly on that side for sequence 15A. "I don't think
you will run into any trouble if you don't try to make the dwarfs
do too much," he said.[87]

By then, he had seen most of the dwarf animation for the rest
of the film in sweatbox; he knew that Tytla and Moore had
brought those characters to life in a variety of situations. Now, by
showing the dwarfs' grief—and presenting it with a directness
that admitted of no excuses—he could give them an emotional
fullness that no cartoon characters had approached before. The
problem was that the dwarfs, as Disney wanted to present them
in sequence 15A, threatened to strain character animation's
capacities. In addition to an acting challenge, the animator
assigned to the dwarfs would face a purely technical challenge of
unusual severity.

Neither Tytla nor Moore would animate the dwarfs in sequence
15A; the job fell instead to Frank Thomas, who by the summer of
1937 had emerged as the strongest of the other dwarf animators.
By early in 1937, he was animating critical scenes of the dwarfs
that probably would have been Moore's if Moore could have got-
ten to them; for instance, he animated almost all the scenes of the
dwarfs when Snow White orders them outside to wash. Thomas
was, moreover, as Dave Hand had said in June, "terribly particu-
lar about every little action."[88] Hand was not speaking out of
admiration—he made the remark in his straw-boss role, whipping
the dwarf animators to move their work along—but Thomas's

meticulousness was a powerful reason to assign him to sequence 15A.

In effect, Thomas had to respond, through his animation of the grieving dwarfs, to Disney's complaint in his 1935 memo to Graham: "The animators don't make the held positions and the relaxed positions express anything. They try to do all the expression with the parts that are moving." As Disney had conceived sequence 15A, Thomas really had no choice but to find expression in "held positions." The dwarfs would move very little and very slowly; solemn organ music had already been recorded for the sequence, and Thomas listened to that music again and again to help him maintain the right mood in his animation.[89]

Extremely slow movement is difficult to manage in animation, so much so that Wilfred Jackson offered this rule to a studio audience in 1939: "Never put a piece of business in the picture where the action must move so slowly that you can't squeeze in inbetweens."[90] In other words, the animator should not be forced to choose between an obvious held drawing, on the one hand, and movement so finely graduated that it jitters because it requires an impossibly precise positioning of the drawn lines, on the other. Thomas summed up his dilemma this way: "If [the dwarfs] stopped moving they became stiff, flat, lifeless, and completely unconvincing. So-o-o, pack in more drawings, and be sure there are no jitters!"[91]

Thomas relied on his inbetweener, Bob McCrea, to decide how many inbetweens "he could squeeze in," that is, how much of that very slow action could be managed by holding an inbetween drawing for two or more frames and how much required a separate drawing for each frame of film. But the real solution to the jitter problem, as Thomas said, "was building the individual acting on each character so no one was looking for jitters."[92] To help with that, Thomas had some live-action shot for the sequence, "mainly on Grumpy breaking down.... It gave me more in the way of reassurance than help with the action, as it turned out."[93]

Despite Thomas's reputation for worrying over drawings, his work on the sequence went quickly. Disney saw Thomas's scenes in a sweatbox session on 18 August, barely three weeks after the last story meeting on the sequence. Most of the changes he ordered, couched in words like "too abrupt," "too extreme," and "too violent," were in the direction of still greater restraint. In the sequence as it finally emerged, the dwarfs seem to be occupied with their own sorrows, each in his own way: Dopey sobbing like

a child on Doc's shoulder; Grumpy staring wide-eyed through his tears, stunned and disbelieving, before he breaks down. Disney ordered a completely new test, as opposed to corrections, only for that scene with Grumpy. Here he wanted not just restraint but greater precision—in effect, he wanted a Grumpy more like Bill Tytla's: "As it is now there are two sort of hold positions on Grumpy that seem out of character, then suddenly he breaks.... Get a tense and sad and more Grumpy character to start, like he is suppressing his grief, and a tear welling up in his eyes, then the break and turn."[94]

In his new version, Thomas got it just right: the dwarf who so strongly resisted Snow White's appeal now finds himself, to his profound shock, the most deeply wounded by her apparent death. As Tytla did in his scenes, Thomas used Grumpy's cartoon features and proportions to make the character's emotions fully visible. In doing so, Thomas provided the strongest justification for the restraint that Walt Disney insisted upon. When communication can be so direct, there is no need for histrionics.

Thomas's animation of sequence 15A took place during a flurry of work on other sequences, most of them at the beginning and end of the film; Disney saw the first pencil tests for dozens of scenes in August. It was now, as work wound down toward the December premiere date, that Disney began to settle for compromises that he probably would not have accepted a few months before. He was, in part, paying the price for earlier mistakes. Very late in work on the film—probably sometime in the last half of November—he made a decision that must have been as painful as killing the soup and bed-building sequences: he lopped off about two minutes of the bedroom sequence, by then completed in cleaned-up animation.[95] He was fully justified in doing so—a noisy pushing and shoving match between Doc and Grumpy was a slapstick duplication of what had already taken place earlier in the sequence, and Snow White in her scenes was disconcertingly cold and teasing[96]—but the weeks that Fred Moore and Grim Natwick had spent on the abandoned scenes could not be recaptured.

Snow White began to look like a rotoscoped character in scenes for the first part of the film, those showing her in rags at the Queen's castle. Jack Campbell, whose scenes these were, did not conceal Marjorie Belcher's filmed movements in his animation, as Luske and Natwick did, and what wound up on the screen looked too little like animation, and too much like the tentative

movements of an inexperienced actress. (By this time, the animators were working not with tracings from the live-action film, but with photostatic frame blowups, so that using the live action as a crutch was easier than ever.) The Prince, in his brief courtship of Snow White, looked even worse: he was no more than tracings from film of Louis Hightower, another dancer from the Belcher studio. With the premiere only a few weeks away, though, Disney could avoid rotoscoping no longer, and even the best animators lacked time to transform the live action they started with. Natwick animated Snow White and the Prince at the close of the film, when he wakes her with a kiss and carries her away, and Natwick's work, too, looks traced. As painful as such compromises must have been, though, Disney now *could* compromise without risking mortal damage to his film. He had surmounted his greatest hurdle in sequence 15A. Having got that right, and so much else besides, he could not now be defeated if a few things went wrong.

In the final weeks of work on the film, the pressure was extraordinary, in inking and painting especially, where it was common for the women to work from seven in the morning until ten or eleven at night.[97] Any thoughts that *Snow White* might be made for the cost of a year's worth of Silly Symphonies had long since vanished. The studio's staff had grown steadily through 1937, rising from 540 in May to 650 at the end of the year.[98] "Roy was very brave and manly," Walt Disney said of his brother's attitude toward *Snow White*, "until the costs passed a million."[99] Ultimately, the negative cost grew to $1,488,422.74.[100] The studio had borrowed heavily to make *Snow White*, and its survival now depended on the film's success.

Snow White and the Seven Dwarfs opened on 21 December 1937 at the Carthay Circle Theatre in Los Angeles. Three weeks later, it opened at Radio City Music Hall in New York and at a Miami theater; those runs, with the one in Los Angeles, tested the film's box-office potential. It soon became clear that that potential was huge. At the Music Hall, the box-office take rose from $108,000 the first week to $110,000 the second—the first such rise in the theater's history. Scalpers were charging $5.00 and more for $1.65 reserved-seat tickets. *Snow White* ran at the Music Hall for five weeks—two weeks longer than any film before it—and could have stayed there even longer, except that the Music Hall was committed to show other films.[101]

After two years of intensive labor, Walt Disney stood early in

1938 on the threshold of an enormous popular success—the best kind, gained not by pandering to his audience but by trusting that it would respond to what moved and excited Disney himself.

The psychologist Bruno Bettelheim, in a footnote to his study of fairy tales, harshly dismisses *Snow White and the Seven Dwarfs*:

> Giving each dwarf a separate name and a distinctive personality...seriously interferes with the unconscious understanding that they symbolize an immature pre-individual form of existence which Snow White must transcend. Such ill-considered additions to fairy tales, which seemingly increase the human interest, actually are apt to destroy it because they make it difficult to grasp the story's deeper meaning correctly.[102]

That "deeper meaning," in Bettelheim's view, has to do with Snow White's entrance into adolescence. But as the critic Roger Sale has pointed out, there was no conception of adolescence as a distinct phase of life at the time the fairy tale came into existence. What the story is about, Sale argues, is the Queen's desire for Snow White's beauty—not for Snow White herself, but for her beauty. In fairy tales

> the primary task for women is bearing children, and childbearing was often fatal; whatever other power women had lay in youth and beauty. After a brief blossoming...people grew old rather quickly, and most of the palliatives against a grim and crimped existence were controlled by men.... For an older woman to fight against these facts and values made her frightening, and no fairy tale can imagine defeating such a woman without also destroying her.... Snow White and the queen are locked in a terrible likeness, because they are the same person at two different stages of life.[103]

The Disney film is consistent with Sale's interpretation, but only up to a point. Walt Disney's Snow White has virtues—of kindness and compassion and maternal love—that the Queen never had; she will win a victory of some sort over age, with a beauty of spirit if not of the flesh. Disney thus introduced a note of hope and love into a very stark, elemental story, without violating that story's basic structure. To do that, he had to deal directly with

emotions that most of us are reluctant to express, lest we be embarrassed by their very commonness. I. A. Richards, addressing the difficulties encountered by poets in such situations, wrote in *Practical Criticism* that such

> thoughts and feelings, in part because of their significance and their nearness to us, are peculiarly difficult to express without faults of tone. If we are forced to express them we can hardly escape pitching them in a key which "overdoes" them, or we take refuge in an elliptic mode of utterance— hinting them rather than rendering them to avoid offense either to others or to ourselves.[104]

Disney's way of avoiding "faults of tone" was to concentrate on his characters—as Bettelheim said, "giving each dwarf a separate name and a distinctive personality." Bob Stokes recalled how intense Disney's concentration could be:

> I can remember nights when I worked a little bit of over- time, say, and he'd come in and pull up a chair and we'd talk...until eleven o'clock, just his views on things. Animation, the character, the type of person this character was—he believed that this character was a live person, and he had a way of instilling that in you.[105]

Disney seems to have approached the writing of the story, and the animation of it, with an actor's sensibility—as if the writing were a way to penetrate each character's personality and the ani- mation, a way to translate that understanding into action.

"Walt was so immersed in these characters," Frank Thomas and Ollie Johnston have written,

> that at times, as he talked and acted out the roles as he saw them, he forgot that we were there. We loved to watch him; his feeling about the characters was contagious.... The most stimulating part of all this to the animators was that every- thing Walt was suggesting could be animated. It was not awk- ward continuity or realistic illustrations but actions that were familiar to everyone.[106]

If he was to maintain that kind of identification with his char- acters, Disney could not forever tolerate the kind of mistake that the soup and bed-building sequences represented, and he had to remedy many smaller transgressions, too, like dialogue that mud- died the point of a scene. Ultimately, for all the scars of other

kinds that *Snow White and the Seven Dwarfs* bears—especially the patches of weak animation—almost everything its characters do and say rings true, permitting even the most melodramatic moments to shoulder a larger meaning without strain. When the dwarfs pursue the Queen in her guise as an old peddler woman, the conflict is one between warmth and honesty, on the one hand, and coldness and deceit, on the other—traits that the characters embody in the most concrete form and not as abstractions.

Norm Ferguson, who had been the first of the Disney animators to give his characters a semblance of life, animated the disguised Queen, and she is, predictably, a striking character, but in a highly colored, theatrical, and ultimately false manner. Disney certainly wanted this effect—in one sweatbox session he said that the Queen's ghastly smile should be "more Lionel Barrymore"[107]— but he may have assigned Ferguson to the Queen out of concern that Ferguson would have trouble dealing with characters like the dwarfs. Ferguson excelled at producing a lifelike *effect*, but by the time he began animating the Queen-as-crone, around the end of 1936, Tytla and Moore had demonstrated conclusively, through the dwarfs, that a lifelike effect was not the same as characters living in animation.

It is because the dwarfs are such vivid characters, and their feelings about Snow White so clearly visible, that the film enriches the Grimms' story as it does. Snow White's virtues emerge mainly through her relationship with the dwarfs, and particularly with Grumpy (who comes to love her for reasons that obviously have nothing to do with physical attraction). But the emotional traffic is not all one way: the dwarfs grow a little tiresome before the spooks sequence ends, and not because of the occasional raggedness of the animation. They are, the film makes clear, crotchety old fellows whose monotonous labor consumes their dull lives; left alone for very long on center stage, they would soon be revealed as tedious old bores. For them, Snow White is a startling burst of sunshine, stirring each of them in a different way.

The characters are simple, but their relationships—like real human relationships—are not. As Robin Allan has observed, "The dwarfs are children to Snow White as mother figure, adults to her as child."[108] And in the most emotionally complex sequences, like the one showing the dwarfs in their grief, they are both at once, or pass from one to the other in a twinkling. Snow White is, besides, more a mother with some of the dwarfs—Dopey in par-

ticular—and more a daughter with others, especially the most Tytla-flavored dwarfs, Grumpy and Doc.

Snow White's failings do not count for much when weighed against its great central successes, and the film's most obvious failing—the weak, rotoscope-derived animation of Snow White and the Prince in the opening and closing scenes—actually gives it a dimension that Disney himself surely did not intend. It is in those scenes that the film is most wholly "fairy tale," artificial and removed from reality; the all-but-weightless animation in the opening scenes is of a piece with the operetta-like musical treatment. Snow White seems more substantial when the animals lead her through the woods and into the dwarfs' cottage, and then as she cleans the cottage—the music here is a work song. By the time she meets the dwarfs, she is at last a solid figure. She is most real in the evening musicale, as she dances with the dwarfs; her graceful movements, although they originated with Marjorie Belcher, are wholly the character's.

Disney decided as early as the fall of 1934 to fence off the final sequence from the rest of the film by using a highly artificial device, three title cards that represent the changing seasons.[109] It is in that sequence that Snow White melts again into a reverie. When the Prince appears at her glass coffin, operetta returns with him—he is singing "One Song," his serenade at the beginning of the film. The dwarfs are mere spectators as the Prince kisses Snow White and lifts her to carry her away. He pauses long enough for her to kiss the dwarfs; she addresses only Grumpy and Dopey by name. The boy and girl are like two wraiths, bidding farewell to creatures of flesh and blood. Only what comes in between the fairy-tale sequences seems altogether real: the homely particulars of housekeeping and cooking and amusing one another, and the girl's death most of all. It is as if the dwarfs dreamed this lovely girl's life before she joined them, ever so briefly, and now that she is dead, they dream of her resurrection.

That the film should admit of such an interpretation is owing not just to the weakness of the rotoscoping, but to the tremendous vitality of the best dwarf animation. Because that animation is so emotionally revealing, it is the dwarfs, and not the characters who look more nearly human, who are the most like us. And like us, they long for a world where kindness can vanquish cruelty, and love conquer death.

Disney,
1938-1941

Walt Disney chose for his second and third features two stories that were strikingly different from the Grimms' "Snow-White." The Grimms provided him with a simple and serviceable plot but no characters to speak of; moreover, the version of the story in the Grimms' book was only one of many variations. *The Adventures of Pinocchio: Tale of a Puppet* had only the loosest sort of plot, but it was far more fixed, as a literary entity, than "Snow-White." The story, by Carlo Lorenzini, writing under the name C. Collodi, appeared as a book in Italy in 1883. It had first been published as "The Tale of a Puppet" in weekly installments in a children's publication, and it had the episodic structure that periodical publication invited. Collodi's *Pinocchio* is like a picaresque novel for children, with a rogue-hero—Pinocchio, the puppet brought to life in the book's opening pages—whose misbehavior leads him from one fantastic adventure to another. For Disney's purposes, Collodi's impudent protagonist was, in contrast to the characters in "Snow-White," all too distinct. "One difficulty in *Pinocchio*," as Disney said on 3 December 1937, in one of his first meetings with the film's writers, "is that people know the story, but they don't like the character."[1] Although the book's Pinocchio suffers spasms of regret, he often repels sympathy—and his inhuman qualities are, in fact, central to what little structure the story has: it is by subduing his weaknesses that he earns his transformation into a real boy.

Bambi was the other feature film that Disney's story men began writing in 1937, before the release of *Snow White and the Seven Dwarfs*. Sidney Franklin, a producer and director of live-action films at MGM, had in 1933 bought the rights to *Bambi: A Life in the Woods*, a novel by Siegmund Salzmann (who used the pen name Felix Salten), but Franklin apparently realized that filming it in live action would be extraordinarily difficult. Hopeful that someone else could bring the story to the screen, he approached Walt Disney, ultimately transferring his rights to Disney in April 1937.[2] Disney's writers began studying the Salten book almost immediately,[3] and Disney himself was attending meetings on *Bambi* by 21 August 1937, more than three months before his first recorded attendance at a meeting on *Pinocchio*.[4]

It was evidently because *Bambi*'s characters would be animals that Disney intended it to be his second feature; he expected the animals to create fewer difficulties for his animators than the human beings who would make up most of *Pinocchio*'s cast.[5] In other respects, though, *Bambi* was far more problematic than *Pinocchio*. Like *Pinocchio*, *Bambi* existed as a very specific literary artifact—and a very recent one, since the novel had first been published in German in 1923 and in English only in 1928. The novel traces the life of a stag; its deer and other animals think and speak, and the protagonist eventually rises to a sort of pantheistic serenity, but the flow of incident is true to a vision of nature "red in tooth and claw." Salten's *Bambi* was written for adults; its narrative is too grim, and its tone too somber, to permit pigeonholing it as a children's book. As late as October 1937, Disney was still speaking of *Bambi* as if it would be his next feature,[6] but by December, he had put *Pinocchio* at the head of the line.

Even more significant than Disney's choice of stories was that he put two into work at the same time. In the twenties, Chaplin, Keaton, and Lloyd—all of them, like Disney, film artists who owned their own studios—had produced one feature at a time, giving it their attention until it was finished. Disney had something else in mind. His studio would release not just one feature every year or two, but two or more every year (and shorts, too), in effect joining the small, independently owned studios (Goldwyn, Selznick) that released a handful of relatively expensive features each year through one of the major distributors. Disney's own role in the production of his films thus had to change. He wouldn't have the time to bring the same intense involvement to every new film that he had brought to *Snow White*.

In the December 1937 meetings on *Pinocchio*, Disney showed, as he had not during work on *Snow White*, a strong desire to push forward with the writing of the film and get work into the hands of animators who were marking time on short subjects. Disney's own ideas were often weak, though, sometimes nothing more than crude fanny gags. He was no doubt weary and distracted—those meetings took place during the last frantic weeks before the premiere of *Snow White*—but *Pinocchio* clearly did not engage him as *Snow White* had. Repeatedly, he gnawed on the worry he had voiced on 3 December: something had to be done, he said, to make up for the literary Pinocchio's lack of charm. Not only was that Pinocchio a frequently cold and malicious creature, but he was also a puppet—and in the earliest model sheet, too, drawn for the story department's use, he was unmistakably a creature made of wood. The film story, as it evolved late in 1937 and early in 1938, underlined Pinocchio's nonhuman origins: when he set out for school, he was to encounter a group of schoolboys who would taunt him for his wooden body.

Animation of *Pinocchio* evidently began around the middle of January 1938; most of the story was still being written then, but the opening sequence, called 1-A, had been reduced to a scene-by-scene continuity by 13 January. This was the sequence that would introduce Pinocchio, Geppetto, the Blue Fairy, and Geppetto's old tomcat, the four characters that would appear throughout the film; it was here that Pinocchio would come to life, and it was this sequence that Walt Disney believed must, as he said on 6 January, "win the audience to the little guy." The 13 January continuity presented Pinocchio as a mischievous child; in one scene, he was to clamp a vise on the cat's tail.[7]

Disney entrusted the animation of Pinocchio to Frank Thomas and Ollie Johnston; after working as Fred Moore's assistant on *Snow White*, Johnston had become an animator on a Mickey Mouse cartoon called *Brave Little Tailor*. When he went onto *Pinocchio*, Johnston worked with live action for the first time, for "a scene about forty-five feet long of Pinocchio coming to life; I worked my tail off on the thing."[8] Thomas was animating other scenes of Pinocchio at the same time. No actor had been chosen to speak for Pinocchio yet; the two animators worked with a temporary soundtrack using Ted Sears's speeded-up voice.[9]

Around the beginning of February 1938, Disney saw Thomas's animation of Pinocchio. He was supposed to see Johnston's the next day, but he stopped production instead. Work on *Pinocchio* would have to wait until he had wrestled with his doubts about

the story and the title character.[10] Accelerating work on *Bambi* to take up the slack was not really possible; the writing of that film had scarcely begun. Transforming the Disney studio into a true film factory was going to be difficult.

Disney and his writers spent much of 1938 reworking *Pinocchio*'s opening sequence, even as they wrote later ones. Actors were auditioning for voices by February, and animation on sequences dominated by other characters began as early as April, but Disney could not settle on what he wanted in the title character. Deep into the summer, the opening sequence was still not ready to go to the animators again.[11]

As the story went through revisions, it began to shed reminders of Pinocchio's status as a carving from wood. By the summer, gone was what had been planned as the major part of the second sequence, in which Pinocchio would have encountered the mocking schoolboys (and a curious dog would have sniffed at his wooden leg).[12] It was in this episode that his nature as a puppet would have become most cruelly evident to him, and to the audience. As the story was evolving, though, Pinocchio would be seen with other children only during the revels on Pleasure Island, a mysterious place where bad boys, lured by the promise of forbidden pleasures, were transformed into donkeys.

The changes in the story worked against animating Pinocchio as what Frank Thomas called "a skinny, brash, cocky piece of cherry wood," like the Collodi character.[13] Thomas had wanted to animate Pinocchio "from the joints, making him move in a stiff, puppety way," and a revised model sheet, drawn by Fred Moore around the time animation began, showed a Pinocchio that lent himself to such animation. That revised Pinocchio had already moved some distance away from the bluntly wooden figure in the story department's original model sheet, but he still had undifferentiated wooden hands, a long nose, squared-off wooden limbs, prominent mechanical joints, and, especially, a saucy bearing. (A second revised sheet gave Pinocchio fingers, but left him unchanged otherwise.)

This time it was not Moore who established a critical character's design. Milt Kahl was, like Thomas and Johnston, one of the studio's rising young animators; his first significant assignment was as one of several animators of the animals in *Snow White*.

Kahl recalled in 1976 that Moore, Thomas, and Johnston were, in his eyes, "rather obsessed with the idea of this boy being a wooden puppet." Kahl's idea was to "forget that he was a puppet and get a cute little boy; you can always draw the wooden joints and make him a wooden puppet afterwards." Ham Luske suggested to Kahl that he demonstrate his ideas by animating a scene, and so, Kahl said, "I did one."[14]

Kahl chose to animate a scene not for the opening sequence, where Pinocchio was newly brought to life and his puppet origins would thus be hardest to escape, but from sequence 10, much later in the film. In that sequence (still being written when Kahl animated his scene),[15] Pinocchio was to enter the sea, on his way to save Geppetto from Monstro the whale. It had been in a meeting on that sequence, in February 1938, that Walt Disney finally started to seem engaged with *Pinocchio*; the drama of Pinocchio's encounter with the whale clearly stirred him, as the earlier sequences did not.[16] Everything conspired to encourage Disney to receive Kahl's Pinocchio favorably—and he did. "I made kind of a cute little boy out of him," Kahl said, "and Walt loved it."

Disney was probably just waiting for drawings that fit a conception of the character that had taken shape in his mind some weeks or months before, perhaps around the time that Pinocchio's confrontation with the schoolboys fell out of the story. Eliminating that episode meant that there was no longer any inescapable reason to depict Pinocchio as primarily a puppet. The question before Disney had been, should he try to find some way to make Pinocchio likable *as a puppet*, or should he try to make him likable by making him less of a puppet and more of a boy? By embracing Kahl's design, he gave his definitive answer to that question, even though, as Wilfred Jackson said many years later, it cut out "the guts of the whole story": because Pinocchio was no longer set so firmly apart from flesh-and-blood boys, his transformation into one at the end of the film lost its significance.[17] Animation of the opening sequence resumed in September 1938.

The new Pinocchio, as he emerged in the rewritten story and finally in Kahl's design, was likable, perhaps, but, even more, he was passive—not the willful, often spiteful Pinocchio of Collodi's book, but a helpless innocent, swept along all too easily by the stronger characters, almost all of them villains, that surrounded him. To shore him up, Disney and his writers had already gone back into Collodi's story and retrieved a character that had been

absent from Otto Englander's initial continuity. In the book's early pages, a cricket lectures Pinocchio for his transgressions; the puppet responds by crushing the insect's head. Collodi had second thoughts about the cricket's usefulness: it returns in a later chapter as a ghost, and then twice more as itself, with no heed paid to its earlier demise. The cricket—ultimately dubbed Jiminy—had entered the Disney story by the summer;[18] as a "conscience," trying to steer Pinocchio away from trouble, he would be a counterweight to the villains.

In the earliest drawings, Jiminy Cricket did look cricketlike, more a caricature of an insect than a cartoon approximation on the order of the bugs in Silly Symphonies like *Woodland Cafe* (1937). Such a caricature, it soon turned out, was not what Disney wanted. Ward Kimball, the lead animator for Jiminy, recalled "taking a lot of different drawings" of the character "up to Walt's office.... He'd just frown and say, 'Those aren't cute enough.'" Finally, Kimball produced an acceptable design, one that made Jiminy Cricket not an insect but a miniature man with an egg-shaped head and no ears.[19]

Jiminy was to be, moreover, a miniature man who was ingratiating in the way that certain Hollywood actors were—actors who had none of the moral authority of a conscience. Ham Luske supervised much of the live-action filming for *Pinocchio*; he said in October 1938 that when he filmed an actor as Jiminy, he explained to the actor "that the Cricket was to be a combination of Mickey Rooney and W. C. Fields."[20] Luske's instructions were certainly in keeping with Walt Disney's desire that the film's characters be immediately appealing. That desire had been evident during work on *Snow White*, too. What was much stronger in work on *Pinocchio*, though, was Disney's pursuit of such appeal even when he placed in jeopardy the film as a whole.

Although Collodi's Pinocchio was in many ways repellent, he was trapped in circumstances that a strong animator could have used to give him emotional substance and so win an audience to him. As Jackson suggested, there was a powerful reason for Pinocchio's wanting to become a boy of flesh and blood: to be a living puppet was to be profoundly separated from every other kind of living creature. Only by becoming flesh and blood could Pinocchio escape from that isolation.

Nothing indicates that Disney ever considered assigning Bill Tytla to animate a Pinocchio of that kind; in early February 1938, when work on *Pinocchio* stalled, Tytla was getting handouts for

scenes in a highly ambitious Mickey Mouse short subject based on *The Sorcerer's Apprentice*—the Dukas music and the Goethe story that inspired it. Tytla was animating the sorcerer, a severe, imposing figure who had been designed to contrast sharply with Mickey, the wayward apprentice. When Tytla moved on to *Pinocchio* a few weeks later,[21] he was cast again as the animator of full-size human characters. He animated a few scenes of Geppetto that come early in the film, but his most important assignment, before and after he animated those Geppetto scenes in the fall of 1938, was to Stromboli, the hulking, black-bearded master of a traveling puppet troupe. Although *Pinocchio* was set in an undifferentiated Europe, and several of the characters were to have accents of one kind or another, Stromboli was to be the most emphatically "foreign" character in the film. Assigning Tytla to animate Stromboli was, in fact, typecasting of a particularly obvious sort. Tytla—whose given name was Vladimir Peter Tytla—was the son of Ukrainians who entered the United States a few years before he was born; not many other people at the studio had such clearly visible immigrant roots.

Thomas and Johnston have described Tytla as "very striking with his swarthy complexion and broad shoulders. He had a big mop of coal black hair, heavy black brows, and very piercing dark eyes."[22] From all accounts, Tytla overflowed with feeling. "He was a bundle of nerves," said the animator Eric Larson, whose room was near Tytla's. "He exploded, in his normal life.... He was vibrant, about anything."[23] The early model sheets identified Stromboli as "the Fire-Eater," the name of a roughly equivalent character in the book, and Stromboli seemed to be a character who demanded only that Tytla give expression to his own passion, rather than channel it through a personality—like Grumpy's—that was substantially different from his own. Tytla's engagement with Stromboli, as Larson described it, sounds almost like a parody of "method" acting: "He'd act out a scene down in his room, and I thought the walls would fall in."

Despite his central role in work on *Snow White,* Fred Moore was always on the periphery of *Pinocchio,* even more than Tytla was. That was because, Ollie Johnston said, Disney had told Moore and Ham Luske, after the completion of *Snow White,* that he wanted them to spend most of their time working with the newer animators. Luske, as was his wont, seems to have taken his new responsibilities seriously—such general supervision was in any case only one step removed from the kind of work he had already

done on *Snow White*—but "Fred spent the whole time with the secretaries," Johnston said.[24] Finally, though, at some point early in 1939, Moore wound up animating on one of the last parts of *Pinocchio* to assume solid shape in the story department. He animated Lampwick, Pinocchio's companion on the ill-fated journey to Pleasure Island. This was more typecasting: Lampwick's jejune swagger echoed Moore's own personality. But Lampwick was also a dim reflection of what Pinocchio himself could have been, had the film that bore his name been conceived very differently.

When Walt Disney adopted Milt Kahl's version of Pinocchio in the summer of 1938, it was undoubtedly because Kahl had given him what he wanted in the character, but another motive may have been at work, too. With *Pinocchio*'s central problem solved, however questionably, Disney had freed himself to pursue a project that was much closer to his heart. It was in September 1938—the same month that animation resumed on *Pinocchio*'s opening sequence—that Disney plunged into work on another feature, this one to be grounded not in a children's story, but in classical music.

Although the Silly Symphonies had acquired stronger narratives in the years just before *Snow White and the Seven Dwarfs*, Disney had not given up all thought of making cartoons in which narrative was secondary or absent. "In the future," he wrote in an essay published in 1937, "we will have more Silly Symphonies in which sheer fantasy unfolds to a musical pattern: this was the idea originally behind them. In the future, we will make a larger number of dance-pattern symphonies. Action controlled by a musical pattern has great charm in the realm of unreality."[25]

By 1937, Disney had been trying for a couple of years to bring just such a Silly Symphony into existence: a flower ballet, organized around the changing seasons. "The actions of the ballet will be burlesqued, but in line with modern ballet," he told a small group of his writers and musicians in October 1935, when work on a flower ballet had already been under way for several months. "Everything will have the effect of design—even the scenery.... The motions of the dancers will be echoed in the backgrounds."[26] Disney's writers struggled with this idea in the ensuing months; the largest obstacle seems to have been the difficulty of bringing rooted flowers to life in a true ballet.

Disney was thus primed for the sort of film that an animated

version of *The Sorcerer's Apprentice* promised to be. Work on the film would begin with both strong music and a clear, simple story already in hand, giving it a head start over the flower ballet or any other Silly Symphony like it. By May 1937, Disney was negotiating for the rights to the Dukas music, and by July he had them.[27] It was soon after, apparently, that Disney encountered Leopold Stokowski, the celebrity conductor, at a Los Angeles restaurant. Stokowski had just concluded more than two decades as the leader of the Philadelphia Orchestra, and in 1937 he was becoming a Hollywood figure by appearing in feature films. When Disney told him of his plans to film *The Sorcerer's Apprentice*, Stokowski was immediately interested in collaborating.[28]

By early November 1937, Perce Pearce, fresh from directing part of *Snow White*, was working on the story. By mid-November, when an outline circulated in the studio, the story was all but complete. The storyboard passed into the hands of James Algar, newly named a director, at the end of December. (Algar was a musician—he had played the clarinet in the Stanford University band—and it was probably his knowledge of music, combined with the patronage of Dave Hand, that got him such an important assignment.)[29] Stokowski recorded the music with a Hollywood orchestra on 10 January 1938. By then, *The Sorcerer's Apprentice* was being treated as a "special," a cartoon that would be rented to theaters outside the Mickey Mouse series. It would be, in the outline's words, "an opportunity to achieve a new high in imaginative quality." Carl Fallberg, who worked with Pearce, recalled the storyboard as much more elaborate than the storyboards for ordinary shorts: "Almost all of it was in color, for one thing—pastels or watercolors.... We gradually refined it, so that by the time it got to Algar it was pretty darned well laid out, with scene numbers and everything else."[30]

Algar, who like Milt Kahl had been one of the animators of *Snow White*'s animals, approached his work with the caution and self-conscious thoroughness of a novice. After he discussed each scene with one of *Sorcerer*'s animators, he prepared an extraordinarily detailed scene instruction sheet, in addition to the usual exposure sheets. One scene instruction sheet prescribed how the sorcerer's hat should look when Mickey Mouse emerged from the water wearing it: "When Mickey comes up, draw the hat to look dented and dripping, but not soggy. That is, it should retain some of its stiff, cardboard feeling. Get as cute and comic a pose on the hat as possible."[31]

Algar was taking such pains not just because of his own

inexperience, but also because the atmosphere at the Disney stu-
dio had changed so radically in just a couple of years—altered
first by the effort required to produce *Snow White* and, now, in
early 1938, by its success. Differing as much as it did from every
animated cartoon that had come before it, *Snow White* had
required an intensive scrutiny of detail, a constant return to work
that had already been done, always in the hope of making the
film a little better. *Snow White*'s success seemingly validated such
methods. It also brought to the studio money (almost five million
dollars in rentals from the film's initial release)[32] to extend those
methods to other films—and to go even further. There need be no
equivalent, in the new films, of the weakly rotoscoped Prince.

In the new atmosphere, old doubts crumbled. Most of the peo-
ple who came in contact with live action during work on *Snow
White* regarded it as a useful but not altogether trustworthy tool;
now it was just another device for making the animation more
nearly perfect. Live-action film was shot for most of *The Sorcerer's
Apprentice* (for one scene in which Mickey is struggling through
water, the animator Preston Blair recalled, a college athlete was
filmed jumping over barrels),[33] and Algar's instruction sheets for
the animators were often specific to the frame as to how closely
the live action should be tied to the animation. Only the scene
instruction sheets for Bill Tytla and Fred Moore showed any ten-
dency to loosen up. The animation of the film, first of the char-
acters and then of the special effects, spread over most of 1938—
a long time for a short subject—and its cost rose to more than
$160,000, two to three times as much as the cost of a normal
Disney short made around the same time.[34]

Other members of the Disney staff slipped all too smoothly
into this expensive new rhythm. Perce Pearce and Carl Fallberg,
after completing their story work on *Sorcerer*, were assigned a few
months later to preliminary story work on *Bambi*. They worked
at first in the annex across Hyperion Avenue from the main stu-
dio buildings, and then, in October 1938, they and a few other
artists and writers moved into the old Harman-Ising building on
Seward Street in Hollywood.[35] As Pearce soon demonstrated, the
fastidiousness that might retard a film when it was being ani-
mated could bring it to a virtual halt when it was still being writ-
ten—especially with Walt Disney several miles away (he almost
never visited Seward Street). In notes from meetings in the fall of
1938, Pearce seems concerned less with the film itself than with
filling the storyboards with immaculate sketches.[36]

Not even the short subjects were immune from this solemn search for perfection; in fact, the virus seems to have struck with special force the more removed its victims were from Walt Disney's presence, and he gave the shorts even less attention than he gave *Bambi*. Dave Hand had become the general manager of the studio—a sort of sub-Walt Disney—and he began overseeing the shorts as part of that job. Hand had always been a forceful manager, the sort of director who never forgot that his first obligation was to put something on the screen, but so pervasive was the new longing for perfection that even he succumbed.

It was Hand who initiated a "development program" in the studio; starting in the fall of 1938, a dozen members of the staff, chosen by a vote of fifty of their peers, lectured on Thursday evenings to small groups on one or another aspect of their craft.[37] Some of the lecturers took their work all too seriously, searching out academic texts and regurgitating their contents. During this "Dave Hand period," said Milt Schaffer, who was a Disney writer then, "they thought, by all this studying they'd been doing about stories, that there must be a formula, and if we just went by the formula everything would be a smash hit. Dave Hand was sort of [in sympathy with] that idea. Well, it never did work out."[38] The relentless search for exactly the right answer led to heavy revisions of some cartoons after they had been completely animated. In January 1939, for instance, Hand kneaded and pounded *The Hockey Champ*, a Donald Duck cartoon; he ordered that finished animation be cut and reworked—and a completely new ending written.[39] By the time *The Hockey Champ* came out in April 1939, all that heavy lifting had yielded a graceless cartoon full of forced gags. It was one of many.

Throughout the studio, directors and writers were responding, however clumsily, to the changes they saw in Walt Disney himself. For the first time, Disney had the money to make films on a truly large scale—not just feature length, but highly elaborate, in just the way that Hollywood's most prestigious live-action features were elaborate. *The Sorcerer's Apprentice* suggested to him the kind of feature that would let him spend his money in a most satisfying way. By early in 1938, he was telling reporters of his plans to, in *Liberty* magazine's words, "put animation to various well known pieces of music," with *Sorcerer* only the start.[40] There are traces from the spring of 1938 of work on an animated short based on Debussy's *Prélude à l'Après-midi d'un Faune*,[41] but by late summer—with *Sorcerer* nearly finished—Disney's plans had

grown much more ambitious. Now he envisioned a feature film of which *Sorcerer* would be a part, a "concert feature" made up of visualizations of classical music by the Disney artists.

In *Snow White and the Seven Dwarfs*, Disney had broken through into character animation of a kind that could hold an audience's attention as firmly as the finest live-action performances. Having done that, he chose not to extend character animation's horizons even further, but to test his audience's appetite for animation of a very different kind. As before, the stakes for his studio would be immense.

Starting early in September 1938, Disney, Stokowski, and a handful of other people listened to records and talked about which pieces should go in *Fantasia* (a title that was sometimes being used for what was otherwise called the concert feature). Some pieces of music suggested pictures to Disney—he said on 10 September, after listening to Bach's Toccata and Fugue in D Minor (in Stokowski's orchestrated version), "I would like to plan an abstract sort of thing on that Bach Fugue"[42]—but he sometimes spoke of what he wanted to see and asked if there was music that would fit that idea. "Was there ever anything written on which we might build something of a prehistoric theme—with prehistoric animals?" he asked Stokowski on 13 September. Stokowski suggested Stravinsky's *Le Sacre de Printemps*, or *The Rite of Spring*, still an aggressively modern work to many ears in 1938. When records of that music were played, Disney was delighted: "This is marvelous!"[43]

The next day, Stokowski broached, and Disney liked, the idea of blowing scents through the theater during *Fantasia* —including the smell of incense during Schubert's "Ave Maria." Disney rambled enthusiastically about candle-lit images of the Madonna, as Stokowski rooted him on. "What we're going to give the public is about thirty of the most beautiful Madonnas," the conductor said. "You're going to give them a million dollars in beauty."[44]

Disney approached *Fantasia* with much greater enthusiasm than he had shown for *Pinocchio* in its early months. The longing he expressed for cartoons in which "sheer fantasy unfolds to a musical pattern" was genuine. Strong character animation had proved to be fiercely difficult to master, at first in the shorts and then, especially, in *Snow White* and *Pinocchio*. Compared with the

other two features, *Fantasia* must have looked to Disney like a vacation, free of gnarly challenges like those surrounding the animation of the dwarfs and *Pinocchio*; but because of its highbrow associations, it might bring him even greater prestige than *Snow White* had.

There were, however, signs in Disney's exchanges with Stokowski that his enthusiasm for *Fantasia* might be just as dangerous as his indifference to *Pinocchio* had been. To be sure, most of the preliminary program choices—a list had taken shape by the end of the 13 September meeting—had one foot in the visual world. There was music from four ballets; besides *The Rite of Spring*, they were Tchaikovsky's *Nutcracker*, Pierné's *Cydalise et le Chèvre-pied*, and Ponchielli's "The Dance of the Hours" from the opera *La Gioconda*. Two other tentative choices, Mussorgsky's *Night on Bald Mountain* and Debussy's *Clair de Lune*, were tone poems like *Sorcerer*, intended to summon up pictures in the listener's mind. Only Bach's Toccata and Fugue had no traces of a visual element.

From the start, though, Disney and Stokowski talked of *Fantasia* not just as the visualization of music, but as a synesthetic experience, calling the senses into play far more actively than the normal motion picture did—not least through a novel use of sound, with music pouring from speakers throughout the theater. In Disney's imagining, as the pagan celebrations of *Bald Mountain* ended and "Ave Maria" began, a chorus would seem to move through the theater, entering a church just ahead of the camera.[45] Incense was perfectly in keeping with such a conception; so was the idea of filming the abstract images that would accompany the Toccata and Fugue in an experimental three-dimensional form, as Disney suggested on 26 September, or shooting part of *Fantasia* in a wide-screen format.[46] The danger was that this expansive approach would lead to neglect of the comparatively mundane task of binding music and image together.

On the evening of 29 September 1938, about sixty members of Disney's staff, most of them directors and writers, listened to recordings of all the music that was then planned for *Fantasia*. By then, Disney had already started working out the details of *Fantasia*'s segments. He had attended at least three meetings—on *The Nutcracker Suite*, "Dance of the Hours," and *Bald Mountain*—and in all three meetings he showed a real eagerness to get under way, as opposed to the anxiety that attended the start of work on *Pinocchio*. For all the excited talk that *Fantasia* had already

stimulated, Disney at this point saw in the film even grander opportunities that he found difficult to articulate. When he met with Stokowski for a postmortem on the musical presentation to his staff, he said of *Rite of Spring*:

> I don't know what we can do yet, but I feel there is an awful lot that we have wanted to do for a long time and have never had the opportunity or excuse, but when you take pieces of music like this, you really have reason to do what we want to do.[47]

Over the last few months of 1938, as Disney continued to take part in story meetings, this inchoate ambition began, in subtle ways, to run afoul of practical difficulties. In a 17 October meeting on the *Cydalise* segment—which was, like the ballet itself, to have a mythological theme—Disney admonished George Stallings, a veteran animator and writer, not to "get too complicated with story...because the music is supposed to be important here." Disney was trying to rule out complications of the sort that had vexed his efforts to film the flower ballet, but he went considerably further: "In our ordinary stuff, our music is always under action, but on this...we're supposed to be picturing this music—*not* the music fitting our story."[48]

If the music could not be violated, there could be no dialogue and no sound effects. For the film to exist in a single aural and visual world, then, the action would have to be planned so carefully that the absence of real sound, other than music, would not be noticed. The task that Disney was setting before his staff was at least as difficult as that facing any choreographer, because in ballet the relationship between dancer and music is organic: the one moves in response to the other. There could be no such relationship in *Fantasia*, where the music would only accompany the action and not be its engine. Even for "The Dance of the Hours," Disney ruled out any suggestion that the animal dancers might be performing in a theater—with, presumably, an orchestra in the pit.[49]

One way out of this dilemma would have been to return to something like the old Silly Symphonies style—an aggressive synchronization of music and images, fundamentally the same as in Ub Iwerks's 1929 cartoons, even if much more sophisticated. Segments of the film lent themselves to that approach; *Nutcracker* was one, made up as it was of short ballet numbers (the files for the flower ballet were transferred to the *Nutcracker* unit in

October 1938). But Disney sealed off that exit, too, making it clear that he did not want *Fantasia* to be, in effect, a program of short subjects. "We don't want people to say it's just a collection of Silly Symphonies or Harman-Isings," he said at a *Nutcracker* story meeting on October 24. Not only did he rebel against what was apparently a cluttered *Nutcracker* narrative that had been worked out by a story crew led by Jerry Brewer—who had come to the Disney studio from Harman-Ising—but he virtually ruled out any kind of narrative at all, even one as simple as the story of *The Sorcerer's Apprentice. The Nutcracker Suite* should be presented "as a series of little numbers," he said, "and I'll lay you anything, it will go over.... You'll ruin it by getting story into it."[50]

By eliminating the obvious ways to knit music and images together, Disney was trapping himself, too, because it was not at all clear how *Fantasia* could be made to work otherwise. In those early months of work on the film, though, an alternative gradually seemed to suggest itself.

●●・・●●

In November 1937, shortly before the completion of *Snow White and the Seven Dwarfs*, RKO released a Disney short called *The Old Mill.* Essentially plotless, *The Old Mill* showed a storm's effects on a windmill and the small animals and birds that lived in it. It was the first Disney cartoon to be filmed in part with the multiplane camera, a gargantuan device designed to enhance the illusion of three-dimensionality. For multiplane scenes, the animation, background paintings, and overlay paintings might be on as many as six different levels, with the backgrounds and overlays painted on sheets of glass mounted a foot or more apart. As the camera trucked forward, different levels would come in and out of focus, as if they had been photographed by a live-action camera.

The Old Mill was conceived not as a test of the camera, though, but as something akin to the flower ballet. An April 1936 outline described the idea behind *The Old Mill* as "the visualization in cartoon form of musical moods."[51] There was no talk of anything like a "dance pattern," though, and few references to action of any kind. "We are anxious to strive for pictorial effects, camera angles," the outline said. "Every setup should be interesting and supplement the musical treatment. DESIGN in this Symphony is MOST important."

What Walt Disney had in mind for *The Old Mill* had already

been anticipated to some extent by a Silly Symphony called *Water Babies* (1935), in which the smooth flow of Leigh Harline's music creates the dominant mood; the gags are plentiful but so restrained in execution that they invite chuckles rather than laughter. Dick Rickard, the principal writer for *The Old Mill*, spoke of it in August 1936 as the same sort of cartoon, but with a stronger pictorial slant; he anticipated *Fantasia*, then two years away from conception, when he said, "We are trying to make of this picture the sort of thing you might visualize in your mind's eye as you listen to a symphony at a concert."[52]

The Old Mill was particularly appealing in 1936, though, not because of its musical component, but because it was to be a cartoon, as its director Wilfred Jackson said, "that depended more on the pictorial aspects of it than on characterization of personalities."[53] Work on *The Old Mill* got under way just as Disney was beginning to struggle with the animation of *Snow White*, and he hoped that it would, as he said in a March 1936 memorandum, "give us a relief on animators."[54]

Thanks probably to this pictorial emphasis, *The Old Mill* became the first Disney cartoon to be truly designed. The earlier shorts had a stylistic unity mostly in a negative sense, that is, there were no jarring inconsistencies in background treatment from scene to scene and no conspicuous lack of harmony between characters and backgrounds. A distinctive styling of the backgrounds "was foreign to Disney," said Dave Hilberman (who moved from assistant animation on *Snow White* into layout) because Disney was concerned almost exclusively with the "actors," the animated characters, and not with the "sets" in front of which they performed. "He emphasized it so many times: if you didn't know the backgrounds were there, they were good backgrounds."[55] *The Old Mill*'s backgrounds make a much more positive statement, to the point that the film's animals and birds are not so much characters as they are necessary parts of the compositions. *The Old Mill* was thus a sharp departure for Disney, even though its visual style is as conservative as a nineteenth-century landscape.

The film's design was apparently the first work for Disney by Gustaf Tenggren, an illustrator of children's books who joined the studio's staff in April 1936, around the time the outline for *The Old Mill* circulated.[56] Working in the story department, Tenggren made at least seventy-one small sketches for the film, many of them in watercolor (some transparent, others gouache). It's clear

that the sketches strongly influenced the appearance of the film, to the point that some sketches, notably those for the climactic storm, were transferred more or less directly onto the screen.[57] (Tenggren's influence is visible in some of the transparent-watercolor backgrounds for *Snow White*, too, although their most striking feature—the carved surfaces that fill the dwarfs' cottage—originated in sketches by Albert Hurter.)

It was during work on *The Sorcerer's Apprentice*—a watershed film in so many other ways—that design made a decisive leap forward in importance. Not only were the storyboard sketches largely drawn in color, but Tom Codrick, a layout artist, translated those sketches into what Dick Huemer called "brilliantly colored thumbnails,"[58] small paintings in gouache that showed the proposed color handling. *The Sorcerer's Apprentice* itself made much bolder use of color and lighting than any Disney film before it. The results, however attractive, were still fundamentally conservative—no more advanced than, say, the richly colored storybook illustrations of N. C. Wyeth, and thus just the sort of thing that might stimulate Walt Disney without making him uneasy. Disney, in his complaints about the excess of story in the initial boards for *Nutcracker* and *Cydalise*, was probably responding as much to the routine nature of the sketches as to the narratives themselves. The segments that moved forward with Disney's most enthusiastic encouragement were those whose artists produced the most alluring sketches, even when the writing itself proceeded awkwardly.

The Rite of Spring, for example, turned out to be relatively intractable, to the point that by mid-November 1938 the plan was to insert narration over some of the music, to accompany the first appearance of the dinosaurs. Despite this violation of his own rule, Disney was excited by what Dick Huemer described as "Robert Sterner's cataclysmic pastel pictures"[59] of volcanic activity ("Bob, I'm crazy about those sketches," Disney said to Sterner in a 17 November 1938 meeting),[60] and he expressed strong confidence in the segment itself. He also responded warmly to a segment whose style came ready-made: by the time the first recorded meeting on "Dance of the Hours" took place on 29 September 1938, the German artist Heinrich Kley's satirical animal drawings had been chosen as the starting point.

In the course of that autumn, finding a rich, inviting visual style for each segment became at least as important as coming up with appropriate incidents to illustrate the music; if the film's

surface was sufficiently dazzling, that dazzle would render moot any questions about how successfully music and image really fit together. The closest Disney came to articulating such a vision was on 8 December 1938, in a meeting on *Clair de Lune*. Ed Starr, who was making sketches for that segment, expressed doubts about the planned "Ave Maria" segment, with its evocation of cathedrals and stained glass. When Starr said, "I always wonder if we're taking full advantage of the cartoon medium, with a picture like this," Disney responded sharply: "This is not the cartoon medium. It should not be limited to cartoons. We have worlds to conquer here." "Ave Maria" would be "four precious minutes when we're through," he said. It would be "richer...like a painting," and far more accessible than the dimly lit cathedrals of Europe, where "you have to get back and squint your eyes, or have to see it at a certain hour or a certain minute of the day." He continued in that vein for what must have been several minutes, before saying:

> Excuse me if I get a little riled up on this stuff, because it's a continual fight around this place to get away from slapping somebody on the fanny or having somebody swallow something.... It's going to take time to get ourselves up to the point where we can really get some humor in our stuff, rather than just belly laughs; and get beauty in it, rather than just a flashy postcard.[61]

There was in Disney's response to Starr the same mixture of respect for the fine arts and suspicion of them that he had shown throughout the thirties, since the days when he first sneered at Art Babbitt's Cézanne print and then suggested that Babbitt get a little "Cézanne" in his animation. Up through the production of *Snow White*, though, Disney had been developing a new art form, character animation; he had never confronted the fine arts on their own terms. Now he was doing exactly that: to put the aural and visual on an equal footing meant that Disney's images had to rise to the same level as images that the music did as music. Disney risked alienating not just what he called "the stiff shirts that are supposed to be the ones that this music is created for,"[62] by vulgarizing what they admired, but also the broader public, by baffling them.

In early January 1939, barely three months after story work began in earnest, Disney made a decision that threw into question how well he understood the risks he was assuming.

His dissatisfaction with one of the musical selections had sur-
faced early in work on the film. A suite from Gabriel Pierné's
Cydalise et le Chèvre-Pied (Cydalise and the Satyr), a ballet written
in 1919, enjoyed a certain popularity in the late thirties mainly
because of its opening march, "The Entry of the Little Fauns." It
was that music, and the opportunity that the ballet offered to
depict mythological creatures, that had drawn Disney to *Cydalise*
in the first place. *Cydalise* appeared to sort itself into a workable
story pretty quickly, but then it resisted as Disney and his writers
tried to clean up the details. Disney ordered a search for stronger
music, and on 5 January 1939, he replaced *Cydalise* with music
from Beethoven's Sixth Symphony, the *Pastoral.*[63]

The *Pastoral* was programmatic in only the most general sense;
it did not paint aural pictures the way that most of the music in
Fantasia did. It was almost as uncongenial to illustration as Bach's
Toccata and Fugue, and yet Disney planned to match it with some
of the most specific images in the film. Those images would make
up not so much a story as what Disney called "a travelogue
through the Elysian Fields,"[64] but there was still no way that such
a travelogue could be considered "picturing this music."

At the start of work on the film, Stokowski had encouraged in
Disney a cavalier attitude toward the music. On 13 September
1938, Disney asked him: "Should we stick as closely as possible to
the original ideas behind this music? That is, where there is a
story connected with it?" Stokowski replied: "We shouldn't worry,
if the spirit of the music is with us."[65] At the same meeting, he
spoke casually of making cuts in *The Rite of Spring.* But the shape
the film was assuming in the *Pastoral* and in one other section
gave even Stokowski pause.

Disney had from the start, and repeatedly, used the word
"abstract" to suggest what he wanted to see accompany Bach's
Toccata and Fugue, but he recoiled from efforts to translate that
general idea into film. On 8 November 1938, when the effects ani-
mator Cy Young showed him a storyboard that was not even
wholly abstract—Young had used patterns derived from the
soundtrack's striations as the basis for much of the segment's
design—Disney fastened on the genuinely abstract drawings
Young had made for the fugue's closing moments. "I would like to
see you stick to the soundtrack pattern all the way through," he
said, emphasizing that "we have never dealt in the abstract; we
have given things a reason for existing, and tried to convince the
audience that it could happen, or was possible."[66]

Stokowski spoke in that meeting as if he wanted to preserve some musical integrity: "When there is counterpoint in the music, there should be counterpoint in the picture. The music explains the screen, and the screen explains the music." This clear and simple statement of what "picturing the music" could mean had no noticeable effect on Disney's wariness toward the abstract, and by the end of the meeting Stokowski—always quick to follow Disney's lead—was saying that the middle of the fugue "should be light and smiling, like little cherubs."

Early in 1939, Disney hired Oskar Fischinger, a German film-maker who had made a dozen or so relentlessly abstract animated films—most of them synchronized to recordings of classical music—to work with Young. Despite this seeming commitment to abstraction, Disney in subsequent meetings continued to hover anxiously between the abstract and the concrete, asking for images that suggested the concrete but didn't really look like it. That was a prescription for inherently weak drawing, and that was probably what Disney got; in the first half of 1939, Young and Fischinger made at least three "Leica reels"—filmstrips of story sketches, synchronized with a recording—and Disney found none of them acceptable. Work on the Bach was suspended at the end of August, and Young and Fischinger turned to test animation for *The Nutcracker Suite*. It had been Disney's own idea to bring Fischinger into the studio, Dick Huemer said, but "all he did was little triangles and designs.... It didn't come off at all. Too dinky, Walt said, so he let him go."[67] After nine months at the studio, Fischinger left at the end of October 1939.

By that time, much of *Fantasia* was in the hands of the animators, or nearly there. The segments of the film were, in fact, moving through the studio about as might have been predicted. Animation began first on "The Dance of the Hours," the animal ballet, on 15 August 1939; just behind was *The Nutcracker Suite*, the closest thing in the film to a dance-pattern Silly Symphony. Work on other segments lagged behind, roughly in proportion to the severity of the challenge in reconciling music and images. Substituting Beethoven for Pierné had been no cure-all; by August 1939, only the first two of the symphony's five movements had solidified onto Leica reels. But in a meeting on 8 August, Disney spoke with firm confidence when Stokowski expressed concern that Beethoven's admirers might be offended by *Fantasia*'s treatment of the *Pastoral*. "I think this thing will make Beethoven," he said. Disney was particularly stubborn about sticking to the

mythological theme: "I defy anybody to go out and shoot centaurs, or gods making a storm. That's our medium, and that's how I feel about this."[68]

Disney had retreated from picturing the music—most conspicuously in work on the Bach and the Beethoven, but elsewhere in the film, too (for instance, by reordering *The Rite of Spring* so that the music better fit the evolution narrative he had in mind). When artwork appealed to him, he found it all too easy to cede primacy to the drawings, even when there was every reason to fear that they would collide with the music; likewise, when he found drawings uncongenial, their compatibility with the music didn't count for much. As a result, many of the storyboards that were passing now into the hands of directors and animators were fundamentally incoherent. In his enthusiasm for storyboards like those for the Beethoven, Disney was actually endorsing the outcome of a sort of visual revolution—one that left his studio a far different place than it had been two years earlier.

The Disney animators drew Mickey Mouse differently for *The Sorcerer's Apprentice*. For the first time, he had eyes with irises and pupils, not the black ovals that had been part of his design since *Steamboat Willie*. In other respects, too, he was a more physically plausible character (if by no means a plausible mouse), drawn as he was with arms, legs, torso, and ears that all suggested a three-dimensional roundness much more strongly than before. Mickey looked, in short, more like a Fred Moore character than he had in any previous incarnation, even *Brave Little Tailor*, for which Moore drew the model sheet. Moore not only drew the model sheet for *Sorcerer*, but he also scrutinized the work of the less experienced animators who were drawing Mickey for the film, all as part of his new role as a sort of guru.

Moore's influence was pervasive in the Disney studio because his kind of drawing and animation was the standard against which other character animators' work was measured. It was a Moore-like "cuteness" that Walt Disney wanted from Ward Kimball for Jiminy Cricket, and when Milt Kahl designed his successful version of Pinocchio, he used Moore's work as a foundation. Kahl's Pinocchio, in his earliest model sheets, looked like a Moore character, but with subtleties of expression—and an element of calculation in the cuteness—that were not in Moore's

vocabulary. As Ollie Johnston said, Disney "liked that refine-
ment."[69]

From the studio's earliest days up through the production of
Snow White, defining the appearance of new characters, and
remodeling old ones like Mickey Mouse, was ultimately the
province of animators like Moore. Even taking into account the
contributions of Albert Hurter and a few other artists who drew
exploratory sketches, new characters came to the animators in
essentially embryonic form, in storyboard and layout sketches,
and it was up to the animators to find the best way to draw them.
What was unusual about Moore's role on *Brave Little Tailor* and
then on *Sorcerer* was that he wound up animating nothing for
either film except two scenes in *Tailor*, so that character design
and animation were more distinct functions than usual.

That separation was one that Walt Disney was encouraging:
character design was caught up in the same tide of elaboration
that was engulfing every other phase of producing a Disney car-
toon. By the time animation of *Sorcerer* and *Pinocchio* got under
way in January 1938, Disney had introduced a new layer of char-
acter designers. These people would draw preliminary model
sheets of new characters, improving on the story sketches, but
would not animate the characters; the animators, in pilot scenes,
would uncover flaws in the designs and draw the final versions.

Disney had been thinking about such a move at least since late
in 1935, when he wrote that "we should try to develop models of
the characters that express more actual personalities, or carica-
tures of personalities. I do not mean caricatures of prominent
personalities, but bringing out a caricature of the personality we
are trying to express. I think we should utilize the talent of *Joe
Grant* [Disney's emphasis] for the making of these models."[70] For
whatever reason, Disney did not act on this idea until just after
the premiere of *Snow White* in December 1937. Grant recalled
that he and Disney ran across each other in a studio hallway and
Disney said, "Why don't you set up a little department?"[71]

Grant and Bill Cottrell had most recently collaborated on the
writing of those parts of *Snow White* involving the Queen. Grant
had always tilted toward the visual side of story work, and he had
acquired a reputation in the studio as being, in his colleague
Martin Provensen's words, "much more sophisticated, aestheti-
cally, than a great many" of the Disney people. Grant was,
Provensen said, "more European...interested in peripheral
aspects of drawing."[72] Grant's broad knowledge of cartoon and

caricature, coupled with his facility as an artist, appealed to Disney; and there was something else, too.

During story work on *Snow White*, Grant made a three-dimensional model, a few inches high, of the Queen in her peddler guise; to judge from photographs, that figure was probably constructed mainly of plasticine, like Marc Davis's model of Snow White's head. Although work on *Snow White* also spawned some rather crude-looking mannequins of the dwarfs, it was evidently Grant's much more detailed model that gave Disney the idea that clay models of the characters could help the animators (and, especially, their assistants) to draw the characters as if they were turning in three-dimensional space. When Grant set up his "little department," it included at least two people whose job was to mold the characters in clay. Grant fired those clay models in a kiln in his own backyard.[73]

To staff his new department otherwise, Grant sought out Disney artists who were, in the words of one of them, Campbell Grant, "able to draw anything, and rather easily."[74] This small group's numbers, and the boundaries of the model department itself, seem to have been fluid, encompassing even such veterans as Albert Hurter, but the usual total was probably around eight or ten; it turned out model sheets marked "O.K. J.G." or "O.K. Joe Grant" almost from the beginning of work on *Pinocchio*. Campbell Grant, for instance, recalled drawing model sheets in 1938 for the villainous Stromboli and for Geppetto's cat and goldfish.

By the summer of 1938, as work on *Pinocchio* quickened, Joe Grant's artists were producing a steady stream of preliminary model sheets: in June, for example, a set of sheets devoted to the fish (many of them incongruously tropical) that Pinocchio was to encounter in his underwater search for Geppetto. Grant, however, envisioned a larger role for his department. He adopted, he said many years later, "a Machiavellian approach.... It didn't sacrifice anybody, it was just a matter of being diplomatic and creating the right propaganda for your ideas."[75]

Grant cultivated Walt Disney more assiduously, and more adeptly, than anyone who had preceded him. Of all the artists who came to the Disney studio in the Depression years, Grant may have been unique in his understanding of how to use artistic skills for what were essentially political purposes. Grant "had the tremendous faculty of being very

simpatico with Disney, who admired his mind," said Campbell
Grant. "Joe could always talk to him, which was not always
easy."[76]

The work of the model department was just one step removed
from the writing of *Pinocchio*—in the early stages, Grant's artists
developed characters that may not have appeared yet in story
sketches—and Grant attended a great many story meetings on
that film. He is mostly silent in the surviving meeting notes, but
his work on the film obviously impressed Disney. When Disney's
meetings on *Fantasia* with Stokowski began in September 1938,
he brought into them only two members of the Disney staff who
were to be directly involved in how the film looked. One was Dick
Huemer, the former animator who until then had been slated to
direct parts of *Pinocchio* and was now to be *Fantasia*'s supervising
director; the other was Joe Grant.

It was in work on *Fantasia*—the film that Disney himself
approached so much more enthusiastically than *Pinocchio*—that
Grant was first visibly the Machiavellian of his own description.
Early meeting notes show him doing something he would later
boast of: handing sketches to Disney as soon as he entered the
room, so that Disney was immediately stimulated by Grant's
ideas. When Disney entered the 29 September 1938 meeting on
"Dance of the Hours," midway in a discussion, Grant immediately
gave him some sketches of the characters and offered up, as if it
were his own, the idea that the animal dancers should burlesque
Vera Zorina's ballet performance in the pretentious film called
The Goldwyn Follies; a sketch artist named Mike Arens had
broached that idea a few minutes before.[77]

Members of Grant's department were deeply involved from the
beginning in the writing of parts of *Fantasia*—Campbell Grant as
story director for *Bald Mountain*, the newly hired James Bodrero
as sketch artist for "Dance of the Hours"—and they filled their
storyboards with what were, to judge from surviving examples,
unfailingly attractive sketches. Joe Grant himself was a constant
presence in *Fantasia* meetings and far more vocal than he had
been in meetings on *Pinocchio*. As Bodrero put it, Grant "built
himself a power structure within the power structure" by using
his "top of the line" people in the model department to bolster his
position with Disney.[78]

As seen from elsewhere in the studio, the model department
was populated mostly by gifted but rather lazy young men from
privileged backgrounds. The drawings that came out of the model

department were of a piece with their authors, speaking more of talent, facility, and charm than any strong artistic vision. Animators regarded Grant and his department with skepticism at best; Frank Thomas spoke in 1976 of artists in Grant's department "who could sit and whistle and make a pretty little thing without much effort" while the animators endured sweaty struggles.[79] The model department's members regarded the resentful animators with a corresponding disdain, Joe Grant said in 1988: "I would admit that we were great snobs, that we looked upon these guys as a hundred percent yokel."[80]

The model department was the easy winner in the contest for Walt Disney's attention and enthusiasm because it was feeding his growing appetite for pictorial solutions to the problems that *Fantasia* posed. It was here that Grant's Machiavellian approach found its clearest expression, through sketches that validated Disney's own yearnings—however much those yearnings needed to be called into question—and thus elevated Grant's importance.

Pictorial solutions were nowhere more welcome than in work on the *Pastoral*. "Walt was very susceptible to stimulation," Huemer told Joe Adamson, citing the *Pastoral* as an example: "Little character sketches by Joe stimulated him into doing the centaurs and other mythological characters. He'd say, 'That's good, we ought to do something like that!' "[81] By late in the summer of 1939, Grant's men Bodrero and Provensen were working on the last three movements of the symphony, producing "pretty little things" that a crew of writers and sketch men would use as the basis for the actual continuity. Bodrero worked in pastels on brown paper, and his sketches thus combined a brilliance of color with a warm earthiness. As difficult as it might be to translate such sketches into animation, there was no gainsaying their appeal—and they could only have bolstered Disney's confidence in his choice of the *Pastoral* for the program, and of mythology for its subject matter.

As pleased as Disney was with the work being done on the *Pastoral*, he was by August showing some of the same anxiety about the need to move ahead that he had shown almost two years earlier, when *Pinocchio* was getting under way. "This is one that we want to get in work pretty soon," he said. "I'm going to put the whole plant on this thing pretty soon."[82] The reason for his urgency was that animation

From Pinocchio (1940), a film dominated by a new reliance on live action as the basis for the animation—exemplified here by the Blue Fairy—and by a quest for more cuteness in its puppet hero.
© *Disney Enterprises, Inc.*

was coming to a close on *Pinocchio*, a film that by the late summer of 1939 had turned into something like a very large and very expensive stepchild.

There is no way to know exactly how much of *Pinocchio* was shot first in live action, but the percentage was very high. Actors performed as Geppetto, as Jiminy Cricket, and as the two foolish villains, the fox and the cat, and the story man T. (for Thornton) Hee played the puppet master Stromboli in film shot for Bill Tytla's use.[83] Walt Disney—so wary of live-action film's hazards during the animation of *Snow White*—had not altogether forgotten about those hazards by the time his animators were working on *Pinocchio*. In his meeting with the Jiminy Cricket animators, Ham Luske told them: "Walt wants the cricket to be lively, active, and a high jumper. He must never feel as heavy as the actor in the live action." But by 1939 Disney tilted strongly in the other direction.

Luske had proposed, at some point early in work on *Pinocchio*,

that the puppet be brought to life by a fairy who was herself child-like—"a sisterly type," he said in October 1938, who "could have done little frivolous things with her hands and voice and body that would have given us business to draw."[84] Such a representation of the Blue Fairy would have been in keeping with the character as she appears in Collodi's book, but Disney overruled Luske: the Blue Fairy had to be drawn as a beautiful young woman instead. Marjorie Belcher modeled for her in live action, as she had for Snow White, but the Blue Fairy's proportions, in rotoscoped animation by Jack Campbell, were far more realistic than Snow White's.

Live action dominated the work even of those animators who insisted that they could keep their distance from it. When Art Babbitt began work on Geppetto in the fall of 1938, Luske provided him with photostats from the live action for the character; he made no use of the photostats, Babbitt later claimed, although he subsequently received tracings of every other frame. "I flipped through them several times," he said, "to get an idea of what occurred in the scene, what little mannerisms I might be able to get out of it, and those drawings were cast aside."[85] And yet Babbitt's Geppetto, like the animation of the character by Bill Tytla and Bob Stokes, was so much on "the live-action side," the assistant director Hal Adelquist said a few years later, that Walt Disney asked Fred Moore to work with those three animators to "get the character cuter."[86]

Babbitt's assistant William Hurtz remembered that "Walt asked [Moore] to do [test animation] to get some spark into Geppetto, to get him out of this rotoscope mold that even Art was kind of trapped in. Freddy drew Geppetto, and...he acted like a high-school kid.... Laughs, raises his hands, come down, slaps his knees, laughing all the way, and comes up into a perky little pose."[87] Moore's version of Geppetto is visible still in model sheets made up of his animation poses, and that version is as Hurtz describes it, distressingly broad and obvious.

Ultimately, Babbitt animated the great majority of Geppetto's scenes, and whatever reservations Disney felt about their live-action flavor had disappeared by September 1939. With animation all but done, Disney said that Babbitt "finally did the best stuff on Geppetto. Gee, he goes through that picture swell now. He's awfully true and sincere."[88]

By late in work on *Pinocchio*, the special-

effects staff had grown to fifty-two (including ten airbrush artists), and they devoted much of their time, too, to contriving a realistic surface for the film. Inked cels of ocean waves were not painted, but were instead photographed over specially prepared blue paper cut to the shape of the waves. Before the shooting, several assistant animators applied a continuous tone to the blue paper—a separate sheet for each cel—to simulate light and shade on the waves. To create the tone, they used pencil dust made from a mixture of blue and black mechanical-pencil lead. Each drawing took hours to complete; and each one could be ruined by as little as a single drop of perspiration—a constant hazard since the work was being done in the summer of 1939 in buildings that were not air-conditioned.[89]

Disney had used a vertical multiplane camera in the shooting of *Snow White*; for *Pinocchio*, he introduced a horizontal camera that could, he said early in 1940, accommodate background paintings twice as large as before—a change that permitted shooting *Pinocchio* "on the same principle as motion-picture photography in a live-action studio."[90] The search for a particularly smooth and blemish-free equivalent of live-action photography continued until *Pinocchio* was previewed in Glendale in January 1940. After the preview, in Frank Thomas's account, Milt Kahl redrew the scenes at the end of Pinocchio as a "real boy": "The hands were too large and a few sections of the body, or the legs or something, looked too much like the model we had been drawing,"[91] that is, a little too real.

By then, many of the *Pinocchio* animators had long since moved on to *Fantasia*, and the studio's personnel were in the midst of moving to new quarters in the San Fernando Valley, about five miles from the Hyperion studio. In the wake of *Snow White*'s success, Disney at first considered expanding and remodeling the Hyperion plant, but then he decided to build on a fifty-one-acre site in Burbank.[92] Time seemed to support his decision: by 1939, the Hyperion studio had expanded not just into adjacent apartment houses and across Hollywood to Seward Street, but to a building on Vine Street as well.[93] The studio's personnel had roughly doubled in number, to around twelve hundred, since *Snow White*'s release.[94] The new studio cost three million dollars,[95] and that money purchased buildings whose careful planning contrasted sharply with the haphazard growth of the Hyperion buildings.

Bill Garity, the engineer who oversaw the design and con-

struction of the new plant, wrote soon after it opened of the many features that had been incorporated in the three-story animation building for the benefit of the artists working there: air-conditioning, recreation facilities, north light. The appointments were not just lavish but sometimes almost comically so. The animator Robert Carlson recalled that "any animator could pick up his phone and call the coffee shop and have a soda delivered, or hot coffee, hot chocolate, ice cream—anything. And a waiter dressed in white would come running down the hall, with service right to your room."[96]

Such coddling was just one face of a paternalism that was stronger than anything seen before at the Disney studio, and that was embodied more ominously in the floor plan of the animation building. Walt Disney's office was on the third floor, which he shared with the writers and the character model department; directors and layout artists were on the second floor and animators, on the first. A secretary was posted at the entrance to each wing, eight to a floor. "She controls the door to the wing," Garity wrote, "in order that no one may interrupt the artists without first being announced."[97] That the artists might *want* to be interrupted, as they so often had been at the highly informal Hyperion studio, and might even benefit from being interrupted, may not have crossed Garity's mind.

Character animation—the object of such concentrated attention during work on *Snow White*—had been subtly devalued during the production of *Pinocchio* by the growing reliance on live action, and now as the animation of *Fantasia* proceeded at Burbank, it was all but irrelevant to much of that film. Effects animation was much more prominent. Samuel Armstrong, who had been not an animator but a background painter, was directing two sections, Toccata and Fugue and *Nutcracker*; Paul Satterfield, an effects animator, was directing half of *The Rite of Spring*. Those choices, which once would have seemed so curious, made sense for the kind of film *Fantasia* had become.

Live action was shot for *Fantasia*—for "The Dance of the Hours," in particular—but less than for *Pinocchio* because less of *Fantasia* could be staged and shot as live action. (The live action for "Dance of the Hours" seems to have been more important as an aid to the story men than to the animators: film had been shot for the entire story, with obese

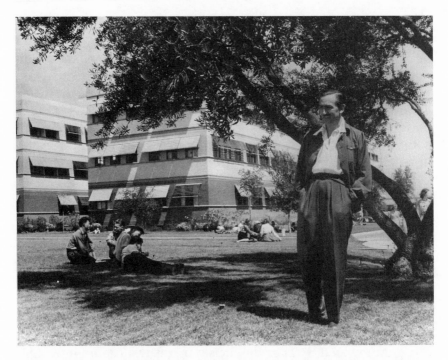

Walt Disney walks the grounds of his new Burbank studio in 1940. ©
Disney Enterprises, Inc.

dancers impersonating the hippos, by 16 November 1938, when
"Dance" was still many months away from animation.)[98]
Ironically, the section of the film that promised to rely on char-
acter animation more than any other was the *Pastoral*. The seduc-
tive drawings by Joe Grant's unit could not be translated to the
screen except as character animation, no matter how difficult that
translation threatened to be.

Bill Tytla was typecast again, animating Tchernobog, a gigantic
demon from Ukrainian folklore, for *Night on Bald Mountain*, and
here again, he seems to have approached the animation of his
character in something like the spirit of an overly intense method
actor. Robert De Grasse, his principal assistant then, remembered
that Tytla worked on Tchernobog in a darkened room: "I'd look
into this bottomless pit that snuffling and grumbling were coming
out of. He could work for hours and never take a break. I doubt
he even knew what time it was."[99]

Sometimes a character animator like Art Babbitt occupied so
tiny a corner of work on *Fantasia* that, in accounts of that time,
his shoulders can be felt jostling against those of other people.

Babbitt animated two parts of *The Nutcracker Suite*: the "Chinese Dance," performed by seven mushrooms whose tops are treated as coolie hats, and the "Russian Dance," in which thistles and orchids take the parts of male and female Russian dancers. Before starting work on those brief sections (about a minute each), Babbitt said a few years later, he took "dancing lessons for two months four or five days a week." He also "took piano lessons for a year and a half...so I would understand music and its relationship to animation." On this occasion as on others, he claimed, he discarded the live action shot for his guidance "because it didn't have a semblance of a suggestion in it."[100] When he finally began animating the "Chinese Dance," he spent two and a half months on it.[101]

For all of the effort Babbitt put into the "Chinese Dance," though, his animation went through rough handling before it finally reached the screen. The idea was that six large mushrooms would change shape constantly as they moved—small, squatty ones becoming tall, thin ones, and vice versa—while a single small one struggled to keep up, very much as if it were Dopey trailing the other six dwarfs. Elmer Plummer had drawn most if not all of the story sketches, and Plummer was, Babbitt's assistant Hurtz recalled, not at all happy with what Babbitt had done, because "it was very un-mushroomlike." A Babbitt mushroom "looked like, literally, a little Chinaman...a little head, little hat on a long skinny mushroom, as against Plummer's model of a character that was almost all head and short, stubby stem." With Babbitt's agreement, "Plummer made roughs over Art's animation...passed them over to me, and I would clean them up...putting in all the rhythms and forms we were trying to get out of it."[102]

The Plummer-Hurtz collaboration was not the end of the story, though: Babbitt himself returned to the animation and revised it further. "What essentially happened" when Plummer revised the animation, Hurtz said, was that the mushrooms became both taller and broader, "so the volume of the character was maybe four times that of Art's character. When you increase the volume of something that much, you necessarily slow it down, four times." Babbitt thus had to return to his animation so that the mushrooms would "jump higher, and more crisply—things like that."[103]

Babbitt later claimed that his own participation was critical to the undeniable success of the "Chinese Dance." When he picked up the scene, he said in a letter published in 1976, "the music and the storyboard were in conflict—nothing was working. My meager knowledge of music enabled me to point out the obvious statements, answers and repeats in the music, and suddenly everything became clear."[104] But Howard Swift, who emerged on "The Dance of the Hours" as one of the strongest of the studio's character animators—he animated the ostrich ballerinas—suggested that the "Chinese Dance" could have been handled just as well by any number of Disney animators because Plummer's storyboard and the music itself provided so much support. "The jewel was in the box," Swift said. "All one had to do was take it out and expose it properly."[105] Nothing remotely similar could have been said about *Snow White and the Seven Dwarfs*.

While the Disney studio was in the midst of the animation of *Fantasia*, *Pinocchio* finally reached the screen. It opened in New York on 5 February 1940. Just five months earlier, in October 1939, with *Pinocchio* largely completed, Walt Disney had written to the manager of Radio City Music Hall that he was still not ready to set a release date for the film. Making *Pinocchio* had been "far worse" than making *Snow White*, he wrote. "It's the toughest job the animators have ever had, and I hope I never have to live through another one like it."[106] As it happened, *Pinocchio* did not open at Radio City anyway because the Music Hall would not guarantee a minimum engagement of ten weeks, twice as long as *Snow White*'s run.[107] *Pinocchio* needed the kind of push that so long an engagement at the Music Hall would give it. The film's negative cost was $2.6 million, more than $1 million higher than *Snow White*'s.[108]

Of the film that emerged from so much effort and expense, Walt Disney himself said, less than a year after its release: "*Pinocchio* might have lacked *Snow White*'s heart appeal, but technically and artistically it was superior."[109] There was powerful irony in those words because Disney had made his most significant departures from Collodi's book precisely to enhance *Pinocchio*'s "heart appeal."

As Disney finally constructed the film's story, the heaviest part of the narrative load fell on Jiminy Cricket. For that reason, probably, Jiminy is an unmistakably American character in a story

that is otherwise strongly European in flavor. The cricket's nasal voice, by the vaudeville entertainer Cliff Edwards ("Ukulele Ike"), is pure twentieth-century American, as are his expressions ("Break it up, boys"), and he is direct, earnest, and cheerful in a way that speaks of midcentury Americans' conception of themselves. Despite Ham Luske's invocation of Rooney and Fields, Jiminy resembles no Hollywood actor so much as he resembles one of Disney's own stars, as he had evolved by the late thirties: Mickey Mouse. Even their nervous chuckles are alike. Jiminy is, in short, a character with much the same sort of contrived appeal as Pinocchio himself.

Despite the role assigned to him, Jiminy is not the story's natural center; struggle as he may against its villains, most of them are not even aware of his existence. It is Pinocchio who commands attention, and Disney had chosen to make Pinocchio a cipher for much of the film's length (Snow White is a far more dynamic character). In effect, Disney and his writers tried to correct the imbalance they had created, by resorting to clumsy manipulation near the end. Thus Pinocchio spends many minutes underwater, with no noticeable ill effects, but then, conveniently, drowns (or suffers an equally implausible blow to his wooden head), so that the Blue Fairy can restore him to life as a real boy.

Throughout *Pinocchio*, aspects of the film that should be secondary are worked too hard, as if Disney were loading on production values to conceal weaknesses in the film's story. The work of the ten airbrush artists is everywhere, prominent in many scenes that would have looked better without it; and in more important ways, too, strain shows. *Pinocchio* boils with a kind of razzle-dazzle that has no parallel in *Snow White.* Cuts from scene to scene are plentiful—the camera almost never lingers—and within each scene, movement is constant. Sometimes this pervasively restless animation adds life to a scene that might have gone flat without it. Much more of it is painfully literal, a slightly exaggerated (at best) version of a live-action original. "If the live action is correct when the scene is picked up," Ham Luske said in October 1938, "the animator is held down to not doing too much," and it is just such prissy restraint that is most often visible on the screen, beneath a constant flutter.

Art Babbitt's animation of Geppetto thus made that character a virtual duplicate of

Christian Rub, the Austrian actor who provided the voice and performed in the live action. "Sincere"—the word that Disney used in praising Babbitt's work—was acquiring a talismanic force at the studio by the time *Pinocchio* was released, and it worked against the kind of animation that had so distinguished *Snow White and the Seven Dwarfs*. Many of the Disney people had grown concerned that pursuing caricature could diminish audience acceptance of their characters. "There is a very important thing in animation that you have to hit," Ben Sharpsteen said at one of the development program sessions in March 1939, "which is reality to a certain degree; otherwise your audience doesn't feel for the character."[110]

The exaggeration—and thus the strangeness—intrinsic to caricature required emotional validation of the kind that Bill Tytla brought to Grumpy in the scene in which that dwarf warns Snow White against the Queen's trickery. Grumpy and Snow White are so wildly dissimilar, in appearance and in the way they move, that they might almost belong in two different films, but Grumpy is so focused emotionally on the girl that there is no doubting their presence together in that place. Trying to give to character animation such validity was difficult and risky; retreating to a more nearly literal kind of drawing and movement seemed safer.

No animator suffered more in this changing environment than Tytla. His expertise is everywhere evident in his animation of Stromboli—in the sense of Stromboli's weight and in his highly mobile face—but however plausible Stromboli is as a flesh-and-blood creature, there is in him no cartoon acting on the order of what Tytla contributed to the dwarfs. At *Pinocchio*'s Hollywood premiere, Frank Thomas said, W. C. Fields sat behind him, "and when Stromboli came on he muttered to whoever was with him, 'he moves too much, moves too much.'" Fields was right—although not for the reason Thomas advanced, that Stromboli "was too big and too powerful."[111]

In the bare writing of his scenes, Stromboli, more than any of the film's other villains, deals with Pinocchio as if he were, indeed, a wooden puppet—suited to perform in a puppet show, and perhaps to feed a fire—rather than a little boy. But the chilling coldness implicit in the writing for Stromboli finds no echo in the Dutch actor Charles Judels's voice for the character. Judels's Stromboli speaks patronizingly to Pinocchio, as he would to a gullible child, and his threat to use Pinocchio as firewood sounds like a bully's bluster. As Tytla strained to bring this poorly con-

ceived character to life, he lost the balance between feeling and expression. The Stromboli who emerges in Tytla's animation is too vehement, "moves too much"; his passion has no roots, and so he is not convincing as a menace to Pinocchio, except in the crudest physical sense. There is nothing in Stromboli of what could have made him truly terrifying: a calm dismissal of Pinocchio as, after all, no more than an object.

To some extent, Tytla may have been overcompensating for live action that even Ham Luske acknowledged was "underacted." But Luske defended the use of live action for Stromboli by arguing that it had kept Tytla on a leash: "If he had been sitting at his board animating, without any live action to study, he might have done too many things."[112] In its use of Bill Tytla, and in many other ways, *Pinocchio* was fundamentally different from *Snow White and the Seven Dwarfs*, even though it was made by virtually the same people. The question was whether its reception by the public would be fundamentally different, too.

●◗◄

The initial returns from New York were not encouraging. Disney had said, just before *Pinocchio*'s release, "I'd rather have an artistic flop than a box-office smash hit any day";[113] but now, confronted with the possibility of just such a flop, he "was very, very depressed about it," Joe Grant said.[114] But however disappointing *Pinocchio*'s first receipts may have been, it was still only one film in what had become an ambitiously large program. In February 1940, not only was the animation of *Fantasia* well under way, but so was the writing of *Peter Pan*; *Alice in Wonderland* was alive, if just barely; and some writing had been done for a feature that would star Mickey Mouse and be based on "Jack and the Beanstalk." Most important, there was real movement on *Bambi*.

Off and on during 1939, Dave Hand—in his role as Disney's majordomo—had pressed Perce Pearce to move more quickly on the story. Finally, on 17 August 1939, Disney put Hand in charge of the *Bambi* unit full time. Pearce was still supervising the story crew, but now everything moved with a new urgency. On 31 August and 1 September 1939, Disney attended what appear to have been his first *Bambi* story meetings in more than a year. With *Pinocchio* all but

finished and *Fantasia* going into animation, Disney had fewer demands on his time, and now he began attending *Bambi* meetings more frequently. (He had even attended a flurry of meetings on the shorts in early August, expressing sharp impatience with the laboriously worked-out stories that Hand's oversight had spawned.) By the time the *Bambi* story unit moved to the new Burbank studio late in the year, there was reason to hope that the writing could at last be completed in a matter of months. It was around the end of 1939, too, that Frank Thomas and Milt Kahl began experimental animation of the deer.

In a 9 September 1939 *Bambi* meeting, Kahl had proposed what he thought was "a swell idea. Working units."[115] The animators would not specialize by character but would instead deal with whole sequences, just as the directors did—they would, in fact, animate all of the characters in those sequences. Kahl's motive was clearly to relieve his own boredom at having to animate the same character for months on end—he said of Pinocchio, "I get so I can't even draw the guy"—but he dangled in front of Disney the lure of greater efficiency: a sequence wouldn't be held up because the animator who was supposed to animate Bambi, say, was still working on some other part of the film.

Because it could entail such delays, casting by character worked against the feature schedule that Disney wanted to maintain. But as he had learned during the animation of *Snow White*, parceling out a character among several different animators held its own hazards. (Here was one reason he was so much more sympathetic to live action during the animation of *Pinocchio*: he now accepted Hand's argument that it could help smooth out inconsistencies in the animators' work.)[116] As Disney immediately realized when Kahl made his proposal, it would "be up to the animators to keep together and keep the characters the same" from one sequence to another—a task that would, he suggested, be beyond many animators' capabilities. What made Kahl's proposal a plausible alternative to casting by character was the animators involved. Kahl and Thomas had already shared the animation of Pinocchio, with no obvious seams separating their versions of the character; the two animators were, Disney had said in a 1 September *Bambi* meeting, "the best all-around men we have."

By the end of 1939, Disney had assigned Kahl and Thomas to handle whole sequences in *Bambi*. Work on *Bambi* would be stretched out, he had decided, so that other animators could be

brought onto the film slowly and not jeopardize Kahl's and Thomas's control; that way, too, the two lead animators could handle more sequences, finishing one and then moving on to another. There was no way for Disney to assess the wisdom of this arrangement until he had seen Kahl's and Thomas's first few minutes of rough animation for *Bambi*, as he did on 1 March 1940. Thomas had animated scenes of the "child" Bambi, as he learned to walk; Kahl, scenes of the "adolescent" Bambi, as he meets the young doe Faline. Disney was strikingly enthusiastic: "That's great stuff—no kidding.... Those personalities are just pure gold."[117]

By then, Disney's thinking about his films had crystallized. There would be two tiers of Disney animated features. In the top tier would be films like *Bambi*, distinguished by pictorial opulence and characters that required, as the director Bill Roberts said, "straight drawing."[118] They would get special treatment in the studio—and quite possibly in the theaters. "These pictures represent a lot of work and a lot of thought," Disney said in a *Bambi* meeting on 1 February. "They're not just an ordinary run-of-the mill type of production."[119] In the second tier would be films closer to "an ordinary run-of-the-mill type of production." The Mickey Mouse version of "Jack and the Beanstalk" would be one, and *Peter Pan* another, and Disney had in mind others that were still in the earliest stages of work, including one inspired by Joe Grant's spaniel, Lady. He also envisioned the production of "feature shorts"—features made up of several short cartoons.

One second-tier feature was rapidly moving to the head of the line. It was based on a children's story that the studio had bought while it was still in manuscript, evidently early in 1939.[120] Called *Dumbo*, it told of a baby circus elephant that overcame the general ridicule of its enormous ears by learning how to fly with them. The idea at first had been to make *Dumbo* as a short cartoon, and Disney put Joe Grant in charge of developing the story as one of the Leica-reel filmstrips made up of story sketches.[121] A few months later, though, in January 1940, Grant and Dick Huemer began collaborating on a feature treatment, a detailed narrative broken down into chapters. (Their work on *Fantasia* had effectively ended now that all segments of the film had gone into animation.) As they submitted the chapters to Disney one at a time, Huemer told Joe Adamson, he "used to come down and say, 'That's coming along

good. We'll make it!'"[122] By late in February 1940, Disney had still not seen all of the treatment, but he spoke of *Dumbo* as if he felt no doubt it would be made.

Dumbo, he said at a 27 February meeting on *Bambi*, was "an obvious straight cartoon," and so a natural fit for certain kinds of animators. "It's caricature all the way through," he said. "I've got the men for it"—animators, he said, who "don't fit here," on *Bambi*. "Tytla, I'm afraid of, on these things. I'm afraid he is going to get tied up in a knot.... He's a caricaturist. Fergy is a caricaturist, too."[123] Other familiar names—Art Babbitt, Ward Kimball—floated into the conversation, categorized in the same way. These were not animators, Disney was saying, whose work could rise to the elevated level that *Bambi* required. "Caricature"—the banner he had raised in his December 1935 memo to Don Graham—had acquired a slight but unmistakable shabbiness in his eyes, compared with "straight drawing."

Dumbo had one inescapable advantage over films like *Fantasia* and *Bambi*: because it called for less elaborate animation of both characters and effects, it could be made for less money. There is no sign in the meeting notes from the months immediately following *Pinocchio*'s release that Disney's commitment to his more elaborate films had yet been tempered by *Pinocchio*'s disappointing box-office performance, but that film's domestic troubles were great cause for alarm, considering that Disney's European market had already been drastically curtailed by the outbreak of war in September 1939.

That market disappeared entirely when the "phony war" ended and the Nazis conquered France in the spring of 1940. *Pinocchio* wound up being dubbed into only two foreign languages, Spanish and Portuguese.[124] In August, Disney's bankers imposed a $2.25 million ceiling on the studio's line of credit; they insisted, too, on a cut in salaries.[125] Walt Disney Productions became a public corporation in April 1940, raising more than $3.6 million through the sale of preferred stock, but that money went toward the cost of the Burbank plant and paid off other debts.[126] So attentuated was Disney's revenue stream in 1940 that he had no choice but to heed his bankers.

Seven months after its release, *Pinocchio* had returned rentals to the studio of less than a million dollars. In its first annual report as a public corporation, Walt Disney Productions charged off a million-dollar loss to the film. The company told its shareholders that *Pinocchio* "suffered from excessive cost which was a

direct result of the transition period through which the company passed when it changed its policy of making one feature in two years...to a policy of producing from two to four features a year as presently projected."[127]

Pinocchio failed domestically even though it had gone into American theaters bedecked in glowing reviews; moreover, the public should have been primed to receive it, given how joyfully it had greeted *Snow White and the Seven Dwarfs*. Whatever *Pinocchio*'s own shortcomings, it was still hard to explain why its box-office receipts fell so far short of *Snow White*'s. There was, however, a chilling possibility: that animated features were, in box-office terms, genre films like westerns and horror movies. Occasionally such a film might break out and achieve a broader success—as *Stagecoach* had, or *Frankenstein*—but otherwise, a genre film's prospects were limited. *Snow White*'s box-office success could thus have been a tremendous fluke, and *Pinocchio*'s much smaller receipts a more accurate measure of what an animated feature could expect at the box office. That was not a cheerful thought to contemplate as *Fantasia* neared completion.

Work on *Bambi* and *Dumbo* proceeded according to plan, that is, *Bambi* moved ahead slowly, while *Dumbo* all but flew through the studio. Starting in March 1940, a *Dumbo* story crew headed by Otto Englander translated the Grant-Huemer treatment into story sketches. Disney's desk diary for 1940 shows him attending three dozen meetings on the film in the last seven months of the year, but no meeting notes were kept (saving the cost of a stenographer's time) and, from all appearances, no knotty problems delayed production. Animation handouts were well under way by October. The writing of *Bambi* did not end until July 1940, but by the fall large parts of that film, too, were in the animators' hands.[128] As of the end of the studio's fiscal year in September, *Bambi*'s cost had already risen to more than $858,000.[129]

The studio's finances discouraged dawdling and encouraged Disney to turn his attention to films that could be made cheaply. As early as 6 May 1940, when he wrote a three-page memorandum to Ben Sharpsteen, he was thinking of the Mickey Mouse "Jack and the Beanstalk"

feature as one that could be made by shorts animators on a shorts budget: fifty-five dollars per film foot, or around $350,000 for a seventy-minute film, a preposterously low figure.[130] By June 1940, he had begun work on *The Reluctant Dragon*, which was to be, for most of its length, an inexpensive live-action feature, organized around a behind-the-scenes tour of the studio.

Even in work on *Bambi*, Disney retreated from his earlier expansive tone. On 24 October 1940, he viewed what was apparently a running reel of the entire film—a mixture of story sketches and pencil animation, accompanied by music that was keyed to each section but not fully scored and synchronized with the action. The music worried Disney: "I hate to see us taking the risk of being subtle. The music is inclined to be a little too different and new. We've got to take this thing out and make it appeal to a very broad audience."[131] It was an odd thing to say less than three weeks before *Fantasia*'s premiere.

Fantasia opened 13 November 1940, as a road-show presentation at the Broadway in New York, a two-thousand-seat theater that was called the Colony when *Steamboat Willie* was first shown there, twelve years earlier. The Broadway had been especially equipped with a sound system for "Fantasound," which had a much wider decibel range than conventional sound films. The nine tracks used in recording the music had been combined in four tracks (including a "frequency control track") for use with the film itself. Ninety speakers had been installed in the theater—thirty-six behind the screen, the rest around the hall.[132] Stokowski had actually done stereophonic recording, using different microphones to pick up the different sections of the orchestra, for a 1937 Universal feature called *100 Men and a Girl*; *Fantasia*'s innovation was to reproduce such sound through multiple speakers, and the results were, from all accounts, highly impressive. What was on the screen got a more mixed reaction from reviewers, who were variously ecstatic and troubled.

They had, in fact, seen a very peculiar film. So caught up had Disney been in *Fantasia*'s pictorial possibilities that he had made a gigantic catalogue of effects animation: a two-hour demonstration of what the Disney effects animators (and their even more specialized colleagues, like the airbrush artists and multiplane cameramen) could do. Of the eight thousand feet of animation shot on thirty-five-millimeter film for the completed *Fantasia*, more than thirty-five hundred feet were shot by the multiplane camera—more than for *Snow White* and *Pinocchio* combined. The

average number of camera exposures per frame of film was around two and a half, the studio's newsletter reported, because of "an unprecedented amount of multiple exposure."[133]

The work of the effects animators is not unfailingly convincing. In *The Sorcerer's Apprentice*, for example, when Mickey Mouse stands atop a rock, the waves at its base seem to be composed of kernels of popcorn. If the representation of some natural phenomenon is questionable in one segment, though, a better representation can probably be found in another; there is wetter water in other parts of *Fantasia*. This rich and plentiful effects animation swaddles the character animation within segments and throughout the film as a whole. Sometimes the line between the two actually blurs, as in the "Arabian Dance" that makes up part of *The Nutcracker Suite*: tropical fish are the characters, but their fins move in what amounts to effects animation even though it was apparently done by a character animator, Don Lusk. The fins billow as if they were silken draperies; movement conveys texture. The fish themselves are mere vehicles for their appendages.

Only the strongest character animators could hope to make an impression on a screen dominated by spectacular effects animation, sumptuous color, and Fantasound—and even then there was sometimes the question, as with Babbitt's *Nutcracker* numbers, as to how much credit the animator really deserved. Sometimes the question was closer to the reverse: Had the animator's work been diminished by its surroundings? An example is the work done by Bill Tytla, who was not only the animator of the gargantuan demon Tchernobog in *Night on Bald Mountain* but the overseer of that sequence's other characters, too. Tchernobog rules a screen that is otherwise populated mostly by his servants, a host of deformed and inhuman creatures; they were drawn by young animators—Bill Shull, Les Novros, Bob Carlson—who had been Tytla's assistants, and who now worked under what was called his "animation supervision." For all the control that Tytla might be thought to have exercised over *Bald Mountain*, however, he was working within a pictorial scheme that was much more confining than anything he had known before.

Kay Nielsen, like Gustaf Tenggren, a Scandinavian-born illustrator (Nielsen was Danish), had worked with Campbell Grant on the storyboards for *Bald Mountain*, and when

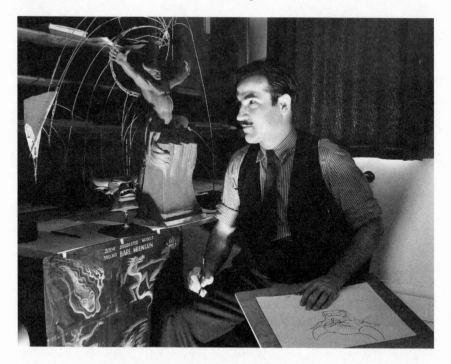

Bill Tytla poses in suitably dramatic lighting for a publicity photo for Fantasia. Tytla was the principal animator of the Night on Bald Mountain sequence in that film. The three-dimensional models of the demon Tchernobog were made by Joe Grant's model department; the model sheet at lower left was drawn by Kay Nielsen. © Disney Enterprises, Inc.

Wilfred Jackson began putting the sequence on the screen, his job was largely a matter of realizing Nielsen's stark, melodramatic designs in the animation and backgrounds. (Thor Putnam, who drew layouts for the sequence, recalled that Nielsen's sketches were so strong that no exploratory layout sketches were needed; nothing more was required than working out the mechanics of the staging.)[134] Tytla animated a Tchernobog wholly in keeping with Nielsen's conception—the demon, as he revels in flames and summons the spirits of the dead, is persuasively huge and powerful—but near the end of the sequence, as Tchernobog recoils from the sound of church bells, something goes subtly wrong.

In the earlier scenes, Tytla had no choice but to animate Tchernobog as the embodiment of pure (and thus not very interesting) evil; it was only in the scene in which the demon faces defeat that Tytla had even the opportunity to present him as a

character of any psychological complexity. For that scene to work, the demon's face and body had to betray a flood of emotion, a fever compounded of fury, defiance, despair, and finally resignation. It was only in that scene, in other words, that Tytla could animate Tchernobog with anything approaching the emotional fluidity of his animation of Grumpy (as opposed to the almost wholly *physical* fluidity of the earlier scenes). To the contrary, though, Tytla's animation of that critical scene suffers from a faint but perceptible stop-motion quality. Each movement, each drawing, is a shade too discrete. It is as if Tytla felt compelled to keep glancing over his shoulder at Nielsen's originals; perhaps he knew, at some level, that he would stray too far from those originals if he let himself ride the tide of his character's emotions. In his animation of Tchernobog, as in his animation of Stromboli for *Pinocchio*, Tytla was forced to labor under the weight of conceptual errors.

Similarly, it was Walt Disney's distrust of abstraction, rather than trust in anything else, that shaped the Toccata and Fugue. The Toccata portion is not even accompanied by animation, but by shadowy images of the members of the on-screen orchestra. (Disney had come up with that idea in November 1938 as a way to hold down the abstract animation.)[135] The troublesome Fugue, after being shelved in August 1939, went back into work a few months later; the effects animator Cy Young was still very much involved, along with Lee Blair, who had previously done watercolor story sketches for "Dance of the Hours" and *Pastoral*. Not only was Oskar Fischinger gone, but, according to Blair, the storyboard for the Fugue was based "not at all" on Fischinger's sketches: "We just followed our own impulses in the interpretation of the music."[136]

Young, if not Blair, may have responded to those parts of the Fischinger films that could be interpreted as objects moving in space—blocks of light, for instance—rather than abstract patterns, but otherwise the Fugue owes little to Fischinger's films. The images have no other unifying idea behind them. There was clearly no effort to follow Stokowski's suggestion and construct a series of images that would be the visual equivalent of counterpoint. What is lacking, in other words, is any reason for attaching these pictures to this music.

Other segments offend in the same way,

none more than the *Pastoral*. The "centaurettes" look like American teenage girls attached to horses' bodies. According to Dick Huemer, "That was all done on purpose.... I still believe that to the average person in the street, there's nothing more alien than something ancient Grecian, or Persian. No identification. It's outside of their ken.... You can't laugh at something you don't dig."[137] In other words, the *Pastoral* character animators labored under a double disadvantage: they had to withstand comparisons with the work of Joe Grant's artists, and they also had to bring to life story material that was—beneath the glossy surface of the story sketches—hopelessly puerile. The animators included some of the studio's brightest names—Fred Moore, Art Babbitt, Ward Kimball, Ollie Johnston—but the *Pastoral* diminished and defeated all of them.

It was the *Pastoral*, and to a lesser extent the other two character-dominated segments, *The Sorcerer's Apprentice* and "The Dance of the Hours," that could most easily have accommodated sound effects. There are none, though—save for two in "Dance of the Hours"—because Walt Disney did not want them. The surviving *Fantasia* meeting notes do not reflect such a conflict, but Disney said at a *Bambi* meeting on 3 February 1940, in the midst of the animation of *Fantasia*, that "at first there was quite a battle" over whether to add sound effects to the soundtrack. "Every time we had a meeting somebody wanted to put some sound effects in. Now, by God, I think you couldn't get any of them to even think about it."[138]

Disney's resistance to sound effects can be explained only as a by-product of his determination to put pictures and music on an equal footing. But since he had violated that self-imposed rule repeatedly, there was no reason to draw the line at sound effects—especially not for "Dance of the Hours," the ballet parody, since dancers generate sound effects aplenty as feet strike the stage. No such noise accompanies the cartoon ballet, though; the sound effects are limited to a discreet "thump" as an ostrich ballerina drops onto the floor from a split and to a crash as the doors of the Grand Duke Alvise's palace collapse, just after the last notes of the music have been heard.

There is no record of why Disney decided to allow the ballerina's "thump," but presumably it was because the lack of a sound effect when she fell was too conspicuous otherwise. So well constructed are "Dance" and *Sorcerer* and much of the rest of *Fantasia*—so snugly are the pictures harnessed to the music—that

sound effects are usually missing, as it were, subliminally; the mind may be half-aware that *something* is lacking, but it is probably not sure what it is. Only in the *Pastoral*, where music and pictures threaten most insistently to go their separate ways, are sound effects needed desperately as a kind of glue. It is through their absence that *Fantasia* reveals its secret: touted in 1940 as a revolutionary film, it is instead profoundly retrograde. It is a silent film, with orchestral accompaniment.

Disney's original plan had been to open *Fantasia* in a dozen key cities in the fall of 1940 and then expand to other cities as more of his specialized sound equipment became available from RCA.[139] But the war in Europe now affected his domestic market, too: government defense orders slowed down RCA's production of Fantasound equipment,[140] and *Fantasia* did not open in a second city, Los Angeles, until January 1941. Over the next few months, *Fantasia* spread gradually until it finally was a road-show attraction in thirteen cities. As Walt Disney Productions' 1941 annual report put it, "Experience...demonstrated that a nation wide [*sic*] distribution of this picture was impractical." The receipts from these road-show engagements were only $325,183.91.[141] That was a very small figure when set beside *Fantasia's* negative cost of almost $2.3 million.[142]

Despite *Fantasia's* poor showing at the box office, Disney clung to the idea of making, as he said, "a new version of *Fantasia* every year" by removing some segments and replacing them with new ones.[143] In February 1941, Leopold Stokowski recorded five more compositions for future programs. (One substitution was ready at hand since Stokowski had recorded *Clair de Lune* for the original film. That segment had been all but completed when it was set aside in favor of *Bald Mountain*.)[144] By April, though, the walls were closing in: *Invitation to the Dance*, one of the five new numbers, had dwindled into a short subject to star "Peter Pegasus," a flying colt from the *Pastoral*, and the Chinese mushrooms from *The Nutcracker Suite*. (Art Babbitt began animating the mushrooms again in May.)[145] Disney was planning extensive cuts in *Fantasia* itself, especially in *The Rite of Spring* and *Pastoral*, after what the

studio newsletter "comprehensive study of audience reactions."[146]

In April, too, Disney got a $500,000 advance from RKO for *Dumbo,*[147] but the studio's condition had become too desperate for so small an infusion of cash to do much good. All that could really help, in the absence of audiences on a *Snow White* scale, was a drastic reduction in costs. Disney now had three features in work that he planned to bring in for around $700,000 each, or about one-third the cost of *Fantasia*—the new ceiling his bankers had set. *Dumbo* was, by May, complete in pencil-test form, and animation had begun on both *The Legend of Happy Valley*—as the beanstalk story was now known—and an adaptation of Kenneth Grahame's *The Wind in the Willows*. The latter film was absorbing writers and animators as they came off *Bambi*, which was complete, or close to it, in pencil form by late in the spring. *Bambi* had not escaped the cost-cutting axe: in March, Disney went through the film as it then stood and slashed about twelve minutes out of it.[148]

The studio was saving money in other ways. The training program had slowed down soon after the move to Burbank, and classes ended altogether early in 1941.[149] Layoffs in response to the studio's financial crisis had begun in the spring of 1940, but there was no way to cut costs enough except by reducing the studio's staff in large numbers. As the prospect of such layoffs grew, Disney's personality—for so long a source of strength—began to threaten the studio he had created.

Campbell Grant described his boss in terms that many other people on the Disney staff echoed, and that could, up to a point, apply to almost any small businessman:

> He was the kind of man that, until some particular subject touched on his business, the cartooning business, he wasn't interested. For that reason, he was no guy to sit down with and talk small talk. He didn't have any small talk, at all; you talked about cartooning or else you didn't talk about anything.[150]

As much could be said, probably, of Paul Terry or Charles Mintz. What distinguished Disney from them was his ability to see connections between cartooning and many other things. As Grant put it, "When he started to make *Fantasia*, he didn't know anything about the great composers because it hadn't affected his business. But, boy, once he got into it, he educated himself fast."

It was that narrow kind of openness that led Disney to attend

the opera three nights in a row (as his desk diary shows he did in October 1939) and that made him receptive to Stravinsky's *Sacre*. ("It tears you up to listen to that as music," he said. "But the minute you put a picture to it, it means something.")[151] Disney became an artist in order to realize ambitions that were fundamentally those of a businessman; as his studio grew, he continued to treat it as a typical self-made entrepreneur would—as an extension of himself, despite the studio's size and increasingly industrial character. As Frank Thomas said, "The things that Walt asked you to do called for organization. You wouldn't get it done otherwise. And yet Walt hated organization, just hated to be pinned down."[152] Dave Hand lamented that Disney "caused a great deal of trouble by ordering a certain man, or group of men, to do something else *right now*."[153]

The first loyalty that those men owed was to Walt Disney, and not to his studio, which he regarded as indistinguishable from himself in any case. Disney could make such personal devotion seem reasonable as long as the studio was thriving, particularly before the move to Burbank. He demanded perfection, but "in a very constructive way," said Zachary Schwartz, the layout artist for *The Sorcerer's Apprentice*. "He made people feel as though they wanted to do the best that was in them. It was a tremendously satisfying kind of atmosphere to work in."[154]

But Disney's remoteness from much of the staff, already evident by the midthirties, was far advanced by the late thirties; for instance, Ralph Wright, who started in the story department in December 1938, had not so much as seen Disney several months later.[155] Only by working on weekends and evenings—when Disney was likely to be prowling through the studio to see what was going on—could many people on the staff hope to speak with him directly.[156] The move to Burbank intensified that sense of separation because, as Hand said, the departments were isolated from one another—"intentionally so, but of course the spirit went with it."[157]

Repeatedly, in memories that can be attached to the early Burbank days, Disney sounds removed from his employees, much more so than at any time since he opened his studio in 1923. "People were nervous about Walt," said Van Kaufman, an assistant animator on *Dumbo*. "Walt had a cough; he smoked too much.... The minute we heard the cough, I

think everybody got paralyzed. We couldn't say a word."[158] Story meetings in particular generated a lot of anxiety. When Disney came into a meeting, Martin Provensen recalled, "it was still and awkward, it was never an easy, relaxed atmosphere.... I think it increasingly became the entrance of the czar."[159] Disney, so adept at finding connections between his cartoons and the larger world, was, finally, unaware that he was losing his own connection with the bulk of his employees.

His estrangement showed itself most nakedly in his handling of wages. In keeping with his intensely personal management of the studio, Disney had always dispensed money in an essentially arbitrary way, passing out substantial raises on the spot when he liked someone's work. He initiated a sort of profit-sharing in 1933 under which, as he said, the studio paid 20 percent of its profits to employees, "according to the length of time a man has been here, plus his value to the studio."[160] Disney suspended such profit-sharing during work on *Snow White;* starting in April 1936, though, the studio paid "salary adjustments" through a complicated plan—the details of which may have been lost—that called for ratings of animators' work on quality and difficulty, among other factors.[161]

Animators who turned out high-quality work in less than the allotted time could earn substantial amounts: in 1936, when Art Babbitt received almost $8,000 in salary, he received another $3,363 in such bonuses.[162] When Disney distributed $141,003 in salary adjustments to people who worked on *Snow White,* though, he seems to have done so as arbitrarily as he passed out raises; he cut and raised the figures that someone had recommended to him, excluding some prominent members of the crew. Among the animators, Babbitt and Dick Lundy got nothing.[163]

Disney had at least worked closely with many of the people involved in *Snow White;* his opinions of their work carried great weight. But by 1940, only two years later, Disney could no longer be aware of the kind of work that most members of his staff were doing, and there were grumblings over inequities.[164] Regular raises are a superb salve for bruised feelings, though, and until 1940, almost all Disney employees were seeing their pay rise rapidly. But then, as the studio's financial condition worsened, the increases stopped. "It didn't matter if you had a contract that said seventy-five dollars," the sketch artist Donald Christensen said. "Nobody paid any attention to it."[165] What employees like Christensen found disquieting, though, Walt Disney saw as proof

of his benevolence.

"Naturally a lot of increases that would have normally come we had to forego," he said a few years later. "I went on the assumption, putting myself in the employees' shoes, that I would rather be working at the business I wanted to make my profession...than to be making more money in an outside business, and I thought that I was, by doing that, that I was giving them the break." It was only later, Disney said, that he found out that denying "these little increases" caused "a lot of dissension."[166]

When the studio had to cut salaries to satisfy its bankers, Roy Disney cut salaries uniformly by 10 percent in the administrative departments that he ran. Walt Disney, on the other hand, cut the salaries in the creative departments only of "those that I thought were being overpaid, and in addition I asked some of the loyal ones in the higher brackets to help by taking a cut that they, in their own minds, thought they could stand."[167] In saying that, Disney was clearly congratulating himself on his own sensitivity and discrimination, but had he wanted to fertilize resentment, he could hardly have found a better way to do it than by distributing salary cuts in such a capricious pattern.

By 1940, the Screen Cartoonists Guild had succeeded in organizing several other Hollywood animation studios, but not Disney's. The studio's employees had chosen instead an independent union called the Federation of Screen Cartoonists; Art Babbitt was its president. When, in February 1938, the federation asked the National Labor Relations Board to recognize it as the bargaining agent for 602 of the Disney studio's employees, it submitted membership cards signed by 568 of those employees. The NLRB certified the federation in July 1939.[168]

The federation came into existence only because its organizers felt a sympathy for Walt Disney's aims that they thought an outside union would lack; it was for all practical purposes a company union. By December 1940, though, Babbitt and other members of the federation had grown uncomfortably aware that Walt and Roy Disney and their attorney, Gunther Lessing, regarded the union merely as useful camouflage and felt only contempt for it otherwise; the studio refused to bargain with the federation, but insisted that it block other unions' organizing efforts.

Walt Disney's attitude, as Babbitt summarized it at a meeting of the federation's board on 16

Walt Disney watches as pickets pass by his studio's front gate on Buena Vista Street in Burbank during the 1941 strike. Photo by and courtesy of Don Christensen.

December 1940, was, again, indistinguishable from that of many other small businessmen: "He's said as much—that the only people who belonged to unions are guys who want something for nothing or guys who want to get something out of dues."[169]

The Screen Cartoonists Guild claimed that month that it, and not the federation, represented a majority of the Disney employees, and it continued to grow stronger. On 10 and 11 February 1941, Disney spoke to groups of his employees, reading from a speech that had been tailored to meet the requirements of the National Labor Relations Act. Disney the artist was not in evidence in that talk; Disney the small businessman was everywhere, mingling self-pity and self-congratulation. He spoke at length of the hardships he had endured and the success he had achieved. The weight of his remarks fell on how patient he had been with "all the green help making honest mistakes" and on how generous he had been with all of his employees. "I want to tell you fellows," he said, as if he believed it really should matter

to them, "that I have never worked harder in my whole life than I have this last year."[170]

Disney continued to refuse to recognize the guild, insisting on an election even after the guild presented cards signed by a majority of the employees in its proposed bargaining unit. Art Babbitt left the federation to join the guild in February and became the Disney unit's chairman in March. In mid-May 1941 — just a year after completion of the move to Burbank[171] — Disney began the inevitable layoffs, but by laying off around two dozen employees of whom most were guild members, he challenged the union harshly.[172] The union voted on 26 May to strike unless Disney met with a guild committee; his response came the next day when he fired Art Babbitt. At 6 A.M. on 28 May, almost three hundred Disney employees went on strike. Babbitt was in the picket line; so was his friend Bill Tytla.[173]

Declines and Falls,
1937-1942

When MGM set up its own cartoon studio, the core of its staff came from Harman-Ising: Bill Hanna and the animator Robert Allen as directors, Max Maxwell as the production manager, Allen's brother Henry ("Heck") as a writer, and Fred MacAlpin as the sound editor. They started working together in mid-1937 in a house across the street from where a building for the new studio was going up (to a plan in accordance with the wishes of the new staff).[1] Hugh Harman believed that Hanna, Maxwell, and MacAlpin "really undercut us" by working for MGM secretly while they were still on the Harman-Ising payroll,[2] but as with Harman himself when he left Walt Disney in 1928, Harman's employees had seen in their boss's behavior all the justification they might need for making a switch.

The new hires got some unpleasant surprises. MGM, producer of the glossiest and most expensive-looking live-action features, was no longer going to underwrite cartoons of the same kind, like the Happy Harmonies. It saddled its new cartoon studio with ready-made comic-strip characters from the version of "The Katzenjammer Kids" called "The Captain and the Kids" and denied it the prestige (and the added cost) of Technicolor. Most of the new MGM cartoons

would be monochromatic, with only a sepia tint. The dominant strain in the parent studio's thinking seems to have been that it had to have presentable cartoons to make up a complete program, but they were a disagreeable necessity.

There were a few positive signs. The new studio was going to be well equipped ("We had really good equipment, for those days," Max Maxwell said),[3] and it would make cartoons on a schedule that was relaxed—thirteen releases the first year—compared with those at most other Hollywood cartoon studios. Jack Chertok, the producer of MGM's live-action short subjects, "conducted the story meetings for each cartoon at the start," Bob Allen said, "and we were very impressed with this guy. We started to become conscious of the fact that...what we had to learn and get into our cartoons, was story." Chertok soon "became uninterested," though, "and we got less and less of his time."[4]

The MGM cartoon studio moved into its new building, at Overland and Montana Avenues in Culver City, on 23 August 1937 with a staff of twenty-five. By November, the staff had grown to eighty-six.[5] The newest staff members included a large contingent from the East Coast, from the Terrytoons studio in particular, including George Gordon, Terry's head animator; Fred Quimby, the cartoon studio's business head, had somehow heard about him from Ted Sears, the Disney writer.[6] There were new staff members from other West Coast studios, too. Friz Freleng was one; by 1937, he had been directing cartoons for Leon Schlesinger's studio for four years. When he became an MGM director in September, Freleng said, "there was already a feud between the two factions" from the two coasts.[7]

Other studios had their factional rivalries, but the new MGM studio was uniquely riven—far more so than, say, the Disney studio when the first New York animators joined its staff in 1930. It was not just that cartoon makers from the two coasts had grown apart in their attitudes toward their work and in how they went about it. Everyone's differences were magnified, even among people from the West Coast studios, because the MGM studio was a place where no one's ideas about cartoons held sway. Freleng and Bob Allen were at extremes as directors, the animator Paul Sommer said (in criticism echoed by others), with Allen picky, ordering many small changes, while Freleng might want a whole scene redone after he saw it in pencil test.[8] Allen in particular wanted Disney-like animation, but the animation in the Captain and the Kids cartoons evokes Terrytoons instead: it is active, ami-

able, and utterly superficial, the sort of animation that speaks of haste and a low tolerance for revisions.

Of the new studio's three directors, it was Bill Hanna who slipped into that role most smoothly, even though he, unlike Allen and Freleng, had never animated. He had started with Harman-Ising in that studio's earliest days, when it was still on Western Avenue, "basically, as a cel washer," he said in 1976, "and I used to get there early and empty wastebaskets and sweep and wash cels. That didn't keep me busy, so I painted [cels]."[9] He was, Rudy Ising remembered, "an enthusiastic kid,"[10] and he became the head of the inking and painting department while the studio was still on Hollywood Boulevard. His path to directing was through music, the critical organizing tool for the Harman-Ising cartoons. Hanna wrote what he called "songs and lyrics" for Hugh Harman's cartoons, "and I used to get [the songs] down on bar sheets and do the timing.... They had bar sheets, but they didn't know how to put the notes down and get the values, like a sixteenth note, an eighth note, a quarter note...all of that, which I understood."[11] By 1936, Hanna was directing for Harman on a Happy Harmony called *To Spring*: "I was doing the music and the timing and handing out the animation," while the animator Lee Blair drew the character layouts.

Directing at the new MGM studio, Hanna brought to the job what Bob Allen remembered as a diplomatic style that contrasted with his own. Before Hanna asked an animator to make changes in a pencil test, Allen said, "first he would laugh at the scenes. It was just a psychological thing, and he was damned good at it.... He got his training running an ink and paint department with a bunch of fickle girls with their problems."[12]

However effective Hanna may have been in his own way, he could hardly be expected to remedy the chaos in the cartoon studio. To do that, MGM—still enamored of New York newspaper cartoons and cartoonists—turned to Harry Hershfield, who had been a newspaper cartoonist since early in the century and whose comic strip "Abie the Agent" was still running in the Hearst papers. Hershfield was on the MGM staff by October 1937 to "work on cartoon ideas," *Motion Picture Herald* said,[13] and he was head of the cartoon studio by March 1938.[14] He lasted for only a few weeks, not even long enough to make a film with his name on it. Yet another newspaper

cartoonist, Milt Gross, had succeeded him by early May.[15] Gross, too, was a New Yorker, and under him fellow easterners like George Gordon were briefly ascendant (Gordon replaced Bob Allen as a director). Gross began making cartoons—he completed two—using his own newspaper characters, Count Screwloose and J. R. the Wonder Dog. The westerners ganged up on Gross,[16] but it was, Gordon said, Gross's clashes with Quimby that were crucial: "They didn't get along at all."[17] The advantage was all with Quimby, an MGM veteran who was then in his early fifties; MGM had put him in charge of selling all of its short subjects as early as 1927.[18] Gross was gone by September.

While the new MGM cartoon studio was wallowing in bile, the Harman-Ising studio was struggling to survive after it delivered *The Little Bantamweight*, the last of the cartoons under its MGM contract, early in 1938. It was, ironically, Walt Disney who was keeping the studio alive. In October 1937—just after Harman-Ising shut down for three weeks in the midst of a quarrel with MGM over the cartoons still to be delivered under its contract[19]—Disney borrowed all of Harman-Ising's inkers and painters, about thirty in all, and two of its background painters. He needed their help in the rush to finish *Snow White*. That same month, the demands on his own staff prompted Disney to farm out to Harman-Ising a Silly Symphony about infant mermaids; it probably existed at that point only as inspirational sketches.[20]

Disney himself never came to the Harman-Ising studio, but Dave Hand and Ben Sharpsteen, as well as the writer Otto Englander, "used to come over," Ising said.[21] Harman—growing ever more pugnacious as his difficulties mounted—surrendered direction of the film to Ising "to preserve peace and order," he said, because he could not get along with the Disney people.[22] The making of what was eventually released as *Merbabies* stretched over eight or nine months, until early in the summer of 1938. The finished film looks like the Silly Symphonies the Disney studio itself was making; Harman and Ising, after years of struggling to match Disney, had proved themselves capable of the most precise sort of imitation (and at a lower cost: *Merbabies* cost around thirty-nine thousand dollars, much less than almost every other Disney short produced for the 1938–39 release season).

Harman and Ising had already begun work on three more cartoons that they hoped Disney would release as Silly Symphonies, although they had no contract for their release.[23] But the Harman-Ising studio, kept alive only by the trickle of Disney money, had

closed and reopened spasmodically in 1937 and 1938 in a series of what a union newsletter called "sudden and inconvenient shutdowns."[24] Now, with *Merbabies* finished and no Disney money coming in, the inevitable finally arrived. Harman-Ising Pictures filed for bankruptcy in July 1938.

Harman and Ising and MGM were, however, like a quarrelsome couple who find nothing more difficult than living together, except living apart. There was, by the late summer of 1938—with Harman-Ising in bankruptcy, MGM's cartoon studio in disarray, and exhibitors unhappy with the new MGM cartoons—every incentive for the two sides to reach an accommodation. So Harman and Ising leased their Seward Street studio to Disney (to house the *Bambi* group) and went on MGM's payroll on 6 October 1938 at four hundred dollars each per week. They were, once again, the producers of MGM's cartoons, but under separate contracts, as individuals. The budget ceilings in their contracts did not allow for much extravagance: each man was entitled to a thousand-dollar bonus if he held the average cost of a cartoon (as considered in groups of three) under twenty-five thousand dollars in the first "bonus year."[25]

Despite its executives' evident low regard for cartoons, MGM's publicity apparatus had since the success of *Snow White and the Seven Dwarfs* made occasional noises about producing an animated feature, most improbably when Harry Hershfield took charge of the cartoons. By the time Harman and Ising became MGM employees, though, MGM's response to Disney's film had long since taken another form: the studio was making a live-action musical version of *The Wizard of Oz*. Harman and Ising would make all their cartoons in Technicolor, even so, and they had the satisfaction of kicking aside wreckage their predecessors left behind: Quimby wanted them to salvage a few unfinished cartoons—Ising believed that Gross had started them—but they refused.[26]

A few MGM staff members lost their jobs, too, to make way for employees that Harman and Ising brought with them.[27] Hard feelings persisted from the earlier break: Harman wouldn't speak to Bob Allen.[28] Ising was more forgiving, and both Allen and Bill Hanna became members of his unit, Allen drawing character layouts and Hanna as a writer. Friz Freleng became a "junior director" under

Harman, but he suffered through the new arrangement for only six months, leaving in April 1939 to return to what now seemed like the safe haven of the Schlesinger studio.

Max and Dave Fleischer announced on 1 February 1938 that they were moving their studio—not to California, but to Miami.[29] Even though there was no film industry, much less an animation industry, in Miami that was worthy of the name, it was the Fleischers' natural destination, said Ruth Kneitel, Max's daughter, because "we always had a winter home in Florida."[30] Moreover, unions were weak in Florida; Dave Fleischer said years later in an affidavit that the studio moved to Florida "because of labor troubles."[31]

Fleischer Studios signed an agreement with Paramount on 27 May 1938 that provided for Paramount's financing of the move to Florida, with previously produced cartoons as collateral.[32] Construction proceeded rapidly, and production began at the new Miami studio in early October 1938.[33] The Fleischers very quickly achieved one of their goals in making the move: on 31 October 1938, a union local called United American Artists sought certification in an election as the bargaining agent for 124 employees; it lost, 66–58.[34]

The decision to move all but coincided with another major development. On 28 February 1938—when the enormous scale of Disney's success with *Snow White* was just becoming clear—Paramount and the Fleischers agreed that the Fleischer studio would make an animated feature. What the title would be, no one yet knew.[35]

The Florida studio's staff had to expand to make the feature, which the Fleischers (or more likely Paramount) eventually decided should be based on Jonathan Swift's *Gulliver's Travels*. In a reverse of the pattern the year before at the new MGM studio, the Fleischers hired from the West Coast, starting with writers like Edmond Seward from MGM and Cal Howard from the Leon Schlesinger studio. "*Gulliver's Travels* was completely finished, in storyboard, when we got down there," Howard said in 1976. "There were thirty or forty storyboards in this sound stage, all the way around the wall." The storyboards "had a Popeye tinge," he said, so he and three other West Coast imports—Seward, Ted Pierce from Schlesinger's, and Dan Gordon from MGM—"did it all

over. Of course, that caused a little friction between the New
Yorkers and the 'west coasters.' "[36] Ultimately, the west coasters
shared screen credit for the story with Isidore Sparber from the
New York studio.

To join the two hundred or so people who made the move from
New York to Miami, the Fleischers eventually recruited around a
hundred employees from California.[37] By February 1939, total
employment had risen to 387 (including 88 from the Miami area),
and the new studio was so crowded that the writers were working
in a nearby house.[38] The animator Al Eugster, who left Disney in
March and joined the Fleischer staff in April, recalled: "I'd be in
a room with about twelve other guys, trying to animate and con-
centrate; that was really a harrowing experience."[39] By July 1939,
at the height of work on *Gulliver*, employment had risen to 460.[40]

The East Coast–West Coast friction at the new Fleischer studio
during work on *Gulliver* replicated what had gone on a year before
at MGM, but on a lower level because the California imports, as a
group, approached their work with less seriousness than the
Fleischer veterans. The animator Myron Waldman referred con-
temptuously to the "California discards" who came to the Miami
studio: "For the most part, these guys were awful.... Some of them
were big drinkers; they'd come in stinking from liquor."[41] Almost
no West Coast animators with any sort of credentials made the
move to Florida, except for Disney animators like Eugster and
Grim Natwick, who had worked for the Fleischers in New York.

The Fleischers were making *Gulliver* on what was, compared
with the time Disney had devoted to making *Snow White*, a much
brisker schedule. It was, in fact, comparable to the schedule that
Disney envisioned for his subsequent features, with actual pro-
duction consuming roughly a year. In *Gulliver*'s case, the schedule
may have been determined by Paramount's desire to release the
film for Christmas in 1939. What made such a schedule so prob-
lematic was that graphically, and in many other ways, the
Fleischer shorts of the late thirties were still
rooted in the early thirties and even the twen-
ties. Because the Fleischers had not struggled
through the evolution of animation and char-
acter design that had so occupied Walt Disney
and his animators in the thirties, their work on
Gulliver was in effect a cram course. The anal-
ogy can be extended further: not only were the
Fleischers learning in a hurry how to make

From Max Fleischer's Gulliver's Travels (1939). Museum of Modern Art Film Stills Archive.

features, they were skeptical about the value of a lot of what they were learning.

The move to Florida did bring with it a shift not just toward more Disney-like drawing, but also toward more Disney-like procedures, pencil tests in particular. "We never had a pencil test until we went to Florida," Waldman said. The Fleischers' acceptance of pencil tests was, however, grudging at best, especially when the animators involved were not people who had worked at Disney's or had some other claim to special treatment. Bob Bemiller, for one—who as "still kind of the junior animator" got no screen credit for his animation in *Gulliver*—recalled no general use of pencil tests: "If you had some kind of an action that you weren't sure about, they'd let you make a test on it."[42]

What had become central to Disney animation by the late thirties, the exploration of character through animation, was incidental at best in the Fleischer scheme of things because of the threat it posed to the steady flow of production. That flow could best be maintained by adhering to formula. Here again, it is probably the voices of the lower-ranking animators that convey the

studio's priorities most clearly. Ed Rehberg said, for instance, of Seymour Kneitel, an animation director for part of *Gulliver*, that he "had a stock formula for walks and runs, and you either did it his way or it was wrong. There was never any experimenting. He'd say, 'You're stupid if you do it that way. Don't you have any more sense than that?' He was that crude."[43]

The Fleischers in making *Gulliver* thus observed essentially the same priorities that the studio had observed for years. Those priorities were to some extent validated when *Gulliver's Travels*, seventy-seven minutes long, premiered at two theaters in Miami on 18 December 1939; it beat Disney's *Pinocchio*, which had been in production much longer, into theaters by about two months.

As in the Fleischers' more elaborate shorts of the midthirties, there are traces throughout *Gulliver* of something like a passion for animation's equivalent of stage machinery. There is an impressive attention to detail, both in the settings—the castles and towers of Lilliput have a fairy-tale richness that is especially charming when Gulliver's presence makes them toylike—and in some of the animation. As the Lilliputians pull the prone Gulliver into town, for instance, his foot brushes against a shop sign and sets it swinging.

In every other way, though, *Gulliver's Travels* seems half finished, a rough draft for a potentially better film. The writing preserves only the skeleton of Swift's plot; as in the book, the kingdoms of Lilliput and Blefuscu go to war over a trifle. In the film, though, the disagreement concerns not which end of an egg should be eaten first, but which song shall be sung at a wedding uniting the two royal houses. Since there is not a hint of Swift's acid satire, the film in effect asks its audience to take this ridiculous quarrel seriously.

However perilous that might seem, the sequence in which King Little of Lilliput and King Bombo of Blefuscu fall out was made to order for animation of the kind that emerged in *Snow White*: bring the kings to life, make their quarrel real, and the pretext for that quarrel could quickly become irrelevant. The animation of the two kings is, in fact, impressively fluid and three-dimensional, easily the most technically accomplished in *Gulliver's Travels*, but it is nothing more. Moreover, the two kings' design, like that of the other characters, is fatally generalized; they lack the sharp individuality of

the Seven Dwarfs. One of *Gulliver's* principal characters, Gabby the night watchman, is highly dwarflike; he evokes Grumpy not just through his sour, scowling manner but through his voice— like Grumpy's, it's by Pinto Colvig, this time speeded up so much that it's unpleasantly shrill. Gabby would, however, look very odd in the dwarfs' presence, his features too simple compared with theirs.

Gulliver himself looks odd, too, but in a wholly different way. As Disney did, the Fleischers turned to rotoscoping, the technique they pioneered, for the animation of a human character. The animator Nelson Demorest modeled, under Dave Fleischer's direction, for the early scenes when the shipwrecked Gulliver struggles ashore. After that, Gulliver, unconscious, is nothing more than a prop for fully half the film, until he wakes up in Lilliput. Sam Parker, the Miami radio announcer who also provided Gulliver's incongruously Southern-accented voice, modeled for the rotoscoping of the later scenes.[44] Although the Disney animators tried to conceal the live-action origins of their animation of Snow White, the Fleischers' Gulliver is unmistakably, even flagrantly, a tracing—the purest expression in the film of their limited interest in putting on the screen characters who commanded interest in the way that the Disney characters did.

Financial data are scarce that show accurately how much *Gulliver's Travels* cost or how well it did at the box office, but one plausible report is that it cost around $1.5 million,[45] about the same as *Snow White*, and was at least modestly profitable—certainly enough so that by the spring of 1940 the Fleischers and Paramount were ready to proceed with a second feature. *Gulliver's* real significance, though, was to confirm how much in thrall even the most ambitious Fleischer cartoons were to rigid formulas and old habits.

Fred Quimby exerted no control over Hugh Harman's and Rudy Ising's cartoons, Ising said many years later, "as long as you stayed within certain bounds of budget." Otherwise, "he had nothing to say about story, or anything else."[46] Ising's qualifier was important, though, at least where Harman was concerned. Harman, it always seemed to everyone, was indifferent to cost, in a way that even Walt Disney was not. Animators' memories ran toward occasions like the one when Harman spent several hours

discussing just how a door should open in *Goldilocks and the Three Bears* (1939).[47] Harman was willing to give animators footage breaks on difficult scenes like the one in *A Rainy Day* (1940) that involved hundreds of wind-ravaged shingles, the animator William Littlejohn said: "He could care less; it was MGM's money. He was always going over budget, and the boss was always on his ass."[48]

For most of Harman's time at MGM, though, his seeming extravagance did not translate into cartoons that were terribly expensive when measured against Ising's or against the competition's. Figures that survived in Harman's and Ising's papers show that the negative costs of their cartoons were similar, hovering between $25,000 and $30,000 for the most part, with some markedly less expensive, others more so. (The short cartoons that Disney was making at the same time were much more expensive; Disney's accounting showed negative costs of more than $50,000 for almost every cartoon produced for the 1938-39 release season, ranging up to more than $110,000 for *The Autograph Hound*, a Donald Duck short whose cast includes caricatured Hollywood celebrities.)

Harman's costs did rise above $30,000 for his last few cartoons at MGM; the rich look of *The Field Mouse* (1941), for instance, came at a cost of $34,316.58.[49] "I remember one time just before we finished up at MGM," the animator Jim Pabian said. "I was doing the timing and he was looking after the story....I reminded Hugh we were nearly double our story budget and nowhere near completion.... He said, 'Pabe, you worry too much about money.' "[50] It was, however, not so much Harman's cavalier attitude toward money as his arrogance—the same arrogance that expressed itself in quarrels with the Disney people during work on *Merbabies*— that earned him so much skepticism and hostility. "I started with Schlesinger when he started his new studio," Pabian said, "and I heard him call Hugh all the names you could think of.... The same way with MGM. Quimby told me he didn't want to have anything to do with Hugh, but he took him because Rudy wouldn't sign without him."

Harman had no use for people like Schlesinger and Quimby. He always measured himself against Disney, and by 1938, with *Snow White and the Seven Dwarfs* in theaters, Harman-Ising in bankruptcy, and Harman an

From Peace on Earth (1939), a Hugh Harman cartoon for MGM. ©
MGM; courtesy of Bob Allen.

MGM employee, such comparisons invited immense frustra-
tion—and, of course, a corresponding rise in Harman's petulance.
When Harman began making cartoons for MGM, he resumed his
competition with Disney, in part by giving his cartoons a visual
richness; he challenged the Disney films most aggressively,
though, by making cartoons that were far more serious in tone
than would have been possible before *Snow White.*

The results were peculiar, and in the case of *Peace on Earth*
(1939), a cartoon that Harman counted among his own favorites,
considerably more than peculiar. That cartoon offers what is
clearly intended to be a grimly realistic warning about the conse-
quences of war but is in fact nothing of the kind: there's little or
no evidence of *civilian* losses amidst all the rotoscoping of sol-
diers. Moreover, *Peace on Earth* shows the devastated earth inher-
ited by conventional cartoon animals, including owls that can
read and show no interest in eating the baby squirrels sitting
beside them. Contributing to a general theological messiness is
the rewording of a Christmas carol to eliminate references to

Christ—whose face has been blasted out of a stained-glass window.

Such material could be redeemed, or at least dried out a little, if there were the slightest trace of an ironic tone, and it is the absence of any such thing that is really deadly in Harman's MGM cartoons. Harman insists, over and over again, on a straightforwardly emotional response to material that is basically cold and artificial. In *The Field Mouse*, when two mice, grandfather and grandson, struggle to survive inside a threshing machine, the action is both intricate and generally plausible; but it's impossible to care much about the characters, who are, typically for Harman, shallow and false (and, in the case of the grandfather mouse, insufferably peevish).

Harman failed just as emphatically in his rare forays into broad comedy. He made *The Lonesome Stranger* (1940) and *Abdul the Bulbul Ameer* (1941) "as a sort of joke," he said, because Quimby kept saying to him, "Why don't you make something that's as silly as some of that stuff Schlesinger is making now?"[51] By the late thirties, Harman was hopeless as a slapstick director, for reasons that George Gordon explained:

> A [double] take would be the fellow's hat flying off, and his hands would go up and grab for the hat. I would do it with about four drawings—boom, back on the head—and Hugh would say, "No, you can't see that. I want it slower." It would finally wind up [very deliberate], so it was no take at all.[52]

His supposedly silly cartoons lack anything like a light touch. In *The Lonesome Stranger*, there's grotesque distortion as the lead bandit yells, "Yeah!" at a sheriff; his mouth becomes huge, like that of a character in an early thirties cartoon, but it is drawn with the realistic and ostentatiously expensive detail (lots of teeth) of a late thirties cartoon. Always in Harman's MGM cartoons, even the most broadly comic, the visible idea is not so much to entertain as to impress.

The Ising cartoons actually bear much closer resemblance to the Disney cartoons than Harman's do, because there is in them the same concern with the characters, especially with psychological plausibility. Ising's signature character was a shambling bear based on actors like Wallace Beery and Edgar Kennedy—and on Ising himself. "Quimby used to call me

'the bear,' " Ising said. "He was sure it was an imitation of myself."[53] (Ising was, Carl Urbano said, "kind of the sleepy bear all the time.... He drank a lot of coffee, and he looked out the window a lot.")[54]

Ising's animators remembered him as a director who expected them to contribute materially to their scenes, in ways that the Disney animators did. He functioned as a sort of mini-Disney in another way, by overseeing a cluster of directors who made cartoons that went out under his name; first, Bill Hanna and Joseph Barbera and, later, Jerry Brewer and Bob Allen directed "Rudolf Ising Productions,"[55] with results that sometimes echoed the Disney cartoons more persuasively than Harman's more strenuous efforts. Brewer, when he directed *Dance of the Weed* (1941), had just spent a year (1938–39) working as a writer on *The Nutcracker Suite* for Disney's *Fantasia*; the MGM cartoon's balletic romance between a graceful flower and a gawky weed takes place in a miniature world like the one in the Disney film. The resemblance extended to production methods: the music for *Dance of the Weed* was composed and recorded before the story was even written,[56] and the animators used live action as an aid.[57]

Given the virtues of Ising's cartoons, it's a little surprising that their total effect is so often unsatisfactory. The reasons typically go to the conception behind the cartoon. In the case of *Home on the Range* (1940), it's the use of cattle as the principal characters. Beef cattle, that is, which are going to be slaughtered anyway; a calf escapes death at a wolf's hands, but only so that it can become veal sometime after the cartoon ends. What if *Home on the Range* had focused on the wolf, and on his frustrated hunger, instead of the cattle? Ising could make such cartoons; as he said, all of his bear cartoons were "based on the idea of the single character, and frustration, really."[58] But Ising, unlike Harman in many ways, shared Harman's limited interest in the merely funny.

Ising resisted Quimby's plea to make rowdier cartoons. His natural bent, by the time he made his MGM cartoons, was toward warmth and cuteness; and it is a measure of his success in introducing those characteristics into his cartoons that in 1941 he won the first Academy Award given to any cartoon besides one of Disney's. Ising's *The Milky Way*, an entirely characteristic cartoon in which three kittens make a nighttime journey to a galaxy filled with dairy foods, was named the best cartoon of 1940. Disney had, however, nominated none of his short cartoons for the award, ostensibly because his studio was concentrating on fea-

tures,[59] and he had stopped making Silly Symphonies, the cartoons with which *The Milky Way* was directly comparable. By 1941, it didn't mean a lot to be making cartoons at least as good as those Disney would have been making—if he were still making that kind of cartoon.

Harman left MGM on 5 April 1941 at the end of a six-month extension of his original contract.[60] Soon after he left MGM, in typically grandiose fashion, he announced the formation of his own studio—to make features. The story for the first feature was being prepared, *Daily Variety* reported early in May, "and will be announced shortly after final details on the release are completed."[61] Ising left MGM a year and a half later, on 5 October 1942, after four years on MGM's payroll, to take charge of the Army Air Force's animation unit.[62]

By then, the MGM cartoon studio had already changed radically. In 1939, long before Harman left, Fred Quimby pulled Bill Hanna and Joe Barbera out from under Ising's wing and gave them their own unit, and in 1941 he hired Tex Avery, a director at the Schlesinger studio, to take Harman's place. These new directors were subordinate to Quimby to a much greater extent than Harman and Ising were, but their cartoons, too, were very different. When Quimby urged Harman and Ising to make slapstick cartoons, it turned out, he was expressing a desire for change that involved more than simply enhancing his own position.

●∵∴●

The Fleischers had begun casting around for the subject of a second feature as early as March 1939, when Sam Buchwald, the studio's business manager, circulated a memorandum listing eighteen story ideas and asked the recipients to list their five favorites. Those ideas were shockingly inadequate—too weak for shorts, much less a feature. The bulk of the memo was made up of synopses of Raggedy Ann stories by Johnny Gruelle, but there was also a suggestion for a feature built around Pandora's box, and another for "a very elaborate and beautiful color picture...in which the butterfly is shown as an insect, but very beautifully colored and attractive.... Black (villain) butterflies induce her to leave and go to the big

city where her beauty would be appreciated, etc. and subsequently she gets her wings burned."[63] As Walt Disney had already found, stories suitable for adaptation as an animated feature were simply not plentiful.

By 1940, too, the Fleischer studio was laboring under a handicap that had no equivalent at the Disney studio: a growing estrangement between the two brothers who owned the place.

As different as Max and Dave Fleischer always were—even more different than Walt and Roy Disney—for many years the contrast in their personalities generated no visible problems for their business. Dick Huemer, for one, observed no friction between Max and Dave when he animated for them in the twenties: "They seemed to get along like good brothers."[64] By the time the studio had moved to Miami and *Gulliver's Travels* was in production, though, Max was becoming visibly resentful of what to him looked like Dave's undisciplined behavior. Ruth Kneitel recalled: "Dave, in his office...—it's funny as hell, but my father resented it—he had a direct wire to the track, and a ticker going, all the time. He had the bookie in there, and Seymour [Kneitel, Ruth's husband] and all the boys were in there. The bookie moved from New York to be with his group, and Dave's office was the betting parlor. Saturday, we'd go out to dinner with the bookie. My father couldn't stand that. Outside of business, you could do as you damned well pleased, but...that bothered him, he couldn't stand seeing the bookie and the ticker tape and all that."[65]

Worse, Dave separated from his wife and became romantically involved with a longtime studio employee, whom he subsequently married. Max, conservative burgher that he was, could only have been discomfited by the breakup of Dave's marriage, but Dave's new relationship was on top of that a particularly flagrant mixing of business life and personal life. "I remember in the studio in Miami," the animator Gordon Sheehan said, "after *Gulliver* was released, Dave and Max meeting each other in the corridor and both looking to the wall instead of at each other—not even speaking."[66]

There was peril in such estrangement because Max and Dave were what a legal document called the "sole active directors and stockholders" first of the New York–based Fleischer Studios and then of its Florida-based successor (organized in July 1938). They each owned 50 percent of the stock.[67] Moreover, neither man dominated the life of the studio in the way that Walt Disney did. Roy Disney's job was, essentially, to help his brother realize his

goals for the company; there was no comparable division of responsibilities at the Fleischer studio and, for that matter, no comparable goals. So, as growing personal animosity pulled the brothers apart, there was nothing as strong to pull them back together, and a sort of hole opened up in the center of the studio's life.

Paramount approved the script for a second Fleischer feature on 6 December 1940 and called upon the Fleischers to complete the new feature by 1 November 1941.[68] As the end product, perhaps, of the 1939 suggestion for a butterfly-centered story, the new film was to be called *Mr. Bug Goes to Town*, a play on the title of Frank Capra's highly popular 1936 comedy, *Mr. Deeds Goes to Town*. The idea was to transpose a stock Hollywood romantic-comedy cast into an insect setting. There would be a Jimmy Stewart sort of grasshopper, his honeybee girlfriend and her kindly father, a greedy beetle in the Lionel Barrymore–Edward Arnold vein, a grouchy snail of the Ned Sparks kind, and so on. With their homes in a vacant lot destroyed by the construction of a skyscraper, the bugs would clamber up the skyscraper and find refuge in a penthouse garden.

Well before *Mr. Bug* was finished, the Fleischers passed through a disastrous crisis in their relationship with Paramount. That relationship was similar to Walt Disney's with his early distributors: Paramount made advances to the Fleischers to finance production, recouping those advances when it distributed the films.[69] Disney, when he signed with RKO, stepped away from such an arrangement. Starting in May 1936, his financing came through a line of credit from the Bank of America, of the same sort that the major studios had.[70] The difference was critical: when Disney ran into financial difficulties in 1941—just as the Fleischers did—his bankers, who were not moviemakers themselves, had strong incentives to keep his business alive. For Paramount, though, replacing the Fleischer brothers with new managers could have been no more troublesome than making similar changes in other parts of the business. Moreover, because the name "Max Fleischer" had never acquired the cachet that "Walt Disney" had, especially on licensed merchandise (the Fleischers' most popular character, Popeye, was of course not even theirs), Paramount could shed the Fleischer name without losing much of consequence.

Paramount called its loans around 19 May and ordered the Fleischers to end production.[71] The Fleischer brothers were by then deeply in debt to Paramount; with bankruptcy their only alternative, they signed a new agreement with Paramount dated 24 May (the Fleischers put off signing until July). Under the agreement, as a New York state judge later wrote in response to a suit brought by Dave Fleischer, "Paramount purchased outright all of the assets of Fleischer Studios, and agreed to advance money for the production of certain new cartoons," including *Mr. Bug Goes to Town*, twelve Popeye cartoons, and twelve Superman cartoons, a new series to be based on the wildly popular comic-book character introduced three years before.[72]

Superman, the first cartoon in the series, appeared in September 1941 and a second appeared in November. Bob Bemiller, who animated on the series, remembered that the Superman shorts were produced with care like that given to the Fleischer features; the storyboards were more detailed, the layout drawings more dramatic. But even though the characters were human beings of a more or less realistic design, the pains taken did not extend to striving for realistic movement. Steve Muffati, who was in charge of the Superman cartoons, "got the idea...of just having the people act the stuff out, and we'd sketch it as they acted it," Bemiller said; but there was no rotoscoping, just animating from sketches. Bemiller recalled pencil testing only one scene for a Superman cartoon, of a running Lois Lane.[73] The characters in the Superman cartoons move woodenly, but they are in any case emphatically subordinate to extraordinarily plentiful explosions and robots.

Such effects made the cartoons expensive: *Superman* may have cost as much as fifty thousand dollars, or more than three times as much as a typical Popeye.[74] The 24 May 1941 agreement contemplated spending that much—strong evidence that the Superman series was Paramount's idea—but it was in other respects a brusque expression of Paramount's opinion of the brothers. The Fleischers committed themselves to another twenty-six weeks at the studio, but Max and Dave were required to put up their shares of stock in Fleischer Studios to guarantee their performance and to give Paramount "resignations in blank," to be exercised at Paramount's discretion after the twenty-six weeks were up. Paramount got the exclusive use of the name "Fleischer Studios."

The Fleischer brothers both severed their connections with

their studio around the end of 1941, after their twenty-six-week obligation to Paramount ran out. By then, Ruth Kneitel suggested, both Max and Dave may have been ready to leave the studio they had created. "It was a mutual thing," she said of the brothers' break with Paramount and with each other. "It was impossible for them to ever work together any more."[75]

Mr. Bug Goes to Town—finished by late in 1941 and dropped into an indifferent market early in 1942—actually looks a little more polished than *Gulliver*; it has fewer of the earlier film's long stretches of poor drawing and weak animation. But it is fatally bland. The insect characters look less like insects than like very simply drawn human characters—*Pinocchio*'s Jiminy Cricket has as much bug in him as *Mr. Bug*'s characters do, and his design is much more sophisticated in other respects. The film encourages the audience to think of its characters as insects only when their tiny size becomes convenient. More even than *Gulliver*, with its ridiculous dispute between the two kings, *Mr. Bug* demands at least a trace of wit in the handling of what is, at bottom, very silly material; there is instead a wholly bogus sentimentality that strains to find an emotional link between insects and people. The film's box-office performance was, from all appearances, dismal; when Paramount stopped distributing *Mr. Bug* in 1946, it had recouped about $241,000 of the $713,511.06 it had advanced to the Fleischers to cover the cost of producing that film and some miscellaneous charges associated with it.[76]

Paramount assembled a new management team made up of three longtime members of the studio's staff—Seymour Kneitel, Izzy Sparber, and Sam Buchwald—and created a new studio around them. It was formed on the model of the 1941 agreement with the Fleischers, that is, the new Famous Studios (Paramount had used the "Famous" name in various ways for decades) was a separate entity, but under Paramount's control. The new studio did not come formally into existence until May 1942, after Paramount's contract with Fleischer Studios— by then a mere corporate shell—had run out.

Only Kneitel, who first worked for the Fleischers in 1925 and had been with them continuously since 1928, had any real animation experience. Sparber, who started with the Fleischers around 1922,[77] was by the time the studio moved to Florida a sort of aide-de-camp to Dave Fleischer. Buchwald, the business

manager, started in 1931.[78] "Paramount called Seymour in...,"
Ruth Kneitel said. "They asked him, very carefully, how he felt
about working with them, since he was Max Fleischer's son-in-
law, after this big blow-up. He said, 'I have to work, I have to earn
my living.... I can assure you that this will not affect the work I
turn out.' "[79] In effect, Kneitel and Sparber took Dave Fleischer's
place—and his title of director—and oversaw the work of the head
animators more or less as he had. The transition was, in Myron
Waldman's words, "very smooth."

By November 1942, rumors were circulating that Famous was
about to return to New York.[80] The move back began in January
1943, with the studio paying the bills.[81] One reason the studio
returned to New York, Ruth Kneitel said, was because it was
becoming difficult to replace members of the staff who were
drafted.[82] However much they may at first have relished Florida's
beaches and warmth, by 1942 many of the New Yorkers among
the employees were ready to go back. "So many of them were
from the Bronx," the animator John Walworth said, "and the wives
had left their mothers."[83]

On 5 June 1941, at the end of the workday, the strikers at the
Disney studio showed their muscle. Around twelve hundred pick-
ets—led by a fife and drum corps from the Schlesinger studio's
unit of the Screen Cartoonists Guild—marched in front of the
main Disney gate on Buena Vista Street. They burned Gunther
Lessing, the Disney attorney, in effigy.[84] Lessing, who was more
than fifteen years Walt Disney's senior, had been a lawyer in El
Paso, dealing with the likes of Pancho Villa, before he moved to
Los Angeles; he had a frontiersman's contempt for unions.[85]

The strikers were drawn disproportionately from the lower
ranks: assistant animators and inbetweeners, many of them rela-
tively new to the staff. Most of the animators stayed in, as did
most of the writers, and even the inkers and painters. Disney
himself drew this distinction: "The men inside this studio have
been with this studio for a good many years," he told a union del-
egation on 11 June 1941. "And I can't say that for the people that
are outside the gate."[86] But it was, of course, Disney's own ambi-
tious plans for his studio that had led to the hiring of so many
new people.

"It was an ivory tower," Bill Tytla's assistant Robert De Grasse

said of the Disney studio in the years before the strike. "You were safe from the world." His colleagues, he said, "were absolutely sure that Walt would always protect them, Walt would always pay them."[87] Since Disney, for his part, expected unyielding devotion, there was on both sides a strong sense of betrayal. Ben Washam, who as a Schlesinger animator took part in the picketing at the Disney gate, recalled that Art Babbitt "used to stand across the street from Disney's, where we had the soup kitchen, on the back of a truck with a loudspeaker, and as Disney would come out the gate, they'd turn up the speaker, and Babbitt would go to work on him."[88] On one occasion, Babbitt himself recalled, he called out to Disney, "Walt Disney, you ought to be ashamed of yourself," and Disney got out of his car and wanted to fight.[89] Howard Swift said that while he was picketing, "Walt drove his big Packard up and hit the brakes right next to me, at the main gate. He looked right at me and said, 'I never thought you'd be out here.'"[90]

Throughout the strike there were reminders that energies that had gone into making films were being warped in other directions. When *The Reluctant Dragon* opened in Los Angeles, the Disney strikers picketed the theater with a large cut-out dragon whose head was a caricature of a scowling Walt Disney and whose body bore the word "UNFAIR."[91] (That film suffered because it showed a happy Disney studio, in a live-action tour conducted by Robert Benchley; there was no reconciling the film's sunny atmosphere with the bitterness of the strike. *The Reluctant Dragon* died quickly at the box office, yielding only $541,840.86 in receipts to the studio—almost $100,000 less than its negative cost.)[92]

The Disney strike took place in an economic environment that was newly prosperous. A prewar boom was bringing with it a wave of strikes as unions tried to wring higher wages out of companies that could no longer plead poverty. The Disney strike was different, of course, but even though the strike grew out of the studio's difficulties, the strikers, if they felt compelled to look for other jobs, could expect to find tolerable work of some kind. For Disney, on the other hand, the strike was potentially fatal: by disrupting production, it delayed the release of films whose revenue the studio desperately needed. The guild had time on its side.

The critical point of contention between

Disney and the guild was whether he would recognize the union on the basis of the cards that his employees had signed, authorizing the union to represent them, or only after an election had intervened—an election that Disney believed he could win. What could have been mere maneuvering for advantage (Disney could have recognized the union and later sought an election to decertify it) was instead highly charged. In part that was because Disney and the guild were acting out, on a much smaller and milder scale, conflict of the kind that had erupted between Henry Ford and the auto workers' union a few years earlier and in other industries as well: economic issues were subsumed in a much larger ideological struggle. Disney later said of the strike: "It was a Communist group trying to take over my artists and they did take them over."[93] Art Babbitt's politics were merely liberal, but the strike's other leader, Dave Hilberman—the "real brains" behind it, Disney believed—had been a Communist Party member for several years,[94] and a few other strikers were, at the least, fellow travelers.

As with many other Hollywood labor disputes, though, it's difficult to see anything specifically "communist" in what the guild sought, much less in what the sprinkling of party members put on the screen. Hilberman was a layout artist for two pastoral cartoons, *Farmyard Symphony* and a color remake of *The Ugly Duckling*, and then for the equally bucolic *Bambi*; there is no way to read any political content into his work. But any communist taint to the strike, however slight, would have been too much for Disney, already smarting as he was over the surrender of much of his independence to bankers and investors.

The strike finally ended after two months, on 28 July, when Disney and the guild agreed to submit their dispute to arbitration. The strikers began returning to their desks the next day, and Disney almost immediately accepted a closed shop.[95] The only significant issue remaining was which members of the staff would lose their jobs in the inevitable layoffs. On 11 August, Disney absented himself from the studio and its labor troubles;[96] with fifteen members of his staff (all nonstrikers), he was going to make an extended goodwill tour of South America, undertaken at the behest of the federal government as part of an effort to counter growing Nazi influence there. The day Disney left, the studio, through Roy Disney, proposed layoffs that would have removed 207 strikers and only 49 nonstrikers. When the union balked, the studio shut down most of its operations, for what

turned out to be four weeks. Before it reopened in mid-September, a federal arbitrator imposed a settlement that required the studio to lay off strikers and nonstrikers in proportion to their numbers in each department.[97]

Two features, *The Legend of Happy Valley* and *The Wind in the Willows*, were still in production when Walt Disney returned to the studio on 27 October, but Roy Disney had already concluded, after a trip to New York, that *Happy Valley* would have to be shelved because RKO doubted its box-office prospects (a contemporaneous memo refers to "distribution difficulties").[98] Walt Disney spent two weeks looking at the work that had been done on both features—more than three thousand feet of animation had been issued on *Wind in the Willows* and forty-five hundred feet on *Happy Valley*. He decided first to halt work on *Happy Valley* and then, a little later, on *Wind in the Willows*. The problem, he said a few years later, was that "the quality was too far below the standard necessary to be successful on the market."[99] He had finally abandoned the idea that his studio could survive by cranking out low-budget features. Although Disney's bankers allowed him what he called "a certain leeway" to finish *Bambi*, they permitted him to spend only a thousand dollars a week to develop another feature. This was how far Disney had fallen in less than two years: from presiding over a studio that was making several prestigious features at once, some costing millions of dollars, to scraping together a few dollars to keep story work alive on *Peter Pan*.[100]

With work halted on the two features, more layoffs were sure to follow. Late in November 1941, Disney announced plans to lay off two hundred employees, thereby reducing his total staff to 530, or less than half the number just before the strike.[101]

It was at this low point in the Disney studio's fortunes that *Dumbo* entered American theaters; it premiered on 23 October 1941 and went into general release a few weeks later.

Walt Disney had found *Dumbo*'s budget a tight fit. "It wasn't an easy job to get on the screen something that had the same entertainment value at almost one-third the cost," he said a few years later[102]—and *Dumbo* did, in

fact, cost less than one-third as much as *Pinocchio*. During work on *Dumbo*, when "we were trying every way we could not to spend so much money making the pictures as we had been doing," as Wilfred Jackson put it, the studio's personnel sought out shortcuts that would have been rejected out of hand a few years earlier. Jackson recalled, for example, that Ben Sharpsteen, who had been in effect *Pinocchio*'s producer and now was *Dumbo*'s (his actual title was "supervising director"), came up with the idea of giving photostats of some of the story sketches to the animators, for them to use as character layouts.[103] That eliminated the cost of having a layout artist make such drawings.

A "supervising animator" arrangement had taken shape during work on *Pinocchio*; some animators were assigned to particular characters and animated their most important scenes, but also oversaw the work of other animators of those characters.[104] That arrangement carried over onto *Dumbo*, but with a stronger role for the supervisors, thus stretching expensive talent as far as it would go. Jackson, who directed all the sequences with significant amounts of animation by Bill Tytla, handed out scenes to Tytla, "but there would be others who would work with him who would do certain scenes.... Quite often Bill would knock out a few poses to get them started and would supervise what they did, very carefully," to the point that he accompanied those junior animators when Jackson looked at their pencil tests in sweatbox sessions.[105] Another animator, Wolfgang "Woolie" Reitherman, definitely played the same role, and the other four animators listed as animation directors in the screen credits probably did, too.

Other animators, reporting directly to a director like Norm Ferguson and unburdened with supervisory responsibilities, sometimes approached their work in a freewheeling spirit that had grown increasingly rare during work on films like *Pinocchio* and *Fantasia*. Howard Swift recalled roughing out about a hundred feet of the phantasmagoric "pink elephants" sequence in one week, which was, as he said, "unheard of at Disney's at that time." Swift animated the elephants "straight ahead, on twos—just as straight ahead as you could do it. I didn't make any key poses. I put down a piece of paper and made the next move."[106] He animated, in his description, much as Bill Nolan had at the Universal studio in the early thirties—with the critical difference that Swift was much stronger as a draftsman and more sophisticated as an animator. *Dumbo* was produced on a schedule (as well as a budget) even more compressed than the one the Fleischers followed

when they were making *Gulliver's Travels*, and Swift's response to such pressure was emblematic: the Disney people turned the shortage of both time and money to their advantage, so that *Dumbo* moves with a lightness and quickness—it runs only sixty-four minutes—that had no real precedent in the Disney films.

Dumbo's tight schedule did, however, work against the casting of animators by character. The logistics of such casting, difficult under the best of circumstances, became all the more imposing when the animation had to be crammed into about six months in late 1940 and early 1941 with cost an ever present consideration. The sense that the animators have been cast by character is, even so, stronger in *Dumbo* than in any previous Disney feature. In part this is because Jackson, in particular, had learned over the years how best to deploy his animators. The key animator identified with a particular character is almost always present as the animator of a scene when he is most needed; there is never the disorienting sensation that a character has suddenly been replaced by a not-quite-right double.

Apparently, too, the expedient of using the strongest animators to guide the less experienced men strengthened rather than diluted the principal animators' role. In only one case—that of Timothy, the mouse who befriends Dumbo and helps him to fly—was a character spread among several animators in a way that suggests that the need for rapid production had triumphed over casting by character. Timothy came under the wing of not one but two supervising animators: Woolie Reitherman animated the most important of Timothy's earlier scenes, and Fred Moore did the most important of the later ones, although it was Moore who first animated the character. Walt Disney spoke in 1939 of using Moore as one of the principal animators on *Bambi*, but he had dropped that idea by the spring of 1940. By then, Moore was slipping rapidly from the studio pinnacle he had occupied during work on *Snow White*. Timothy suffered—in scenes, like those when he and Dumbo get accidentally drunk, that look a little shallow and obvious—from Moore's growing carelessness.

Still, it's only Moore's best animation from earlier cartoons that makes his *Dumbo* animation look relatively weak; *Dumbo* bears other scars that speak much more directly of a shortage of time and money. The drawing in one of the film's great comic climaxes—when a pyramid of elephants collapses—is conspicuously weak, and patches of bad drawing mar the film in other places. Ultimately, though, such disappointments count for very little

*From the first sequence animated by Bill Tytla for Disney's Dumbo
(1941). The sequence introduces Dumbo, his mother, and four
female elephants who scorn Dumbo for his large ears. © Disney
Enterprises, Inc.*

because the most important animators performed so well. Two of
those animators, Ward Kimball and Bill Tytla, handled not single
characters but rather groups of characters so closely related that
they demand to be regarded as units (as the Seven Dwarfs do
not). Kimball animated the four crows who provide Dumbo with
a "magic feather" and the courage to fly; Tytla animated the ele-
phants.

Both Kimball and Tytla were what Walt Disney considered car-
icaturists, and the sense of caricature is strong both in the crows
and in the four female elephants who share a railroad car with
Dumbo and his mother early in the film; all of them are humans
masquerading as animals (very well-drawn animals, to be sure).
The crows are stereotypical blacks, but rescued from embarrass-
ment by the immense good humor that suffuses Kimball's ani-
mation, the voices, and the crows' song, "When I See an Elephant
Fly." The female elephants' voices and their dialogue make it
clear immediately that they, too, are types familiar from live-
action films: one is a Margaret Dumont-like dowager, another

catty, a third giggly and thoughtless. Tytla animated Dumbo and his mother, too, but in them something else is at work besides caricature as the term is usually understood.

Animation of the kind that Walt Disney had begun cultivating in the middle thirties—and that had flowered in Tytla's scenes of the dwarfs—was powerful because its cartoon exaggeration could reveal so fully the emotional life of its characters. When an animator immersed himself in that emotional life, the bond between character and animator could be as strong as any bond between character and actor on the stage. Tytla said in 1936: "It's almost a physical pain to rough out one character and space it a certain way, and try to get his attitude a certain way, then go on to another character."[107] The more closely an animator identified with a character in a scene, the more difficult it was to change emotional focus and animate another character in that scene. When casting by character was as tight as it was in most of *Dumbo*, that difficulty disappeared, but the animator faced a different kind of challenge: to the extent that he failed to reveal his character, he would reveal himself. Moore's animation of Timothy falls a little short because there is visible in it not just the cocky little mouse, but also traces of an animator who is losing his grip. When Disney animation was at its zenith, character and animator could have no secrets from each other.

Dumbo is, however, never more than the equivalent of a very small child (he says nothing throughout the film), and Tytla spoke, shortly after *Dumbo* was made, as if bringing the character to life was really nothing more than a matter of careful observation, of transposing the behavior of human children into elephant form. "I don't know a damned thing about elephants," he told *Time*.

> It wasn't that. I was thinking in terms of humans, and I saw a chance to do a character without using any cheap theatrics. Most of the expressions and mannerisms I got from my own kid. There's nothing theatrical about a two-year-old kid. They're real and sincere—like when they damn near wet their pants from excitement when you come home at night.[108]

Tytla's first animation of Dumbo was of the character's first appearance in the film, when the baby elephant has literally just been delivered by the stork.[109] The opening moments of Tytla's animation, as Dumbo awakens and smiles at the sight of his

mother, are very much as his description suggests, the evident fruits of sharp observation of real children—but then there is an all but audible "click," and suddenly it seems as though the animation has started to come from inside the character. That holds true throughout the rest of the film.

Tytla's animation of Dumbo is, however, not some peculiar animated equivalent of "method acting" by a two-year-old. The effect is rather as if Tytla had taken to heart what Richard Boleslavsky wrote in *Acting: The First Six Lessons*, the book that Tytla owned: "If you are a sensitive and normal human being, all life is open and familiar to you."[110] Tytla makes full use of what Boleslavsky's mentor, Stanislavski, called "emotion memory": his animation of Dumbo reflects his awareness not only of his son's actions and emotions, but also of emotions he has felt himself—as a child, surely, but especially as a parent. In Tytla's animation of Dumbo, what he has felt is constantly shaping and disciplining what he has seen, and of course, the reverse is also true, so that observation is a check on sentimentality. What might otherwise be mere cuteness acquires poignance because it is always shaded by a parent's knowledge of pain and risk. Tytla's feelings as a parent were particularly useful in animating Dumbo's mother, Mrs. Jumbo, who is wholly plausible as a mother—but Dumbo himself is always at the center, and it is only because Tytla's animation is such a subtle compound that so limited a character can hold the film together.

By the time *Dumbo* was released, *Bambi*—in work in some way since 1937—was still not finished. The strike had caught it in the final stages of cleanups and inbetweening, and with many of the people who did such work out of the studio, completion of the film slipped toward the end of 1941; the inking and painting of the cels was not finished until around the beginning of December.[111] Then, with a preview planned just before Christmas, *Bambi* hit another snag: Walt Disney decided that an instrumental portion of the musical score required lyrics, and writing and recording those lyrics added at least another month to the schedule.[112] What had been envisioned as an Easter release[113] slipped four months; *Bambi* did not reach theaters until August 1942. By then, it was already a relic of another time: a film about gentle animals, released in the midst of war, and—despite the heavy cuts made in March 1941—an expensive, elaborate film, from a studio that could no longer afford to make such things.

Bambi was by no means a dead end, though; because it departed so emphatically from the idea of casting animators by charac-

ter, in favor of casting by sequence, its animation was a distinct alternative to the kind of animation that gave *Dumbo* such a rich texture. Frank Thomas and Ollie Johnston outlined the advantages they saw in casting by sequence, as opposed to the disadvantages they saw in casting by character, with its concomitant sharing of scenes:

> The first man to animate on the scene usually had the lead character, and the second animator often had to animate to something he could not feel or quite understand. Of necessity, the director was the arbitrator, but certain of his decisions and compromises were sure to make the job more difficult for at least one of the animators.[114]

The casting of animators by sequence not only eliminated such problems, they said, but "more important, produced a major advancement in cartoon entertainment: the *character relationship*. With one man now animating every character in his scene...he was free to try out his own ideas of how his characters felt about each other." In other words, *Bambi*'s supervising animators were in some ways more like directors than like animators. Thomas made that comparison in 1987 when he said that Walt Disney "felt that the animators...were the ones who were going to really make [*Bambi*] work, so...I would say supervising animators had as much authority as directors."[115] As a supervising animator on *Bambi*, Eric Larson said, he "had ten animators, and a staff of about thirty people" under him—numbers that suggest a director's reach more than an animator's.[116]

The junior animators on *Dumbo*, with its strong casting by character, were like understudies, mastering a role under the tutelage of more experienced actors. The *Bambi* animators who worked under the supervising animators were, by contrast, carrying out instructions rather than learning about a character. The fruits of this tight control were disappointing to Thomas, although he blamed the animators rather than the system:

> Once you got a scene down to where it was foolproof, and where it was working, or where it was so definite the guy couldn't really screw it up, then you had to give it out to one of these younger guys.... They always screwed it up and you had to come back and make little changes in it and put it back the way it was.... You didn't have anyone who really gave you a lift and who did something better than you thought they were going to.[117]

*From Disney's Bambi (1942), like Dumbo a film rooted in a child's
separation from his mother.* © *Disney Enterprises, Inc.*

Casting by sequence, with its expanded role for the supervising
animator, was a pulling away from the collaborative nature of ani-
mated filmmaking for the sake of giving the supervising animator
a few shards of the power that Walt Disney himself enjoyed.
Strong casting by character, with the frequent sharing of scenes
by two or more animators that it necessarily entailed, was collab-
orative at its core. Animators had to respond to one another's
work, just as actors did—an irksome burden to some animators,
but a source of tremendous energy to animators who had truly

assumed parts.

The greatest apparent danger in casting by sequence—that the characters would vary, in personality or appearance, from one sequence to another—was never a serious problem in work on *Bambi*. The animal characters aged from childhood to adulthood, giving them a different appearance in different parts of the film, and the principal animators were all strong draftsmen who could match the approved models (which were mostly drawn by Milt Kahl). In any case, the *Bambi* animators did not seek the kind of strong identification with their characters that could have made reconciling their different versions more difficult. They assumed that the conditions under which animators worked made such identification impossible, and that animators must therefore analyze and construct their characters—in effect, reverting to the kind of animation that Ham Luske had pioneered in the middle thirties, if in a more sophisticated manner. Thomas and Johnston, writing many years after *Bambi* was made, offered one of the baldest statements of this position: "While the actor can rely on his inner feelings to build his portrayal, the animator must be objectively analytical if he is to reach out and touch the audience."[118]

Most of the drawing and animation in *Bambi* is unfailingly expert, but there is in the way that *Bambi's* animals look and move no caricature at all—only mere prettiness of the kind bought by giving them graceful movements and large, liquid eyes; the young animals' cuteness is only that, with none of Dumbo's complexity. When a hunter kills Bambi's mother, the film toils mightily to generate a tear by taking the fawn through the snow until he confronts his father and learns the worst. *Dumbo's* most affecting moment is, by comparison, tactfully understated, even given that its constricted staging did not permit any grand gestures: when the young elephant is reunited with his imprisoned mother—only her trunk can reach him through the bars—he is momentarily joyful; but tears well in his eyes as he gazes upward at her, and then, in a spasm of grief, he clutches her trunk. Bambi's loss of his mother can be moving because it appeals to emotions that are real (as anyone knows who has watched the film in a theater full of small children), but in *Dumbo* what happens *is* real.

Frank Thomas, speaking in 1978 to an audience made up of people working in the cartoon industry, said of Tytla's handling of that scene with Dumbo and his mother: "He was telling the

audience just what he wanted to tell them; he wasn't showing how smart he was, he wasn't showing how much he knew, he was doing what was right for that part of the picture." Tytla's animation, he said, "just overwhelms me."[119] Like many other animators, though, he spoke of Tytla as sui generis—a special case rather than an exemplar.

Dumbo returned a little more than $1.3 million to the Disney studio on its initial release, almost $600,000 less than *Pinocchio*. Roy Disney believed that *Dumbo* "always suffered...because it needed a little more length, really, to be sold as a feature picture. Had it been feature length and kept up the same interest and entertainment it would have been a really top grosser."[120] But it was highly profitable anyway because its negative cost was under $800,000. *Bambi* came in at a negative cost of just over $1.7 million. Once again, the receipts from a Disney film's initial release suggested that the normal market for an animated feature was of middling size: for *Bambi*, those receipts totaled about $60,000 less than the film's cost.[121]

The very characteristics that had made *Dumbo* both financially and artistically successful may have made the film somewhat suspect in Walt Disney's eyes. These fragmentary notes in the Disney Archives from a midfifties interview with Ham Luske suggest why: "Dumbo made as a quickie—cheaply and quickly done—Walt left it alone—bothers him still for lack of quality."[122] There are strong indications, in what Luske and other Disney veterans said, that Disney was less engaged in work on *Dumbo* than he was on other early features. The demands on Disney's time, from *Fantasia*, *Bambi*, and the studio's financial crisis, were extraordinarily severe when *Dumbo* was in production.

Dumbo was, in fact, a prototype for Disney features of a new kind: films animated by a sort of repertory company of strong character animators who answered to a producer and directors who were themselves under relatively loose supervision. Moreover, *Dumbo* opened up new possibilities for stories; premises as slender as *Dumbo*'s could be more than adequate, as long as they offered opportunities for animation like Tytla's. Because the most important animation in *Dumbo* is so deeply felt, it turns back the questions a critical audience might otherwise be tempted to raise. (Is it even conceivable that an elephant could fly, no matter how large its ears?) In the almost simultaneously released *Mr. Bug Goes to Town*, on the other hand, the Fleischer animation is so flat and literal that impertinent questions refuse to lie still.

(As the insects climb a building under construction, over what must be many months, what do they *eat*?) Here was a wonderful paradox: when a film's animation is emotionally truthful, fantasy of almost any kind is open to it.

For Walt Disney, though, the critical issue may have been control: to make more features like *Dumbo* would have required giving up some of it, and Disney, so much the small businessman in spirit, could only have found that prospect troubling. By 1942, questions about the future course of the Disney features were all but moot, anyway. For the moment, there weren't going to be any. The Disney studio became a virtual defense plant soon after the Japanese attack on Pearl Harbor, devoting almost all its resources to the production of training films.

By then, too, Disney's principal rivals of the previous few years—rivals in their own minds, if not in his—had retired from the field. The Fleischers were gone, as was Hugh Harman from MGM; Harman, for all his vainglorious talk of a King Arthur feature, was nowhere close to making one. The energies that for years had gone into making both shorts and features on the Disney model had ebbed; the task of enriching animation's language was passing into the hands of people who were making more modestly scaled films.

Part II: Cartoon Reality

Warner Bros.,
1933-1940

Early in 1933, the animator Don Williams was working at the Universal cartoon studio. He decided to seek a job at the Harman-Ising studio on Hollywood Boulevard. As he came down the stairs after a meeting with Rudy Ising, Williams said many years later, "I ran into a guy named Ray Katz. He introduced himself and he said, 'Were you looking for a job up here?' I said, 'Yes, in fact, I got one.' He said, 'Come on outside.' I went downstairs with him and he said, 'What did they offer you?' 'Sixty bucks a week.' He said, 'Will you go to work for me for sixty-five dollars?' I said, 'Yes, but where are you?' He said, 'There's a friend of mine opening a new studio over at Warner Bros., called Leon Schlesinger. We need good animators, and if these guys will hire you, I know damned well he will. Would you be interested?' I said I sure would."[1]

Since Katz, nominally Harman-Ising's business manager, held that title only because he was Schlesinger's brother-in-law, there was never any question about where his first loyalty lay. When Katz spoke with Williams, Schlesinger was setting up his own cartoon studio on the Warner Bros. lot on Sunset Boulevard. He stocked a building on the lot with freshly carpentered animation desks,[2] and he scraped together a staff mainly by raiding other studios. Bob Clampett, Schlesinger's first recruit from the Harman-Ising studio, assisted Jack King, who was probably the first Disney animator Schlesinger hired. Schlesinger also took

talent from the New York studios; on one trip east, he hired Frank Tashlin, an animator for Van Beuren.[3]

Because Schlesinger knew almost nothing about making cartoons, he took help where he could find it. A case in point is Bernard Brown, the musician who was in charge of recording the sound for the cartoons. He worked on them, he said, in addition to "my regular work," recording scores for Warner features: "I'd spend so many hours with a big production, doing the score on that, then back to the cartoons."[4] Brown apparently had the ability—useful everywhere, but especially in Hollywood—to approach big shots with just the right mixture of deference and ease, and they were comfortable turning to him for help beyond the scope of his nominal expertise. Brown could, as Clampett said, "just ooze in any hole that needed filling."[5] Brown brought two friends onto the staff: the animator Tom Palmer and Norman Spencer, a songwriter.

Early in June 1933, Schlesinger announced that he had completed his staff and had started making cartoons. Palmer had been named production manager, which in this case meant he was the director, and King was the head animator.[6] Palmer and King had brought with them two other Disney animators, Paul Fennell and Bill Mason,[7] and several animators had joined Tashlin in migrating west from New York. The staff may have totaled about three dozen.[8] Even though it was ostensibly complete, a trickle of Harman-Ising people joined it over the next few months. Both Friz Freleng and the animator Bob McKimson left Harman-Ising for Schlesinger at the end of September.[9] Clampett watched his former colleagues as, one by one, they walked past his window to talk with Schlesinger about jobs—"all these guys who had told me, don't, under any circumstances, work for Leon."[10]

The new studio was, Clampett said, "like a gold-rush town.... We all had our picks and our bags, and we've all got a chance to make it." Animators in particular held a strong position. The Schlesinger studio opened in the depths of the Depression, but "animators were so scarce that you could get away with murder," Nelson Demorest said. "You could drink, or come in at any hour you wanted.... They were on us every minute, to keep working—but they wouldn't fire you."[11] The Schlesinger studio's animation staff consisted of very young men (scarcely anyone was over thirty) who were required to work long hours (two nights a week, as well as Saturday morning)[12] and were pressed for output, but who had little reason to fear their employer's wrath if they divert-

ed their energies from their assigned tasks. The studio thus turned out to be one where, in Demorest's words, "they all had water pistols...and they'd have regular wars down the hall. You'd see beetles or cockroaches with signs pasted to them, walking across the floor, and big flies towing streamers."

However restless the atmosphere in his studio's early months, Schlesinger had put former Disney animators in charge, and he no doubt hoped that they would give him cartoons that competed more effectively with Disney's than Harman-Ising's did; one member of the studio's staff heard him proclaim, "From now on, boys, we're going to make 'em cute."[13] To replace Bosko as the continuing character in the Looney Tunes—and be the new studio's answer to Mickey Mouse—Palmer introduced a character named Buddy. Like Bosko and Mickey, Buddy came equipped with a girlfriend and a dog; but in a departure from the prevailing pattern, Buddy was recognizably human, a prepubescent boy of the kind that populated comic strips like "Out Our Way."

Palmer seems to have approached *Buddy's Day Out* (1933), the first of the new Looney Tunes, as loosely as many animators approached work on silent cartoons. Bernard Brown remembered taking part in story conferences where Palmer said, "And now we do a funny piece of business here," but never specified what the funny piece of business was to be. According to Brown and Clampett, funny pieces of business were so conspicuously absent from the first new Looney Tune that *Buddy's Day Out* had to be reworked extensively, with gags added, before Warner Bros. would accept it.[14] The cartoon as released remains desperately unfunny. Following Disney's lead, Palmer shunned the most obvious of the "impossible things," as Wilfred Jackson called them, that had flourished in the earliest Bosko cartoons—the disconnected heads and rubbery arms. For the most part, however, he replaced them with forced sight gags that were neither as well conceived nor as well executed as the comparable gags in the Disney cartoons. (In one implausible transformation, Buddy and his girlfriend Cookie use a ladder to route a train off its tracks and through a house.)

Palmer left the studio after making only two cartoons. The director's credit on the next few went to Earl Duvall, a former story man for Disney and Harman-Ising who had worked for Schlesinger since early in the studio's short life.[15] Duvall evidently carried with him an aura of sophistication—Norman McCabe, an inbetweener at the time, remembered that he "looked just like

the Prince of Wales"[16]—that earned him the benefit of the doubt for a time wherever he worked, but he was gone after directing three Looney Tunes and two Merrie Melodies. In the turmoil that attended Schlesinger's efforts to find reliable directors, even Bernard Brown, no artist, directed two Merrie Melodies. All the Schlesinger cartoons made by these first few directors lacked not only cuteness or charm of any kind, but often simple coherence.

Because the Schlesinger budgets were much smaller than Disney's, the Schlesinger cartoons could not have duplicated the Disney cartoons' visual richness even if the directors had been equal to the task. Schlesinger's 1933 contract with Warner Bros. was amended on 8 February 1934 to raise his payment for each cartoon, but only by five hundred dollars. Warners paid him seventy-five hundred dollars per cartoon in the last half of the 1933-34 release season;[17] Disney was spending more than three times as much on each of his cartoons.[18]

By early in 1934, Schlesinger had assigned direction of his cartoons to men whose greatest virtue was that they could turn out films that made a certain kind of sense, on however low a level. Friz Freleng, who began by directing Looney Tunes, became the principal and then the only director of the Merrie Melodies; Jack King was the principal director of the Looney Tunes. Some of Freleng's earliest Merrie Melodies, released in 1934, did come surprisingly close to the Disney cartoons in both spirit and execution. *The Girl at the Ironing Board* and *The Miller's Daughter* are rich in production values—painstaking drawing, modeling, rotoscoped movement—compared with the Merrie Melodies that preceded them. *The Miller's Daughter*, Freleng's seventh Merrie Melodie, is very Disneyish in its careful drawing and, especially, its subject matter: the characters are china figurines and obviously owe their existence to Disney's *The China Shop*, released earlier the same year.

Freleng slipped from that peak very quickly, though; staying atop it was undoubtedly difficult and expensive. The Schlesinger directors never worked with budgets as such; they thought in terms of time, not dollars, and for them, the lower Schlesinger budgets meant that they had to complete one cartoon every four or five weeks—a pace roughly twice as fast as that of the Disney directors. For that reason alone, it would have been difficult for Freleng to make very many cartoons that came close to matching the Silly Symphonies on their own terms; any extra time devoted to one cartoon had to be made up by skimping on another.

Although Freleng's first Merrie Melodie, *Beauty and the Beast*, released in April 1934, was in a two-color process, his next six, including *The Girl at the Ironing Board* and *The Miller's Daughter*, were in black and white. Starting with *Those Beautiful Dames* in November 1934, the first cartoon of a new release season, all the Merrie Melodies were made in color (the Looney Tunes stayed in black and white). With the change to color, Warner Bros. raised its payments to Schlesinger by $1,750 per Merrie Melodie, to a total of $9,250.[19] That figure was still paltry by Disney standards, and color did not bring with it any greater refinement in Freleng's Merrie Melodies.

Most of those cartoons merely extended and revised formulas that Rudy Ising had used a few years earlier. Since Freleng had drawn the character layouts for most of Ising's Merrie Melodies, the resemblance between his Merrie Melodies and Ising's was very strong: if *Beauty and the Beast* had been made in black and white instead of two-color Technicolor, it could easily have passed as a Harman-Ising film, down to details (the little girl who is the principal character says, "Ain't he cute?" in echo of a Harman-Ising catch phrase). Like many of Ising's Merrie Melodies—and some early Silly Symphonies before them—Freleng's Merrie Melodies often opened with singing and dancing that were interrupted by a villain, who was then defeated through the combined efforts of the singers and the dancers. Characters drawn according to simple formulas and strongly resembling those in the Harman-Ising cartoons persisted in Freleng's cartoons well into the midthirties.

"There was still a little gold-rush feeling" left at the Schlesinger studio even after the place settled down, Bob Clampett said;[20] and the studio was indeed still loose enough that an ambitious young inbetweener could rise very rapidly, in a way that was not possible at, say, the Fleischer studio. Witness Phil Monroe, who started at Schlesinger's in June 1934:

> Some guys would sit there and be inbetweeners all their lives, and other guys wanted to do something else, so they kidded around and talked with the guys, and...they got a chance to move up. Bob McKimson and I got along well together. I was his inbetweener for a while, and the first thing you know, I was his assistant.[21]

Monroe was animating by the end of 1935.

Even though individual members of the staff could still find

avenues to the top, the Schlesinger studio as a whole was mired in making mediocre cartoons that held no seeds of anything better. Such were the circumstances when a new director, Frederick Bean Avery, joined the staff in the spring of 1935.

The Schlesinger title cards identified him as "Fred Avery," but everyone in the business knew him as "Tex." He was born in Taylor, a small town near Austin, on 26 February 1908, and he graduated from North Dallas High School in 1926; he carried Texas with him in his voice. He arrived in Los Angeles on New Year's Day 1928, and for a few months held down a variety of menial jobs. He worked in a warehouse and on the docks at night, loading fruits and vegetables, and painted cars, until he finally got a job inking cels for the Oswald cartoons being made at the short-lived Winkler studio. From there he went to Universal, again as an inker. He moved up rapidly, becoming an animator by 1930.[22]

So lax was the atmosphere at Universal that it bred a lot of horseplay, much of it crude even by the standards prevailing at other animation studios, and Avery—by all accounts an exceptionally gregarious and good-natured young man in the early thirties—was in the thick of it. One standby, Avery told Joe Adamson, "was the rubber band and paper spitball shot at the back of the head. You'd pop a guy, hit him, and he'd yell, 'Bull's-eye!'" One animator, Charles Hastings, "went a step further and used a wire paper clip," Avery said. "One of the boys yelled, 'Look out, Tex!' and I turned and caught the clip in my left eye. That lost me one eye in a split second."[23]

Whatever the psychological scars from that episode, Avery always spoke as if he found the working conditions at Universal congenial. Leo Salkin, as a Universal inbetweener in the early thirties, observed Bill Nolan delegate heavily to Avery on the sequences that Avery animated, for all the world as if they were working together at one of the old New York studios where Nolan animated in the teens and twenties: "He would say, 'Okay, it's a scene in the woods, and Oswald is running from right to left, and he's being chased by a bunch of bees. You bring him in from the right and work out 250 feet, and run him out to the left.' That was all the connection there would be."[24]

Eventually Manuel Moreno was handing out work to Walter Lantz's animators, and Avery was doing the same for Nolan.

Avery wanted more control, and thus he became a de facto director: "I told Bill...that I'd like to draw up a story and do it all, because I was turning in gags then, and some were used and some were not that I thought were funny. With that in mind, I thought I'd like to get *all* my gags in a picture.... He said, 'Hell, yes, Tex, draw one up,' and I drew a whole board. Bill said, 'Yeah, do it, time it, and lay it out.' I did two for him, I guess, and they were terrible, but they got by."[25]

Avery lost his job at Universal in April 1935. "I started laying down on my work," he said, because he was unhappy with his salary, and "after about six weeks they let me go." He and his girlfriend (an inker at the studio) "got married about two days after I got canned"[26] and went on a long honeymoon to Oregon, "until we ran out of money, and then we came back," probably sometime in May. After returning to Hollywood, Avery "went down to Schlesinger, and I said, 'Hey, I'm a director.' Hell! I was no more a director than nothing, but with my loud mouth, I talked him into it. He said, 'Okay, you draw up a board. Here's our characters. I'll run some stuff for you.' Among the characters was a stuttering pig who recited a poem."[27]

Avery arrived at the Schlesinger studio as Buddy was being phased out in favor of animal characters. The process began with the cartoon Avery mentioned—a Freleng Merrie Melodie, *I Haven't Got a Hat*, released in March 1935. The Merrie Melodies were still off limits to continuing characters, but *I Haven't Got a Hat* served as a showcase for characters that were being groomed to take Buddy's place as the stars of the Looney Tunes. The cast was made up of animal schoolchildren: two cats named Beans and Kitty, a pair of spotted puppies named Ham and Ex, a bespectacled owl named Oliver, and, easily the most distinctive of a nondescript lot, that stuttering pig. Not a black pig with a white face— such obvious formula characters were finally fading from the Schlesinger cartoons, years after Disney had shed them—but a round, pink pig named Porky.[28]

Only Freleng ever took credit for giving Porky his single outstanding trait: his stutter. "I used the stuttering," Freleng told Joe Adamson, "because I thought it would give him something different, some character."[29] Porky's voice in that first cartoon was provided by a man who actually stuttered: Joe Dougherty, a dress extra for Warner Bros.; his voice as heard in the film was speeded up, giving it a higher pitch. Porky's role in *I Haven't Got a Hat* consisted mostly of a stammering recital of "The Midnight Ride of

Paul Revere." "Porky stood out like a toupee in the first row of a burlesque," Schlesinger was quoted as saying in 1936. "Porky was sensational, history making, good."[30] That was surely a press agent's tongue-in-cheek prose. When Buddy breathed his last in *Buddy the Gee Man*, about six months after the release of *I Haven't Got a Hat*, it was Beans the cat—not Porky—who got the first crack at stardom in a cartoon called *The Cartoonist's Nightmare*, directed by Jack King.

Beans in King's cartoons—he made eight with the character—suggested the Mickey Mouse of the early thirties as much as Bosko suggested the Mickey of the late twenties (like Bosko, Beans had a white face and black body that resembled Mickey's). King presented Beans as a pint-sized hero, like the plucky, boyish Mickey of *The Klondike Kid* (1932) and *The Mail Pilot* (1933), cartoons made shortly before King left the Disney studio to go to work for Schlesinger.

With Avery as the third full-time director, in addition to King and Freleng, the Schlesinger staff had outgrown its original building. Avery moved into a small frame building in the middle of the lot. He worked with four animators: two young Schlesinger veterans, Clampett and Charles M. "Chuck" Jones, and two former colleagues from Universal, Sid Sutherland and Virgil Ross. Until Avery came along, the Schlesinger animators formed a pool on the Disney model, each man working for one director and then another, as the need arose. With Avery in a separate building, that arrangement was not practicable for him, and so the four animators were assigned to him exclusively.

Gold Diggers of '49, Avery's first Schlesinger cartoon, was released late in 1935 as the third Looney Tune starring Beans (who got featured billing on the title card); Beans was a gold miner, in a western setting. It was also the first cartoon with Porky Pig since *I Haven't Got a Hat*. No longer a little boy with a high-pitched voice, Porky was instead a bulky hog who spoke in Dougherty's natural voice, not speeded up this time, and yelled "Whoopee!" a lot. In Avery's second cartoon, *Plane Dippy*, he restored Porky's schoolboy proportions and voice.

Even when Porky's voice was speeded up, its human origins were a little too obvious—Dougherty strained to get the words out—but the higher pitch at least masked some of the effort, and Porky's stutter made him promising material for reasons that had nothing to do with Dougherty. Stuttering comedians like Roscoe Ates were familiar to thirties audiences from vaudeville and

films; stuttering lent itself to comic twists like those in *The Broadway Melody* (1929), in which the character "Uncle Jed" tries to say "over the footlights," trips on a stutter, and settles instead for "in the theater." Dougherty's stutter was too insistently the real thing to permit Avery to indulge in many such twists (years later, he recalled how much film was wasted in recording sessions because Dougherty could not control his speech),[31] but at least the aura of comedy hung around Porky.

Avery dropped Beans—a born straight man—after *Gold Diggers* and used only Porky as his star. Porky remained dumpy looking, though, and decidedly piglike; he was very fat, with small eyes, a large snout, and pronounced jowls. For *Porky the Rainmaker* (1936), his fourth cartoon starring Porky, Avery redesigned the pig, giving him more prominent eyes, a smaller snout, and chubby cheeks rather than jowls; his body's rounder shape spoke less of fat than of softness. Arguably, the redesigned Porky was, because of his cuteness, no longer so comic a figure as the original Porky. (The original, which King continued to use, was a sort of porcine Roscoe Arbuckle—unmistakably an object of fun, but too large and coarse to be readily adorable.) The new Porky was, however, more emphatically a *cartoon* character than the earlier version, with fewer traces of Disneyish realism in the drawing. For Avery's purposes, that may have been more important.

By the time Avery went to work for Schlesinger, directors at that studio had been trying for more than two years to find comedy in something besides impossible things. In a quest for plausibility, they had succeeded mainly in laying bare the mechanics of what were often terribly contrived gags; watching a cartoon like King's *Alpine Antics* (1936) is like listening to someone explain at length a joke that wasn't funny to begin with. Avery was different. It was not just that he strongly preferred impossible things like those that had turned up so often in the Bosko cartoons as well as in the Oswald cartoons that he helped make at Universal; other directors—like Wilfred Jackson—felt the same way. Alone among cartoon directors in the midthirties, Avery accepted the challenge of finding a way to make such gags work in the climate created by Disney's logical fantasies.

He moved cautiously at first. His third Looney Tune, *The Blow Out*, with Porky and a mad bomber, has little in it that is even *supposed* to be funny. Bob Clampett remembered working on those first few cartoons: "Tex and I used to sit around, when I was first put with him, and we'd talk about the old Felix the Cats, how he

would...lift the top of his head and the ears, as if he were tipping his hat to somebody." Although Avery looked favorably on comic business of that kind, he was cautious about moving in that direction while he was still a new director, Clampett said: "He wasn't about to blow it by carelessly trying out a lot of things on the screen that might backfire."[32] After Avery had been a Schlesinger director for about a year, though, his cartoons were rising above the studio's sluggish norm. He started using gags that flatly contradicted reality—so that, in *Milk and Money* (1936), his fifth Looney Tune, the milkman Porky dumps a tray of empty bottles into a milk can, turns the spigot on the can, and full bottles of milk pop out of the spigot and into his tray. He also started using speed to make such comedy more acceptable.

Avery had made speed an ingredient in his cartoons from the start—in *Gold Diggers of '49*, Beans's car hurtles across the desert after he fills the radiator (not the gas tank) with moonshine liquor—and he had always paced his cartoons more quickly and lightly than the other Schlesinger directors did. But it was not until well into 1936, when he made his sixth Looney Tune, that he seemed to understand that many gags were the more appealing the less time he allowed his audience to think about them. In *The Village Smithy*, released in December 1936, a horse whose rump has just been scorched by a hot horseshoe hurtles through town at such speed that it pulls away the facade of a bank, revealing a burglar hard at work inside, among other kinds of damage. The horse rushes into a wire fence that snaps it back through the town, and this time its speed pulls the bank's facade back into place and undoes all the other damage. Speed is vital not only to the premise of the gags triggered by the horse's flight, but to the way Avery presents them: everything happens quickly enough to surprise, yet not so quickly that the clarity of the action is compromised.

In that gag sequence, however, Avery was really doing nothing more than extending what Disney had done two years earlier in *The Tortoise and the Hare*, when the Hare's speed sucks the feathers off birds. Disney exaggerated speed's effects on stationary objects; Avery did the same, even though for more aggressively comic purposes. It was only when he made his seventh Looney Tune, *Porky the Wrestler*, which was released in January 1937, that Avery took his first firm steps into a different world.

In that cartoon, Porky finds himself—by accident, of course—trapped in the ring with a champion wrestler, an enormous

bearded fellow who foams from his fanged mouth at the sight of the little pig. The champ unwittingly wrestles with himself, instead of with Porky, and as he does, he pounds on the canvas, jarring a tobacco pipe out of a ringside spectator's mouth and down his own throat. After he has swallowed the pipe, the champ presses on his stomach, and smoke puffs out of his mouth. The champ grins with delight and begins chugging like a locomotive, billowing smoke; Porky and the referee grab hold, forming a train that races around the ring.

Instead of winding up the gag in some way, as anyone else would have, Avery expands his metaphor: the bell used to signal rounds swings back and forth on a corner post, as if at a railroad crossing; when a spectator goes to a water cooler, the floor sways beneath him as if he were on a train; a butcher boy, like those on trains, hawks his wares; a spectator lifts a window shade and finds the scenery passing by; he looks again, then gets up and heads for the exit—carrying his suitcase. In this sequence, Avery achieved the same kind of momentum—giving his comedy the same kind of sustained line—that Disney had, but with much less plausible action. As one gag follows another, the train metaphor swallows up first the champ, then Porky and the referee, and finally the entire arena, with credulity stretched further each time—but upheld by what has come before. After all, if the arena is now swaying like a train, how much greater a suspension of disbelief is required if scenery is moving past the windows of what was, a moment ago, an immobile building?

In the last half of 1936, when Avery made *Porky the Wrestler*, Disney was deep in work on *Snow White and the Seven Dwarfs*. There is visible in *Porky the Wrestler*—if on a much smaller scale and in a more embryonic form—some of the same intensity that Disney was bringing to work on his feature. In his film, Avery demonstrated that a silly idea could become a funny idea if a director pursued it with disarming vigor and single-mindedness. In the shadow of Disney's successes, impossible things might still thrive if a director offered them without a trace of hesitation or embarrassment.

Jack King's *Shanghaied Shipmates* (1936) was the last cartoon with Beans and any of the other new characters—except Porky Pig. By keeping only Porky, Schlesinger may have been giving Avery a

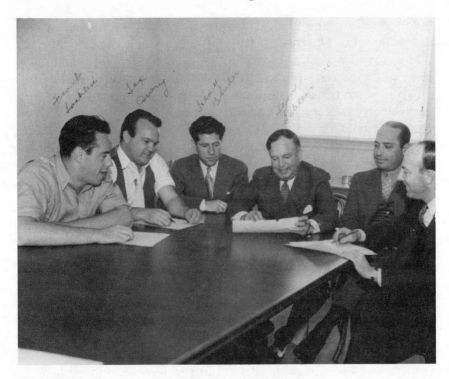

Leon Schlesinger meets in 1936 with his three directors and his two principal assistants. From left: Frank Tashlin, Tex Avery, Henry Binder (Schlesinger's aide-de-camp), Schlesinger, Ray Katz (Schlesinger's brother-in-law and the studio's business manager), and Friz Freleng. Courtesy of Michael Maltese.

vote of confidence, at King's expense: Avery had already started making cartoons with Porky alone, even while King continued to use Beans as his star. King directed only three Porky Pig cartoons before he returned to Disney's in April 1936, as director of the new series of Donald Duck cartoons.[33]

His departure just preceded a consolidation of the Schlesinger studio's units. Avery and his unit occupied their little frame building for about a year, until 11 May 1936. The whole Schlesinger studio (by then the staff totaled around 115)[34] moved that day into the Vitaphone Building, on a corner of the Warner lot, at Fernwood and Van Ness Avenues. (The building also housed Warner Bros.' radio station, KFWB.)[35] At that time, the pool of animators broke up, and each director began working with a permanent crew of at least four animators.[36]

Frank Tashlin replaced King. He had left the Schlesinger studio

just a few months after he was hired in 1933: he had sold a comic strip—"Van Boring," about a silent little man who was a caricature of Amedee Van Beuren—to the *Los Angeles Times*. Schlesinger "wanted a cut of it," Tashlin said, "and I said go to hell. So he fired me." Tashlin then worked simultaneously as a newspaper cartoonist and an animator at Ub Iwerks's studio and then as a gag writer for the comedian Charley Chase at the Hal Roach studio before Schlesinger hired him back as a director; he was all of twenty-three at the time. His first cartoon as a director, *Porky's Poultry Plant*, was released in August 1936. Their earlier clash had no bearing on Schlesinger's decision to rehire him as a director, Tashlin said: "He was a man who thought in money terms. He never let personalities interfere too long; his wallet spoke."[37]

Tashlin was a conspicuous figure at the Schlesinger studio—he was a very large, heavy man, standing well over six feet—but he was never really a part of it. In later years, what some of the Schlesinger people remembered most clearly, and held against him, was how cold and odd he could be (he was, in particular, ridiculously stingy). He was very different from his mostly gregarious colleagues, not just as a personality but as a filmmaker. Unlike King, Tashlin did not linger over gags; he was, if anything, more devoted to speed than Avery was. But he emphasized not the characters' speed but the director's speed. Tashlin's cartoons abound in rapid cutting, especially at the climaxes, and he used montages combining the rapid action from several earlier scenes.

Tashlin approached cartoons far more cinematically than the other Schlesinger directors did—or, for that matter, the directors at other cartoon studios did. Most cartoons in the thirties were conservative in strictly cinematic matters. Cutting, simulated camera angles and camera movement—all were usually functional rather than expressive, just ways of getting at the gags and the characters. Tashlin's strong interest in film techniques thus set him apart from his colleagues. He filled his cartoons with cartoon equivalents for claustrophobic closeups, deep focus, and oblique camera angles, in scenes that suggested F. W. Murnau more than Walt Disney. "When I was doing cartoons," Tashlin said, "I was concerned with one thing: doing feature motion pictures.... I was always trying to do feature-type direction with little animals."

More than any other Schlesinger director, Tashlin scooped up ideas from films of all kinds; but he did not give them a specifically animated quality. In *Porky the Fireman* (1938), he borrowed

a gag from Keaton's *Steamboat Bill, Jr.*, in which the front of a building topples over onto the comedian, all in one piece, but he survives because an open window just clears his body. Tashlin simply multiplied the gag, so that a half dozen or so windows fall over that many firemen. The multiplication of the Keaton gag made it no funnier; what was needed was an *extension* of the gag that somehow transformed it into something that even a superb mind like Keaton's could not duplicate in live action. But Tashlin was not interested in expanding the language of animation itself; he wanted instead to become more fluent in the language of film. It was only in Avery's cartoons that a Schlesinger director was trying to say something that was both distinctive and unique to animation.

In one respect, though, Tashlin's and Avery's cartoons were much alike: both men had to work around Porky Pig to get at what really interested them about making animated cartoons. In the strongest parts of Avery's cartoons—like the horse's wild ride in *Village Smithy* and the train gags in *Porky the Wrestler*—Porky is a bystander; the gags have nothing to do with what kind of character he is. It was not until he made *Porky's Duck Hunt*, released in April 1937, that Avery introduced a character that could be the engine for comedy rather than its pretext.

Bob Clampett, who animated some of the key scenes in that cartoon, said in 1969 that Avery originally planned to have Porky harassed by a number of crazy ducks, but that, at Clampett's suggestion, he decided to boil all those ducks down to one black duck: a squat, square-beaked fowl with a white ring around its neck.[38] There is, however, much less of Daffy (as the duck was to be named later) in *Porky's Duck Hunt* than Clampett's remarks suggest: in addition to performing acrobatics on the end titles, a duck that is unmistakably Daffy appears in only two brief gag sequences. He pops up to pester Porky in between gags that have nothing to do with him.

Still, even Daffy's brief turns in *Porky's Duck Hunt* were enough to establish him as something new in the Schlesinger cartoons. In the first, Porky fires as Daffy flies, and the duck plunges into the water; but when Porky sends his dog after Daffy, it is the dog, not Daffy, who is "retrieved" and flung onto the lakeshore. Porky complains: "Hey, that wasn't in the script!" Daffy responds in a voice with more than a trace of madness in it: "Don't let it worry you, skipper. I'm just a crazy darnfool duck!" Then he bounces away across the water like a feathered Ping-Pong ball, whooping

crazily in an exaggerated version of the high-pitched "woo-woo!" made famous in the thirties by the comedian Hugh Herbert. Later, Porky tries to fire at Daffy again, but his gun seems to be empty. Daffy takes the gun and fires it, says, "It's me again!"—as if to remind Porky of his impotence in dealing with this particular duck—and bounds across the water to the accompaniment of more "woo-woos."

Daffy was an anomaly in the cartoons of 1937 because he was deliberately one-dimensional; he lived only in the gags he pulled on Porky. If he wasn't funny, he was pointless, as Avery made clear by having Daffy disregard the "script" to get a laugh. There was nothing cute or poignant or charming about Daffy. Unlike Porky Pig, Daffy had no trace of Disney in him. He was, in other words, a character wholly compatible with Avery's developing ideas about what should go into an animated cartoon.

In *Porky the Wrestler*, released three months before *Porky's Duck Hunt*, Avery's thinking about animated comedy was most clearly visible when he pursued a slender idea so vigorously that it acquired surprising strength; in *Duck Hunt* the idea is frailer, and the pursuit of it more narrowly intense, than in the earlier cartoon. Neither Porky nor Daffy takes part; the comic load is borne entirely by some ordinary-looking cartoon fish. When the fish get drunk on liquor that spills into the water, they stagger onto the land, climb into a rowboat, and row away singing a drunken rendition of "On Moonlight Bay." Gradually, the fish become funny because Avery will not admit that they are ridiculous. The single-mindedness Avery had shown in *Porky the Wrestler* was here more like ruthlessness—an iron determination to get laughs, and only laughs.

Even taking the drunken fish and Daffy into account, *Porky's Duck Hunt* is cluttered and uneven. But in that cartoon, as in none of Avery's work before it, his audiences could see clearly what he thought was funny, and they could see that he was trying to find the best way to make them think that it was funny, too.

In *Porky's Duck Hunt*, Porky's voice came for the first time from the mouth of Mel Blanc. He was the voice of Daffy, too. Blanc's first voice of any kind for a Warner cartoon was that of a drunken tramp in *Picador Porky* (1937), directed by Avery; it was released about two months before *Porky's Duck Hunt*. By then

Avery's dissatisfaction with Joe Dougherty must have been acute, because Porky's dialogue in some of his cartoons had shrunk almost to nothing. The same was true in Tashlin's Looney Tunes. Dougherty's stutter not only made recording sessions a trial, but it also had questionable effects on what appeared on the screen. Dougherty often sounded as if he were locked in a terrible struggle, and the animators picked up on that; in Avery's *Plane Dippy* (1936), Porky contorts his face as he wrestles with a word that refuses to leave his mouth. Blanc's stuttering in *Porky's Duck Hunt* is strikingly different. His Porky gets tongue-tied, but his stutter sounds like a minor inconvenience.

When Blanc began working for the Schlesinger studio, most voices for the Schlesinger cartoons were provided by contract players from the Warner lot, radio announcers, and even members of the studio's staff. The hiring of Blanc was a major step up. Blanc was only twenty-eight when he first provided dialogue for Porky and Daffy, and his voice was a very flexible instrument. Both voices were speeded up, which reduced the differences between them, but they remained distinctly different—not just in mannerisms (the stutter for Porky, manic whoops for Daffy) but in tone as well. Even without his stutter, Porky would have been a befuddled innocent; Daffy would have still sounded unhinged if his whoops had been taken away. In other words, Blanc could act, as well as change his voice. He had worked as a radio comedian for several years in Portland, Oregon, and in Los Angeles before auditioning at the Schlesinger studio, and he had the good radio actor's ability to create a character through the voice alone.

Blanc was hired by Tregoweth "Treg" Brown, who had joined the Schlesinger staff just a few months before; by the time he interviewed Blanc, he had succeeded Bernard Brown as the cartoons' sound editor. He and Blanc were two of the three men who came to dominate the soundtracks of the Warner cartoons in the late thirties. The third was Carl Stalling, who was hired in July 1936 to compose the music for the cartoons.[39] Both Stalling and Brown were considerably older than the directors they worked with—Stalling turned forty-five in 1936, and Brown thirty-seven—and they brought with them valuable experience outside animation studios.

After leaving Disney in January 1930, Stalling had worked briefly for the Van Beuren studio in New York and then for Ub Iwerks and for Disney again before joining the Schlesinger staff. Stalling's first Schlesinger screen credits were for *Toy Town Hall,*

a Merrie Melodie, and *Porky's Poultry Plant*, a Looney Tune. His early scores were not so obvious an improvement over the prevailing pattern as Blanc's first voices were, for the ironic reason that Stalling's scores more nearly mirrored the still relatively weak action on the screen. Many of the scores written before Stalling's arrival resembled Leigh Harline's music for the Disney Silly Symphonies, in that repeating and embroidering an attractive theme mattered as much as synchronizing music and action. That approach, so often valid for Disney's fantasies, worked far less well when applied to a cartoon like *Plane Dippy*, where Avery's tentative push toward stronger comedy could have used more help from the composer, Norman Spencer; instead, Spencer leaned heavily on repeated use of "I'd Love to Take Orders From You," an Al Dubin–Harry Warren song from a 1935 Warner musical, *Shipmates Forever*.

Stalling tended not to return to the same song over and over, but rather to use bits of one tune after another, often linking them with bridges of original material; even when he returned to a tune, or stuck with one for a while, he usually enhanced a comic effect. In Avery's *Porky the Wrestler*, for instance, Stalling uses two minutes of "California, Here We Come" to accompany the gags that follow the champion's transformation into a choo-choo train; that driving tune intensifies the momentum Avery created and helps pull all the gags together.

Stalling's music was thus much closer to what Frank Churchill provided for the Disney cartoons than to Harline's scores. Like Churchill, Stalling had mastered his craft in the days of silent films. For about twenty years before leaving Kansas City, Stalling played piano and organ as an accompanist for the silents, a job that required virtually the same skills needed in composing scores for cartoons. In 1969, he explained the similarity this way: "I'd have to put music out for the orchestra, for features, but for comedies and newsreels we just improvised at the organ," producing a continuous flow of music by drawing on a reservoir of familiar tunes. "So I really was used to composing for films before I started writing for cartoons. I just imagined myself playing for a cartoon in the theater, improvising, and it came easier."[40] Because Stalling applied what he had learned in Kansas City theaters to the scores he wrote for the twenty-five-member Warner studio orchestra, he was fully prepared, as his predecessors were not, to support stronger comedy once it started appearing on the screen. At Schlesinger's, moreover, he could use the songs owned by

Warner Bros.' three music publishers; "That opened up a new field," he said.

Treg Brown, too, was a musician; before he started work at Schlesinger's, he played a variety of instruments with bands (including Red Nichols's) in the Midwest and New York City, eventually winding up in Los Angeles in 1932. There, he found work editing live-action features at Paramount. He came to Warner Bros. as a film editor, cutting both features and cartoons: "[Bernard] Brown and Spencer would do the sound effects and the music, and I would just cut them in."[41] Eventually, when Bernard Brown left to become head of the sound department at Universal, Treg Brown assumed his responsibilities, "the sound and the editing and that sort of thing." Providing all the sound effects for the Warner cartoons was soon a far more important aspect of his job than it had been for his predecessors. By the time Brown joined the Schlesinger staff, a sound editor could accumulate a large library of sound effects that had been recorded on film—some of them picked up from the soundtracks of features—and add them to each cartoon as needed. An editor still had to invent new effects, but he had abundant resources at his command. Brown's skill in using such resources showed up quickly in sound effects that were both far more numerous and more pointed than before, attributes increasingly valuable as aggressively comic cartoons became more important in the Schlesinger scheme of things and musical cartoons like Freleng's Merrie Melodies less so.

The Schlesinger soundtracks—inconsequential a few years before—had suddenly, by mid-1937, become one of the studio's greatest assets, and a challenge to the directors. Blanc's voice in particular seemed to demand stronger visual caricatures to match the vocal caricatures he provided, and Stalling's music was supple enough to keep up with action far more rapid and complex than what the Schlesinger directors typically put on the screen.

When Tex Avery directed a cartoon called *Miss Glory*, released in March 1936, he was the first director besides Friz Freleng to make a Merrie Melodie in almost two years. The number of Schlesinger cartoons was growing, from twenty-six in the 1935–36 season to thirty-four in the 1936–37 season, and although Freleng continued to direct most of the Merrie Melodies, he needed help. For the next year and a half, Avery directed about one Merrie Melodie in three, while Freleng handled the rest.

Avery was starting to show in his Looney Tunes that he did not want to charm and delight his audiences (as the Silly Symphonies did), but to make them laugh. It was difficult to reconcile that aim with what audiences had come to expect from musical cartoons, and Avery did not speak fondly of his early Merrie Melodies: "We were forced to use a song, which would just ruin the cartoon. You'd try like a fool to get funny [during the song], but it was seldom you did."[42]

Early in 1937, when Schlesinger needed still more cartoons to fill out his expanding release schedule, he hired Ub Iwerks to make Looney Tunes at his Beverly Hills studio. Pat Powers had withdrawn from film production the year before, and Iwerks's Comicolor series had consequently ended; he was now making cartoons for Columbia as well as Schlesinger. Avery, second in seniority to Freleng among the Schlesinger directors, would now, like Freleng, direct only the more prestigious Merrie Melodies.

Even though Avery was being promoted, he was also being robbed of his two strongest animators—Bob Clampett and Chuck Jones were sent to work with Iwerks—and deprived of the platform, his Looney Tunes, from which he had best been able to express his ideas about animated comedy. (*Porky's Duck Hunt* was his next-to-last Looney Tune before he began devoting himself to Merrie Melodies.) Avery responded by turning the Merrie Melodies themselves into a more congenial environment.

He had started work on *Uncle Tom's Bungalow* by January 1937, shortly before Jones and Clampett left for the Iwerks studio.[43] Until Avery made *Uncle Tom's Bungalow*, almost every Merrie Melodie had borne the title of its featured song or some slight variation on it. *Uncle Tom's Bungalow* not only broke with that practice, it had no featured song at all. The songs' role had been eroding for some time—even in Freleng's Merrie Melodies, the number of complete choruses had shrunk from two to one, and some of Avery's Merrie Melodies had only a partial chorus. "Finally," Avery said, "when Schlesinger let us get by [without using the songs], the cartoons started picking up."[44]

Uncle Tom's Bungalow burlesqued *Uncle Tom's Cabin*, and in that respect, too, it differed sharply from the musical fantasies that had been the norm. Avery had first flirted with parody in one of his Looney Tunes, *The Village Smithy*, which opens with a recitation of the Longfellow poem; as the testy narrator mentions the chestnut tree and the smith, they plop into place from out of the sky. The cartoon diverges from parody after its opening minutes, but Avery must have awakened to the possibilities. Parody and

burlesque could give him the leverage he needed; impossible things could win audience acceptance most easily when they were not just gags in themselves, but also instruments of ridicule. In *Uncle Tom's Bungalow*, when Simon Legree twists and curls across a floor as if he were a snake, he does nothing more than what an earlier Avery villain, Mr. Miser in *Milk and Money*, had done in a Looney Tune less than a year before. But the comedy is stronger because Legree is the snake. When Legree looms over Uncle Tom with a whip, it produces its "crack" by snapping fingers at its tip.

Friz Freleng made *Clean Pastures* about the same time as *Uncle Tom's Bungalow*, and Avery may well have been inspired by Freleng's example.[45] *Clean Pastures'* title, like *Uncle Tom's*, proclaims it a burlesque of a serious work whose leading characters are black. The two cartoons were scheduled for release within a few weeks of each other in May 1937, with *Clean Pastures* to appear first, but *Clean Pastures'* release was held up until October. It was one of the few cartoons to run afoul of the Production Code. The Code required rejection of any film that was a burlesque of religion, and the Code's administrator, Joseph I. Breen, condemned *Clean Pastures* as exactly that. In a letter to Leon Schlesinger, Breen cited the portions of the film set in an ersatz Heaven called Pair-o-Dice, and said, "I am certain that such scenes would give serious offense to many people in all parts of the world."[46] Ultimately, however, Breen let *Clean Pastures* pass with only a couple of minor changes in the soundtrack.[47]

Possibly *Clean Pastures* could have been blasphemous if it had really burlesqued *The Green Pastures* with any point, especially since the Marc Connelly play and the 1936 Warner Bros. feature based on it flirted with burlesque themselves. But *Clean Pastures* parodies *Green Pastures* only in the most general terms, by populating a version of paradise with black characters. (Freleng's cartoon leans heavily on caricatures of four famous black musicians—Louis Armstrong, Duke Ellington, Cab Calloway, and Fats Waller—who are sent from Pair-o-Dice to Harlem to lure the residents from their sinful ways.) Freleng did not have Avery's consuming interest in impossible things, and so parody was not liberating for him, as it was for Avery.

After making *Uncle Tom's Bungalow*, Avery made a few more Merrie Melodies of the conventional kind, and as the Merrie Melodie framework loosened, he made some cartoons that were very much like Looney Tunes, only in color. But the lure of bur-

lesques was strong, and he parodied, first, fairy tales, in *Little Red Walking Hood* (1937), and, then, travelogues, in *The Isle of Pingo Pongo* (1938). In Avery's travelogue, the impossible things could not work against a serious story, as they had in *Uncle Tom's Bungalow* and *Little Red Walking Hood*, but only against a far less substantial target, the live-action travelogues that often accompanied cartoons on theater programs. *Pingo Pongo* thus splinters into a series of self-contained blackout gags, tied to a cruise ship's trip from New York to the island. The Statue of Liberty acts as a traffic cop; the ship sails past visual puns labeled "Canary Islands" and "Sandwich Islands"; an Eskimo and a polar bear tell the surprised narrator that they are visiting the South Seas on vacation; a Ubangi's distended lower lip serves as a plate at the "Dark Brown Derby" restaurant. *Pingo Pongo* resembles nothing so much as a slicker version, in color, of the Fleischer studio's Screen Songs as they had evolved by the midthirties; they also hung blackout gags on thin premises (but, in addition, had to surrender half their length to a live-action singer).

Pingo Pongo held no trace of what had been so distinctive and daring in a few of Avery's Looney Tunes—the relentless working out of a foolish idea—and in it, he reduced the burlesque format to nothing more than a convenient frame for his gags. Avery was thus taking fewer risks. But he had found a way to win laughs easily, and laughs were, of course, what he wanted most of all.

Ub Iwerks directed two Looney Tunes for Leon Schlesinger in 1937, both of them hybrids: Iwerks worked from storyboards prepared at the Schlesinger studio, and Clampett and Jones, the two Schlesinger animators, helped the finished cartoons look more like the usual Schlesinger product. After those first two cartoons, a few more Schlesinger cartoons were made at the Iwerks studio, but Iwerks himself was not present. Clampett came to work one Monday morning to find, he said, that he had inherited the director's chair. Clampett received screen credit for directing *Porky's Badtime Story*, the third Schlesinger cartoon made at the Iwerks studio; according to Clampett, its story, too, came from the main Schlesinger plant, and Iwerks had begun drawing layouts before he left. Starting with the next cartoon, *Get Rich Quick Porky*, Clampett and his colleagues wrote their own stories.

Clampett's promotion was announced in May 1937.[48] A month

or so later, his unit moved back to the Warner Bros. lot on Sunset Boulevard, where it occupied the first floor of the building that had housed the entire cartoon studio in 1933. The unit was not only physically separate from the rest of the Schlesinger studio, but it was also run as a separate company, with Ray Katz, Schlesinger's brother-in-law, at its head.[49] Katz occupied an ill-defined position as an assistant to Schlesinger, and giving him his own studio was essentially a bookkeeping device, a way to cut him in on the profits.[50] There was by no means a hard and fast line between the two studios; Katz used Schlesinger's musician, Carl Stalling, and other members of the Schlesinger staff. The Katz studio made nothing but Looney Tunes, which Katz sold to Schlesinger for resale to Warner Bros.

Clampett and Jones had worked their way up the Schlesinger studio's ladder pretty much in tandem for four years. Clampett received his first screen credit as an animator on Bernard Brown's *Pettin' in the Park* in January 1934; Jones's first credit came eight months later, on Freleng's *The Miller's Daughter*. Over the next three years, Clampett probably continued to stay a step or two ahead of Jones as an animator, although Jones has always been acknowledged the superior draftsman. The two men were good friends in the midthirties, although Clampett enjoyed what Phil Monroe described as a considerable edge in personal charm. Clampett, he said, "was tall and straight and always had that shock of black hair, and he'd come up and grin and shake your hand and look you straight in the eye and give you all of his attention. Chuck would never do that."[51] Clampett was also visibly more ambitious than Jones; he left the studio briefly in August 1936 to develop a projected series of cartoons based on Edgar Rice Burroughs's Mars novels, and he was lured back only by what he said was Schlesinger's promise to make him a director, a promise realized when Iwerks departed.[52]

Clampett was at the beginning not fully in control of the cartoons that bore his name. He said that he felt "conservative" directing the first few because he was uncertain about his crew, a mixture of Schlesinger and Iwerks people.[53] Perhaps for that reason, Chuck Jones filled the gap. Jones even claimed that he and Clampett were sent to the Iwerks studio as a team—as equals—and after Iwerks's departure worked as codirectors, although Jones received screen credit only as an animator.[54] Some of the animators who worked with Clampett and Jones at the Iwerks studio did, in fact, speak of them as codirectors.[55] Clampett

emphatically rejected Jones's account, but he was heavily dependent on Jones at the start. For example, *Get Rich Quick Porky*, the second Clampett cartoon, includes two long scenes—one lasts more than a minute—in which Jones's animation of a slow-witted hound echoes Norman Ferguson's animation of Pluto in the Disney cartoons. Jones's scenes dominate the whole cartoon through the superiority of his draftsmanship and the strength of his feeling for animation in the Disney vein.

Jones left the Clampett unit a little over a year after he and Clampett were sent to the Iwerks studio. Near the end of his time with Clampett, Jones's hand was still shaping that unit's cartoons, but only by setting their drawing style (he always drew the character layouts). The hound in *Porky's Party*, released in June 1938, looks much like the hound in *Get Rich Quick Porky*, released ten months earlier, but the atmosphere of the later cartoon is radically different. Jones's sensibility has been displaced by a sensibility far more eccentric.

In *Get Rich Quick Porky*, Jones's hound, like Ferguson's Pluto, struggles to think his way through a situation that is a little too complex for his dull brain to master. In *Porky's Party*, the characters seem not to think at all. A penguin enters Porky's house, shoves a birthday present into the host's hands, and immediately starts wolfing down ice cream; a foolish-looking goose with a rubbery neck shakes Porky's hand with what turns out to be a false hand with a sign attached: "Happy birthday, fat boy." Moreover, these ridiculous creatures find themselves in situations where thought not only seems impossible, but would no doubt be a hindrance if it *were* possible. Whereas *Get Rich Quick Porky* tells a generally sensible story about a confidence man who sells Porky and his sidekick Gabby Goat a phony oil well, *Porky's Party* offers a chaotic birthday party: a silkworm gets loose in the ice cream, and the guests find themselves eating women's undergarments along with the tutti-frutti. The chaos descends to the submolecular level thanks to Porky's hound—here named, ridiculously and thus appropriately, Black Fury (the title of a 1935 Warner Bros. feature starring Paul Muni); the dog drinks an almost wholly alcoholic hair restorer, grows long hair, puts shaving cream on his face, and as a "mad dog" throws the party into a panic.

By the time Jones left, Clampett had become very much the lord of his unit's cartoons, but he was in some ways the lord of a dustpile. "When we were doing the black-and-whites, we felt very much the poor relative," Clampett said. "When one of our

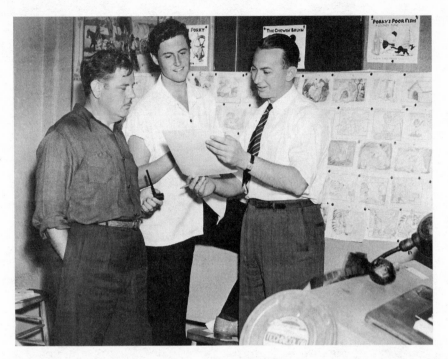

Bob Clampett (center), as a director of black-and-white Looney Tunes, with writers Melvin "Tubby" Millar (left) and Warren Foster, in a 1940 photo. The storyboard behind them is for Prehistoric Porky (1940). Courtesy of Bob Clampett.

black-and-whites would come over [for a screening at the main building], we always felt that the people in the studio looked down their nose at them, and sat on their hands."[56] There was a rapid falling off in the draftsmanship of Clampett's cartoons after Jones left, and the weaker drawings magnified the ways in which Clampett's own technique fell short of what had come to be expected in Hollywood cartoons—he often seemed indifferent to how well scenes matched and to the rules of perspective.

Daffy Duck turned up occasionally in Clampett's cartoons, after Gabby Goat vanished, but on management's orders, Porky Pig had to be used in every Looney Tune. Since his first appearances in Avery's cartoons, Porky had never been presented as much more than a cheerful, rather naive little boy, and he did not become a stronger character in Clampett's hands. The characters that did flicker to life in Clampett's Looney Tunes inhabited their fringes for the most part. Pinky, the title character in *Porky's Naughty Nephew* (1938), is not just a disconcerting blend of the

adorable and the vicious: he knows that's what he is, and he enjoys it.

Life on the bottom rung did have its compensations. As John Carey, one of Clampett's animators, pointed out, if an animator worked on the Looney Tunes, that meant he probably was not as good as the animators on the Merrie Melodies, but it also meant that "you didn't have to *be* as good, either."[57] Clampett himself remembered that when he went to work at Harman-Ising in 1931, he was surprised to find that so many members of the staff were "the newspaper cartoonist type.... They do it all in drawing, and when they go to talk about it, there's not much feeling for it, or love or excitement."[58] That sense of being dutifully humorous dominates many Schlesinger cartoons of the late thirties, Freleng's especially, but Avery's better cartoons are exceptions ("That was a wonderful experience, working with Tex, because he was the complete opposite," Clampett said), and so are many of Clampett's Looney Tunes. In them, the director is plainly having a good time and not just trying to anticipate what the audience will think is funny.

Robert Emerson Clampett was a very young man when he directed those cartoons—he turned twenty-four on 8 May 1937, around the time he took Iwerks's place. He got Katz to hire a high-school friend, Ernest "Flash" Gee, to help him come up with gags. "Ernie wasn't really a writer, he wasn't a guy who could sit down and consciously think up a story, or even hardly gags," Clampett said, "but when you'd talk to him, it came fast.... We'd go off at night, maybe go to some place where they had night Ping-Pong, and play a few games of Ping-Pong and keep talking story."[59] Gee worked only a few months in Clampett's unit (as Clampett explained: "His dad, who was a plasterer, a very practical guy, thought, 'This is a way to make a living?'"), but even so, the comedy in Clampett's black-and-white cartoons was always the kind of stuff that a couple of high-school chums might have come up with over a Ping-Pong table. When in *Kristopher Kolumbus Jr.* (1939) Porky gets "directions from the stars," he sees an arrow made up of stars, pointing toward the New World. In *Pilgrim Porky* (1940), a reference to "whitecaps" leads to a shot of the ocean with "white caps"—the cloth kind, with neat little bills—on the waves. When Clampett edged into burlesque occasionally, as in *The Lone Stranger and Porky* (1939), there was rarely any sense that he was poking fun at his source material. He borrowed heavily from radio, vaudeville, and movies, but he was more likely to use a

radio catch phrase as a crutch—a substitute for a real joke—than to suggest any criticism.

For all the ingenuousness of their gags, many of Clampett's Looney Tunes are surprisingly odd and unsettling, for reasons that have nothing to do with the gags as such but may have something to do with Clampett's own early years. His parents separated when he was small; an only child, he was raised by his mother and grandmother in Glendale, just north of Los Angeles, sometimes in near poverty.[60] Richard Thomas, a classmate at Herbert Hoover High School in Glendale, remembered Clampett as a "very shy" boy who ate his sack lunch in some out-of-the-way place to avoid the other students.[61] Clampett left high school early in 1931, lacking a few credits to graduate, so he could start work at Harman-Ising.[62] At that studio, his colleagues regarded Clampett as a mother's boy; he actually fainted if the language got salty or a picture of a naked woman was shoved in his face.[63]

By the midthirties, Clampett still fainted occasionally, but during his first few years at the Schlesinger studio he shed his most obvious inhibitions and became the self-assured young charmer described by Phil Monroe. When Dick Thomas went to work for Ray Katz as a background painter in 1937, he found a Clampett who no longer seemed to be the shy loner Thomas had known in high school.[64] Many years later, Clampett explained his fainting spells in terms broader than his embarrassment in the face of sex: "I was very, very imaginative at that time, and my senses were much more alive than they are now. I saw everything really clear, and I heard things clear, and I felt things.... So I, from time to time, would faint."[65]

What is most arresting in many of Clampett's black-and-white cartoons is not their schoolboy comedy but their crazy, restless energy—the sort of energy that might be expected to show itself in the work of a "very, very imaginative" director who was working himself free of severe emotional restraints. Usually this energy revealed itself in small ways: in characters who were a little more excitable than was really necessary, in spasms of frenetic movement, and sometimes in an obsessively intense scrutiny of physical details. Occasionally, though, Clampett pushed well past the boundaries of what was feasible in his Looney Tunes, given the limitations of his animators.

In *Porky in Egypt* (1938), a camel succumbs to the heat and sobs and shrieks violently, as if he were some character out of *The Lost Patrol*, "It's the desert madness!" In *Porky's Tire Trouble* (1939), Porky's dog, Flat Foot Flookey, falls into a vat of rubberizing liq-

uid and his body becomes as stretchy as Silly Putty. As Flookey absentmindedly walks up a board propped at an angle, he doesn't notice that only his left legs are on the board—his right legs are stretching several feet to the ground below. In such scenes, Clampett in effect asked his animators to go some distance beyond the animation he had done for *Porky's Duck Hunt* shortly before he became a director. (It was Clampett who animated Daffy as he bounced wildly across the lake, whooping like a maniac. Chuck Jones, who was also animating for Avery then, remarked in 1976 that "if Clampett had been able to move that way, he would have moved that way himself.")[66] Clampett's animators were, however, still struggling to produce reasonable facsimiles of human and animal movement; they could not exaggerate movement even as well as Clampett had, years earlier.

In both *Porky's Tire Trouble* and *Porky in Egypt*, the idea behind the action (and, in *Porky in Egypt*, the urgency in Mel Blanc's voice for the camel) demanded far more fluid and vigorous animation than what is on the screen. Norm McCabe, probably Clampett's best animator after Jones left, said of his director: "He always liked to force things—go a little farther, a little farther— and I probably didn't go as far in that direction as he would have liked. A lot of the guys had the same problem."[67] The animation in Clampett's cartoons could support only comedy based on how something looked, not on how it moved. "Since we couldn't depend on animation," Clampett said, "we were depending upon surefire gags; like the sign gags, or something blowing up and coming down as something else...was always a tremendous laugh."[68]

John Carey said that as Clampett made rough sketches to show what he wanted in a scene, "he'd practically animate the whole scene sometimes," and so enthusiastically did Clampett act out what the characters were supposed to be doing that "it was just like seeing a floor show, going in and picking up a scene." Clampett, Carey said, took his animators through the entire storyboard "at the slightest provocation."[69] That energy could not be incarnated satisfactorily in the characters and the gags and, above all, the animation that Clampett had at his disposal.

Most of the cartoons that Tex Avery made between 1938 and 1941 were burlesques of some kind. After *The Isle of Pingo Pongo* in 1938, he made a dozen or so parodies of documentaries, travel-

ogues, and the like. Most of those cartoons were, like *Pingo Pongo*, simply collections of blackout gags, some of them with a tenuous relationship to the ostensible subject of the burlesque; others, like *Believe It or Else* (1939), which ridiculed the live-action shorts based on the newspaper feature "Believe It or Not," were a little more sharply focused. A few Avery cartoons had a semblance of a story line. He burlesqued American history in *Johnny Smith and Poker-huntas* (1938) and gangster movies in *Thugs With Dirty Mugs* (1939). He followed his first fairy-tale burlesque, *Little Red Walking Hood*, with two more, *Cinderella Meets Fella* (1938) and *The Bear's Tale* (1940). It was in burlesques of the latter kind that Avery most obviously declared his independence from the Disney cartoons.

In *Little Red Walking Hood*, for example, the wolf is chasing Red Riding Hood's Grandma around the house when the phone rings. She cries "King's X" and talks to the grocer on the phone, concluding her order with "a case of gin." Later on, when the wolf is in bed impersonating Grandma, he and Red Riding Hood go through the usual routine—what big eyes you have, and so on—but Red Riding Hood pauses at one point to remark to the audience (in a reasonable facsimile of Katharine Hepburn's voice) on how childish it all is. Finally, the wolf has cornered Red Riding Hood and they are struggling, but then they stop and scowl disapprovingly as two silhouettes pass across the screen—the shadows of latecomers, taking their seats.

Avery used the shadow idea again and again, searching for all its comic possibilities. In *Cinderella Meets Fella,* the Prince arrives at Cinderella's house only to find a note saying that she got tired of waiting and went to a movie—the one the Prince is in. Her shadow appears on the screen as she calls to the Prince from the audience; she joins the Prince on the screen, and then they both go into the audience to watch the newsreel.

In *Thugs With Dirty Mugs*, the boundary between cartoon reality and "real" reality is even harder to define. This time the villain, Killer Diller, is plotting a burglary with his confederates when a theatergoer's shadow appears on the screen. "Hey, bud, you in the audience—where do you think you're going?" Killer Diller demands. "Well, Mr. Killer," the unfortunate patron replies in a tremulous voice, "this is where I came in." Killer will have none of that: "You sit right back down there till this thing's over, see?" And to the audience: "You know that mug's trying to sneak out of the theater, to squeal to the cops." Unfortunately for Killer

Diller, the police chief is in the next scene, and as he wonders aloud where Killer Diller will strike next, the theatergoer's shadow appears on the screen again: "I know, Captain. I sat through this picture twice, and the Killer's going to be at Mrs. Lotta Jewels's at ten o'clock tonight."

Avery never tried to create an illusion of reality along Disney lines, or even to create an alternative reality where completely different rules applied. Neither was there ever any sense, in Avery's cartoons of the late thirties, that he was pressing against the limitations of the animation in his cartoons, as Clampett did. Instead, Avery seemed content to live within those limitations, and his cartoons were not very well drawn or animated even by the relaxed standards prevailing at Schlesinger's then.

For Avery's purposes, the quality of the animation was close to irrelevant. If a good animator enhanced a gag, so much the better, but Avery could bring no expertise to that side of his films—he had been taught to animate by Bill Nolan in what by the late thirties was considered a hopelessly old-fashioned style. Chuck Jones recalled that "Tex, when I animated for him, very seldom went very deeply into [the animation of a scene].... He'd give you a couple of drawings and then describe the action the way he wanted it. You had to go by his actions...but he was perfectly willing to have you go a little nuttier than that."[70] Avery was interested not in animation as such, but only in his gags and how he could use his director's tools—pacing, timing, staging—to make them work. It was probably in gag sessions with the story men that Avery was most in his element. David Monahan, a Schlesinger writer in the late thirties, described Avery as "the kind of guy you get in a session and just start cooking and he really comes alive."[71] (Avery retained his enthusiasm, too, for coarse practical jokes of the kind that were so common at Universal. There was a junior high school across the street from the Schlesinger studio, and Avery once recalled how some of the Schlesinger employees gathered pennies and dropped them out a window onto the sidewalk when the children were going home from school—after first heating one of the pennies. As Avery said, "You knew which one got the hot one.")[72]

By the end of the decade, something had started to go wrong. *Hamateur Night* (1939) brims over with hyperbolic gags that probably excited lots of laughter in a session of the kind Monahan described. At the start, a conductor calls the members of his orchestra to order with a rap of his baton, but then *they* begin

conducting *him*, each man with his own baton, as their leader turns out to be a one-man band. The lineup of amateurs includes the world's smallest entertainer, "Teeny Tiny Teentsy Tinny Tinny Tin," a female flea with enormous liquid eyes who recites "Mary Had a Little Lamb." Gonged, she plunges through a trap door, falling for a very long time before she lands with a very loud offscreen crash. All of these gags are, however, clothed in very dull and literal animation that is not simply beside the point, like the animation in many of Avery's earlier films, but actually muffles the comedy.

In his strongest Looney Tunes, like *Porky the Wrestler* and *Porky's Duck Hunt*, Avery rode over weaknesses in drawing and animation through his own intensity, but that was harder to do in cartoons cobbled together from blackout gags. Moreover, the animation in his cartoons of the late thirties reflected—dimly at first, but with increasing force as the decade ended—the great advances in character animation that the Disney studio had made: more and more, the Avery characters moved realistically, in a very general sense, even though Avery was using those characters in gags that cried out for a more stylized kind of animation. His gag timing slowed, as though more natural-looking animation compelled him to step back from the faster timing he had introduced in his black-and-white cartoons.

Instead of using the animation in his cartoons to support his gags, Avery had largely ignored it. In the late thirties, it started to sneak up on him. By 1940, it was ready to pounce.

When Chuck Jones left the Clampett unit in March 1938,[73] it was to become a director: he replaced Frank Tashlin, who had quit after a quarrel with Henry Binder, Schlesinger's chief assistant.[74] Jones stepped from second in command in a unit that made nothing but black-and-white cartoons to head of a unit that made nothing but Merrie Melodies, the more prestigious color cartoons. (The Tashlin unit had made its last Looney Tune a few months before Jones took charge.) Jones became a director almost exactly five years after he joined the Schlesinger staff.[75] He was another of the Schlesinger studio's very young directors: Warners released his first cartoon, *The Night Watchman*, in November 1938, two months after his twenty-sixth birthday.

Charles Martin Jones was born in Spokane, Washington, on 21

September 1912, the third of four children. His parents had moved to Spokane a few months before he was born, and they moved to southern California soon after that. His father was, Jones told magazine interviewers, "a frustrated gallant with Micawberish business instincts"[76] who "kept trying to start new businesses, buying new letterhead stationery, and every time the business failed, we children inherited a new legacy—ample drawing material."[77]

In 1929, Jones set himself apart from most of his future colleagues at the Schlesinger studio by seeking formal training in art. He enrolled as a scholarship student at the Chouinard School of Art; for a year or so, he worked at the school as a janitor in the morning, attended classes in the afternoon, and worked as a commercial artist in the evening. He entered animation as a cel painter and inker at the Iwerks studio, early in 1930. For the next couple of years he moved in and out of animation, working as an inbetweener at Universal, Mintz, and Iwerks before traveling to Mexico as a merchant seaman on a yacht (a career that ended when the ship caught fire at the tip of Baja California). According to the *Exposure Sheet*, the Schlesinger studio's employee newsletter, he spent the next year or so on Olvera Street, in the old Mexican district of Los Angeles, "doing portraits, caricatures, owning part interest in a book shop, and designing puppets" before going to work for the new Schlesinger studio as an inbetweener.[78]

In the Depression thirties, plenty of trained artists decided to work on cartoons rather than starve to death, but most of them gravitated to Disney's or Harman-Ising, the studios where schooling in the fine arts was most likely to be put to use. In the late thirties, when Jones began directing, not only had the typical Schlesinger employee come to his job equipped with little formal training in art, but he was unsophisticated in most other ways as well. Here is how the *Exposure Sheet* described him, in a piece that is tongue-in-cheek in tone but deadly accurate:

> [The typical Schlesinger employee] graduated from a local high school where he did a few desultory cartoons for the weekly, and was president of the Art Club in his Senior year—his lone achievements in four years.... After graduation he worked in a gas station for a year, then as a show-card writer until a friend got him a job at Universal as an opaquer, where he stayed until he came here....
>
> He...thinks Norman Rockwell and [J. C.] Leyendecker are

"tops."...Off-hand, Rembrandt is the only "old master" he can name, and he thinks Michaelangelo [sic] is two words. He has no use for Picasso, Van Gogh, Renoir, or any of those "futuristic guys."

He thinks Disney cartoons are terrific even when they're not.... He is positive he could do "just as good animation if I could spend the time those guys do on retakes."... Once or twice a year, in order to appease his stunted conscience, he goes to a high school night class. He...spends forty-five minutes getting settled, twenty-two minutes on a half-hearted sketch and an hour and thirty-three minutes drawing animation characters around the edge of the paper so the other (ha-ha) art-students will know he works in a cartoon studio.[79]

Jones came into the Schlesinger studio from a more stimulating environment than the one the typical Schlesinger employee had enjoyed. "Fortunately for me," he said, "I had a father who devoured an enormous quantity of books. So I read everything that fell into my hands: Aesop, Balzac, La Fontaine, Peter Rabbit, Mark Twain, Dickens, the dictionary, O. Henry, anything."[80] The young Jones, as glimpsed in the memories of people who knew him in the early thirties, seems to have thought himself destined for a milieu more colorful, intellectually active, and sophisticated than the places where he was employed. When he first worked at the Schlesinger studio in 1933, assisting Paul Fennell,[81] he was "constantly talking" about the University of California campus at Berkeley, Fennell said. "He was too young to have gone through Cal, but he acted like a fraternity brother and a college boy."[82]

When Jones was still living at home while working at the Iwerks studio, his mother rented a room to Jim Pabian, then an Iwerks inbetweener. Pabian, whose history was not too different from that of the *Exposure Sheet*'s typical Schlesinger employee, remembered that the Joneses were kind to him but that the atmosphere was, compared with what he had known, rarefied: "I always felt a little lost among them because they would talk of things, and had read things, that I hadn't."[83] Jones's parents were living apart then, and the four Jones children went once a week to the home of their father, a severely Teutonic-looking man with a crewcut.[84] Pabian was brought along to take part in what he remembered as "high-level conversation. The father would keep harping on Chuck: 'You're too goddamned good to be in the cartoon business.' "

At that time, Jones may well have agreed, as evidenced by his

drifting in and out of jobs in animation studios; Jones was not serious about animation when Pabian first knew him, Pabian said, but "he grew into it." Jones began directing with every reason to believe that he was more advanced, intellectually and artistically, than most of his fellows. Such a sense of superiority, coupled with his skill as an animator, fitted Jones not just to be a director, but also to be the first Schlesinger director to enter serious competition with the Disney cartoons.

After Jones began directing in 1938, the first few of his Merrie Melodies bore a passing resemblance to Clampett's Looney Tunes; it was, after all, Jones's drawing style that dominated in the first year of Clampett's cartoons. That lingering resemblance to the Clampett cartoons disappeared rapidly, though, as Jones matured as a draftsman and shed a vestigial crudeness in his drawing style. He approached his character layout drawings in a spirit entirely different from Avery's: to guide his animators toward realistic movement of the Disney kind, he made hundreds of drawings for each of his early pictures. "In a way I overdid it," Jones said, "because what I was really doing was semianimating, instead of finding and clarifying the poses...the drawing that keyed the scene, the key to a particular action. It's a lot different than drawing a bunch of extremes."[85]

Jones's cartoons paid homage to Disney not just in their painstaking drawing and animation, and in a prevailing gentleness and cuteness, but often in particulars as well. By the time Jones began directing, continuing characters had been admitted to the Merrie Melodies; as he created a repertory company, most of its members had obvious Disney roots. Sniffles, a mouse who starred in several cartoons each year, had the personality of a charming, sweet-tempered child, and he resembled the mice in *The Country Cousin* (1936). After Jiminy Cricket appeared in *Pinocchio*, Jones used similarly endearing insects in four of his cartoons. Conrad, a lanky cat who appeared in three cartoons, owed much not just to the comedian Ben Blue, but also to Goofy.

In some cartoons, Jones even used relatively lush effects like those that had become commonplace in the Disney cartoons. In *Good Night Elmer* (1940), for instance, Elmer Fudd tries to extinguish a candle that insists on staying lit, and the cartoon brims over with rising and falling light, and with elaborate modeling of Elmer himself. Schlesinger's payment for each Merrie Melodie had risen to $12,750 by 1938 (an increase of more than $5,000 in four years),[86] and with the Depression lingering and salaries

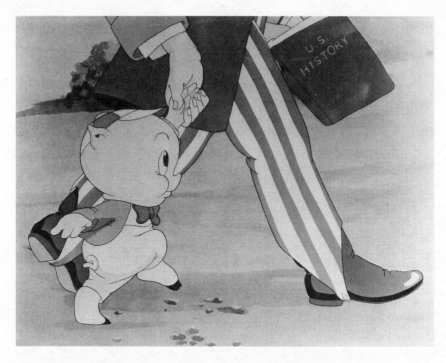

From Chuck Jones's Old Glory (1939), with Porky Pig and Uncle Sam, made when Jones's cartoons, and the Schlesinger cartoons generally, were most under Disney's influence. © *Warner Bros.; courtesy of Jerry Beck.*

unaffected by any union demands, he could put money into the cartoons in a way that showed on the screen.

The Jones cartoons' resemblance to the Disney cartoons reached a peak in *Tom Thumb in Trouble*, released in June 1940, about two years after Jones started directing. The tiny title character is as cute as any Disney creature could hope to be, the story is as earnest as any Disney fairy tale, and one of the principal characters—Tom's father, a human of normal size—is so realistically animated that he appears to have been rotoscoped, like *Snow White*'s Prince. Almost a year earlier, Jones had directed *Old Glory* (1939), a patriotic cartoon starring Porky Pig; in it, too, a human character—Uncle Sam—is animated so realistically that one's first reaction is that surely an actor was filmed in the role and that film traced by the animators. But such was not the case. According to Jones, Bob McKimson animated both characters without the aid of live-action film: "If you laid it out for him and told him what you wanted, he could do a hell of a job."[87]

McKimson was animating for Frank Tashlin when Jones took charge of the Tashlin unit, and he remained with Jones until 1940.

Old Glory and *Tom Thumb in Trouble* were rarities among the Schlesinger cartoons in that they were virtually gag free; in *Old Glory*, Uncle Sam delivers a potted history of the United States, and in *Tom Thumb*, Tom almost drowns in his father's dishwater. It was in these cartoons and a few others that Jones most emphatically cast his lot with Disney, but in Jones's explicitly comic cartoons, too, he modeled himself on Disney more than Avery. For example, his second cartoon, *Dog Gone Modern* (1939)—in which two dogs run afoul of an automated "House of Tomorrow"—owes a great deal not only to a 1937 Donald Duck cartoon, *Modern Inventions*, but also to all the other Disney cartoons, starting with *Playful Pluto* and its flypaper sequence, in which the characters reveal their personalities through struggles with recalcitrant props.

Despite the care that he lavished on his cartoons, and even though he was so different in other ways from the *Exposure Sheet*'s "typical Schlesinger employee," Jones could with justice echo that prototypical employee's complaint that "he could do 'just as good animation if I could spend the time those guys do on retakes.'" Bound as they were to the Schlesinger schedules, there was no time for Jones and his animators to nourish and build their characters into more than simulacrums of Disney characters. However strongly Conrad the cat, wrestling a palm tree in *The Bird Came C.O.D.* (1942), recalls Goofy in *Moving Day*, Conrad still has only mannerisms (he rubs his nose a lot and grins foolishly), and not a personality. Jones's cartoons were at once the most polished and the weakest of the Schlesinger cartoons. They invited comparisons with Disney, but no one who paid attention could ever think that Disney had made them.

Continuing characters slipped into the Merrie Melodies just a few months before Jones became a director. Tex Avery introduced Daffy Duck in his next-to-last Looney Tune, *Porky's Duck Hunt*, and under the old rules, he could not have used that character again once he was making only Merrie Melodies. But he did anyway, in *Daffy Duck & Egghead* (1938), the first cartoon in which Daffy was identified by name. The character Egghead, a

big-nosed simpleton, was also making his second appearance—
Avery had introduced him a few months earlier in a Merrie
Melodie called *Egghead Rides Again* (1937)—so *Daffy Duck &
Egghead* was a double blow against the idea of the Merrie
Melodies' being off limits to continuing characters. By the late
thirties, though, Leon Schlesinger had grown much more relaxed
about such departures from precedent.

Schlesinger emerges in many recollections from the thirties as
a slightly ridiculous figure. He "would come around personally
and hand you his checks on payday," Nelson Demorest said, in a
typical reminiscence. "He loved to hear you say thanks. He was
portly, always immaculately dressed with a carnation, an aroma
of perfume, and spats."[88] But once he had assembled a group of
directors—Freleng, Avery, Tashlin, Clampett—who gave him car-
toons much stronger than what he had gotten from the likes of
Palmer, Duvall, and King, he gave them much more leeway than
the earlier directors had enjoyed. Avery found such evidence of
his boss's confidence warming. "Schlesinger laughed at every-
thing," he said. "He was the best boss I guess I ever had in the ani-
mation business.... I could sell him anything I wanted to do."[89]

Avery's *Little Red Walking Hood* was released in November
1937, about two months before *Daffy Duck & Egghead*, and its cast
includes a little man who resembles Egghead and could even be
considered another version of the character, except that Avery
made *Little Red Walking Hood* between his two cartoons with the
"real" Egghead. The little man in *Red Walking Hood* has a big red
nose, squinty eyes, a derby, and a high collar, and he strolls
through the cartoon repeatedly, carrying a violin case, until final-
ly the exasperated wolf asks him who he is. Speaking in a goofy
voice, the little man replies, "Who, me?" and bashes the wolf with
the big mallet he has taken from the case. "I'm the hero in this
picture!"

Avery used the same character in *The Isle of Pingo Pongo* and
Cinderella Meets Fella (the publicity for the latter film identified
him as "Egghead's brother"),[90] but it was not until his fourth film,
A Feud There Was (1938), that he got a name. He intervenes in a
hillbilly feud, riding a motor scooter and carrying a briefcase
labeled "Elmer Fudd—Peacemaker." There was little to connect
the Elmer in one of Avery's cartoons with the Elmer in another.
He simply helped hold each cartoon together, usually by taking
part in some running gag. Like most of the characters Avery used,
Elmer could be anything his creator wanted him to be because he
wasn't much of anything to begin with.

In 1940, Elmer first appeared in cartoons directed by Chuck Jones and Friz Freleng. His nose shrank and his eyes opened, and his voice acquired an impediment, so that "r" and "l" emerged as "w." That voice was provided by Arthur Q. Bryan, who was, like Mel Blanc, an experienced radio performer (his best-known role was as Doctor Gamble on the *Fibber McGee and Molly* show), and it gave Elmer a distinctive personality at last. It was not a particularly attractive personality—Elmer was a foolish weakling—but it was far more specific than before. The new Elmer starred in the first two cartoons that Friz Freleng directed after returning to the Schlesinger studio from MGM in April 1939, but Jones directed the most significant of the cartoons with the new version of the character; it was also the first to be released, in March 1940. Called *Elmer's Candid Camera*, it was the first cartoon to pair Elmer with a rabbit.

Like Elmer, this rabbit had undergone a metamorphosis over the preceding few years. The direct line of his evolution led back to a Looney Tune, *Porky's Hare Hunt*, which was released in April 1938. *Porky's Hare Hunt* owed a lot to *Porky's Duck Hunt*, which had been released just a year earlier. Bob Clampett said that when a story was needed in a hurry, he took some gags left over from *Duck Hunt*, reworked them with a rabbit in place of a duck, and submitted the gags to Leon Schlesinger, who in turn gave them to Ben Hardaway, who was going to direct the cartoon.[91]

Hardaway, whose nickname was "Bugs," was another of the Kansas Citians who dominated the Hollywood cartoon studios in the thirties. Like Walt Disney, he worked for Kansas City Film Ad—first in Kansas City, and then as a branch manager in Milwaukee—before moving west, in his case around 1932.[92] After working briefly as a writer at the Iwerks and Disney studios, he filled the same job at the Schlesinger studio starting in 1933, as well as in some sense directing a few of the early Looney Tunes with Buddy. He was probably assigned to direct *Porky's Hare Hunt* when Schlesinger was trying to decide how to fill Freleng's chair after Freleng left for MGM.

The rabbit in *Porky's Hare Hunt* is white, with an oval head and a shapeless body, and he is a rural buffoon: very loud and oppressively zany, with a goofy, guttural laugh and a hayseed voice (by Blanc) that seems to be struggling past two buck teeth. He is somewhat magical, as if he were a magician's white rabbit: he pulls himself out of a hat, and when Porky's dog charges at him the dog vanishes into the bullfighter's cape the rabbit is holding.

In his fourth Merrie Melodie, Chuck Jones used a large white

rabbit very much like the one in *Hare Hunt*, but gave him a far more understated personality—one that can be traced back to the Clampett Looney Tune *Get Rich Quick Porky*, in which Jones animated the Pluto-like hound. In that cartoon, a gopher comes whirling up from a hole and very casually frustrates the hound as he tries to bury a bone. The gopher is, in fact, a magician: he makes the bone appear and disappear with no apparent effort. In *Prest-o Change-o*, released in March 1939, Jones picked up that one thread in *Get Rich Quick Porky*—the effortlessly magical gopher—and wove a whole cartoon out of it. *Prest-o Change-o*'s magical animal is, however, a rabbit. The rabbit is cool, graceful, and controlled; he has the *Hare Hunt* rabbit's guttural laugh but is otherwise a far more insinuating character.

After *Hare Hunt*, Hardaway codirected more than a dozen cartoons, both Merrie Melodies and Looney Tunes, with the animator Cal Dalton. When they put the *Hare Hunt* rabbit into a second cartoon, it was a 1939 Merrie Melodie, *Hare-um Scare-um*, which was released four and a half months after *Prest-o Change-o*. The rabbit is, as before, a self-conscious loon who is pestering a hunter (not Porky this time, but a cantankerous little human). The rabbit's appearance had changed and he had a name, both thanks to Charles Thorson, a former Disney story-sketch artist who had joined the Schlesinger staff as a character designer in 1938. When Thorson made a model sheet of the rabbit character in different poses for *Hare-um Scare-um*, he labeled it "Bug's [sic] Bunny" because he had drawn the model sheet for Bugs Hardaway. The name was picked up and used in publicity for *Hare-um Scare-um*, but with a corrected spelling: Bugs Bunny. The rabbit was now gray, with white cheeks and belly. His Disney pedigree was evident in his contour, an awkward merger of the lean and streamlined Max Hare of *The Tortoise and the Hare* and the round, soft bunnies that Thorson had drawn for *Little Hiawatha*.

By the time Warners released *Hare-um Scare-um* in August 1939, Hardaway and Dalton had been bumped from their directors' chairs by Freleng's return four months earlier. Dalton had gone back to animating, and Hardaway had been given the title of head of the story department. (By early in 1940, Hardaway had left; he landed later in the year on the staff of the Walter Lantz studio. His arrival there coincided with the creation of Woody Woodpecker, a character with a marked resemblance to the early Daffy and Bugs—right down to his laugh, which was provided by Mel Blanc, the voice of the two Warner characters.)[93]

Elmer's Candid Camera, the first cartoon with the new,

improved Elmer Fudd, was the second cartoon with the Thorson-designed Bugs Bunny. It was released only about seven months after *Hare-um Scare-um*, and Bugs may have been added to the cast in response to early exhibitor and public enthusiasm for *Hare-um Scare-um*; in 1939, the gap between the start of work on a Warner color cartoon and its national release could be as short as five or six months.[94] Instead of giving Bugs some of the characteristics of the magical rabbit in *Prest-o Change-o*, Jones simply slowed him down, so that *Candid Camera* moved at the same pace as Jones's other cartoons. Bugs was still fresh off the farm, and his laugh could still curdle milk; the big change was that he was no longer hyperactive. As might have been expected from the forced hilarity in *Porky's Hare Hunt* and *Hare-um Scare-um*, the rabbit when slowed down stood revealed as a spiteful bumpkin. His vexing behavior could not even be justified by Elmer's gun, since Elmer had come to the woods as a harmless photographer, and not as a hunter.

Jones made a second cartoon of that kind, *Elmer's Pet Rabbit* (1941), but in the meantime, the question of what kind of character Bugs Bunny was to be had been settled by Tex Avery's *A Wild Hare*, which was released on 27 July 1940. That is probably the best choice for a birthdate for Bugs. The Bugs Bunny of *A Wild Hare* does not differ radically from the Bugs Bunny of *Elmer's Candid Camera*, but he is instantly recognizable as Bugs Bunny, whereas the rabbit in *Candid Camera* is not.

For one thing, Bugs looks much better in Avery's cartoon; he stands more nearly straight and is sleeker and trimmer. Robert Givens, who succeeded Thorson as the Schlesinger studio's principal character designer, said that the directors considered Thorson's version of Bugs "too cute, so Tex asked me to do [another] one."[95] Givens drew a model sheet—labeled "Tex's rabbit"—that guided the animators on *A Wild Hare*. In the Givens design, Bugs was no longer defined by Thorson's tangle of curves. His head was now oval, rather than round. In that respect, Bugs recalled the white rabbit in *Porky's Hare Hunt*, but Givens's design preserved so many of Thorson's refinements—whiskers, a more naturalistic nose—and introduced so many others—cheek ruffs, less prominent teeth—that there was very little similarity between the new version of Bugs and the *Hare Hunt* rabbit. Instead, Bugs now resembled Max Hare much more than before. "I practically stole it," Avery said. "It's a wonder I wasn't sued. The construction was almost identical."[96]

The resemblance was only superficial, however, because Max

Hare was a rural braggart, and Bugs was now a city slicker. Mel Blanc, providing still more evidence of his flexibility at the time, gave Bugs a dry, urban voice, with no trace of the loutishness that had made the earlier voices so grating. The new Bugs was, however, not entirely distinct from his predecessors; he was, in fact, a blend of the two strains that had originated in *Get Rich Quick Porky* and *Porky's Hare Hunt.* He was as audacious as the rabbit in *Hare-um Scare-um,* but also as cool and controlled as the magical rabbit in *Prest-o Change-o.*

The opening scenes in *A Wild Hare,* as Elmer tracks Bugs to his hole in the ground, echo those in *Candid Camera*—except that this time Elmer has a gun and is thus a threat to Bugs. It is one thing to be calm and unconcerned when facing a photographer, like the Bugs of *Candid Camera*; it is something else again to confront a hunter in the same attitude. The rabbits in *Porky's Hare Hunt* and *Hare-um Scare-um,* like Daffy in *Porky's Duck Hunt,* are cavalier before hunters with guns, but those characters are not self-evidently sane. The Bugs of *A Wild Hare* is fully aware that he is in peril, but he remains cool anyway; he first appears by spinning up out of a hole and casually asking Elmer, "What's up, doc?" (an expression that Avery carried with him from high school in Dallas in the twenties).[97] Bugs goes so far as to toy with his adversary, at one point coming up behind Elmer, covering his eyes and inviting him to "guess who."

One reason it was possible to make Bugs so playful was that Elmer, although a threat, was not much of one. Givens had remodeled Elmer, too, for this cartoon, by giving his head the proportions of a baby's, with a high bald dome, a button nose, and a generally naive and trusting countenance; Elmer now closely resembled Dopey of *Snow White and the Seven Dwarfs,* but without Dopey's blue eyes and long lashes. The match between Bugs and Elmer is so unequal, in fact, that the cartoon suffers. Avery said that when he saw *A Wild Hare* after a lapse of many years, he was surprised that it had created such a stir when it was first released: "I sat there and I didn't see one damned laugh in it. I couldn't understand it. I thought I had a lot of gags in there, but there was hardly a gag in it."[98]

A Wild Hare is slow and heavy compared even with Avery's other Warner cartoons; it resembles Jones's cartoons of the time more than it resembles most of the films that Avery himself was directing. In it, Avery uses character-defining close-ups and medium shots of a kind that turned up much more often in Jones's car-

toons. Repeatedly in *A Wild Hare*, in between long shots that show a Bugs who looks not quite right in one way or another, the character suddenly seems to snap into focus, drawn with a precision that overshadows the model sheet and animated with a subtlety new to Avery's cartoons. Bugs greets Elmer's threats with chilly savoir faire; he feigns his death throes, after Elmer has fired at him; he beams with delight when Elmer sobs remorsefully at having shot the "poor widdle wabbit." This is personality animation in the Disney vein, all of it by Bob McKimson.

McKimson came to Avery's unit around the start of 1940, after almost two years with Jones; *A Wild Hare* was one of the first Avery cartoons on which he animated. McKimson and Jones had never been a perfect match. In the very areas in which Jones was strongest, drawing and animation, McKimson showed an imperturbable self-confidence that was, in some ways, fully justified. Not only could McKimson turn out highly realistic, technically impeccable animation like that in Jones's *Tom Thumb in Trouble*, but he did it with an apparent minimum of effort. (McKimson said he owed his great facility to an automobile accident that "pinched a couple of nerves in my neck." From then on, "I could do fifty, sixty, seventy, eighty feet a week"—at least twice the Schlesinger norm—"and it was easy.")[99]

McKimson was held in such esteem as an animator and a draftsman that Schlesinger gave him the title of the studio's head animator in August 1939.[100] The idea seems to have been that he would help everyone keep the characters "on model"—consistent with the model sheets—and maintain a certain level of professionalism in other respects.[101] Until 1939, there wasn't much reason to worry about consistency in how the characters looked because there were so few continuing characters, and most of them were used by only one director apiece, as with Jones's Sniffles. But when characters like Elmer Fudd and the early Bugs Bunny began to appear in different directors' films, the case was made for a head animator who would play a role like that of the head clean-up man for a Disney feature, that is, someone who could smooth away the imperfections in others' more creative work. McKimson was ideally suited for such a job.

He was only about a year older than Jones, but he spoke in later years as if he had played the part of a condescending elder in Jones's unit. It was his good word, he believed, that put Jones into the director's chair after McKimson turned down that job himself (he decided "I would rather learn a little more about

making pictures");[102] then, McKimson suggested, he tutored a timorous Jones in how to fill it. Jones—who always wanted to mold the drawings and the animation in his cartoons in his own style—could not have been comfortable with such a strong-willed animator in his unit once he had his sea legs.

McKimson's arrival in Avery's unit marked the end of the long dry spell, starting with the departure of Jones and Clampett in 1937, when the animation in Avery's cartoons was relatively weak. By 1940, not only did Avery have McKimson as his principal animator, but he also had at least one other animator, Roderick Scribner, who could draw and animate at a level much higher than Avery's average animator of a year or two earlier. After years of indifference to the animation in his cartoons, though, Avery had trouble putting Disney-level animators to good use. If the animation in Avery's cartoons had grown slow and literal in the late thirties, and his gag timing had slowed in response, he had now gone one step further: his *ideas* had grown slower and more literal, more like the ideas behind the Disney cartoons. Once he finally had animators who were capable of strong character animation, Avery felt obliged to have them *do* strong character animation; McKimson, fresh from working with Jones, pushed him in that direction. "When I worked with Tex," McKimson told Mark Nardone in 1976, "he never drew too well. And I would take his rough characters and make them work."[103] Avery thus had to rein in his more extravagant ideas so they would not work against the characters' plausibility. In some cartoons he went back to telling real stories, departing from his reliance on all-but-naked gags. That phase was very short-lived, and in fewer than a dozen cartoons did Avery clearly hold himself back. *A Wild Hare* was one of them; had that cartoon fallen a little earlier or a little later in Avery's career, Bugs Bunny might have emerged a much shallower character and made a weaker impression, even if the cartoon itself had been funnier.

Such was the impact Bugs made in *A Wild Hare*, though, that he immediately started to receive from the Schlesinger studio the close attention that every film studio gave to promising new stars. Bugs was, in fact, the first real cartoon movie star, deserving that title more than Mickey Mouse or Donald Duck, much less Felix the Cat. Live-action movie stars tended to fill their roles by magnifying aspects of their own personalities, so that audiences went away aware of performer as well as character. In the same way, Bugs's cool underplaying in *A Wild Hare,* so different from the

behavior of most cartoon characters, encouraged the sense that he existed outside that particular cartoon—and, in particular, outside the weak animation that makes up much of *A Wild Hare* apart from McKimson's scenes. Inconsistencies that would have diminished another character severely were all but irrelevant in *A Wild Hare*, so powerful was the conception of Bugs Bunny that emerged from the synthesis of Avery's and McKimson's contradictory talents.

Bob Givens began drawing a more refined model sheet of Bugs, labeled "Bugs Bunny Sheet #1," but that model sheet was apparently never finished or used in production.[104] Bugs was instead returned to the animator who had done so much to bring him to life in the first place. Bob McKimson made two model sheets soon after *A Wild Hare* was released; he adopted many of Givens's poses, but rendered them far more crisply and sharpened the rabbit's appearance overall. He gave Bugs's face a distinctly triangular shape, so that the mouth and eyes no longer seemed cramped by Givens's narrow oval, and he added high cheek ruffs that extended beyond the line of Bugs's jaw, as they did not on Givens's model sheet. The latter change made Bugs's face brighter and more alert, and it eliminated a disturbing impression in some *Wild Hare* animation based on the Givens model that Bugs's cranium and jaw did not form a single unit.

Avery directed only three more Bugs Bunny cartoons. Early in the summer of 1941, he and Leon Schlesinger quarreled over Avery's determination to make a series of live-action shorts in which real animals would speak funny lines with animated mouths, an idea that grew out of such Avery mock documentaries as *Wacky Wildlife* (1940). Schlesinger wanted Avery to stick to making cartoons. Avery wound up laid off for eight weeks, and in September 1941 went to work for MGM. The animal shorts began coming out around the same time, from Paramount, in a series called Speaking of Animals; Avery was involved in only a few of them before selling his interest in the series.[105]

Like many another star, Bugs Bunny survived the departure of his mentor. By the time Avery left Schlesinger, the Bugs Bunny cartoons had acquired a momentum wholly independent of their originator; six were released in 1941 alone.

The Disney Diaspora,
1942–1950

Even in making the Disney studio's stripped-down government films, Dick Lundy said, "you couldn't put out work too fast." When Lundy was directing training films for the navy, "they allowed me seventeen dollars a foot, and I think I spent twelve dollars, especially on *Torpedo Plane Tactics*. The Navy...thought they were great. But Walt said, 'Don't you think, Dick, that you could have spent a little more dough, and got 'em a little bit better?'"[1]

Disney may have been thinking wholly, or in large part, about the flow of money through his studio—money that would keep useful people on the payroll even though an increased cash flow might not lead directly to increased profits. (For the fiscal year that ended on 2 October 1942, the Disney company reported a loss of more than sixty thousand dollars on its films for the federal government.)[2] It seems likely, though, that Disney was, in fact, concerned with making such films "a little better" because his name was on them; mundane training films proclaimed in their title cards that they were "produced by Walt Disney Productions."

In the early thirties, Disney ventured briefly into making animated inserts for two live-action features, *Servants' Entrance* and *Hollywood Party*, both released in 1934. He evidently saw such work as a way to ease into the making of his own features, but the

inserts turned out to be more a source of irritation than of profit of any kind.[3] Such sponsored films were inherently problematic, in Disney's scheme of things, because they were not under his control in the way that his shorts and features were. They were work for hire, made for clients whose wishes had to be paramount. Once the feature inserts were behind him, Disney shunned most sponsored films. The only notable exception was *Mickey's Surprise Party*, a cartoon made for the 1939 World's Fair under the auspices of the National Biscuit Company; it is for most of its length indistinguishable from a theatrical release.

The war in Europe, which so intensified the Disney studio's difficulties, also created opportunities to make war-related films—opportunities that became the more attractive to Disney as his studio's finances deteriorated. He began actively seeking such work in March 1941 when, with the help of an engineer from the Lockheed Aircraft Corporation, he was already making a sample filmstrip called *Four Methods of Flush Riveting*. He sent memoranda then to the aircraft companies concentrated in southern California, soliciting their business; in April 1941, he hosted a luncheon for about three dozen people, mostly from the aircraft industry and the federal government, to show films and talk about what he could do. A week later, he sent a letter to some of the same people, formally offering to make training films "for national defense industries at cost, and without profit. In making this offer, I am motivated solely by a desire to help as best I can in the present emergency."[4] Disney was, in short, trying to preserve his dignity, even as he shilled furiously for work he would have scorned a year or two earlier.

Some commissions did come his way in 1941: the National Film Board of Canada (represented at the April luncheon by the documentary filmmaker John Grierson) gave him an order for four cartoons, all incorporating old animation, for use in selling war bonds. By late in the year, just before the United States entered the war, Disney was talking with the navy about making films to help sailors identify enemy aircraft and warships.[5] The navy responded to the attack on Pearl Harbor by issuing a contract to Disney for twenty such training films the next day.[6] In 1942, films for the federal government finally began to take up some of the slack left by the shrinking feature program.

Such films could not, of course, take up the slack in Disney's own interests. "He didn't have the release for his creative energy that his system demanded," the animator Ollie Johnston wrote

many years later. "I think he got lonesome for us. When I would run into him in the hall, he always seemed anxious to talk...just general conversation. He just didn't seem happy without some project he could run with."[7]

In the first few months after the United States entered the war, Disney could come no closer to a "project he could run with" than the twelve short cartoons he was making as a result of his trip to South America. He had agreed to make those films in exchange for the federal government's underwriting seventy thousand dollars of the cost of his South American trip and 25 percent of the negative cost of the twelve shorts.[8] Work on the South American cartoons moved quickly; nine had emerged from the story department and gone into animation by April 1942.[9] It was then, apparently, that Disney hit on the idea of packaging four such cartoons in a short feature and using live-action footage taken during his South American tour to bring the film up to a barely respectable running time.[10]

At forty-two minutes, *Saludos Amigos* is much shorter even than *Dumbo*. It premiered throughout Latin America in the fall and winter months of 1942–43 before it was released domestically in February 1943.[11] The film's returns to the studio were modest, around $623,000, but were still more than twice as great as its cost, which totaled less than $300,000;[12] the government did not have to make good on its guarantee.

Saludos Amigos is almost shockingly small in scale compared with the features that immediately preceded it. It doesn't have a particularly strong Latin flavor, either; most of the Disney people who took part in the South American tour wound up not working on the shorts that grew out of it, and in any case, the ideas behind those shorts had been reduced to paper before the trip even began.[13] The trip served mainly to add a little local color to cartoons that otherwise could have been made without anyone's leaving Burbank.

Saludos's directors and animators were all veterans of the early features, but in the new film, they were working with story material—like the obvious gags that make up a Donald Duck cartoon set at Lake Titicaca, in Bolivia—far more confining than what they had grown used to. The habits bred in feature work could be less than helpful in such circumstances. For instance, Ham Luske directed "Pedro," about a humanized mail plane that must fight its way across the Andes to deliver a mail pouch. The story, by Joe Grant and Dick Huemer, demanded a tongue-in-cheek treatment,

but Luske, with *Snow White* and *Pinocchio* behind him and with Bill Tytla and Fred Moore among his animators, apparently could not resist asking his audience to care about his anthropomorphic hero. All the clever, tongue-in-cheek gags—present in abundance—do not generate laughter so much as they undermine the sympathy the director is trying so hard to create.

The animators, too, could stumble when feature-bred skills proved unsuitable. In "El Gaucho Goofy," the comedy suffers when Goofy (as an Argentine gaucho) is dancing with his arms akimbo, while his legs flail furiously: Goofy moves a little too much above his waist. His movements—skillfully animated by Woolie Reitherman—are too much like those of a real dancer, and thus diminish what should be a comic contrast. Shortcomings of that kind may have reflected Walt Disney's own difficulties in adjusting to the studio's reduced circumstances, but it's even more likely that he accepted what he had neither the time nor the money to correct. When he reviewed all of *Saludos Amigos* in sweatbox sessions in May and June 1942, he said relatively little about the animation—but he was critical of "Lake Titicaca," saying, justifiably, "A lot of this stuff is very uninteresting," and complaining, "The animated llama is very funny but they slipped over him."[14] Milt Kahl's animation of a supercilious llama is, in fact, the bright spot in the segment.

The trip that gave birth to *Saludos Amigos* also stimulated Disney's interest in making a short feature about aviation; by the time he returned to Burbank from South America, after many hours in the air, he was, one report said, "extravagantly airminded."[15] Like the idea for packaging several shorts as *Saludos*, the idea for an aviation feature first assumed concrete form in April 1942. Initially, Disney and RKO planned that a film with the working title "History of Aviation Stressing Aerial Warfare" would substitute for the shelved Mickey Mouse feature based on "Jack and the Beanstalk." Disney expected the film to run only forty or fifty minutes and to cost about $200,000, a figure low enough to calm the most skeptical banker.[16] It was evidently through such cut-rate films that Disney hoped to retain a foothold in the market for features, at a time when even so modestly budgeted a film as *Dumbo* was beyond his financial reach.

Alexander de Seversky's book *Victory Through Air Power*, which made the case for using long-range bombers as the decisive weapon in the war against the Axis powers, appeared in bookstores that spring and rapidly became a best-seller. By early May

1942, Disney was trying to get in touch with Seversky.[17] Within a few months Disney had acquired the film rights and was collaborating with Seversky on a feature in which Seversky would appear. Seversky's book thus became the device through which Disney could translate his own interest in aviation into a film; Seversky himself, who was, of course, interested only in publicizing his ideas, became something of an irritant to Disney, who never stopped thinking of what would hold his audience's attention. On 10 November 1942, when work on the film was well under way, Disney spoke of Seversky in a meeting with his animation writers and directors: "He keeps saying the same thing all the time only in a different way. And there are a lot of things he is overlooking that are important to the general public [if it is] to understand his theory. There has to be a certain amount of logic and reasoning, and he skips over it."[18] Even as a propagandist, Disney wanted to tell a story that made sense.

The same day as that meeting, Disney signed a distribution contract for *Victory Through Air Power*—not with RKO, which had passed on the film, but with United Artists.[19] RKO's wariness turned out to be justified. By the time *Victory Through Air Power* was released in July 1943, it was, if not out of date, close to it, and the flood of war-related films was beginning to recede in the nation's theaters. *Victory* ran sixty-five minutes and cost four times as much as Disney predicted, almost $800,000, and it brought receipts to the studio of only about $335,000.[20]

That the film cost more than Disney's projection is not to be wondered at, given its attention to detail. At the end, when animated long-range bombers are taking off from Alaska to attack Japan, they do so in the rain; the rain would not have been an expensive addition to the film since it is a cycle—the animation of the rain, on a few constantly repeating cels, was laid over the cels showing the planes taking off—but it was clearly an *unnecessary* addition. On the other hand, that the film cost as little as it did was surely owing to the skills the Disney people had acquired, while making training and propaganda films for the government, in the kind of animation that fills *Victory*: animated maps and diagrams, and animation that brings concepts to life, as in the literal "screen of wings" that protects the British evacuation from Dunkirk, an arch extending from Britain to France and composed of airplanes moving in both directions. *Victory* has almost no character animation, and what little there is does not much resemble the animation in *Snow White* or *Pinocchio*; the

stylization lacking in *Saludos Amigos* is present in *Victory*—animated only about a year later—with a vengeance.

In its fiscal year that ended on 2 October 1943 (and that thus embraced much of the production as well as the release of *Victory Through Air Power*), Walt Disney Productions produced 94 percent of its film footage for the government, most of that for the army and the navy. But government films accounted for only a little over 50 percent of production costs.[21] That was because those films were, by comparison with Disney's entertainment films, so skimpy in their animation and in production values of all kinds; *Victory Through Air Power*, as stripped-down as it was, was positively luxurious by comparison. The studio had done little more than dabble in live action before the war, but now about half its film footage was live action, and some military films (like the two-part *High Level Precision Bombing*) contained almost no animation. The studio was producing about ten times as much film footage as it had before the war, with a smaller staff. In the first four months of 1943, it shipped fifty thousand feet of film— almost as much as in 1941 and 1942 combined.[22]

War production gave the studio the financial strength not only to absorb the disappointment of *Victory Through Air Power*, but also to permit Walt Disney to begin exploring possible new features of a less tendentious kind. Such exploratory work had never quite ended, even in the dark days of late 1941 and early 1942; in the spring of 1943 it picked up again in earnest. One new feature grew, as *Saludos Amigos* had, out of Disney's commitment to provide RKO with three sets of four Latin American shorts each, in addition to the eighteen shorts in his regular annual program. Just as he had delivered *Saludos Amigos* in lieu of the first set, he and RKO agreed in May 1943 that a feature called *Surprise Package* would take the place of the second.[23]

Disney was otherwise severely limited in his choices for new features. He had for several years considered making a feature based on "Bongo," Sinclair Lewis's 1930 magazine story about a circus bear, and in late May he assigned Joe Grant and Dick Huemer—the team that had written *Dumbo*, another story about a circus animal—to adapt "Bongo" for film. "Bongo" was plausible as raw material only for a short and inexpensive film, and Grant and Huemer complained, after what they called "two weeks' intensive investigation into the possibilities," that it was too thin even for that: "we find Bongo himself too shallow to build on."[24] "Bongo" went back on the shelf. In mid-1943, Disney talked of

putting *Peter Pan* or *Alice in Wonderland* into production. A story
crew put up new storyboards for *Alice* throughout much of 1943,
but work evidently went no further than that.[25]

By 1944, Disney had finally reached an accommodation of
sorts with his reduced circumstances. As in the prewar years, he
would make two kinds of films, but now the lesser films, the ones
previously assigned to the "caricaturists," were not to be full-
length stories. They were to be what Disney had once called "fea-
ture shorts," packages of short subjects generally similar to
Saludos Amigos; as *Saludos* had proven, the economics of such
compilations could be attractive. The new package films bore
working titles like *Swing Street* and *Currier & Ives*. The more ambi-
tious (and expensive) films would be even more radically differ-
ent from the prewar features. They would not be animated fea-
tures at all, but rather live-action features with animated inserts.
By the summer of 1944, the writing was well under way for such
a film based on Joel Chandler Harris's Uncle Remus stories. Even
though it was Remus's stories of Brer Rabbit that had attracted
Disney's interest in the first place, those stories would be inter-
ludes in what was otherwise a live-action feature.

By the time of its premiere in Mexico City in December 1944,
Surprise Package had become *The Three Caballeros*; it had also
become something much more ambitious—and much odder—
than *Saludos*: an awkward mixture of the two kinds of films that
Disney now planned to make. It opens with two short subjects
(both from the batch in work just after the 1941 trip), but they
turn out to be the prelude to an aimless narrative—involving
Donald Duck, the Brazilian parrot Joe Carioca, and the Mexican
rooster Panchito—that leans heavily on live-action film of Latin
American performers. Those performers often appear on screen
with the cartoon characters, in combination work that was some-
times frightfully complicated. For the musical sequence "*Os
Quindins de Yaya*," the animation of Donald Duck and Joe Carioca
was completed first, and projected (from fifty feet in the rear)
onto a translucent screen. The singer Aurora Miranda performed
in front of the screen, where both she and the animation were
photographed by a camera twenty-five feet away.[26] As the layout
artist Kenneth Anderson said, "We had to make layouts and make
[animation] drawings, and time them, choreograph them, so that
[Donald Duck] and the other characters would animate with a girl
that had not been photographed yet." Worse, the actress had to
perform eight to ten feet in front of the screen if it were to appear

that she was occupying the same plane as the animated charac-
ters.[27]

Three Caballeros revealed a larger obstacle to successfully com-
bining live action with animation—an obstacle that becomes the
more imposing, ironically, the better the animation is. Well-
animated cartoon characters typically move both a little faster
and in more clearly defined phrases than live-action actors. These
differences in timing can suggest that gravity affects the cartoon
characters a little differently than it affects real people; combine
the two on one screen, and there is a subtle but disturbing dis-
crepancy in apparent weight. The combination work in *The Three
Caballeros*—so much more advanced than anything before it, both
in technical complexity and in the quality of the animation
itself—thus cast into doubt, by its very success, the wisdom of the
whole endeavor. Thanks in part (probably in large part) to the
cost of its combination work, *The Three Caballeros* was a much
more expensive film than *Saludos Amigos*; its negative cost was a
little under two million dollars. It lost money—the studio's
receipts were almost $186,000 less than the film's cost[28]—and that
shortfall probably sank the plans for a third Latin American fea-
ture, *Cuban Carnival*.

Ham Luske had said, at a 20 August 1943 meeting on a misbe-
gotten feature project called *The Gremlins*: "It seems to me, in this
studio, whenever we think we have a really good picture, it turns
out to be a good picture. When we get a picture where we wonder
if it has got an awful lot, but we are not sure, that is just exactly
the way the public takes it."[29] The problem for Walt Disney and
his people as the war came to an end was not only that they had
not made "a really good picture" since *Dumbo* in 1941; they could
no longer be sure that they even knew what such a really good
picture might be like.

The Disney strike and the ensuing layoffs spilled hundreds of tal-
ented people into the animation industry's labor market. At the
same time, the military draft was sucking talented people out of
the other studios. The result was the rapid spread of artists with
Disney training, and Disney-bred attitudes, to studios where nei-
ther had been common before. The studios that felt the greatest
impact were those whose prestige in the industry was lowest, like
the Walter Lantz and Screen Gems studios.

In the early forties, some production methods akin to Disney's—pencil tests, for example—had long since taken hold at Lantz's. The Lantz cartoons themselves reflected Disney's supremacy throughout the late thirties, sometimes mimicking them precisely. For Lantz to make cartoons comparable even to those of Harman-Ising was not really possible, though. The Lantz studio always lived more or less on the edge, thanks largely to the difficulties experienced by Universal, at first Lantz's employer and later his distributor.

Lantz became an independent producer in November 1935 in the midst of a financial crisis at Universal that led to the ousting of its founder, Carl Laemmle.[30] Four years later, still foundering, Universal cut off Lantz's weekly advance. Lantz had until that time sold his cartoons to Universal outright, but now—in a reversal of the pattern taking hold elsewhere in the animation industry, such as at MGM—he became more of an independent. What Universal told him, Lantz recalled in 1971, was this: "We'll turn all the copyrights over to you of the characters you've created for us...if you'll produce cartoons for us and do your own financing."[31]

So much difficulty did Lantz have in finding alternative sources of funds that his studio closed completely for a time in early 1940. He was able to begin production on his first completely independent cartoon, *Crazy House*, with his star Andy Panda, only by enlisting animators to work "on the cuff.... I didn't even pay them until I made the second or third picture."[32] In early 1941, the Lantz studio's finances were still so precarious, or so the Screen Cartoonists Guild believed, that the union halted its efforts to be certified as bargaining agent at the studio; it feared that it might have to accept too low a wage scale and thus weaken its position with the other studios.[33]

The reopened Lantz studio made only half as many cartoons as before—thirteen a year, and all of them now in Technicolor—but they were slovenly in a way that the few Lantz color cartoons of the thirties had not been. Lantz now all but flaunted an indifference to how well a gag, or anything else, was executed, once the idea behind it had been made visible; and the strength of that idea made no real difference as long as it had a recognizably comic shape. That is true, for instance, of *Knock Knock*, released in November 1940, the cartoon that introduced the raucous, gaudy Woody Woodpecker as a foil for Andy Panda (who was, unlike Woody, an imitation not of another cartoon character but of a

radio character, Baby Snooks). At one point, Woody advances threateningly on Andy and swells up enormously, but then he turns and walks away, gradually diminishing in size while he plays his beak as if it were a flute. Neither his swelling up nor his shrinking down occurs quickly enough to make sense as a reflection of his mood—the only possible point—as opposed to a purely physical change.

The Lantz studio's records listed Lantz as the director of *Knock Knock*, but the actual director was almost certainly Alex Lovy (who has screen credit as one of two artists; no one is credited as director). Lovy had gone to work for Lantz in 1937, drawing story sketches for Lantz's principal writer in the thirties, Victor McLeod; he began directing soon after that.[34] It is Lovy's drawing style—a crude cartoon style, with no trace of caricature—that dominates the cartoons of the early forties.

The Lantz cartoons offered scant encouragement to anyone who might hope to reshape them along Disney lines. And yet, after Lovy entered the navy in 1942, Lantz hired Shamus Culhane to replace him. Culhane, who had been an animator for Disney and then a director of Disney-flavored short cartoons for the Fleischers, went on the Lantz payroll at the end of March 1943. Lantz hired other former Disney animators, too. Dick Lundy, who had been directing Donald Duck cartoons as well as training films for Disney, came to the studio as an animator in November 1943. Grim Natwick and Bernard Garbutt, a *Bambi* animator and an expert on animal anatomy, also joined the animation staff.

The Disney influence extended beyond the animators. Art Heinemann was a widely admired draftsman who had worked at first for Harman-Ising and then in story sketch and layout on most of the early Disney features; he was part of the Lantz staff from June 1943 to September 1944. He spruced up the settings for the Lantz cartoons, simplifying them and introducing strong, pure colors, sometimes cut from colored paper (Culhane cited such cutout backgrounds for *The Greatest Man in Siam*, released in March 1944). Heinemann also came up with a new color scheme for a streamlined, more immediately appealing Woody Woodpecker.[35] In the new design by the animator Emery Hawkins, Woody looked no more like a woodpecker than before, but Hawkins and Heinemann smoothed away many of the grotesqueries—buck tooth, receding chin, heavy yellow legs—of the original Alex Lovy design.

After Culhane's arrival, the Lantz cartoons for the first time showed that someone was paying attention to all the important elements in an animated cartoon—timing, drawing, staging, characterization—instead of relying on the idea behind a gag alone. Occasionally, Culhane even came close to making a plausible character of Woody, who was in most of his appearances in the early forties an unmotivated heckler. In a cartoon like *The Beach Nut* (1944), Woody is completely heedless and inconsiderate, but he is just as plainly lacking in malice. He succeeds as a comic figure on the order of the W. C. Fields character in *It's a Gift*: he is not flouting civilized norms so much as he is oblivious of them.

Even Culhane's best cartoons falter, though—the cutting or the staging of a gag may be awkward, the animation inadequate. Moreover, Culhane constantly had to apply directorial finesse to writing that was fundamentally weak, if not altogether hopeless. Some of the musical cartoons called Swing Symphonies, a jazz-flavored series that began in 1941, were Culhane's strongest cartoons for Lantz. The best ones, like *The Greatest Man in Siam*, consist of almost nothing but color and music, with no story or gags to speak of, as if it were only in that way that Culhane could seal himself off from bad ideas. (Lantz was put off by the precision that musicals required: "You can't cheat on musicals. You've got to animate to the beat.")[36]

Culhane's most grating collisions were not with Lantz but with Ben Hardaway, the former Schlesinger story man; Hardaway wrote *Knock Knock*, probably as a freelancer shortly before he joined the Lantz staff.[37] As far as Hardaway was concerned, Culhane wrote many years later, "a gag was a gag. The fact that it was out of character or did not advance the plot, he dismissed with impatience as too scientific and technical for an animated cartoon—this at a time when I was deep in the writings of Sergei Eisenstein! I was discreet enough not to advertise this fact."[38]

Hardaway was far more attuned to the Lantz ethos than Culhane was. For all that he was hiring former Disney animators to direct his cartoons, Lantz was not enthusiastic about trying to emulate the Disney films. Dick Lundy recalled: "Lantz would say, 'We got more laughs when I was putting out pictures for nine thousand dollars. Now they cost me fifteen thousand dollars, and I'm not getting a laugh.'"[39] Lantz, in 1971, described himself as "more gag-minded" and, significantly, used his brief stint as a gag man for Mack Sennett in the twenties as a point of reference: "We

can't afford to work it out on the set, but I still go for the gag."[40]

Culhane left the Lantz studio in October 1945; he wrote many years later that he and his unit were let go after the war because "the studio was only allocated enough [film] stock to photograph eight cartoons."[41] Lundy by then had been a Lantz director for a year and a half, and he continued as the studio's sole director. Like Culhane before him, Lundy found Lantz of little help: "He would come in, and he might offer suggestions, but, usually, his suggestions weren't too good."[42] Lantz's stamp was, however, much more clearly visible in the cartoons Lundy directed than in most of Culhane's, showing itself in a pervasive shallowness and carelessness.

Lantz "was always yelling about budget," Lundy said. When Lundy began "putting all the pencil tests together and making a reel," so that the complete film could be seen in pencil-test form—a practice that had become commonplace at the other Hollywood cartoon studios by the middle forties—"Oh, he screamed about that! He said, 'Oh, no, that's too expensive.'"[43] Likewise, the writer Milt Schaffer recalled that "Lantz always used to look at my story sketches...and say, 'We don't need a lay-out man.' That would be his attitude, like, oh, man, we can short-cut a job here."[44] But, of course, Schaffer's drawings probably were good enough to use as character layouts, just as some of the story sketches for *Dumbo* were.[45] And once Lantz actually saw a pencil-test reel, Lundy said, "he thought it was a great idea." Ben Hardaway probably did not know the difference between a good cartoon and a bad one; Lantz probably did, and he probably feared, too, that trying to make good ones would tip his studio over the financial precipice on which it so often perched.

Lantz signed a distribution contract with United Artists on 12 February 1947,[46] and his new contract soon brought with it difficulties that were reminiscent of his bumpy ride with Universal. He had traded a contract with one weak distributor for a contract with one that was even weaker. In December 1947, Lantz laid off his creative staff for a planned three months, citing a shortage of prints from Technicolor and conflicts with UA's management.[47] The studio never really opened again before it finally closed down completely at the end of 1948.[48] By closing for a year while his cartoons were still in circulation—Universal continued to distribute cartoons he had made under his contract with that studio—Lantz could get out of debt and build up capital for renewed production.[49] When he reopened, after his studio's third brush

with extinction, he would have every reason to try to make cartoons that entailed as little risk as possible.

Like the Lantz cartoons of the late thirties, the Mintz studio's cartoons—especially its Color Rhapsodies—labored in Disney's shadow, to no good purpose. *Let's Go* (1937), for example, is a variant on the fable of the grasshopper and the ants, which Disney had made into a Silly Symphony in 1934. The Mintz film is much less coherent than its predecessor: at one point, in this paean to industriousness, a grasshopper drops a coin into a slot machine and hits the jackpot. (The grasshopper's good fortune is not a wry comment on the cartoon's theme; the Mintz cartoons were strangers to irony.) By the late thirties, many Color Rhapsodies were comparably odd, as if stitched together from half-finished ideas. They were exceptionally ugly cartoons, too, often drawn in a tight, crabbed style.

After Charles Mintz's death late in 1939, management of the studio fell into the hands of his brother-in-law, George Winkler. Columbia had bought a half interest in Mintz's studio around 1933, changing the name to Screen Gems, and it had acquired complete ownership in September 1937;[50] Winkler was thus Columbia's representative, and as such he apparently pitted the directors against one another in what was—to judge from the recollections of two of those directors, Art Davis and Harry Love—a heavy-handed effort to cut costs.[51] The cartoons that emerged from this competition were feebler than even the weak cartoons of a year or two earlier.

Someone, it's not clear who, made an offer to Frank Tashlin, by then a writer at the Disney studio. He accepted it in March 1941 after Walt Disney refused to give him a raise (understandably enough, given the Disney studio's difficulties at the time).[52] Tashlin went to Screen Gems as a writer, he said: "They didn't have a story department. Then there was a reorganization over there, and Columbia sent a new man in. He fired everyone in the place except me, and he said, 'You're going to be in charge of the studio.'"[53] That was in October 1941. When Columbia swept away, if not "everyone in the place," at least the remnants of the Mintz-period management, George Winkler lost his job as general manager—he soon wound up at the Schlesinger studio as head of its ink and paint department—and was replaced by Ben Schwalb,

who had been producing the live-action short subjects that Columbia made in New York.[54] Tashlin assumed the day-to-day production responsibilities; he directed *The Fox and the Grapes*—the first cartoon with the characters the Fox and the Crow—"and from there on," he said, "I wasn't doing any directing, I was working on stories and running the place."[55] (The screen credits show him directing at least one other cartoon, *The Tangled Angler*.)

Tashlin took charge just as the dust was settling from the Disney strike, and he filled the staff with former strikers. Within a few months, a distinct sensibility began to manifest itself, however imperfectly, in some of the Tashlin-supervised cartoons, in much the way that Shamus Culhane's directorial personality began to shape his cartoons for Lantz. As at Lantz, the new Columbia cartoons actually looked less like Disney cartoons than many that had come from Screen Gems before, but the new cartoons *felt* more like Disney cartoons because there was behind them the same urge to expand the vocabulary of the medium.

For instance, *The Bulldog and the Baby*, directed by Alec Geiss (a former Disney writer) and released in July 1942, offers not exaggerated athletic speed, like Max Hare's, but speed of a highly subjective kind. In a building under construction, a bulldog is rushing downstairs faster than a baby is falling; he even pauses to make futile efforts to grab the child. When he finally reaches the bottom, it is just in time to make the catch. The baby falls at a more-or-less normal rate, but the dog moves much faster than he could in real life—he is propelled so powerfully by his emotions that he slips free of physical laws.

By the time *The Bulldog and the Baby* appeared in theaters, Tashlin had left the Screen Gems studio. Early in April 1942, Columbia effectively demoted Tashlin when Schwalb assumed greater control over cartoon production.[56] Later that month, Columbia named Dave Fleischer—newly departed from the Florida studio that had borne his name and newly arrived in California—to be head of Screen Gems, as its executive producer. Tashlin still had the title of supervisor of production, but he was gone less than two months later.[57]

John Hubley, who after working in layout for Disney had done the same at Screen Gems, began codirecting with the animator Paul Sommer after Fleischer took over. Hubley said of Fleischer: "The only thing you could say good about him was, he was so out of it, he was so completely detached, that he was never any problem."[58] Fleischer's detachment bred cynicism, too, of course, but,

as Hubley suggested, when Fleischer kept his distance, at least some of his artists had unusually wide latitude to experiment—more so, perhaps, than they had under Tashlin. It was only after Fleischer took over that Hubley and the layout artist Zack Schwartz designed a few cartoons that departed sharply, in their general appearance, from the Disney cartoons they both had worked on. It was at Screen Gems, Hubley said, that Disney alumni mounted "the first revolution against the characteristic Disney round and opaque forms."[59]

By the early forties, most of the studios that had continued making black-and-white cartoons were, like Schlesinger, dropping them in favor of an all-color schedule, but Columbia was an exception; for the 1941-42 release season, for instance, it released ten black-and-white cartoons and only eight in color. "Nobody cared what you did in black and white," Schwartz said, "because nobody expected that the films would ever be shown anywhere." That was why Schwartz was free to design *Willoughby's Magic Hat*, released in April 1943, in "very strong patterns and textures—linear patterns and textures—wherever I could."[60] *Willoughby's Magic Hat* and its sequel, *Magic Strength*, released in February 1944, concern Willoughby Wren, an unprepossessing little man who acquires magical strength by wearing a cap made of Samson's hair. Despite their fantasy content, both convey through their crisp black-and-white design—design that exploits patterns like those made by light falling through windowpanes—a strong sense of urban drama.

What the cartoons designed by Schwartz and Hubley made clear, though, was this: if a cartoon's weight shifted toward a more forward sort of design, and away from what Hubley called "humanized pigs and bunnies," that is, away from expressive cartoon characters of the kind that the Disney animators had spent most of the thirties developing, the burden on that cartoon's writing was immense. Sophisticated design alone could not hold an audience's interest; cleverness of other kinds had to plug the gap left by those pigs and bunnies.

The Willoughby Wren cartoons, directed by Bob Wickersham and written by Dun Roman, barely pass that test; they adopt and sustain an arch tone that implicitly recognizes that the films' characters are of little interest in themselves. On the other hand, the five cartoons that Hubley codirected before he entered the army late in 1942 give reason to doubt that he even realized that such a test existed. In *The Vitamin G-Man*, a black-and-white

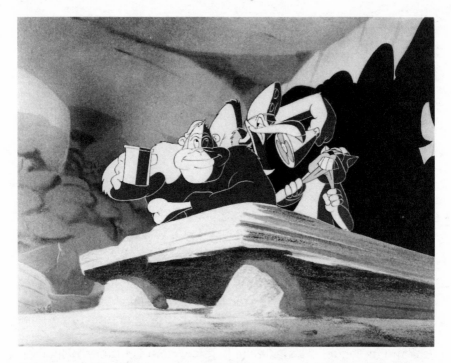

From Song of Victory (1942), a Columbia cartoon on a wartime theme—the three animal characters represent the Axis powers—and designed by Zack Schwartz. Although this cartoon was made in color, its design is similar to that of the black-and-white cartoons that Schwartz designed.© Columbia Pictures.

Hubley-Sommer collaboration released in February 1943, a detective is graduating from Flatfoot College and is undergoing a "final exam" that will, he is told, involve several attempts on his life. When the detective sprinkles "footprint powder" outside a door, the powder becomes railroad tracks, and a train bursts out of the door and pursues the detective, but there's no reference to his seeing "tracks" in the powder, even though some gag of that kind must have been intended. The cartoon displays a startling indifference to the bare requirements of craft: it's as if Hubley and Sommer thought that robbing a trite gag of any point was the same as reshaping it into something better.

The writing for the more conventional Screen Gems cartoons was, if not so insolently weak, no stronger. In the Fox and Crow series, in particular, the gags tended to be either too simple or too complicated; directness and ingenuity were both lacking, as was, sometimes, an awareness of what a gag might mean. At the close

of *Plenty Below Zero* (1943), the Fox puts Roman candles in a sandwich just before the Crow eats it, and the Crow shoots into the air after swallowing the sandwich—a discomfiting gag, because after all, where are the Roman candles exiting?

Writers at other studios might have enjoyed and exploited such ambiguities; those at Columbia didn't think about them, or if they did, didn't care. Even though the directors sometimes grumbled, there was probably very little pressure on the writers to put more effort into their work. The general atmosphere at Screen Gems was so casual, Paul Sommer recalled, that on Fridays, "when guys came back from lunch, they'd be half stinko, and the rest of the afternoon they'd be fooling around, and no work would be done, really. Things were very relaxed, as a regular thing."[61]

Dave Fleischer left the Screen Gems studio late in 1943.[62] By then, Hubley had been gone for a year. Schwartz left early in 1944, and with his departure the studio's brief burst of creative energy was spent. The cartoons that straggled onto Columbia's schedule over the next few years were sometimes hopelessly inept. When Bob Clampett worked briefly at Screen Gems in 1945, involved in story work as what he called the studio's creative head, "I was shocked," he said, "because the whole feeling of the studio was so different from Warners.... If you started talking gags to them, or some funnier voice, they didn't seem to be on the same wavelength."[63] Columbia had all but closed the Screen Gems studio by November 1946;[64] six months later, when the final cartoons had been what a contemporaneous report called "completed"—put through camera, presumably—Columbia announced a bouncing-ball song series as their replacement.[65]

●∵ ● ●

After the strike, one member of the Disney staff found Bill Tytla much the same as before. "He worked me over, as I directed him," Wilfred Jackson recalled. "When the parrot [Joe Carioca, in *Saludos Amigos*] was to pat the duck's head...Bill would pat my head, to see what it was like to pat somebody's head."[66] Moreover, Art Babbitt said, even though the strike had irreparably poisoned Babbitt's own relations with Walt Disney, Tytla encountered no comparable problem "because Walt had tremendous respect for Bill."[67] Bob Carlson, who had been a junior animator under Tytla during work on *Fantasia*, thought his old boss was a changed man, though: "He was aloof; he just stayed by himself. He didn't

mingle with the boys very much.... He just came to work and stayed in his room, and went home."[68]

Tytla's ties to the Disney studio had, in fact, been fatally weakened. As Babbitt said, "Bill owned a very nice farm back in Connecticut, and his wife wanted to go there."[69] The opportunity arose when Paul Terry and his wife visited California in January 1943. The Terrys saw Tytla and his wife, Adrienne,[70] and it was then, or soon thereafter, that Terry offered Tytla a job at his studio in New Rochelle, just outside New York City. Tytla accepted. He left the Disney staff as of 25 February 1943. That Terry even wanted to hire Tytla must be counted odd but not inexplicable, given their friendly association of many years. By hiring Tytla, whom he knew so well, Terry could hope to raise the quality of his cartoons to a more acceptable level without putting his studio through wrenching change.

In 1943, the Terrytoons studio was shabby—"a loft-type place," the animator John Gentilella recalled[71]—compared with even some of the rougher hewn Hollywood studios. Faint traces of ambition had shown up in the Terrytoons of 1936 and 1937, but as soon as people like George Gordon and Joe Barbera left for MGM, the Terrytoons' dominant characteristic was once again an astonishing fecklessness. More even than the Lantz and Mintz cartoons from the same period, the Terrytoons of the late thirties and early forties are full of undigested ideas from better films. *The Two Headed Giant* (1939), for example, is a clumsy imitation of Disney's *Brave Little Tailor* (1938). The idea in the Terrytoon appears to be that the audience should approve when the giant drowns and identify with Jack the Giant Killer, but the giant is the only character who comes close to being sympathetic, and Jack doesn't appear until the cartoon is almost over.

Tytla (who animated the giant in the Disney cartoon) was entering an environment that had nothing in common with the Disney studio even in its reduced wartime circumstances. Disney connections of any kind were scant at the Terry studio, although Eddie Donnelly, one of the directors, had been a Disney animator ten years earlier. Like Terry himself, most of his key employees had formed their habits in work on the Aesop's Fables and the early sound Terrytoons; Terry had made John Foster, a Fables veteran, the head of his story department, and Phil Scheib still composed and recorded the music for the cartoons in advance of the animation.[72]

As of April 1943, the studio had only eighty-nine employees,

about the same as before the war, including just nine animators.[73] Other cartoon studios with comparable output were about twice as big—and were spending about twice as much on each cartoon. In the early forties, the negative cost of a Terrytoon typically ran only ten thousand to twelve thousand dollars. (Terry also paid for the release prints, at an additional cost of five thousand dollars or so per cartoon.)[74] The number of Terrytoons released theatrically was going down, to seventeen in 1943 from twenty-six the previous year, but as with the other cartoon studios, defense-related work was taking up the slack.[75]

When Tytla first came to the Terrytoons studio, Gentilella recalled, "Terry didn't seem to have a picture ready for him for a while, so he was animating for Mannie Davis and Connie [Rasinski] and Ed [Donnelly]."[76] There are glimpses of what is probably Tytla's animation in just a few cartoons: scenes with a drunken mouse in *The Lion and the Mouse* (1943) and with a satanic figure in *The Butcher of Seville* (1944) could be his work. Some of the scenes with Mighty Mouse's antagonist in *Mighty Mouse Meets Jekyll and Hyde Cat* (1944) certainly are by Tytla, but his animation of the cat shows only traces of the weight and power that Tytla brought to Stromboli and Tchernobog, and then only in the transformation scene. "I think it was frustrating for him," Gentilella said of Tytla. "He really couldn't do what he wanted to do. He was such a perfectionist. If a cat was sneaking along the ground, he'd put so much drawing in there, and work at it and work at it, and do it over."[77]

Ultimately, Tytla's name appeared as director on only one Terrytoon, *The Sultan's Birthday*, released in October 1944. It is a Mighty Mouse cartoon like many others: cats disrupt the birthday celebration—the sultan is a mouse, in a mouse-filled Middle Eastern city—by attacking with machine guns from flying carpets, until Mighty Mouse (a Superman-inspired character who is for all practical purposes a demigod, here and in many other Terrytoons of the forties) appears suddenly and inexplicably to save the day. "Paul Terry must have expected Bill to turn out pictures the equal of Disney's," the Terrytoons animator Larry Silverman said, "but with Terrytoon facilities. Nobody could do it, and Bill couldn't either."[78] In its animation as in every other way, *The Sultan's Birthday* is a typical Terrytoon: there is, for example, as much cycle animation as always, that is to say, a great deal of it.

Tytla was a Terry employee for a little over a year. In May 1943

the Screen Cartoonists Guild won an election at the studio giving it the right to represent Terrytoons' employees in collective bargaining.[79] Predictably, Terry dragged his feet, and he and the union did not sign an agreement until June 1944.[80] It was probably soon afterward that Terry—trying to save money, now that he was paying union wages—"skimmed the top a little bit," as Gentilella said, by laying off higher paid employees. Two former Disney animators were obvious targets: Isadore Klein was one; Tytla was the other.[81] Klein recalled that Terry came in with two envelopes and handed one to him and the other to Tytla, firing both of them; Tytla rushed out of the studio.[82]

Tytla was not unemployed long. By September 1944, he had joined the staff of Famous Studios—the old Fleischer operation, which by then had been back in Manhattan for about a year and a half—as a director, and he was writing the story for his first cartoon there with Klein, his Disney and Terrytoons colleague.[83]

The Famous studio was as rigid, in its way, as the Terrytoons studio was flaccid. The three producers—Kneitel, Sparber, and Buchwald—encased their cartoons in stupefying formulas. Those formulas were already visible by early in 1942 as the Fleischers' control of the studio was ending. In *Blunder Below,* a Popeye cartoon released in February of that year, Popeye is feeding coal to a ship's furnace by stepping on the handle of his coal-laden shovel, flipping it into the air and over to the furnace's door. The shovel then somehow ricochets back to its original position. The comic business is, in other words, forced, and the timing underlines its impossibility because it is so slow and literal. Forced gags and literal timing had been common hazards not just at Fleischer's (as witness the floating barber-chair seat in *A Clean Shaven Man*) but at other studios in the middle thirties; now they dominated the Famous cartoons not because the people making them lacked the skills to do better, but as a matter of choice, as if telling a bad joke slowly and distinctly would somehow make it funny.

John Gentilella left Terrytoons and became an animator at Famous before Tytla began directing there. "He was a frustrated director," Gentilella said. "He didn't know sometimes what he wanted."[84] In Tytla's films for Famous, he did nothing that echoed his work at Disney's except in the weakest way, through imitation: for example, *Service With a Guile,* a 1946 Popeye cartoon—Tytla's first with the character—is a straightforward copy of *Mickey's Service Station,* one of the first Disney shorts on which Tytla animated. Otherwise, the Tytla cartoons were indistinguish-

able from the leaden Sparber and Kneitel cartoons that shared the release schedule with his. Stranded in an artistic swamp that bore no resemblance to the studio where he had done his best work, Walt Disney's greatest animator was simply swallowed up.

The Disney studio, as the war drew to an end, was in many ways a very different enterprise from the one that had been so badly divided a few years earlier. By 1944, more than two-thirds of the people on the payroll had not worked there before the strike; former strikers made up only 6 percent of the work force.[85] Many of the new employees knew the studio mainly as a war plant.

Government films had, of course, been a very useful financial cushion for the studio, and Walt Disney for a time thought that he could replace them with films for civilian clients in private industry. In the summer of 1943—around the time that his studio's production of military training films was at its peak—he was speaking with his characteristically expansive optimism about postwar educational uses of film.[86] Later that year, he hired a Lockheed executive named J. V. Sheehan to seek out clients for industrial training films. Sheehan was successful: by the fall of 1944, five such films were in production for companies like General Motors and Westinghouse under contracts that would bring the studio a pretax profit of $71,600.[87]

Disney's own enthusiasm cooled even as the viability of his industrial-film strategy began to prove itself. By mid-1944, he was speaking much more cautiously about the postwar market for educational films than he had just a year earlier.[88] Two former members of the Disney staff, Herb Lamb and Tom Codrick, set up their own industrial-film studio, called Herb Lamb Productions, and Disney eventually transferred the contracts for several such films to them. Campbell Grant, who worked on the Disney studio's military films during the war, attributed Disney's withdrawal from industrial films to his resentment of outsiders' involvement: "Walt got the impression, in more than a few cases, that he was being told how to run his own business."[89]

The elimination of industrial films as a financial backstop meant that the studio would be heavily dependent on the success of its theatrical releases, but in the immediate postwar period, the prospects for such films were newly harsh. As Disney wrote in his company's annual report for 1946: "The flush days of wartime,

when almost any motion picture found profitable reception at the box office, are gone. A seller's market has suddenly turned into a buyer's market."[90] Walt Disney Productions' revenues fell from $4.8 million in fiscal 1944 to $4.1 million two years later; its net income fell from nearly $500,000 to less than $200,000.[91] It was thanks only to reissues of *Snow White and the Seven Dwarfs* and *Pinocchio* that the company did not show losses in 1945 and 1946.

The prewar stock offering in Walt Disney Productions had been of preferred stock; the Disney family had retained all the common stock. The Disneys agreed in August 1945 to public owner-ship of common stock—and thereby to a dilution of their own control of the company—and the holders of 88 percent of the pre-ferred stock converted it to common.[92] Walt Disney Productions, once an elite sort of company that had given outside investors a seat at the foot of the table, was now a publicly owned corpora-tion like any other.

As chilly as the climate for new films was, Walt Disney did not give up hope of making feature-length cartoons again. In July 1946, he told the *New York Times* that he wanted to release three features a year: one combination of live action and animation, one compilation of short cartoons, and one full-length animated feature. He spoke of releasing *Peter Pan* as early as 1948.[93] Just a couple of weeks after that interview appeared, though, the Disney studio announced that it was going to lay off 450 employ-ees—approaching half the total work force—because of a 25 per-cent increase in base pay, granted the previous week; the Screen Cartoonists Guild had insisted on the raise in return for continued negotiations on other issues.[94] The number laid off actually totaled 459, leaving 614 on the staff. Work was halted on all but four features, two of them mostly live action and two of them package features.[95] Full-length animated features were again receding from any important place in the studio's plans.

What had borne the working title *Swing Street* in 1944 had become, by the time of its release in August 1946, *Make Mine Music*, a package feature subtitled "A musical fantasy in ten parts"—in other words, ten shorts linked to one another only through a common emphasis on the performers of the music for each segment. Much of the film originated before the war. Disney had once envisioned one of its segments, *Peter and the Wolf*, as part of the constantly changing *Fantasia* (the studio signed a con-tract with the composer, Serge Prokofiev, in February 1941),[96] and what emerged in *Make Mine Music* as "Blue Bayou" had been all

but completed for *Fantasia* as *Clair de Lune* (in *Make Mine Music,* an insipid popular song took the place of Debussy's tone poem). Even "Johnny Fedora and Alice Blue Bonnet," the romance of two hats, originated in Joe Grant's model department in 1939 as an idea for a short subject.[97] *Make Mine Music* is, compared with the prewar features, shallow and obvious for most of its length, but like *Saludos Amigos,* it proved that package features could be profitable: its negative cost was $1.37 million, the studio's receipts nearly $2 million.[98]

The more ambitious of Disney's two 1946 features had its premiere in November, in Atlanta, Georgia. This was *Song of the South,* as the Uncle Remus feature had come to be called. It was the first Disney feature that was fundamentally a live-action narrative film; the three animated inserts with Brer Rabbit, Brer Fox, and Brer Bear take up a total of about twenty-five minutes of screen time, spaced at thirty-minute intervals in the ninety-four-minute film, and part of that time is shared with Remus (James Baskett) himself.

Wilfred Jackson, who directed the animation, recalled that Disney got more involved in work on *Song of the South* than he had on some of the preceding features—a mixed blessing, as it turned out, because Disney balked at accepting the complexities of fitting animation to live action. (The combination work in *Song of the South* is so intricate that at one point a cartoon rail, painted on a cel, seems to be resting atop a virtually identical rail that is part of a full-size painted backdrop.) "Walt got pretty irritated with us on *Song of the South,*" Jackson said, "because of how carefully we were planning [the combination scenes] and how carefully we supervised what was done on the live-action set.... He thought we were spending too much money on the live-action part of the combination scenes. I think Walt was 100 percent wrong only that particular time, which is why we went ahead and did it anyway and got scolded."[99]

Combination work was, in other words, as frustrating to Disney as making industrial films: in both cases, the freedom that animated films offered was compromised by the need to defer to some external authority—the client in the one case, the live-action film in the other. (Disney had, after all, sharply diminished the live-action Alice's presence in his Alice Comedies of the twenties as that series progressed.)

When animation for *Song of the South* began, the idea of casting by character lingered: Marc Davis, the first animator on the film,

A Bill Peet story sketch of Brer Fox and Brer Bear for the Tar Baby sequence in Disney's Song of the South (1946). © Disney Enterprises, Inc.; courtesy of Phyllis Williams.

was given responsibility for setting the personalities of Brer Fox and Brer Bear when he started work on the Tar Baby sequence in October 1944. Milt Kahl followed on Brer Rabbit, probably by January 1945.[100] But once animation got under way in earnest, as Frank Thomas and Ollie Johnston later wrote, *Song of the South* became one of the first features "where all the supervising animators handled footage in large blocks," much as they had on *Bambi*. Thomas and Johnston linked this development to the story work, for which Bill Peed (later Peet) was largely responsible.

Joel Chandler Harris's Remus stories had much in common—their compactness, their admonitory flavor—with the fairy tales and animal fables that Disney had adapted to the screen so successfully in the previous decade. In some stories the conflict between Brer Rabbit and his adversaries is truly a battle of wits, an intellectual contest, but in others, the ones Disney chose to include in the film, Brer Rabbit's stratagems could be translated much more readily into visual comedy. The expressive sketches on Peet's storyboards suggested powerfully, for example, how the

animators might show Brer Rabbit becoming entangled in the tar baby. Peet, who started at the Disney studio as an inbetweener on *Snow White* and quickly became a sketch artist on first *Pinocchio* and then *Fantasia* and *Dumbo*, had gradually won more and more respect in the studio as an effective writer who was, unlike many of his colleagues in the story department, also a gifted cartoonist; it was easy to envision his drawings as animated cartoons.

Peet's versions of the Remus stories "called for much personal contact between the bear, the fox, and the rabbit," Thomas and Johnston wrote. "Also, his relationships demanded split-second reactions between characters that would have been impossible to handle in co-animation."[101] That is not a very persuasive argument for not sharing scenes, no more so than the arguments made by Thomas and Johnston in support of the way *Bambi* was animated. The animated segments in *Song of the South* are, in fact, the sort of material that Walt Disney would have assigned to the animators he called "caricaturists," like Bill Tytla and Ward Kimball, before the war, and not to the animators who wound up handling most of it. Four of the animators of the three animal leads—Davis, Kahl, Johnston, and Eric Larson—were veterans of *Bambi*; only John Lounsbery could be considered a caricaturist.

Although the animation in *Song of the South* defines the three characters clearly through their movements—the fox quick and nervous, the rabbit also moving rapidly but with more assurance, the bear slow and heavy—ultimately it is a little too restrained for it to be as effective as it should be. Such restraint was inevitable, given the way that the film was animated: had any one animator really seized a character in his scenes and interpreted that role in a vivid but highly individual way, his colleagues would have had to surrender themselves to his interpretation, or risk having their versions of that character differ too much. (Davis and Kahl, in their scenes with the characters they developed, show no such idiosyncratic tendencies.) The animation in *Song of the South* is, in this way, closer to the animation in *Bambi* than might at first be guessed. To conceive of how very different—and how much richer—the film might have been, it's necessary only to imagine what it could have been like if, say, Tytla had animated most of Brer Bear, and Kimball most of Brer Fox.

The cartoon part of *Song of the South* won general praise from reviewers when the film was released, but the sentimental live-action story—set on a southern plantation and turning on the friendship between Uncle Remus, the old black man, and

Johnny, a white boy from the "big house"—was judged far more harshly and sometimes condemned as racially backward. *Song of the South* was a box-office success, but not on a large scale: the film brought to the studio about a half-million dollars more than its negative cost of over two million dollars.[102] It was, in other words, not quite as profitable as *Make Mine Music*, even though it was considerably more expensive.

The tepid reception given *Song of the South* may have sealed the fate of another combination film. By the fall of 1945, work was well under way on such a version of *Alice in Wonderland*. Disney had hired the English writer Aldous Huxley, who had devised a story centered on Lewis Carroll and Alice Liddell, the little girl who gave her name to the Alice of Carroll's books. Huxley's story had Carroll and Alice misunderstood and persecuted by the adults around them—Alice by her nightmarish governess, Carroll by his fellow churchmen and academics. Ellen Terry, the actress, was to be sympathetic to both of them, and Queen Victoria was to act as deus ex machina, validating Carroll through her enthusiasm for his book.[103] Huxley's story was strikingly similar to the screenplay for the Uncle Remus film. In that story, too, a child and an eccentric, storytelling adult—Uncle Remus—have to endure the scorn directed at them by an unsympathetic adult world, until they ultimately triumph.

Alice was not the only combination feature Walt Disney was planning in the middle forties. In the fall of 1946, he and Perce Pearce, who had been in charge of *Song of the South* as its associate producer, spent several weeks in Ireland, preparing in some way for production of *The Little People*.[104] But it was *Alice* to which Disney had returned repeatedly since 1938. By the spring of 1947, though, when returns were in from *Song of the South*, *Alice in Wonderland* had fallen from the studio's own inventory of potential combination subjects. That list had grown to include *Treasure Island* and a Hans Christian Andersen feature (another recurring idea in the forties),[105] but combination features were probably losing their allure: if they were going to be so difficult and expensive to make, they had no obvious advantages over full-length animated features.

Thanks to postwar economic realities, Disney's return to the production of full-length features was slipping further into the future. In September 1947, he released another package feature (with some framing live action) called *Fun and Fancy Free*. It speaks painfully of how straitened the Disney studio's circum-

stances were then, both financially and artistically. "Mickey and the Beanstalk," the last half of the film, is in fact the low-budget Mickey Mouse feature that Disney had begun making in 1940 and had shelved in 1941; at roughly half an hour, it is none too short. The first half of the film is devoted to "Bongo," the story that Joe Grant and Dick Huemer had rejected as too thin to serve as feature material; the film version—in effect, a heavily padded short subject—makes their case powerfully.

Most of the Disney short cartoons released as shorts in the forties were even weaker than the shorts that made up the feature packages. The shorts had lost their stride in the late thirties, and they never really regained it. The Disney shorts were, moreover, about twice as expensive as those of most other studios, typically costing in excess of fifty thousand dollars each.[106] Disney talked late in 1946 of abandoning shorts if RKO could not command higher rentals.[107] The rare bright moments came in the first half of the forties in a series of Goofy cartoons directed by Jack Kinney. In that series, which began in 1941, Goofy struggled with the paraphernalia and the rules that defined a particular sport: first riding (*How to Ride a Horse*, released initially as part of *The Reluctant Dragon*) and then skiing and boxing. In 1942, the series' scope broadened to encompass team sports, with each team made up of multiples of Goofy himself; *How to Play Baseball* was the first. If Goofy in the first few "how to" cartoons resembled the self-confident idiot of the thirties, he was by the time of *How to Play Football* (1944) a wholly different character—or, really, not much of a character at all. He filled the screen as player and spectator, in a range of sizes and shapes, but the dozens of Goofys were just extras in Kinney's comic spectacle. This was comedy of a kind that had no precedent in the Disney cartoons, rooted as they had been in personality.

Most of the Disney shorts of the forties reflected, in their faltering tone, their directors' tenuous position within the studio. The form demanded that a director start with a clearly stated premise and develop it tightly—a discipline that these Disney directors usually violated, as if they were afraid to commit themselves to a distinct and possibly vulnerable point of view. Kinney, unlike the other shorts directors, moved back and forth between shorts and features; his first direction was on *Pinocchio*, on short sequences that showed Pinocchio and Geppetto inside the whale. He did not occupy the wholly secondary position of shorts directors like Jack Hannah, Jack King, and Charles Nichols, and his

Goofy shorts, strong ones and weak ones alike, are vigorous and self-assured in a way that theirs are not.

After *Hockey Homicide* (1945), though, Kinney directed no more Goofy shorts for four years, while he worked on as many package features; the weak "Bongo" section of *Fun and Fancy Free* is his. His occasional triumphs earlier in the decade probably occurred in large part because Walt Disney wasn't paying attention. Kinney spoke fondly of "a fun time at Disney's"—evidently the early forties—"when Walt didn't pay too much attention to the shorts. Really, we let ourselves go pretty well at that point."[108]

For much of the last half of the forties, Disney had no choice but to pay more attention to shorts—the ones that made up the package features—since he couldn't make films of any other kind. He scheduled *Melody Time*, a *Make Mine Music*-like package made up of musical shorts, for release in 1948. *So Dear to My Heart*, a live-action film with very brief animated inserts, and *Two Fabulous Characters*, another package feature, were to follow. Once again, in the latter feature, he would be salvaging discarded prewar work: one of the "fabulous characters" would be Toad, from *Wind in the Willows*, which like "Mickey and the Beanstalk" had been shelved in 1941. Disney had for several years toyed with the idea of releasing a truncated *Wind in the Willows* paired with something else; now he had finally settled on a newly animated cartoon based on Washington Irving's "Legend of Sleepy Hollow." And as for a full-length animated feature—late in 1947, in his company's annual report, Disney expressed what by then sounded like the forlorn hope that *Alice in Wonderland* would follow, finally, in 1950.[109]

Even employees who crossed the picket line thought that Walt Disney had been changed by the 1941 strike. "He never took the personal interest in people that he did before," the layout artist Thor Putnam said.[110] Said Bob Carlson: "He got hostile; it was as if he felt he couldn't trust anybody."[111] And from Joe Grant: "He was always suspicious of people after that."[112] The strike was to Disney an expression of a pervasive ingratitude, and it left him permanently wary of his employees.

In the forties, people who had been among Disney's mainstays were pushed out of the studio or sometimes into reduced positions within it. David Hand left in July 1944. "I got to a point in

the studio where I think I wasn't too welcome," he said almost thirty years later. "At least, I was made to feel that way."[113] Hand sought, and got, a release from his three-year contract, and in November 1944 he left for England, to set up a new cartoon studio for the producer J. Arthur Rank.[114] Norm Ferguson, who had been in charge of *Saludos Amigos* and *The Three Caballeros*, dropped back to animation after the war; the studio gossip was that he had somehow offended Disney. Joe Grant, who supervised *Make Mine Music*, insisted in later years that his departure in 1949 was "by mutual agreement."[115] He went into the greeting-card business.

In anecdotes that can be dated to the immediate postwar years, Disney often sounds strikingly adversarial in his dealings with his writers, in particular, and sometimes with his animators, too. "If no one [else] was in the room," Ward Kimball said, "if you were one-on-one with Walt, things were a lot more agreeable. He didn't feel he had to demonstrate his position, and you could talk with him.... But when you got into a room full of people, he was a different man."[116] If any employees emerged with their positions enhanced in the late forties, though, they were animators. Some of the dominant animators of the thirties, like Bill Tytla, had left the studio years before; Ham Luske had long since moved into direction; Fred Moore had been destroyed by alcohol. (Moore was fired in August 1946, and his rehiring a year and a half later— after he had worked as a freelancer on the Lantz cartoons—was essentially an act of charity.) Art Babbitt, who had successfully challenged his firing before the National Labor Relations Board and in the courts, returned to the studio briefly after his military service ended, but only as an act of defiance. The ascendant animators were not such veterans but men who, like Kimball, had risen to prominence on the early features.

In the postwar years, Frank Thomas and Ollie Johnston wrote, those animators broke out of the "isolation" they felt after the studio moved to Burbank: "With a smaller staff, team effort was stressed to an even greater degree, and Walt began to rely more and more on animation to carry the films."[117] Disney was making cheaper and less visually impressive features than in the past, and so he needed skilled animators who were also strong draftsmen—men who could dress up the films. Animators like Kimball, Thomas, and Johnston filled that bill precisely.

Disney's increased reliance on his animators did not mean that, at bottom, he regarded them any less skeptically than he

regarded his other employees. "He could be a better story man, he could be a better gag man," Kimball said, "but he couldn't animate, so there was a slight bit of respect there, but with a slight bit of smiling bitterness built in. He resented it, maybe, because he had to depend on us."[118] Kimball—possessed of a satirical, not to say cynical, turn of mind—was the animator who most thrived in the sharp-edged new environment. As Thomas and Johnston wrote of his work in *Three Caballeros* and *Melody Time*, with barely concealed condescension: "He was caricaturing the whole idea of his sequence, not just the action or the character, which enabled him to make a very direct and pure statement of what he considered funny."[119]

The comedy in Kimball's animation of the title song in *Caballeros*, and of Pecos Bill's hyperbolic adventures in *Melody Time*, is very broad. In *Caballeros*, for instance, it consists for the most part of taking the lyrics of the song very, very literally, but with never ending comic twists: when, for instance, Panchito sings of "guitars here beside us," guitars appear beside him and Joe Carioca as they gesture—but when Donald Duck does the same, a huge saxophone materializes. The animation, which could have made the song seem as heavy-footed as a comparable passage in, say, a Lantz cartoon of the early forties, is instead dazzling because Kimball's timing is so sharp, and his staging and incidental business so inventive.

In flippant animation of this kind, just as in Jack Kinney's Goofy cartoons, the vaunted "sincerity" of Disney feature animation was completely beside the point. Kimball made clear through his animation that he was not encouraging his audience to accept his characters as real; rather, he was putting as much effort into keeping everything on the surface as the other animators were into trying to suggest depth. Since by the late forties the Disney features offered few satisfactory avenues for animators who wanted to bring characters fully to life, that animator was best off who could enjoy his virtuosity for its own sake, as Kimball so clearly did.

The other animators knew that Kimball was enjoying himself, and they resented it. Kimball "always had a talent for protecting himself," Frank Thomas said. "He'd smell which way the wind was blowing on each picture, and take advantage of it."[120] Milt Kahl suggested that Kimball "didn't have the feel for getting the character's personality and making him believable that Frank or Ollie or I did."[121]

Kahl also claimed that he wound up animating realistically drawn human characters not because he was better at them than anyone else (although he probably was), but "because I was out-maneuvered." Disney did not frown on such intramural rivalry; he encouraged it. "Walt's basic credo [was] to play one guy against another," Kimball said. "If he had a director there who infuriated me and the other animators, it was good, it was healthy."[122] The director in question was Gerry Geronimi, who after animating for Disney in the thirties started directing shorts in the early forties and then moved up to features with *Victory Through Air Power*. Geronimi antagonized not just Kimball, who animated for him on both *Three Caballeros'* title number and *Melody Time*, but many other animators who worked under him. Geronimi himself found the animators not at all reluctant to take advantage of their stronger position within the studio: "When the pencil test came into the sweatbox, that's when the hollering really started."[123]

Such struggles for advantage had come to seem natural to Walt Disney, who by the late forties had spent almost a full decade living hand-to-mouth as a film producer. In the spring of 1947, so painful had his financial straitjacket become that he and Roy briefly explored the possibility of a merger of some kind with their distributor RKO, a dilution of their control of the studio potentially far greater than the outside ownership of stock they had permitted in 1940 and 1945.[124] For the Disneys to undertake production of a new feature of the old kind was thus a great gamble, but that is what they decided to do, apparently around the beginning of 1948—after strong disagreement between the two brothers. "Roy didn't want to make another feature, and they had a big battle about it," Bill Peet said. "Walt loved to tell me about it, as if I didn't know what was happening, as if I was a stranger."[125]

Disney had made a *Cinderella* Laugh-O-gram in Kansas City, and he had been interested in making a second version of Perrault's fairy tale at least since December 1933; an outline for a *Cinderella* Silly Symphony circulated in the studio then, listing characters that included "white mice and birds" that would be "Cinderella's play-mates."[126] The story was clearly too complicated to fit within a Silly Symphony's length, however, and thereafter *Cinderella* bobbed up occasionally as a possible feature. Various members of the staff wrote treatments starting in the late thirties, and in September 1943, Disney evidently gave his blessing to a "general plan of action" for production of the film, with Dick Huemer and Joe Grant as story supervisors (and an unrealistically low budget of a million

dollars). The work that followed did not progress past the preparation of storyboards.[127]

Disney held at least three meetings on *Cinderella* in March and April 1946,[128] but it was not until the next year that the film began to loom large in the studio's plans. Ted Sears, Homer Brightman, and Harry Reeves wrote a treatment dated 24 March 1947, and by May, according to a story inventory report prepared that month, a "first rough-out on storyboards [was] in process."[129] By early in 1948, *Cinderella* had shouldered past *Alice in Wonderland* and was firmly on track to be the first new Disney full-length animated feature since *Bambi*.

"Cinderella" as a story is probably much older than "Snow-White," but the fairy tales are similar. Members of the staff yielded variously to the temptation to exploit the resemblance and to the desire to minimize it. For instance, the March 1947 treatment introduced Prince Charming very early in the story, obviously mimicking *Snow White and the Seven Dwarfs*, but the May inventory report signaled a different approach: "We intend to tell this story largely through the animals in the barnyard and their observations of Cinderella's day-to-day activities." However much Disney wanted to avoid direct imitation—in a 17 March 1948 meeting, he said: "We can't have her go[ing] in and just doing a lot of work, and the animals coming in and helping her, because it's *Snow White* again"—he did not shrink from *Cinderella*'s general resemblance to *Snow White*. Writing in the studio's annual report at the end of 1948, he conveyed a genuine enthusiasm for *Cinderella*, expressing it through a comparison with the earlier feature: "Ever since *Snow White and the Seven Dwarfs*, I have been eager to make a full length all-cartoon feature which would possess all of that picture's entertainment qualities and have the same world-wide appeal. I think we have this picture presently in work. It is *Cinderella*."[130]

That similarity to *Snow White*, with its promise of comparable audience appeal, was a large part of what made such a feature conceivable. There was, however, a quid pro quo: to hold *Cinderella*'s costs under control, most of the film was, as Frank Thomas and Ollie Johnston wrote, "shot very carefully with live actors, testing the cutting, the continuity, the staging, the characterizations, and the play between the characters. Only the animals were left as drawings, and story reels were made of those sketches to find the balance with the rest of the picture."[131] Such filming, as Thomas said, "helped Walt see what he was getting before he spent his money on it."[132]

Starting in the spring of 1948, actors were filmed working to a playback of the dialogue soundtrack, and that film was run for Disney, Wilfred Jackson said, to "give him a feeling of the personality we were reaching for in the characters."[133] This live action differed from the live action shot before the war; its purpose was not at all to improve the animation, but only to control it and, above all, to hold its cost down. The animators felt highly restricted by the photostatic frame enlargements that they had to use to guide their work. "There was nothing imaginative, no scenes that started inside you," Thomas said, "because Walt had to find a cheaper way to make his picture."[134]

In other respects, too, *Cinderella* took on some of the coloration of a live-action film. The songs were recorded beforehand, as always; their timing dictated the timing of the accompanying animation. But there was no way to integrate music and action in the old way in the rest of the film when so much of its timing was dictated by live action. By the end of the war, Jackson recalled, it was becoming common procedure to "postscore" dialogue-heavy sequences in the Disney animated features, that is, Jackson timed the action in such sequences to a "free beat," without regard for the incidental music and without a musician's help. For the first time, during work on *Cinderella*, "action-oriented sequences," too, began to be animated to a free beat. Only after the animation was approved for inking on cels did Oliver Wallace compose the music, as he would have composed the incidental music for a live-action film.[135]

Walt Disney's own role was changing, too; in Jackson's account, he was coming to resemble a typical producer of live-action films—and he was, in fact, becoming one, since production of *Cinderella* overlapped with the shooting in England of his first wholly live-action feature, *Treasure Island*. Once envisioned as a combination film, *Treasure Island* had metamorphosed into a live-action film when expensive combination films slid out of the studio's plans. Shooting a live-action film in England also gave Disney the opportunity to spend British earnings that he could not transfer back to the United States under postwar currency restrictions. The three *Cinderella* directors—Jackson, Geronimi, and Ham Luske—communicated with Disney increasingly not in meetings but by sending him memoranda, scripts, photostats of storyboards, and acetates of soundtrack recordings; they mailed such things to him when he was in England for two and a half months in the summer of 1949.[136] Sometimes work went ahead when he did not respond—and then had to be undone when he

*Lucifer the cat in pursuit of Gus the mouse, from Disney's Cinderella
(1950). © Disney Enterprises, Inc.*

finally did.[137] However much *Cinderella* might resemble *Snow
White* as a story, and even as a film, Disney was making it in a
very different way.

During work on *Cinderella*, Ollie Johnston recalled, all the princi-
pal animators "were fussing with stacks of photostats"—except
Ward Kimball.[138] He animated the most important scenes of
Cinderella's mouse companions Gus and Jaq, and even more of
their nemesis, Lucifer the cat, and he supervised the rest; he had,
once again, "smelled which way the wind was blowing." In meet-
ings in which he reviewed animation for *Cinderella*, Disney wor-
ried aloud repeatedly that the live action was too confining—even
though it had to be, if it was to serve its purpose. Only in respond-
ing to the animation of the mice and the cat was he consistently
positive.

 Cinderella is easily imaginable as a live-action film for much of
its length. As in parts of *Snow White*, photography of a real young
woman's rather self-conscious movements can sometimes be

detected beneath the animators' drawings of the heroine (an impression heightened by Ilene Woods's voice for the character, which is stagy compared with Adriana Caselotti's ingenuous voice for Snow White). The mouse-and-cat episodes are like brilliant short cartoons inserted into this live-action film; there is even an intricate musical number, as the mice construct Cinderella's dress, that recalls the Silly Symphonies (Jackson directed that part of the film). Because the mice and especially the cat are Kimball characters, their comedy is broad comedy, deftly executed. There is caricature in Lucifer's appearance and movements, but there is ultimately no sense, as there is in so much of the animation in the early features, that Lucifer is anchored in physical reality, at two or three removes. The cat's mouth gives the game away—when he smiles, it stretches wide, to comic effect but in a manner wholly inconsistent with the idea that this is any sort of real creature.

Cinderella's principal characters are either bound too tightly to reality or a little too far removed from it to permit accepting them as the equals of the strongest characters in the earliest features. It took expert narrative carpentry—Bill Peet, listed first among the writers in the screen credits, did more of it than anyone else— to conceal the disparate nature of the different parts of the film. What happens to one group of characters is so tightly connected with what happens to the other group—at the climax, it is only because the mice are victorious in their conflict with the cat that Cinderella triumphs over her stepmother—that it's easy to overlook how little they have in common. Structural ingenuity could not, however, substitute entirely for a sense that the animators had become actors through their characters; *Cinderella* lacks the emotional coherence that permitted characters as different as Snow White and Grumpy to occupy the screen together comfortably. Walt Disney had returned to making full-length feature cartoons, but *Cinderella* was, at its heart, as much an uneasy combination of live action and cartoon as *The Three Caballeros*.

Cinderella's virtues were such, though, that when it was released nationally, in February 1950, it became the Disney studio's most successful release since *Snow White*. It cost around $2.2 million, little more than each of the two package features, *Melody Time* and *The Adventures of Ichabod and Mr. Toad* (as *Two Fabulous Characters* had ultimately been named), that just preceded it, but its gross rentals—an amount shared by Disney and RKO—were $7.8 million, almost twice as much as the two package features

combined. *Treasure Island*, released in July 1950, was successful, too, if on a more modest scale, yielding $4.6 million. The Disney studio found itself in financial good health for the first time in more than a decade.

More animated features were in the works—*Alice in Wonderland* for 1951, with *Peter Pan* to follow—along with another live-action feature, *The Story of Robin Hood*, to be filmed like *Treasure Island* in England. Live action, having proved its usefulness during work on *Cinderella*, would govern much of the animation of *Alice* as well. The Disney studio's ability to make truly animated features, like *Snow White* and *Dumbo*, had withered, even as its writers and animators became ever more skilled as craftsmen.

The values nourished at the Disney studio in its heyday, and the practices that flowed from those values, had proved to be terribly fragile. Transported to studios like those of Lantz and Terry—and even to the less hospitable environment of the Disney studio itself in the later forties—they had vanished as quickly as water poured onto desert sand.

The cartoons from two other studios evidenced respect for Disney's achievements, but they did not owe much to his example. It was those cartoons from MGM and Warner Bros. that Dick Huemer had in mind when he said that he and his colleagues at Disney's in the forties liked some of the cartoons being made elsewhere but had no desire to emulate them: "It was like admiring the kind of a dame that you wouldn't introduce to your mother."[139]

MGM,
1939-1952

When Bill Hanna and Joe Barbera began making cartoons together, it was at Fred Quimby's instigation. Hanna said that Quimby asked him and Barbera "to develop a cartoon" because Hugh Harman and Rudy Ising "were not able, physically, to turn out as many cartoons per year as MGM wanted."[1] It was probably Friz Freleng's departure from the MGM studio in April 1939 that triggered Quimby's interest in finding someone to make more cartoons. Hanna was the obvious candidate. From the time he was directing Captain and the Kids cartoons in 1937 and 1938, his diplomatic skills apparently served him just as well in his dealings with Quimby as they did while he was handing out work to his animators. In contrast to many of his colleagues—Barbera among them—Hanna had no criticism of Quimby: "My feeling with him was that he wanted us to make good cartoons.... We'd give him a paragraph [summarizing an idea for a cartoon], and he'd say fine, go ahead. He never turned down an idea."

Barbera, who was Hanna's almost exact contemporary (he was born in 1911, Hanna in 1910), had become a gag and story-sketch man for Freleng soon after he began working at MGM. Hanna had first known him as an animator, though ("I can remember handing out Katzenjammer animation to Joe"), and he saw in Barbera's draftsmanship a way to plug a gap in his own skills: "I had always been shy that talent that I felt I needed." Both Hanna and Barbera

were members of Rudy Ising's unit, and Ising worked with them on the story for *Puss Gets the Boot*, which pitted a large gray cat against a small brown mouse, after they began writing it on 8 May 1939.[2] Ising acknowledged that his role was minor. "Joe did most of the story sketches," he said, and Hanna "most of the direction."[3]

Even before Hanna and Barbera finished their first cartoon together, Quimby decided to put them at the head of their own unit.[4] Ising said that he got "fed up" with Hanna and Barbera "because of the conniving they were doing with Quimby.... I finally said, 'Go ahead and give them their own unit if you want to,' or something like that."[5] MGM announced the unit's creation in the trade press in September 1939.[6] Although Hanna and Barbera took *Puss Gets the Boot* with them to their new unit, it still bore Ising's name as producer when it was released in February 1940; in keeping with MGM's practice at the time, his was the only screen credit for an individual.

Puss resembles Ising's own cartoons in the way the characters look: Bob Allen, who designed Ising's characters, drew a model sheet for the cat and the mouse that is dated 8 August 1939, or about three months after story work began. *Puss Gets the Boot* also mimics Ising's cartoons in its rather labored pace. A subtle difference surfaces, though, when the mouse slugs the cat in the eye. Ising muffled such gags when he used them at all, but Hanna and Barbera show no comparable diffidence—the mouse quite literally does not pull his punch. The cartoon's Ising-like pace does not soften the gag's impact; if anything, it makes the gag more graphic by permitting a clear view of fist hitting cornea.

Quimby thus had good reason to believe Hanna and Barbera could bring to the screen cartoons more aggressively comic than those Ising was willing to make. They started *Swing Social*, their second cartoon together, while they were still in Ising's unit; then, on their own, they made two cartoons, *Gallopin' Gals* and *The Goose Goes South*, that were essentially blackout-gag cartoons like those that Tex Avery had been making at Schlesinger's and that every other studio had been copying. These were cartoons of the kind that Quimby had sought in vain from Rudy Ising; from the start, Hanna and Barbera were giving the boss what he wanted.

It was with their fifth cartoon, *The Midnight Snack*, that Hanna and Barbera returned to the cat and mouse that had starred in *Puss Gets the Boot*. They started writing *Midnight Snack* on 18 April 1940,[7] almost exactly two months after the release of *Puss Gets the*

Boot—long enough for favorable exhibitor reaction to get back to the cartoon studio.[8] A black maid in *Puss Gets the Boot* addresses the cat as Jasper, and he kept that name during early work on *Midnight Snack*, but by the time the cartoon was released in July 1941, the cat and mouse had become Tom and Jerry—a familiar coupling of names for cartoon characters since Barbera's former employer Van Beuren had used it for two human characters ten years earlier.

The two new codirectors hewed to the pattern they had established in making *Puss Gets the Boot*, Hanna said: "I would do all the timing on the bar sheets, and [Barbera] would do the sketches. We worked full size, and we didn't do storyboards.... I used to take those character layout sketches and time them, and then we shot them," as "pose reels," that is, each sketch was photographed under the animation camera for however long Hanna prescribed. The resulting reel, in its total effect, gave a rough idea of what the finished film would be like. In addition, Hanna said, he, and not Barbera, "always handed the animation out to the animators."[9]

Hanna thus directed much as Ising did, not by drawing but through the writing and control of the timing. Barbera played a role roughly comparable to Bob Allen's, telling the story not through a storyboard—although Ising's writers turned out lots of sketches, he rarely if ever put up a complete storyboard of the Disney kind—but through character layout drawings that doubled as story sketches. Hanna also inherited the use of pose reels from Ising, who made such reels from Allen's layout drawings. In the eyes of some members of the Hanna and Barbera unit, though, Barbera contributed much more than Hanna did.

Gus Arriola began working for Hanna and Barbera as a gag man around the time they were making *The Midnight Snack*. Not only did Barbera draw the character layouts, but he also came up with "about 75 percent of the gags," Arriola said. "He would inspire the rest of us to come up with material, because he was so fast."[10] Jack Zander, as an animator in the new unit, also noticed that Barbera drew very rapidly. More explicitly than Arriola, Zander described Barbera as the superior codirector: "The pictures were all Joe's, and the only thing that Bill did was write out the sheets.... Mostly we directed those pictures ourselves because all you needed were some good layouts, which Joe Barbera would provide.... We'd time it the way we felt like it."[11]

Barbera had the legs of his desk extended so he could work

standing up, Arriola said, "and I remember seeing long layout sheets hanging over the end of it because he would be laying out the whole background." There were limits even to Barbera's energy, though: after a few more pictures, Harvey Eisenberg began drawing finished layouts, for both characters and backgrounds, from Barbera's rough sketches. From then on, Hanna said, "we both spent most of our time on stories."[12]

It was in the writing of the cartoons that the two directors might have been expected to clash because they came out of such contrasting environments—Hanna from Harman-Ising, Barbera from Van Beuren and Terrytoons—and their taste in animated comedy varied accordingly. Hanna, said Michael Lah (who animated on *Puss Gets the Boot*), "loved cutesie stuff.... Joe was the other way, wild as hell."[13] Similarities to Ising's cartoons lingered in the early Tom and Jerry cartoons, especially in their deliberate timing, which was clearly attributable to Hanna. The Ising influence—and behind it the Disney influence—could also be felt in more constructive ways. *The Night Before Christmas*, released in December 1941, hinges on the successful characterization of the two antagonists. That characterization (which arises through Tom's response when Jerry kisses him under the mistletoe) is adequate to the purpose: it makes plausible Tom's change of heart near the end of the cartoon, and Jerry's consequent saving of Tom from getting his paw caught in a mousetrap. Cat and mouse are more like rival siblings than hunter and prey.

A Terrytoons flavor is, however, just as strong in *Officer Pooch*, released in September 1941. In this cartoon without Tom and Jerry, the title character is a canine policeman whose low-slung design and rubbery animation evoke the characters in midthirties Terry cartoons. As if it were a Terrytoon, *Officer Pooch* boils with activity, but there's no thought visible behind it; watching such a cartoon is like watching a plant grow in time-lapse photography. The Tom and Jerry cartoons themselves were rooted in a conception they shared with a great many Terrytoons: Barbera wrote many years later about how hackneyed cat-and-mouse conflict was in the eyes of his MGM colleagues at the time he and Hanna started making *Puss Gets the Boot*,[14] but such conflict was, in fact, far more common in the Terry cartoons than in any other studio's.

After *Officer Pooch*, Hanna and Barbera made almost nothing but Tom and Jerry cartoons. Even though Quimby had apparently planned for them, like Harman and Ising, to make cartoons

with a variety of characters, the Tom and Jerry series was proving to be too popular—or was judged as potentially too popular in a theatrical environment newly filled with aggressive, energetic characters like Woody Woodpecker—to waste them on anything else.[15] Any reconciliation of Hanna's and Barbera's different styles of cartoon making would have to take place within the confines of that series.

Closing the gap was, in part, simply a matter of picking up the pace. Tom and Jerry themselves, as relatively simple and inherently active characters, all but dictated faster timing. By 1942, in releases like *Dog Trouble*, Hanna's timing was becoming sharper than in the earlier entries; he was starting to break free from the music-based timing that he inherited from Ising. There are in *Dog Trouble* some animated equivalents of turning on a dime (as Tom flees from a bulldog), even though much of the timing is still dull and regular.

Increasingly, though, Hanna and Barbera dealt with their aesthetic incompatibility simply by ignoring it. A cartoon like *Fine Feathered Friend*, released in October 1942, was the result. Scott Bradley's music often sounds like the slightly sentimental score for a Harman or Ising cartoon, a hen looks like a Bob Allen design, and so on, but some of the gags are far more brutal than anything in an Ising cartoon (or, for that matter, in the earlier Hanna and Barbera cartoons). Twice, Jerry almost cuts Tom's head off with hedge clippers. In *Sufferin' Cats*, released in January 1943, there is prolonged business at a chopping block, first with Jerry, who is on the verge of being cut in two, and then with Tom, when a devil urges him to bring his axe down on another cat's skull. (This is one of the rare cartoons in which Tom pursues Jerry as a potential meal.)

The accommodation that Hanna and Barbera reached in cartoons like *Sufferin' Cats* entailed clothing a Terrytoons sensibility in a Harman-Ising shell. The drawing style and the animation— literal at its core, for all that it had speeded up—encouraged accepting the cartoon's world as a sort of reality. Translated into such a visual language, Barbera's broad and careless gags often suggested that the characters were suffering severe and extremely painful injuries.

That was the significance of the clippers and the axe. By 1937, when a memorandum titled "Tips to Remember When Submitting Gags" circulated in the Disney studio, many people in animation had recognized that preserving the body's integrity

From the Tom and Jerry cartoon Sufferin' Cats (1943), at the start of extended activity involving a very dangerous axe. © *MGM.*

was critical to the success of animated comedy involving characters like those in the Disney and Harman-Ising cartoons. As the memo said, "When a sharp, pointed weapon is used as a prop, it should never pierce any living character."[16] In the early forties, all the Hollywood cartoon studios were exploiting their characters' resilience (itself the fruit of a decade's experience with stretch and squash) by using those characters in gags more violent than the gags of a few years before. But sharp objects threaten to violate a cartoon character's body in a way that a blunt object does not: resilience is no real protection against a spear or an axe, as it is against a club.

Strictures like those in the Disney memo never had any force at a studio like Terrytoons; any shift toward aesthetic coherence tended to take place not out of conviction, but out of a dim awareness that better received cartoons were doing things differently. Hanna, by giving Barbera's gags respectable dress, alleviated any pressure for change that might have originated in such unfavorable comparisons, so that the Tom and Jerry cartoons of the middle forties actually manifested the Terrytoons sensibility more powerfully than did the contemporaneous Terrytoons themselves.

The MGM studio, as a physical facility, was the class of the industry, next to Disney; for Richard Bickenbach, who had been an animator for Friz Freleng at Schlesinger's, going back to MGM (where he first worked soon after the studio opened) "was like going from the slums to the elite."[17] The MGM directors also had more time to do their work; they made as few as four or five cartoons a year, half as many as the directors at some rival studios. The MGM cartoons were more finished looking than the norm for the period, just as the parent studio's features were, and that superficial gloss further obscured the Tom and Jerry cartoons' base origins.

Having no real center, the Tom and Jerry cartoons changed over time, but they did not evolve in the way that Disney's did. Even Tom's design differed markedly from film to film, as if Harvey Eisenberg never got a firm grip on the character. On into the middle forties, the Hanna and Barbera cartoons swayed back and forth between brutality and sentimentality, sometimes within the same film. The first half of *Baby Puss*, released in October 1943, is almost like an Ising cartoon—full of cute stuff, with no really violent gags. But its tone changes sharply as soon as three other cats appear and begin manhandling Tom. From that point on, even the sound effects contribute to the violence: when Jerry applies a nutcracker to Tom's tail, the resulting crunch is all too realistic.

In *Tee for Two*, released in July 1945, there is in one striking gag the suggestion that even Barbera's brutal comedy could have been reshaped into something more satisfying. Tom, fleeing from hornets, takes refuge in a pond, breathing through a reed—but the hornets pour down through the reed and, by implication, into Tom's mouth. "Then," as Mark Kausler has described it, "after we have waited *just* long enough, *all* the water...*flies* up in the air, and there is the most terrifying drawing ([by the animator] Ken Muse) of Tom being stung in his wide open mouth and throat by the angry bees, accompanied by the most anguished scream ever put on film."[18] As dreadful as that scene may sound, the sheer scale of Tom's reaction—so big it's preposterous—cancels out his pain.

By then, though, what had begun in the early Tom and Jerry cartoons as an accidental mating of incompatible elements was hardening into a formula, one in which the intention to inflict pain, and the suffering of pain, were everywhere present. Not only did Tom show no interest in eating Jerry, but the characters'

siblinglike rivalry in the early cartoons gave way to an unshaded thirst for damaging each other.

The Tom and Jerry cartoons were by the middle forties starting to pick up Academy Awards almost as regularly as Disney had in the previous decade. Hanna and Barbera's strong position with Quimby, and MGM's strong position in the industry, probably accounted for most of the five Oscars that the Tom and Jerry cartoons won during the forties. (Only one of Avery's MGM cartoons, *Blitz Wolf*, from 1942, was even nominated over that period; a Tom and Jerry cartoon was at least nominated every year from 1943 on.) Quimby seems not to have cut as much slack for Avery as he cut for his favored directors. Quimby "had no sense of humor," Avery said. "He was a dog, he was rough."[19] Then again, Avery tested Quimby's patience in a way that Hanna and Barbera never thought of.

The Avery and Hanna and Barbera units were "almost like two different studios," the animator Ed Barge said (he worked on the Tom and Jerry cartoons). The units did not have much to do with each other.[20] Claude Smith, who drew character layouts for Avery in the early forties, remembered that Avery was secretive about his gags and would cover his drawings when Hanna or Barbera came into his room.[21] Avery was a director apart: he had no roots in MGM or any allegiance to what had become the cartoon studio's normal ways of doing things. He claimed never to have used pose reels of the kind that Hanna relied on so heavily: "I was so sure of what we had in a picture that a pose reel would have meant nothing to me."[22]

When Avery started with MGM, though, he probably did try to adopt such methods for a while. George Gordon recalled putting together "two or three" pose reels for Avery—it may have been only one[23]—and there are other indications that Avery tried at first to supervise his cartoons in the relatively loose manner that was characteristic of Ising's unit in particular. Berny Wolf, who began drawing character layouts for Avery within a few months of Avery's joining the MGM staff in 1941, claimed to have exercised significant control over the cartoons' timing and staging, under Avery's general guidance: "Tex, [Richard] Hogan [Avery's story man on his first few MGM cartoons], and I would rap on story concepts.... To pick up on Tex's viewpoint...I would be

checking with him constantly."[24] In Wolf's account, so much did Avery delegate to him that he assumed responsibilities that at other studios would have been considered a director's, as with his preparation of the exposure sheets: "It got to the point where, instead of Tex doing the sheets himself...he'd lay them out very loosely and give them to me. I'd add the detail."[25]

Wolf may have overstated how much control Avery ceded to him, but such relaxed supervision would have been very much in keeping with the way things had been done at MGM. That way of working was, however, at odds with Avery's natural bent. Claude Smith, who began drawing Avery's character layouts in late 1942, after Wolf left for the army, recalled how intensely Avery approached work on a story: "The atmosphere built up like a cyclone.... Even Quimby stayed away during those story sessions. A story seemed to mushroom in about a week. The drawing of the story usually took an intense three days and sometimes nights. All fast. Then the stuff was ready for me."[26]

Avery's writers—first Hogan, from Schlesinger's, and then Heck Allen, Bob Allen's brother—served as what Avery called "bumpers"; as Avery said of Allen, "He could talk me out of things."[27] Allen, who had been Rudy Ising's principal writer for years, returned to MGM as Avery's story man late in 1942 after Hogan went into the army.[28] His experience with Ising undoubtedly prepared him to act as a restraining influence, since the Ising cartoons were so much more subdued than Avery's. Claude Smith, like Wolf, was a former Disney animator who wound up at MGM in the wake of the 1941 strike. Avery's unit in the early forties was always heavy with former Disney people; his two strongest animators, Ed Love and Preston Blair, had worked on Disney shorts and features. His animators at Schlesinger's had still been learning, Avery said, whereas "they were all improved at MGM; everyone was going up, we were getting better animation. They understood me."[29]

Avery's best MGM animators were about as skillful as Bob McKimson, the best of his animators on his Warner Bros. cartoons—and to roughly the same effect. In appearance and general atmosphere, the first MGM Averys, like *The Early Bird Dood It!* and *Blitz Wolf*, both released in August 1942, resembled the Tom and Jerry cartoons being made around the same time. As in the Hanna and Barbera cartoons, Disney-flavored drawing and animation did not fit comfortably with the kind of comedy that the director favored. In Avery's cartoons, though, there were almost

*Tex Avery, around the time he started work at MGM in 1941.
Quigley Collection, Georgetown University.*

none of the painful injuries that were becoming increasingly
prevalent in the Tom and Jerry cartoons; Avery, unlike Hanna
and Barbera, understood the hazards involved in piercing his
characters' bodies. Aesthetic conflict surfaced in Avery's cartoons
not through a violation of the body, but as a violation of style.

Such violations occurred sometimes in Avery's Schlesinger car-
toons, where the dominating presence of McKimson's very subtle
and realistic animation made them all the more glaring. At one
point in Avery's fourth Bugs Bunny cartoon, *All This and Rabbit
Stew*, Bugs registers surprise by literally going to pieces: his arms,
legs, and head separate from his torso, even though there has
been until this point no suggestion that the characters' bodies are
not flesh and blood. It was rare, though, especially in his MGM
cartoons, for Avery to announce so openly that his ideas about
comedy weren't wholly compatible with the kind of animation he
had welcomed into his films. Much more common was a quiet

tug-of-war that took place without anyone's being fully aware of it. Avery's gag ideas constantly called into question the existence of his characters, even as the animation implicitly criticized those ideas for being so bald and unshaded.

Avery actually gave up vital ground as soon as his story sketches passed from his hands into those of his character layout artists (or model men, as he sometimes called them); it was they who established the Disney-like drawing style of his films in the early forties. In animating for Avery, Preston Blair recalled, "I would use a lot of Claude Smith's [character layouts] just verbatim [as animation drawings]; there was no sense in doing anything [else] with them."[30]

Sometimes Avery tried to turn the talents of his layout artists and animators to his advantage, as in *Red Hot Riding Hood*, released in May 1943; it was the third of his MGM cartoons to go into production. The cartoon presents Red Riding Hood as a sexy nightclub singer drawn in a generally realistic style, the sort of character that was well within the range of a former Disney animator like Blair. The wolf is a playboy, and Red's Grandma the occupant of a glamorous penthouse (Blair said that Avery "was thinking of Peter Arno," the *New Yorker* cartoonist who specialized in the sexual comedy of cafe society).[31] Red Hot Riding Hood was not really a radical departure for Avery: he had already used realistically drawn human figures of the McKimson kind in some of his later Schlesinger cartoons, notably the caricature cartoon *Hollywood Steps Out* (1941). And he had shot live action of a strip teaser as a guide for one of his animators in *Cross Country Detours* (1940); although the strip teaser in the cartoon is a lizard (shedding its skin, you understand), it is only one short step removed from its human original.

What most set Red Hot Riding Hood apart from her predecessors was not her design or even her sexiness, but that Blair animated her without using live action as a guide—"Quimby would never have paid for it," he said (although Quimby was probably never asked)—and instead turned out drawings laboriously, at a footage rate about half that of his colleagues.[32] That was, Avery said, "the only time that was ever allowed."[33] It was as if, given that he had animators who could do such things, Avery felt compelled to let them, in just the way he had surrendered to McKimson's talents in his Schlesinger cartoons.

In *Little Red Walking Hood* (1937), one of Avery's fairy-tale parodies for Schlesinger, the wolf's interest in the girl is sexual, but

only in the most general and innocuous way—he is merely a walking pun. In *Red Hot Riding Hood,* by contrast, in keeping with the girl's much more realistic design, Avery depicted the wolf's arousal far more explicitly (if by no means literally). The gags in the first half of the film are metaphors for the wolf's sexual arousal; in the second half, the wolf flees from Red's grandmother, whose interest in *him* is sexual, too. Jack Stevens, who was an animation cameraman for MGM in the forties, remembered being present—the time was probably October 1942—when Avery and Quimby looked at what Stevens called a "first cut" for a film that was almost certainly *Red Hot Riding Hood.* When Quimby expressed doubts, Avery said, "Oh, Mr. Quimby, let's try it," and Quimby went along—to his regret, perhaps.[34] *Red Hot Riding Hood* ran into such serious objections from the Production Code Administration that parts of it had to be remade.

The difficulty did not lie in the wolf's lust for Red; Avery toned that down while the cartoon was still being written, substituting for the originally planned reactions (panting, sweating, emitting sparks) some others that studio executives evidently could accept as less suggestive (whistling, beating on the nightclub table, eyes popping out). The critical territory was, rather, Grandma's lust for the wolf and what Avery originally showed as the consequences of it: namely, the wolf and Grandma wound up married (by a justice of the peace who, in a surviving publicity still, looks very much like Avery himself). At the close of the film, the wolf and his superannuated bride were in a theater box, cheering for Red— along with their three lustful wolf-cub children.[35] The fragmentary surviving evidence suggests strongly that the Production Code Administration objected to this denouement, finding in it too strong a suggestion of bestiality.[36] The original ending gave way in the finished film to one in which the despairing wolf shoots himself with two pistols; his shade cheers and whistles in his stead.

Even that image of Grandma as the mother of the wolf's children might have slipped past the censors if *Red Hot Riding Hood* did not make the implicit claim, as embodied in the drawing and animation of the girl, that on some level it took sex seriously. The Disney coloration of Avery's crew thus worked against him even when he had come up with an idea that seemed to take advantage of its strengths. *Red Hot Riding Hood* was an exceptionally popular cartoon[37]—it entered theaters in May 1943, in the midst of the wartime rise in the country's sexual temperature—but it is at

heart no less confused than the other cartoons Avery was making for MGM in the early forties: there is the same conflict between animation that yearns for subtlety and comedy that scorns it.

In some cartoons, Avery actually seems embarrassed by the obviousness of his gags. In *Batty Baseball,* released in April 1944, the name of the baseball stadium is "W. C. Field," and under that name appears this line: "The guy who thought of this corny gag—isn't with us any more." Avery had occasionally made such a mock apology in his Schlesinger cartoons, most notably in *Cross Country Detours*: immediately after the narrator, Robert C. Bruce, says, "Here we show you a frog croaking," the frog shoots itself and a card appears onscreen, announcing that the theater's management disclaims any responsibility for the puns used in the cartoon. The timing of the frog's "croak" is perfect, though—there's no opportunity for an audience to anticipate the gag—and so the "apology" is more like a smirk. The frequent apologies in Avery's early forties MGM cartoons are much closer to the real thing and so much more at odds with Avery's greatest strength, as manifested most clearly in Schlesinger cartoons like *Porky's Duck Hunt*: his seemingly intense belief in even his most preposterous gags, and his comparably intense effort to present those gags with just the right kind of finesse—to display his jewels, such as they were, in the most appropriate setting.[38]

Finesse was all important. *Batty Baseball* resembles Avery's blackout-gag cartoons for Schlesinger, and like those earlier cartoons, it was born of an impulse no more elevated than the one that gave rise to such pitiful specimens as a Van Beuren cartoon called *The Ball Game* (1932). That cartoon is a string of simple gags that resulted when someone said, "What kind of gags do you get when you cross bug gags with baseball gags?" or words to that effect: a mosquito catches a ball on its stinger, a caterpillar swings four bats, and so on. Even Avery's sustained intensity—his willingness to carry anything to extremes, as with the drunken fish singers in *Duck Hunt*—can be seen in embryo in a Van Beuren cartoon like *Barking Dogs* (1933): as a villainous wolf tries to break into a girl's house, andirons in the shape of dogs come to life and bark, but then the andirons remain prominent characters, finally thrashing the wolf in a climactic battle. (They never seem to be real dogs either; their long bodies slither like snakes.)

The difference between those cartoons and Avery's lay almost entirely in execution, which was, of course, vastly superior in Avery's. It was not good enough, however, to overcome the doubts

One of the censored scenes—their offense was the suggestion of bestiality—from Avery's Red Hot Riding Hood *(1943). The justice of the peace is a caricature of Avery himself.* © *MGM.*

raised constantly by both the nature of the animation and Avery's own occasional sheepishness. Just as Avery admired his animators' skills, so his animators admired his audacity; but their mutual esteem, and the deference it encouraged, aggravated rather than eased a fundamental incompatibility. The Disney influence was all-pervasive, and yet there was in Avery's MGM unit no dominant animator, like Bob McKimson, who could bend the cartoons toward a path of his own choosing—who could make them his cartoons, as much or more than Avery's, and in doing so bring about a character like Bugs Bunny.

Avery introduced only one character in his MGM cartoons who was clearly envisioned from the beginning as a continuing star: Screwy Squirrel, who first appeared in April 1944 in *Screwball Squirrel*, and then in Avery's next three cartoons. Screwy embodied the contradictions that beset Avery's films. On a model sheet for the character, Claude Smith instructed the animators that keeping Screwy's nose low on his face made him cuter (presumably by making his facial proportions more like those of a human

baby, a standard animation formula for cuteness). In his handling of the character, though, Avery went out of his way to minimize such appeal. He evidently modeled Screwy on the lamentable example of Woody Woodpecker, but in place of Woody's manic laugh, he gave Screwy a harsh cackle—Wally Maher provided Screwy with the voice of Wilbur, the uncouth adolescent he portrayed on the radio show *Tommy Riggs and Betty Lou*.[39] Screwy had an even more disagreeable mannerism, again picked up from Maher's Wilbur: a conspicuous sniff that makes him sound like the first cartoon star to suffer from postnasal drip. The films' most assured gags are reflexive—as when Screwy lifts the corner of the screen to see what happens next—and such gags are the most at odds with interest in the characters themselves.

Mercifully, the Screwy Squirrel series was replaced by more cartoons with Red Hot Riding Hood and the wolf; three were released in 1945. Avery had started work on two of them by the fall of 1943, in response to the popularity of *Red Hot Riding Hood*.[40] (Another small measure of the first cartoon's success was that for the second, *The Shooting of Dan McGoo*, some film was shot of what Preston Blair called a "contract dancer," and he used live action as a guide for "bits and pieces" of his animation.)[41] Avery's timing in his MGM cartoons had mostly been laggard; the Disneyish animation was a drag in that as in other ways, discouraging him from going as far toward an arbitrary and unrealistic timing as his gags often demanded. In his third Red Hot Riding Hood— *Swing Shift Cinderella*, released in August 1945—the timing is a little crisper, perhaps, than in his earlier MGM cartoons. It's also wittier: the wolf has a delayed reaction to his first sight of the girl—he descends without pause into gibberish when he realizes how sexy she is—and the audience is tricked into a delayed reaction to *his* delayed reaction because the transition into the gibberish is so smooth and unaccented, both vocally and visually.

By 1944, in his third year as an MGM director, Avery was beginning to assert himself in the way he had in some of his Schlesinger cartoons. For the mock western *Wild and Woolfy*, released in November 1945, Claude Smith was still drawing the character layouts, but Avery's own drawings are noticeably closer to the surface. (Smith's initials are on the model sheet, which is dated 5 May 1944—wartime delays were beginning to slow down release of the cartoons.) The horses' anatomy in particular bears almost no resemblance to that of real horses; they are pure cartoon horses, with sausage bodies and clodhopper hooves, but

they are still well drawn—not softened and nudged a little closer to real horses, in the Disney manner, but drawn as Avery would have drawn them himself, if he were a better draftsman, or if he were taking more time.

After Smith left the Avery unit late in 1944, the animator Irven Spence began drawing Avery's character layouts. Spence, who had been animating for Hanna and Barbera, had no Disney experience (he worked at the Iwerks and Schlesinger studios in the thirties). More than his predecessors, he translated Avery's ideas into finished drawings without embellishing them. Avery "would plan out the scene with very rough sketches—very little detail," Spence said. "I would take his sketches and clean them up and make some nice poses, and I would add a lot of them, too." Even though Avery's "style was just real sketchy," Spence said, "the drawing was there, the pose was there."[42]

In the middle forties, then, just as Avery's cartoons hit bottom, they began to brighten, with drawing and timing better aligned with the gag ideas at their core. How well those gags would acquit themselves without any artificial barriers in their way was always an open question. Nothing could have saved *Batty Baseball*, for instance, and even as Avery's cartoons improved, the pedigrees of some of his gags necessarily gave pause. In *Wild and Woolfy*, a wolf villain pushes a section of roadway around so that it will lead a pursuing posse over a cliff; Paul Terry's Farmer Al Falfa had done exactly the same thing in 1928, in an Aesop's Fable called *Coast to Coast*.

Avery's influence sometimes showed itself in the Tom and Jerry cartoons. When a girl cat responds to Tom's zoot suit in *The Zoot Cat*, released in February 1944, her eyes bug out, and she whirls in excitement until her legs are braided. The echoes of the wolf's excitement in *Red Hot Riding Hood* are unmistakable. Distortion as a metaphor for sexual arousal was much less common in the Tom and Jerry cartoons, though, than distortion as the product of violence. For the most part, the Hanna and Barbera cartoons moved on a separate track from the Avery cartoons, truly as if they were coming out of two separate studios. Influence, when it flowed from one MGM unit to another, ran another way—not from Hanna and Barbera to Avery, but from Hanna and Barbera to the studio's third unit. That unit, in its various incarnations, was

essentially a continuation of Rudy Ising's unit; under its different directors, it made cartoons starring Barney, the bear who first appeared, nameless, in Ising's *The Bear That Couldn't Sleep* (1939).

George Gordon became an MGM director again in July 1942, probably in anticipation of Ising's leaving to head the Army Air Force's animation unit, and he began making the Barney Bear cartoons after Ising left. Gordon, like Barbera a former Terrytoons animator, brought a Terrytoons sensibility to his cartoons, too. Gordon had been animating in the Hanna and Barbera unit, and their example could only have reinforced what was a natural inclination on his part; there is no trace in the Gordon cartoons of anything that could be attributed to Avery.

After Gordon left in 1943, there was a hiatus of about three years when there were only two units. In early 1946, when Mike Lah and Preston Blair began directing as a team on Barney Bear cartoons, it was, the screen credits said, under the "supervision" of Hanna and Barbera. The new team's cartoons—there were only three of them before the unit broke up—were, like those of their "supervisors," full of gags made painful by their fundamentally literal animation: in *The Bear and the Bean*, released in January 1948, parts of Barney's body swell as if they were truly flesh on the verge of bursting.

What gave Hanna and Barbera such authority in the MGM cartoon studio was not simply success in the theaters and at the Academy Awards, or their being on good terms with Fred Quimby. By the middle forties, the Tom and Jerry cartoons exuded the powerful self-confidence that a successful formula bestows. For one thing, the cartoons *looked* slick. By the time of *Solid Serenade*, released in August 1946, the inconsistencies in Tom's appearance from cartoon to cartoon had been almost entirely smoothed away; he was sleeker, his body not so bulky as before, and his design less cluttered by hair and by superfluities like dots on his muzzle (although those still turned up some scenes, no doubt thanks to animators who were used to drawing Tom that way). Jerry underwent fewer changes, probably because his design was more economical to begin with; he mainly became cuter.

Dick Bickenbach began drawing layouts for Hanna and Barbera in 1946. Like Harvey Eisenberg before him, Bickenbach redrew Barbera's sketches as character layouts and sometimes, as he explained, added drawings: "Whenever I had a chance, like if somebody turned, I'd throw in about three drawings for a turn."

Bickenbach's drawings were polished and very much on model, and such detailed guidance contributed mightily to the cartoons' glossy surface, but his drawings, unlike those of Tex Avery's lay-out artists in the early forties, did not bend the cartoons in a direction that was recognizably the layout artist's rather than the director's. "It was tied down very tight for poses—what they wanted to see," Bickenbach said. "If [Barbera] wanted a certain look on Tom or Jerry, he would have it down there, and I had to get that in this pose, in the size that they wanted."[43] When Hanna handed out sections of a film to the animators, Ed Barge said, he gave them not just the exposure sheets and Bickenbach's layout drawings, but also Barbera's story sketches.[44] Barbera "really was my boss," Bickenbach said. "He was the one I had to please."

Hanna and Barbera worked together on the stories, seated at desks facing each other, with what sounds like the comfortable familiarity of an old married couple. Bickenbach, who worked in the next room, observed them as they assembled stories: "They talked it over all day long, between the two of them.... 'Well, the little guy does this, and he goes here, and he does this'—that's the way their story came out. It wasn't written, to begin with. They had a basic plot, maybe...and they'd work at it as they went along."

As in the early days of their collaboration, Barbera probably came up with most of the gags, but during the handouts to the animators, Hanna was clearly in charge. Said Irv Spence: "When I would pick up...Bill would have all of the timing on the exposure sheets, for every little thing, every little accent, every little bit of action.... Bill acted out *everything*."[45] It was Hanna, Ed Barge said, who "was just a genius at picking out a few frames here and adding a few there to make something stand out a little better" when he reviewed an animator's pencil tests on a Moviola. Hanna and Barbera both looked at pencil animation in the early years, Barge said, but later Hanna alone looked at the pencil tests, while "Joe stuck strictly to boarding," that is, to drawing the sketches that Bickenbach transformed into layouts. It was, however, Barbera to whom the animators went if they wanted to make a significant change in a Bickenbach pose: "Joe was the drawing man."[46]

The sense always in the Tom and Jerrys released in the late forties and early fifties is that directors, animators, and layout artists are pursuing their objective as relentlessly as a cohesive infantry squad. A high level of expertise manifests itself literally

down to the frame, as in the razor-sharp timing in *Kitty Foiled*, released in May 1948: at one point, Jerry, disguised preposterously as a tiny, lethargic Indian, turns around very slowly to look back toward Tom, and then breaks into a high-velocity run with Tom right behind him. In contrast to typical practice, Jerry begins running instantly; there's none of what animators call "slowing in," no building up of speed, and the comic contrast between Jerry's very slow walk and very fast run is all the more striking as a result.

By the late forties, too, Scott Bradley's music was very much of a piece with what was happening on the screen. Bradley had been the composer for Harman-Ising in the thirties, and in the early years of the Tom and Jerry series his scores didn't always fit: his score for *The Million Dollar Cat*, released in May 1944, sounds like ordinary dance-band music, related only tenuously to the cartoon action. But as Hanna and Barbera perfected their formula, so did Bradley: in *Puttin' on the Dog*, released in October 1944, a cartoon filled with furious activity, his music stokes the feverish atmosphere as much as mirrors it. He was cultivating a musical equivalent for the screen violence, and within a few years he had achieved it.

Like Carl Stalling, his counterpart at the Schlesinger studio, Bradley used a lot of familiar tunes—for instance, "Sweet and Lovely" and "Don't Get Around Much Any More" in *The Mouse Comes to Dinner*, released in May 1945—but they tended to be more sophisticated songs than those Stalling used. Bradley was, moreover, a serious composer whose works were performed by the orchestras of both Los Angeles and San Francisco; separate his music from the cartoons and for some long stretches it could be confused with a particularly cold and disagreeable contemporary classical score. What truly set Bradley apart from Stalling was a cynical, opportunistic streak in Bradley's scores. Stalling, when confronted with a weak cartoon, had difficulty pretending that it was any better than it was, as when in his accompaniments for some of Chuck Jones's cartoons of the late thirties and early forties, he clearly marks time while waiting for something to happen on the screen. Bradley was ever the brassy pitchman, trying to drum up excitement even when a cartoon was a stinker.

(Bradley and Avery—one of the least cynical of directors—did not get along. "Tex Avery didn't like my music," Bradley said. "We disagreed a lot on what kind of music was appropriate for his

Bill Hanna (left) and Joe Barbera act out the storyboard for the Tom and Jerry cartoon Two Little Indians *(1953) for their boss, Fred Quimby.*

cartoons. His ideas on music were so bad that I had to put a stop to it.... I gave in to him for a while, but finally I went down to see Quimby in his office and complained.... And Quimby backed me up."[47] Exactly when that happened, or what it meant, is not clear; but Bradley's music was never as obtrusive in Avery's cartoons as it was in many of the Tom and Jerry cartoons.)

In their music, as in every other way, the Tom and Jerry cartoons were the fruits of painstaking calculation and highly developed skills. But the cartoons' very polish—because it made so clear that nothing got into them by accident—emphasized the contradictions that had been integral to the Tom and Jerry series from the beginning. Hanna and Barbera never addressed the aesthetic issues that the violence in their cartoons constantly raised; there's no reason to believe that they ever recognized that such issues existed. The collaborative effort that went into making the Tom and Jerry cartoons was so thoroughly harmonious that it foreclosed anyone's raising such fundamental questions.

As if to compensate for their consistently high level of violence, the Tom and Jerry cartoons in the late forties began to offer

ever larger helpings of sentimentality. It consumed whole car-
toons, like *Heavenly Puss*, released in July 1949. There is remark-
ably little comedy in that cartoon, which has Tom seeking a seat
on the "Heavenly Express," a train headed for Paradise, after he
has been crushed by a piano; at one point, some kittens come
sloshing up to the reservation desk in a water-logged sack.
Heavenly Puss confesses its fraudulence when the cartoon's feline
equivalent of Saint Peter reveals that Tom's mortal sin is "perse-
cuting an innocent little mouse"—a sin that is convenient rather
than credible, since every cat would be guilty of it.

In other cartoons, sentimentality manifested itself in the for-
mulaic adorability of characters like Nibbles, the baby mouse who
is the title character in *The Little Orphan*, released in April 1949.
Cute kittens that could have come straight from Bob Allen's
model sheets for Rudy Ising turned up with increasing frequency
in the Tom and Jerry cartoons of the late forties and early fifties.
In some cases, such characters *did* come from old model sheets:
a model sheet for the goldfish in *Jerry and the Goldfish*, released
in March 1951, is exactly the same as the model sheet for Ising's
Little Goldfish of a dozen years earlier.

As sentimentality grew in importance, those rare moments
when the violent gags had any real emotional content—some
point other than pain—all but disappeared. In the 1946 cartoon
Solid Serenade, Jerry hits Tom with a cream pie that has a comi-
cally superfluous iron in it. Although Tom's face is flattened
momentarily, he looks not injured but disturbed—his song has
been interrupted, as if by a heckler, and *that* is what bothers him.
Nuances of that kind gave way in the late forties and early fifties
to generalized, repetitious facial expressions; Tom and Jerry (and
the supporting characters, too) all scowled exactly the same
way—brows knitted, lower lip stuck out—and they scowled a
large part of the time.

The Tom and Jerry formula, like any successful formula, could
not be sustained indefinitely, and cracks were starting to show by
the early fifties. A cartoon like *Cat Napping*, released in
December 1951, suffers not just from gags that are often unpleas-
ant, but from gags that are just too silly: it defies belief, on the
terms already set by the cartoon itself, that Jerry could kick a frog
so precisely that it would land in Tom's drinking glass and that
Tom would not notice that he was sucking the frog through his
straw and into his mouth.

In addition to such failings, the Tom and Jerry cartoons of the

early fifties were very noisy. The same loud sound effects—glass breaking, explosions, crashes—turned up over and over again. That was, however, just what the stories called for. The monotony was built in. It was no wonder that even Hanna and Barbera were finally getting tired of it.

"During the Warner days, I was just learning timing," Tex Avery said in 1977. "I feel that it took me about eight years to get my timing the way I liked it"[48]—until, that is, sometime in the early to midforties. That was when the timing of Avery's MGM cartoons quickened noticeably, a development of critical importance to his cartoons.

It is easier for an animator to deal with an action that "seems a little rushed," as Ed Barge said—because not enough screen time has been allowed for it—than with one that is a little slow. Clarity alone can save a rushed scene, but a distended scene requires an inventiveness that not every animator can muster. As Avery's cartoons speeded up, they depended more on the strength of the characters' poses, which originated with him and his layout artist; greater speed thus gave Avery the opportunity for greater control.

It was not until 1946 that one of Avery's cartoons signaled unmistakably that he was picking up the pace. That cartoon was *Northwest Hounded Police*, which was released in August of that year. It had gone into production in the fall of 1944 and was the last Avery cartoon on which Claude Smith worked. *Northwest Hounded* is superficially similar to Avery's fourth cartoon for MGM, *Dumb-hounded*, which was released in March 1943. In the earlier cartoon, a wolf convict (essentially the same character Avery had just used in *Red Hot Riding Hood*) breaks out of prison and is pursued by bloodhounds—and by a terribly wrinkled, molasses-slow dog that somehow awaits the wolf wherever he flees, even if it's the North Pole. (Avery told Joe Adamson that the dog, who much later acquired the name Droopy, was "built...on a voice," specifically Bill Thompson's mush-mouthed Wallace Wimple voice for the *Fibber McGee and Molly* radio show: "It was a steal; there ain't no doubt about it."[49] Thompson also provided the voice for the dog.)

That the phlegmatic dog could anticipate the frantic wolf's every move, much less beat him to every hiding place he chose, was, of course, a ridiculous premise; it thus offered a challenge

tailor-made for Avery since the premise had to be argued with utter conviction to conquer an audience's natural reservations. That was where *Dumb-hounded* failed, a casualty of the ongoing tension in Avery's early cartoons between his own predilections and those of his artists. *Dumb-hounded* moves a little too slowly, and the wolf's reactions when he sees Droopy are too mild, so there are too many opportunities for doubt to insinuate itself. *Northwest Hounded Police* is built on the same scheme—this time the lupine convict flees from a Droopy who is playing the role of Sergeant McPoodle of the Mounties—but it is a much stronger cartoon than *Dumb-hounded*. The characters move with a new quickness that is more compatible with the gags because it is just as unrealistic as they are. But speed also makes the cartoon more purposeful because it transforms what had been a merely ridiculous idea into one that is truly insane: Droopy, like God, is everywhere (or, as it turns out, exists in uncountable multiples of himself, an idea no less crazy). Avery is so relentless in his timing that this governing dogma brooks no dissent. The wolf's takes are far more extreme than in the earlier film, to the point that not just his face and body but the stripes on his prison uniform react hysterically to the sight of Droopy, and so, paradoxically, they are more plausible. When the wolf flies apart as Bugs Bunny did in *All This and Rabbit Stew*, his reaction seems perfectly normal under the circumstances. It is as if Avery were taking Aristotle to heart: "A likely impossibility is always preferable to an unconvincing possibility."[50]

In the cartoons that followed, after Irv Spence began drawing his layouts, Avery's own drawings rose ever closer to the surface of his films. Those drawings, like the ones shaping the animation of a bulldog in *Hound Hunters,* released in April 1947, were not just crude cartoons, but were very simple and direct. That quality had been compromised in even the best translations of Avery's drawings by his layout artists and animators, but now it was becoming more clearly visible as his unit saw the departure of some of its strongest talents. *Hound Hunters* was the last cartoon on which Ed Love animated for Avery; the next, *Uncle Tom's Cabaña*, released in July 1947, was the last for Preston Blair before he began directing with Mike Lah.

Uncle Tom's Cabaña is, of course, another burlesque of *Uncle Tom's Cabin*, on the order of Avery's *Uncle Tom's Bungalow* for Schlesinger. But, in places, the animation differs sharply not just from the animation in that 1937 cartoon but from the animation

in Avery's MGM cartoons of only a year or two earlier. As Simon Legree strides across a room, toward a map that shows Tom's little plot of land, the camera pans with him. He walks onto and across a desk that is in his path—but the top half of his body moves in a straight line, as his legs scrunch up to accommodate the height of the desk, and he misses not a beat as he walks. There's a faint bow to animation of the Disney kind—Legree's trunk and arm move slightly, in a cycle, as he walks—but Legree's movements as a whole are highly stylized because of the arbitrary patterns that Avery has imposed on them. Such crisp stylization was alien not just to the Disney cartoons but also to Hanna and Barbera's.

Avery's next cartoon, *Slaphappy Lion*, released in September 1947, was his first without either Blair or Love. He was working now with less distinguished animators, and there was for the first time in one of his MGM cartoons a notable lack of any Disney gloss; there was instead a stronger reliance on poses derived from Avery's own drawings. Avery was more fully present in his cartoons now than he had been for a decade, since his early days at Schlesinger's, and he had become a far more skilled director since then.

It was not, however, until he made his next cartoon, *King-size Canary*, released in December 1947, that he finally shed the Disney-flavored drawing, animation, and character design that had compromised his cartoons since he went to work for MGM. He may have been working without a character layout artist when he made *King-size Canary*. (The model sheet, unsigned and dated 30 January 1946, looks like the work of the animator Walt Clinton. Irv Spence had left the studio for another job by then—the model sheet for *Slaphappy Lion* was his last for Avery—and when he returned to MGM later in 1946, it was as an animator for Hanna and Barbera.) At the least, whoever was drawing the layouts did not sweeten Avery's own drawings. The cartoon that resulted was the strongest that Avery had ever made.

King-size Canary is, like *Northwest Hounded Police*, a cartoon that ruthlessly pursues a single crazy idea: in this case, that Jumbo-Gro, a plant food, can stimulate instantaneous giantism, first in a canary and then in a cat, a mouse, and a bulldog. Not only are the Disney-like moorings of the earlier cartoons gone, but in *King-size Canary* Avery actually works pretty hard to minimize any temptation to regard the characters as individuals: he gives each of them the identical head-scratching gesture and

sound effect when they're puzzled, for example, and, as drawings, they are all generic (the cat in particular could pass as a feline version of a tramp from many twenties comic strips).

Even though the animals cover a great deal of ground—at one point the giant cat chases the giant mouse through the Grand Canyon—they do not live in anything like a real world; there are no people in it, even on city streets. In Hanna and Barbera's 1945 cartoon *Mouse in Manhattan*, the city seems simply empty; there is no cycle animation of crowds, of the kind that could have made the cartoon seem fully populated. In *King-size Canary*, by contrast, there's never any doubt that Avery wants the city streets clear, the better to depict what really interests him. He never trips over any details—people on the street or anything else—that might obscure the audience's view of his comic structure. As Clare Kitson observed in notes for a 1972 Los Angeles County Museum screening of the film, "the cat's vest, never growing an inch, gets tinier by the moment as his shoulders grow to enormous proportions." A more careless director might have permitted the cat's vest to grow along with him—or Avery might have devised a somewhat different premise that permitted a growing vest. Or he might have dispensed with the vest entirely. But having made his choice, he stuck with it, accepting an artistic discipline that was too often lacking in his films.

The critic Vincent Canby, writing about Harold Lloyd's silent feature *The Freshman*, could more appropriately have been discussing *King-size Canary* when he invoked "a series of gags so beautifully timed and choreographed, and so disconnected from character, that the comedy appears to be surreal, if only because there is absolutely no subtext. It exists in an emotional vacuum."[51] That may be true of the comedy in Lloyd's film, but it is not true of the film itself, which depends ultimately for its appeal on Lloyd's own earnest, dogged persona. In Avery's cartoon, on the other hand, there is nothing but the comedy, as cold and impersonal as an asteroid hurtling through space.

Having attained such a pinnacle, though, Avery immediately began sliding down it. Cartoons like *Northwest Hounded Police* and *King-size Canary* were inherently demanding; packages of gags were easier to deal with. Avery had turned to them repeatedly throughout his career, beginning with his travelogue parodies for Schlesinger, so it would not have been surprising if his cartoons had slipped back into that pattern. What he did instead, though, was return to the prison from which he had just escaped: his

cartoons again began showing a strong Disney influence.

What Price Fleadom, released in March 1948, was Avery's first cartoon after *King-size Canary*. In it, as in the immediately preceding cartoons, Avery's presence is stronger, through his poses, than it was in the cartoons he made when he had a more Disney-flavored crew. There is, however, an element of cuteness in the story, and especially in the handling of the flea, that has no parallel in *King-size Canary* or *Slaphappy Lion*. The flea looks like the character in Rudy Ising's *The Homeless Flea* (1940), and the story owes altogether too much to the 1938 Disney cartoon *Goofy and Wilbur* (Wilbur is Goofy's pet grasshopper; in Avery's cartoon, a flea is a hound's pet rather than his parasite).

Little 'Tinker, released in May 1948, looks and moves very differently from *King-size Canary*. Louie Schmitt, yet another former Disney animator, had begun drawing Avery's character layouts by June 1946, when *Little 'Tinker* was in production, and there were, as well, two animators (Bill Shull and Grant Simmons) new to Avery's crew who had worked at Disney's. The results were not happy: in *Little 'Tinker*, cuteness is pervasive. Its opening encounters between the lovelorn B. O. Skunk and various girl animals have a bargain-basement-*Bambi* flavor that undermines the comedy; the girls' reactions to the skunk's smell can't come close to being extreme enough. At one point, the skunk, disguised as a fox, gets so excited his body runs out from under his head, but this cavalier treatment of his body is in effect a mockery of the audience, which by then is supposed to feel something for the skunk; not even having Bugs Bunny's body fly apart was as much a betrayal. Avery had boxed himself in: he had to provide a comedy of character that was basically alien to him. The shallowness of his characters, which he had used to such advantage a couple of films ago, now worked against him.

In the cartoons that followed, the battle lines kept shifting, as Avery reclaimed and yielded ground. For example, *Bad Luck Blackie*, released in January 1949, actually starts as if it might build up the same single-minded energy as *Northwest Hounded Police* and *King-size Canary*, but it runs down in its second half. By the time of *Señor Droopy*, released in April 1949, the bright stylization in some of Avery's earlier cartoons was reasserting itself: at one point, the wolf—here, Droopy's rival as a bullfighter—bows repeatedly to the bullring crowd from the waist, and as he does, he is absolutely motionless from the waist down, bending as if on a hinge.

Miraculously, Avery was able at this time—even with Preston Blair once again gone from his unit after a brief return when the Lah-Blair unit shut down—to revive the Red Hot Riding Hood character and to make the first cartoon with her that was wholly successful when measured against Avery's own highest standards.This was *Little Rural Riding Hood*, released in September 1949. The key was that he compartmentalized Red Hot Riding Hood: she appears only in Blair animation picked up from *Swing Shift Cinderella*, as a nightclub singer (the song is "Oh, Wolfie"); for the first time in any of her five cartoons, she is never onscreen with other characters. The wolf plays not against her, but against himself; he is divided into two characters, a testosterone-crazed country wolf and a butter-wouldn't-melt-in-his-mouth city wolf. The country wolf moves with a jittery excitement, the city wolf with a cool elegance. The strong stylization in the city wolf's movements (when the wolves enter a nightclub, he all but glides) was of the sort that Avery used only when he was most confident, and so least solicitous of his collaborators.

The wolf, in any of his incarnations, was not much of a character; he was never vague, but he was always distinct only as a frantic creature caught in the web of Avery's gags. It was inconceivable that he had any life off the screen. Avery never gave him a name; indeed, through his indifference to names—Droopy did not get one until *Señor Droopy* came out, six years after the character's first appearance—Avery expressed a clear disregard for the fundamentals of cartoon stardom. Characters of the Disney kind, with real personalities, were limiting in a way that conflicted with Avery's preferences in comedy.

The Avery character who most nearly approximated a character in the Disney vein was not the wolf, or Droopy, but a bulldog who was, typically, identified at one time or another as "Butch" or "Spike" (both generic names for a bulldog, of course). He first appeared in *Wags to Riches*, released in August 1949; it was Avery's first cartoon after *Little Rural Riding Hood*. In it there's a sense, stronger than in any cartoon since *King-size Canary*, that Avery's own sketches are present not far beneath the animators' drawings, particularly in the bulldog's poses. Those poses are very strong statements, without a trace of ambiguity, and Avery, by giving them just enough time on the screen—even while maintaining a rapid pace—brings out their strength.

What made the bulldog something like a real character was that Avery's directness of presentation tied into a directness of

personality. There could have been a hidden side to Droopy's personality if he had had a personality; but with the bulldog, everything was in plain sight because he was always cast as so desperate a character. In cartoon after cartoon—the bulldog turned up in eleven Avery cartoons released between 1949 and 1952—he really seemed to believe in what he was doing. For at least some of those cartoons, Avery's character layouts were drawn by Gene Hazelton, who was a sort of utility layout artist for both the Avery and Hanna and Barbera units. Hazelton learned to resist the temptation to dress up Avery's rough sketches, even though they were "simple as hell, almost a childlike drawing.... I finally got smart, and whenever Tex gave me a layout, no matter how crude it was, I traced it and just rendered it up a bit. It *had* to be that way, to be a personal statement by Tex Avery."[52]

As sturdy as he was, though, the bulldog had his limits. For *Droopy's Double Trouble*, released in November 1951, Avery gave him a voice (with an Irish accent, probably because the story required a voice and Bill Thompson had an Irish accent handy). The voice diminishes him; for one thing, his directness is compromised by the more naturalistic timing the voice imposes on him. Avery's cartoons were, as always, surprisingly vulnerable to such damage—and that was when the cartoons were not hopelessly weak to begin with, as was more and more the case at the beginning of the fifties. Even though the bulldog dominated the schedule (sometimes in tandem with Droopy), he was often the saving grace in otherwise slack packages of overly familiar gags. The cartoons that filled out the schedule were usually much worse: "cheaters" made up of visual puns, or virtual remakes of much earlier cartoons. *One Cab's Family*, released in May 1952, is an astonishing throwback: the story of a family of automobiles, told with scarcely a trace of irony. It differs from Friz Freleng's 1937 Schlesinger cartoon *Streamlined Greta Green* mainly in its brighter colors and less fussy drawing style.

By early in 1950, around the time he was making that cartoon, Avery had stretched himself to the limit. He was intensely involved in every detail of his cartoons, not just roughing out a drawing for every foot of film,[53] but calculating pan moves ("so I'd have an opening where I wanted it") and timing everything to the frame ("I was very strict with my timing").[54] Avery's cartoons, like all the Hollywood cartoons at the time, required both exposure sheets and bar sheets. Typically, a director prepared one set of sheets first, and then an assistant of some kind transferred the

necessary information from that set of sheets to the other. With Hanna and Barbera, as with Freleng, the bar sheets came first, followed by the exposure sheets. Avery started with exposure sheets, and he transferred the information from them to the bar sheets himself rather than entrust the job to someone else. "I was a particular devil," he said. "I did too much work."[55]

He was, said Mike Lah, who animated for Avery in the late forties, "a worry wart about everything; I mean he really was a worry wart."[56] In direct contrast to Hanna and Barbera, Avery seems not to have been particularly comfortable with the collaborative nature of animation and of filmmaking in general; he too often allowed his collaborators to dilute his own strengths, most notably where his character layout artists were concerned. Avery did not want his animators to use his own drawings, Lah recalled, even though it was Avery's style that made the drawings funny; Avery thought his drawings too crude. He was usually at his best when he wasn't working with anyone—writer, animators, layout artist—who could trump him in a particular specialty. But such circumstances also encouraged him to do more work.

"That's why I took a year off," Avery said, "because I I attempted to do everything. I would come in on Saturdays and flip drawings and change timings that I'd perhaps seen in pencil test the week before. Rather than involve the guys, I would pull out drawings, perhaps, and change a little timing."[57] By the middle of May 1950, he had left the studio on a sort of sabbatical, surrendering his director's chair to Dick Lundy.[58]

Warner Bros.,
1941-1945

Avery's departure from the Schlesinger studio, which might have seemed disastrous a few years earlier, did not have that effect in 1941. The studio had achieved an identity that did not depend on a single director, even though Avery had contributed more to it than anyone else. In 1940, Avery's *Detouring America*, one of his travelogue parodies, had been nominated for an Academy Award as best cartoon of 1939—the first Schlesinger cartoon to be nominated for an Oscar. The next year, *A Wild Hare* was nominated. Neither cartoon won, but the Oscar nominations were evidence not just of Avery's growing reputation but of the Schlesinger studio's new stature in the industry.

That stature had been fairly won; many people at the studio had learned to do their jobs better, particularly the animators. By the early forties, the Schlesinger animators had at last achieved a rough parity with the Disney animators in basic techniques, even though they were by no means indulged like Disney animators. Most of them were expected to produce enough drawings each week, with help from assistants and inbetweeners, to fill twenty-five feet of thirty-five-millimeter film apiece, a requirement common to most of the studios making short cartoons in the forties. Ordinarily, only one pencil test, of the finished animation, was permitted; a second test of a corrected scene was a rarity.[1]

Leon Schlesinger was never mesmerized by the Disney

cartoons, even after the success of *Snow White and the Seven Dwarfs*, and he rejected (in earthy terms) any suggestion that he make an animated feature.[2] The Schlesinger studio had grown several times over since 1933, but it was still a small operation, especially measured against the requirements a feature would have imposed: in 1939, when Disney employed more than a thousand people, Schlesinger employed fewer than two hundred.[3] Around that time, the character designer Bob Givens was drawing story sketches, "and I was trying to make some good things out of them—fun drawings, Disney-type things," using washes, crayon, and pen and ink. "Leon saw me one day doing them, and he said, 'Cut out the Rembrandt, kid. Just do a bunch of them.'"[4]

Tightfisted though he was, Schlesinger still could give his animators the support they needed—the assistants and inbetweeners—because such help came cheap. Like the other cartoon producers, he benefited first from the pool of talent that the Depression made available, and then from the Disney strike; a number of former Disney employees joined the Schlesinger staff after the strike was over. The people who came from Disney's new Burbank studio to work on the Warner cartoons were shocked by the shabby Schlesinger plant. Said Bill Melendez, a Disney alumnus who joined the Schlesinger staff as an assistant animator:

> They had never painted the place. The windows had never been washed, they were filthy. The building was so unfinished that the metal cross beams overhead were all exposed. The partitions were just cheap wallboard; the guys could punch holes in it with their fists. There were coffee stains on all the walls—and guys would throw grapes at the walls, and draw little eyes on the stains.[5]

The studio's animation desks and camera stands, many of them undoubtedly dating from the studio's earliest days in 1933, were rickety and makeshift—"nailed together by whoever had a hammer and saw and nails," the animator Ben Washam said.[6] Unlike the animators' desks at the Disney and MGM studios (and much to the amazement of the Disney animators who joined the staff after the strike), the Schlesinger desks had no rotating discs that permitted the animators to turn their drawings as they worked on them, without removing them from the pegs that held the drawings in place.

And yet the studio was "completely open and completely silly,"

the background painter Paul Julian said.[7] Because "every room opened onto [one of] the two halls, upstairs and downstairs," said the story man Don Christensen, another former Disney striker, "it was a mixer, all the time."[8] The Schlesinger studio underwent its own brief labor crisis in late May 1941, just before the Disney strike; Schlesinger closed the studio for two days when the cartoonists' union threatened to strike over his refusal to sign a contract (he eventually signed one for three years).[9] So relaxed was the atmosphere, though, that the confrontation damaged it only a little.

Bob Clampett replaced Avery as a Schlesinger director, moving up to the color unit after more than four years as a director of the black-and-white Looney Tunes. Clampett's place was taken by one of his animators, Norm McCabe. Soon after McCabe became a director, his Looney Tunes unit moved into the main building at Fernwood and Van Ness, effectively erasing the distinction between the "Katz unit" and the three "Schlesinger units."[10] At about the same time, the studio began erasing the distinction between Looney Tunes and Merrie Melodies. Starting in February 1942, when Warners exercised an option in its contract with Schlesinger,[11] half the Looney Tunes were made in color; all of them were assigned to the three Merrie Melodies directors (Friz Freleng, Chuck Jones, and Clampett), who no longer had to make any black-and-white cartoons. The remaining black-and-white Looney Tunes were left to McCabe.

Frank Tashlin, after four years at the Disney and Screen Gems studios, returned to Schlesinger's in September 1942 as a story director,[12] but he replaced McCabe as a director after a few weeks, when McCabe joined the army.[13] "I kept leaving," Tashlin said, "and when I came back, I had lost my seniority, I had to come up from the cellar again." Tashlin resented being "stuck with the damned pig. It takes him so long to talk."[14] He was soon directing color cartoons again, though, because in April 1943 Warners ordered that all the Looney Tunes be made in color, starting with the 1943-44 season.[15] From then on, there was no real difference between Looney Tunes and Merrie Melodies.

When Clampett took Avery's place, Bob McKimson still reigned as the unit's principal animator. His understated kind of animation dominated the first few cartoons Clampett made with his new

unit, much as Chuck Jones's animation dominated the first few Clampett Looney Tunes. But in 1942, as in 1937, Clampett soon tilted the cartoons away from a literal, restrained style. "McKimson's control became abrasive," Clampett said, speaking of McKimson's role as head animator. "It stopped any experimentation. I, in effect, knocked him out of that," by freeing the unit's other two experienced animators, Virgil Ross and Rod Scribner, from any duty to answer to McKimson.[16] In this freer atmosphere, Clampett discovered Scribner's hidden talents.

Bill Melendez, who was Scribner's assistant in the early forties, described him as "a tough little guy, kind of gristled, with beady blue eyes, and he had a funny grin all the time, kind of a crooked grin.... He was a fitting partner for Clampett, except that Rod was a little more down to earth, I thought, and perhaps not as creative as Clampett in the story sense. But a lot of fun to work with."[17] Clampett himself described Scribner as "a little mischievous elf" who harassed the Jones unit, in rooms directly below Clampett's, by dropping "something like a manhole cover" on the floor to create a tremendous noise.[18]

Scribner came to the Schlesinger studio soon after it opened. He was an assistant animator by 1935 and an animator for Avery by the late thirties. Like everyone else in the Avery unit, Scribner worked in McKimson's shadow; his animation in the Avery cartoons has few distinctive contours. It was under Clampett, in an atmosphere more tolerant of idiosyncrasy, that Scribner flourished. He found ways, Melendez said, of "making the job a little fun and different."[19] He often animated in ink, with a pen or a brush—the sort of thing that could, and apparently did, create crises in the ink and paint department since Scribner's drawings were, in Melendez's words, "very bold and kind of dirty," and the women transferring his drawings to cels had to choose which ink lines to trace.

Clampett recalled that soon after he took over the Avery unit, Scribner proposed introducing a "Lichty style" of drawing into the cartoons. Scribner was referring to George Lichty, the newspaper cartoonist whose "Grin and Bear It" panel cartoons were masses of very loose and fluid lines that somehow added up to very lively and funny figures. Animation of such drawings would, if it caught the spirit of the drawings at all, necessarily be very loose and fluid, too. "We studied it, and discussed what could be animated and what couldn't," Clampett said. "And I told him, 'Now, as we go along here, I will try to find places that you can experi-

ment and try some of these things that you have the urge to do.' Then we'd come to a scene, and I'd say, 'Okay, Lichty this a little.' He would be so enthused."[20]

This Lichty style asserted itself late in 1942 and early in 1943 in two Clampett cartoons: first in parts of *A Tale of Two Kitties*, the cartoon that introduced the bird character Tweety, and then to stunning effect in *Coal Black and de Sebben Dwarfs*, with an all-black cast. In many of Scribner's scenes in those cartoons, the characters are highly elastic, squirming like excited rubber bands; their bodies become wildly distorted, almost beyond recognition. A lot of this distortion is visible on the screen, but what is not clearly visible, because it occupies only a single frame of film, is even more spectacular.

In the early thirties, animators' extreme distortion of the body—as the characters did impossible things—had destroyed any illusion that the characters were real, but Scribner's Lichty animation had the opposite effect: it made the characters more believable. It succeeded in part because Scribner could draw much better than most of the animators of the early thirties, but the more significant change was not in draftsmanship. The earlier animators and directors had imposed distortion on their characters for the sake of a gag; they worked from the outside in. Clampett took the opposite approach: he permitted Scribner to introduce distortion only when it could be seen as the expression of a character's own powerful emotion—the stronger the emotion, the wider the range of acceptable distortion. When Prince Chawmin' in *Coal Black* attempts to awaken So White with a kiss, his body writhes with incredible intensity, but Scribner's animation is not simply wild—it registers an enormous variety of mental states as they flare through the Prince's brain, everything from extreme overconfidence to frenzied determination to the bleakest despair. The animation is both flamboyant and precise, revealing a tumultuous inner life.

Coal Black is not so much a parody of *Snow White and the Seven Dwarfs* as a reversal of it; there is no hint of ridicule of the Disney film. The Queen, icily beautiful in *Snow White*, is in Clampett's film an Amazon. Snow White, demure, barely more than a child in the original, becomes So White, a sexy babe. Prince Charming becomes the zoot-suited Prince Chawmin'. *Coal Black* was released four

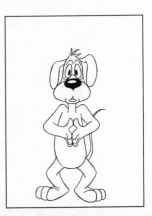

months before Avery's *Red Hot Riding Hood,* which also uses a fairy tale as a starting point and does not really parody it. But otherwise the two cartoons are strikingly different, especially in the way in which their characters are presented. When Avery's wolf explodes in lust, it is not his passion that Avery shows—as Clampett shows the passion of his characters—but rather elaborations on the *idea* of lust, as if Avery were seeing how many metaphors for sexual desire he could find before he crossed the boundaries imposed by the Production Code. Avery's cartoon may in fact be funnier than Clampett's—at least on a first viewing—because Avery was a better builder of gags, but Clampett's cartoon is far more exciting, because its emotional content is so much richer and because Clampett had so much keener a sense of how energy could be released through rapid changes in shape.

Clampett took pains with *Coal Black* to the point of having Scribner draw a large number of styling sketches that were given to the animators in addition to the character layout drawings.[21] Full-blown Lichty animation appears only in Scribner's scenes, but the other animators gave to their animation some of the energy of Scribner's drawings, so Scribner's hand is visible everywhere, even when it is obvious that particular scenes were not animated by him. This combination—of Scribner's unique animation, Clampett's insight into how it could be used most effectively, and the other animators' willingness to follow Scribner's lead—produced extraordinary results. In Scribner's animation, as in Bill Tytla's, the line between "inner" and "outer" disappears; everything that is going on inside the characters is instantly visible. The characters in *Coal Black* were the first Warner characters to be fully alive, as the Disney characters were alive, but no one could confuse Clampett's cartoon with a Disney film.

The characters in *Coal Black and de Sebben Dwarfs* embodied a paradox because they originated in racial stereotypes—always a means of denying individuality rather than creating it. It was as if these abundantly alive creatures had no business being alive at all. They appeared, moreover, when such stereotypes were cresting in the Warner cartoons. Racial stereotypes had hardly been absent from the prewar cartoons: the Warner cartoons started with a stereotypical black character, Bosko himself. Jewish stereotypes popped up occasionally in the Harman-Ising and

Schlesinger Merrie Melodies (as one did even in Disney's *Three Little Pigs*, when the wolf disguises himself as a peddler), but they were little more than casual reflections of the dialect humor that was a staple of vaudeville and radio. Likewise, the cartoons using black stereotypes were broad and bland. The characters in those cartoons ate watermelon and rolled dice and did everything that black stereotypes were supposed to do, but there was scarcely a hint that the people who made the films had ever paid much attention to real blacks. (African Americans held only menial jobs in the industry itself.)

The wartime cartoons with racial stereotypes were much more pointed than their predecessors; here, as in other ways, the Warner animators brandished new skills. Some of the wartime stereotyping portrayed the Japanese enemy as jabbering, buck-toothed runts, but more of it was directed at African Americans. Black characters were now drawn and animated with a sharpness that reflected close observation; but that observation was of performers who themselves conformed to stereotypes. The Stepin Fetchit characters in Avery's *All This and Rabbit Stew* (1941) and Chuck Jones's *Angel Puss* (1944) are more like Fetchit than Fetchit himself. Fetchit is not caricatured in a way that suggests any criticism of his shuffling and mumbling; those characteristics are simply magnified for what is supposed to be comic effect, but reeks more of contempt (Avery's Fetchit character was identified on the model sheet as "Tex's Coon").

Coal Black and de Sebben Dwarfs—so seminal a cartoon in other ways—was also the only Warner cartoon of the World War II period to transcend its origins in racial stereotypes. Clampett traced his conception of the cartoon to a Duke Ellington revue, *Jump for Joy*, that enjoyed great success in Los Angeles after it opened in July 1941. He said that when he went backstage to meet the performers, "they said to me, 'Why don't you ever use us?'" Out of that encounter grew visits to the studio by members of the cast, auditions for voices, and work on an all-black musical. Clampett went to a black nightclub, the Club Alabam, and later took his animators there so that they could study the dancing.[22]

Coal Black's characters snap and bounce continuously to bright and jazzy music; Clampett said that he wanted to have black musicians play the entire score, but management turned

him down. A black trumpeter and drummer play when Prince Chawmin' is trying to awaken So White with a kiss, but otherwise the music was composed by Carl Stalling and played by the Warner Bros. orchestra. (Similarly, a few bits by a black trumpeter were permitted in Clampett's *Tin Pan Alley Cats*, which he made a few months after *Coal Black*; the principal character is a cat modeled on Fats Waller.)

Clampett said that he invited the performers who came to the studio to criticize the story and the gags as they developed.[23] It is impossible to know how free those performers felt to object to anything they found offensive, especially since they may have believed that jobs were riding on their opinions. (Several African American performers provided voices for *Coal Black*: Zoot Watson is Prince Chawmin' and Vivian Dandridge is So White.) The National Association for the Advancement of Colored People considered the film insulting to African American soldiers—the Sebben Dwarfs are in uniform—and called upon Warner Bros. to withdraw it.[24]

Coal Black does not, however, contain a great deal of specifically racial elaboration on its basic idea of a reversal of *Snow White*. One of the dwarfs is a Fetchit character, and when Prince Chawmin' flashes a brilliant smile, his two front teeth are dice and all his other teeth are gold. But other than that, the characters are comic exaggerations of the kind that one would expect in a cartoon, particularly one of Clampett's. It is almost incidental that they are black. In contrast to the other wartime cartoons on racial themes, *Coal Black* bases its appeal not on the stereotypes themselves, but on the energy that Clampett poured into them in response to the energy he found in black dancers and musicians. It is a transforming energy; there is no way to read *Coal Black* as a commentary on racial stereotypes since it does not condemn them or endorse them, but it does, in the end, render them irrelevant.

Bill Melendez complained that Chuck Jones's animators, in their room below the Clampett animators, ignored the Clampett unit's practical jokes: "They were very snobbish, they were the 'A Unit.'... It was kind of embarrassing, at this shabby studio, to have this kind of nonsense."[25] Ben Washam, one of the Jones animators, said of that unit: "We got a funny kind of reputation around

there, for reasons I could never quite understand. We were called the Boy Scout unit and 'Unit A,' and we had the reputation of feeling we were a little better than anyone else. And all we did differently from anyone else was study."[26]

Most members of Jones's unit, if not all, stayed after work a couple of nights a week in the early forties to sketch from models, using Kimon Nicolaides's *The Natural Way to Draw* as a guide. Other units occasionally had such classes, too. The problem (as far as the rest of the studio was concerned) was not that Jones's people studied; it was that many of them took their studies, and their work, seriously, in a way that was implicitly critical of everyone else. Paul Julian, Jones's background painter from 1939 to 1941, recalled that Jones "had a very verbal attitude toward the morale of his unit. They were united in a spirit of brotherhood, and he saw to it that they stayed that way."[27] Jones attracted animators who were willing to accept the discipline, including the director's plentiful drawings, that went with trying to meet Disney standards.

Almost everyone else in the studio admired the Disney cartoons, too; whether or not they liked Jones's cartoons, they could understand what he was doing. Sometimes, though, for some people at the studio—including his boss—Jones crossed a line that separated grudging acceptance from annoyed bafflement. Jones cited what happened when he made *Little Lion Hunter* (1939), a cartoon starring Inki, a black African child:

> They hated it, both New York and Leon Schlesinger, but the exhibitors and the audience loved [it].... The word got down to Leon, and Leon told me to do another one. I said, "Well, you hated the first one, I don't see why you [want to] do it now." He said, "I changed my mind." Of course, what he meant was that he had received word it had done well in the theaters.[28]

Inki himself was always drawn with a surprising lack of comic exaggeration, even though the second and third cartoons in the series were released in 1941 and 1943, when racial caricature was peaking at the Schlesinger studio. The cartoons were made memorable, though, less by Inki himself than by his co-star, the Minah Bird, a dark, impassive creature that was drawn as, more or less,

a large crow. The Minah Bird was the only Warner cartoon character that was unmistakably supernatural—not in a literal, banal sense, like a cartoon ghost, but in the sense of being in touch with powers so vast that human lives are puny by comparison. In *Inki and the Minah Bird* (1943), the Minah enters a clump of straw, which then hops in the Minah's distinctive gait. But the straw dwindles as it goes, until finally nothing is left. A little later, a single piece of straw moves along the ground in the Minah's rhythm, and gradually other pieces of straw join it, until the original clump of straw has reconstituted itself, at which point the Minah emerges.

For all their strangeness, the Inki cartoons still look, and move, like close cousins of the Disney cartoons. In the early forties, though, the Jones cartoons began to reflect influences of a sharply different kind. In *Conrad the Sailor*, a Daffy Duck cartoon released in February 1942, Jones for the first time resorted to the cinematic device called matched cuts. "We used a lot of overlapping graphics on that particular cartoon," Jones told Greg Ford and Richard Thompson, "so that one scene would have the same graphic shape as an earlier scene, even though it would be a different object: first we'd show a gun pointing up in the air, then in the next shot, there'd be a cloud in exactly the same shape. It gave a certain stability which we used in many of the cartoons."[29]

In fact, Jones used such "overlapping graphics" prominently in only one more cartoon (*Hold the Lion, Please*, a 1942 Bugs Bunny, in which the laughing faces of jungle animals cross-dissolve into foliage shaped like the faces), and his invocation of "stability" has a strong *ex post facto* ring to it. From all appearances, Jones introduced matched cuts and dissolves not because they would solve a problem or add some strength to a particular cartoon, but as an intellectual exercise. What was really new about *Conrad*, at least for the Schlesinger cartoons, was the attitude embodied in it: that each cartoon could be a small laboratory where any idea could be tried for its own sake.

John McGrew was Jones's layout man in the early forties, but his influence extended beyond designing the backgrounds for the cartoons: Jones described McGrew as "a great student of film techniques"[30] who "had very interesting ideas that I was willing to try."[31] McGrew no doubt suggested to Jones the matched cuts in *Conrad*, as well as the Art Deco look given to the backgrounds. The stimulus may have been the advent of a new background painter: Eugene Fleury, formerly an instructor in the Disney

training program, who in February 1941 took Paul Julian's place.³²

McGrew controlled what Julian and then Fleury painted by making, as Julian said, "small color sketches that I would turn into backgrounds."³³ As long as Julian was the background painter, McGrew did not exercise that control to give the Jones cartoons a design that departed significantly from the Schlesinger norm. It was only in early 1942, around the time Fleury's backgrounds began appearing on the screen in cartoons like *Conrad the Sailor*, that the Jones cartoons started to look different. "Gene and I fitted together perfectly in what we were looking for," McGrew said in 1995.³⁴

Warners released the most striking of the Jones-McGrew-Fleury collaborations in September 1942. This was *The Dover Boys at Pimento University*, a parody of turn-of-the-century boys' fiction and melodramas. The three Dover brothers—"fun-loving," square-jawed, and athletic Tom; small, dark, and studious Dick; and rotund, red-headed Larry—are the most popular students at "good old PU." They rescue "their" fiancee, dainty Dora Standpipe, from the clutches of Dan Backslide, "coward bully cad and thief." Those words were spoken—with no trace of punctuation—by John McLeish, a former Disney artist who was also the pompous narrator of Jack Kinney's Goofy sports cartoons. McLeish spent a little time at the Schlesinger studio after the Disney strike, providing an appropriately ripe voice-over for *The Dover Boys* and contributing to the design of the characters.³⁵ Of the *Dover* characters, only the overwrought Dan Backslide looks like an individual (he is a caricature of Ken Harris, one of Jones's animators); the Dover Boys and Dora Standpipe are exaggerated types, with faces and bodies too rigid to admit emotion easily. They are notably more astringent-looking than the Disney-like characters of the earlier Jones cartoons, with their yielding curves and eager faces.

Similarly, the Disney-like animation of Jones's earlier cartoons gave way in *The Dover Boys* to a different kind of movement. Jones burlesqued the stiffness of nineteenth-century photographs by throwing his characters into ludicrously theatrical poses—bulging arms folded ostentatiously across a manly chest here, maidenly arms raised in demure horror there—and calling attention to those poses by holding them on the screen for much longer than normal. The

THE DOVER BOYS
A LEON SCHLESINGER PRODUCTION

MERRIE MELODIE
CARTOON
IN TECHNICOLOR

A lobby card for Chuck Jones's The Dover Boys (1942), in which the three Dover brothers confront the villainous Dan Backslide. The lobby cards for the Warner Bros. cartoons frequently used drawings that bore scant resemblance to those in the film, but this one is an exception. © Warner Bros.

characters often shoot from one pose to another with only a few frames of film in between. The drawings in those few frames are stretched and even smeared as much as any drawings in a Clampett cartoon (in fact, *The Dover Boys* was released two months before *A Tale of Two Kitties*, the first Clampett cartoon with Scribner's Lichty animation), but the effect is completely different. Clampett calls attention to the distortions—or, more to the point, the enormous energy released through them—whereas Jones calls attention to the poses.

The background designs for *The Dover Boys* are likewise stylized—unusually simplified for the Schlesinger cartoons, but softened and rounded by airbrush, as if seen through a mist of sentiment. They echo the work of painters like Thomas Hart Benton and Grant Wood. *The Dover Boys* pulled together successfully elements that were foreign to most of the short cartoons of the early

forties: human characters, an unmistakably parodistic story, stylized movement and design. The cartoon was quickly recognized as something out of the ordinary, both by those people who found it heartening and by those who found it alarming.

John Hubley—recently transplanted from Screen Gems to the army—spoke approvingly in 1943 of how Jones had adapted "new animation techniques and new background treatment to a story material that dealt with a parody on human behavior," as opposed to the "pure comedy" of the Disney cartoons.[36] But "New York was shocked," Jones said. "I don't think they would have released it at all except that they had to have a picture."[37] According to Gene Fleury, Leon Schlesinger did not care for *The Dover Boys*: "I suppose what really upset him was the fact that the characters were human—not just one or two, but all of them."[38] Jones remembered no Schlesinger edict against using human characters, "but that's quite possible. It would have bothered [Fleury] more than it bothered me, because I was used to Leon being bothered by things. He hated any picture he'd never seen before. But it had no effect on me."[39] Perhaps. But Jones did not confront Schlesinger with an all-human cast or such openly subversive animation again.

Whatever the restrictions Jones may have imposed on himself, his first few cartoons that followed *The Dover Boys* do not suggest that he imposed any on McGrew and Fleury. In that early phase, however, their designs were still mild enough that even Schlesinger could sometimes respond to them with surprising warmth. Fleury recalled that for *The Case of the Missing Hare*, a 1942 Bugs Bunny cartoon released about three months after *The Dover Boys*, "John McGrew and I reduced most of the backgrounds to patterns—stripes, zig-zags, and the like—or to colored cards. Still, after the studio preview, Schlesinger came over and congratulated us on these rather outlandish backgrounds. We never did figure out why."[40]

The Case of the Missing Hare takes place mainly in a theater, where Bugs confronts an arrogant magician named Ala Bahma, and contrived-looking backgrounds could thus be rationalized as representing stage flats. A few

months later, though, in *The Aristo-Cat* and *The Unbearable Bear* (both 1943), the backgrounds were much flatter, even starker, than those of earlier cartoons, with few reminders of the ripe color, plentiful detail, and, especially, illusion of depth that had once been standard in all the Schlesinger cartoons. At the same time, Jones's editing and his simulated camera angles had changed in ways that reflected the thinking of McGrew and Fleury. In Jones's earliest cartoons, he was, in keeping with his Disney bent, a *mise-en-scène* director, whose camera was more often a casual observer than intensely interested and highly selective; the camera often panned languidly until it noticed something worth paying attention to. By the time of *The Aristo-Cat* and *The Unbearable Bear*, though, Jones was cutting much more rapidly and expressively, and often presenting the action from unexpected points of view.

McGrew's last work for Jones was on such 1943 releases; he entered the navy in September 1942.[41] Fleury worked for Jones only a few months more, then entered the army in April 1943.[42] Even before that, he had begun working one month on, one month off, so that he could devote more time to easel painting. During his off months, his wife, Bernyce Polifka—herself a serious painter and designer, without any previous animation experience—filled in for him in the Jones unit; by the end of 1942, she was doing what the Screen Cartoonists Guild's newsletter called "special [background] work at Schlesinger's."[43] After Fleury entered the service, she began painting backgrounds for Jones full time, staying with the unit until sometime early in 1944.

Fleury may have introduced to the Schlesinger studio the use of cel paints—opaque watercolors—as background paints,[44] but Polifka went much further, using, as her husband said, "all sorts of materials: designer's colors, pastels, cel paint, colored pencils, dyes, colored paper and so forth."[45] Animation studios had tried since the early thirties to encourage audiences to forget that they were watching drawings, but in cartoons like *Wackiki Wabbit* (1943), a Bugs Bunny set in the South Seas, and *Tom Turk and Daffy* (1944), with Porky Pig and Daffy Duck, Polifka followed the lead of many contemporary painters in the fine arts by calling attention to her materials.

Some people in the business responded eagerly to such innovations. The Disney layout artist Karl Van Leuven, writing of *Wackiki Wabbit* in the cartoonists' union newsletter in December 1943, reviewed the backgrounds rather than the film:

This opus is notable not for its habit-formed story, but for the imaginative experimentation of its layout and background. Particularly noteworthy was the discovery that a flat tone can carry background movement. Novel but not so successful was the use of tapa cloth patterns with overlays of stylized foliage plotches as backgrounds for action on a typical tropical isle.... [Schlesinger] is pacing the current background breakaway from the cute.[46]

Thanks to Fleury's and Polifka's background paintings, and their connections in the art world, Jones's cartoons got attention from some people who ordinarily would not have noticed them. A brief article in *California Arts & Architecture* for February 1944—unsigned, but mostly written by Gene Fleury—reproduced a dozen backgrounds from cartoons like *The Unbearable Bear* and *The Case of the Missing Hare* and discussed the Jones cartoons in highly self-aware language. The article said of the animation in *The Dover Boys*: "When a character was to move from one pose he did so in a manner and at a speed which best related the two positions in an expressive pattern integral to the picture. An effort was made to prevent natural or quasi-caricatured action from being guiding factors in the designs."[47]

That kind of writing about cartoons had few precedents in the early forties; most people in the industry, if they verbalized much at all, did so in more down-to-earth terms. The more self-consciously experimental approach espoused in Gene Fleury's article clearly appealed to Jones,[48] but there was, even so, an ebb and flow of novelty in his cartoons; *The Dover Boys* and *Wackiki Wabbit* stood out among more conventional-looking efforts. Paul Julian—who, after leaving Jones's unit, painted the backgrounds for Friz Freleng's cartoons—spoke of reaction within the studio against a scene in *Wackiki Wabbit* that Van Leuven singled out for praise:

The picture culminated in a chase where two people ran off into the distance, and the background...was so flat it came off like, here are two people shrinking on a piece of wallpaper. That created kind of an upset...a popular outcry—what the hell is going on here? The expression "arty-farty" got used a good deal that month.[49]

Such criticism of Jones's more daring cartoons undoubtedly had an effect. Jones's critics also had a point. The McGrew-Fleury-Polifka devices sometimes enhanced a narrative: in *The Aristo-Cat*, jagged background patterns and low-level camera angles accentuate a pampered cat's comic despair after a disgusted butler walks out and leaves him on his own. More often, though, those devices moved on their own track. In cartoons like *My Favorite Duck* (1942), *Flop Goes the Weasel* (1943) and *Fin 'n Catty* (1943), quick cuts and oblique angles are used only for effect, like the matched cuts in *Conrad the Sailor*.

Jones's cartoons of the early forties were at war with themselves. His characters were more insistently three-dimensional than those of the other Schlesinger directors, and they did not belong in the same universe with aggressively artificial backgrounds. They required settings like those Julian was providing for Freleng's cartoons. Julian followed Gene Fleury's example in switching from transparent watercolors to opaque cel paints, but, he said, he used the cel paints not in flat blocks of color but as thin washes, "building into opaque areas where it was necessary."[50] His backgrounds had a cartoon brightness and simplicity, but they also seemed solid and real, as the Fleury backgrounds did not.

Even in *The Dover Boys*, the characters, however stylized their movement and design, were still drawn as three-dimensional figures and animated in depth; Jones did not reduce them to cardboard. The parody in *The Dover Boys* actually loses force because the characters so much resemble the cartoon characters that theater audiences of 1942 were accepting as believable creatures with distinct personalities. The outlandish poses do not diminish the Dover Boys; instead, they seem to be pretending to be less substantial than they really are.

The Disney animators shunned strong poses as much as they shunned visible distortion, and for essentially the same reason. A pose, if it is held too long, can reveal too plainly that the character on the screen is nothing more than a drawing. When a Disney animator did use strong poses, he usually concealed them behind whirling draperies and other distractions. But in *The Dover Boys*, Jones demonstrated—in a backhanded way—that if strong poses were used for a definite purpose, and were not stiff and blank but had life, they could actually encourage audiences to accept the reality of cartoon characters. Good poses could reveal clearly the entire body's capacity for expression. They could, in short, be yet

another vehicle for the caricature of thought and emotion. *The Dover Boys*, hailed as a breakthrough cartoon pointing away from Disney animation, was, in fact, a breakthrough on the order of Clampett's *Coal Black*: it showed there were ways to create an illusion of life other than by simply imitating the Disney cartoons.

The Dover Boys' lesson may have been obscured by the cartoon's parodistic origins, but the lesson was not lost on Jones himself. In his cartoons that followed *The Dover Boys* in 1943 and 1944, he began exploring—tentatively, at first—how he might use strong poses to bring his characters into sharper focus. In a cartoon like *The Unbearable Bear*, which stars a quicker, less cute version of Sniffles the mouse, the poses are still too general; they do not tell enough about the characters. Gradually, though, Jones sharpened his poses; by the time of such 1944 releases as *Tom Turk and Daffy*, *Angel Puss*, *From Hand to Mouse*, and *Lost and Foundling*, he was, more and more, revealing his characters through poses that were not simply distinct but also psychologically acute. *From Hand to Mouse*, for example, is a rather cynical retelling of the fable in which a lion releases a mouse that later saves his life; the mouse of the Jones version repays the lion's kindness by calling "Sucker!" to his benefactor from the safety of his hole. The cartoon's flavor comes not just from the mouse's ingratitude, but also from the lion's smugness and stupidity, as revealed—if not yet fully—in Jones's poses.

As Jones's poses improved, some of his other tools became more useful. This was especially true of his rapid cutting, since a scene with a strong pose can make a clear impression even when it is very brief. A directorial style that relies on strong poses and rapid cutting is highly economical; it does not require much time, or many drawings, to put a point across. For that reason, it requires unusually dense material to start with—a storyboard rich with gags and situations. In the early forties, Jones worked mostly with Ted Pierce, who had returned to Schlesinger's in June 1941 from the Fleischers' Florida studio.[51] Pierce, Jones said, was "good at structure, and it was a humorous structure—but it wasn't gags."[52] Pierce was, in other words, a writer whose storyboards had in them plenty of elbowroom for Disney-derived personality animation. As well suited as he may have been to the Jones of 1939 or 1940, he was wrong for a director whose style was now based not on

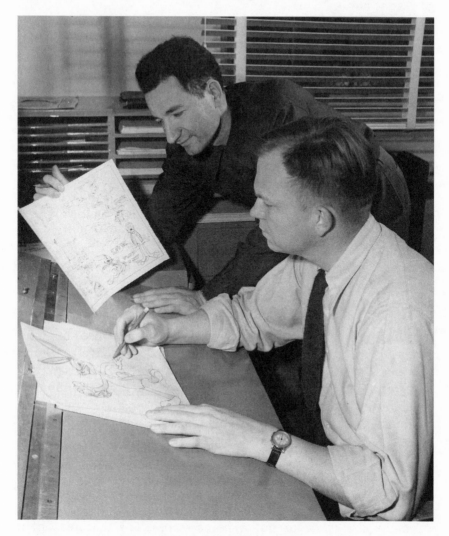

Chuck Jones (seated) with layout artist Earl Klein in early 1945.

realistic movement but on poses as sharp as rapier strokes. Increasingly, Jones's cartoons looked like the work of a man who had to spend seven minutes telling a story he could have told in four or five.

After Bernyce Polifka left the Schlesinger studio early in 1944, Earl Klein designed the backgrounds for Jones's cartoons and Robert Gribbroek painted them. Klein recalled many years later that Jones actively encouraged them to emulate the "contemporary work" Polifka had done; he gave to Klein exceptionally detailed rough layouts for the backgrounds and called for specif-

ic colors. Beyond that, Klein said, "he told me, 'Look, use exaggerated perspective, and think of it as a flat, two-dimensional design instead of trying to get fake aerial perspective.' He encouraged me to use way-out colors, wherever I could. That's what I started doing for him, and he liked what I was doing."[53]

Despite this effort to follow in Polifka's footsteps, the Klein-Gribbroek backgrounds still emerged as more compatible with the animation—more suggestive of three-dimensional space—than hers. Jones's cartoons now spoke with one voice; but he still needed a writer who would be, for him, what Rod Scribner had been for Bob Clampett.

Coal Black had been a triumph, but as far as Clampett's career as a director was concerned, it came very close to being a flash in the pan. None of his cartoons from the succeeding two years measured up to it, and if he had left the studio in 1944 instead of 1945, it would be much more difficult to make the case for him as a major director. Clampett did not have Scribner draw styling sketches for the cartoons he made after *Coal Black*—he did not want one of his best animators to spend a large part of his time in that way[54]—and none of his cartoons from the next two years has the consistency of drawing style and, more important, the consistently high level of energy that *Coal Black* has.

When he was directing his color cartoons, Clampett never used his character layouts the way other directors did, to give their cartoons a uniform drawing style and to shape the animation along certain lines. It was taken for granted at all the leading cartoon studios that each cartoon should look as if it had been drawn by a single hand; character layouts were one way to accomplish that because if the animators drew in the style of the layout drawings—and perhaps even used the layout drawings as part of their animation, as Preston Blair did at MGM with Claude Smith's drawings—the finished cartoons would seem to have been drawn entirely by the artist who drew the layouts.

Clampett—who disparaged his own drawing ability—drew the character layouts for the first few color cartoons he directed. After that, Tom McKimson, the older brother of Bob McKimson, drew them. Clampett usually had

Tom McKimson make a limited number of drawings of the characters, mainly to show their positions in each scene. Then, as Clampett told each animator about his scenes, he scribbled sketches indicating how he wanted the action in a scene to flow. "I put extra sheets of paper over the layouts and made little quick roughs," Clampett said. "Sometimes I would sketch with a big, soft grease pencil. The scribbles and the dynamics of it...the paths of actions, and the anticipations and squashes and stretches, the changes in perspective and size, like a hand swinging up and past the camera."[55]

Clampett said those sketches were sometimes

> done right to the actual timing of what was going to happen, by moving a pencil across the paper; that suggests a path of action that a character is likely to take, especially if the character is moving at a high speed. You probably wouldn't think to give the character quite that path of action if you just started with a drawing, but when you run the pencil through it with just that feel, you do some things you wouldn't consciously think to do.[56]

Clampett likened such sketches to "the wave of a baton, if I were leading an orchestra—the waving of the pencil would give them the feel of the motion. It wasn't so much what the sketch looked like; it might be little paths, little bits of energy, as I was talking it.... An extension of the energy of the character, the urge of the character, what he's feeling inside."[57]

When some of Clampett's animators talked about his sketches, years later, they remembered best how rough they were. "Some weird bunch of lines," Bob McKimson said.[58] "Chicken scratches," Phil Monroe said.[59] "Really scribbled," Bill Melendez said.[60] That is the way that animators always talk about drawings that are not immediately useful in their work; and Clampett's rough sketches certainly could not be used as animation extremes. Moreover, when Clampett handed out a scene, "he was always a picture and a half behind anyway," Monroe said, "and he would rush it out. He'd say, 'Oh, God, I've got thirty-five feet here to do. Let's start here and have this guy run along here, and Porky Pig jumps in here and joins him here, and we go down here....' And the first thing you know, you've got—by word of mouth—what he wanted to have happen in the scene. That is good experience for an animator because he has to do it himself."[61] So loose were the reins, Bob McKimson said, that "working with Clampett, I had to do

practically everything that a director had to do, most of the time, because he was out doing something else or he'd just had it. He'd come in and tell me to time it out and fix it up and lay it out and give it to the animators."[62]

Clampett sounds, from such descriptions, like a director who barely deserves the title, a man whose films must have been as raggedy as those of such early thirties Schlesinger directors as Tom Palmer and Earl Duvall. And yet, his cartoons reveal their director's personality as clearly as any cartoons ever have. The Clampett cartoons' shortcomings and virtues can be traced almost always to their director's decisions, not to his abdicating those decisions to others. In particular, Scribner's animation for Clampett differs so markedly from his earlier and later work that the director's influence is unmistakable. And it is simply inconceivable that Bob McKimson "directed" any of the Clampett cartoons, in any meaningful sense.

Casting by character, on the Disney model, never took hold in the Schlesinger cartoons, and its lack was felt in the shallowness of many characters, especially in the late thirties. The emergence of Bugs Bunny was the first break with that debilitating pattern, but Clampett offered an even more radical alternative: in his cartoons, the director himself is playing all the parts, to the hilt. Clampett "knew what he wanted," Bill Melendez said, "because he knew the story better than almost anybody I've ever known. He remembered every bit of it.... When we were looking at pencil tests, he'd remember every bit of dialogue for each scene."[63] And Phil Monroe: "His strongest point would be that when you talked to him about the overall story, he'd get you enthused with his story points.... He was always willing to talk to you. He would get up and act out something; he was very descriptive."[64]

It was surely through his rough sketches that Clampett was most often "very descriptive," leaving a receptive animator with both a clear sense of what Clampett wanted and—because Clampett's drawings were not at all confining—a sense of freedom in finding the means to achieve that result. In other words, Clampett's drawings were extensions of the pep talks—what John Carey called floor shows—that he used in the thirties to get his animators excited about their work. In many of his cartoons, his "baton" is almost visibly at work, in animation that is filled with elegant

loops and swirls, and whose paths of action are so clear that no character ever vanishes no matter how radical its changes in shape. It is easy to imagine Clampett's pencil moving in just such baroque patterns.

Clampett's approach made excellent sense in so far as Rod Scribner was concerned because director and animator were so sympathetic in their aims. Clampett could count on Scribner to give him animation of high quality; all he had to worry about was the spirit behind the animation, and he didn't have to give Scribner a stack of detailed drawings to get that across. In his four years as a director of color cartoons, Clampett worked with a number of other animators, like Bill Melendez and Manny Gould, who—even though they were not on Scribner's level—turned out work that was compatible with the kind of animation that flowed from the Clampett-Scribner collaboration. The animator whose style was the least compatible with Scribner's was the one who was still, in many ways, the Clampett unit's best animator: Bob McKimson.

McKimson's animation continued to be restrained even as Scribner and some of the other Clampett animators were discovering the rich possibilities in a completely different kind of animation. Clampett said he valued McKimson "because he had this tightness, this little detail, and I wanted to try and get fine acting, little things with the fingers, little actions on the characters.... With him, you wouldn't have to sketch it [make scribbled sketches] as much as you'd just give him key sketches, little ideas, and then act it out for him. Boy, he'd come back like he'd photographed it mentally."[65]

In other words, Clampett scarcely tried to bring out in McKimson's work the qualities he sought in the work of his other animators. However much Clampett may have diminished McKimson's control over the other animators, Clampett still treated McKimson "as his head animator, his best animator," Bill Melendez said. "He was the most productive and dependable, whereas the rest of us were kind of crazy.... We deferred to him."[66] McKimson was actually capable—at least under Clampett's direction—of extraordinarily graceful animation of cartoon characters. His animation in *Falling Hare* (1943) and *What's Cookin' Doc?* (1944) makes Bugs Bunny move as subtly as the human figures in *Tom Thumb in Trouble* and *Old Glory*; Bugs's movements seem somewhat exaggerated compared with human movements, but they are natural and restrained movements for a cartoon rabbit.

McKimson did not add any exaggeration to the exaggeration that was built into the character, and since Bugs, as McKimson drew him in those cartoons, was a very elegant, beautifully proportioned rabbit, his movements took on the same qualities.

In Clampett's cartoons, scenes by McKimson in which characters behave "normally" alternate with scenes by other animators in which the characters behave anything but normally. Because the animation that most resembles real life is always the measuring stick for everything else in a cartoon, his animators' incompatible styles magnified lapses in Clampett's judgment. To have Bugs Bunny use a magnet to pull the fillings out of his foe Red Hot Ryder's teeth in *Buckaroo Bugs* (1944) would have been a difficult gag to bring off under any circumstances, but in a cartoon grounded in McKimson's animation, the gag's effect is more than unpleasant.

Such lapses were common in the Clampett cartoons of 1943 and 1944. He could not always give mildly off-color gags, in particular, the tongue-in-cheek handling that they required—the kind that he gave to one memorable gag in *An Itch in Time* (1943). A dog's rear end has been set on fire by a flea who is camping on him, and the dog drags himself rapidly across the floor, yelping in distress. He stops abruptly and grins at the camera: "Hey, I better cut this out. I may get to like it." Immediately, it's back to scooting across the floor. The joke is handled with flawless timing; there has been just enough time for the audience to get the general idea, but not enough for it to anticipate the particular gag. On other occasions, though, Clampett presented such gags with a disconcerting intensity. It is one thing for a phallic symbol, say, to be introduced in an offhand manner; it is another to be hit over the head with it, as in Clampett's *Russian Rhapsody* (1944), in which a gremlin with a very long nose sticks his head out emphatically from between the legs of another gremlin.

There is something almost threatening about many of Clampett's cartoons from this period because the director seems to be letting slip into them so many things—bizarre gags, childish obsessions, sadistic urges—that more methodical directors would have excluded. His cartoons can make audiences uneasy, as few cartoons can. Some of Clampett's former colleagues suggested that the turmoil in his cartoons was merely an accurate reflection of what was

going on in Clampett's head when he made them. "I think Bob
was hysterical inside," Chuck Jones said, "and he expressed him-
self that way.... The control element was usually lacking [in
Clampett's films]."⁶⁷ Bob McKimson spoke of Clampett with
amused disdain:

> He was like a slippery eel. Schlesinger would call him into
> the office and get ready to bawl him out, and Clampett
> would say, "Wait just a minute, I'll be right back, I've got to
> go to the gentlemen's room." He'd leave, and he'd never
> come back. Maybe two days later, Schlesinger would meet
> him in the hall, and say, "Where the heck did you go?"
> [Clampett] would say, "What do you mean?"⁶⁸

The Clampett who emerges from his colleagues' anecdotes is
fundamentally remote ("Bob at times was a recluse," the story
man Dave Monahan said),⁶⁹ yet incessantly testing the limits of
acceptable behavior. At a costume party Clampett threw for his
unit, Bill Melendez said, "Clampett came as a prick; he had this
see-through paper—it looked just like transparent plastic—and
he'd written 'Sheik' across it. His feet were two huge gunny
sacks."⁷⁰ It is hard to find in such anecdotes about him any trace
of a man who was, as Chuck Jones said, hysterical inside.
Clampett seems instead to have been propelled in his films and
in his relations with his colleagues by a spirit of cool inquiry:
What can I get away with today? He exercised a director's control
not as Jones did, by giving his cartoons smooth surfaces and log-
ical structures, but by trying to make them as surprising and out-
rageous as possible.

There was no way, given this attitude, that Clampett could
have attached much importance to blending his animators'
styles—the more individual the styles, in fact, the greater the pos-
sibilities for fireworks. (Sometimes, as in *Falling Hare*, he had one
animator take over for another in midscene, without a cut, so that
Bob McKimson's drawings of Bugs Bunny suddenly give way,
without interruption, to Rod Scribner's). The problem was, the
Clampett animators' styles were not simply different, they were
in conflict. Just as the animation in Chuck Jones's cartoons
clashed with the backgrounds, so the Clampett animators' styles
worked against one another. Clampett's approach to direction was
highly risky because it was so vulnerable to accidents, and by not
even attempting to reconcile his animators' conflicting styles,
Clampett made a large number of accidents inevitable. But he

was rarely if ever fazed by disagreeable results on the screen: "I was never afraid that the world would come to an end if one scene or one cut didn't work"[71]—or, he might well have added, if a whole film didn't work.

The shortcomings in Clampett's direction were most acutely visible in some of the ten Bugs Bunny cartoons he directed between 1941 and 1944. In the first half of the forties, all of the directors had problems with the character, even though they were of a different order than Clampett's.

As Avery did in *A Wild Hare* and in two other cartoons, Friz Freleng paired his heavyweight character with bantamweight opponents. Chuck Jones, once he had switched to the real Bugs from the grumpy rabbit of *Elmer's Candid Camera* and *Elmer's Pet Rabbit*, almost immediately gave Bugs adversaries who posed a real threat, but his style as a director had not caught up with Bugs. Bugs was a sly, dry, tongue-in-cheek character; Jones's cartoons were changing rapidly, but they were still sweet and gentle, and really rather flabby. Putting Bugs in a Jones cartoon was like mixing gin and Coca-Cola. Moreover, Bugs didn't look right in the Jones and Freleng cartoons. He was poorly drawn. His features were too loose, the proportions wrong. In Clampett's cartoons, by contrast, Bugs was a very handsome animal.

For a couple of years, the studio worked with the model sheets of Bugs drawn by Bob McKimson shortly after *A Wild Hare* was made. By 1942, though, the Bugs in Clampett's cartoons looked better than the Bugs on McKimson's 1940 sheets, and the Bugses in Jones's and Freleng's cartoons looked worse. A new model sheet that would eliminate such inconsistencies was in order. McKimson drew one in October 1942. On that model sheet, Bugs was a reasonably good caricature of a rabbit, but, as Clampett said, the "face was 'pinched.' Too small. The head was a trifle too small. And his chin was weak." McKimson reworked the model sheet, accepting suggestions from Clampett and other members of the unit, and "from this process," Clampett said, "we ended up with the 1943 model sheet."[72]

On that model sheet, Bugs's cheeks were broader, his chin stronger, his teeth a little

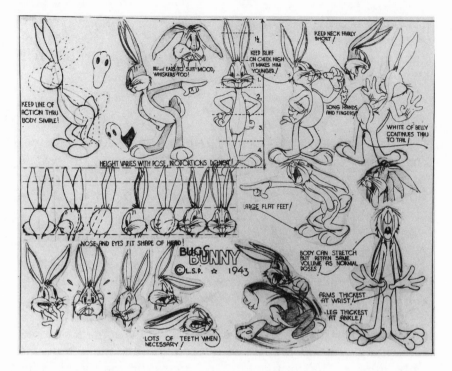

The 1943 Bugs Bunny model sheet by Robert McKimson. © *Warner Bros.*

more prominent, his eyes larger and slanted a little outward instead of in. The most expressive elements of the rabbit's face had all been strengthened and drawn much more precisely than in the 1942 sheet, but because the triangular shape of Bugs's head had been subtly accentuated, Bugs was, if anything, further removed from cuteness than ever before. McKimson's model sheet must be given some of the credit for the marked improvement in Bugs's looks in all the directors' cartoons starting in 1943. Not that everyone drew Bugs to match the model sheet, but the awkwardness and uncertainty of the early forties were gone; it was as if everyone had suddenly figured out what Bugs really looked like.

Clampett's first few cartoons with Bugs—*Wabbit Twouble* (1941), *The Wacky Wabbit* (1942), and *Bugs Bunny Gets the Boid* (1942)—resembled Avery's, with Bugs facing two outclassed opponents, Elmer Fudd (in the first two cartoons) and Beaky Buzzard (in the third). At worst, the Bugs of those cartoons was a boring pest and not really offensive. Serious problems arose only when Clampett became a distinctive director. Bugs was, in his essence,

a cool, restrained character, and those qualities were difficult to reconcile with a directorial style that depended for its strongest effects on unrestrained displays of emotion. Bugs was a character who was in control of himself and therefore in control of his situation, and when Clampett tried to translate Bugs's aplomb into terms that made sense in his cartoons, the results were usually poor. In some cartoons, such as *What's Cookin' Doc?*, Bugs is only a little too frantic and egotistical, but in three of Clampett's Bugs cartoons released in 1944—*Hare Ribbin'*, *Buckaroo Bugs*, and *The Old Grey Hare*—he transformed the rabbit into a bully who regarded his opponents with pointed contempt.

It was only in Clampett's last six or seven months as a director of Warner cartoons, late in 1944 and early in 1945, that his cartoons finally escaped the confusion that constantly threatened to engulf them. Bob McKimson left the Clampett unit in September 1944; even before that, his presence was no longer being felt as it had been. The animation of Daffy Duck's opening monologue in *Book Revue* is recognizable as McKimson's thanks mainly to the calculation visible in it and the lack of spontaneity; it is not meticulous, fine-grained animation of the kind he had done in the past and so is more compatible with the flamboyant animation surrounding it. With McKimson's influence receding, Clampett's cartoons were again as satisfying as wholes as *Coal Black* had been, and they were satisfying in a subtly different way. It was not Scribner's style that unified the cartoons now, but rather a common devotion to the kind of animation that Scribner did so well and that Clampett used so well. McKimson-style realism was no longer the measuring stick, so that in *Baby Bottleneck*, when a little character walks calmly into Porky Pig's office, he does so by walking straight through a closed door—and it seems like the most natural thing in the world.

Only six of Clampett's last cartoons show no damage from McKimson's influence: *Book Revue*, *Baby Bottleneck*, *The Great Piggy Bank Robbery*, *Kitty Kornered*, *The Big Snooze*, and *Bacall to Arms*. Art Davis finished *Bacall to Arms* after Clampett left the studios and *The Big Snooze* has its weak spots and rough edges, perhaps because Clampett was preparing to leave, but the other four cartoons—which include three starring Daffy Duck—rank with *Coal Black* as Clampett's most exciting work.

By the time Clampett made those cartoons,

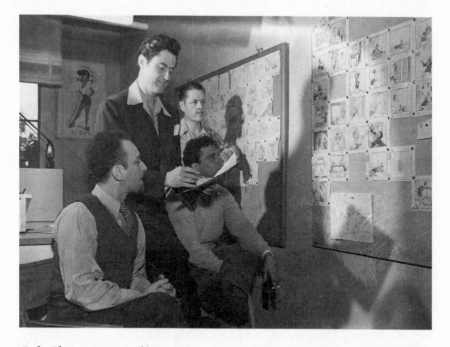

Bob Clampett (standing, center) at work in early 1945. Seated left is Michael Sasanoff, a layout artist; seated right is Hubie Karp, a writer; standing to the rear is Tom McKimson, who drew character layouts for the Clampett cartoons. The storyboard at left is for The Big Snooze (1946), the one at right is for the Daffy Duck cartoon The Great Piggy Bank Robbery (1946); what may appear to be damage to the latter board is actually damage to the photographic negative. On the wall at the left is a drawing of "So White," the heroine of Clampett's Coal Black and de Sebben Dwarfs (1943).

none of the directors was presenting Daffy as the lunatic heckler he had been in Avery's three cartoons with the character. Over the years, his appearance had changed in ways that made him compatible with a broader range of emotions. At the start, Daffy had a compact, rather lumpy body whose proportions strongly echoed a real duck's, and a head that was relatively small for a cartoon character's body, with a stiff beak and inconsequential eyes. Clampett, when he began using Daffy as an occasional supporting character for Porky Pig in Looney Tunes like *The Daffy Doc* (1938), gave Daffy a more elongated, upright design, but his early Daffy was, if anything, even more rigid and inexpressive than Avery's version. The Daffy of *The Daffy Doc* seems to be stretched and attenuated by some never-ending hysterical fit.

Only gradually over the next few years, as the different directors worked with the character, did Daffy's design evolve toward the complexity that sophisticated animation requires. By the early forties, the Schlesinger directors and animators were settling into a consensus on what would distinguish Daffy from his cartoon cousin, Donald: Daffy's body would suggest a human in a duck suit, more than a real duck, and his large, increasingly flexible beak would dominate his eyes and serve as the primary vehicle of expression. Avery's original conception of Daffy survived only to the extent that the cuteness and cuddliness that had been added to Donald would not be added to Daffy.

The changes in Daffy's appearance coincided with a refining of his voice. Starting with Clampett's *Porky and Daffy* (1938), he spoke in an increasingly sibilant, "slurpy" voice (Clampett remembered asking Mel Blanc to come up with a voice that sounded more ducklike by introducing a "raspberry" effect),[73] and by the early forties, he was the kind of fellow with whom one would hesitate to hold a face-to-face conversation.

Daffy's lunacy in Avery's cartoons was a kind of armor; even when a lunatic has been locked up, his mind remains beyond reach. In the cartoons Clampett made after *The Daffy Doc*, Daffy started cooling down, and by the time he reached full-fledged stardom, in 1942, he was clearly sane. He was more vulnerable, and so a little more interesting, but in cartoons like Jones's *My Favorite Duck* (1942) and Friz Freleng's *Daffy—the Commando* (1943), Daffy was still very much the heckler, an innately aggressive character not all that different from Walter Lantz's Woody Woodpecker. The Daffy in Clampett's last few cartoons was unmistakably sane, like the heckling Daffy in Jones's and Freleng's cartoons of the early forties, but he lived at the same high emotional temperature as Avery's Daffy. He was not aggressive, he was passionate—and his passion was his undoing.

This Daffy was first clearly visible not in one of Clampett's cartoons but in Frank Tashlin's *The Stupid Cupid* (1944), in which Daffy is the target of a Cupid who looks like a miniature Elmer Fudd. Daffy resists fiercely, pointing out that Cupid has already stung him repeatedly (he opens a folding photograph of his huge family—which includes a two-headed duckling—to prove it). Cupid retaliates by piercing Daffy with an arrow big enough to fell an elephant. Instantly

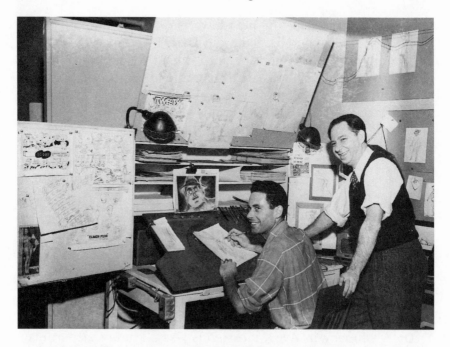

Rod Scribner, the most original of Clampett's animators, at his animation desk in early 1945, with another Clampett animator, Manny Gould, looking over his shoulder. The layout drawing above Scribner's desk is of one of the gangsters in The Great Piggy Bank Robbery; the model sheet visible at far left is for Kitty Kornered (1946).

smitten at the sight of an unfortunate hen, Daffy pursues her with an ardor that is ludicrous in its intensity. When the hen's rooster husband intervenes, Daffy defends his unseemly behavior as vehemently as he had wooed the hen—and as vehemently as he had resisted Cupid's initial attack. He is accustomed to living at a high pitch.

This Daffy Duck was almost as powerfully conceived as the Bugs Bunny of *A Wild Hare*—and he was, unlike Bugs, a character that played directly to Clampett's strengths. He turns up in *Draftee Daffy* (1945), at first seized by the most fervent kind of patriotism after reading about Allied victories, and then the victim of the most craven panic imaginable when a "little man from the draft board" asks him to put his patriotism into practice by accepting his draft notice. Fleeing, he hurtles through his house with such tremendous speed that he becomes alternately a comet and a bolt of lighting. Here, as in other Clampett cartoons, a char-

acter's strong emotions propel him through space with the same kind of subjective speed that had turned up a few years earlier in Tashlin's Screen Gems cartoons, used now with far more assurance and zest.

The sane-but-hysterical Daffy reached his zenith in Clampett's *Book Revue*, *Baby Bottleneck*, and *The Great Piggy Bank Robbery*, all released in 1946. Warren Foster, who got story credit on *The Stupid Cupid*, was writing for Clampett before he switched to Tashlin's unit early in the spring of 1943;[74] he worked with Clampett again after Tashlin left the studio, and his is the story credit on those Daffy Duck cartoons. The writing for all three cartoons is, however, fundamentally conventional.

Book Revue was the last in a long series of Warner cartoons built around books and magazines that come to life; Daffy enters the cartoon by stepping off the cover of a copy of a comic book and impersonating the comedian Danny Kaye, complete with a blond wig. (It was fitting that Clampett brought the series to an end: he came up with the basic idea in 1931, in his first few days at the Harman-Ising studio, when he suggested gags in which trolley-car advertisements come to life in the second Merrie Melodie, *Smile, Darn Ya, Smile!*)[75] In *The Great Piggy Bank Robbery*, Daffy's enthusiasm for his Dick Tracy comic book is so overpowering that he decks himself with a haymaker and dreams that he is Duck Twacy, the great detective. In *Baby Bottleneck*, Daffy and Porky have taken over a baby factory because the stork is drunk under a table at the Stork Club. In bare outline, all three cartoons sound like throwbacks to the Merrie Melodies of the thirties, but their real subject matter is their characters. The stories are not much more than pretexts for sending Daffy into action. There are no other Warner cartoons in which gags are so close to being irrelevant; the last few Clampett cartoons are more exhilarating than amusing.

Since Daffy as Clampett presented him was so overwrought a character, he was made to order for expressive distortions. When as Duck Twacy in *Piggy Bank Robbery* he confronts a hulking villain called Mouse Man, his body shrinks as quickly as his bravado does. He doesn't just become a smaller version of himself—it's not a case of the expression "feeling small" being taken literally, as had happened in other cartoons for thirty years—but really shrinks down into himself,

so that he looks not only smaller, but different. Throughout *Piggy Bank Robbery* (and *Book Revue* and *Baby Bottleneck*, too), Daffy changes size and shape as a reflection of his state of mind, and he does it *constantly*, hurtling to extremes scarcely approached in Clampett's earlier cartoons. Moreover, Daffy changes shape in different ways, according to which animator is drawing him; he may be rubbery in one scene, spiky and angular in another.

Differences in the animators' styles are even more visible in these later cartoons than in the earlier ones, but the differences are much less important because they are not signals of changes in the emotional tone or the energy level. It would be difficult in any of these cartoons to find a scene in which Daffy looks exactly like the character as he might have been drawn on a model sheet—and yet, as Daffy changes shape radically within scenes, and throughout each cartoon, there is never any sense that the animators have lost sight of what Daffy "really" looks like. It is instead as if a model sheet is an unstated melody on which the animators, like so many jazz musicians, are playing a series of brilliant improvisations.

In these cartoons, because they were so much more cohesive than his earlier ones, Clampett could freely introduce visual excitement that would have been out of place in other directors' cartoons and would have threatened to tear his own apart while McKimson's influence was strong. The cartoons themselves were now as expressive as only the characters had been before. In *Book Revue*, for the first time since *Coal Black*, backgrounds change color to accent a change in a character's mood—but the changes in *Book Revue* are much more intense and dramatic than before. In *Kitty Kornered*, a cat tries to dive through a keyhole and crashes into a door instead; any other director would have been satisfied to show the impact on the cat by squashing his body down. But as soon as the cat hits the door, Clampett changes the background so that it seems for an instant that he has cut to a more exaggerated perspective of the same door—but not of the cat! It is not enough for the cat to feel the impact of hitting the door; the audience has got to feel a little of it, too, by being disoriented in this way.

In these last few cartoons, Clampett was freer with all the elements of film than he had been before. In the first half of the forties, only Tashlin among the other Warner cartoon directors was nearly as fluent. The effect in Tashlin's cartoons was subtly different. Tashlin was warming up for the career in live-action films

he had always wanted; he was, as he said, "writing stories at home and trying to sell them for features,"[76] so in his cartoons he was thinking, even more than he did in the thirties, in feature-film terms. He concerned himself first with the film aspects of his cartoons—the angles, the cutting, and so on—and only then with the animation. Tashlin's techniques did not work against his characters, as Chuck Jones's worked against his at the time, but they added nothing to them. Clampett, by contrast, was concerned first with the characters, and the cinematic razzle-dazzle in his last few cartoons is there because it enhances the characters and makes them seem more real.

The Big Snooze was the last of Clampett's Warner cartoons to be released, in October 1946, about a year and a half after he left the studio. It was the first Bugs Bunny cartoon that he had directed in at least a year; he had made none for the 1944–45 season, after making more than any other director for the three previous release seasons. Sadly, *The Big Snooze* is not a triumph—the drawing is surprisingly weak—but in it, Clampett handles with a casual mastery the ingredients that had given him trouble before. There is sex, there is violence, but neither is in the least disturbing: they are stylized—and tamed—not only by having most of the action take place in a dream, but also by the pervasive extravagance of feeling and gesture. Clampett even pokes fun at this highly colored atmosphere. As the cartoon begins, Elmer Fudd has been outwitted by Bugs yet again and has decided to tear up his Warner Bros. contract and go fishing. Bugs pleads with him to reconsider, in the most piteous manner, even breaking into tears, but then pauses to give the camera a toothy smirk as he says, "Bette Davis is gonna hate me for this."

There was a world of difference between the relaxed, witty spirit of this cartoon and the spirit of the Bugs Bunny cartoons Clampett made a year or two earlier, and for that reason alone, *The Big Snooze* was a fitting coda to Clampett's career as a Warner Bros. director.

Warner Bros.,
1945–1953

On 1 July 1944, Leon Schlesinger sold his studio to Warner Bros. for $700,000.[1] He remained associated with the studio in a limited way by retaining 25 percent of the profits from the merchandising of the characters, but Edward Selzer, a Warner Bros. veteran with no animation experience (he had been in charge of the Warner trailer and title department for the previous seven years)[2] took Schlesinger's place at the head of the renamed Warner Bros. Cartoons, Inc.

When Warners bought the cartoon studio, it acquired along with it the contracts of the directors and a few key writers and animators. Within a year, though, two of the four directors had been replaced. Frank Tashlin left in September 1944, after two years back on the staff, to direct stop-motion puppet films for the John Sutherland studio. He saw this change, Tashlin said many years later, as yet another step toward writing and eventually directing live-action films.[3] Bob McKimson, promoted from Bob Clampett's unit, took Tashlin's job. By 7 May 1945, Clampett, too, was no longer a director of Warner Bros. cartoons; that was when a Selzer memorandum told the studio that Art Davis would be Clampett's successor.[4]

Davis had by then been a Warner animator

(for Tashlin and then McKimson) for several years, but it was probably his experience as a director at the Screen Gems studio in the thirties that led Selzer to choose him. Clampett insisted years later that he was eager to leave, to take advantage of some fleeting opportunity in television; his strong interest in TV was obvious to other people in the studio long before he left.[5] An option on Clampett's contract came up in April 1945, and the timing of his departure was probably connected with that. There is no direct evidence that Selzer or anyone else in the Warner Bros. hierarchy was eager to get rid of him, but many of his colleagues took it for granted that he was forced out.

Clampett and his cartoons were, by the time he left, brilliant anomalies. A director could make cartoons comparable to Clampett's only by trusting his instincts and shrugging off the constant risk of disaster. Very few directors of short cartoons in the forties were prepared to do that, and certainly no one at Warners was. The echoes of Clampett in the Warner cartoons made after he left came not in the directors' work, but in some of the animation and writing—in bursts of energy that momentarily violated the boundaries imposed by directors who were much more cautious than Clampett had been.

McKimson's cartoons in particular reflected a contest of wills. When he took charge of Tashlin's unit, McKimson said, "they were used to overanimating, and I had to calm them down."[6] His methods were much like Chuck Jones's, McKimson said, "making character layout drawings throughout a whole scene and for every scene in a picture." McKimson's drawings were, however, rigid rather than expressive; what Clampett called McKimson's "tendency to make everything smaller and tighter and more pinched" dominated his work as a director.[7]

As soon as Clampett left the studio, Rod Scribner joined McKimson's unit; in fact, he took Art Davis's place, picking up where Davis had left off animating in the middle of a scene for *One Meat Brawl* (1947).[8] He was almost immediately hospitalized with tuberculosis, though, and did not return to work for nearly three years, until the end of March 1948.[9] What happened to him then resembled what happened to Bill Tytla at Terrytoons. Even though Scribner presumably respected McKimson and wanted to animate for him—they had worked together for years under Avery and Clampett—McKimson did not appreciate Scribner's strengths. "After he started calming down more," McKimson said of Scribner, "he was a much better animator."[10] McKimson's liter-

al timing and confining layouts were deadly to Scribner's anima-
tion, which depended heavily for its effects on a very free
approach to both timing and drawing.

The other new director, Art Davis, bore scars from his early
months at Schlesinger's. When he started around the end of 1942,
he said, "I had trouble because I had been with the Mintz studio,
and it didn't have such a hot reputation."[11] Tashlin was in charge
at Screen Gems when Davis was forced out, along with other
holdovers from the thirties, and he apparently objected to Davis's
being hired at Schlesinger's; when Davis was hired anyway, he
was put in Tashlin's unit. "We got along fine," Davis said, but being
knocked around in that fashion probably took its toll: Davis was
not an assertive figure at Warners. To judge from the animation in
his cartoons, he may have been more comfortable with a
Clampett-flavored style than McKimson was, but it seems just as
likely that he simply gave strong animators like Pete Burness and
Emery Hawkins their head.[12] Likewise, his cartoons benefited,
after their first year, from exceptionally witty writing by William
Scott and Lloyd Turner, but Davis seems not to have attached any
great value to that story team.[13]

Most of Davis's cartoons were what might have been called, by
the last half of the forties, meat-and-potatoes Looney Tunes: fast
moving, not especially elegant in drawing or design, full of black-
out gags, and, most important, populated by tiny casts, usually
two clearly defined characters locked in a simple, easily grasped
conflict. It was during the war—itself so clear-cut a conflict—that
the people making the Warner cartoons boiled most of them
down to such basics. That happened not just in those cartoons
that used the war itself as a pretext for gags, but also in cartoons
like Friz Freleng's *Hare Force* (1944), in which Bugs Bunny and a
hound compete vigorously for a warm place to sleep in front of
an old lady's fireplace. After the war, what had become a hard-
ened formula dominated most of the Warner cartoons.

That formula was useful in several respects.
For one thing, it was economical: cartoons
could be produced more efficiently with only
two principal characters, especially if those
characters were used in many cartoons and
the animators got accustomed to drawing
them. For another, a cartoon with only a few
characters typically required a minimum of
preliminaries: just put two characters with

roughly equal capabilities, but sharply antagonistic interests, in the same cartoon, and let them have at it. Through the conflict formula, the Warner writers and directors could preserve a thread of narrative and thereby add interest to gags that otherwise tended to be as self-contained as those in Tex Avery's prewar blackout-gag cartoons.

Violent gags were highly compatible with this kind of animated conflict, and the acceptable scope of that violence had grown, thanks to the changes in the animation of the cartoons. Those changes, even though they had originated mostly in Clampett's and Jones's cartoons, had rippled throughout the studio. However much a director like McKimson might stifle his animators, the animation in his cartoons, like that in all the Warner cartoons, had diverged irrevocably from the sort of naturalistic animation that was more and more prevalent in the Disney features. In effect, the animation in the Warner cartoons—however strong or weak it might be in a particular film—now occupied a middle ground between the two kinds of MGM cartoons, Hanna and Barbera's and Avery's, neither so literal as the one nor so stylized as the other. The cartoons could thus accommodate a great deal of violence before their gags either turned painful, in Tom and Jerry fashion, or reduced the characters to ciphers, as in Avery's cartoons.

Even though Clampett was the most original of the Warner directors in the early forties, his cartoons fell outside the development of the conflict formula. He worked quite often with small casts and basic conflicts, especially in his Bugs Bunny cartoons, but as a dramatist he excelled at showing characters in conflict not with one another, but with their own emotions. It is the turmoil inside Prince Chawmin's head that is central to *Coal Black and de Sebben Dwarfs*, and the same is true of Daffy Duck's roller-coaster moods in *The Great Piggy Bank Robbery*. In the midforties, the two-character format yielded its secrets most willingly to directors who were content to work closer to the surface. Freleng was the most successful initially in exploiting the two-character format, and he set the tone for the studio's cartoons for several years.

Freleng's strongest cartoons in the early forties were built around music, as his old Merrie Melodies had been, but now the music was classical (Liszt for *Rhapsody in Rivets*, Brahms for *Pigs in a Polka*) and the cartoons themselves straightforward and energetic. Freleng was not wholly in his element, though, until the

end of the war, when he was directing such Bugs Bunny cartoons as *Hare Trigger* (1945) and *Baseball Bugs* (1946). It was in these cartoons, and a few others like them, that the conflict formula—still fresh, but already tested and refined in dozens of wartime cartoons—showed to its best advantage. In the Freleng cartoons released just after the war, as in no others before them, Bugs Bunny at last faced adversaries worthy of him. Not pathetic boobs, like the Elmer Fudd of *A Wild Hare,* but, in *Baseball Bugs,* a whole team of interchangeable Gas-House Gorillas: hulking, blue-jawed, cigar-chewing monsters who pound umpires into the dirt when they don't like a call. There is no sense in such Freleng cartoons that Bugs holds his enemies in contempt, as he did in some of Clampett's cartoons; he knows they are dangerous, but that makes the sport of outwitting them all the more delicious.

Bugs in these cartoons emerged as something approaching a true *eiron*—the "canny and restrained" stock figure in ancient Greek comedy who, in Max Eastman's words, "always had something more in mind than he was telling you."[14] Bugs was not the "laconic Yankee" that Eastman held up as the American equivalent of the Greek model—he was too cheerful and outgoing—but like any other *eiron*, he was capable of much more than he seemed to be. On the comic stage, as Eastman wrote, the *eiron* "was set off against another character called *alazon*, a loud-mouthed, blustering, swanking, cock-and-bull-story-telling lad." Eastman used Davy Crockett as an American example of the *alazon* (and literature from antiquity to the present offers many more examples), but one of Bugs's foes filled the role perfectly: Yosemite Sam, a tiny bandit, all hat and nose and huge handlebar mustache, who first appeared in *Hare Trigger.* As Freleng himself said, "There were no subtleties in Sam's character."[15] (Michael Maltese, who received story credit on *Hare Trigger*, said he based Sam, who was short, red haired, and wore a mustache, partly on Freleng himself, who was short, red haired, and wore a mustache;[16] mostly, though, Sam was one of the many radio-based characters in the Warner cartoons, modeled in his case on the shady cowboy Deadeye, from Red Skelton's one-man repertory company.)

Bugs was not the only character that Freleng reshaped to fit comfortably into the two-character conflict format. He adopted Clampett's character Tweety, and in *Tweetie Pie* (1947) paired the bird with Sylvester, a

black-and-white, red-nosed cat that Freleng had already used in two other cartoons. Sylvester assumed a role in the Tweety cartoons like the one Sam was playing in Freleng's Bugs Bunny cartoons. He clearly intended to do Tweety harm, and he was big enough and mean enough for the job—he was a genuine threat, much more so than the cats in Clampett's three Tweety cartoons—but not quite smart enough. Such virtues as these Freleng cartoons had, though, were soon outweighed by his greatest shortcoming as a director. He was simply too cautious.

Freleng never took any risks in his choice of camera angles or in his cutting from scene to scene—Clampett-style pyrotechnics were completely foreign to him—but his caution showed up most tellingly in his handling of his character layouts. Freleng's own layout sketches were rough—he was not a draftsman of Jones's or McKimson's caliber—but were also, in the memories of many people who saw them, very funny. Rather than risk giving his sketches to his animators, Freleng usually had them redrawn by his layout artist. The longest-tenured of the several men who filled that job in the forties was Hawley Pratt, who began redrawing Freleng's character layouts in 1944. Considered simply as drawings, Pratt's character layouts were handsome enough, and they gave to the cartoons a consistency of drawing style that might have been lacking if Freleng's own sketches had guided the animators. But Pratt's drawings had no comic vigor, and they were notably lacking in precision and variety of expression.

Freleng's animators thus picked up scenes hobbled by a vagueness that was itself a sign of caution, a reluctance on Freleng's part to commit himself. Like his animators at MGM in 1937, Freleng's animators at Warner Bros. had to bear in mind while animating every scene that they might have to redo their animation—with no extra time allowed—if Freleng decided when he saw it that he wanted something else. Their quandary is surely one reason so much of the animation in Freleng's cartoons is dull and literal, the sort of animation that could be easily altered: it is made up of stock poses, set in motion with stock gestures that could be added or subtracted as the need arose, without much tinkering required to make the adjacent drawings compatible. There is in Freleng's cartoons almost none of the organic flow so typical of Clampett's cartoons.

There was no spirit of adventure in most of the Warner cartoons of the last half of the forties. The studio's earlier innovations in characters and comedy had won it so much popularity

that departing from the new formulas seemed too risky. The studio had changed radically in just a few years from the days when first Avery and then Clampett, Tashlin, and Jones innovated, each in a distinctive way. Three of the remaining directors— Freleng, Davis, and McKimson—were precluded, by talent or temperament, from breaking new ground. Freleng honed the two-character conflict format to a kind of perfection, but having done that, his caution condemned him to repeat himself. Davis and McKimson followed pretty much in Freleng's wake.

Under such circumstances, a great deal depended on the studio's writers. Cartoon gags presented without much flair had better be solid if the cartoon is to be funny at all; cartoon characters drawn and animated stodgily had better be characterized sharply in the writing, and particularly in their dialogue, if the characters are to come alive at all. The last half of the forties was, in fact, a time when the Warner cartoon studio's center of gravity shifted sharply toward its story men.

Baseball Bugs is set in New York City; when one of the Gorillas hits what appears to be a home-run ball, Bugs takes a cab to the "Umpire" State Building, rides an elevator to the top, reels himself up the flagpole, and tosses his glove into the air to catch the ball. Freleng's *A Hare Grows in Manhattan* (1947) is one of those rare Warner cartoons whose title actually tells something about the cartoon itself: it deals with Bugs's childhood in New York. A New York tang carried over to many postwar Warner cartoons whose settings were nowhere near the East River. New York-accented characters abound in these cartoons; the early postwar years were, for example, the brief heyday of the disreputable hound Charlie Dog, a Chuck Jones character who tried, with the energy and calculation of an expert panhandler, to browbeat Porky Pig into giving him a home.

The most prominent of the New York–flavored characters was, of course, Bugs Bunny, although there was disagreement among the people who worked on the cartoons about just how much of a New Yorker Bugs really was. Mel Blanc described the voice as a combination of Bronx and Brooklyn accents;[17] Tex Avery said, to the contrary, that he asked

Blanc to give him not a New York voice as such, but a voice like that of the actor Frank McHugh, who turned up frequently in supporting roles in the thirties and whose voice might be described as New York Irish.[18] (The resemblance is slight at best.)

Bugs's voice in *A Wild Hare* is actually "straighter," that is, with a less sharply defined accent, than his voice in many of the cartoons made a few years later. It was in the late forties that Bugs sounded most like a cagey New York street kid. The only hole in the ground where this rabbit was truly at home was the subway— and, in fact, in Bob McKimson's *Hurdy-Gurdy Hare*, he bamboozles an unfortunate gorilla (a real one, not the human equivalent) in the authoritative tones of a subway conductor: "Okay, push in, plenty of room in the center of the car, push in, plenty of room," pausing to remark to the camera, "I used to work on the shuttle from Times Square to Grand Central."

There was a lot of breezy dialogue in the Warner cartoons of the late forties, not just in the Bugs Bunny cartoons but in many others as well. Here is Daffy Duck, for example, in a McKimson cartoon called *Daffy Duck Hunt* (1949), pretending to have been shot and letting Porky Pig's dog retrieve him: "Be careful with those fangs, Lassie, I bruise like a grape." In the last half of the forties, the writing for the Warner cartoons flowered in much the way that screenwriting for live-action films flowered in the thirties, when playwrights and authors flocked to Hollywood from the East and gave to the dialogue·for the new sound films a crackle and wit that many directors and actors could barely do justice to. Again echoing what happened in live-action films, the eastern origins of the Warner cartoon writers revealed themselves not just in geographical settings and characters' accents, but in a bantering cynicism and toughness.

All three of the principal story men at the Warner studio after the war had their roots in the East. The oldest of the three, Ted Pierce (who for some reason made himself "Tedd" in the early forties), came from what seems to have been a privileged background. He was born on Long Island and educated at an eastern prep school; in between, he was raised in Pasadena, that most eastern of southern California cities. He wrote for the *Los Angeles Daily News*, and then, in Somerset Maugham-ish fashion—Frank Tashlin said Pierce had the air of an "English remittance man"[19]— he spent a year bumming in Tahiti before he joined the Schlesinger staff in 1933.[20]

If Pierce slipped into a career as a cartoon writer without going

through any sort of grueling apprenticeship, Michael Maltese's path was much steeper. He was one of four children of Italians who had immigrated to New York from a village south of Naples, and his father deserted the family a few years after Maltese was born.[21] He got his first job in animation—after trying for many months—with the Fleischer studio in July 1935. He started on the lowest rung, painting cels. Warren Foster had joined the Fleischer staff by October,[22] evidently as an opaquer, too; Foster's origins are obscure, but at that time he was, Maltese said, "a short-cut music school owner on Broadway who [had] folded up."[23]

Maltese left the Fleischer studio in 1936. Having risen from opaquer to inbetweener by early in that year,[24] he wanted to become an assistant animator and was, by his entirely believable account, fired for trying to advance too rapidly at what was by then a heavily stratified operation. After two months at the Jam Handy industrial-film studio in Detroit, he moved to Hollywood in April 1937 and joined the Schlesinger staff as an inbetweener in May.[25]

Foster became a gag man at the Fleischer studio and then at Schlesinger's while Maltese was still trying to become an animator. "Warren wanted to get out here," Bob Clampett said, "so Mike spoke to the office about Warren. [Ray] Katz came to me and said, 'We've got a chance to get a Popeye gag man.' In those days, the Popeye gags were real good, and it was about the kind of a story we could animate at Katz's, where you weren't depending on the animation."[26] Foster worked for Clampett on his black-and-white cartoons starting in 1938.

Because he was physically separated from the rest of the studio at that time, Clampett usually worked with his own writers. The story department that provided material for the other directors in the late thirties was a pool on the Disney model. Certain story men might work continuously with one or another of the directors, while others worked with any director who needed a story.

Maltese was pushed into the story department in August 1939, he said, because "the front office" was impressed by the comic pieces he wrote for the *Exposure Sheet,* the studio's newsletter.[27]

The Schlesinger story department seemed to be even more easygoing than the studio as a whole. "I know that we wouldn't average an hour a day actually working," Dave Monahan

said. "Lunch hour was poker time, and the rest of the time was just trying to think up [practical jokes] to relieve the boredom."[28] That casual atmosphere was deceptive, though. At Schlesinger's, as at Disney's, it was much easier for an outstanding animator to make an impression than for a writer to break out of the pack, and the more talented the writer, the more obstacles he was likely to find in his path.

When Maltese started in the story department, he recalled many years later, it occupied two rooms, one for "the Kansas City boys"—Ben Hardaway chief among them—and the other for a younger, looser crew—Pierce, Monahan, Richard Hogan, and Cal Howard. The Kansas City boys tried to freeze him out, Maltese said; they were working on a Porky Pig cartoon about a bullfight (apparently Clampett's *The Timid Toreador*, released in 1940), and they scornfully rejected every gag he suggested. "I got wise," he said. "I wrote down all my gags." After two weeks, Schlesinger's assistant Henry Binder summoned Maltese, "and he said, 'Mike, you didn't work out.... Bugs Hardaway says you didn't open your mouth once. You didn't make any suggestions.' I said, 'Is that so?' Ta-dah! I whipped out pages of gag material. 'Look—two weeks' work.' " When Binder sent him back to the story department, Maltese said to Hardaway, "Who the hell did you expect, Mark Twain?"[29]

Such experiences fostered a powerful self-protective urge, one that surfaced even more in other story men than in Maltese. "Ted used to dramatize his jokes," Clampett said of Pierce. "He wouldn't have that many gags in a picture, for sure, but if he had an especially good one, he would advertise it around the studio. He wouldn't show it to you; he would cover it and peek at it." A gag that Pierce nurtured in that fashion might not get a big laugh when it finally reached theaters, "but it was so well sold and dramatized by Ted that everybody knew it was great."[30] Foster in particular "was like a ward heeler," Chuck Jones said. "He protected himself at every turn, and he seemed to feel that it was important to downgrade other people, the other writers."[31]

The pool broke up in the early forties; some story men were drafted or left for other jobs, and the rest were teamed with individual directors. Pierce and Maltese worked as a team in the mid-forties doing stories for both Freleng and Jones. Maltese received sole story credit on *Baseball Bugs*, *Hare Trigger*, and *Racketeer Rabbit*, three pivotal Bugs Bunny cartoons directed by Freleng, and he shared story credit with Pierce for two others, *Buccaneer*

Bunny and *Bugs Bunny Rides Again*. Around June 1946, Maltese had to leave the Warner studio for a couple of months after serious back surgery. Something happened while he was out; apparently Maltese, hard up for money, wrote a story while he was recuperating and was paid for it as if he were an outside writer, and someone complained to Selzer about that unusual arrangement. Pierce may have been to blame; at least Maltese thought he was. When Maltese returned to the studio, he threw Pierce's belongings out of the room they shared, crying, "I've carried you long enough!"[32]

From then on, Maltese worked exclusively with Jones, and Pierce with Freleng—for a few years. Foster, after getting story credit on many of Clampett's and Tashlin's color cartoons, had become firmly attached to McKimson's unit; then, through what McKimson described sourly as "a few political maneuvers,"[33] Foster moved to Freleng's unit in the spring of 1949. Pierce moved to McKimson's, unmistakably demoted.[34]

In many Warner cartoons of the late forties, anger and hostility hover not far beneath the surface, just as in the comedy of New Yorkers—the Marx Brothers, for example—who rose out of struggling immigrant families and menial jobs in the first few decades of the century. Unlike many of the Schlesinger animators, who started work at that studio soon after they left high school, Maltese and Foster got their first jobs in animation when they were in their late twenties (Maltese was born in 1908, and Foster was a year or two older) and after enduring hard times, and in Maltese's case, several years of debilitating illness.[35] The Warner writers approached the world and their colleagues at the cartoon studio in what was, even in its most benign form, an essentially adversarial spirit. Simply observing changes in the studio's payroll could have generated some well-founded anxiety. In the postwar years, not only was the trend toward assigning just one story man to each director, but even being attached firmly to a director was no guarantee of a job.

Starting in mid-1946, Bill Scott and Lloyd Turner—who were both in their twenties and therefore much younger than the other story men—worked together for a year on the Davis cartoons. Scott spoke to Paul Etcheverry about what happened next: "Though we didn't know it at the time, we were competing with each other. At the end of the year, we were to do a

story, each of us do a solo story, and [the] best one was hired and the other was fired. And I was the loser, so I got bounced out of Warners after a year."[36] Warren Foster had befriended Turner, and a few months later, near the end of 1947, he warned Turner that, in Turner's recollection, "Artie's on the frying pan; they're not happy with what he's doing, and he's laying it off on you pretty heavy. So don't be surprised if something happens." Turner had been an inbetweener before becoming a story man at a much higher salary; now, after a year and a half in story, Selzer "called me down and said, 'It's either go back to inbetweening or you're out.' " Turner chose to leave.[37]

Davis replaced Turner with Sid Marcus, his colleague at the Screen Gems studio in the thirties. But Marcus's credit appeared on only one Davis cartoon. By late in 1947, a decision had been made somewhere in the Warner hierarchy to eliminate one of the four cartoon units. The number of new cartoons released each season had remained at the reduced wartime level of twenty-six, and there was no war work to take up the slack. Warners was releasing fourteen "Blue Ribbon" reissues each season, further diminishing the need for new cartoons. In addition, delays in Technicolor processing were backing up the new cartoons, so that they came out months later than they should have. On top of all that, theater attendance was starting to fall from its postwar peak. Under the circumstances, it would have been difficult to argue that Warner Bros. really needed four cartoon units. Art Davis was the newest of the four directors, and his unit got the axe. Davis himself became an animator for Freleng, and most members of his crew moved to other units. A few were put to work as inbetweeners, but at least they had jobs. Sid Marcus lost his.

So it was that the Warner story men took readily to putting up storyboards that found comedy in vigorous conflicts and hazardous existences. It usually becomes evident only on repeated viewings, but there is bleakness at the bottom of many of the Warner cartoons, especially the McKimson and Freleng cartoons with stories by Foster. Bob Clampett said of Foster that he "was the guy who would know all of the gags on a certain subject that had ever been used anywhere,"[38] and in many of the cartoons he wrote there is an endless reshuffling of fundamentally cold, mechanical gags by directors who seem concerned only with manipulating the gags adroitly.

If there had been nothing more to the postwar Warner cartoons than that kind of comedy, they would have dribbled away into

insignificance very quickly, mere echoes of the exciting wartime cartoons. But the postwar years also saw the collaboration of Chuck Jones and Mike Maltese.

It took a few years for Jones and Maltese to get together. Jones, with his refined approach to cartoon making in the early forties, found Ted Pierce a natural companion; and when Schlesinger hired Pierce back from the Fleischer studio in 1941, it was at Jones's urging. Maltese was, by contrast, no "English remittance man," but rather a voluble Italian, and, more than that, a per-former—an entertainer, the sort of person who is constantly on stage. At Fleischer's, the animator Gordon Sheehan recalled, Maltese was "always ready to go into a tap dance or something like that. Sort of like a ham vaudeville fellow."[39] At Schlesinger's in the early forties, Don Christensen said, "Mike would take something that happened to one of us...and by the time he had embellished that story and told it over and over again, acting it out like he was making a storyboard in our minds, you could stand there and laugh at yourself."[40]

Only a few of Maltese's story sketches have survived, and they are quite crude, but, in any case, it was not through his drawings that Maltese made his strongest impression. Maltese shone at "jam sessions"—group meetings, initiated by Selzer, of all the directors and their story men—and on any other occasion when he went through a storyboard. "What an artist!" Treg Brown wrote admiringly in *Warner Club News*, a Warner Bros. employee newsletter that usually devoted a page to the cartoon studio. "Mike can assume the character of any of our actors with the flip of a page"—with the exception of Inki (who was mute).[41] The 150 or so sketches on a storyboard were not enough to put a story across, Maltese said in 1976; to sell a story through drawings alone, "you'd have to animate the damned thing yourself. You're selling a mood, a pac-ing," as well as gags. So, "I would act out every little bit."[42] It was probably in Maltese's zest for performing that he differed most from Foster, who is never described in such terms.

In the early forties, as the old pool arrange-ment disappeared and story men and directors became more firmly aligned, Maltese worked

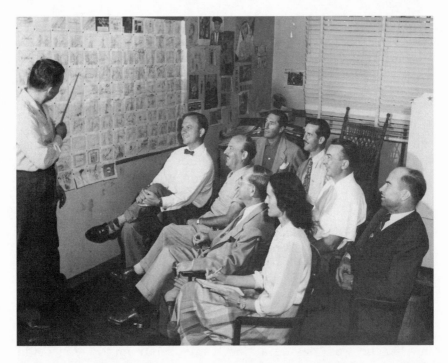

*A 1951 Warner Bros. "jam session" of directors and writers, on the
story for Chuck Jones's Bugs Bunny cartoon The Hasty Hare (1952).
Jones's writer, Michael Maltese, is at the storyboard. Jones, Friz
Freleng, and Edward Selzer, the cartoon studio's business head, are
in the front row, along with Selzer's secretary; in the second row are
Ted Pierce, Robert McKimson, Warren Foster, and John Burton, the
production manager. Courtesy of Friz Freleng.*

for Freleng, who was hardly an ideal collaborator. Their relation-
ship was one-sided: Maltese gave Freleng meaty storyboards, but
Freleng's caution—Maltese described him as "cold-blooded"[43]—
meant that he added little to what Maltese gave him; he also
resisted permitting his writer the stimulation of trying anything
new.

Maltese's first work for Jones, in the days before the pool sys-
tem had fully broken up, was on the 1942 cartoon *The Squawkin'
Hawk*.[44] Over the next several years, Maltese's name turned up in
the credits for Jones's cartoons once or twice a year. Some of
those credits may have represented collaborations with Jones's
regular story man, Pierce; Maltese and Pierce did not receive
their first dual credit until Freleng's *Holiday for Shoestrings* (1946),
but that cartoon was released shortly after all the Warner cartoons

started carrying fuller credits, and Maltese and Pierce had almost certainly worked together before then.

As Jones became a more skilled director of comedy, he found himself drawn to Maltese. "I liked to work with Mike, more than Ted," Jones said in 1976, "because Mike was a great gag man, and I'm better at putting the gags together."[45] In the early and middle forties, when the short cartoons of all studios—even Disney's— had become more intensely comic than ever before, good gags were the indispensable raw material. That is why Jones said that working with Maltese "was a matter of survival with me; I had to have a strong gag man."[46] For Maltese, too, Jones was a good fit, much better than Freleng. Maltese said, for example, that when he was with Jones, he took the storyboard for each cartoon to Carl Stalling's room, "and Carl and I would go over what type of music should go in there." He did nothing of that sort when he worked for Freleng: "Chuck was not above letting you take responsibilities. Freleng, no."[47]

Maltese described Jones as "one of the easiest directors I ever worked with.... He gave me complete freedom."[48] That was a double-edged compliment since it carried the suggestion (amplified in other remarks by Maltese) that Jones abdicated so much responsibility to Maltese that Maltese deserved the largest share of the credit for the successes among the Jones cartoons. Jones, for his part, estimated in a 1976 interview that "an average of 40 percent of the picture happened on the drawing board," that is, when Jones was drawing his character layouts, "even as far as the business [the gags and comic details] was concerned."[49] A few months later, he had raised that figure to 50 percent.[50]

In fact, such disagreements were really beside the point. Take a Maltese-written Freleng cartoon from the midforties—a straightforward Bugs Bunny cartoon, say—and set it beside a Maltese-written Jones cartoon of the same general kind from a year or two later. The sharpest difference is not in the gags—they come about as fast and funny in Freleng's *Racketeer Rabbit* as in Jones's *Rabbit Hood*—or even in the much stronger presence of the director's personality in the Jones cartoon. What is most striking is how perfectly the temperaments of writer and director complement each other. The nature of the collaboration can be illustrated by turning to one of the first Jones cartoons on which Maltese received a story

credit, *Fresh Airedale* (1945). Neither Maltese nor Jones could offer any specific memories of that cartoon, and given its date (it was released a few months before *Holiday for Shoestrings*), there is some possibility that Maltese did not write the story alone. But even if he collaborated with Pierce, the Weltanschauung that shaped the writing for *Fresh Airedale* is the same as shaped the cartoons that Maltese wrote for Jones in the late forties and early fifties.

Reduced to an outline, *Fresh Airedale* is a tale of gross injustice. A dog and a cat are the pets in a home, and they are treated most unequally. Their owner tosses a large piece of meat to the dog, Shep, speaking to him affectionately, and then, speaking contemptuously, "Here, stupid," throws fish bones to the little black cat. Looking around suspiciously and growling jealously, Shep swiftly eats his meal, cleaning the bone. Then he sees the man putting a piece of meat on the table. The dog grabs and eats the meat. The cat, seeing this, sweetly takes his fish bones and puts them on the plate, sharing with his master. The man, finding the bones, immediately draws the wrong conclusion ("You contemptible sneak! Just like a cat!") and kicks the cat out of the house. Shep—a hypocrite of staggering dimensions—brings the bone from his first hunk of meat to the man, who is so touched that he gives Shep *another* hunk of meat, just to show that he appreciates the offer.

The more perfidious the dog's actions, the greater his rewards. Finally, huge crowds hail him as a national hero. As Shep rides by in a parade, the cat stands sullenly on the sidewalk until he is hit by something messy (a tomato, or worse). When he pounds in frustration on a nearby statue of "Justice," Justice's scales fall from the statue onto the cat's head. (Events conspired to rob *Fresh Airedale* of some of its potency before it was released. As Jones originally made it, the cartoon had Shep credited—undeservedly, of course—for saving the life of Fala, President Franklin Roosevelt's Scottish terrier. When Roosevelt died in April 1945, some last-minute changes had to be made in the already completed cartoon so that *Fresh Airedale* could be released the following August. Fala was changed to Champ, a sign pointing to Washington was changed to one pointing to Philadelphia, and color was added to a background painting of the White House. Champ is still identified in a newspaper headline as "No. 1 Dog," but the reason for his ranking is no longer self-evident.)[51]

Handled carelessly, this story might have curdled into a dis-

tastefully adolescent exercise. Jones instead transformed it by giving his characters a depth and complexity that could have been no more than suggested in the sketches on the storyboard. The cat is endearing, but he is also a little bit in love with his own sweetness and innocence. When he puts the fish bones on his master's plate, his face says that he is thinking more about himself, and about how good he is, than about his master. The dog is a revolting cur, but he is plainly compulsive, driven to be a scoundrel even when reason commands him to stop. In the opening scenes, when the dog receives his *third* piece of meat, it is all he can do to keep from gagging.

Fresh Airedale was one of the first cartoons in which Jones used his newly acquired tools, his expressive poses and his sense of how to present them most effectively, with something close to full mastery. The cat and the dog emerge as full-blown personalities in this short cartoon because Jones's drawings get at their essences so quickly—and in the process, Jones transforms the rather nasty cynicism inherent in the story into delicate irony. Something similar happened in all of the best Jones cartoons written by Mike Maltese. There was a blending of the sweetness that dominated Jones's earlier cartoons with the brusqueness and energy that leaped from Maltese's storyboards, especially when Maltese was standing in front of one and telling the story himself. The result was often a cartoon richer and subtler than either man could have hoped for while working with someone else. Maltese's gags were more than just raw material for Jones—they were a challenge, one that Jones met superbly.

●∴●

By the time he and Maltese began working together regularly, Jones was already collaborating with experienced animators— Ken Harris, Ben Washam, and Phil Monroe chief among them— who had adjusted to him, and he to them. When he animated for Jones before World War II, Monroe recalled, Jones "liked you to follow his way of drawing, and do it his way.... I wanted to do it my way, [although] maybe my way wasn't as good." When Monroe returned to Jones's unit after the war, Jones "didn't do quite as many drawings in his scenes. He'd give you one drawing, and then on his

exposure sheet he'd be more descriptive, I think." Neither did Jones expect his strongest animators to adhere strictly to his character layouts: "You could either do it his way, exactly, or you could start using your imagination a little bit and changing his stuff as you went along."[52]

Jones's own comments in later years often jibed with the animators' remarks. He said, for instance, that he did not want his animators to use his layouts unchanged, "working into my layouts, and working from them, like wire between telephone poles.... I wanted...to demonstrate what the action should be and what the expression should be." Ken Harris, he said, used the character layouts, "to be sure, but usually the body was in a different position; he would preserve the expression."[53]

Yet just as Jones was reluctant to concede too much credit to Maltese, he was gingerly about conceding too much credit to his animators. He tended to speak of providing his animators with many hundreds of layout drawings; he said in 1975, for example, that he gave them a key drawing for every two-thirds of a second of screen time, or one for every sixteen frames of film[54]—an extraordinarily high figure, considering that the Warner cartoons were shot almost entirely on twos and that Jones would thus have been making one layout drawing for roughly every eight cel setups (the drawings traced onto one or more layers of celluloid). Few animators, if confronted with so many drawings, could do much more than inbetween them. On another occasion, Jones said that the number of layouts for a six-minute cartoon "probably came out between 250 and 350, sometimes more,"[55] a more reasonable ratio of one character layout to every ten to fifteen cel setups. He spoke, too, of holding his animators to strict timing, "by necessity, because I found out if they...lengthened a hold by two more frames [shooting on twos], they would also lengthen the other end by two frames, and that's four frames; and if it's a twelve-frame hold, the difference between twelve and sixteen is enormous."[56]

What does seem clear is that, as far as Jones was concerned, he was exercising control; as far as his strongest animators were concerned, they had plenty of elbowroom. "All of my animators had to obey my exposure sheets," Jones said, "but I soon learned the kinds of persons they were, and I'd give them the kinds of scenes that related to the kinds of persons they were, and I adjusted the action to fit the people."[57] As his collaborators assumed more of the load, Jones's stamp on their work actually became stronger;

he may have given his animators fewer drawings than in the early forties, but those drawings were far more dominant.

Jones understood, probably better than any other director has, the implications of one of animation's basic principles: that there is a hierarchy of drawings, and some drawings—in Jones's case, the poses he put into his character layouts—are more important than others. Strong animation poses, like strong poses in painting and sculpture, convey a sense of both dynamism and repose: they define a moment of equilibrium. Jones's drawings in the late forties did more than define moments of physical equilibrium, though; they defined moments of *emotional* equilibrium, when a character's feelings came into focus.

If an animator's mandate is to "preserve the expression," and the director's drawings are intensely expressive, it may not make much difference that the animator feels he enjoys the freedom to alter the position of the character's body or tinker with the timing; he may not be able to do either without losing the expression he is charged with preserving. Jones's cartoons from the late forties are, in fact, remarkably uniform in both animation and drawing style, almost as if Jones made every drawing himself. Although he generally assigned action scenes to Ken Harris and personality scenes to Ben Washam, the results were action scenes as Jones would have animated them and personality scenes as Jones would have animated them. As in Clampett's case, the director so fully played all the parts that casting of any kind, much less casting by character, was all but irrelevant.

Apparently, no complete sets of Jones's character layouts have survived for any of his cartoons from the late forties and early fifties, or even for short sequences. But many individual layout drawings have survived, and many others were used to make up the model sheets of new characters. Those drawings by Jones are emotionally precise, but rarely subtle; it is almost always possible to attach a single label to what the character is expressing through its face and body. The complexity of a good drawing is absent—but only when the drawings are seen individually. When they emerge one after another in a cartoon, imposing an emotional rhythm on it, the result is the kind of psychological variety found in *Fresh Airedale* and, to greater and lesser degree, in dozens of other Jones cartoons.

It is the kind of variety found also in

Clampett's best cartoons, where movement rather than a pose was the director's principal tool. Both directors' methods had their advantages: Clampett could depict tumult of all kinds with a verisimilitude that Jones could never approach. When Jones tried—as when Daffy Duck swallows what is supposed to be an awesomely potent drink in *Drip-along Daffy* (1951)—the results were usually pallid. Jones had become freer in introducing distortion into his poses by the early fifties, but highly elastic animation was simply not compatible with adherence to those poses. On the other hand, because Jones's cartoons were basically more serene and detached than Clampett's, he could convincingly portray a wider range of mental states than Clampett could.

Through the late forties and into the early fifties, the poses in Jones's cartoons gradually became more powerful: the characters seemed more and more to act through poses rather than through movement. That is not to say that the poses in Jones's cartoons looked frozen on the screen; there could be—and frequently was—movement *within* a pose, and, in any case, the stronger and more particular a pose, the greater the weight it can bear. But everything on the screen worth paying attention to seemed to be happening in the poses. Often, Jones conceived even action scenes so that his poses stood out *within the action*—through an expressive pause in the midst of some desperate lunge, say, or through some stratagem like the one Jones used in *For Scent-imental Reasons* (1949). That cartoon is one of the Pepé le Pew series, in which an amorous skunk pursues a terrified cat whom he mistakenly believes to be a skunk, too. In *For Scent-imental Reasons*, when the cat first flees from Pepé, her body is immobile—held in a pose, as if paralyzed by shock—except for her flailing legs. *They* are stiff, too, held straight out as they churn. By relying on a pose here, Jones suggested paralyzing fear while he showed a furious effort to escape.

Even as his poses swallowed up his cartoons (and the work of his animators), Jones made such cunning and economical use of movement that his cartoons rarely seemed static. In *One Froggy Evening* (1955), one of the last Jones cartoons to go into production before the studio closed for six months in 1953, movement is often little more than a seasoning that brings out the flavor of Jones's drawings. The cartoon is a fable about a singing, dancing frog (it specializes in songs of the Gay Nineties) that will sing and dance only in the presence of the dumpy, middle-aged worker who uncovers the frog in the cornerstone of a demolished build-

ing. The worker, at first joyful at the thought of the wealth to be gained from exhibiting his marvelous frog, falls into frustration and then into despair; the frog will not perform for an audience. If on rare occasions it appears willing to do so, fate (with which the frog is clearly on intimate terms) prevents anyone from seeing it.

Because the frog is so vigorously animated when it *does* move, its enervated poses when anyone else is around become a large part of the joke. As the frog croaks a very deep, languid croak, its mouth opens only a little—but rather than its whole very wide mouth opening a crack, its mouth opens in only one small place, and that small opening seems to slide across the frog's face as the croak emerges. There is very little animation here, and what there is only points up the frog's immobility.

One Froggy Evening is like a contest between energetic animation and strong poses; and the poses always win. Like many of Jones's better cartoons, it has no dialogue (the frog's singing voice is the only one), which means that no conflicts arise between the literal timing that dialogue often demands and the much less realistic timing that highly accented poses may require. At one point, the frog's owner has gone to a talent agent and is trying to sell him on the frog; Jones shows them through a glass pane (so that the lack of dialogue seems natural) as the frog's owner gestures and pleads and dances frantically. The theatrical agent does not move at all, except for his eye (Jones shows him from the side), but his expressions say so much, and the movements of his eye are so apt, that his image, and not that of the frog's flailing owner, defines those scenes.

Jones had begun in the late thirties by controlling his animators as a sort of superanimator. Then, in the midforties, through the poses in his character layouts, he began exercising a kind of control that was specifically a director's. He always dominated his animators in some way. It was different with Mike Maltese; Jones was not the dominant partner when he and Maltese began working together. But their relationship changed, too, in ways that can be traced through how the characters changed in Jones's hands.

Early in 1947, a few months after Jones and Maltese began working together regularly, a cartoon called *Mississippi Hare* was moving through the Jones unit. (Because of the two-year lag between

production and release that had built up during the war years, it was not released until 1949).[58] The story was very much like those that Maltese wrote for Freleng earlier in the decade: it pitted Bugs against Colonel Shuffle, a small, blustering, mustachioed opponent—his role could almost have been filled by Yosemite Sam—in yet another version of the *eiron-alazon* conflict, this time set on a Mississippi River sternwheeler. The Jones cartoon is, however, dense with comic business in a way that a Freleng cartoon never is. It is filled with invigorating details, like the suspicious manner in which Bugs regards a ten-dollar bill for which the colonel is desperately seeking change (the colonel needs a penny to buy a paper cup, which he will fill from a water cooler; he will then sit in the cup, to extinguish the fire blazing merrily on his rump). Bugs not only eyes the bill as if it were bogus and voices his misgivings ("You sure it's a good one? Lots of counterfeits around, you know. Oh well, you gotta trust somebody"), but he bites it, as if it were a bad coin. (Here, as so often, a throwaway gag in a postwar Jones cartoon would have been a big joke in a prewar Warner cartoon.)

There is really no way to assign credit for the many pieces of comic business, like the biting of the bill, in Jones's cartoons of the late forties and early fifties. They could have originated on Maltese's storyboards (or in his telling of the boards), or in Jones's layouts, or even with one of the animators. Most of the drawings and other pieces of paper that might make such attributions possible have long since disappeared. But, in any case, such embellishments become possible only when a storyboard is thick with gags to begin with, and Maltese's clearly were.

In the first few years of the Jones-Maltese partnership, the characters in the Jones cartoons were typically noisy, brash, and aggressive—New York tough guys and broadly conceived slapstick comedians. They were Maltese's characters more than Jones's. Jones made a short series of cartoons with Hubie and Bert, two New York-accented mice who, like many other cartoon characters, recalled the dumb Lennie and smart George in the movie made from John Steinbeck's novel *Of Mice and Men*, and another series with the Three Bears, a burlesque troupe made up of a tiny, bull-throated father, a slovenly mother, and an enormous, cretinous "baby bear," Junyer.

The mice and the bears and Charlie Dog, the New York sharper, appeared at approximately one-year intervals in the late forties. Those characters had been around for a while when Jones

and Maltese started working together exclusively, and Maltese may have been involved in the first stories for all of them: he shared screen credit with Ted Pierce for the first Charlie Dog cartoon, *Little Orphan Airedale* (1947), and he was the voice of Hubie, the smart mouse (Pierce was the voice of Bert, the dumb one), for the mice's first appearance, in *The Aristo-Cat* (1943). By far the strongest cartoons in each series were made after Jones and Maltese became a team.

Maltese's presence was not quite so overpowering in the cartoons Jones made with the established "stars," Bugs and Daffy. However closely Jones's Bugs in *Mississippi Hare* resembled the rabbit in the Freleng cartoons, there were subtle differences, which Jones soon magnified. Jones's Bugs lacked some of the child's delight in outwitting his enemies that Freleng's Bugs had. He seemed a little older, a little more stable, a little more reluctant to get into contests—unmistakably an adult. Jones described his Bugs as a "counterrevolutionary," a character who just wanted to be left alone, but who reacted powerfully when other characters imposed on him.[59] (Freleng's Bugs did not seek out conflict, but relished it when it arrived.) This conception was clearly Jones's, since it emerged not from the gags but from how Bugs was drawn and animated; moreover, a Bugs of this kind was simply not the kind of character that Maltese, with his penchant for simpler cartoon rowdies, was likely to come up with.

Jones's conception of the counterrevolutionary Bugs solidified so quickly that it found its paradigmatic form in his first Bugs Bunny cartoon to go into production after *Mississippi Hare*.[60] *Long-haired Hare* (1949) opens with Bugs playing the banjo and singing outside his hole, which happens to be near the home of Giovanni Jones, an opera singer. Bugs's cheerful singing intrudes on Giovanni's practice and gives Giovanni the opportunity to demonstrate the arrogance and short temper that make him a perfect antagonist for Bugs. Rather than ask Bugs to please desist, Giovanni takes the banjo from him and jams the body of the banjo over Bugs's head. Such brutality would have been sufficient provocation for Bugs in a Freleng cartoon of a year or two earlier; but in this cartoon, Bugs turns the other cheek not once but twice, until finally he says to the camera, "Of course, you know this means war."

Because Bugs has been so slow to seek revenge, his revenge is the more satisfying to watch once it gets under way; and because the audience's thirst for justice has been excited, the scope of his

revenge can be awesome. Bugs goes on the attack while Giovanni is performing at the Hollywood Bowl, but at first with little more than sniper fire. He strikes the shell with a sledgehammer so that Giovanni vibrates around the stage and plunges into a tuba; he sprays Giovanni's throat with alum, so that when Giovanni goes onstage to sing, not only his voice but also his head shrinks almost to the vanishing point. Bugs has only disrupted the performance, though, he hasn't taken control of it. He does *that* when he strides imperiously toward the podium, wearing a flowing white wig. "Leopold!" the musicians cry—for who else could this be but Leopold Stokowski? The conductor yields his podium abjectly, handing Bugs his baton, but Bugs, true to Stokowski's habit of conducting only with his hands, breaks it and tosses it away. Bugs then conducts not only the orchestra but also the singer: Giovanni's voice rises and falls wordlessly as Bugs moves his hands and waggles his fingers. When the concertgoers respond with applause, Bugs conducts *them*, too, instantly silencing their applause with a gesture. Bugs is not done until he makes Giovanni hold a high note for a long, long time, so that, finally, the shell of the Hollywood Bowl cracks and comes crashing down around his ears.

It is difficult to imagine a Freleng version of *Long-haired Hare* building so smoothly in a crescendo; the gags in Freleng's cartoons tend to be of equal weight, so that a cartoon simply stops when its time is up (as is true of Jones's *Mississippi Hare*, too). So as early as 1947, only about a year after Maltese and Jones began collaborating, some Maltese stories were assuming a shape on the screen that differed markedly from what could have been expected if Maltese had continued to work for Freleng.

In his early cartoons, in the late thirties and early forties, Jones tried less to be funny than to reveal character. He succeeded rarely; a director cannot reveal character in a vacuum, and a vacuum was, too often, what the stories for the early Jones cartoons amounted to. But with Maltese writing the stories, Jones could give greater depth to the comedy that was already there by making it less a comedy of gags and more a comedy of character. As he explored the characters, the characters changed—just as Bugs Bunny changed between *Mississippi Hare* and *Long-haired Hare*.

As the characters changed, Maltese must have responded by having them behave differently on his storyboards, too. Increasingly, as Jones and Maltese worked together, the cartoons, and the characters in them, reflected Jones's sensibility rather than

Maltese's, until, at the end of the forties, Jones began retiring the most strongly Maltese-flavored characters—Charlie Dog, the Three Bears, Hubie and Bert—in favor of more subtly delineated characters that were unmistakably his, like Pepé le Pew, the amorous skunk.

Jones could not, however, retire the most important Maltese-flavored character: Bugs Bunny, the most popular of the Warner characters and the only one that had to be used in at least eight cartoons a year—three of them Jones's—to meet Warners' commitment to exhibitors. Jones had, in *Long-haired Hare,* given Bugs a much more complex and interesting personality than the one that emerged in the Freleng-Maltese collaborations, but he had brought his counterrevolutionary Bugs to perfection so quickly that there was nothing left for the character to do, no secrets left to reveal. Jones's cartoons that followed over the next several years added nothing to the Bugs portrayed so completely in *Long-haired Hare*; cartoons like *Rabbit Hood* (1949) and *Bunny Hugged* (1951) are not even repetitions of *Long-haired Hare* but are, like *Mississippi Hare*, enhanced versions of the Freleng-Maltese original.

Near the end of the forties, Jones began handling Bugs as if he were trying to keep his interest in the character alive. *Rabbit of Seville* (1950) is a musical in which Bugs evades Elmer Fudd on an opera stage; character is less important here than a kind of balletic comedy. And, most important, Jones paired Bugs with Daffy Duck. The two characters first "co-starred" in Jones's *Rabbit Fire*, made in 1949 and released in 1951. By putting them together once or twice a year, Jones could meet his obligation to the Bugs Bunny series, even while working with a character that clearly had become more interesting to him than Bugs.

In his prewar cartoons, Jones had presented characters like Elmer Fudd and Conrad Cat as sweetly, adorably incompetent. (This was sentimental and self-indulgent—Jones often professed in later years to find himself mirrored in his more inept characters.)[61] Now, a decade later, he began to present not just some new postwar characters but also—and especially—Daffy Duck as *comically* incompetent, without the prewar cartoons' sickly, condescending smile. He was, in effect, giving some of Maltese's vigor to characters who were at their core extensions of his prewar favorites.

Jones brought his incompetent Daffy fully to life in two 1951 cartoons: first *Rabbit Fire* and, a few months later, *Drip-along*

Daffy. In *Drip-along Daffy*, a parody western, Daffy is, as the cowboy hero (Porky Pig plays the Smiley Burnette role), one of those people who sabotage their own efforts to assert authority: when he draws his guns, he pulls his chaps off with them and is left standing in his underwear. When Nasty Canasta, a hulking bandit, enters, Daffy shoves his revolver into Nasty's face and, botching yet another western cliché, cries, "Stick 'em up, *homber!*" Nasty responds by biting most of Daffy's gun away.

Nasty Canasta was, of course, the sort of villain that Bugs Bunny would have dispatched without working up a sweat. In *Rabbit Fire*, the contrast between the ever competent Bugs and the incompetent Daffy is so stark that Daffy himself becomes fully aware of his incompetence, and he can't stand it—he explodes in frustration. In *Rabbit Fire*, and in two Jones cartoons that are very much like it—*Rabbit Seasoning* (1952) and *Duck! Rabbit, Duck!* (1953)—the premise is that it is duck-hunting season, and Daffy, to throw the hunters off his own scent, is steering them toward Bugs with signs proclaiming rabbit season. The visible hunter in each instance is Elmer, legitimately a boob this time because a boob is what is called for. Bugs can manipulate the boob hunter with ease; Daffy cannot manage even that.

It is a blessing that Daffy is so incompetent in these cartoons; if he were any good at what he tries to do to Bugs, he would be appalling rather than funny. But a merely clumsy Daffy would have made Bugs look intolerably smug and superior by comparison, so Daffy had to be presented as something close to a villain in his appearances with Bugs if the cartoons were to succeed. Succeed they do, but really as acrobatic feats: watching Jones bring Bugs and Daffy through these cartoons whole is like watching circus aerialists perform without a net. Jones paid a price for the convenience of using Bugs and Daffy in the same cartoon: the risk of devastating failure—of making one or both of these characters hateful instead of funny—is a little too great. Daffy is a much more sympathetic character in the cartoons he shares with Porky Pig, since Jones presents Porky as an amused observer rather than an antagonist.

Jones never used Bugs and Porky together, and for good reason: as relatively subdued characters who were not especially funny in themselves, they needed strong comic foils. Daffy did not; he could even carry a cartoon by himself, as he did in *Duck Amuck* (1953). Daffy is not exactly alone in *Duck Amuck*; he is tormented by an unseen animator whose identity Jones reveals only

in the closing moments of the cartoon. But Daffy is the only character on the screen, and the cartoon belongs to him.

He enters dressed as a musketeer, swashbuckling his way in front of a painted background—but the swashbuckling lasts longer than the background does, and Daffy finds himself in front of a plain white card. When he protests ("Hey, psst! Up there! The scenery! Where's the scenery?") another background, this one of a farm, is painted in, and Daffy changes into farm clothes. As he strolls across the farm, that background changes to one of snow and ice. The treacherous backgrounds have been only a prelude, however. Within the next few minutes, Daffy is robbed of his voice (animal sounds emerge when he opens his mouth), his body (he is erased and redrawn as a bizarre creature from whose tail waves a banner bearing two emblems: a screw and a ball), and most important, his dignity. When he is a long distance from the camera and calls for a close-up, the screen seems to shrink around him, leaving him the same size as before. When he protests, the screen returns to its normal size and the camera zooms in for an extreme close-up of his eyes.

In *Duck Amuck*, Daffy's personality—his reality as a character—survives the sort of rough handling usually reserved for the characters in Tex Avery's MGM cartoons. Jones emphasizes, from the beginning of the cartoon, that Daffy is mere drawings projected on the screen. His body, his voice, the settings in which he exists—all are revealed as artificial. (Some of the settings are far more stylized than any of the settings in the Jones cartoons of the early forties; this was the third cartoon designed for Jones by Maurice Noble, who succeeded Robert Gribbroek as Jones's layout artist in 1950.) But it is because Jones is so relentless about bulldozing all the externals that Daffy's reality is affirmed rather than destroyed. Jones leaves nothing untouched—he says, in effect, that nothing is important—except the idea that Daffy has a mind and emotions; since nothing else could make Daffy seem real, the character remains intact. Whatever can be seen of Daffy, in whatever shape, is vividly, insistently alive.

Mike Maltese was indispensable to *Duck Amuck*—it was through collaborating with Maltese that Jones learned how to use vigorous gags as vehicles for the caricature of emotion—but he is almost invisible in it. The gags, abundant as they are, count for very little, the character for everything; what matters is not what happens to Daffy but his feelings as he is erased or redrawn. *Duck Amuck* is thus closer in spirit than any of Jones's other cartoons

to Clampett's best work.

How Jones transformed what Maltese gave him can best be seen not in a unique cartoon like *Duck Amuck*, but in a series of much more typical Jones cartoons. Those cartoons were rich with gags, and as much in debt to the conflict formula as any cartoon Friz Freleng ever made. They were, moreover, cartoons in which violence was central to much of the comedy. They could be considered the Warner cartoons at their purest—and so, perhaps, the cartoons that best illustrate how the most distinctive Warner cartoons crowned an evolution that could be traced not just to Tex Avery's arrival at the Schlesinger studio in 1935, or even to its opening in 1933, but to the roots of animation itself.

The first Coyote and Road-Runner cartoon, *Fast and Furry-ous*, was released in September 1949. "Mike Maltese was the writer that worked with me, and he pretty much had the idea for this," Jones told a television interviewer thirty years later. "We were talking about crazy chases, like aardvarks chasing wildebeests.... Actually, we were trying to do a takeoff on chases, because everybody was chasing everybody, including all our stuff."[62] Evidently, Jones regarded that first cartoon as a parody because the pursued character, the Road-Runner, did not outwit its pursuer (as in most chase cartoons); instead, the pursuer, the Coyote, was defeated by his own ineptitude.[63] The characters' appearance matched their roles: the Coyote shaggy and knobby, all snout and elbows and dingy brown fur; the Road-Runner as briskly impersonal as an animated hood ornament. There was no thought, Maltese said in 1971, that *Fast and Furry-ous* might be the start of a series: "It was just another one-shot, just another workaday cartoon."[64] Work on a second Road-Runner cartoon, *Beep, Beep*, did not begin until the spring of 1950—about six months after the release of *Fast and Furry-ous*, and thus long enough for favorable exhibitor reaction to have filtered back to the cartoon studio.[65]

Four months before the release of *Beep, Beep* in May 1952, the Coyote appeared with Bugs Bunny in a cartoon called *Operation: Rabbit*.[66] He speaks, as he did not in *Fast and Furry-ous*, introducing himself to Bugs as a genius by trade, and he has the smooth self-assurance of the "expert" who doesn't know what he's talking about. The Coyote and Bugs in this cartoon are both calm, self-confident characters, and even though the Coyote's self-confi-

dence is misplaced, that doesn't alter the fundamental mismatch. Bugs always needed blustering, threatening, energetic opponents; with any other kind, he tended to be either overbearing (as in some of Clampett's cartoons) or supercilious (as in *Operation: Rabbit*). As for the Coyote, when he was paired with the Road-Runner he was a much more resourceful opponent for himself than even Bugs could be.

In many respects, *Fast and Furry-ous* was the template. It was natural for the Coyote and the Road-Runner to be alone in *Fast and Furry-ous* because they were in the desert. Having started with only two characters, Jones and Maltese continued that way, to the point that if other characters *had* been introduced, they would have seemed like intruders. Only at the end of the sixth cartoon in the series, *Ready...Set...Zoom!* (1955), do other characters appear, and that is a special case: when the Coyote disguises himself as a road-runner, he is immediately beset by a mob of hungry coyotes, all of whom look like him.

In *Fast and Furry-ous*, both characters are frozen for "scientific identifications" in bogus Latin: the Road-Runner as "*accellerati incredibus*," the Coyote as "*carnivorous vulgaris*." The same scientific labels (with minor variations in spelling) were used for the next two cartoons; then, starting with the fourth one, *Zipping Along* (1953), the Coyote and the Road-Runner got new identifications for each outing: *batoutahelius*, *birdibus zippibus*, and *digoutius hot-rodis* for the Road-Runner and *evereadii eatibus*, *famishus vulgarus*, and *hardheadipus oedipus* for the Coyote, to mention only a few.

Likewise, the Road-Runner and the Coyote do not speak in *Fast and Furry-ous* or in any of Jones's twenty-three remaining cartoons in the series. The Coyote does yell or laugh on rare occasions, but other than that, the only vocalizing is the Road-Runner's "beep, beep"—a sound that Jones picked up from Paul Julian, the background painter, who used it to signal his approach when he was carrying an extra-long painting down the hall. Julian recorded his "beep, beep" for Jones, and it was used (speeded up) for years after Julian himself had left the cartoon studio.[67]

Jones described some of the "disciplines"—all of them traceable to *Fast and Furry-ous*—that he observed in directing the Road-Runner series:

> The basic one, right away, was that the Road-Runner was a road-runner, and therefore stayed on the road.... He only

leaves the road when he's lured off, by the simple device of drawing a white line, or a detour, or something of this kind.

Second, the Coyote must never be injured by the Road-Runner, he always injures himself.... The Road-Runner never enters into it, except perhaps coming up behind and saying, "beep, beep," which seems not too violent.

Third, the cartoons were set in the American Southwest desert, and although we used a lot of different styles in the pictures, in the backgrounds and such, it always had to be in that context.[68]

It's open to question how consciously Jones observed such disciplines in the early years of the series; Maltese said that he never bothered with any rules when he was coming up with gags: "If we had laws or anything, I never heard of them."[69] And yet the cartoons did follow the rules, for the most part.

Because the Road-Runner cartoons were so tightly circumscribed in so many ways—settings, number of characters, kinds of gags, absence of dialogue—there was always the danger that monotony would overtake them. There is, indeed, a sameness about the cartoons in the series. They tend to look alike, even though the dominant colors and their treatment changed over the years (from semirealistic buffs and browns in the early years to semiabstract reds and golds later on, with side trips along the way). The titles are a lot alike, too, full of "zooms" and "zips" and "beeps." With effort, it is possible to remember that certain gags go with certain titles—the "harpoon gag" with *Zoom and Bored* (1957), for instance—but not many of the gags lend themselves to such labels because—need it be said?—the gags are very much alike, too.

Very much alike, and yet very fresh and very different, because Jones and Maltese played so many ingenious variations on a limited repertoire of props and situations. The Road-Runner cartoons are full of gags that were polished, expanded, and turned inside out as the series continued. The Coyote was never safe around a boulder or a dynamite plunger or a cliff because Jones and Maltese found so many ways to use them against him.

One example of this improvising-on-a-theme must suffice. In *Fast and Furry-ous*, the Coyote paints a white line off the road and across the desert to a rock wall, where he paints the opening of a tunnel. The idea, of course, is that the Road-Runner will run off the road and smack into the wall—but as the Coyote watches in

astonishment, the Road-Runner runs into the painted tunnel as if it were really there. The Coyote overcomes his surprise and makes a running start at the tunnel—and smashes into the rock wall because, after all, the tunnel isn't there. As the Coyote staggers around in a daze, the Road-Runner dashes out of the nonexistent tunnel, knocking him down.

In the third cartoon in the series, *Going! Going! Gosh!* (1952), the Coyote again tries to fool the Road-Runner with a painting, on canvas, of the road continuing in perspective. This time the Coyote stands the painting upright where the road ends at the edge of a cliff. Again, the Road-Runner rushes into the painting as if the road were really there. As the Coyote stands puzzled in the road, a truck roars out of the painting and runs him down. Furious, the Coyote hurtles into the painting—or, rather, through it, because now the painting is just a piece of canvas.

In the eighth cartoon in the series, *Gee Whiz-z-z-z-z-z*, Jones and Maltese once again used the idea of a painting that becomes the real thing, but this time the Coyote's painting shows that the road is gone, a chasm in its place. The Coyote can assume, on the basis of his previous unhappy experiences, that the Road-Runner will either stop in front of the painting, where the Coyote can grab him, or will rush into the painting and tumble into the gaping hole. But no; the Road-Runner simply bursts through the painting. It is the Coyote, when he tries to follow, who enters the painting and takes the plunge.

There is nothing automatically funny about a painting that becomes three-dimensional and then flat again, but these changes always occur at the moment of maximum inconvenience for the Coyote. The laws of physics are suspended—the glue that holds the world together comes unstuck—just so the Coyote will fall into a hole. In cartoon after cartoon, the Coyote is the victim of a hostile universe; the trucks that mow him down seem to have no human drivers.

Sometimes, to be sure, the Coyote comes to grief simply because he makes stupid mistakes and pays for them. In *Fast and Furry-ous,* he puts on a "super outfit" from Acme (a mysterious company that provides him with a steady flow of unreliable merchandise). Dressed in this baggy superhero suit, he bounds off a cliff in a super pose—and plummets to earth. In *Gee Whiz-z-z-z-z-z*, the Coyote tries the same thing with a "bat-man" outfit, and, wonder of wonders, it actually works—as the Coyote reminds the audience by turning his head to smile smugly at the camera.

The Road-Runner and the Coyote as they appeared in Zoom and Bored (1957). © Warner Bros.

While his head is turned, he smacks into a cliff face and loses the webbing of his wings. Frantically flapping what is left of the wings, he flutters to a crash landing far below.

Jones and Maltese did not typically portray the Coyote as a dunce, though; he is more often unlucky than stupid or careless. He is quite clever at assembling devices to catch the Road-Runner, but the devices either fail to work or they work at exactly the wrong time. In *Stop! Look! And Hasten!* (1954), the Coyote has rigged a huge metal slab so that it will pop up out of a slot in the highway at the press of a lever; the idea is that the Road-Runner will slam into it at high speed. The Coyote hears the Road-Runner coming and presses the lever, but nothing happens, not even when the frustrated Coyote leaves his hiding place and jumps up and down on top of the slab. He gives up and returns to a more conventional pursuit, finally hitting on "super vitamins": his legs become highly muscular as soon as he takes the pills. The Coyote takes off in pursuit of the Road-Runner, literally burning up the road. At last, the Coyote is keeping pace with the Road-Runner, even at the bird's fastest speed. A great moment of triumph! It is, of course, at this point that the metal slab springs out of the road, just in time to acquire a large Coyote-shaped dent.

Jones, in describing the disciplines that he observed in directing the Road-Runner cartoons, expressed the most important one this way: "The sympathy always had to be with the Coyote. The Coyote was never hurt or in pain, he was insulted, as most of us are when we suffer misfortune."[70]

The Road-Runner cartoons were perhaps the most consistently violent of all the Warner Bros. cartoons; a string of gags comprises each one, and in most of those gags, the Coyote attempts violence of some kind on the Road-Runner and is himself the victim of violence, usually self-inflicted. At the same time, the cartoons are not violent in any meaningful sense, because the Coyote is not only vividly real—a struggling creature whose emotions are constantly in flux—but also very much a cartoon character. For him, accordingly, the boundaries of plausibility are very wide, certainly wide enough to encompass a stupendous yet injury-free fall or explosion of the kind he so often experiences. Rather than make the Coyote seem vulnerable, Jones constantly encourages the audience to think of him as virtually indestructible. Because the violence and the Coyote's physical immunity cancel each other out so emphatically, though, they leave a hole to be filled at the center of each gag.

Jones spoke of what happened when he began translating Maltese's story sketches into character layouts, for a Road-Runner cartoon specifically:

> When you sit down and start working, the characters develop on the board, and as the character develops, the gag has to change.... Certain characters Mike could hold onto. But there were some that were difficult for him.... The Road-Runner and Coyote, he seldom did the personality touches, or the responses.[71]

And yet nothing in the Road-Runner cartoons was more important, because it was through such "touches" in his drawings that Jones introduced the critical element, the insult. He understood that violence must have consequences in a cartoon's fantasy world, just as it has consequences in the real world; otherwise, a gag with violence in it will seem incomplete and unsatisfying. But the consequences can be different, and in the world of Jones's cartoons, they are: the grisliest fate is not to be maimed or killed, but to be embarrassed.

That is, more or less, what happens to the Coyote, time and again. The Coyote is at the center of each gag; the long falls and

tremendous explosions are simply means of making *him* funny. What matters is that a boulder is falling on the Coyote, but how he feels, as revealed in his face and body, when he sees it coming. At such moments, the Coyote becomes a bridge between his audience and the fantastic events on the screen. In his 1935 memorandum to Don Graham, Walt Disney said: "Comedy, to be appreciated, must have contact with the audience. This we all know, but sometimes forget. By contact, I mean that there must be a familiar, sub-conscious association. Somewhere, or at some time, the audience has felt, or met with, or seen, or dreamt, the situation pictured."[72] Somewhere, at some time, we have seen that boulder, most members of the Coyote's audience could say, and we have felt that feeling.

UPA,
1944–1952

By 1942, men from every Hollywood cartoon studio were entering the military. Most of those new soldiers, whether draftees or volunteers, did not go into combat units but were put to work instead on animated training films. The Army Signal Corps had established its first small animation unit in the middle thirties,[1] and some World War II draftees from the animation industry went to Signal Corps studios in New York City and at Wright Field in Dayton, Ohio. The Signal Corps was, however, locked into a kind of animated filmmaking that relied heavily on instructional diagrams; the Hollywood draftees who wound up in New York or Dayton were simply absorbed into that system.

By October 1942, another branch of the army, the Army Air Force, was setting up its own movie studio, called the First Motion Picture Unit,[2] on the Hal Roach Studios lot in Culver City, California, and building a staff dominated by industry veterans. Most of the FMPU was devoted to live-action filmmaking; an animation wing began operating in some sense shortly after the unit as a whole was set up. By late in November, John Hubley from Screen Gems, Berny Wolf from MGM, and Norm McCabe from Schlesinger's were all in the army and at Culver City.[3]

The new studio did not move into production rapidly: although Rudy Ising quit MGM in October to take charge of the animation unit, he did not leave for officer candidate school until the end of

February 1943,[4] and it was not until May, newly commissioned as a major, that he officially took command.[5] Ising recalled that after that he ran into "an awful lot of opposition from the Signal Corps in New York.... We won out, and I went back and took over a complete unit at Wright Field and a unit in New York and brought the cream of them out here."[6]

The Schlesinger artist Bob Givens said that by the time he joined the FMPU sometime early in 1944, "it was the old Disney tour...low-footage stuff."[7] The FMPU was, in fact, more Disney-like in the way it produced animated military films than was the Disney studio itself (the FMPU films were, after all, being made by animators who were getting low military salaries instead of union wages). Two former Disney animators, Wolf and Frank Thomas, headed subunits, both making films with character animation that embraced some comedy.

Around the time the FMPU opened its doors, the army established another Hollywood outpost at the old Fox studio on Western Avenue; it was there that the director Frank Capra made a series of propaganda films, mostly live action, under the umbrella title Why We Fight. Although the Capra unit, officially the 834th Signal Service Photographic Detachment, did not have its own animators, the Disney studio made animated maps and diagrams for Why We Fight. By late in 1942, Capra was ready to farm out a new series of short cartoons (around half the length of theatrical releases) to Disney, but Leon Schlesinger offered to do the job for less and so won the contract.[8] Most of the new series, called Private Snafu, wound up being made at his studio; Snafu was a boob soldier who made every possible mistake. Starting in 1943, the Snafu cartoons and a companion series called A Few Quick Facts were shown to military audiences as part of a pseudo-newsreel, the *Army-Navy Screen Magazine*.

Theodor Seuss Geisel—much better known as the children's author Dr. Seuss—headed the Capra unit's animation and graphics section after he joined the unit as a major early in 1943, with Otto Englander, the former Disney writer, as his second in command. "Having been sent to Hollywood from the East," Geisel wrote in 1978, "I knew nothing about Hollywood animation talent at the time. But Otto did. And he brilliantly put our unit together by getting artist-draftees assigned to us."[9] Gene Fleury and Phil Eastman, both former Disney artists, moved to the Capra unit from the Schlesinger studio in the spring of 1943. The Schlesinger directors made the cartoons from stories that Geisel and his colleagues wrote (Fleury said that Chuck Jones's unit, where he had

just worked, "was the most cooperative").[10] Geisel's involvement is evident in six early Snafu cartoons with rhyming dialogue, all written before Capra assigned him to other projects in March 1944.[11]

In contrast to Capra's unit, the FMPU farmed out very few cartoons; Ising recalled sending one to MGM and another to Hugh Harman, who had responded to the new market for training films by opening a small studio in Beverly Hills.[12] As much as they could, the studios used such military contracts to shield their best talent from the draft. Schlesinger "went all out to save the cream of the animators," Bob Clampett said, and the draft thus took mainly assistants.[13]

The war not only sucked animators and other artists away from their studios and into special film units, but it also arranged the artists within those units in rather haphazard fashion. Before the war, Dave Hilberman pointed out, many Disney people were pigeonholed as layout artists (as in his case), story sketch artists, and so on. When they went into the military, he said, they often found themselves in new positions "and solving problems that called for solutions other than the Disney solutions. The war...provided them with an opportunity for discovering something about themselves and animation that they never would have found out at Disney."[14] Gene Fleury remarked on the strange freedom that the military's otherwise strict requirements could bring:

> The last question on the Army's list of things to really worry about was whether pictures done by the animation section should look just like regular cartoons or not. The question was at the bottom of our list, too. What mattered most of all was the information to be conveyed.[15]

Some of the people working on the military films soon began thinking beyond them, to new kinds of films for civilian audiences. John Hubley, speaking at a writers' congress at the University of California, Los Angeles, in October 1943—that is, less than a year after the FMPU began producing animated training films—said that in making such films, "writers have been forced to deal with positive ideas, and there have been significant new developments in techniques as a result. But the material has been essentially technical.... The inherent human appeal of the medium and its application to all forms of cartoon production has just begun to be realized."[16]

Measuring such statements against the films made by the

*John Hubley at work, brush in hand, in the Army Air Force's First
Motion Picture Unit in the early forties. Standing are, at left, Joe
Smith, a layout artist from the MGM cartoon studio, and Robert
McIntosh, a background painter from Disney. Courtesy of Rudy
Ising.*

FMPU's animation studio is largely impossible; most of them
were destroyed when they had lost their usefulness as training
films. The surviving films produced by the military animation
units, or commissioned by them, are almost all like the Snafu car-
toons, that is, close kin to contemporaneous theatrical cartoons,

or else diagrammatic cartoons, like those that the Disney studio made, whose animation solutions reflect more a desire to save money and time than a search for visual power. It seems certain, though, that some of the lost military cartoons employed graphic language similar to that in the cartoons that John McGrew and Gene Fleury began designing for Chuck Jones in early 1941 and that Hubley and Zack Schwartz began designing at Screen Gems about a year later. Those theatrical cartoons had revealed how difficult it was to use such language effectively in films rooted in Disney-derived character animation. In the military films, that problem did not exist to anything like the same extent; whatever their comic garnish, they were wholly in the service of information.

The critical nature of the difference is apparent in one of the few surviving wartime films consistent with statements like Hubley's and Hilberman's. The FMPU did not make that film; the Capra unit farmed it out as part of the Few Quick Facts series around the end of 1944 to a small Hollywood studio then called United Film Productions. Zack Schwartz, who had become one of United Film's principals, designed *A Few Quick Facts About Fear.* Schwartz and his colleagues wanted to put their ideas to work in films made for civilian audiences, too. Their underlying purpose, whether the intended audience was military or civilian, was to attack the aesthetic foundations of the Disney cartoons on which they had once worked.

One day in the fall of 1938, when the Disney studio was beginning work on *Fantasia*, Walt Disney entered the room where Zack Schwartz was drawing the background layouts for *The Sorcerer's Apprentice.* Schwartz recalled forty years later that Disney had just come from a story meeting on *Cydalise*, the segment later replaced by Beethoven's *Pastoral* Symphony. Disney expressed his worry about *Cydalise*, and Schwartz—who had, as he said many years later, "been feeling very restive about the fact that every film that we made looked like every other film"—seized the opportunity:

> It happened that just the night before this meeting I had with Disney, I had bought a book of photographs of ancient art...from the Louvre museum collection.... I had also

bought a book on Persian miniature painting. I told him about the books I'd just bought, and I tried to describe to him the Greek vase paintings and the Persian miniatures. Just to make it more understandable, because I guessed he'd never seen any of these things. I said, "For example, in the story they're working on now...there's no reason why you can't have a god Pan who is emerald green, and all of his details are white line. You don't have to use realistic colors; you can design your characters and backgrounds so that the end result will be a picture unlike anything anyone has ever seen before."...At the end of this one-sided conversation, Walt got up to leave, and I said I would send the books up to his office.... I did that, and some weeks went by, and finally the books were returned to me—without a note, with no acknowledgment, and without even a thank you.[17]

Disney was in the late thirties expansive in his own thinking about where his films might go, in design and in every other way, but he may have sensed in Schwartz's enthusiasm a basic incompatibility. Even though Disney was at the time himself retreating in the face of character animation's demands, he was not shrugging them off, and that was essentially what Schwartz was proposing that he do.

As Disney's staff grew rapidly during work on *Snow White and the Seven Dwarfs* and in the aftermath of that film's success, many new hires came fresh from art school or from unsuccessful careers as commercial artists or serious painters. Some of those people—Zack Schwartz among them—wound up designing and painting backgrounds or drawing story sketches or in similar jobs. Because these artists were a rung or two below the animators in prestige, in salaries, and in the interest that Disney himself took in their work—and because they were often the equals of the animators in general artistic skills—discontent was inevitable. One form it took was criticism of the design of the Disney films, that is, of the styling of the backgrounds and how the characters related to them.

In the Disney cartoons, and in other Hollywood cartoons of the thirties, the characters—composed of lines and flat, bright colors—typically stood out from the background paintings like actors performing in front of stage sets. The backgrounds were realistically modeled and painted in muted colors, and so the characters "read" against them as color accents. Schwartz and others like him were steeped not in stagecraft but in art, and in commercial art in particular (Schwartz studied at the Art Center school in Los

Angeles in the thirties, preparing for a career in advertising; John Hubley was a classmate and friend). They inclined more and more to the idea that the boundary between characters and background paintings should be erased. If a character and its setting were cut from the same bolt, with movement alone separating them, the likeliest effect would be to elevate design—the overall "look" of a film—and thus the designers, at animation's expense.

Schwartz's ideas, and those of Disney staff members who thought like him, had little if any effect on the Disney films. Schwartz was a striker, as were Hilberman, Hubley, and others sympathetic to a stronger role for design; after the Disney strike and the layoffs that followed, most of those people scattered to other studios—as Schwartz, Hubley, and Hilberman did—and then, often, to the military. Sometimes the strikers set up shop on their own, trying to pick up crumbs from the booming new market for instructional films. As Bill Hurtz said, "Whoever had a job and got some money for it at the time was in business."[18] Stephen Bosustow, who had shuttled from animation to story work and back to animation again on the early Disney features, and Cy Young, the effects animator, went into business together briefly, using their own savings to rent space. Bosustow remembered making the rounds in New York and Washington and finding no customers.[19] By February 1942, he was working at Hughes Aircraft as a production illustrator. His eventual title was chief of project control and scheduling for Hughes's gigantic flying boat, his first management experience.[20]

While Bosustow was at Hughes, Hilberman and Schwartz were both working for Screen Gems. They had become close friends while they were layout artists at Disney's. "I remember one night we had gone to a movie or something," Schwartz said,

> and we were walking along and chatting, and we were both feeling unhappy about the fact that...we weren't doing anything for ourselves, as artists. The more we talked about it, the more we felt we ought to do something about it. So we decided that we would look around to see if we could find a little room somewhere that we could use as a studio, where we could come in the evening, when we felt like it, and draw and paint.[21]

They rented "a very nice room with a big window, on the north side" in the Otto K. Olesen Building, the same building where Hugh Harman and Rudy Ising made their first Bosko film.

Hilberman left Screen Gems after just a few months, around

the middle of 1942, and went to the Schlesinger studio; he worked there in layout for Norm McCabe and then Frank Tashlin. Around the end of 1942, Hilberman and other members of the Schlesinger staff—working at night and donating their time—made a five-minute, black-and-white film called *Point Rationing of Foods* for the federal government's Office of War Information. Chuck Jones directed the film, and Hilberman designed it. For all the traces it bears of Jones's Disney-like drawing style, *Point Rationing* does not look like a Schlesinger cartoon; it leans heavily on Hilberman's streamlined design, which is very much in keeping with the design of Zack Schwartz's black-and-white cartoons at Screen Gems, and includes very little animation. There is not much humor, either, but instead a very clear explanation of how food was going to be allocated under the rationing system. *Point Rationing* was, in other words, a civilian equivalent of the military films that Disney was already making, and that the FMPU was just starting to make.

As at the FMPU, making a film of this unusual kind stirred in some of the people working on it a desire to move further in that direction. Hilberman recalled "informal meetings," involving people like himself, Jones, John Hubley (by then at the FMPU), and Bill Pomerance, the cartoonists' union's business agent, "about some day forming a studio that we would run ourselves and do the kinds of films we wanted to do."[22] Hilberman left Schlesinger early in 1943 and took a job with Les Novros, the former Disney animator, who had gone into business for himself two and a half years earlier. By 1943, as Graphic Films, Novros was making animated inserts for navy training films as well as filmstrips for clients like Union Oil. Hilberman was one of only two employees.[23]

Steve Bosustow, still working at Hughes, began teaching a course in sketching for industrial purposes at the California Institute of Technology in February 1943. "One of the guys in one of the classes I had was from [Consolidated Shipyards]," Bosustow said thirty years later, "and he asked me if I'd do a filmstrip; I'd never even heard of what a filmstrip was. But I found out."[24] Bosustow "approached Les about doing [the filmstrip] on a speculative basis," Hilberman recalled, "and Les wouldn't do it." Hilberman, working in Novros's studio and so privy to such conversations, "told Steve to come and see Zack and myself.... Zack and I decided to go ahead and do it...and meanwhile Steve said he could get some posters to do, so we could cover some of our

expenses."[25] Hilberman left Novros around that time to take a job as a civilian employee in the Capra animation unit—there was no question yet of going into business full time.

The filmstrip, called *Sparks and Chips Get the Blitz*—safety instruction for welders—was, as Hilberman said, "the first bit of film we did, as Industrial Film." The new little company was a messy one at first, in keeping with its offhand origins. Technically there was probably a Hilberman-Schwartz partnership, with Bosustow associated with it as an independent contractor— although in one sense it was Bosustow who was really the company, dispensing work to the other two, especially since he left Hughes in September 1943 and began selling for Industrial Film and Poster Service, as it was then called, full time in November.[26] The question of who was really in charge, hardly a burning issue at a tiny filmstrip company run by three part-time owners, began to grow more important soon after that as Industrial Film took on an exceptionally ambitious project for so untested a producer.

Point Rationing of Foods, the film made after hours at the Schlesinger studio, was a union project; its titles included the line "This production is a contribution of Screen Cartoonists' Local 852." Hilberman and Schwartz both remembered that Bill Pomerance wanted the union's members to make more "education and propaganda materials," as Schwartz said, that large unions would underwrite. Schwartz thought "it was during the time that I was just finishing up painting the scenes for *Sparks and Chips* that Dave and I were invited to go over to John Hubley's house...to see a big storyboard that he had been working on...that was planned as an animated-cartoon political propaganda film" for the United Auto Workers to use in the 1944 Roosevelt campaign.[27]

The UAW, through its political director, had approached Hubley about making such an animated cartoon from a script by the screenwriter Robert Lees. Hubley and Bill Hurtz—both in the army by then—drew the storyboard and went AWOL with it to the Ambassador Hotel in Los Angeles, where they showed it to the UAW's executive board.[28] Once the UAW had approved it, the storyboard had to be translated into film—and quickly, if it was to serve its purpose. "Hubley and I discussed where it might go," Hurtz said. "Les [Novros] was mentioned, [Shamus] Culhane was

mentioned, and Chuck Jones was mentioned."[29] Hubley's first thought was that Jones should make it.[30] There was, after all, the successful example of *Point Rationing*, made just a year or so earlier, and Jones was politically liberal.

"They again approached Schlesinger," Hilberman said, "to repeat what he had done with [*Point Rationing*]"—that is, permit the use of his studio's facilities at night—"but Schlesinger didn't want to get involved with a political film."[31] Hubley then talked to Les Novros about making the UAW film, to be called *Hell-bent for Election*, and "we worked out a budget," Novros recalled. Hubley, Pomerance, and the actress Karen Morley—who was working full-time as a Hollywood liaison for the Congress of Industrial Organizations, to which the UAW belonged—followed through with visits to the Novros studio.[32]

The assignment went instead to Industrial Film, which, unlike Graphic Films, had at that point made no films at all, much less anything as demanding as a thirteen-minute cartoon that had to be completed in a hurry. (By then, in Steve Bosustow's recollection, the time available had dwindled to something like ninety days.)[33] Hilberman recalled that "the UAW and Bill Pomerance came to us at the Otto K. Olesen Building to see if we would undertake the doing of the film. We had no staff, just that small room. We decided to go for it."[34]

The circumstances suggest strongly that Industrial Film won the job for political reasons. Novros had the strong artistic credentials that came with having animated on *Fantasia*, but he had left the Disney studio in August 1940, long before the strike; whatever Novros's political views were in 1944, Hilberman's leadership of the strike, and Bosustow's and Schwartz's participation in it, surely carried more weight, especially with Pomerance. Bosustow acknowledged the strike's importance when he saw Hilberman in the audience for a panel discussion in 1978: "I really got to know you, Dave, on the strike lines.... We all began to know each other, so when the UAW-CIO came out to Hollywood, to have a film made, we were there."[35]

Because *Hell-bent* was, like *Point Rationing*, a one-shot film, it was made in the same way: at night, by people who held full-time jobs at other studios during the day. "In no time at all," Schwartz said, "we had recruited, with a lot of help from [Pomerance], people from Screen Gems and from Warner Bros. A lot of them were our close friends, many of them were just people we knew from union meetings." Chuck Jones was again the director; Robert

"Bobe" Cannon and Ben Washam from the Jones unit animated on the film. As Schwartz said:

> The overriding and basic problem was that work had to be prepared during the day so that the people who arrived in the evening would have something to do.... There was no way to handle this thing, except for me to quit my job at Screen Gems and just take over the function of the supervising art director. For me it represented a very big gamble. There was nothing stacked up ahead once *Hell-bent for Election* was completed.[36]

Although Bosustow and Schwartz were now devoting their time to Industrial Film, Hilberman was still working for the Capra unit. "It was decided," he said, "that it would be unwise for me, a civil servant, to be working on this political film, so I continued to do the posters and other odd jobs." The work on *Hell-bent* that took place around him "was a fantastic thing," he said, "because people would come and work all night long. We started seeing ourselves as a studio that would work on political, union type films. The 'Industrial Film' name started being a handicap, and we started thinking in terms of Union Films, and out of Union Films came 'United.' "[37]

The new company changed its name to United Film Productions on 1 May 1944.[38] Work on *Hell-bent for Election* was probably winding down by then; the film was copyrighted as of 11 July 1944, in plenty of time for use in the general election campaign that pitted Roosevelt against Thomas E. Dewey.[39] The cartoon depicts the campaign as a contest between two locomotives, the decrepit Republican "Defeatist Limited" and the Democratic "Win the War Special." It elaborates on the fundamental metaphor in detail: Joe, a worker loading war materiel at a train station, is told by a telegraph operator (Uncle Sam) that only one train can get to Washington on "track 44" and that he'll have to sidetrack the Defeatist Limited.

Even though the film credits Schwartz as its production designer, *Hell-bent for Election* looks very much like any other Jones cartoon of the early forties, with the same self-conscious use of both modern design and film techniques (matched dissolves, odd angles, and so on). The gulf between characters and backgrounds is even greater than it is in Warner cartoons like *Wackiki Wabbit*. In Dave Hilberman's words, "There's a terrible contrast...between the backgrounds, which are very designed and abstract, and the

characters, as directed by Chuck and animated by mostly Warner Bros. animators."[40]

When they produced *Hell-bent for Election*, United Film's principals had to accept such compromises because they could not make so long and complex a film in any other way. But with *Hell-bent* as its calling card, United Film was in an excellent position to establish itself as a real studio by winning contracts with government agencies and contractors—and it did, in fact, win a contract for a training film just as work on *Hell-bent* was ending. Commissions from the navy and the Capra unit followed. *Hell-bent*'s political slant helped get the contracts for navy films, Bosustow said: "some of the guys in charge were pro-Roosevelt, and thought the film was great, and said, some day, if they had more pictures, they'd give them to us."[41] Strike-born connections could be helpful, too: United Film landed a navy series on flight safety in part through the good offices of Aurelius Battaglia, a former Disney artist—and striker—who was then in the navy at Washington.[42] As for the Capra unit, not only was Dave Hilberman working there, but so was Gene Fleury, and his wife, Bernyce Polifka, had painted backgrounds for *Hell-bent*.

The transition to continuing operation as a real film studio was not easy, even so. United Film had cash-flow problems in its early days, Schwartz recalled: "Though we had work in the studio, and contracts, we didn't have any money for paying weekly salaries." Their supplier of art materials guaranteed a bank loan to tide them over until they received payments on contracts.[43] Because the military films were made on small budgets, Schwartz said, "we arrived at what we called 'limited animation'—it was limited by the money we could spend."

Schwartz had experienced an epiphany at Screen Gems, when he realized that "our camera is closer to being a printing press, in the way we use it, than it is to being a motion-picture camera"; he began preaching that doctrine to co-workers like Hubley and Hilberman. Someone who thought of animated films in those terms could not regard severely circumscribed movement as a handicap. For Schwartz, a great advantage of working with a limited budget, and usually in black and white, was that there was so little to distract him from making the kind of design-dominated film he had longed to make since his Disney days. He saw in *A Few Quick Facts About Fear* in particular "my dreamed-of opportunity to make a film that owed nothing to the traditions of animated cartooning or to live-action motion pictures. A film that

would be purely graphic design in every aspect and that would break away, totally, from everything that had been done before."

Fear is, in fact, a less attractive and less visually interesting film than the Willoughby Wren cartoons that Schwartz designed at Screen Gems. Its design is almost entirely subtractive, through a drastic simplification of drawing and design. Although in *Fear* Schwartz dispensed with such "traditions of animated cartooning" as individual characters (a knight is glimpsed as Private Snafu when he raises his visor, but there's otherwise no connection with the character in that series), *Fear* actually leans heavily on some of animation's hoariest devices—metamorphosis, for instance (in *Fear,* the liver transforms itself into a sugar bowl)—and it honors almost to a fault one of animation's fundamental rules, that figures should read clearly in silhouette.

There was, in short, a sort of artistic vacuum at the heart of United Film, even though that was probably not at all apparent to its founders. Hilberman could not do much to help fill it; even though he left the Capra unit to direct government films at United Film after production of *Hell-bent for Election* brought in new business, he was drafted near the end of the war, in 1945 (he blamed Bosustow for not filing the necessary papers with his draft board).[44]

It was at this point that John Hubley began to play a role in the new company, for the first time since he prepared the storyboard for *Hell-bent for Election.* "Hubley used to come to me after they had already started working on it to complain that they wouldn't let him into the studio," Les Novros said. "Despite the fact that he had done the storyboard, they still had discouraged him from coming in to see what was happening."[45] That may have been because Schwartz and Bosustow didn't want to risk trouble with the army, or it may have been, as Novros thought, because "they just didn't want his ideas," which Hubley could express vigorously. In any event, Hubley's involvement with the studio picked up in 1945 when the UAW brought another film project to United Film: *Brotherhood of Man,* a cartoon intended to combat racial prejudice.

Ring Lardner, Jr., and Maurice Rapf, two live-action screenwriters, wrote "a kind of script," Hubley said, "and in effect we sort of boiled down the words...and visualized them." Hubley was still in the Army Air Force at the time—he was not discharged until November 1945[46]—but he "took it into direction," and Bobe Cannon, who had left the Chuck Jones unit to work for United

Film, animated it. "Bobe sort of directed, too," Hubley said, because Hubley could work on the film only at night and on weekends.[47] "John would lay [scenes] out," Bill Hurtz said, "and sort of give a broad notion, and Bobe would work into the acting and the business. And above all, timing, which John felt very insecure about. That would be the area where he knew the least because he hadn't done frame-by-frame work."[48]

Cannon, who was five years Hubley's senior (he was born in 1909, Hubley in 1914) was the more experienced not just as an animator but in animation generally; he entered the business at the Schlesinger studio several years before Hubley started work at the Disney studio in 1936. Cannon received screen credit as the sole director of *Brotherhood of Man* (Hubley shared credit with others for writing and designing the film), but there was, even so, "a little bit of feeling" between the two men after *Brotherhood* was completed, Hurtz said. "Bobe did express to me once that he felt he did more in that picture than John ever credited him for."[49] Those hard feelings may have contributed to Cannon's leaving; he went to work at Disney in March 1946.

Only occasionally in the animation for *Brotherhood* are there suggestions of stylization of movement, of what Hilberman called "a different kind of animation that came out of the stylized characters."[50] Cannon's animation, although by no means limited in Schwartz's sense, is instead pervasively bland—and is in its blandness subordinate to the film's design. *Brotherhood* was thus wholly in keeping with Schwartz's ideas. It was not designed by Schwartz, though, but by Hubley, and it is his design that distinguishes the film.

Hubley's design is not just flat and simple in the Schwartz manner but has in addition a sharp edge with no real precedent in Hollywood animation, including the films that Hubley himself designed at Screen Gems; there are strong echoes in *Brotherhood* of the work of Saul Steinberg, the magazine cartoonist. What the Disney animators tried to avoid, Hubley embraced. In 1936, for example, when Bill Tytla spoke to one of Don Graham's action-analysis classes, Tytla's assistant Bill Shull said: "This point has been stressed by Don—no parallel lines on jowls whenever we want form or depth because naturally that flattens them out."[51] It was just such an effect that Hubley wanted. He called *Brotherhood of Man* "the major breakthrough from the Disney tradition because these characters were simpler, more expressive, not so cute."[52]

"Not so cute," definitely; but "more expressive"? No, not in the way that Bill Tytla's Grumpy was expressive or Bob Clampett's Daffy Duck. As Dave Hilberman told John Canemaker, "the two-dimensional characters we were designing didn't lend themselves to a fully acted-out Disney emotion."[53] Hubley's characters are more expressive only in the sense that his design is more assertive; because the characters, through their appearance, command attention more forcefully than those in *Hell-bent* or *Fear*, they are sturdier vessels for the ideas that are *Brotherhood*'s reason for being. It is ideas alone that are being expressed, and the characters exist only as vehicles for those ideas. Hubley and Schwartz wrote in an article published in 1946: "Instead of an implied understanding resulting from the vicarious experience of a specific situation, animation"—of the *Brotherhood* kind—"represents the *general* idea directly. The audience experiences an understanding of the whole situation."[54] To advance that general understanding, they were more than willing to sacrifice the sort of expressiveness that Tytla and Clampett had achieved.

In the eyes of Hubley and Schwartz and their colleagues, modern design was more than an effective tool for conveying information. What shaped *Brotherhood of Man*, even more than it shaped the earlier films—and what gave United Film itself so unusual a tenor compared with other cartoon studios—was a belief that modern design had a political, not to say moral, dimension.

●∴●

While he was in the First Motion Picture Unit, Bill Hurtz recalled, "several of us" became very excited by *Language of Vision*, a book by Gyorgy Kepes "on design, really, as taught at the Bauhaus...a book of revelation" to Hurtz, who had "never had any formal graphics."[55] Kepes, a Hungarian-born designer, had been living in the United States for ten years at the time his book was published in 1944. It's difficult to say how much *Language of Vision* influenced United Film's artists in the middle forties, but probably quite a lot, directly and indirectly. (When he left the army, Hurtz gave up animation and went to work for United Film as a layout artist, that is, a designer.) Dave Hilberman remembered that the book "did have an impact."[56]

Language of Vision validated films of exactly the kind that United Film was starting to make. Kepes presented modern art as

not just different from earlier art—specifically, the art of the Renaissance—but superior to it. In modern works, he wrote, the image "became once more a dynamic space experience instead of a dead inventory of optical facts." Modern artists, as their work became more abstract, had been discovering "a visual language which would reduce to the lowest common denominator all experience, old and new," refining "the image to its most elementary structure."[57] This progress in the visual arts should be an element in a broader social progress: "The task of the contemporary artist is to release and bring into social action the dynamic forces of visual energy." From images of the right kind "the nervous system can acquire the new discipline necessary to the dynamics of contemporary life."[58] Better pictures would make better people.

For such pictures to have the desired effect, they would, of course, have to reach the whole of the population—"speaking simultaneously to many"—and so Kepes wrote in terms sure to appeal to people working in a medium like the animated cartoon: "The mass spectator demands the amplification of optical intensity and leveling down of the visual language toward common idioms."[59] Such "leveling down" implied a blurring of the boundary between the fine arts and commercial art, and Kepes wrote of advertising as "art" that "could disseminate socially useful messages, and...train the eye, and thus the mind, with the necessary discipline of seeing beyond the surface of visible things, to recognize and enjoy values necessary for an integrated life."[60] Flattering words, for people who were making sponsored films. (Phil Eastman, who joined United Film as a writer after the war, had spoken favorably at the 1943 Writers' Congress of magazine ads' use of ideas borrowed from modern art).[61]

Language of Vision was, in its total effect, considerably more elevated than a mere call for functionality—the Bauhaus idea, reduced to its essentials, that every element of a design should have a job to do, without any extraneous ornament. The problem was that precious little of the work that United Film was doing lent itself to anything more than such functionality; *Brotherhood of Man* was an exception. When Hubley went to work for United Film full time after leaving the army, he worked on the navy training films and "a couple of filmstrips for the Auto Workers that I drew." Neither Hilberman nor Schwartz was "very excited about that Navy stuff," he said. "It sort of bored them, so they were happy to see me take them over."[62]

The company changed its name to United Productions of

America when it incorporated on 31 December 1945. It was per-
haps as an antidote to boredom that by the spring of 1946, as
Schwartz told an interviewer then, the newly renamed UPA was
"getting away from specialization by rotating personnel" so that
members of the staff changed roles from film to film.[63] Paul
Julian, who came to the new studio from Warner Bros., remem-
bered that staff members did "what came handy"; Julian himself
drew layouts and storyboards as well as his usual work, painting
backgrounds.[64]

Whatever communal spirit may have been expressed through
such a work arrangement was not proof against the clash of egos
that UPA's lofty artistic ambitions all but guaranteed. Hilberman,
after he got out of the army in 1946, "sort of felt he should run the
place," Bosustow said, "and there was a conflict between us
because I'd been running it then for three years." Hilberman, for
his part, said that "Steve had not been very effective as a studio
manager or a salesman—primarily as a salesman,"[65] the roles
Bosustow had played since the studio came into existence. The
conflict came to a head when Bosustow got a contract for a gov-
ernment-sponsored film—on labor unions, for the U.S. Infor-
mation Agency—that Hilberman and Schwartz had told him they
didn't want to make.

By that time, Hilberman said, he was anxious to accept an offer
from the Soviet Union to set up animation studios throughout
that country. "Zack felt that in that case, since some of his fami-
ly's money was tied up in UPA, he would want to get out of UPA
and pull his family's money out of it. So when we sat down with
Steve...we simply told him that we were pulling out." Schwartz
also remembered wanting to get out of what he thought was a
shaky company, but other members of the staff spoke of a contest
between Hilberman and Schwartz, on one side, and Bosustow, on
the other, to raise the money to buy each other out—a contest that
Bosustow won.

John Hubley said in 1976 that when "they got into this hassle"
both sides "came to me and said, 'Which side do you want to be
on?'" Bosustow made Hubley an offer that "was more concrete.
He said, 'I'll give you a big piece of the stock.' The other guys were
just talking about staying on as an employee. Also they had a kind
of an attitude like I owed it to them somehow, which pissed me
off.... I just weighed the two and I decided I would have an
easier time being the creative head of the studio with Steve as the
business head than I would with Zack and Dave, who were both

creative guys.... And I really wasn't totally tuned in to them artistically."[66]

Hilberman and Schwartz had been president and vice president, respectively. They resigned on 29 July 1946 and left UPA then or soon thereafter.[67] Bosustow made himself president and Hubley vice president because, Bosustow said, "he was the most talented guy in the studio, to head up the creative end of things, with Zack gone."[68] Not just Hubley but other members of the staff "bought some of this stock that Dave and Zack had dropped," Bosustow said.[69] The Soviet deal fell through; by October, Hilberman and Schwartz were in New York and had formed a studio called Tempo.[70] "The big sixteen-millimeter field that was going to blossom after the war was what interested us," Hilberman said, "getting into the whole area of educational and social films."[71] In the event, they were soon making television commercials.

Few of the UPA films made in the months after Hilberman and Schwartz left are accessible now. *Public Opinion Polls*, copyrighted in February 1947 and made for the U.S. State Department, was directed by Hubley and designed by Bill Hurtz. It is a straightforward explanation of the subject matter, presented through very limited animation drawn in a Picasso-like style. The effect is like one of those high-school texts full of "visual aids," some of them simpleminded. (For example, a weighted question is depicted as a question mark with a weight attached.) It is hard to connect such a dull film, except through the modern cast of its styling, with the fervor its makers had been expressing for their medium.

Work even of that kind was starting to dry up before Hilberman and Schwartz left—thus the importance everyone attached to the commission that Bosustow brought back from Washington—but by late in 1947 the drought had struck in earnest. UPA's political connections, so useful a couple of years earlier, were now, in a more conservative climate, a growing problem. Even the auto workers had been lost as a client; a 1946 purge of the left wing in the UAW's education department had ended the union's commissions to UPA.[72] An August 1947 list of twenty-six projects, in progress or completed—animated films, filmstrips, animated inserts, and main titles—includes only four titles that appear to be for clients other than the federal government. Most of the government titles were for branches of the military.[73]

The Federal Bureau of Investigation first investigated UPA in the summer of 1947, interviewing Hubley and at least one other

person (probably Bosustow, although his name was concealed in the materials that the FBI would make public in the eighties). A report listed numerous communist connections, including Hubley's. He had been a member of the Communist Party in the early forties, as had Hilberman, Schwartz, Phil Eastman, and other members of the staff. For most of them, as for many others in the arts, party membership seems to have been no more than an incidental expression of an enthusiasm for radical change in general. In September the FBI's director, J. Edgar Hoover, advised military intelligence of the FBI's findings. UPA had only one military project in work in August—a navy film called *Marginal Weather Accidents*—and the studio's prospects for getting any more military films were cloudy at best.

Even before the FBI appeared, UPA had responded to its shrinking fortunes by moving in July 1947 from the Otto K. Olesen Building to an office building on Highland Avenue in Hollywood, sharing space with the producer of a sex-education film called *Understanding Ourselves*;[74] UPA was making "Human Growth," an animated film-within-the-film that took up about half of the overall nineteen-minute length. By late in 1947, Bill Hurtz recalled, that was the only work UPA had left. Before Hurtz fell victim to one of a string of layoffs that had probably begun as early as late 1946, the staff had shrunk to a handful that included him, Hubley, and Eastman.[75] Hurtz moved over to the John Sutherland studio for six months; Sutherland, a former Disney writer, headed an industrial-film studio that had the inestimable advantage in the late forties of a stoutly anticommunist political coloration.

While Hurtz was gone, though, Bosustow was able to parlay UPA's now suspect history into a theatrical release: "If I happened to be talking to a Democrat—which I did at Columbia—and he saw *Hell-bent*, I was in the front office."[76] UPA also now had enough films to its credit that Hubley had directed, particularly navy films like *Flat Hatting* (a comic treatment of the dangers of show-off flying), to make itself credible as a producer of a theatrical series. By sometime early in 1948, Bosustow and Hubley had struck a deal with Columbia to make four cartoons on a trial basis. The first one, called *Robin Hoodlum*, was released on 23 December 1948.

He had made a tentative deal for a Columbia release in 1946, Bosustow said, but Schwartz and Hilberman didn't want to do that kind of work, and Bosustow grudgingly acceded to their wishes.[77]

Hilberman remembered no such episode, but since Columbia was preparing to close down its Screen Gems studio, it is certainly possible that it was looking for someone else to produce its cartoons. If Hilberman and Schwartz did, in fact, turn down a deal with Columbia, that would have been consistent with their conception of UPA as distinct from the other producers of animated cartoons. Bosustow was, though, as Hubley said, not "a creative guy"; so far as his contributions to the cartoons were concerned, if by no means in his taste, he more nearly resembled Walter Lantz than Walt Disney. And now UPA, rather than making films that were groundbreaking in design and subject matter, was at Columbia's insistence going to make Fox and Crow cartoons.

When UPA, in its embryonic form as Industrial Film, was making *Hell-bent for Election* in 1944, a Warner Bros. connection proved useful. Such was the case again four years later when work began on *Robin Hoodlum*: Chuck Jones and Friz Freleng and their writers, Mike Maltese and Ted Pierce, helped with gags for that cartoon. Paul Julian had by then returned to Freleng's unit from UPA, but he painted some of *Robin Hoodlum*'s backgrounds, and their flatness and patterns recall Jones's cartoons of the early forties.[78] In their fundamentals, though, UPA's earliest theatrical cartoons summoned up other Columbia cartoons, the ones John Hubley codirected in 1942.

For instance, there is in *The Magic Fluke,* UPA's second cartoon for Columbia, released in March 1949, a striking lack of precision: Hubley uses strongly accented poses, like Jones's, but they are emotionally vague, reflecting a confused story. The characters' relationship—this was another cartoon with the Fox and the Crow—is so ambiguous that it suggests one annoying question after another. (Is the Crow a patsy? Does he sabotage the Fox deliberately? When he walks across the prone Fox, what does that mean?) It was not as if Hubley deliberately introduced such ambiguities to contrast with the clear-cut conflicts in other studios' cartoons; the effect (as in Hubley's Screen Gems cartoons) was rather that Hubley thought it beneath him to clarify the muddle. He was, he seemed to say, too good to be making Fox and Crow cartoons; and so his Fox and Crow cartoons were no better than the ones that Screen Gems had made.

The last couple of leftover cartoons from the Screen Gems stu-

dio followed *The Magic Fluke* into theaters in 1949, and it was not until September that another UPA cartoon, *The Ragtime Bear*, appeared. It was the only one of UPA's first four cartoons for Columbia without the Fox and the Crow; its star was instead a human character, Mister Magoo. Magoo is nearsighted, a characteristic brought out at the beginning of *The Ragtime Bear* when he is standing beside a sign for Hodge Podge Lodge and demands, "Which way to Hodge Podge Lodge?" Asked by an offstage voice, "Can't you read the sign?" Magoo replies indignantly (in a bombastic voice provided by the radio actor Jim Backus), "Certainly I can read the sign!" But, of course, he can't—in a subjective shot, from his point of view, the sign is merely a blur.

Virtual blindness is in itself merely a lamentable handicap; what made Magoo more than pitiable was the way his nearsightedness magnified his personality. Said John Hubley, who directed *The Ragtime Bear*: "A great deal in the original character, the strength of him, was the fact that he was so damn bull-headed. It wasn't just that he couldn't see very well; even if he had been able to see, he still would have made dumb mistakes, 'cause he was such a bull-headed, opinionated old guy."[79]

It was apparently UPA's success with Magoo that persuaded Columbia to sign with UPA for the long term; as UPA's principals wished, the Fox and the Crow disappeared from theater screens after *Punchy de Leon*, the third UPA cartoon with those characters, came out in January 1950. Starting with *The Ragtime Bear*, UPA's cartoons appeared under the umbrella title (one not of UPA's choosing) Jolly Frolics—except for the Magoo cartoons, which began appearing as a separate series in September 1950 upon the release of the third cartoon with the character, *Trouble Indemnity*.

After *The Ragtime Bear*, the former MGM and Warner Bros. animator Pete Burness directed the Magoo cartoons, with Hubley as what the screen credits called the "supervising director." Hubley's original conception of the character was still very much in evidence: the Magoo of *Bungled Bungalow* (1950), the fourth cartoon with the character, is a ferocious old crank who simply charges ahead without acknowledging his affliction. His house is stolen by "Hot House Harry," a thief who carries houses away to another part of town, selling them there at bargain prices as if he were a burglar unloading jewelry or television sets. That Magoo should be able to overlook so obvious a theft is very much in keeping with his obstinacy. The disruptions caused by Harry's men goad Magoo into moving to a new home

in a quieter neighborhood—and, of course, the home he chooses is his own, in a new location.

Magoo was the first continuing character to emerge from UPA, a studio that had for five years disdained the studios that enjoyed great success with such characters. Directors and writers from Warner Bros. might be asked to help with a Fox and Crow cartoon, but that was like calling in the plumber or the electrician for help in an emergency. Bill Scott, the former Warner Bros. story man who began writing for UPA in time to get a screen credit on *Trouble Indemnity*, recalled that "at UPA any kind of slam-bang rowdy and raunchy slapstick was referred to—icily—as 'Warner Bros. humor.'"[80] Magoo was a human character, to be sure, in contrast to the animals who dominated the other Hollywood studios' cartoons. But the gulf between the Magoo cartoons and those of UPA's rivals was not really all that wide; there was ample precedent in the Popeye series for the use of human characters in cartoons of the most conventional kind.

By the time Columbia released *Trouble Indemnity*, UPA was enjoying the new prosperity and stability that had come with its distribution agreement. It had moved in December 1948 into a new building in Burbank, near Warner Bros.' main lot, and the staff was growing to meet the expanding release schedule. Hubley was overseeing the work of three other directors: Burness, Art Babbitt, and Bobe Cannon, all of them experienced as animators, as Hubley was not. UPA's films now reflected Hubley's sensibility more perhaps than they did when he was actually directing them, because his limitations as a director were no longer so much in the way.

When Hubley was directing, "he was so damned disorganized," said Willis Pyle, who animated for him on the earliest Columbia releases. "He would hand out a scene to one animator and give him a drawing and say, 'This is the character.' He'd hand out a scene to another animator and say, 'This is the character,' and they're supposed to be the same character, but they didn't look anything alike. These were things you wouldn't discover until you saw the pencil tests."[81] Bill Hurtz, who drew the layouts for those Hubley cartoons, described Hubley in terms that make him sound like a director of the Friz Freleng kind—but rather than animation, he would order layouts redone: "When the layouts were done, only then could John know what he wanted. So we had this famous scene, where you do it once, and now we start over.... By then, you'd used up your budget."[82]

Hubley himself ascribed "the simplified nature of the UPA style...to the fact that we were working on lower budgets. We had to find ways of economizing and still get good results. So we cut down on animation and got into stylized ways of handling action."[83] In fact, the budgets for UPA's Columbia cartoons appear to have been comparable to those for the Warner Bros. cartoons and higher than those for, among others, the Lantz cartoons. According to Adrian Woolery, the production manager at the start of the Columbia release, UPA initially agreed to provide six cartoons a year in return for $27,500 per cartoon, plus 25 percent ownership. "Unfortunately," he said, "we never were able to produce the shows for the agreed flat fee figure and were forced to have Columbia pick up the overage, for which they demanded part of our 25 percent ownership." Woolery attributed those overages to "working for quality"—insisting on retakes and other costly steps, "which is good, if you can afford it. But we couldn't."[84] It was thus in all likelihood the way the cartoons were made, more than their budgets, that created pressures for a simpler sort of animation—a simplicity that sometimes rose to a certain elegance, to be sure.

Bosustow, Hubley said, "was always fighting us on money.... I was always going over budgets, and Steve was screaming."[85] Hubley was in some ways a real-life equivalent of Mister Magoo, forcing his way impatiently past such obstacles as his own technical limitations. In the eyes of many of his collaborators, he was a strong and insensitive man, a brilliant but incomplete artist who often bullied the colleagues who had to make up for his shortcomings—"a miserable bastard to work for," in Bill Scott's words.[86] UPA in 1950 was, in fact, an enlarged version of the UPA of 1945, when Hubley bruised Bobe Cannon's feelings during work on *Brotherhood of Man.*

Cannon worked for the Disney studio for less than a year after leaving UPA in 1946. He then worked for MGM, in the even less likely environment of the Tex Avery unit, before returning to UPA around the time work began on the first Columbia releases; he was credited as an animator on both *Robin Hoodlum* and *The Magic Fluke.* He was at a severe disadvantage as an adversary for Hubley. "He was sort of small and quiet and very gentle," Paul Julian said of Cannon, in words echoed by other members of the UPA staff, "and he very much disliked conflict."[87] But somewhere around the beginning of 1950, Cannon enjoyed a wonderful piece of luck.

From Gerald McBoing Boing (1951), designed by Bill Hurtz and directed by Robert Cannon. © Columbia Pictures.

Steve Bosustow, who had first gotten to know Ted Geisel when Geisel was writing cartoons for the army, related in 1973 how a Geisel "Dr. Seuss" story fell into UPA's hands:

He came to the studio one day with a record and asked the girl at the front desk to see somebody, to talk to us about a picture. So they introduced him to the business manager [presumably Ed Gershman], and the business manager said, "We can't handle that, we're doing Magoos, we're doing specials, we just don't do this kind of stuff." So he got up, and as he was leaving, I came down the hall.... He said, "Goddamn your outfit, I've just been turned down on a story." I said, "You're kidding, come on." So we went to the office, and we played the record, and I said, "I'll take it."...We bought the record, the whole story rights, all of it; I've forgotten what we paid him for it, but it was a bargain.... We probably paid two hundred dollars, something like that.[88]

Cannon directed the film, which was titled, like the Geisel record, *Gerald McBoing Boing*. "Hub dropped in occasionally" dur-

ing work on *Gerald*, said Bill Hurtz, who designed the film, but otherwise left it alone.[89] Cannon had completed work on *Gerald* by August 1950.[90]

Gerald is the story of a small boy who speaks in noises rather than words, and who is in consequence rejected by his playmates and even by his own father. At the film's climax, Gerald is leaving home because his handicap—his noise-making voice can be described as nothing else—has become too much of a burden on his parents. But before he can board a train, he is stopped by the owner of a radio station, who wants to hire him to provide the sound effects for his programs.

The same sort of story—of a handicapped child whose handicap turns out to be a blessing in disguise—had been told almost ten years before, as *Dumbo*. The two films differ, though, in much more than length. In *Gerald*, there is no animation remotely similar to Bill Tytla's of the elephants in *Dumbo*. Cannon and Hurtz manipulate colors and compositions skillfully to suggest Gerald's distress: when Gerald is running away from home at night, for instance, repeated diagonals create an uneasy atmosphere, most dramatically when Gerald tries to board a train. Ultimately, though, the film only demonstrates emotions; Gerald's unhappiness has no immediacy. Neither, in all likelihood, was Cannon seeking any. To have brought Gerald vividly to life would have meant depicting conflict of the kind that made Cannon uncomfortable, however far removed such conflict might have been, in tone and in the characters' behavior, from "Warner Bros. humor."

There is, to be sure, some inventive stylization of movement in *Gerald McBoing Boing*; it shows up, for instance, in the way a doctor's slightly gawky legs accent his rigid verticality. In general, though, animation is clearly subordinate to design. The animation is limited in many respects—when Gerald's mouth moves, the rest of his face doesn't—and posture is stylized even more than movement, as in the graceful curves that parents and doctor form as they bend anxiously over Gerald. Geisel's own rather knotty drawing style is nowhere in evidence in the very simply drawn characters. (Their appearance probably owes most to Phil Eastman, who collaborated with Bill Scott in adapting the Dr. Seuss story; Eastman, a member of Geisel's unit during World War II, evidently prompted Geisel to offer the *Gerald McBoing Boing* record to UPA in the first place.)[91]

"At the time we did *McBoing Boing*," Bill Hurtz said, "we thought we were really boiling it down: What can we get rid of? We

frequently talked about that, Bobe and I, saying, 'Let's be sure we don't get too much of' so and so."[92] That drive toward simplicity turned up, for instance, in the very sparse settings: "We decided to dispense with all walls and floors and ground levels and skies and horizon lines."[93]

Because Cannon and Hurtz clothed their story of childhood distress in harmonious colors, shapes, and movements—so that the film is soothing and even therapeutic in its total effect—*Gerald* echoed the ideas that had shaped UPA's films in the middle forties, the ideas that Gyorgy Kepes had advanced in *Language of Vision*. The difference was that Kepes envisioned design as a tool for changing the world; in *Gerald*, Cannon used it more as a tool for keeping the world out.

Gerald McBoing Boing was released nationally in January 1951, but it had played in Los Angeles long enough in 1950 to qualify for Academy Award consideration. In March 1951, *Gerald* won the Oscar for best cartoon (*Trouble Indemnity* was among the other nominees). That award triggered the most sustained and admiring attention from the press for a cartoon studio since Disney's heyday in the thirties. "The appearance of UPA's *Jolly Frolics* title card on the screen is beginning to produce that same pleased, anticipatory buzz through an audience that once greeted" the Disney cartoons, Arthur Knight wrote in *Theatre Arts* in the summer of 1951. "And these audiences are simply bearing out the basic conviction of the UPA people, that cartoons need not be all cuteness or all violence. That cartoons can be artistic and intelligent and still be popular."[94]

UPA's commercial and even its government work grew in the wake of its new celebrity. In November 1951—according to an FBI report—30 percent of UPA's output was for "television and commercial users, 10 percent in training films for various governmental agencies."[95] Although UPA remained smaller than most of its rivals, the staff had expanded greatly since the advent of the Columbia release; by 1951, it totaled about seventy-five.[96]

The Oscar for *Gerald* "started a lot of internal trouble, like fights for power," Hubley said. In other words, Cannon's Oscar ignited the resentments that had been festering since Hubley and Cannon collaborated on *Brotherhood of Man*. Hubley explained

away what happened next by saying that he was "getting spread too thin" as creative head of the whole studio; there was what he called "a joint decision of a split between Cannon and me, making two units, each independent."[97] However much Cannon hated conflict, he hated working under Hubley even more.

Hubley's friend Paul Julian briefly became Cannon's designer—his layout artist—after Bill Hurtz began directing sponsored cartoons; but then Julian was shuffled out of Cannon's unit, and T. Hee, the former Disney story man, replaced him. Cannon and Hee first collaborated on *The Oompahs* (1952), Cannon's first cartoon after he got out from under Hubley's supervision. Julian moved over to work with Hubley.[98]

"When the rug was slipped under me," Julian later wrote, "it immediately became apparent that Bobe was getting what he wanted—which was cutesy-poo. Tidy little shapes that stayed where they belonged."[99] However spiteful that may sound, it is close to the truth: the "characters" in *The Oompahs* are paper cutouts of musical instruments, pasted to cels. (Hee wanted them to look even more like cutouts than they do by letting the edges of the cutouts curl up, but he couldn't persuade the cameraman to shoot the film without following the usual procedure and pressing a platen glass down over the cels.) Hee, far more than Julian, sympathized with Cannon's aims. "At UPA," he said, "we always talked about animated drawings, never animated cartoons.... We wanted the feeling that you were looking at *drawings that moved*"—not, that is, at characters who happened to be drawn.[100]

With Cannon's ascendancy, Hubley's role in the studio changed as well as shrank. The two directors had undergone a subtle role reversal: Hubley had bent design to political purposes in the middle forties; now it was Cannon's films—through their Kepesian blandness, their conspicuous shunning of conflict and violence—that were advancing a social agenda, in however dilute a form. Hubley, once he began making films that did not have an overtly didactic purpose, was increasingly occupied with aesthetic questions.

Speaking of his work as Hubley's layout man on the early Columbia releases, Bill Hurtz said:

We were thinking in very live-action, cinematic terms and tried to translate them into graphics. That's why Hubley said that to flatten things out into a decorative pattern on the screen violates the dramatic possibilities of deep space—he

didn't say so in so many words, but it really got his teeth on edge when some of the UPA cartoons not directly under his control became what he thought were wallpaper designs.[101]

Hubley himself spoke of character animation in terms wholly consistent with Hurtz's perception. "There's no substitute for full animation," he said, using a term applied to character animation that moves freely, without any conspicuous concern for the additional costs imposed by a large number of drawings. "What the character can do if you make use of full drawings is really irreplaceable."[102] Cannon's films, by contrast, expressed ever more clearly a yearning for stillness and order that could best be fulfilled through "wallpaper designs" and limited animation. T. Hee said of Cannon that "Bobe liked quiet things," in particular stories that Hee could tell calmly as he went through a storyboard, without the display of enthusiasm that was expected in a Disney or Warner Bros. story meeting. But, Hee said, "inside he had an ulcer and he was all stirred up. When we'd go to lunch and somebody came too close to him [in another car], he'd start...to go after him, and we'd have to grab him and say, 'No, no, slow down.'"[103]

Cannon kept his films—and through them, perhaps, his own emotions—on a tight leash. Willis Pyle, who animated for Cannon on his first two Columbia cartoons, *The Miner's Daughter* (1950) and *Gerald McBoing Boing*, remembered that Cannon gave his animators a great many detailed drawings, "and they were animation drawings, as compared with layout drawings," that is, they could be used as extremes.[104] Unlike the poses that Chuck Jones was giving his animators at the time, Cannon's poses did not define the characters' emotions so much as they defined their movements—a far more limiting approach.

Cannon's influence extended to the Magoo cartoons, through a deadly softening of Magoo's pugnacious personality. Hubley was not altogether blameless for this decline—he let Magoo slip into sentimentality in *Fuddy Duddy Buddy* (1951), one of the first cartoons he made after returning to direction—but it was Burness who gave Magoo what Hubley called a "warmer side." Hubley retained a credit on two of Burness's Magoo cartoons, *Grizzly Golfer* and *Sloppy Jalopy*, after he lost it on Cannon's, but the Magoo series was rapidly slipping out of his grasp. Hubley told Howard Rieder: "I felt that as the series developed the formula became somewhat mechanical. There were too many nearsight-

ed gags, not enough situation comedy and character conflict."[105]

Character conflict was of course the last thing that Cannon wanted in his own cartoons. All of the UPA directors eschewed violence of the Warner Bros. kind, but in Hubley's case, he was making a stylistic or aesthetic choice rather than expressing the deep aversion to such comedy that Cannon felt; that was why some of the early Magoo cartoons that Hubley directed or supervised had so much vitality. Paul Julian recalled that Hubley admired the work of David Stone Martin, an illustrator whose work owed a great deal to Ben Shahn, the openly political American painter of the thirties, and beyond Shahn to Picasso, who was, of course, an openly political painter, too. But what Hubley admired in Martin's work, Julian wrote, was that it "almost always had an asymmetric inventiveness about it that John found related to his own sense of exploration at the expense of order and/or inertia."[106] Cannon, by contrast, "loved symmetry and even inertia," as Julian said; he avoided the instability that Hubley found stimulating.

Hubley's task, when he began directing again, was to find some way to fuse the interests and concerns that had never quite coalesced in any of his earlier films, even the best of the Magoos. The vehicle he found was a retelling of the story of Frankie and Johnny: a story steeped in sex, jealousy, and violent death, and thus inconceivable as a Cannon film, as Hubley surely noticed. *Rooty Toot Toot*, as the film came to be called, lent itself to a visual treatment that was just as emphatically non-Cannon. Paul Julian recalled that "I happened to find a gelatin proof-roller that had become sort of withered and pitted, and made some remarkable paint textures that just *happened* to fall into a style that was quite definitely *not* Bobe-and-T. in quality: the scaly and moldy nastiness appealed to John and me for the same reason."[107] Those textures are clearly visible in the cartoon's backgrounds.

When *Rooty Toot Toot* was ready for release, W. R. Wilkerson, the editor and publisher of the *Hollywood Reporter*, wrote about it this way: "It's a gem, something completely new, wonderfully entertaining, with a beautiful background handling that brought applause from the big theater audience."[108] Hubley deserved such praise. The film is by no means wholly successful; Phil Moore's music is particularly weak (UPA, unlike the other studios, had no staff composer but hired a musician for each film). Hubley showed in *Rooty Toot Toot*, though, that he was well on his way to

From Rooty Toot Toot (1952), designed by Paul Julian and directed by John Hubley. © *Columbia Pictures.*

harmonizing strong modern design with a kind of animation whose kinetic vitality depended on the illusion of depth that the motion-picture screen could offer.

The design element is stronger in *Rooty Toot Toot* than in any of Hubley's earlier UPA cartoons, resting in part on a very free and inventive use of color. For instance, the cels for a bartender, depicted in line as a squatty, blank little man, are not painted; they are instead superimposed over a brown oval. Like John McGrew in Chuck Jones's *Fox Pop* ten years earlier, Hubley changes his color scheme to correspond to changes in mood: there's a switch from brown to green as Frankie and her lawyer sit at their table after the bartender has testified, a signal that Nellie Bly, the vamp who seduced Johnny, is arriving. The color changes extend to the characters themselves: the lawyer is solid white after Frankie (jealous of his attentions to the vamp) shoots him. Color is used sparingly in any given scene, but thanks to the great variety of colors and textures over the course of the film, the total effect is one of visual abundance. This rich design never calls undue attention to itself, though, because the colors and textures always speak of the characters and their moods. The bar-

tender *is* a dull brown oval—by separating the line drawing and the color, Hubley permits seeing the character from two different angles simultaneously.

Most important, though, the eye is drawn to the characters by the way they move. Each one moves differently, and none of them move at all realistically; the animation is as thoughtfully stylized as everything else, even though Olga Lunick, who choreographed Frankie's dancing, was filmed as a guide for that animation. True to Hubley's preferences, all the animation is full animation, most of it by such veterans of the Hollywood studios as Art Babbitt, Grim Natwick, and Pat Matthews, a former Lantz animator. The stylization through movement came easier in *Rooty Toot Toot*, surely, because it is a musical, treated almost as a pop ballet, but the link to design is even clearer: the vamp, as cool and remote as a woman in a Modigliani painting, does not preen in dance poses, as the lawyer does, but she is defined just as clearly by her sinuousness (her arms braid together like two snakes). Here, finally, was a clear break with the kind of thinking that had given birth to UPA and had always dominated its films: in *Rooty Toot Toot*, strong design is not animation's haughty rival, but rather its graceful partner.

Hubley described Norman McLaren, the Canadian animator who made extraordinarily inventive abstract films in the forties and fifties, as "a great inspiration to me at a certain point in my career.... He came out to visit us at UPA, and he brought a new print called *Begone Dull Care*.... It was very stimulating to me to see that a film artist can take the path of making his own film and expressing himself."[109] That would have been in 1949, probably, when the UPA studio was just picking up speed. McLaren made *Begone Dull Care*, as he wrote in 1961, by "taking absolutely clear, 35mm motion picture celluloid and painting on it, frequently on both sides with celluloid dyes, inks and transparent [paints]."[110] Such methods could not have been more remote from those that Hubley and other Hollywood animated filmmakers used, but *Rooty Toot Toot* was as intensely personal as McLaren's film. In it, for the first time, Hubley seemed wholly accepting of the need to work through others—strong animators, in particular—to put his ideas on the screen. McLaren's methods were closed to him; but, on the other hand, the results he got on the screen were closed to McLaren. Hubley, as a film artist, had clearly decided by the time of *Rooty Toot Toot* what kind of results he most wanted.

Hubley moved on from *Rooty Toot Toot* to designing black-and-

white inserts for a live-action feature film, *The Four Poster*, that represents stages in a married couple's life. Working again with Paul Julian, he produced inserts that were attractive in their spidery lightness, but that otherwise were—inevitably, given the nature of the work—a step or two down from *Rooty Toot Toot*. Hubley needed a whole seven-minute cartoon as his canvas; but he never directed another one for UPA.

UPA and Columbia expected that *Rooty Toot Toot* would win UPA its second Academy Award; other people, like Wilkerson of the *Hollywood Reporter*, thought so, too. Hubley had completed the film by 21 November 1951, and it qualified for Oscar consideration as a 1951 release; it was not released nationally until 27 March 1952, exactly a week after the Oscar ceremonies. But although *Rooty Toot Toot* was nominated, it lost the Oscar to a routine Tom and Jerry cartoon, *The Two Mouseketeers*.

Politics on a larger scale as well as the usual studio politics may have played a part in that outcome. Not that there was anything political about *Rooty Toot Toot*; quite the reverse. When Hubley reconciled animation and design in that cartoon, he simultaneously severed the always tenuous link between design and politics—there is no way to interpret *Rooty Toot Toot* as a socially ameliorative film. By that spring, though, UPA's political origins, and John Hubley's own youthful political choices, were combining to end his career at UPA and threaten the existence of the studio itself.

The Iris Closes,
1952–1966

In 1951 and 1952, Hollywood suffered through a second round of investigations by the House of Representatives' Committee on Un-American Activities. HUAC, as it came to be called, summoned dozens of actors, writers, directors, and technicians to testify about their connections with the Communist Party. Some refused; some admitted their own membership and told the committee of others who had been members. Fewer than a dozen witnesses had worked in the animation studios, but some of them provided the committee with the names of other cartoonists whom they had known as members of the party. Most of the people who testified, or who were identified as communists, had worked for UPA.

UPA was becoming a target by the fall of 1951, when, almost certainly at Columbia's instigation, UPA employees with a communist taint began to disappear from the payroll. Phil Eastman lost his job in October;[1] Bill Scott, who had never been a communist but had the misfortune to be Eastman's writing partner, was fired along with him.[2] In mid-April 1952, about three weeks after the Academy Awards, Columbia—by then the owner of 20 percent of UPA's common stock—came to Bosustow with the names of eight employees whom it insisted cleanse themselves of what were in most cases the faintest of associations with some left-wing group. The alternative, Bosustow said many years later, was to lose UPA's distribution contract.[3]

From UPA's The Tell-tale Heart *(1953), designed by Paul Julian and directed by Ted Parmelee.* © *Columbia Pictures.*

After Bosustow told the affected staff members about Columbia's ultimatum, everyone's first thought was to stand together against Columbia, Paul Julian said, but the decision ultimately was "that what we were going to have to do, if we were going to keep the studio at all, [was] to go our lonesome way, stand up and get shot." On 2 May 1952 Julian and five other employees wrote letters to Bosustow affirming their loyalty and explaining what had been a fleeting connection, if that, with a left-wing organization.[4]

Two employees posed a tougher problem because they had, in fact, been communists. One inbetweener who had registered to vote as a communist quit rather than make the sort of confession that might have saved his job. (Charles Daggett, UPA's staff publicist and another former communist, had been fired the previous fall but then rehired, at Columbia's instigation, after he testified before HUAC in January 1952 as a "friendly witness.") UPA fired the other employee, John Hubley, on 31 May 1952 after he refused to quit.[5] Wrangling over the financial terms of his departure continued for a few weeks at least. Hubley owned about 10

percent of the common stock, and before he was fired, he was asking twice as much for it (about twenty-five thousand dollars) as Bosustow thought justified. Eventually, Bosustow said, "we paid him a few hundred or a few thousand dollars for back salary, or future salary, or severance pay, or whatever it was." After that episode, "I think I lost heart," Bosustow said. "It never was the same after that."[6]

UPA was actually very different with Hubley gone, because he had taken with him the promise that *Rooty Toot Toot* represented. Pete Burness and Bobe Cannon were locked into the Magoo series and *Gerald*-derived films with child protagonists, respectively, and their cartoons were rapidly becoming as dull and predictable as those of the least inspired directors at the other studios. Cannon's cartoons were almost invariably attractive, in much the way that *Gerald* was, but they were so insubstantial that they all but floated off the screen.

Bill Hurtz, who began directing theatrical cartoons shortly before Hubley left, adapted one story that can be imagined as the basis for a Hubley film: *The Unicorn in the Garden*, from the James Thurber book *The War Between Men and Women*. Released in September 1953, Thurber's wryly misogynistic story was strong meat at a UPA where Bobe Cannon's wispy charm had become the standard. What Hurtz saw as Bosustow's hostility to the film angered him to the point that he was ready to leave when Shamus Culhane, by then a producer of television commercials, asked him to set up a Los Angeles branch of Culhane's New York studio.[7]

In December 1953, UPA released a much odder cartoon, an adaptation of the Edgar Allan Poe story *The Tell-tale Heart;* it was directed by Ted Parmelee, who began directing theatrical cartoons in 1952 after first directing TV commercials. What made *Heart* so unusual, given how the UPA cartoons were contracting into formula, was that it was a wholly serious cartoon, dominated by a joyless pastiche of artistic styles ranging from surrealism to German expressionism (Paul Julian was the designer).

Something else about *Tell-tale Heart* was different: UPA made it in 3-D. The idea for such a film originated with him, Steve Bosustow said. He read the Poe story on vacation; then, when he first saw 3-D features—they began appearing late in 1952—he thought to himself, "Wow, here's a mystery kind of thing, and we can have some fun with it." He remembered previewing *The Tell-tale Heart* in 3-D: "They laughed. We previewed it again, and they

laughed again. And the laughter would dwindle down into nothing." UPA added a title card at the beginning of the film, to alert the audience that it would not be seeing a funny cartoon. To no avail, Bosustow said, the cartoon was "a complete flop" anyway.[8]

The opportunities for such experiments were ending. When UPA's original five-year contract with Columbia expired in 1953, it was renewed with the stipulation that UPA would make only Magoo cartoons, except when Columbia approved proposals for other kinds.[9] A few more non-Magoo cartoons trickled out of the studio over the next couple of years—Gerald McBoing Boing made a total of four appearances—but by 1956 the release schedule was filling up with Magoos.

The ironic result of giving Magoo a "warmer side" and downplaying his crankiness was that the series had to hang its comedy on his nearsightedness, that is, on his physical infirmity. The early Magoo was highly adept at molding the world into whatever he wanted it to be at the moment; the later Magoo was often pitiable instead. To minimize the otherwise inevitable effect—that the cartoons were making fun of a very old man who was virtually blind—Burness and the series' writers manipulated Magoo's nearsightedness shamelessly. In *When Magoo Flew* (1955), his eyesight is highly selective; he sees some things clearly enough. In that cartoon, as in others, Burness could sometimes draw attention away from Magoo's weak eyes only by suggesting that all his senses were equally infirm: he wanders around on the outside of a plane in flight, unaware that he's not still in the cabin.

UPA was a ghost-haunted operation, with John Hubley as the ghost. "Hubley just sort of disappeared from sight" after he left UPA, Bill Hurtz said. "He really went undercover."[10] Les Novros recalled: "I saw him wandering outside my studio one day and called him in; he was woebegone. I said, 'You want to work?' Nobody would hire him. I gave him a little job to do; a guy's got to work."[11] Hubley's virtual invisibility was of limited consolation to the adversary he had left behind. Lew Keller, who was designing cartoons for Cannon in 1955, said that even then, "Hubley was a terrible lacerating memory to Bobe."[12] Cannon complained to Keller that Bosustow liked Hubley's films better than his; he was no doubt right.

UPA left an extraordinarily small legacy of first-rate cartoons—fewer than a dozen, even at a generous estimate, all of them made in a two- or three-year span in the early fifties, and most of them owing their stature to Hubley's contribution. But even after

Hubley's departure, UPA was, in the early fifties, exactly what the Disney studio had been in the thirties: the reference point, the studio with which every other studio automatically compared its cartoons, whether or not a given studio was trying to emulate the UPA films.

There was at the heart of most of the UPA films only a catalogue of prohibitions (against talking animals, against violence) and what amounted to a sample book of very tasteful decorative patterns. Earlier cartoons—those of the Fleischers and of Tex Avery, in particular—had offered themselves more plausibly as alternatives to the kind of animation that flourished first at Disney and then at Warner Bros. But the UPA people took themselves very seriously, critics took the UPA films very seriously, and everyone involved was articulate in singing the praises of the UPA films. The people making other studios' cartoons—the beneficiaries of no critical enthusiasm for their work—could not help finding themselves on the defensive. Thus it was that UPA could impose itself as the industry standard.

The economics of the film industry were not working in short cartoons' favor, either. As always, there was no way to isolate the portion of a theater's receipts for which even the most popular cartoons deserved credit and thus higher rentals; and now, with television drawing customers away from the movies, cartoons looked more like an expensive luxury than ever. The fifties were, in short, an increasingly unhappy time for Hollywood animation.

In mid-June 1953, Warner Bros. announced that it was closing down its cartoon studio until the following January, while it worked off a backlog of completed cartoons and waited to see if the craze for 3-D films would have any lasting effects. Seventy employees, including most members of the Chuck Jones and Friz Freleng units—Jones himself among them—lost their jobs. The McKimson unit had shut down two months earlier when Warners announced cutbacks throughout its operations, live action as well as animation. Only ten people remained on the cartoon studio's staff during the shutdown, including Friz Freleng and Warren Foster.[13]

Norman Moray, who was in charge of selling Warners' short subjects, said soon after the cartoon studio closed that he had surveyed exhibitors on their interest in 3-D shorts and had found majority opinion to be that shorts didn't mean enough to

warrant large production expenses or substantial rentals of the kind that would be required for 3-D.[14] The cartoon studio now existed in a kind of limbo, to be recalled to life only if 3-D's appeal faded, but if 3-D flopped, that would leave the movie industry— and thus the cartoons—in a weaker position than ever.

Chuck Jones went to work for the Disney studio, assigned at first to generate ideas for the weekly television show that Disney was planning.[15] Bob McKimson made Oldsmobile TV commercials at a studio called Cascade.[16] Others of the Warner cartoonists scattered through the animation industry. The 3-D craze died quickly—only one Warner cartoon, Jones's *Lumber Jack-Rabbit*, was ever released in 3-D—and by late in the fall, members of the cartoon studio's staff had started trickling back. McKimson's four principal animators all stayed in their new jobs, though, as did the Jones animator Lloyd Vaughan.

Jones himself left Disney in November 1953 after signing up again with Warners—with, he wrote to Mike Maltese at the time, a fifty-dollar weekly raise.[17] Maltese had gone to work for Walter Lantz, who announced Maltese's hiring on 15 June 1953,[18] the same day Warner Bros. announced the closing of its cartoon studio. Maltese must have worked as a freelancer at first, since he did not go on Lantz's payroll until the following January. When Maltese finally returned to Warners in August 1954, it was only after Jones, acting as his go-between, had helped him negotiate a raise as large as the one that Jones had gotten.[19]

In December 1953, when the cartoon studio was still officially closed, Warner Bros. sold its Sunset Boulevard lot, which the cartoon studio was part of, to Paramount Pictures, as the new home for Paramount's television station, KTLA. The cartoon studio did not move until late in the summer of 1955, though, after a new building had been erected for it on one corner of the main Warner lot in Burbank, on the other side of the Hollywood Hills. The contrast between the grubby old Hollywood studio and the shiny new Burbank studio was stark: Maltese walked the halls of the new building chanting: "Calling Dr. Kildare! Calling Dr. Kildare!"[20]

Maltese's joke was doubly appropriate: the Warner cartoons were slowly becoming as sterile as their new surroundings. As long ago as the late forties, the cartoons had started to stiffen up. It was basically a matter of inking and painting time, as Phil Monroe explained: "If you took the extra trouble to give [the animation] a lot of overlap, like Rod Scribner did...that's one hell of a lot of drawings"—and so a lot of ink and paint work. By the late

forties, pressure was filtering down through the directors to the animators to use more held cels.[21]

The Warner cartoons were thus doubly vulnerable to UPA's influence: not only was there the artistic pressure to move toward a more UPA-like design, but economic pressures made limited animation of the UPA kind ever more attractive. It was not, however, until the fall of 1952, about a year and a half after *Gerald McBoing Boing*'s Academy Award, that Warner cartoons with a distinct UPA flavor in story and design went into production, both of them with child protagonists of the Cannon kind. One was Freleng's *Goo Goo Goliath* (released in September 1954), about a baby giant delivered to a normal household by a drunken stork; the other was Jones's *From A to Z-z-z-z-z* (released in October 1954), whose schoolboy hero, Ralph Phillips, is a juvenile Walter Mitty. Maurice Noble was designing the backgrounds for the latter cartoon in November 1952.[22]

Of the Warner directors, Jones was easily the best qualified to confront the UPA cartoons on their own ground. He had demonstrated his sympathy with modern graphics a decade earlier, and thanks to his reliance on psychologically acute poses, he could employ a sort of limited animation that didn't really look limited. He was, however, at pains to distinguish *From A to Z-z-z-z* from *Gerald*. In a letter written to a fan in 1956, he noted UPA's reliance on a narrator to provide a gloss on Gerald's thoughts and emotions; he preferred that the audience learn about Ralph Phillips through the character's own actions.[23]

There was no question but that Jones had tried over the years to make actors rather than symbols of his characters. Even so, he had always been vulnerable to distraction from the hard work of making his characters come to life, particularly when those distractions took the shape of modish design or flashy cinematic devices. He benefited when he not only had a forceful writer at his elbow in Mike Maltese, but also a crew of capable but hardly intellectual animators. Ken Harris, for example—to judge from the examples of his work that can be identified with certainty, such as the Mother Bear's dance in *A Bear for Punishment* (1951)— excelled at giving physical reality to scenes that were already well conceived in terms of character and psychology. But "Ken Harris just wrote it off," said Corny Cole, an assistant in the Jones unit in the middle fifties. "It didn't mean anything to Ken Harris. He wanted to play tennis, he wanted to go out and drive his new car."[24]

Such people created an extraordinarily healthy atmosphere for Jones to work in. His collaborators could give him whatever he asked for in the way of vivid characters and inventive comedy—they could reinforce his own greatest strengths, rather than encouraging in him the pretentiousness always lying in wait for the autodidact. Maurice Noble's advent as Jones's layout artist decisively altered the unit's balance of talents.

Jones had known Noble from the time of the Disney strike, when Noble, as a Disney background painter, was a striker and Jones marched in support of the strike. Their paths crossed again a couple of years later when Jones was making Private Snafu cartoons for Frank Capra's Signal Corps unit; Noble, like Jones's former background painter Gene Fleury, was in that unit. Noble worked briefly for Jones as his layout artist in the fall of 1946, not long enough to receive screen credit on any cartoons. He returned to Jones's unit around the middle of 1950, this time settling in for an extended stay as the designer of the backgrounds for Jones's cartoons.[25]

Philip De Guard, Jones's background painter when Robert Gribbroek and then Noble were the layout artists, contributed little to the design of the backgrounds or even to their color schemes. He was, in effect, Noble's assistant. "I always insisted that I not only control the layout but that I control the color," Noble said, "because when you're designing [a background], a linear pencil design doesn't mean anything unless you're visualizing this in terms of volume and color."[26] For the more routine cartoons, Noble might prescribe background colors through notations in colored pencil on his layout drawings: for more elaborate productions, or perhaps when setting a new color scheme for the Road-Runner series, he also gave De Guard separate color sketches in the same cel paint that De Guard used to paint the backgrounds.[27] His color sketches were very much like those that John McGrew made for Julian and then Fleury.

Noble's earliest designs for Jones no more than hinted at where he might take the cartoons. The backgrounds for *Duck Amuck* employ flat colors and simplified shapes that recall the UPA cartoons, but such backgrounds were in keeping with the idea that Daffy Duck was a real character in a maddeningly artificial setting. It was only after they had been working together for about two years, in *From A to Z-z-z-z*, that Noble and Jones first made design a powerful element in a cartoon.

What Noble revealed in that cartoon, and then reiterated with

greater or lesser force in each cartoon that followed, was that his general sympathies were indistinguishable from those of the UPA designers. "I've always had a feeling," Noble said, "of liking to stylize and work in patterns.... I felt that animation was a flat form—designed flat forms."[28] He did not, however, share in the priggishness that shaped so many of the UPA cartoons. There was not so much as a hint in the cartoons whose backgrounds he designed that he had ever heard of Gyorgy Kepes. Instead, he luxuriated in his patterns and flat forms—and especially his colors—as much as Matisse ever did.

From all indications, the Warner cartoon studio's staff did not respond any more warmly at a studio showing of *From A to Z-z-z-z-z* than it had to Jones's experimental cartoons in the early forties. That audience's cold response ("I really had problems") didn't carry any weight with the studio's management, Jones said, "but it certainly was uncomfortable."[29] Once again, the audience, however philistine many of its members, had a real point. It may have recoiled from Noble's inventive designs, but more likely it rejected the preciosity that those designs tempted both Noble and Jones into: the boy Ralph Phillips is an "actor" of a highly self-conscious and enervated kind.

In *My Little Duckaroo*, the Daffy Duck cartoon that immediately followed *A to Z-z-z-z-z*, Noble papered the walls of the villain Nasty Canasta's cabin with pages from *The New Yorker*. *Duckaroo* is, besides, a dialogue-heavy cartoon—another source of danger to Jones. If there was too much dialogue, with its demand for relatively realistic timing, a Jones cartoon could slip into a monotonous flow not all that far removed, in its lack of accent, from a Fleischer cartoon of the early thirties. The more static and talky the cartoon, though, the more easily an assertive design can be examined. *Duckaroo* spends so much time in the cabin—as if to make sure that its *New Yorker* joke doesn't go unnoticed—that it becomes claustrophobic.

Noble designed only three more cartoons for Jones, then left the cartoon studio, a few months before it closed in 1953, to take a job in Saint Louis. Jones worked with more conventional layout artists in Noble's absence; deprived of both Maltese and Noble after the cartoon studio reopened in 1954, he made some of his dullest cartoons. The three men were not reunited until Noble returned to the Jones unit around July 1955;[30] their first collaboration, as if to celebrate, was on an exceptionally ambitious cartoon, a Wagner parody called *What's Opera, Doc?*

What's Opera, Doc? was unusual in any number of respects. For one thing, the complete soundtrack was recorded in advance; for another, Jones said, "it was one of the few times that we actually corrected a storyboard before I did all the [character] layouts."[31] Noble made extensive inspirational sketches because, as Jones said, "a lot of the story had to be told in graphics...the imagination of the environment was important."[32]

That environment is both grand and slyly comic, like the action that takes place within it: the cartoon starts with the familiar conflict between Bugs Bunny and Elmer Fudd, but saturates it in the pomp and solemnity of Wagner's portrayals of gods and heroes. (The music consists mainly of "The Ride of the Valkyries" from *Die Walküre* and the overture and Venusberg music from *Tannhäuser*.) Jones obviously respects *both* his principal ingredients, Bugs Bunny and Richard Wagner. He invites his audience to sneer at neither one, but to enjoy the incongruity of Bugs Bunny in a Wagnerian setting instead.

It was in *What's Opera, Doc?*, however, that there was first clearly visible the most serious damage that Noble's unfailingly clever and attractive designs were doing to Jones's cartoons—damage far more subtle and pervasive than the preciosity that surfaced in *From A to Z-z-z-z*. Noble's designs presented Jones with the same problem he faced in the early forties: how to reconcile his three-dimensional characters with what Noble called "designed flat forms." That conflict went unresolved in the forties, until finally Jones returned to more conventional backgrounds. In the fifties, though, almost from the beginning, Noble's influence extended to the characters as well as the backgrounds. Not so much directly—although a few incidental characters, like a nun and a gendarme in *Wild Over You* (1953), a Pepé le Pew cartoon set in Paris, look like Noble's designs—as in another way: gradually, Jones's characters were becoming mere graphic elements, not so much figures possessing weight and moving in space as assemblages of lines.

"In any drawing," Don Graham wrote, "there is a mysterious relationship between the activity of the lines used to delineate a form and the areas generated by these lines, which become volumes or shapes." Emphasize line too much, and what winds up on paper is not a character depicted in line, but rather a "an overly busy and noticeable linear pattern."[33] The lines of which Jones's characters were composed had to suggest a physical reality before those drawings could do their real job of exploring thoughts and emotions. Jones had for years, through his charac-

ter layouts, struck an almost perfect balance; now it was disappearing. And as if he were trying to compensate for his characters' loss of physical reality, he was now working too hard to give them an emotional reality.

In Jones's cartoons, from the start the characters seemed almost always to be absorbed not in themselves, but in what they were doing. Even when his characters responded to the camera's presence—as the Coyote often did—they did so in a way that converted the camera, and through it the audience, into a participant in the cartoon. The Coyote invited the camera's admiration of his skills as an inventor, not his prowess as an actor. Starting in the early fifties, though—two of the earliest examples are a couple of Pepé le Pew cartoons, *The Cats Bah* (1952) and *Little Beau Pepé* (1954)—Jones's characters occasionally showed a new self-consciousness, as if they were not wholly submerged in their roles.

The disease struck the different series with varying force. The Road-Runner cartoons were for a long time the least affected; they benefited because Jones put less work into them than he did into cartoons that he took more seriously, like *What's Opera, Doc?* ("I could lay out a Road-Runner in two weeks or less," Jones said, "because I got so familiar with the characters.")[34] Other series fared much worse. Bugs Bunny in particular was a victim of the change. By the time of *To Hare Is Human*, released in December 1956, Jones's version of Bugs was simply too pleased with himself; in that cartoon, he minces and flounces and verges on effeminacy. It is that Bugs—neither drawn so well as before, nor so winning as a personality—who stands at the center of *What's Opera, Doc?*, and it is because of him that that cartoon is such an empty triumph. Jones purchased its splendors at much too high a price.

However questionable Maurice Noble's designs may have been as suitable settings for Jones's characters, Noble still knew exactly what he was doing: he was achieving the effects he wanted to achieve. His work had none of the baffled, hangdog quality of the many unsuccessful attempts, at the Warner cartoon studio and elsewhere, to ape the UPA designs. Outside of UPA and the Jones unit, a lack of self-confidence pervaded the Hollywood animation studios in the early fifties, even when the cartoons still had a conventional design. It had become difficult to do anything well.

Dick Lundy, in the MGM cartoons he made while Tex Avery

was on sabbatical, showed a singular inaptitude for comedy of the Avery kind. He could bring to it neither crisp timing nor wild exaggeration, and he was not a story editor on Avery's level. When Avery returned to MGM sometime around October 1951, though, and took his chair back from Lundy,[35] it turned out that he was no longer much of a story editor, either. The first cartoon Avery made upon his return was *Little Johnny Jet* (released in April 1953). It is, even more clearly than *One Cab's Family*—the cartoon he made shortly before his sabbatical—a remake of Freleng's *Streamlined Greta Green*; Avery simply used humanized planes in place of the earlier film's humanized cars and added silly gags.

UPA's influence showed itself in Avery's cartoons soon after he returned from sabbatical, starting with *The Three Little Pups,* released in December 1953. In *Billy Boy,* released in May 1954, Avery pursues a single ridiculous idea (a voracious kid goat eats literally anything and everything, finally consuming the moon) with something like the old ruthlessness, but the UPA-flavored styling dissipates the intensity by turning what the goat eats into mere graphic symbols. Once again, as in the late forties—only in the opposite direction—it became clear that Avery's comedy required just the right mixture of reality and unreality. High-style graphics were as alien to those requirements as was Disney-flavored drawing and animation.

As he had deferred to his Disney-trained animators in the forties, Avery was again deferring to an artist whose ideas were fundamentally at odds with his own. After Avery returned from his sabbatical, Ed Benedict, an admirer of the UPA cartoons (and a colleague of Avery's from Universal in the thirties) was his layout artist and model man. Benedict redesigned Avery's characters as well as dressed up his backgrounds, so that Droopy lost his sagging jowls; the sleepy eyes were the only vestige of the old face. It was not, however, until *Deputy Droopy,* released in October 1955, that Avery's characters thoroughly echoed UPA's designs in their flatness, angularity, and generally streamlined appearance: a tall canine outlaw's nose seems embedded in his snout as if it were a black hook. The animation in that cartoon is, as well, more limited than that in earlier Avery cartoons, and the styling emphasizes those limits.

Deputy Droopy was a remake of *Rock-a-bye Bear* (1952), the last cartoon Avery directed before taking his sabbatical. *Rock-a-bye* itself recalls the earlier cartoons built around the single-minded

pursuit of an insane idea (a bulldog struggles desperately to keep a cranky bear from being awakened), but it pursues its idea with noticeably less intensity than, say, *King-size Canary*, and *Deputy Droopy* is like a faded carbon copy of a remote original. It is actually not much of an Avery cartoon at all. Like his old colleagues at the Warner Bros. studio, Avery was caught in the 3-D crush, at almost the same time. MGM closed his unit on 1 March 1953, leaving only the Hanna and Barbera unit in operation.[36] (As at Warner Bros., the backlog of cartoons may have been a factor in the shutdown; the first cartoons that Avery made when he returned from his sabbatical were not released until after his unit closed.) Avery himself left the MGM staff on 24 June 1953.[37] The animators on *Deputy Droopy* and *Cellbound*, the last two MGM cartoons that credit Avery as director, are almost all members of Hanna and Barbera's unit; they finished those cartoons, working with Avery's animator Mike Lah (who is credited as codirector), after Avery and most of his animators were gone.

Fred Quimby spoke of reviving the Avery unit in the fall, after MGM had decided about producing cartoons in 3-D. In December 1953, however, Walter Lantz announced that Avery was going to work for him.[38] Avery went on the Lantz payroll 1 February 1954, about a month after Mike Maltese. Even though the MGM cartoons were by the early fifties taking on a pinched look, the Lantz studio was unquestionably a step down; as Avery said: "Of course, the animation was very limited.... I forget what Lantz's budget was, but it was pitiful."[39] As in UPA's case, though, the budgets were probably not much smaller than what a cartoon studio like Warner Bros. was spending; under a 1950 contract, Lantz was to make Woody Woodpecker cartoons for Universal at a cost of twenty thousand to twenty-five thousand dollars each.[40] Just as UPA's carelessness made the budgets seem smaller than they were, so Lantz's own history made him even more dollar conscious than people like Quimby. Avery found Lantz much more rigid than his bosses at Schlesinger's and MGM in the importance he attached to the length of his cartoons: "You go over eight frames, a foot— good night! You had to trim a foot out of your picture."[41]

In other respects, though, the Lantz studio should have been a tolerable home for Avery. As Paul Smith said—he was Lantz's other director when Avery was there—the Lantz cartoons "were strictly gag pictures—all sight gags, more or less slapstick."[42] That emphasis on gags was, of course, wholly compatible with Avery's own preferences—and Lantz, however limited his own taste, was

not the sort of producer to hover over his directors. "When we went over a story," Smith said, "and had it laid out a certain way, he never saw it again until it was finished on the screen.... If there was anything I'd left out, he didn't know the difference, and he didn't care."

For most of the people working at the Lantz studio, the boss's indifference was, as usual in such situations, a license to be indifferent themselves, and the occasional gifted outsider, like Maltese, disappeared without a trace. As a director, though, Avery had more control than Maltese did, and his expertise is much in evidence in his cartoons for Lantz. In his second Lantz cartoon, *Crazy Mixed-Up Pup* (1955), for instance, Avery establishes a rhythm of role reversals (man behaving like dog, and vice versa), and then syncopates it by introducing unexpected variations. He had to yield to Lantz in only one obvious way: his first and third cartoons starred Chilly Willy, a diminutive penguin that had been introduced in a 1953 cartoon. Chilly Willy was, however, such a blank as a character—more so even than Droopy—that he fit easily in Avery's films.

Avery made only four cartoons for Lantz, all of them released in 1955, after he left the studio. The Avery-Maltese combination, so promising on paper, resulted in only one cartoon, *The Legend of Rock-a-bye Point*. Both Avery and Maltese left the Lantz studio on 20 August 1954, when Maltese returned to Warner Bros. and Avery simply stepped away from theatrical cartoons.

He would have liked to continue at Lantz's, Avery said in 1977, "if it hadn't been for the money."[43] Lantz said of Avery: "He's a loner, and he's always worrying that things won't turn out. I even offered Tex a percentage of the pictures that he worked on, and he couldn't see ahead that it might take him five or six years before he would benefit.... It's very difficult for anyone to work with Tex. He's such a perfectionist.... Tex would get an idea, and he'd sit down and write the whole story himself and lay it out, and it'd turn out great."[44] For reasons that Lantz's comments suggest, working with Avery was difficult for Maltese. "I complained once to Walt [Lantz]," he said, "because I wanted to earn my money there."[45] Money may have been a convenient excuse for doing what Avery wanted to do anyway; the pressure he felt while making theatrical cartoons had not diminished during his sabbatical year.

After Avery left Lantz, he made, thanks to Bill Hanna's recommendation, a secret film on missiles for North American

Aviation.[46] Around the time he finished working on that film, Avery said, MGM approached him about making theatrical cartoons again, but at lower pay, and on lower budgets, than before.[47] Mike Lah, from Avery's old unit, had been called back to the studio to work on a partly animated sequence for a Gene Kelly feature, *Invitation to the Dance*; he wound up taking charge of the new unit. Lah had been at Cascade "doing all their animated commercials," he said, and it was his place that Avery took there.[48] MGM had by then—this was around the beginning of 1955—switched to making all its cartoons in the wide-screen process CinemaScope, yet another device, like 3-D, that was supposed to draw back to theaters all the people who were watching television instead. Hanna and Barbera had remade a couple of Avery cartoons in CinemaScope, but MGM needed a second unit to flesh out a full schedule of CinemaScope cartoons.

The Hanna and Barbera cartoons had long since settled into a pervasive blandness. In *Blue Cat Blues*, released in November 1956, Tom literally "flips his lid"—an Avery-style impossibility that would have grated against the prevailing animation style in the Tom and Jerry cartoons of the forties. The animation in *Blue Cat Blues* is, however, so generally insipid that it smothers the occasional burst of extravagance, like a feather pillow absorbing a blow from a fist. As in those earlier cartoons, there's no aesthetic point of view shaping the Tom and Jerry cartoons of the fifties; the lack simply manifests itself in a different way.

Unlike Avery's MGM cartoons, the Hanna and Barbera cartoons never showed much influence from UPA; they showed instead the effects of tighter budgets in, for example, the simplification of character design (Tom lost his eyes' green irises in the early fifties). Especially after Quimby retired in 1956 and Hanna and Barbera succeeded him as the cartoons' producers,[49] there was no hiding corner cutting behind a curtain of stylization; every dollar saved was visible on the screen in a cheaper look.

Such economies were not enough, Hanna said:

We were working on the last year of a five-year contract, and as we went into that last year, they said they were closing it down. We stayed on to supervise the completion of the work that was in there—the animation, the backgrounds, and whatever it was, during that year. We were on payroll there for a year, knowing that at the end of that year, if we did not do something more with MGM, we would be out on our own.[50]

The score for the last Tom and Jerry cartoon, *Tot Watchers*, was recorded on 6 June 1957, almost exactly twenty years after the cartoon studio opened.[51]

By 1957, the Disney short cartoons had expired, too, except for the occasional "special." In the late fifties, the short-cartoon producers best fitted to stay in business were those, like Lantz, that had always been preoccupied with keeping costs down. Their cartoons filled out some theaters' programs in much the way that low-cost features still filled some backwater screens. *Something* had to be there, and it might as well be a cartoon, if the price was low enough. Cartoons' appeal to audiences—the Warner Bros. cartoons excepted—was now almost entirely beside the point.

Oddly, it was as their role as entertainment diminished that the cartoons made by the East Coast studios, Terrytoons and Paramount (it had dropped the Famous Studios name in 1953), finally felt UPA's effects; the tide took a full five years to cross the country. In Terrytoons' case, Paul Terry's departure—he sold the studio to the CBS television network in 1955—opened the way for the change. CBS hired Gene Deitch as Terrytoons' creative director in June 1956. Deitch, who was thirty-one at the time—much younger than many of the Terrytoons veterans he was supervising—had worked before that for UPA for five years and then on TV commercials for a few months.[52] In his new job, Deitch wrote fifteen years later, he "made all of the creative decisions"; the nominal directors only "did production layouts and handed out the work to the animators." Deitch "put the emphasis in my own personal work on story" and mixed the complete soundtrack in advance of animation; he thus controlled the timing exactly as Paul Terry had. "With the general level of staff I inherited," he said, "this was the only way to set a new style and tempo of action."[53]

The first cartoons of the Deitch regime began appearing in the spring of 1957. Around the same time, the Paramount cartoons began to reflect the UPA influence, first in simplified backgrounds and awkward attempts at limited animation (jerky in a way that suggests that the inbetweens were simply left out) and then in full-blown imitations of the cartoons UPA was making in the early fifties. The Deitch cartoons were the more successful, thanks to the outsiders Deitch brought in as designers and directors. There is in a film like *The Juggler of Our Lady* (1958) no trace of the old Terrytoons' visual squalor; it is instead a faithful translation of the squirmy drawing style of its designer, the advertising cartoonist R. O. Blechman.

What is most tantalizing about the Deitch cartoons is the suggestion in a few of them that such emphatically designed films could be highly effective vehicles for animation of a kind that had been all but driven out of existence by the triumph of the Disney style and its offshoots. This was animation in the old Bill Nolan vein, animation that played freely with characters' bodies and that valued eccentric, eye-catching movement over realism and conventionally good draftsmanship. The longing to do such animation never entirely died out, but from the late thirties on, it ran through many cartoons like an underground river, bubbling up in scenes by such animators as Irv Spence, in the Hanna and Barbera unit at MGM, and expressing itself through how eagerly the animator seized an opportunity to test a character's normal physical boundaries.

The exemplar of such animators at Terrytoons was James Tyer, who was in his early fifties by the time Deitch was hired; Tyer had worked briefly at Disney and Harman-Ising in the thirties, but the bulk of his career had been spent with the East Coast studios, and mostly with Terrytoons.[54] His animation stands out from the cynical hackwork that otherwise fills the Terrytoons of the late forties and early fifties—his are the scenes, animated straight ahead, in which characters are seized by powerful spasms, their bodies radically distorting from one frame to the next. There is, however, in Tyer's animation no distortion of the kind that Rod Scribner introduced into Bob Clampett's Warner Bros. cartoons. Not only could Tyer not draw as well as Scribner, but when his characters suffer breakdowns, Tyer is interested not in their emotions but in the fun he can have while pulling them to pieces. He was, on his own terms, an utterly fearless animator, and if his drawing was bad, it was a swaggering, exuberant sort of badness. In a cartoon like *Movie Madness* (1952), with the magpies Heckle and Jeckle, the characters do not slip off-model in Tyer's scenes, they *lunge* off-model.

Gene Deitch spoke of Tyer warmly in a 1975 letter to Mark Kausler: "Many at Terrytoons laughed at him as representing the corniest of the old school Paul Terry animators—and in a way he was—but Jim was always ready to try new things, whereas most of the old-timers there resisted what I was trying to do in my truncated 'renaissance.'"[55] Tyer's animation turns up in cartoons made throughout the Deitch period, but only rarely to its best advantage. That happens in *Sick, Sick Sidney*, the first cartoon in a short-lived series whose protagonist is a blue African elephant with a fluttery manner borrowed from the vaudeville and radio comic

Ed Wynn. Sidney panics when he learns that a safari has come to the jungle, and as he flees his body distorts as freely and unrealistically as in any other Tyer animation—but Sidney's anatomy (he is basically a ball with legs, trunk, and ears stuck on) is as unrealistic as that of any formula animal of the early thirties, if far more elegantly drawn. Likewise, the strong orange that fills the screen when the safari appears conveys very effectively the African heat, but Sidney's environment is just as far removed from mere illustration as he is. Utterly unrealistic movement suits this utterly unrealistic animal in his utterly unrealistic world; the film's design actually strengthens Tyer's animation, because his bizarre distortions seem less like uncontrolled explosions and more like another element in a subtly conceived pattern.

It was just such vitality that the UPA cartoons so often lacked, thanks to their makers' preoccupation with taming excess, but Deitch had no chance to improve further on his former employer's films. By the time *Sick, Sick Sidney* was released in August 1958, he had lost his job.

At Terrytoons under Deitch, *Juggler's* director (and sole animator) Al Kouzel later recalled, "the studio was split into two camps; each was a mixed bag as far as talent went." Opposed to Deitch was the "old guard": "Some...were truly incompetent, marginal workers who couldn't make it in the higher-paying commercial studios," and who disrupted the studio through their "griping, bad-mouthing, pulling annoying little acts of sabotage."[56] The old guard won: Deitch lasted less than two years, until April 1958, before he was "forced out," in his words, in what he described as a power struggle between himself and William Weiss, Paul Terry's longtime business manager. "Weiss kept pointing out to [CBS] how much my films were costing," Deitch said.[57] There was the rub: truly successful limited animation could be as expensive as traditional full animation because it required careful planning.

As the fifties drew to an end, the American theatrical short cartoon was terminally ill. Hollywood animation in its classic form survived only at the Disney studio; and even there, the decade had not been particularly kind.

The slow disintegration of the short cartoon in the fifties took place, like every development in the shorts since the middle thir-

ties, in the shadow of the Disney animated features. Not even the most admired UPA shorts received a small part of the attention given to each new Disney feature. By the fifties, though, the Disney features had become a breed apart: they were no longer having any visible influence on the short cartoons, even those made by the Disney studio itself. They were, as well, inbred—but owed what strength they had to that very inbreeding.

Cinderella had essentially retold the story of *Snow White*; the next two Disney features, *Alice in Wonderland* (released in July 1951) and *Peter Pan* (released in February 1953), showed why such a narrative anchor was needed. In neither film is there any sense that Walt Disney ever decided what kind of story he was telling and how it should be told. *Alice* is a frantic film; everyone working on it seems to have suffered from discomfort with the material, bordering on panic, and to have tried to disguise that discomfort as high spirits. *Peter Pan* is even more revealing because Captain Hook, the character who is the hinge on which the film swings, is never defined as clown or villain. He is not a mixture of both, but alternates between the two throughout the film. Frank Thomas, the principal animator of Hook, shed some light on what happened, in an interview with John Canemaker:

> I had a particularly bad time getting started on Captain Hook.... These are the first scenes of him where he's walking, pacing the deck, saying, "That Peter Pan! If I get my hook on him!," or whatever. I had four scenes. He was neither menacing nor foppish. This was because of the confusion in the minds of the director and story people. In story, Ed Penner had always seen Hook as a very foppish, not strong, dandy-type of guy, who loved all the finery. Kind of a con man. Gerry Geronimi, who was the director, saw him as an Ernest Torrence [who played Hook in the 1924 live-action film of *Peter Pan*]: a mean, heavy sort of character who used his hook menacingly.
>
> Well, Walt could see something in both approaches, and I think he delighted in thinking, "I wonder what the hell Thomas is going to do when he gets this."

When Disney saw Thomas's first few scenes, he said, in Thomas's account, "Well, that last scene has something I like. I think you're beginning to get him. I think we better wait and let Frank go on a little further."[58]

Nothing comparable had happened on the earlier features. The

animators on films like *Snow White* and *Pinocchio* had not been asked to create characters so much as to define them—to clothe in movement what already existed in the minds of Disney, his directors, and his writers. A character might change considerably as it was animated, but that was not the same as asking an animator to give shape to a character that had only the cloudiest existence on the storyboard. Since the question of Hook's character was never resolved, the broadest sort of comedy intrudes suddenly in *Peter Pan* even when the threat of death is supposed to be taken seriously. As Captain Hook, in his Ernest Torrence mode, pursues Peter inside Skull Rock, it's clear that the hook at the end of his arm really could kill Peter, but then the clownish Hook appears, chasing Peter into the air and falling only when he realizes where he is, in one of the oldest cartoon gags.

In other respects, too, *Peter Pan* suffers from crippling confusion. The film compromises its theme—the flight from growing up—by making Peter so clearly an *adolescent* boy, more than that, a boy who is the subject of a jealous tug-of-war among a remarkably large number of adolescent girls (Wendy, Tinker Bell, the Indian princess Tiger Lily, and several mermaids), as if they were all of them teenagers at an American high school. *Snow White* deals with its Queen's jealousy in a far more sophisticated manner. The sexual element in that jealousy is never stated baldly— as it easily could have been by having the Queen appear to covet the attentions of the Prince for herself—but sexual jealousy burns at the core of her consuming hatred of Snow White's youth and beauty. *Peter Pan*, with its smirks and nudges, is shallow and clumsy by comparison.

Disney's involvement in his animated features continued to decline in the early fifties as he devoted more time to live-action films and spent months at a stretch in Europe. He was gone to Britain from June to August in 1951—that is, when *Peter Pan* was moving from storyboards to animation—for the shooting of *The Story of Robin Hood*. From June to September 1952, he returned to England for the shooting of what was eventually released as *The Sword and the Rose*. He was back in England in 1953, for most of April and then again in July and August, for the shooting of *Rob Roy, the Highland Rogue*.[59] But although Disney's active role in the animated features receded, his control over them did not. The features' directors and writers and animators were sharply limited in what they could do on their own, but Disney himself was not leading them into new territory, as he had fifteen and twenty years earlier.

There's evidence in extensive story meeting notes from the spring and fall of 1952 (themselves a rarity at that stage of the studio's life) that *Lady and the Tramp* caught Disney's interest in a way that the two previous features, *Alice* and *Peter Pan*, had not. With its animal cast, it evolved as a sort of domesticated *Bambi*, the earlier film's forest animals giving way to equally gentle house pets. But Disney adhered to the pattern initiated in work on *Peter Pan* by pushing onto the animators decisions that would have been made in the writing of the story on earlier features. Frank Thomas recalled that he and Milt Kahl got important scenes to animate that had not been developed in story work: "It was as if they had said, 'Well, let's give those two scenes to either Milt or Frank—they'll think of something to do with them.' So there were many cases where we had little support from the director or story man." [60]

Casting by character was still very much alive during work on *Lady*, but much as it had been during the animation of many of the preceding features—several animators split up the major characters, while minor characters each enjoyed the attention of a single animator and were often correspondingly more real. In the scenes at an Italian restaurant for which Thomas animated the dogs, John Lounsbery animated the two Italians who feed and serenade them. Thomas recalled how they shared some scenes: "Whoever had the main action of the scene took the first crack at it but only after checking with the other animator.... It was a clumsy way to make a picture, but I guess it protected the integrity of the characters."

The "integrity of the characters," once the central concern at the Disney studio, was now just one of many. By the time *Lady* was in animation in 1953 and 1954, Disney had new and far more serious distractions than his live-action schedule. He had made his first television program, "One Hour in Wonderland," in 1950, to promote the forthcoming release of *Alice in Wonderland*, and his first animated TV commercials in 1952, for Mohawk Carpet Company.[61] By 1953, he was gearing up for a weekly television series. Walt Disney Productions reached agreement with the ABC television network in March 1954 for a series to begin that fall and for financial help with a theme park south of Los Angeles (ABC wound up owning slightly more than one-third of a separate Disney theme-park company).[62] Both park and show were to be called "Disneyland." The Disney studio was the first Hollywood studio to accept television fully, and Roy Disney emphasized that TV would "serve our motion picture program," essentially as an

advertising medium.[63] But the advent of the TV show and partic-
ularly the theme park meant that Walt Disney could devote much
less of his own time to motion pictures in general, and animated
features in particular.

The feature that suffered most from Disney's preoccupation
with other projects was *Sleeping Beauty*, which he chose to follow
Lady and the Tramp. The writing for the film was under way by
early in 1951—soon after the great success of *Cinderella*, that is—
and even in early treatments it's clear that *Sleeping Beauty* was
envisioned as yet another variant on the *Snow White–Cinderella*
story. As of mid-1952, Disney planned to release *Lady and the
Tramp* in 1954 and *Sleeping Beauty* in 1955,[64] but thanks to the
television show and the Disneyland park, both release dates
slipped. By April 1954 *Sleeping Beauty* was supposed to be a
February 1957 release.[65] *Lady* eventually came out in June 1955,
a few weeks before the park opened. *Sleeping Beauty*'s completion
had receded even further into the future. Making an animated
feature always took longer than Disney predicted, but never
before had the delays stretched out so long, except when a feature
was actually shelved for a while, and *Sleeping Beauty* was never
shelved.

Walt Disney himself caused the delays; he could never get
comfortable with the story, even as it went into production. By
sometime around the middle of 1953, Wilfred Jackson had
recorded dialogue, made a running reel, and was starting to hand
out animation for a pilot sequence in which Aurora, the Sleeping
Beauty, and her Prince were to meet in the forest and dance—but
then Disney threw out that version of the sequence. Jackson
recalled working with Ted Sears and two other writers "for some
months" on a new version. Disney was "lukewarm" about the
revised version, Jackson said, but approved it "with such exten-
sive changes that we were almost completely rewriting it at the
same time we were preparing it to hand out for the preliminary
animation to establish the characters. The key animators, who
were waiting for work, were in the music room, too, not too hap-
pily trying to get it in shape." It was at that point, in December
1953, that Jackson suffered a heart attack; Eric Larson took over
for him.[66]

As Disney's grip on the story and the characters loosened, he
paradoxically became more concerned with *Sleeping Beauty*'s
design. Increasingly too busy to attend to details, he could by the
middle fifties make only broad gestures toward what he wanted

to see on the screen; strong design, since it could govern an audience's general impression of a film, was the easiest lever to grasp. It was not unheard of for Disney to become infatuated with a particular designer's work in the postwar years. When *Song of the South* was being made, he was greatly taken with Mary Blair's styling sketches. Blair, a Chouinard-trained watercolorist, worked—as her husband, Lee, also did—as a stylist for Harman-Ising and then for Disney before World War II; she continued to work for Disney as a freelancer after Lee joined the navy and they moved to the East Coast.[67]

Recognizably "modern" elements—flat, bright colors and strong, simple shapes—entered Mary Blair's work around the time she and Lee accompanied Disney to South America in 1941, that is, at around the same time as John McGrew and Gene Fleury were working together at the Schlesinger studio and shortly before Zack Schwartz and John Hubley began experimenting at Screen Gems. No one ever brackets Blair with such artists, though, and that is because her sketches so thoroughly softened and smoothed away contemporary art's harsh edges, removing from it anything in the least provoking. Disney's enthusiasm for her work was thus the mirror image of the discomfort with abstraction that he so often voiced during work on *Fantasia*; Blair gave him a decorative abstraction that he could live with.

Wilfred Jackson and Ken Anderson, the director and layout artist, respectively, for *Song of the South*'s animated segments, successfully adapted Blair's styling sketches for that film, so that the backgrounds brim with strong, clear color but still have enough detail, and enough sense of depth, to be satisfactory as environments for the emphatically three-dimensional characters. As successful as the background paintings were, though, Disney was not happy with them because they did not duplicate the style of Blair's sketches. And so, for the "Johnny Appleseed" segment of the package feature *Melody Time*, Jackson followed Blair's sketches faithfully.[68] The backgrounds—and the characters, too, since they had to be compatible with them—were so severely simplified that one can almost sense the animators running their hands over those smooth surfaces, trying to find something that will permit them to adapt Blair's style to their own needs.

Kay Nielsen—whose sketches had been the basis for *Night on Bald Mountain* in *Fantasia*—was apparently the first to do some styling sketches for *Sleeping Beauty*, around 1952; the background

*Concept sketches by Eyvind Earle for Disney's Sleeping Beauty
(1959). Sketches like these show clearly the influence on the film's
visual style of such medieval works of art as the unicorn tapestries
and the Limbourg brothers' Très Riches Heures for the Dukes of
Berry. © Disney Enterprises, Inc.; courtesy of Phyllis Williams.*

painter Eyvind Earle remembered them as "little pastels, quite
nicely done, but not adaptable to finished backgrounds."[69] Earle,
who joined the Disney staff in 1951, was an assistant background
painter on *Peter Pan* before becoming a full-fledged background
painter—and getting his first screen credit—on a Goofy short, *For
Whom the Bulls Toil*. His stock rose rapidly after that, much as
gifted animators had enjoyed swift ascents in Walt Disney's
esteem in the thirties; but Earle wanted to be more than a back-
ground painter. "I remember the first day I walked into Disney's,"
he said, "when I got the job, and I saw these Mary Blairs on the
wall, I said, 'My God, that's the job I want!'" He got his opportu-
nity on *Sleeping Beauty*.

It was the layout artist John Hench who brought back the gen-
eral idea for the style adopted for the film, after a visit to the

Cloisters, the Metropolitan Museum of Art's medieval collection in New York. He saw the famous unicorn tapestries there, he said, and decided that "they would fit perfectly with the cartoon medium. They have crisp edges, [and] the planes are not defined very well except by a kind of superimposition for distance rather than the linear perspective."[70] Earle said he "felt totally free to put my own style" into the paintings that he based on Hench's drawings. "Where his trees might have curved, I straightened them out.... I took a Hench, and took the same subject, and the composition he had, and just turned it into my style."

Walt Disney held a meeting after Earle had done just a few such paintings, Earle recalled, "and this was Walt's way: he'd say, 'And, uh, I want you to get that into the picture.' That was about all." For Eric Larson, the message was clear: "Walt said he wanted a moving illustration—and that's what we decided to give him."[71]

Earle's styling for *Sleeping Beauty* was in some ways the opposite of Blair's since it emphasized strong verticals and angles rather than curves; his initial paintings had, as well, a tapestry-like density of detail with no equivalent in Blair's work. The style that he adopted for the film was medieval in feeling if not in specifics; Earle described it as "simply my own style, leaning a little in the direction of all the medieval arts."[72] To forestall modifications like those Jackson and Anderson made to Blair's style for the backgrounds of *Song of the South*, Earle wanted control of the production backgrounds—the paintings that would actually be photographed behind the animation cels—and so he poured out not just styling sketches but what he said were "hundreds" of finished backgrounds, including all those for the "master shots"; he also "made charts showing how to do it" for the other painters who followed behind him on the less important backgrounds.[73]

Earle's de facto authority on *Sleeping Beauty* was such, Eric Larson recalled, that if Earle disagreed with a Larson request—for simpler textures as Aurora is drawn upstairs by a mysterious light, for instance—he ignored it: "He'd argue with Walt, he'd argue with anybody."[74] When Frank Thomas protested to Ken Peterson, the head of the animation department, about Earle's "very rigid design"—its inhibiting effect on the animators was at least as great as that of Blair's designs—Peterson simply cited Walt Disney's instructions.[75] Earle himself remembered no arguments with Disney. "Once Walt had liked what I did," he said, "he never told me what to do."[76] That was, perhaps, because *Sleeping Beauty* was not terribly important in the Disney scheme of things: Earle

was pulled off it to do background styling for the weekly Disney television program, and he also designed some murals for the Disneyland park. "The top priorities were Disneyland and the television shows," he said. "Then, whenever you could, back to *Sleeping Beauty*."

Relatively late in production, Disney removed Larson as the film's principal director, replacing him with Gerry Geronimi; Larson evidently paid the price for the expensive delays that Disney himself had caused. After Geronimi took charge of *Sleeping Beauty*, Earle recalled, "we had some real battles." It was, ironically, Geronimi—so often the target of the animators' anger—who crossed swords with Earle on their behalf. "He lacked the mood in a lot of things," Geronimi said of Earle in 1976. "All that beautiful detail in the trees, the bark, and all that, that's all well and good, but who the hell's going to look at that?"[77]

Earle left the Disney studio in March 1958, before *Sleeping Beauty* was completed, to take a job at the John Sutherland studio. Geronimi won a victory of sorts: in the finished film, Earle's style was softened in many of the background paintings, just enough to dilute its distinctive medieval flavor ("I heard that after I left, Geronimi had them airbrush a whole lot of backgrounds so you wouldn't see them over the animation," Earle said).[78] But the changes did not much alleviate the backgrounds' strong vertical emphasis or, most important, their fundamental seriousness. They demanded a story that was far more serious than the one Disney provided. *Sleeping Beauty* preserved the most obvious ingredients of *Snow White* and *Cinderella*—a beautiful young woman, a handsome prince, an evil older woman, readily adorable comic characters, and situations that could be exploited easily for laughs or for tears—but no one assembled those ingredients as an involving story.

Aurora, the Sleeping Beauty herself, enjoys the protection of three good fairies who assume roles analogous to those played by the dwarfs in *Snow White* and the mice in *Cinderella*, but whereas the dwarfs and the mice were central to the earlier films because they permitted the heroine to reveal herself as a person worth caring about, the fairies play no comparable role. They serve a plot function by deflecting the evil fairy's curse and permitting Aurora to fall asleep rather than die when she pricks her finger, but there's no emotional connection between them and Aurora. *Sleeping Beauty* struggles throughout to give the fairies unmerited significance, an effort that culminates in the film's most excruci-

ating moment. At the climax, when the Prince is battling a dragon (the evil fairy, transformed) that has proclaimed itself an agent of Hell, one of the fairies sprinkles a magic dust on the Prince's sword; he hurls it into the dragon's breast and the dragon plunges dying into a chasm. In the shadows at the bottom of the chasm, the sword shines, unmistakably, like a Christian cross. The film presents the Prince's battle with the dragon as a Christian allegory, yet what saves the Prince is the timely intervention of a fussy old lady with wings—a character who, however much the film might pretend otherwise, has never been more than comic relief.

Sleeping Beauty finally reached theaters in April 1959, fully eight years after work on it had begun. It was far and away the most expensive Disney animated feature, with a cost—six million dollars—almost twice that of each of the three features that had preceded it. But the audiences that had responded so warmly to *Snow White* and *Cinderella* did not show up for *Sleeping Beauty*. Walt Disney Productions' gross income and profits had both just about doubled in its 1955 fiscal year, the first year the weekly television show was on the air and the fiscal year during which the Disneyland park opened, and had continued shooting up after that. *Sleeping Beauty's* expensive box-office failure brought the sharp upward trend in revenues and profits to a jarring halt. Profits fell in fiscal 1959, and revenue fell the next year, when the company suffered its first loss since the forties.[79]

A photograph at the back of *The Art of Animation*, a book by Bob Thomas that was published in conjunction with *Sleeping Beauty's* release, shows Walt Disney and Eric Larson standing together in a hallway during work on the film. Larson remembered that moment because Disney was saying to him, "I don't think we can continue, it's too expensive."[80] If he had set out to prove himself right—and to extinguish what remained of his own once-intense interest in the medium he still dominated—he could hardly have done a better job.

Starting in the middle forties, small studios made animated commercials and, a little later, entertainment cartoons especially for television. In the fifties, the studios that made theatrical cartoons began metamorphosing into television-cartoon studios. The change started at Disney's. When Walt Disney shut down the

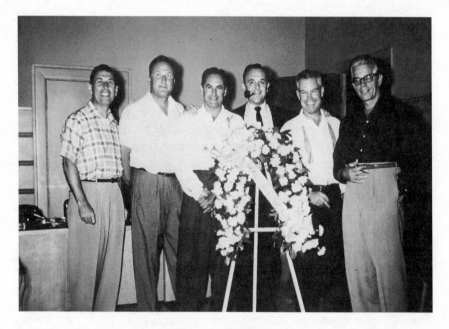

The Hanna-Barbera studio's opening day, 7 July 1957. From left:
layout artist Dick Bickenbach, production manager Howard
Hanson, Joe Barbera, George Sidney, Bill Hanna, and writer
Charles Shows. Courtesy of Bill Hanna.

units making his theatrical shorts, he did not fire the people
working on those films, but instead put them to work on his tele-
vision shows. Cartoons dominated the first few years of Disney's
weekly, hour-long program. Many of them had been released the-
atrically, but old cartoons had to be tied together with new
footage, and some shows consisted entirely of new material. Ward
Kimball in particular flourished in this new environment, devot-
ing himself to programs about the exploration of outer space.
Only after the failure of *Sleeping Beauty* (by which time Disney
was using mostly live action on his weekly show, leaning heavily
on westerns) did Disney dismiss such shorts directors as Jack
Kinney and Charles Nichols. From 1960 on, names that had pre-
viously been more familiar on the features dominated the ani-
mation credits for the Disney show.

When MGM shut down its cartoon department, something sim-
ilar to the Disney transformation took place; however, it was not
MGM but MGM employees who were the agents of the change.
Bill Hanna and Joe Barbera, working out their contracts, lingered
at MGM for a few months after their crew left; they tried to get

into television commercials, making some for Schlitz beer. Dick Bickenbach worked for them on the commercials and, he said, roughed out the animation for the titles of a TV show, to be called *Ruff and Reddy*, "the last two days I was at MGM."[81]

Hanna and Barbera had developed the idea for that show "on the side" during their last year at MGM, Hanna said, and tried to talk MGM into a half-hour show "for seventeen thousand dollars, I think it was. But they didn't want any part of it." George Sidney, an MGM feature director who had worked with Hanna and Barbera when they made animated inserts for *Anchors Aweigh* (1945), sent them to Screen Gems—not the old cartoon studio, but Columbia's television subsidiary—and it bought the idea. "So we formed a partnership," Hanna said, "and they wanted us to take in some of the Cohn boys"—relatives of Columbia's head, Harry Cohn—"and George. They were part of the original Hanna-Barbera company." Hanna and Barbera started the company with money they got from cashing in their MGM pensions.[82]

In the summer of 1957, they set up shop in Hollywood and began producing short cartoons especially for television. But unlike Disney, whose television cartoons had not strayed far from theatrical standards, Hanna and Barbera were eager to comply with television's harsh demands for quantity and predictability. They reduced the animation, the stories, the dialogue, and the characters to increasingly rigid and predictable patterns, the better to facilitate production; in their hands, limited animation became a matter of using so few drawings that even Paul Terry might have hesitated. Within a couple of years, Hanna-Barbera Productions was becoming an industry giant, well on its way to dominating Hollywood animation—if only in the number of its employees—in the way Disney once had.

Hanna-Barbera's rapid ascent, fueled by the success in particular of *Huckleberry Hound*, a syndicated program that began airing in 1958, rippled quickly through the small animation industry. For one thing, Hanna-Barbera hired many industry veterans who had been cut loose by theatrical studios; Charles Nichols wound up there, for instance, as did most of the animators who had worked with Hanna and Barbera at MGM. Other people, drawn by the new studio's high salaries, took new jobs with Hanna-Barbera without first losing their old ones. In the fall of 1958, Mike Maltese called Joe Barbera at his new studio and asked for a job.[83] Maltese left Warners in October. Warren Foster, Friz Freleng's writer, had already left Warners for a job at the John Sutherland

studio;[84] he soon joined Maltese at Hanna-Barbera, where they became the principal writers.

It appeared briefly that Jones and Freleng themselves might become a TV-cartoon team of the same kind as Hanna and Barbera, but not for Warners. Around the end of 1959, the two directors dickered with CBS over a deal of some kind that would have been highly lucrative for them. They stayed with Warner Bros. when it agreed to a three-year deal that kept the cartoon studio open and raised Jones's and Freleng's salaries substantially.[85]

The Warner cartoon studio had begun making television animation—commercials for Blatz beer—by 1957,[86] but now TV was becoming central to its existence. A half-hour *Bugs Bunny Show* was to air weekly on the ABC network starting in September 1960. Warners merged the cartoon studio with its commercial and industrial division—already a heavy borrower of animators from the cartoon studio—and put in charge of the combined operation David DePatie, the son of E. L. DePatie, Warner Bros.' vice president and general manager. The senior DePatie and Jack Warner, the head of the parent studio, visited the cartoon studio in a show of support.[87] The new animation required to connect the three old cartoons used on each *Bugs Bunny Show* not only kept the staff busy, despite a cutback in the number of theatrical cartoons being made, but actually forced the hiring of more people.

By then, the theatrical cartoons, including Chuck Jones's, had lapsed into a numbed stupor. In 1958 and 1959, as in 1954, Jones had worked for a time without the help of either Maltese or Maurice Noble; Noble had left the Jones unit again, this time to work for the Sutherland studio. He rejoined Jones in mid-1959, after an absence of roughly a year and a half.[88] After Noble returned, his designs dominated Jones's films more than ever before. "He just animated it and put it back into the picture," Noble said—and that is how the films look, filled with characters as well as backgrounds that bear a designer's rather than an animator's stamp.[89]

The *Bugs Bunny Show* ended its prime-time run in the spring of 1962, except for repeats, and the cartoon studio again became highly expendable. By midsummer of that year, Dave DePatie said, he had been told to finish the work on hand and close the place down.[90]

Chuck Jones left the studio then, but the stimulus for his departure was not the decision to close. In 1961 Jones and his

wife, Dorothy, sold a screenplay to UPA for a cheaply made animated feature called *Gay Purr-ee*; Abe Levitow, an animator in Jones's unit in the fifties, directed the film. Warner Bros. learned of Jones's involvement the next year when it became the film's distributor, and there followed sharp disagreement over whether it had authorized Jones to moonlight in that way. On 23 July 1962—after he had been on an unpaid leave of absence for several weeks—Jones signed an agreement ending his almost thirty years of employment by Warner Bros.[91]

Friz Freleng, too, left the cartoon studio before it closed; in November 1962, he went to work for Hanna-Barbera, writing the story for a theatrical feature starring the television character Yogi Bear.[92] Even though both Jones and Freleng had left, Warner Bros. lived up to the agreement it had made with them in 1960 to keep the cartoon studio open for another three years: work on animated inserts for a Warner feature called *The Incredible Mr. Limpet* kept it alive until the spring of 1963.[93] When the closing came, Friz Freleng returned to the studio, this time as co-owner with Dave DePatie of a new cartoon-production company called DePatie-Freleng Enterprises; it rented the cartoon studio's building from Warner Bros. and hired many people from the cartoon studio's staff.

Freleng, like Hanna and Barbera, was a director whose cartoons did not embody a strong aesthetic point of view, and the transition to working in a TV-dominated marketplace was easier for such directors. Hanna recalled that when he and Barbera were setting up their own studio, "I talked to Friz a lot about cutting costs.... We would time everything full animation [at MGM], whereas Warner Bros. was doing more cycles than we were. We thought nothing of walking people up in perspective, or away in perspective, and theirs was mostly left to right."[94] The Freleng cartoons of the middle fifties and the contemporaneous Hanna and Barbera cartoons for MGM do not differ all that much in such respects, but Hanna was surely correct in thinking that Freleng, rather than Jones, was the one to talk to.

By the time Jones sold his script to UPA, that studio, too, had transformed itself into a television-cartoon house. Steve Bosustow had sold it in the summer of 1960.[95] UPA was not attractive to most potential buyers because it had so few assets after selling its films to Columbia, but it was attractive to Henry G. Saperstein because, as Bosustow said, he was a "character merchandising guy"—he was not buying a studio so much as he was buying an

exploitable cartoon character, Mister Magoo.[96] Saperstein had already bought the television rights to Magoo earlier that year. He immediately began producing new Magoo shorts for TV, on the Hanna-Barbera model. [97]

Even though its glory days were behind it by the midfifties, UPA in some ways reached its peak then, when it was producing not just theatrical cartoons for Columbia but also television commercials and a *Boing Boing Show* for CBS television. UPA had branches in both New York and London, making TV commercials there as well as in Burbank. By 1959, though, UPA was in turmoil. Columbia was ending its distribution arrangement—it released its last UPA cartoon in July 1959—and UPA was attempting its own distribution of Magoo shorts. Dozens of employees were laid off, and some of the studio's oldest hands, like the production manager, Herbert Klynn, left to form a new TV-animation studio called Format. So removed from its roots had UPA become by early in 1960 that Bosustow hired Gerry Geronimi—who had left Disney's, fired after a run-in with Walt—as the studio's direction supervisor.[98] The sale to Saperstein was a mercy killing.

It was as UPA sank into the dreariest sort of conventionality that John Hubley's fortunes revived, with films of a very different kind. After moving to New York in 1956, he made not only television commercials (Gene Deitch worked for him before going to Terrytoons) but, in collaboration with his second wife, Faith Elliott, short films—some of them sponsored—that echoed the UPA films of the middle forties. There was in these earnest animated lectures no trace of the Hubley of *Rooty Toot Toot*, no trace of that film's wittily stylized animation; instead, Hubley hired strong animators with roots in the Hollywood studios, let them do their work—often supervising them only loosely, from across the continent—and then wrapped their drawings in paint of shifting shades and textures.

One of those animators was Bobe Cannon, Hubley's old antagonist from UPA. Cannon left UPA in 1957, after work suitable for him dried up; the *Boing Boing Show* had been canceled by then, and Magoo had swallowed the theatrical release schedule (Cannon directed two cartoons with the character before he left). He worked as a freelance animator until 1959, when he joined Playhouse Pictures, a television-cartoon studio headed by his old UPA colleague Adrian Woolery.[99] As a freelancer, Cannon animated most of Hubley's *Moonbird* (1959). That Cannon should have worked for Hubley was really not surprising since by 1959

it was Hubley, rather than UPA, who was making cartoons most like those Cannon had once directed (the principal characters in *Moonbird* are children, their voices those of the Hubleys' two sons).

By 1963, all the studios that had contributed most to animation's development had stopped making theatrical shorts. Terrytoons, Paramount, and Lantz continued to make such cartoons, but at those studios, theatricals had long since become indistinguishable from TV cartoons. However shrunken, the market for theatrical short cartoons remained just large enough in the early sixties to tempt other studios into it, if briefly. DePatie-Freleng made new cartoons with the Warner characters; Chuck Jones revived Tom and Jerry for MGM in 1964; and even Hanna-Barbera made cartoons for Columbia, starring a wolf named Loopy de Loop, that were released between 1959 and 1964 (they replaced the UPA cartoons on Columbia's schedule). Most of these cartoons had been infected by television habits, and the rest, Jones's in particular, were strained attempts to recapture past glories. Successful animated shorts require more than money and talent; the people making them must be comfortable working together at a certain pace and in a certain rhythm. When that condition is met—as it was, for example, in Jones's unit at Warner Bros. in much of the forties and fifties—money recedes in importance. But with the old studios broken up, and the new ones lacking the stability that the old ones had, there was no way to recapture the harmony in aims and working methods that had once been commonplace.

As if to administer the coup de grace, television-like habits of mind invaded the Disney features, too.

Walt Disney by the early sixties had become indistinguishable from many another tycoon: he was grim, preoccupied, and intensely self-centered. He was obsessed not with his films, but with the Disneyland theme park.[100] "Since Disneyland opened," he told a writer for *Look*, "I've poured another $25 million into it. To me, it's a piece of clay. I can knock it down and reshape it to keep it fresh and attractive. That place is my baby, and I would prostitute myself for it."[101] The films, once completed and released, were gone, beyond his control, except perhaps for some minor tinkering; Disneyland was infinitely malleable.

One Hundred and One Dalmatians, the feature that followed *Sleeping Beauty*, did nothing to rekindle Disney's interest in animation, even though it was far more successful at the box

office than its predecessor and cost much less ($3.642 million, or less than two thirds as much as *Sleeping Beauty*). One by-product of *Dalmatians'* more economical production aroused Disney's antipathy toward the film. *Dalmatians* was the first Disney feature made wholly with the Xerox Corporation's copying technology, which was used to transfer the animators' pencil drawings directly to cels as black lines, without the intervention of an inker's tracings. The idea was not new. Max Fleischer had filed for a patent on such a process in December 1936 (the patent was issued in 1938),[102] and the Disney studio had used "process cels" for parts of *Pinocchio*, but the processes that Fleischer described and that Disney used were cumbersome and clearly not suited for use on a large scale. Disney first used the Xerox process for a thorn forest in *Sleeping Beauty;* even then, a couple of small television-commercial studios had already made some use of it, as had UPA on its *Boing Boing Show*.[103]

Walt Disney had written—or at least lent his name to—this prediction twenty years earlier: "The full inspiration and vitality in our animators' pencil drawings will be brought to the screen in a few years through the elimination of the inking process."[104] The problem was, as *Dalmatians'* designer Ken Anderson put it, that Disney "inherently hated lines.... He was the one who really pushed us into cel-paint ink lines, where the ink line is the same color as the area it is encompassing.... So he was very upset when he saw what was happening on *Dalmatians*,"[105] which is dominated by lines like no Disney feature before it. Anderson used the Xerox process for the backgrounds as well as the characters, to give the two a consistency of the kind that the UPA designers had once sought. However harmonious the result on the screen, Disney knew that it was a step away from the kind of illusion that more traditional backgrounds—and devices like the now dormant multiplane camera—had once furthered.

Xerox also subtly diminished the very "inspiration and vitality" in the animators' drawings that it was supposed to preserve. After Xerox came in, the animators began trying, as Eric Larson put it, "to draw pretty much on the nose,"[106] in effect reversing the evolution of the early thirties. As Frank Thomas and Ollie Johnston wrote, the new procedure "asked that the animator draw slowly and carefully enough so that the assistant need only touch-up the drawings here and there to make them ready for the Ink and Paint Department."[107] The weight of this change probably fell more on the assistants than on the animators—the assistant had

to make up for any failures by the animator to erase rough sketch lines or make the cleaned-up lines more distinct. But the total effect was undoubtedly to contribute to the increasingly literal quality of Disney animation and the diminishing sense of caricature.

There was in *Dalmatians* one last flowering of caricature, though, and of casting by character. Marc Davis animated all of the villain, Cruella De Vil—"a very rare opportunity," he said. "We had some live action, but I found you had to use it very loosely."[108] He shared scenes with Milt Kahl, who was animating Anita, the female lead. Cruella is easily the most vivid character in the film, although *Dalmatians* has other strengths, notably a story expertly adapted by Bill Peet from the original novel by Dodie Smith (among other things, Peet improved on Smith by compressing the book's two female adult dogs into one). Peet, as *Dalmatians'* sole writer—a first on a Disney animated feature— wrote a treatment and then developed and sketched all the storyboards, and also directed the recording of the voices.[109] As Eyvind Earle had in work on *Sleeping Beauty*, Peet filled some of the vacuum Walt Disney had left.

It was, however, Woolie Reitherman, one of *Dalmatians'* three directors (with Ham Luske and Gerry Geronimi) who emerged with his position in the studio most strengthened. Reitherman became the sole director of the next animated feature, and it was his hand more than Disney's that shaped *The Sword in the Stone*, based on T. H. White's story of King Arthur's boyhood. Reitherman was in some respects a curious choice to be in charge of the animated features. He was never known as a personality animator; he was associated instead with action (Monstro the whale in *Pinocchio*) and boisterous comedy (Jack Kinney's Goofy shorts of the forties). His sequences in *Dalmatians* are correspondingly coarser than those by the other directors. Ward Kimball suggested that Reitherman wound up in charge of the features because "they picked out a guy who wouldn't give them much trouble. Woolie was always subservient to the place."[110] Kimball was surely right; as early as September 1939, Walt Disney had spoken approvingly of Reitherman's willingness to accept any assignment "with a smile."[111]

Compared with Bill Peet's fifty-one-page treatment for *Sword* from 2 October 1961, Reitherman's film is broad and careless. (Peet left the studio early in 1964, shortly after *Sword*'s release, although accumulated resentments, more than his unhappiness

with that film, accounted for his resignation.) Honestly felt emotion—so much a part of the early Disney features—does not figure much in *Sword*, and Reitherman was plainly uncomfortable with it, as he was with irony or anything else that required delicate shading to be effective. There *was* irony, though, in the roles now played by animators like Thomas, Johnston, and Kahl. "By the time we got to *Sword in the Stone*," Johnston said, "as directing animators, we were really directors,"[112] that is, with more control over the staging and characterization in their sequences than they ever had before, even during work on *Bambi*. They were, however, locked inside Reitherman's sensibility, which was far more confining than the limitations of their earlier roles.

The fragmentary meeting notes from the writing of the next feature, *The Jungle Book*,[113] suggest strongly that Walt Disney did not care much for *Sword in the Stone*—he criticized it repeatedly—but by then he, too, was working inside that sensibility; Reitherman was secure in his job, despite *Sword*'s weak performance at the box office. The *Jungle Book* meeting notes do not show Disney working his way past the crudely obvious, as he had done thirty years earlier during work on *Snow White*—instead, he surrendered to it eagerly. He was, after all, mainly in the theme-park business now, and nothing is more obvious than a roller coaster.

Walt Disney Productions had about nine hundred employees when the Disneyland park opened, hundreds fewer than before the 1941 strike; by 1966 it had thirty-three hundred.[114] In December of that year, when Walt Disney lay dying of cancer in the hospital across Buena Vista Street from his studio, he occupied his mind by staring at the ceiling and imagining the grid of acoustical tiles not as anything like story sketches, but as the plan for another and larger theme park, this one in Florida.[115] Theatrical animation of the kind that he had nourished had finally disappeared even from his studio, its first and last sanctuary. In the Hollywood scheme of things, it had always been an odd sort of filmmaking, this intensive effort to give to drawings not just movement but life. But it succeeded for a while, and so the films are alive, too. The best of them will endure for as long as anything that has ever come out of Hollywood.

Afterword

There have been dozens of feature-length cartoons since Walt Disney's death, including many that bear his name. Woolie Reitherman made the first few in the seventies (*The Aristocats, The Rescuers*), all of them as sluggish and heavy-handed as the features he directed while Disney was alive. Such features, by Reitherman and then by successors who had worked under him, gave way in the eighties to much livelier films. Some of those new Disney-studio features have been as successful at the box office as any animated features since *Snow White and the Seven Dwarfs*.

A new Disney-studio feature enters the marketplace bearing the burden of anticipated success not only in theaters but in a much larger arena as well. Merchandise licensing and other ancillary sources of revenue were, in Walt Disney's day, a useful cushion against the occasional box-office failure, but such exploitation has come to assume so many forms—including videocassettes, toys, clothing, restaurant tie-ins, and even Broadway musicals—that its revenues can dwarf those of the film itself. Even before the success of the 1997 Broadway musical version of *The Lion King*, that 1994 feature was expected to bring a billion dollars or more to what is now called the Walt Disney Company (the very name "Walt Disney Productions" having been found too confining).

Given the dollars involved, producing a new animated feature today has more in common with designing a new automobile

than it does with the way that Walt Disney made *Snow White*. Inevitably, the Disney-studio features of the eighties and nineties look like the products of committee decisions rather than true collaborative efforts; their stories, songs, and characters—handsome heroes, charming heroines, melodramatic villains, cute animal sidekicks—are no less the offspring of calculated compromises than the shape of a new car's fenders.

So carefully engineered are the Disney-studio features that they lend themselves to close imitation by anyone who can come up with the money required to do it. The pioneer Disney imitator was Don Bluth, an animator who left the studio in 1979 in the company of a few other animators; he was like the leader of a sect—in its own eyes the repository of the true faith—that was peeling away from some mainstream denomination. The films Bluth began making then, under various auspices *(The Secret of NIMH, An American Tail)*, quoted from Walt Disney's films as reverently as if they were scripture. By late in the nineties, in the wake of the Disney Company's remarkable success with *The Lion King*, other studios—with none of Bluth's zeal, but with a keen eye for the dollar—had begun making films that aped the more recent features from the Disney studio even more precisely than Bluth's mimicked the older ones.

The newer Disney-studio features themselves have echoed not just the earlier Disney features but also the earlier cartoons of other studios. Sebastian the crab, in the 1989 feature *The Little Mermaid*, grins and grimaces like a latterday Chuck Jones character, and the polymorphous genie in *Aladdin* (1993) is equally Warner Bros.–inspired. These borrowings from earlier films have been wedded to a musical-comedy format that in its brassiness and heavy-handed sentimentality owes much more to Broadway than any of Walt Disney's features ever did.

However backward looking such elements, the films themselves have been soaked in a contemporary sensibility that has no doubt contributed greatly to their popularity. At the close of *Aladdin* for instance, the hero turns away from the Princess Jasmine, lamenting that because he is only a commoner, their love cannot be. The Sultan, the girl's father, intervenes to authorize the marriage. In a film of another kind, the girl would show her love by renouncing her own title; no such thought crosses Jasmine's mind.

So bright and clever are the surfaces of these films that when animation slips into them that resembles the old kind—anima-

tion, that is, in which the characters seem to act of their own voli-
tion and occupy the screen with the presence of real creatures—
it can be a little unsettling, as with some of Glen Keane's anima-
tion of the Beast in the 1992 feature *Beauty and the Beast.*
Although that film is much of a piece with other Disney-studio
features in most ways (its heroine Belle becomes a sort of intel-
lectual less by actually reading books, it seems, than by hanging
out with them), it comes closer than the rest to accepting chal-
lenges of the kind that the finest Walt Disney features met.
Toward the end—as directly if not as skillfully as *Snow White*—it
even invites its audience to contemplate the immense sadness
that accompanies the separation by death of people who love
each other. Later films like *Pocahontas* (1995) have minimized the
dangers inherent in such strong material not just by relying on
increasingly schematic writing, but also by adhering to animation
styles that are either oppressively literal (that is to say, all but
indistinguishable from live action) or exaggerated for comic effect
only according to formula (so that the comic sidekicks are all
comic in the same way).

It's acceptable to evoke the earlier films, in other words, but too
risky to try to do what they did. The same is true in the even
more machine-made world of television cartoons. *Tiny Toon
Adventures* and *Animaniacs,* series made by Warner Bros. in the
nineties, refer constantly to the Looney Tunes of the thirties and
forties, but those references are merely decorative. When a car-
toon maker takes the old films seriously and tries to capture their
spirit, as John Kricfalusi did in his *Ren and Stimpy* series of
1991–92, the system cannot accommodate the films or their
maker. Kricfalusi's cartoons testify to his intense admiration for
Bob Clampett's Warner Bros. cartoons; no one else since Clampett
has made cartoons whose characters' emotions distort their bod-
ies so powerfully. But Clampett himself did not, and almost cer-
tainly could not, make real Bob Clampett cartoons when he pro-
duced a *Beany and Cecil* series for television in the early sixties,
and Kricfalusi couldn't either, even in a culture far more hos-
pitable to blue humor. The best Hollywood cartoons of the forties,
like the best live-action features of that period, were intensely
personal even as they respected genre conventions; the govern-
ing conventions are different now, but the critical change is that
they have become all-consuming. After the Nickelodeon cable
network fired Kricfalusi from *Ren and Stimpy,* his successors on
the show employed the same sort of bathroom jokes as its creator

had, but it was obvious that the new people, unlike Kricfalusi himself, didn't find such material particularly funny; they were merely doing what was expected.

Most television cartoons' dialogue, however puerile, has counted for more than their hamstrung drawings. Only in a few cases over the years have the people in charge of the cartoons seemed wholly comfortable with this altered balance, most notably in the Jay Ward series *(Rocky and His Friends, Bullwinkle)* of the fifties and sixties and more recently in *The Simpsons,* the wildly successful prime-time series created by the newspaper cartoonist Matt Groening. Animation in such television films is essentially an adjunct; it permits the writers to be more freely satirical than they could be in a live-action equivalent.

For all the evocations of earlier cartoons in the theatrical and television animation of the last few decades, only rarely has anyone tried to push beyond what was done in the old cartoons, even while building on their strengths. The most notable effort of that kind came in the early seventies, when Ralph Bakshi directed several "adult" features *(Fritz the Cat, Heavy Traffic)* that were not merely provocative but highly ambitious. Bakshi was, however, a graduate of the Terrytoons and Paramount cartoon studios of the sixties, which were not suitable training grounds for work on any kind of animated feature, and his first few features were masses of rough edges. It later became clear, in a string of unfortunate films like *The Lord of the Rings* (1978) and *American Pop* (1981), that Bakshi was utterly lacking in the artistic self-discipline that might have permitted him to outgrow his limitations.

Just as sound film triggered Hollywood animation's last great surge, though, the computer may trigger another. It has already begun to transform the way cartoons are made—so that computer-colored drawings are displacing hand-painted celluloids, with potentially great savings—and to erase the boundary between animation and live action. In live-action films, computer animation's impact has so far been muted, showing up most notably in startling transformations in frivolous science-fiction films. The first wholly computer-animated feature, *Toy Story* (1995), made by the pioneering Pixar company and released by Disney, very cannily offers a cast made up almost wholly of toys—highly artificial characters, that is, whose unreality is more charming than disturbing.

It will surely be just a few years, though, before filmmakers begin manipulating live action and computer animation in new and presently unclassifiable ways, coming up with serious films

that are unquestionably animated, even if not in the earlier manner. The computer may bring an even more significant change in the way animated films are distributed. Kricfalusi, for one, has begun presenting cartoons on the Internet, a vehicle that is so far free from the interference of studio and network executives. It's readily imaginable, in short, that the turn of the century will see the obstacles falling to a new flowering of character animation. Whether the people making the films will seize such opportunities is, of course, another question. But that is always the case.

Notes

The following abbreviations are used throughout the notes:

Corporate Archives
RKO: RKO Radio Pictures Corporate Archives, Turner Entertainment Company, Culver City, California (as of 1988).
WDA: Walt Disney Archives, Burbank.

Court Cases
Fleischer/AAP: Records and Briefs, United States Court of Appeals for the Second Circuit, Docket 28574 (*Dave Fleischer v. A.A.P., Inc., et al.*). Dave Fleischer's unsuccessful suit resulted in the following published court decisions: *Fleischer v. A.A.P., Inc.*, 163 F. Supp. 548 (1958), 180 F. Supp. 717 (1959), 222 F. Supp. 40 (1963), and *Fleischer v. Paramount Pictures Corporation*, 329 F. 2d 424 (1964).

Government Archives
FBI/Hubley, FBI/UPA: Files about John Hubley and United Productions of America released by the Federal Bureau of Investigation, Washington, D.C., in the eighties under a Freedom of Information Act request by the author.

NLRB citations are all to records of the National Labor Relations Board, Record Group 25, National Archives, Washington, D.C. Except as noted, the NLRB citations are to pages in the hearing transcripts; the sources of testimony are identified when the source is not clear from the text.

NLRB/Babbitt: *In the Matter of Walt Disney Productions, Inc., and Arthur Babbitt*; Office of the Executive Secretary, Transcripts, Briefs, and Exhibits 4712, 8 October 1942.

NLRB/Disney: *In the Matter of Walt Disney Productions, Inc., and Federation of Screen Cartoonists*; Office of the Executive Secretary, Transcripts, Briefs, and Exhibits 1296, 24 October 1938.

NLRB/Fleischer: *In the Matter of Fleischer Studios, Inc., and Commercial Artists and Designers Union*; Office of the Executive Secretary, Transcripts, Briefs, and Exhibits 129, 16 June 1937.

NLRB/Lantz: *In the Matter of Walter Lantz Productions, Universal Pictures Co., Inc., and Screen Cartoon Guild*; Office of the Executive Secretary, Transcripts, Briefs, and Exhibits 1675, 31 July 1939.

NLRB/Terry: *In the Matter of Terrytoons, Inc.*; Office of the Executive Secretary, Transcripts, Briefs, and Exhibits 5459, 16 April 1943.

NLRB/Van Beuren: *In the Matter of Van Beuren Corporation*; Regional Records, Region II, New York; Case Files and Transcripts, 1933-35.

References to published NLRB decisions are in standard legal form, e.g., 50 NLRB 684.

Libraries

AMPAS: Margaret Herrick Library, Academy of Motion Picture Arts and Sciences, Beverly Hills.

NYU/JC: John Canemaker Animation Collection, Fales Library/Special Collections in the Elmer Holmes Bobst Library, New York University. (A few of the cited items were not yet part of the collection as of the writing of this book, but Canemaker intended to deposit them in the near future.)

USC/MGM: MGM Collection, USC Cinema-Television Library, University of Southern California.

USC/Universal: Universal Collection, USC Cinema-Television Library, University of Southern California.

USC/WB: USC Warner Bros. Archives, School of Cinema-Television, University of Southern California. (Some of this material was housed at Princeton University when the author examined it but has since been transferred to USC.)

Wisconsin/UA: United Artists Collection, Wisconsin Center for Film and Theater Research, State Historical Society of Wisconsin, Madison.

Wyoming/Maltese: Michael Maltese Collection, American Heritage Center, University of Wyoming, Laramie.

Oral Histories

Adamson/Freleng, Adamson/Huemer: These oral histories were conducted by Joe Adamson with Friz Freleng and Richard Huemer, respectively, for the University of California, Los Angeles, Department of Theater Arts in 1968-69 as part of "An Oral History of the Motion Picture in America." Portions of the Huemer oral history, as edited by Huemer, were published in two magazines, *AFI Report* and *Funnyworld*. The published articles rather than the oral history have been cited whenever possible.

Personal Papers
AC: author's collection
AE: Al Eugster
JC: John Carey
BC: Bob Clampett
BS: Ben Sharpsteen
CJ: Chuck Jones
CGM: Carman G. Maxwell
DH: David Hand
HH: Hugh Harman
JC: John Carey
MD: Maurice Day
PT: Paul Terry
RH: Richard Huemer
RI: Rudolph Ising
RMcK: Robert McKimson
SB: Steve Bosustow
SH: Sylvia Holland

Disney cost and box-office figures were provided by the Walt Disney Archives for features completed after 1947. Disney employment dates are also from the Archives. The Disney meeting notes are ordinarily, although not invariably, transcripts; the term "meeting notes" is one used at the Disney studio itself.

Lantz studio employment dates are based on notes taken by Joe Adamson, Lantz's biographer, from the Lantz studio's personnel files in 1981.

Complete runs of the studio and union newsletters mentioned in these notes are rare or nonexistent. The Walt Disney Archives does not have a complete set of that studio's *Bulletin*, for instance; neither does the USC Warner Bros. Archives have a complete set of the *Warner Club News*. Many of the cited issues are in private collections, including the author's. The same is true of other cited items (model sheets, for instance) that were produced in multiple copies but not preserved in any systematic way.

Although it would be normal to identify the city where each interview occurred, that has not been done here, both to save the space that would otherwise be devoted to essentially redundant information—most of the interviews took place in the Los Angeles area—and, in a few cases, to protect the privacy of the people involved. Except as specified, all interviews were conducted by the author (in many cases with Milton Gray as a participant).

Introduction

1. Walter Kerr, *The Silent Clowns* (New York, 1975), 14-31.

Chapter 1

1. Richard Koszarski, *An Evening's Entertainment: The Age of the Silent Feature Picture, 1915-1928* (New York, 1990), 48.

2. Winsor McCay, "Animated Art," in Federal Schools, Inc., *Illustrating and Cartooning: Animation* (Minneapolis, 1923), 18. This was a mail-order animation course.

3. Although the McCay film, released by Vitagraph, is commonly known as *Little Nemo*, its title card actually identifies it as *Winsor McCay*. Most of the film is live action, devoted to McCay's winning a bet that he can produce four thousand "drawings that will move," those drawings being the Nemo cartoon.

4. John Canemaker, *Winsor McCay: His Life and Art* (New York, 1987), 132, 137, 147.

5. Paul Terry, interview with Harvey Deneroff, 13 June 1970. NYU/JC. Nat Falk, *How to Make Animated Cartoons: The History and Technique* (New York, 1940), 17.

6. John Fitzsimmons, interview, 19 March 1978.

7. Donald Crafton, *Before Mickey*, rev. ed. (Chicago and London, 1993), 81-84.

8. Crafton, *Emile Cohl, Caricature and Film* (Princeton, 1990), 176-77.

9. Paul C. Spehr, *The Movies Begin: Making Movies in New Jersey, 1887-1920* (Newark, 1977), 70.

10. Allan Harding, "They All Thought Him Crazy, but They Don't Think So Now," *American Magazine*, January 1925, 126.

11. *Motion Picture News*, 7 June 1913.

12. Harding, "They All Thought Him Crazy," 126.

13. Pathé evidently released that cartoon in January 1914 under a second, slightly different title, *Colonel Heeza Liar's African Hunt*, the better to promote it as a parody of the travelogue *Paul J. Rainey's African Hunt. Moving Picture World*, 10 January 1914.

14. L. D. Underwood to Clair W. Fairbank (Bray's attorney), 27 February 1914. From the file devoted to Patent 1,107,193, issued 11 August 1914. Records of the Patent and Trademark Office, Record Group 241, National Archives, Washington, D.C.

15. Crafton, *Before Mickey*, 148.

16. *Motion Picture News*, 20 March 1915.

17. *Motion Picture News*, 1 January 1916.

18. Falk, *How to Make Animated Cartoons*, 18.

19. *Moving Picture World*, 21 July 1917.

20. Patent 1,143,542, issued 15 June 1915. U.S. Patent and Trademark Office.

21. Patents 1,159,740, issued 9 November 1915 (filed 29 July 1914), and 1,179,068, issued 11 April 1916 (filed 30 July 1915). U.S. Patent and Trademark Office.

22. Terry interview.

23. Crafton, *Before Mickey*, 196–97, says, without supporting evidence, that Charles

Bowers made the series for the first year and then joined forces with Barré late in 1916. But Barré's name is on no other films that might have been made in that year, other than a few cartoons for the Hearst newsreel—an assignment Barré probably gave up when he agreed to animate "Mutt and Jeff," a comic strip that was by then syndicated by one of Hearst's competitors. Barré alone is mentioned as author of the series in Homer Croy, "Making the Movie Cartoon Move," *Everybody's Magazine*, September 1917, 359. According to Croy, Fisher had never visited the Barré studio.

24. *Variety*, 24 March 1916.

25. On 2 January 1930, Jack King and Burt Gillett, then both animators at the Disney studio, sent a night letter to Barré in Montreal, advising him that Bray was threatening suit over his patents and asking, "Are you able to give us any information regarding use of celuloid [*sic*] or transparent substance in connection with animated cartoons prior to nineteen fourteen." Barré replied by night letter on 4 January 1930: "Bray knows and fears my testimony. I found that out in nineteen nineteen while connected with him. He had me interviewed by his lawyer in his office. This explains why he tries to enforce his patents only when I am out of United States, which he never did while I was there. I used celluloids and register pegs in summer nineteen thirteen. John Terry also claims priority in use of celluloids in California." (Punctuation supplied.) On 25 January 1930, Otto Messmer wrote to King, saying that Barré had written to Alfred Thurber, the Sullivan studio's cameraman, asking him to write to King about the Bray suit. "As far as we know, Barré used celluloid and registration pins in the summer of 1913 in making animated cartoons. He bought his first cells [*sic*] from the Celluloid Corporation, who were then located in Washington Square." This correspondence is part of the Powers Cinephone correspondence file in the Walt Disney Archives. Disney did take out a license in 1930 to use the Bray-Hurd patents (thus the line in early-thirties screen credits, "Licensed under Bray-Hurd patents"), no doubt because the $125 cost per cartoon of a short-lived license—all the Bray-Hurd patents expired by 1933—was less than the cost of fighting Bray in court. Bray also filed a few suits against other cartoon producers, including Paul Terry and Pat Sullivan, between 1925 and 1930. No such suits went to trial; they were probably settled on similar terms, and for similar reasons, as in Disney's case.

26. Falk, *How to Make Animated Cartoons*, 19. Nolan himself, when he was animating at the Charles Mintz studio in the middle thirties, made that claim in conversation with Bob Bemiller, then his assistant animator. Bemiller, interview with Milton Gray, 11 January 1978.

27. Croy, "Making the Movie Cartoon Move," 358; Croy, *How Motion Pictures Are Made* (New York and London, 1918), 318.

28. *Motion Picture News*, 9 February 1918. Bray's side was reported in *Moving Picture World*, 19 January 1918, and *Motion Picture News*, 26 January 1918.

29. *Motion Picture News*, 18 December 1915.

30. *Motion Picture News*, 9 September 1916.

31. "Joe Adamson Talks With Richard Huemer," *AFI Report*, Summer 1974, 11. Huemer said in the Adamson interview that he started at the Barré studio "about 1916," but in 1976 he specified July 1916 as the month when he started. Interview, 27 October 1976.

32. "Adamson Talks With Huemer," 14–15.

33. George Stallings to Huemer, 10 February 1963. RH.

34. Falk, *How to Make Animated Cartoons*, 20.

35. Isabele F. Moser, interview with Harvey Deneroff, 2 July 1970. NYU/JC.

36. Huemer to author, 29 August 1975; interview, 27 November 1973.

37. "Charles Bowers Passes," *The Animator*, January 1947.

38. Huemer, 1973 interview.

39. "Adamson Talks with Huemer," 12.

40. I. Klein, "Pioneer Animated Cartoon Producer Charles R. Bowers," *Cartoonist Profiles*, March 1975, 55.

41. *Moving Picture World*, 23 August 1919.

42. *Moving Picture World*, 8 November 1919.

43. *Motion Picture News*, 7 February 1920.

44. *Moving Picture World*, 16 December 1922.

45. Gerry Geronimi, interview, 5 November 1976; Harding, "They All Thought Him Crazy," 127.

46. *Motion Picture News*, 30 August 1924.

47. John Canemaker, "Profile of a Living Animation Legend: J. R. Bray," *Filmmakers Newsletter*, January 1975, 30.

48. Harding, "They All Thought Him Crazy," 128.

49. David Hand to author, 30 May 1975.

50. Bray gave a typescript of the eleven-page "Early History of the Animated Motion Picture" to the author during a 24 January 1976 interview. Another copy, headed "History of the Animated Motion Picture, as written by John Randolph Bray," is at the Museum of Modern Art's Film Study Center.

51. Patent 1,242,674, issued 9 October 1917. U.S. Patent and Trademark Office.

52. *Motion Picture News*, 22 June 1918. The review was of Paramount-Bray Pictograph 23, released on 9 June 1918.

53. *Moving Picture World*, 30 August 1919.

54. A Bray advertisement in *Motion Picture News*, 30 August 1919, says that "we did a little experimenting with a brand new super-animated cartoon. We wanted to see how the public liked it.... They did," and so "Out of Inkwell" would be appearing "frequently" in the Goldwyn-Bray Pictograph.

55. Crafton, *Before Mickey*, 186, puts the date of Max Fleischer's departure from the Bray studio as June 1921.

56. *Motion Picture News*, 25 February 1922.

57. Joe Adamson, "Working for the Fleischers: An Interview with Dick Huemer," *Funnyworld* 16 (Winter 1974-75), 23.

58. An announcement of the move, drawn by Huemer, shows nineteen staff members, led by Max and Dave Fleischer, walking from 129 East Forty-fifth Street to 1600 Broadway. The drawing is reproduced in Leslie Cabarga, *The Fleischer Story*, rev. ed. (New York, 1988), 36-37.

59. Adamson/Huemer.

60. McCay, "Animated Art," 16.

61. Huemer, 1973 interview.

62. *Motion Picture News*, 26 December 1925.

63. *Motion Picture News*, 16 October 1926.

64. *Motion Picture News*, 27 November 1926.

65. *Motion Picture News*, 13 May 1927.

66. Adamson/Huemer. Huemer worked for the Fleischers before and after the Red Seal episode; he left the studio in the middle twenties to work on a revived Mutt and Jeff series.

67. Walt Disney, visiting New York then, wrote to his brother Roy on 9 February 1929:

> the Inkwell outfit has broken up—Both the Fleischers are out and the place is practically deserted—I was over there today and found that they only have a few assistant animators working finishing up the few remaining pictures on this years [*sic*] schedule and are not planning on any next year— they are going to release a few song cartoons—But I think they are old ones they are digging out and synchronizing [with sound]. WDA.

68. *Film Daily*, 21 October 1929.

69. Those drawings are among Burton Gillett's papers in the Walt Disney Archives.

70. Al Eugster, interview, 17 March 1978.

71. Croy, "Making the Movie Cartoon Move," 357.

72. *Fleischer's Animated News* (studio newsletter), April 1937.

73. *Motion Picture News*, 29 April 1916.

74. John Canemaker, *Felix: The Twisted Tale of the World's Most Famous Cat* (New York, 1991), 49.

75. *Motion Picture News*, 27 March 1920.

76. *Motion Picture News*, 11 February 1922.

77. Otto Messmer, interview, 25 January 1976. Eugster interview.

78. Eugster interview. Geronimi interview.

79. Messmer interview.

80. Eugster interview.

81. Messmer interview.

82. *Motion Picture News*, 27 June 1925.

83. Messmer interview. C. G. Maxwell, interview with Gray, 6 April 1977.

84. Amedee J. Van Beuren, deposition, 20 April 1931, in *Walt Disney Productions, Ltd. v. Pathé Exchange, Inc. and the Van Beuren Corporation*, Equity T-87, U.S. District Court, Southern District of California. Record Group 21, National Archives, Pacific Region (Laguna Niguel). Falk, *How to Make Animated Cartoons*, 17. Van Beuren says in his deposition that Terry's contract "was taken over by Fables Pictures, Inc., from one John Easterbrook," but it's clear from other sources, including Falk, the Terry interview, and various items in Estabrook's own papers at the Margaret Herrick Library of the Academy of Motion Picture Arts and Sciences, that it was Estabrook whom he meant.

85. Terry interview.

86. *Variety*, 3 June 1921.

87. That is the total usually shown in Terry's 1923–25 account book. PT.

88. Walt Disney, "Growing Pains," *Journal of the Society of Motion Picture Engineers*, January 1941, 32. Disney wasn't joking: Wilfred Jackson remembered his saying "Some day I'm going to make a cartoon as good as a Fable" around the time he was making his first Mickey Mouse cartoons. Jackson, interview, 2 December 1973; Jackson to author, 28 July 1975.

89. Bob Thomas, *Walt Disney: An American Original* (New York, 1976), 24-58.

90. Hugh Harman, interview, 3 December 1973. Fred Harman, "New Tracks in Old Trails," *True West*, October 1968, 10–11.

91. Harman, "New Tracks," 10.

92. Harman, 1973 interview.

93. Rudolph Ising, interview, 2 June 1971; joint interview with Hugh Harman, 29 October 1976. The latter interview continued on 31 October 1976.

94. The fullest and most reliable account of this and other episodes in Disney's early career is Russell Merritt and J. B. Kaufman, *Walt in Wonderland: The Silent Films of Walt Disney* (Pordenone, 1992).

95. Walt Disney to Irene Gentry, 17 August 1937. WDA.

96. Harman, 1973 interview.

97. Diane Disney Miller, *The Story of Walt Disney* (1957; reprint, New York, 1959), 65. Rudy Ising remembered no work on such a film taking place before the move to the McConahy Building. Ising to author, 20 December 1979. Disney may have kept his "students" and his paid employees unaware of one another's existence; the "students" might not have been pleased to know that others were being paid to do the same sort of work that they were doing for free.

98. *Motion Picture News*, 17 June 1922.

99. *Motion Picture News*, 26 August 1922.

100. Ising, 1971 interview. Maxwell interview.

101. Sig Cohen to Arabian Nights Cartoons, 9 October 1924. CGM.

102. M. J. Winkler to Walt Disney, 15 October 1923. Disney returned his signed contract to Winkler with a letter dated 24 October 1923. WDA.

103. Winkler to Walt Disney, telegram, 26 December 1923. WDA.

104. David R. Smith, "Ub Iwerks, 1901–1971," *Funnyworld* 14 (Summer 1972), 33.

105. Ising, 1971 interview; interview, 30 November 1973.

106. Ising, 1971 interview.

107. Ising, 1971 interview.

108. Harman, 1973 interview.

109. Ising to Ray Friedman, 7 August 1925. RI.

110. Charles Mintz to Walt Disney, 6 October 1925. WDA.

111. Ising to Maxwell, 28 February 1926. RI.

112. Ising to family members, 13 April 1926. RI.

113. Ising to Maxwell, 10 June 1926. RI.

114. Ising to Maxwell, 1 August 1926. RI.

115. Ising to Friedman, 25 August 1926. RI. Ising, 1971 interview.

116. Ising, 1973 interview.

117. Ising, 1971 interview.

118. *Motion Picture News*, 25 March 1927.

119. Ising, 1971 interview.

120. Harman and Ising to Maxwell, 9 January 1927. RI.

121. Ising to Adele Ising, 29 January 1927. RI.

122. Ising to "Bruno," 29 June 1927. RI.

123. Friz Freleng to author, tape-recorded letter, circa July 1976.

124. Harman said that he observed no such harassment ("Walt was very generous and kind with him"), but he also said, incorrectly, that Freleng remained at the Disney studio until Harman himself left in 1928. 29 October 1976 interview. Freleng's conflict with Disney is reflected in a 10 February 1928 letter from Ising to Freleng, in which Ising refers, sarcastically, to Freleng's "beloved friend, Walt Disney." RI.

125. Harman, 1973 interview.

126. In 1928, when Wilfred Jackson assisted him, Iwerks animated with cleaned-up extremes, leaving inbetweens for Jackson. "Each drawing was numbered, and the missing numbers showed me how many inbetween drawings to make," Jackson said. Jackson to author, 12 March 1985. Merle Gilson, who assisted Iwerks in 1929, likewise remembered that Iwerks left as many as three to seven inbetweens in some cases. Interview with Gray, 7 October 1979.

127. Huemer, 1973 interview.

128. Ising to Freleng, 15 November 1927. RI.

129. Harman, 1976 interview.

130. Ising to Friedman, circa August 1927. RI.

131. From typewritten notes based on an unrecorded interview with Iwerks. WDA. The notes do not indicate the date or the circumstances of the interview, but it was probably conducted in the middle fifties by Bob Thomas as part of his research for *Walt Disney: The Art of Animation* (New York, 1958).

132. *Motion Picture News*, 13 May 1927.

133. *Variety*, 4 May 1927.

134. Walt Disney to Roy Disney, 7 March 1928. WDA.

135. Harman, 1973 interview.

136. Paul Smith, interview with Gray, 22 March 1978.

137. Jackson, 1973 interview.

138. The account book labeled on its cover "General Expense Account 1925-1926-1927 By Roy O Disney" shows a fifteen-dollar expense on that date for "Gag Party—show & dinner" for *The Gallopin' Gaucho*. WDA.

139. Walt Disney to Roy Disney and Ub Iwerks, 11 September 1928. WDA.

140. *Motion Picture News*, 16 June 1928.

141. Walt Disney to Powers Cinephone Equipment Corporation, 27 June 1928. WDA.

142. *Motion Picture News*, 2 June 1923.

143. Jackson, 1973 interview.

144. Les Clark, telephone interview, 19 August 1976.

145. Jackson to author, 22 February 1977.

146. Jackson, 1973 interview.

147. Michael Barrier, Milton Gray, and Bill Spicer, "An Interview with Carl Stalling," *Funnyworld* 13 (Spring 1971), 21, 24. The interviews on which the published interview was based were recorded on 4 June and 25 November 1969. Stalling to author, 21 February 1971 and 16 March 1971.

148. Walt Disney to Roy Disney and Iwerks, undated but written 6 September 1928. WDA.

149. Walt Disney to Roy Disney and Iwerks, 7 September 1928. WDA.

150. Walt Disney to Roy Disney and Iwerks, 23 September 1928. WDA.

151. Walt Disney to "Gang," 30 September 1928. WDA. Roy Disney filed for a patent on such a system on 16 October 1928. Patent 1,913,048, 5 June 1933.

152. Walt Disney to Roy Disney and Iwerks, 1 October 1928. WDA.

153. Walt Disney to Lillian Disney, 27 October 1928. WDA.

154. *Motion Picture News*, 12 January 1929.

155. Miller, *The Story of Walt Disney*, 104.

156. Barrier, Gray, and Spicer, "An Interview with Carl Stalling," 22.

157. *Motion Picture News*, 1 December 1928.

158. *Variety*, 21 November 1928, in a review reproduced in a Powers Cinephone flier distributed soon after *Steamboat Willie*'s release. The flier is reproduced in *Funnyworld* 13 (Spring 1971), 28–29.

159. Walt Disney, 7 September 1928.

160. Arthur Davis, interview with Gray, 28 January 1977.

161. Walt Disney to "Gang," 13 October 1928. WDA.

162. Walt Disney to Roy Disney, 25 September 1928. WDA.

163. Walt Disney to Lillian Disney, 26 October 1928. WDA.

164. Walt Disney, 20 September 1928.

165. Walt Disney to Roy Disney and Iwerks, 6 October 1928. WDA.

166. Walt Disney to Roy Disney and Iwerks, 22 October 1928. WDA.

167. Both agreements were noted in the 22 April 1930 settlement that terminated Disney's relationship with Powers. WDA.

168. Walt Disney, 30 September 1928.

169. Jackson to author, 10 September 1977.

170. A breakdown of negative costs for the early Disney sound cartoons is part of the papers in the Walt Disney Archives related to Disney's break with Powers Cinephone.

171. Ben Sharpsteen, interview, 23 October 1976. Sharpsteen, who worked at several New York animation studios in the twenties, was a freelance commercial artist in San Francisco when Disney hired him.

172. Jackson, 22 February 1977.

173. Jackson to author, 13 November 1975.

174. Jackson to author, 28 October 1975.

175. Jackson to author, 18 November 1975.

176. Jackson to author, 3 June 1985.

177. Iwerks interview notes. Clark, 1976 interview.

178. "The Spook Dance," unsigned and undated typescript. WDA. Although Stalling used some variant of Disney's bouncing-ball system for recording the early Mickey Mouse cartoons that followed *Steamboat Willie*, including a line that moved up and down on the screen, he remembered using a different system starting with *The Skeleton Dance*: it involved the musicians' hearing a "click" through earphones, synchronized with the beat, as they played. Such a system, widely used in later years, made especially good sense for *The Skeleton Dance* since there was no film for the conductor to watch as he conducted; synchronization would thus have been a little more difficult. Barrier, Gray, and Spicer, "An Interview with Carl Stalling," 24.

179. Barrier, Gray, and Spicer, "An Interview with Carl Stalling," 23.

Chapter 2

1. Walt Disney to Pat Powers, telegram, 17 January 1930. Roy Disney to Walt Disney, 18 January 1930. WDA.

2. Roy Disney to Walt Disney, circa July 1929. WDA.

3. Arthur Mann, "Mickey Mouse's Financial Career," *Harper's*, May 1934, 716–17. Thomas, *Walt Disney: An American Original*, 100–102. Mann apparently interviewed both Disney and Powers, or people close to them, and his version of the break is consistent with the documents in the Walt Disney Archives. Thomas's account is the more melodramatic and is weighted heavily on the Disneys' side of the argument.

4. Roy Disney to Walt Disney, day letter, 21 January 1930. Walt Disney to Roy Disney, telegram, 21 January 1930. Roy Disney to Walt Disney, 24 January 1930. WDA.

5. A copy of the release is in the Walt Disney Archives, along with a separate document in which Roy Disney (for himself and as attorney in fact for Walt) undertook to pay the $2,920 within a year, plus interest accruing at an annual rate of 7 percent. Also see Smith, "Ub Iwerks, 1901–1971," 36.

6. Lillian Disney to Roy and Edna Disney, 29 January 1930. WDA.

7. Roy Disney to Walt Disney, day letter, 28 January 1930. WDA.

8. Walt Disney to Roy Disney, night letter, 7 February 1930. WDA.

9. Thomas, *Walt Disney: An American Original*, 102. In an 11 February 1930 night letter, Walt told Roy, "We receive rough draft Metro contract tomorrow." WDA.

10. A set of the settlement papers is in the Walt Disney Archives.

11. Those costs are reflected in a breakdown of negative costs that is part of the Powers settlement papers. WDA.

12. Mann, "Mickey Mouse's Financial Career," 717.

13. Roy Disney, 24 January 1930.

14. Sharpsteen, interview, 3 January 1979.

15. Roy Disney to Walt Disney, 25 January 1930. WDA.

16. Hand, interview, 21 November 1973.

17. Ising to Thurston Harper, circa mid-1927. RI.

18. David R. Smith, "Disney Before Burbank: The Kingswell and Hyperion Studios," *Funnyworld* 20 (Summer 1979), 35.

19. Sears's involvement is reflected in the copyright registrations for such two-reel comedies as *Now You Tell One*, *Egged On*, and *A Wild Romance*, and in the Disney studio's newsletter, the *Bulletin*, 28 February 1939.

20. Sears went on the Disney payroll 15 January 1931. A four-page Disney advertisement in *Motion Picture Daily*, 20 June 1931, assigned to Sears the title "gags" and to Smith the title "asst. to story dept."

21. Jackson, 28 October 1975.

22. They are so identified in the 20 June 1931 advertisement in *Motion Picture Daily*. "Walt called us that," Jackson said. "I don't know what we called ourselves." Interview, 5 November 1976.

23. Jackson to author, 10 September 1977.

24. Richard Lundy, interview with Gray, 5 December 1977.

25. Hand, telephone interview, 29 June 1976.

26. Jackson, 1973 interview.

27. Hand, 1973 interview.

28. Sharpsteen, 1976 interview.

29. Lundy, interview, 26 November 1973. Lundy was not sure when that episode took place, although he leaned toward 1931. The Disney studio's records show no Palmer scenes of forty-nine feet in the cartoons for which such records exist, but in March 1931, Palmer did begin animating a scene of more than fifty-two feet in *The Moose Hunt*. That scene, in which Pluto pretends to be dead and Mickey Mouse sobs into the camera, fits comfortably into Lundy's anecdote since it was a difficult, comparatively subtle scene that an animator might well have wanted to see in its entirety. The Palmer scene's date

is also consistent with Wilfred Jackson's memories: Jackson remembered that complete tests began to be shot not long after he had directed his third or fourth cartoon—*The Delivery Boy* or *Busy Beavers*. Those cartoons were in production in April and May 1931, just after Palmer worked on *The Moose Hunt*. Jackson to author, 3 May 1977.

30. Jackson, 3 May 1977. Hand, 1973 interview.

31. On the Moviola and its role in silent-film editing, see Barry Salt, *Film Style & Technology: History & Analysis* (London, 1983), 210.

32. Lundy, 1973 interview.

33. Marcellite Lincoln to Bob Clampett, 6 April 1971. BC. Lincoln, a Disney inker in the thirties, was also the voice for Minnie Mouse.

34. Jack Kinney, *Walt Disney and Assorted Other Characters* (New York, 1988), 44.

35. Jackson to author, 29 July 1975. In his 3 May 1977 letter, Jackson said, "Along about on *The Musical Farmer* or *Mickey in Arabia*, I believe we were first using our sweatbox." Those cartoons were animated in April and May 1932. The term "sweatbox" was applied to group sessions over a Moviola as well, but given Jackson's general reliability in such matters, probably not until the sweatbox sessions with the projector had begun.

36. Jackson, 3 May 1977.

37. Sharpsteen, 1976 interview.

38. Jackson, 1973 interview.

39. Jackson, 1976 interview.

40. Miller, *The Story of Walt Disney*, 111.

41. In a 29 December 1931 letter to a "Miss Howell," Disney mentions that her 7 October 1931 letter arrived while he was on vacation. "When I returned the work was stacked up so high it took me several weeks before I could answer your letter." WDA.

42. Jackson, 1973 interview.

43. Jackson to author, 23 March 1977.

44. Lundy, 1973 interview.

45. Hand, 1973 interview.

46. Hand, 1973 interview.

47. Hand used that figure when he described the same incident in lectures at the J. Arthur Rank animation studio in England, on 19 September 1946 and in 1947 (the latter transcript not dated but identified as the third lecture in the second series, which other transcripts place in 1947). Hand was at the time in charge of Rank's short-lived animation studio. DH.

48. Jackson, 1976 interview.

49. Lundy, 1973 interview.

50. Clark, 1976 interview.

51. Lundy, 1977 interview.

52. Larry Silverman, interview with Gray, 3 December 1977.

53. Jackson, interview, 3 December 1986.

54. Jackson to author, 10 March 1985.

55. Les Clark and Jack Kinney also remembered that incident. King's difficulties make it possible to assign an approximate date to the transition to rough pencil tests: he left the Disney studio in the spring of 1933 to join the staff of the new Leon Schlesinger studio. Like King, Dick Lundy got into trouble for drawing too cleanly: "What I used to do was clean up, and then I'd make some scratches around to make it look like a rough test because if Walt came in [and saw the clean drawings], he'd give you hell." 1973 interview.

56. E. H. Gombrich, *Art and Illusion*, rev. ed. (Princeton, 1969), 173.

57. *New York Times*, 26 June 1932.

58. United Artists signed a contract with Walt Disney Productions and Walt Disney as an individual on 27 December 1930, and a supplemental agreement on 7 May 1931. The original agreement called for Disney to deliver two sets of twenty-six cartoons each; eighteen Mickey Mouse cartoons and eight Silly Symphonies. On 27 January 1932,

through another supplementary agreement, five Silly Symphonies were added to each set. O'Brien file, Box 51, Wisconsin/UA.

59. Roy Disney to Walt Disney, 15 April 1930. WDA.

60. William Cottrell, interview, 26 September 1990. Thomas, *Walt Disney: An American Original*, 115, says that production had been "half completed" when Disney ordered the change to color.

61. *Motion Picture Herald*, 27 August 1932.

62. Roy Disney to Al Lichtman (United Artists' vice president and general manager of distribution), 15 February 1932. WDA.

63. Roy Disney to Lichtman, 10 November 1932. WDA. The Disneys did not sign a contract with Technicolor until 30 August 1932, covering *Flowers and Trees* and three more Silly Symphonies; before that, as Roy told Lichtman in a 28 July 1932 letter, their arrangements with Technicolor were on "an experimental basis." That agreement was subsequently amended to cover more films, and a separate letter agreement gave Disney exclusive rights to three-color Technicolor for cartoons for a period running from 1 September 1933 to 31 August 1935. David R. Smith to author, 3 October 1979.

64. From a copy of the outline in the papers of Jack Kinney. Kinney's copy bears Disney's signature at the bottom; another copy, part of the Burt Gillett papers in the Walt Disney Archives, does not.

65. Ising, 1973 interview.

66. John Canemaker, "Animation History and Shamus Culhane," *Filmmakers Newsletter*, June 1974, 28.

67. Robert Perine, *Chouinard: An Art Vision Betrayed* (Encinitas, Calif., 1985), 25.

68. Clark, 1976 interview.

69. Ed Benedict, interview with Gray, 31 January 1977.

70. Art Babbitt, interview, 2 June 1971. Babbitt gave essentially the same account in 1942 testimony in NLRB/Babbitt 30-31. He was, however, still listed as an assistant animator in a Disney advertisement in *Motion Picture Herald*, 1 October 1932.

71. Babbitt, interview, 2 December 1973.

72. NLRB/Babbitt 256.

73. Donald W. Graham to Christopher Finch, 25 July 1972. WDA. The letter is excerpted in Christopher Finch, *The Art of Walt Disney* (New York, 1973), 138.

74. From biographical information on the dust jacket of Donald W. Graham, *Composing Pictures* (New York, 1970).

75. Babbitt, 1973 interview.

76. Lundy, 1973 interview.

77. Babbitt, 1971 interview.

78. Clark, 1976 interview.

79. Disney, "Growing Pains," 35.

80. Clark, interview, 1 December 1973.

81. Chuck Couch, interview with Gray, 22 March 1977.

82. Thomas, *Walt Disney: An American Original*, 117.

83. Babbitt, 1971 interview.

84. Clark, 1976 interview.

85. Moore is so listed in the Disney advertisement in *Motion Picture Herald*, 1 October 1932.

86. "Mouse & Man," *Time*, 27 December 1937, 21.

87. Hand, 1973 interview.

88. That casting decisions were primarily Disney's there can be no doubt; his deep involvement throughout the thirties in deciding which animators should work on which short is evidenced by, for example, his 26 March 1936 memorandum to Paul Hopkins in which he discusses in detail possible assignments to a couple of forthcoming cartoons. WDA.

89. Frank Thomas and Ollie Johnston, who worked with Moore later in the thirties, wrote of him: "Fred was an intuitive draftsman, and it is questionable whether more for-

mal art training would have advanced him. He just was not as oriented to classrooms and lectures as some of the men were. He would say, 'Don Graham can give you the rule; I just say it looks better.' " Frank Thomas and Ollie Johnston, *Disney Animation: The Illusion of Life* (New York, 1981), 120.

90. Claude Smith to author, circa February 1991.

91. Bob Clampett, interview with Gray, 7-8 March 1975.

92. Jackson, lecture, "Musical Stories," 12 January 1939. WDA.

93. Harry Carr, "The Only Unpaid Movie Star," *American Magazine,* March 1931, 125.

94. Jackson, 10 September 1977.

95. Jackson, 1976 interview.

96. Jackson, 13 November 1975. Bill Cottrell, who began working on stories in the early thirties after several years in the Disney camera department, also remembered occasions when sketches were spread out on a large table. Interview, 11 December 1986.

97. Lundy, 1977 interview.

98. One such outline from 20 July 1931, for *The Barnyard Broadcast*, is quoted extensively in Thomas, *Walt Disney,* 109–110.

99. From a carbon copy of the outline in the Burt Gillett papers in the Walt Disney Archives.

100. The Disney advertisement in *Motion Picture Herald,* 1 October 1932, lists all 107 names.

101. Bill Cottrell, who began working in the story department late in 1932, remembered that "it was a matter of Walt coming in and talking a story line, then someone just drafting [an outline] in continuity." 1990 interview.

102. William Garity, "The Production of Animated Cartoons," *Journal of the Society of Motion Picture Engineers,* April 1933, 316. Garity's article was based on a presentation to the Society's Pacific Coast section on 14 December 1932.

103. Jackson, 13 November 1975.

104. Cottrell, 1990 interview.

105. Ted Sears, introduction to Albert Hurter, *He Drew As He Pleased* (New York, 1948), unpaginated.

106. Jackson, 13 November 1975.

107. According to Bill Cottrell, who entered the story department around the time work on *Three Little Pigs* began, the idea of using that particular story originated with Walt's wife, Lillian, and her sister, Hazel Sewell, who ran the studio's inking and painting department (and later married Cottrell). 1990 interview.

108. From a copy of the outline in the papers of Ben Sharpsteen.

109. Ross Care, "Symphonists for the Sillies: The Composers for Disney's Shorts," *Funnyworld* 18 (Summer 1978), 38.

110. Stalling, 21 February 1971 and 16 March 1971.

111. Care, "Symphonists for the Sillies," 42.

112. Eric Larson, interview, 27 October 1976.

113. Larson interview.

114. Jackson, 10 March 1985.

115. Hand, 1973 interview.

116. Garity, "The Production of Animated Cartoons," 316.

117. No exact comparisons are possible, since the Disney studio has no footage records earlier than 1944.

118. Jackson, 13 November 1975. Sharpsteen, 1976 interview.

119. Huemer, 1973 interview.

120. Hand, 1973 interview.

121. From figures compiled from the Disney studio's original ledgers by David R. Smith in 1979.

122. Disney, "Growing Pains," 36.

123. Disney, "Growing Pains," 36.

Chapter 3

1. Larson interview.

2. NLRB/Babbitt, Adelquist exhibit 9.

3. I. Klein, "At the Walt Disney Studio in the 1930s," *Cartoonist Profiles*, September 1974, 14.

4. The story sketch book for *The Grasshopper and the Ants* in the Walt Disney Archives is made up of a thick sheaf of Hurter drawings, in no particular order.

5. Graham, *Composing Pictures*, 240–41.

6. Miller, *The Story of Walt Disney*, 123.

7. From a copy of the outline in the papers of Ben Sharpsteen.

8. The "Pluto Analysis" is part of an animator's handbook that was assembled around 1936 and used in the Disney studio in the latter half of the thirties. Variants exist; its contents apparently changed over time and according to who was using it. WDA. Dick Lundy, who also animated part of *Playful Pluto*, said on more than one occasion that Ferguson expanded the sequence considerably. 1973 and 1977 interviews.

9. Jackson, 23 March 1977.

10. Jackson, 13 November 1975.

11. The continuity and the notes are in the Cottrell files in the Walt Disney Archives.

12. "Notes to Members of Staff on Story Writing Contest." Although undated, this memorandum contains enough references to contemporaneous Disney cartoons to permit dating it conclusively to sometime in the early months of 1934. BS.

13. McLaren Stewart, interview with Gray, 31 March 1977. Stewart became a story sketch man soon after joining the Disney staff on 22 October 1934.

14. Jackson, 3 May 1977.

15. Garity, "The Production of Animated Cartoons," 322.

16. Lundy, 1973 interview.

17. From a copy of the outline in the papers of Ben Sharpsteen.

18. Tony Hiss and David McClelland, "The Quack and Disney," *The New Yorker*, 29 December 1975, 33.

19. Milt Schaffer, interview with Gray, 21 March 1977.

20. Lee Server, *Screenwriter: Words Become Pictures* (Pittstown, N.J., 1987), 147.

21. Douglas W. Churchill, "Now Mickey Mouse Enters Art's Temple," *New York Times*, Magazine section, 3 June 1934.

22. Hand, 30 May 1975.

23. Jackson to author, 19 December 1978.

24. Jackson, "Musical Stories."

25. From a copy of the outline in the papers of Ben Sharpsteen.

26. From the cue sheet listing the musical components of the cartoon. Muller Legal File, Box 4, Wisconsin/UA. Such cue sheets were submitted to United Artists by Disney as part of the paperwork necessary for Disney to receive an advance upon the completion of each film.

27. Thomas and Johnston, *Disney Animation*, 109.

28. Art Babbitt wrote then to his former Terrytoons colleague Bill Tytla, "We're definitely going ahead with a feature length cartoon in color—they're planning the building for it now.... Walt has promised me a big hunk of the picture." Babbitt to Tytla, circa 27 November 1933 (the date of the postmark on the envelope). NYU/JC. Photocopy. There's no mention in Babbitt's letter of any subject for the film.

29. *Variety*, 7 August 1934. "The Big Bad Wolf," *Fortune*, November 1934, 148.

30. Disney, "Growing Pains," 36.

31. "The Big Bad Wolf," 94.

32. Disney, "Growing Pains," 38.

33. Creedon's draft of the outline is in the Walt Disney Archives, along with a note instructing a secretary to make around fifty copies of it.

34. *Snow White* meeting notes, 30 October 1934. WDA.

35. "Brief Outline for Gag Suggestions," 6 November 1934. WDA.

36. *Snow White* meeting notes, 16 November 1934. WDA.

37. Walt Disney, "Gag Outline, Sequence 'Dwarfs Discover Snowwhite,'" 19 November 1934. WDA.

38. Walt Disney, "Time and General Sequences of 'SnowWhite' as Described by Walt," 19 November 1934. WDA.

39. Walt Disney, "Skeleton Continuity," 26 December 1934. WDA.

40. Huemer, 1973 interview.

41. From a copy of the outline in the papers of Ben Sharpsteen.

42. A hectographed final draft filed with the story sketches for this cartoon shows a "start date" (the date when the preparation of layouts began) of 15 May 1934. The draft shows that Ferguson began work on his scenes on 4 June 1934—a date confirmed by an entry in Disney's Standard Daily Journal (his desk diary), 1934—and Moore on 9 July 1934. WDA.

43. Billy Bletcher, interview, 7 June 1969.

44. Sharpsteen, 1976 interview.

45. "Mouse & Man," 21.

46. Gillett sent a telegram to Disney on 10 April 1934 telling him he had found other employment. David R. Smith to author, 11 January 1993.

47. Jackson to author, 22 August 1975.

48. Jackson, 3 May 1977.

49. Jackson, "Musical Stories."

50. Hand, action-analysis lecture, 27 February 1936. WDA.

51. Huemer, 1973 interview.

52. Thomas and Johnston, *Disney Animation*, 52.

53. *Bulletin*, 3 March 1939.

54. Joe Adamson, "With Disney on Olympus: An Interview with Dick Huemer," *Funnyworld* 17 (Fall 1977), 38.

55. Jackson, lecture, "Musical Pictures," 9 February 1939. WDA.

56. Jackson, 19 December 1978.

57. Bill Cottrell dictated continuities for *Who Killed Cock Robin?* on 28 November 1934 and 8 January 1935. WDA.

58. Cottrell, interview, 12 December 1991

59. Luske is quoted in the transcript of a T. Hee lecture, "Caricaturing of Characters," 25 November 1938, that was part of the studio's development program. WDA.

60. Both Cottrell and Grant claimed in separate interviews with J. B. Kaufman to have worked on *Pluto's Judgement Day*.

61. Jackson, 1976 interview.

62. Hand, 1973 interview.

63. Disney, "Growing Pains," 37.

64. Larson interview.

65. Joe Grant, interview, 14 October 1988.

66. All sixteen are listed in the memorandum titled "Production Notes—Shorts," which Walt Disney apparently wrote around the end of 1935. WDA.

67. Homer Brightman, interview with Gray, 14 February 1977.

68. *Mickey's Circus* meeting notes, 26 October 1935. BS.

69. Jackson, 1973 interview.

70. Disney, "Growing Pains," 36.

71. James Macdonald, interview with Gray, 7 December 1977.

72. Walt Disney, "Mickey Mouse Presents," in Nancy Naumberg, ed., *We Make the Movies* (New York, 1937), 269.

73. George Goepper, interview with Gray, 23 March 1977.

74. From "Sequence of Construction," for buildings at the Hyperion studio, prepared by David R. Smith in 1972.

75. Claude Smith to author, circa August 1991. Eric Larson also remembered Drake's "glass cage."

76. Lundy, 1977 interview.

77. Sharpsteen to author, 12 November 1980.

78. Graham to Finch.

79. Phil Dike, interview with Gray, 29 March 1977.

80. Stewart interview.

81. Graham to Finch.

82. According to the "Sequence of Construction," the building that housed the apprentice animators was built between September and November 1935.

83. George Drake, "Notes and Suggestions for Animators and Assistants," 22 April 1935. WDA.

84. "Production Notes—Shorts."

85. Disney refers to the talks in a 23 December 1935 memorandum to Don Graham; the written analyses by the four animators, all dated a week or so later, were included in the animator's handbook that was assembled around the same time. The animators' analyses are reprinted in Thomas and Johnston, *Disney Animation*, 545-47, 550-61.

86. Walt Disney to Graham, memorandum, 23 December 1935. WDA.

87. Disney wrote memoranda dated 20 December 1935 to six animators on *Cock o' the Walk*, analyzing their work in detail; the quoted memorandum was addressed to Bill Tytla. Each animator was assigned a "credit rating," which evidently was used in determining his bonus, if any. It's not clear how many similar memoranda Disney may have written for the animators on other films; apparently only those for *Cock o' the Walk* and *Pluto's Judgement Day*, the latter memos dated 5 October 1935, have survived. WDA.

88. Walt Disney to Paul Hopkins, Roy Disney, Bill Garity, and Harry Bailey, memorandum, 25 November 1935. WDA.

89. "Snow White - Dwarfs' Personalities." WDA. The typescript itself is not dated, although the Walt Disney Archives has assigned to it the date 3 December 1935, probably on the basis of a folder or envelope that bore that date and has since been discarded.

90. Tytla's start date for *Snow White* is mentioned in a 21 April 1937 memorandum from Walt Disney to George E. Morris and Luske's (1 January 1936), in a 21 April 1938 memorandum from Herb Lamb to David Hand. WDA.

91. As reflected in Terry's account book.

92. John Canemaker, "Vladimir William Tytla (1904-1968), Animation's Michelangelo," *Cinefantastique*, winter 1976-77, 10-12.

93. It's possible to identify much of Tytla's work for Terry with virtual certainty because of scenes that are attributed to him in production materials from the earliest Terrytoons; those materials are now part of the collection of the Film Study Center of the Museum of Modern Art in New York.

94. George Sherman, [untitled interview with Tytla], *Cartoonist Profiles*, August 1970, 12.

95. Tytla, action-analysis lecture, 28 June 1937. WDA. An edited version of this lecture (misdated 8 June 1937) is in Thomas and Johnston, *Disney Animation*, 548-49.

96. Lamb to Hand, memorandum, 22 April 1938. WDA.

97. Walt Disney to Tytla, memorandum, 1 June 1935. WDA.

98. *Daily Variety*, 25 February 1936.

99. *Daily Variety*, 19 March 1936.

100. Walt Disney, 17 October 1935, memorandum addressed generally to directors, animators, and so on. WDA.

101. Graham, action-analysis lecture, 12 March 1936. WDA.

102. Babbitt, 1971 interview.

103. NLRB/Babbitt 981.

104. Hand, 27 February 1936 lecture.

105. John Hubley, "The Writer and the Cartoon," in *Writers' Congress: Proceedings of the Conference Held in October 1943 under the Sponsorship of the Hollywood Writers' Mobilization and the University of California* (Berkeley, 1944), 109.

106. Wilfred Jackson and Bob Clampett—who directed Babbitt some years apart at the Disney and Leon Schlesinger studios, respectively—discovered during the 1973

Jackson interview, which Clampett sat in on, that they had had similar experiences with Babbitt.

Chapter 4

1. Ising, 10 February 1928.

2. Harman, 1973 interview. Ising to author, 7 November 1988.

3. Ising to Randolph Rogers, 24 February 1928. RI.

4. Ising to Adele Ising, 20 March 1928. RI.

5. Harman, 1973 interview.

6. Charles Mintz to Carman Maxwell et al., 10 November 1928. RI.

7. Ising to Walker Harman ("Rufus"), 9 February 1929. RI.

8. Leonard Maltin, *Of Mice and Magic,* rev. ed. (New York, 1987), 162, cites a Universal press release dated 9 April 1929 announcing that Lantz had "arrived at Universal City to draw a series of pictures for Universal, featuring the pen and ink character 'Oswald the Lucky Rabbit.' William C. Nolan has been signed to assist Lantz."

9. Harman, 29 October 1976 interview.

10. Copyright registration 82196, Class G. Copyright Office, Library of Congress.

11. Harman, 29 October 1976 interview.

12. Harman, 1973 interview.

13. Harman and Ising agreed, in the joint 29 October 1976 interview, that the live action was shot in May 1929.

14. Ising preserved two copies of the script in his papers.

15. Ising, 1973 interview.

16. Harman, 31 October 1976 interview.

17. Harman to Mintz, 2 August 1929. RI.

18. Harman, 1973 interview.

19. Ising to Maxwell (with a copy of a letter to Freleng attached), 21 January 1930. CGM.

20. Ising, 1971 interview.

21. Ising, 21 January 1930. Ising to Freleng, 1 February 1930. RI.

22. Harman, 1973 interview.

23. "Memorandum of Agreement between Leon Schlesinger and Hugh Harmon [*sic*] and Rudolph Ising, dated January 28, 1930." HH.

24. Letter agreement between Schlesinger and Warner Bros., 24 January 1930. USC/WB.

25. Notes from an interview with Schlesinger by Joseph D. Karp of the Warner Bros. legal department, 13 November 1945. The interview was in preparation for legal action that Warner Bros. was going to take against Exposition Doll Company for alleged copyright infringement. USC/WB.

26. *Hollywood Citizen News,* 26 December 1949 (a Schlesinger obituary).

27. As reflected in "General Expense Account 1925-1926-1927 By Roy O Disney."

28. Ising, 31 October 1976 interview.

29. Ising described the studio in his 1 February 1930 letter to Freleng, who had stopped over in Kansas City on his way back to Hollywood from New York, where he had been animating in Charles Mintz's Krazy Kat studio. RI.

30. Ising, 1971 interview.

31. Freleng, interview, 10 April 1981.

32. Robert Watson, "He's the Father of Looney Tunes," *Hollywood Spectator,* 24 June 1939, 11.

33. Letter agreement between Schlesinger and Warner Bros., 17 April 1930. USC/WB.

34. *Song of the Flame* opened on 19 April 1930, but *Sinkin' in the Bathtub* was not mentioned in *Los Angeles Times* advertisements for the film until 24 April.

35. From a copy of the script in Ising's papers.

36. Ising, 1973 interview.

37. Harman, 1973 interview. Bob Clampett, who sat in on that interview, remem-

bered that Ising was animating on the first Merrie Melodie, *Lady, Play Your Mandolin!*, when Clampett started work at the studio early in 1931.

38. Freleng, July 1976 tape recording.

39. Ising, 1973 interview. There was, he said, similar enthusiasm for a gag in the 1931 cartoon *Lady, Play Your Mandolin!*, in which a featherless chicken makes "chicken soup" by waggling its rump in a pot of liquid: "It got a big howl, so we used it five or six times."

40. Letter agreement between Schlesinger and Warner Bros., 13 January 1931. USC/WB.

41. 24 January 1930 letter agreement.

42. This correspondence is part of the USC Warner Bros. Archives.

43. Harman, 1973 interview.

44. From a copy of the meeting notice in the papers of Bob Clampett.

45. Harman, 29 October 1976 interview.

46. Ising, 1971 interview.

47. Clampett made this remark while sitting in on the 1973 Ising interview.

48. Ising, 1973 interview. Even in 1934, when Harman-Ising had begun making cartoons for release by Metro-Goldwyn-Mayer and the cartoons were becoming more elaborate, the footage figures were high; a 3 October 1934 memorandum from Gordon Wilson to Ising shows that Tom McKimson was animating thirty-nine feet a week and Larry Martin, thirty-seven. RI.

49. Jim Korkis, " 'One of the Greats of Cartoons': Bob Clampett on Bob McKimson," *Animato*, Winter 1990, 7.

50. Ising, 29 October 1976 interview.

51. Ising, 1971 interview.

52. Ising, 1973 interview. Harman, 1973 interview.

53. Ising, 1973 interview.

54. Silverman interview.

55. Ising, 1971 and 1973 interviews.

56. Ising, 1973 interview.

57. Bob Clampett, March 1975 interview.

58. Adamson/Freleng.

59. Bob Clampett, March 1975 interview.

60. When Warner Bros. exercised its option to buy a third series of Looney Tunes, its contract with Schlesinger was amended to provide for the purchase of thirteen instead of twelve—and the price of each was cut to seventy-eight hundred dollars from the original contract price of ten thousand dollars. The price was cut by another five hundred dollars in January 1933. Letter agreements between Schlesinger and Warner Bros., 27 January 1932 and 31 January 1933. USC/WB.

61. Letter agreement between Schlesinger and Warner Bros., 1 March 1933. USC/WB.

62. Harman, 1973 interview.

63. Ising, 1973 interview.

64. Ising, 1973 interview.

65. William Hanna, interview, 2 November 1976.

66. Fred Kopietz and James Pabian both remembered being hired on the same day, as two of the studio's first employees; Kopietz specified March 1930 as the month. Pabian, interview with Gray, 6 April 1977. Kopietz, interview, 29 April 1991.

67. *Film Daily*, 29 April 1930.

68. *Motion Picture News*, 14 June 1930.

69. Pabian, 1977 interview.

70. Shamus Culhane, *Talking Animals and Other People* (New York, 1986), 64, describes the interview with Powers at which he was hired for the Iwerks staff; Grim Natwick likewise remembered going to Powers's office "a couple of noon hours" to talk about going to work for Iwerks. Natwick, interview, 4 November 1976. Since Powers was in New York, he could get in touch with such animators much more easily than Iwerks could.

71. Canemaker, "Animation History and Shamus Culhane," 25.

72. Van Beuren deposition.

73. Terry's 1923–25 account book shows him making three hundred dollars a week in early 1925 and Moser two hundred dollars, more than anyone else on the staff. Screen credits and Moser's high output as an animator do not suggest that anyone else (except possibly John Foster) overtook either of them in the next few years. Moser testified about his and Terry's termination on 12 May 1937 during the trial of a lawsuit he brought against Terry and others. *Moser v. Terry, Weiss, et al.*, 254 A.D. 873 (New York Supreme Court, Appellate Division). That testimony is on page 108 of the record of the case on appeal, a copy of which is at the New York State Library, Albany. Terry acknowledged their termination in his testimony on 19 May 1937, on page 515 of the record: "These people [the original owners of Fables Pictures] had sold out to RKO, and the picture changed quite considerably, so in that change I was out." (Moser was unsuccessful in his suit, which alleged that Terry had hoodwinked him into selling his interest in Terrytoons to Terry at a fraudulently low price.) Ferdinand Horvath, a Fables animator, wrote in 1932 of also losing his job, in 1928, in a cutback related to the uncertainty about sound's impact. Horvath to Walt Disney, 15 September 1932. WDA.

74. Both Terry and Moser testified to that effect in *Moser v. Terry, Weiss, et al.* (pages 108–9 and 515 of the record, respectively), Moser in considerably more detail. Dated items in the Museum of Modern Art's collection of Terry production materials show that work on *Pretzels*, the second of the new Terry cartoons to be released, had begun by 7 November 1929.

75. John Gentilella, interview, 6 March 1977. Alex Lovy, interview with Gray, 24 January 1978.

76. Carl Urbano, interview with Gray, 19 December 1977.

77. *Film Daily*, 20 October 1930 and 17 December 1936.

78. Ned Depinet to J. R. McDonough, 6 November 1933. RKO.

79. Gillett's hiring was announced in *Motion Picture Herald*, 23 June 1934.

80. Gentilella interview.

81. NLRB/Van Beuren, Exhibit A, motion to dismiss.

82. I. Klein, "No '3 Little Pigs' to the Rescue," *Cartoonist Profiles*, December 1976, 34.

83. Jack Zander, interview, 24 March 1982.

84. Culhane, *Talking Animals*, 100.

85. Klein, "No '3 Little Pigs,' " 35.

86. NLRB/Van Beuren, Exhibit A.

87. Lundy, 1977 interview.

88. Klein, "No '3 Little Pigs,' " 35.

89. Gillett's name began appearing as codirector on films released almost immediately after he joined Van Beuren, but he could not have had much to do with them.

90. *Motion Picture Herald*, 7 and 14 March 1936, 4 April 1936. *Boxoffice*, 18 April 1936.

91. *Film Daily*, 10 February 1930. *Motion Picture News*, 15 February 1930.

92. Digest of 2 May 1930 agreement. RKO.

93. The music for *The Museum*, the first in the series, was recorded on 23 April 1930, as reflected in cue sheets dated 7 and 9 June 1930. RKO.

94. Huemer, 1973 interview.

95. Sid Marcus, interview with Gray, 24 February 1977.

96. Marcus interview.

97. Adamson/Huemer.

98. Don Patterson, interview, 19 February 1991. Carl Urbano confirmed that "Dick and Artie used to go down there all the time, at least three or four times a day, to shoot pool." Interview, 8 February 1997.

99. Walter Lantz, interview, 24 May 1971.

100. Benedict interview. Benedict to author, 5 December 1990.

101. Ray Abrams, interview with Gray, 9 March 1977. Geronimi interview.

102. Manuel Moreno, interview with Gray, 14 January 1978.

103. Moreno interview. Ed Benedict likewise recalled that Nolan worked roughly, leaving "a pretty fair amount of cleaning up" to be done. Benedict interview.

104. Benedict interview.

105. Lantz interview.

106. Preston Blair, interview, 24 January 1976.

107. Leo Salkin, interview with Gray, 27 November 1976.

108. The studio's four principal animator-directors—Huemer and Marcus, and Ben Harrison and Manny Gould, who made the Krazy Kat cartoons—had left Mintz in what Huemer described as a "strike" over a pay cut. Huemer, 1973 interview. The other three eventually returned.

109. Moreno interview.

110. David Tendlar, interview with Gray, 19 March 1976.

111. *Film Daily*, 10 October 1930.

112. *New York Times*, 28 December 1930.

113. Eugster interview. Eugster's promotion was accompanied by a fifteen-dollar increase (to fifty-five dollars) in his weekly salary. Letter agreement between Fleischer Studios and Alfred Eugster, 17 February 1930. AE. Culhane, *Talking Animals*, 36, says that he was promoted in May (although he also says, probably telescoping events, that Eugster, Zamora, and four other inbetweeners were given the opportunity to animate at the same time). Berny Wolf estimated that he began animating in July 1930. Wolf to author, circa January 1997.

114. Brief biographies appeared in *Fleischer's Animated News*, August 1935 (Sanborn) and January 1936 (Turner).

115. Culhane, *Talking Animals*, 46.

116. Eugster interview.

117. Eugster interview.

118. Tendlar interview. Al Eugster, who was a head animator several years before Tendlar—he left the Fleischer studio in 1932—said of the gag-in-every-scene rule, "That would be about it, I think." Interview.

119. Myron Waldman, interview, 28 March 1982. Waldman began working for the Fleischers in 1930 and began animating for them in 1931.

120. Tendlar to author, 22 April 1978.

121. Waldman interview.

122. Tendlar interview.

123. Waldman interview.

124. *Fleischer's Animated News*, December 1934.

125. Ruth Kneitel, interview, 4 April 1976.

126. Eugster interview. Myron Waldman became a head animator after Eugster followed Natwick to the West Coast—in Eugster's case, to the Mintz studio—in February 1932.

127. *Fleischer's Animated News*, June 1936.

128. A copy of the contract is part of the file for *Fleischer v. A.A.P., Inc. et al.*, Civil No. 125-309, U.S. District Court, Southern District of New York. Records of the District Courts, Record Group 21, National Archives, Northeast Region (New York City).

129. *New York Times*, 18 April 1934 and 6 May 1934. A copy of the record of the case on appeal, *Kane v. Fleischer et al.*, 248 A. D. 554 (New York Supreme Court, Appellate Division), is at the New York State Library, Albany.

130. Grim Natwick, "Animation," *Cartoonist Profiles*, September 1978, 29.

131. Tendlar interview.

132. Patent 2,054,414, issued 15 September 1936. U.S. Patent and Trademark Office.

133. Lou Fleischer described this incident in unpublished memoirs, a copy of which he made available to author in 1979.

134. *Fleischer's Animated News*, December 1935.

135. Richard Hall (known in the thirties as Dick Marion), interview, 8 September 1978. John Gentilella and Hicks Lokey also remembered the change. "We were already

doing that [animating on twos] at Van Beuren's," Gentilella said, "and we told them so, but they didn't believe us." Interview.

136. Gordon Sheehan, interview, 20 April 1973.

137. Gentilella interview.

138. Sheehan interview.

139. Irv Levine, interview, 23 January 1979.

140. NLRB/Fleischer 247, 252 (testimony by Sam Buchwald).

141. NLRB/Fleischer 193, 215 (Buchwald).

142. *New York Times*, 8 May 1937.

143. *New York Times*, 13 October 1937. For a highly detailed account of the Fleischer strike, the events leading up to it, and its consequences, see Harvey Raphael Deneroff, "Popeye the Union Man: A Historical Study of the Fleischer Strike," Ph.D. diss., University of Southern California, 1985.

144. Kneitel interview.

145. From Harman's copy of the contract. AC. This contract is between two corporate entities, MGM and Harman-Ising, whereas the contract with Schlesinger was signed by Harman, Ising, and Schlesinger as individuals.

146. Harman, 1973 interview.

147. Harman and Ising differed in their memories of whether MGM even wanted them to make cartoons in color. "They didn't like color," Ising said. "I think it was strictly a print-cost item with them." Ising, 1973 interview. Harman said, in contrast, that MGM "did everything they could to try to get us, as early as possible, three-color [Technicolor]. They wanted color; they knew its value." Harman, 1973 interview. Both men may have been right: their contract provided that the cartoons would be in three-color Technicolor, if possible, but if not, the cartoons would be in two-color Technicolor or in black and white, at MGM's option. MGM may have doubted that two-color Technicolor would be worth the added cost, especially given audiences' rejection of poorly made two-color live-action features a few years earlier.

148. *Film Daily*, 31 May 1934.

149. Harman, 31 October 1976 interview.

150. *Metro-Goldwyn-Mayer Distributing Corporation v. Harman-Ising Pictures, Inc., et al.*, Superior Court, Los Angeles County, No. 416781, filed 9 June 1937. Harman-Ising had not yet delivered the last four cartoons due under its contract, and in its complaint MGM asked the court for "the right to take over and complete said four uncompleted cartoons." Plaintiffs and defendants agreed on many of the facts—including that Harman-Ising had spent far more than the contractual amount on most of its cartoons—but Harman-Ising argued that MGM had acquiesced to such spending because it made the cartoons better and thus more marketable. The suit was eventually settled, and Harman-Ising completed the four disputed cartoons (which everyone expected at the time of the suit would wind up costing more than thirty thousand dollars apiece).

151. Ising, interview, 2 December 1986.

152. Harman, 1973 interview.

153. Ising cited one instance of conflict with the Production Code Administration over his depiction of a rattlesnake, one with a baby's rattle on its tail, in *The Early Bird and the Worm*, released in February 1936. 1971 interview.

154. Mel Shaw, interview, 11 October 1988.

155. Harman, 1973 interview.

156. Ising, 1971 interview.

157. Ising, 1986 interview.

158. Harman, 1973 interview.

159. Robert Stokes, interview with Gray, 9 March 1977.

160. Lee Blair, interview, 25 October 1976.

161. Urbano, 1977 interview.

162. The contract called for a length of approximately seven hundred feet, or roughly eight minutes of screen time.

163. *Metro-Goldwyn-Mayer Distributing Corporation v. Harman-Ising Pictures, Inc., et al.*

164. A memorandum by Harman-Ising's attorney, Earl Shafer, memorialized a 22 March 1937 conversation with the animator Frank Tipper about such a recruiting effort by MGM. HH.

Chapter 5

1. Walt Disney Standard Daily Journal, 1934. WDA.

2. Natwick interview.

3. Walt Disney to Natwick, memorandum, 1 June 1935. WDA.

4. Marc Davis, interview, 13 June 1993.

5. Les Novros, interview, 15 December 1986.

6. Dan Noonan, interview with Gray, 12 December 1977.

7. Natwick interview.

8. *Snow White* sweatbox notes, sequence 3C, 20 August 1936. WDA.

9. Marge Champion, in an interview with John Canemaker on 26 October 1994, was clearly incorrect about the year ("I think I started to work in November of '34") but probably correct about the month, since such filming would necessarily have preceded the first attempts at animation. Live-action filming was still months in the future when Roy Scott of the Disney staff wrote a memorandum to Walt Disney on 17 May 1935: "Some time ago we discussed the advisability of making some pictures of dancing subjects as a help for the animation department. I mentioned that it would be an excellent idea to have one or more routines created for use in Snow White having our characters dressed in the costumes that would be used in the picture." Scott was seeking Disney's approval to talk to Ernest Belcher about collaborating on a live-action instructional film. WDA.

10. NLRB/Babbitt 955.

11. Marc Davis, interview, 3 November 1976.

12. Champion, telephone interview, 2 December 1993.

13. Novros interview.

14. Natwick interview.

15. *Snow White* meeting notes, "Discussion of Dwarfs Personalities and Characteristics," 8 December 1936. AC. Photocopy.

16. Natwick interview.

17. Walt Disney, 25 November 1935 memorandum.

18. The analysis is filed with other *Snow White* materials at the Walt Disney Archives.

19. Chouinard School of Art catalog, 1932–33.

20. Stokes interview.

21. Huemer to author, 1 August 1979 and 17 and 26 September 1979.

22. Marc Davis, 1993 interview.

23. That deleted scene, from the bedroom sequence, can be seen in pencil animation, as Marc Davis redrew it, in the CAV laser-disc set of *Snow White and the Seven Dwarfs* released in 1994. Snow White in Davis's version still carries herself with a certain hauteur, but no more so than in the scene's ill-conceived writing (the girl, by threatening to leave, is teasing the dwarfs into letting her stay); he has smoothed away the provocativeness in Natwick's drawing.

24. "Talking with Grim Natwick," *Animania*, 3 June 1983, 11.

25. Graham, action-analysis lecture, 26 July 1937. WDA.

26. Natwick interview.

27. Marc Davis, 1993 interview.

28. Sam Slyfield, lecture, "Sound Recording," 17 January 1939. WDA.

29. Sneezy first turns up, mentioned by name, in notes from a 6 January 1936 meeting on sequence 8A, the entertainment sequence. He seems to have overlapped with Deafy as a possible member of the cast since Johnny Qualen, a potential voice for Deafy, was at the studio on 10 January 1936. Scott to Walt Disney, memorandum, 10 January 1936. WDA.

30. The surviving story sketches for sequences 5A and 6A, the first two dwarf

sequences to go into animation, were drawn largely by Bob Kuwahara, who began working on *Snow White* around the end of 1935 after two years as a sketch artist with Bill Cottrell and Joe Grant. Kuwahara's dwarfs are like very early, very general versions of the dwarfs as they subsequently emerged in Fred Moore's model sheets, but it's impossible to say whether Moore built his designs on Kuwahara's or the reverse was true, especially since story work on sequence 5A, which Moore animated, was still under way after Moore drew his first set of model sheets in late February. If there was cross-fertilization, Moore's influence no doubt dominated.

31. Johnston, telephone interview, 24 May 1994. After Dopey was redesigned, another animator, Fred Spencer, reworked Moore's animation to conform to the new design, and it is he who is credited with the scene in the Disney studio's records.

32. Johnston, conversation with author, 7 June 1993.

33. *Snow White* sweatbox notes, sequences 5A and 6A, 16 April 1936. WDA.

34. *Snow White* sweatbox notes, sequence 5A, 11 August 1936. WDA.

35. *Snow White* meeting notes, "Discussion on Personalities of Dwarfs," 17 November 1936.

36. Thomas and Johnston, *Disney Animation,* 127.

37. Johnston, May 1994 interview.

38. From photocopies of the relevant pages, as provided to author by Tytla's widow, Adrienne.

39. Ward Kimball, interview, 2 November 1976.

40. Richard Boleslavsky, *Acting: The First Six Lessons* (New York, 1933), 47.

41. In *An Actor Prepares,* the first and most influential of his handbooks for actors, Stanislavski—no slave to consistency—took a different tack. Although he acknowledged the importance of "real physical actions" as a stimulus to the imagination, the weight of his argument was that feelings should come first: if an actor comprehends his role emotionally, the appropriate actions will follow naturally. That would be a vastly more difficult approach for an animator to adopt. *An Actor Prepares* was not published in the United States until the fall of 1936, though, probably too late to have had much influence on Tytla's animation of the Dwarfs; he seems not to have owned a copy of the book. David Hilberman, who became Tytla's second assistant late in the summer of 1936, did remember talking with Tytla about Stanislavski: "I had my copy of *An Actor Prepares* and talked to Bill about how the 'method' would seem to apply so well to the animator's role. Bill was very interested.... [He] asked questions, and came back to the subject from time to time." Hilberman to author, circa August 1992. Although he never worked at Stanislavski's Moscow Art Theatre, Hilberman worked briefly in a Leningrad theater in the early thirties.

42. Thomas, *Walt Disney: The Art of Animation,* 53.

43. *Snow White* meeting notes on Sequence 8A, 6 January 1936. WDA.

44. Graham, action-analysis lecture, 7 June 1937. WDA.

45. Tytla, speaking during Graham, action-analysis lecture, 28 June 1937. WDA.

46. Graham, 7 June 1937 lecture.

47. William Shull, speaking during Graham, 7 June 1937 lecture.

48. Constantin Stanislavski, *Building a Character* (New York, 1949), 283.

49. Thomas and Johnston, *Disney Animation,* 332.

50. *Snow White* meeting notes, "Personalities of the Seven Dwarfs," 3 November 1936. WDA.

51. Natwick interview.

52. Robert Murphy, "A Tribute to: Grim Natwick," *In Toon,* Spring 1991, 3.

53. Tytla, during Graham, 28 June 1937 lecture.

54. *New York Times,* 26 April 1936.

55. Novros interview.

56. *Daily Variety,* 9 July 1936.

57. "Supplementary Action Notes—5A," 26 October 1936. WDA.

58. 3 November 1936 meeting notes.

59. Stewart interview. Stewart and Pearce were inbetweeners at the same time.

60. 3 November 1936 meeting notes.

61. 17 November 1936 meeting notes.

62. *Snow White* meeting notes, "Story Conference on Characteristics and Personalities of the Seven Dwarfs," 15 December 1936. WDA.

63. Walt Disney, in a 15 January 1936 memorandum to Scott, said: "Collins is the character I have in mind for doing the pantomime of Dopey. When we want him, we will call you and you can get in touch with him." WDA.

64. 15 December 1936 meeting notes. *Snow White* meeting notes on building sequence, 14 January 1937. WDA.

65. *Snow White* meeting notes, "Discussion on Dopey," 9 December 1936. WDA.

66. *Snow White* meeting notes, "Discussion of Seven Dwarfs Personalities," 24 November 1936. WDA.

67. 8 December 1936 meeting notes.

68. *Snow White* meeting notes, "Conference of Assistant Directors on Feature Procedure," 3 February 1937. WDA.

69. *Snow White* meeting notes, 18 February 1937. WDA.

70. Graham, action-analysis lecture, 26 July 1937. WDA.

71. 3 November 1936 meeting notes.

72. NLRB/Babbitt, Hand exhibit 22 (a transcript of the meeting).

73. Miller, *The Story of Walt Disney*, 138.

74. Hand, lecture at Rank studio. Undated (identified as the second lecture in the second series), but delivered early in 1947. DH.

75. Babbitt said in later years that he did not use live action in his animation of the Queen, but sweatbox notes on his animation for sequence 2B, on 2 August 1937, refer to his planned use of photostats. WDA.

76. *Snow White* meeting notes, "Dwarfs Personality Meeting, Soup Sequence, 6B," 29 December 1936. WDA.

77. *Snow White* meeting notes, "Dwarfs Personality Meeting," 22 December 1936. WDA.

78. *Snow White* meeting notes on Sequence 13A, 24 December 1936. WDA.

79. *Snow White* meeting notes on Sequence 8B, 8 December 1936. WDA.

80. *Snow White* meeting notes, dialogue conference, 9 February 1937.

81. According to a list of sequences that bears that date. WDA.

82. An edited and annotated selection of entries from Eugster's journal was privately published by the animator Mark Mayerson in 1998.

83. That sequence, called 4A, was part of the story until Disney scrapped it in November 1936; he restored it in the summer of 1937, after dropping the somewhat similar bed-building sequence. Animation of sequence 4A did not begin until August 1937 at the earliest. The first sweatbox sessions on animation for sequence 4A were on 9 September 1937. WDA.

84. Babbitt, 1973 interview.

85. Hand, lecture, "Staging as Applied to Presentation of Story and Gag Ideas," 13 October 1938. The lecture is part of the 1939 version of a compilation volume titled "Story Department Reference Material." AC. Photocopy.

86. *Snow White* meeting notes on Sequences 15A and 16A, 6 May 1937. WDA.

87. *Snow White* meeting notes, 27 July 1937. WDA.

88. *Snow White* meeting notes, talk by Dave Hand at a meeting of the dwarf animators, 8 June 1937. WDA.

89. Thomas and Johnston, *Disney Animation*, 293.

90. Jackson, "Musical Stories."

91. Frank Thomas to author, 11 November 1990.

92. Frank Thomas to author, circa August 1991.

93. Frank Thomas to author, 12 August 1992.

94. *Snow White* sweatbox notes, sequence 15A, 18 August 1937. WDA.

95. A hectographed "2nd final draft" for sequence 5A, dated 16 November 1937, shows the deleted scenes still part of the sequence. Private collection.

96. The deleted scenes, in pencil animation, were released as part of the CAV laserdisc set of *Snow White and the Seven Dwarfs*, as were, variously, pencil animation and story sketches of the deleted sequences.

97. Margaret Smith, interview, 2 December 1990. Dodie Monahan, interview with Gray, 28 March 1977.

98. *New York Times*, 30 May 1937. "Mouse & Man," 21.

99. Disney, "Growing Pains," 37.

100. From a 29 March 1947 balance sheet submitted to RKO Radio Pictures by Walt Disney Productions during negotiations for an investment by RKO in Disney. RKO.

101. *Motion Picture Herald*, 12 February 1938.

102. Bruno Bettelheim, *The Uses of Enchantment: The Meaning and Importance of Fairy Tales* (New York, 1976), 210n.

103. Roger Sale, *Fairy Tales and After* (Cambridge, Mass., 1978), 42–43.

104. I. A. Richards, *Practical Criticism* (1929; reprint, New York, n.d.), 198.

105. Stokes interview.

106. Thomas and Johnston, *Disney Animation*, 393–95.

107. *Snow White* sweatbox notes, sequence 13, 20 August 1937. WDA.

108. Robin Allan, "The Fairest Film of All: *Snow White* Reassessed," *The Animator*, Oct.–Dec. 1987, 21 (a British publication, not to be confused with the union newsletter cited elsewhere).

109. "Time and General Sequences of 'SnowWhite' as described by Walt."

Chapter 6

1. *Pinocchio* meeting notes, 3 December 1937. AC.

2. Oliver Johnston and Frank Thomas, *Walt Disney's Bambi: The Story and the Film* (New York, 1990), 108.

3. Bianca Majolie prepared an analysis of the story dated 13 May 1937. WDA.

4. Walt Disney Standard Daily Journal, 1937. WDA. This desk diary shows Disney attending his first *Pinocchio* meeting on 3 December, but there are references in the notes from that meeting to an earlier meeting that he attended, probably on 26 November.

5. Don Graham, in his 26 July 1937 action-analysis lecture, said:

> If an animator is given animals to draw because he can't animate figures, where's his squawk? He hasn't got a comeback. All Walt says is, "Can you draw the figure?"...When an animal picture is proposed, that just means that some-body doesn't trust the draftsmanship and the ability of the animators to handle the figures. WDA.

6. Walt Disney to Gregory Dickson, 26 October 1937. WDA.

7. *Pinocchio* meeting notes, 6 January 1938. "Rough Continuity," sequence 1A. AC.

8. Johnston, joint interview with Frank Thomas, 13 July 1987.

9. Johnston, telephone interview, 22 November 1994.

10. Art Babbitt, in uncontradicted testimony before the National Labor Relations Board, said that the animation of *Pinocchio* stalled on 7 February 1938. NLRB/Babbit 278.

11. Walt Disney to Sharpsteen, memorandum, 20 June 1938. BS. *Pinocchio* meeting notes, 7 July 1938. WDA.

12. *Pinocchio* shooting script for sequence 2, 21 March 1938. WDA.

13. Steve Hulett, "The Making of 'Pinocchio'—Walt Disney Style," *San Francisco Chronicle*, Datebook section, 24 December 1978.

14. Milt Kahl, interview, 4 November 1976.

15. Work on sequence 10 was still under way on 1 and 2 December 1938, as reflected in *Pinocchio* meeting notes bearing those dates. WDA.

16. *Pinocchio* meeting notes, 16 February 1938. AC.

17. Jackson, 1973 interview.

18. There are no references to Jiminy Cricket in the surviving *Pinocchio* meeting notes from before 7 July 1938.

19. Hulett, "The Making of 'Pinocchio.'"

20. Ham Luske, lecture, "Character Handling," 6 October 1938. WDA.

21. Tytla was "working hard" on *Pinocchio* by the end of March. Tytla to "Pop and John," 31 March 1938. NYU/JC. Photocopy.

22. Thomas and Johnston, *Disney Animation*, 130.

23. Larson interview.

24. Johnston, November 1994 interview.

25. Disney, "Mickey Mouse Presents," 270.

26. "Flower Ballet" meeting notes, 3 October 1935. WDA.

27. David R. Smith, "'The Sorcerer's Apprentice': Birthplace of *Fantasia*," *Millimeter*, February 1976, 18.

28. "*Fantasia*—Impromptu, The Editor in Conversation with Leopold Stokowski," *Royal College of Music Magazine*, Easter Term, 1971, 19. The correspondence between Disney and Stokowski in the Walt Disney Archives begins in October 1937, and it indicates strongly that the chance meeting between the two took place not long before that.

29. James Algar, interview with Robin Allan and William Moritz, 8 June 1985.

30. Carl Fallberg, interview with Gray, 1 April 1978.

31. "Note for first rough test," scene 47 (animated by Preston Blair), 23 January 1938. WDA.

32. The 29 March 1947 balance sheet shows the studio's receipts from *Snow White*'s initial release as $4,990,027.54.

33. Preston Blair, 1976 interview.

34. By 5 November 1938, most of *Sorcerer* had been approved for cleanups; by January 1939, the cost had risen to $162,605.42. Lamb to Walt Disney, memoranda, 16 November 1938 and 24 January 1939. WDA.

35. Fallberg interview. Various documents in Hugh Harman's papers reflect the lease to Disney of both the building and its furnishings and equipment.

36. *Bambi* meeting notes, 15 October and 4 November 1938. MD.

37. NLRB/Babbitt, Hand exhibits 19–21. Transcripts of many of the lectures are in the Walt Disney Archives.

38. Schaffer interview.

39. *The Hockey Champ* sweatbox notes, 9 January 1939. AC.

40. Miriam Stillwell, "The Story Behind Snow White's $10,000,000 Surprise Party," *Liberty*, 9 April 1938, 8.

41. Disney's Standard Daily Journal, 1938, shows a "Dance of the Fauns" meeting on 25 April and an "Afternoon of the Faun" meeting on 9 June. Some of this work may have been absorbed into what eventually became the *Pastoral* segment of *Fantasia*. WDA.

42. *Fantasia* meeting notes, 10 September 1938. WDA.

43. *Fantasia* meeting notes, 13 September 1938. WDA.

44. *Fantasia* meeting notes, 14 September 1938. WDA.

45. 14 September 1938 meeting notes.

46. In a 23 January 1940 meeting on the "Ave Maria" segment, Disney said, "We had originally thought of using [the wide screen] for the orchestra between numbers." WDA.

47. *Fantasia* meeting notes, 30 September 1938. AC.

48. *Fantasia* meeting notes (*Cydalise*), 17 October 1938. WDA.

49. *Fantasia* meeting notes ("Dance of the Hours"), 17 October 1938. WDA.

50. *Fantasia* meeting notes (*Nutcracker Suite*), 24 October 1938. WDA.

51. The outline is present in the Walt Disney Archives as a typewritten draft. "25 copies" and "ditto" are written in pencil at the top of the first page, suggesting that the outline was to be hectographed and distributed in that quantity.

52. Dick Rickard, interview with Boris V. Morkovin for gag-manual project, 12 August 1936. WDA.

53. Jackson, 1973 interview. Although Jackson was the director of *The Old Mill* at the start, his assistant director Graham Heid completed the film after Jackson began working on *Snow White*.

54. Walt Disney to Hopkins, memorandum, 26 March 1936. WDA.

55. Hilberman, interview, 24 October 1976.

56. Tenggren worked at the Disney studio 9 April 1936–14 January 1939.

57. Tenggren's sketches for *The Old Mill* are filed at the Walt Disney Archives with a "story sketch book" made up of the usual mixture of story sketches (from other hands) and preliminary layouts.

58. Huemer to author, 9 September 1974.

59. Huemer to author, 4 March 1974.

60. *Fantasia* meeting notes (*The Rite of Spring*), 17 November 1938. WDA.

61. *Fantasia* meeting notes (*Clair de Lune*), 8 December 1938. WDA.

62. 17 November 1938 meeting notes.

63. "Toby" to "those listed," memorandum, 12 January 1939. RH.

64. *Fantasia* meeting notes (*Cydalise*), 23 December 1938. WDA.

65. 13 September 1938 meeting notes.

66. *Fantasia* meeting notes (Toccata and Fugue), 8 November 1938. WDA.

67. Huemer, 1973 interview.

68. *Fantasia* meeting notes (*Pastoral*), 8 August 1939. SH.

69. Johnston, November 1994 interview.

70. "Production Notes—Shorts."

71. Joe Grant, interview, 6 December 1986.

72. Martin Provensen, interview, 4 July 1983.

73. Joe Grant, interview with Gray, 15 April 1977.

74. Campbell Grant, interview with Gray, 2 February 1977.

75. Joe Grant, 1986 interview.

76. Campbell Grant interview.

77. *Fantasia* meeting notes ("Dance of the Hours"), 29 September 1938. WDA.

78. James Bodrero, telephone interview, 19 January 1977.

79. Frank Thomas, joint interview with Ollie Johnston, 28 October 1976.

80. Joe Grant, 1988 interview.

81. Adamson, "With Disney on Olympus," 43.

82. 8 August 1939 meeting notes.

83. Jackson, 1976 interview. In addition, Aurelius Battaglia, who worked on the story for *Pinocchio*, demonstrated for Tytla how his Italian uncle "would move, jump off his feet with a gesture.... And he used those gestures." Interview with John Canemaker, 21 March 1975. NYU/JC.

84. Luske, "Character Handling."

85. NLRB/Babbitt 982.

86. NLRB/Babbitt 629.

87. William Hurtz, interview with Gray, 15 January 1977.

88. *Bambi* meeting notes, 9 September 1939. WDA.

89. Edwin Parks, interview with Gray, 30 January 1977; telephone interview with Gray, February 1977.

90. *New York Times*, 4 February 1940.

91. Frank Thomas to author, 12 August 1992. Excised after the preview, too, were some scenes on Pleasure Island of boys transformed into donkeys that Walt Disney apparently decided were too horrific. Lee Blair, who worked on the color styling of the film, recalled:

> We previewed *Pinocchio* over at Glendale, and we had a whole sequence in there of the little boys turning themselves into donkeys. It's still in there to a certain extent, with these goons shipping them off in crates. These little kids [in the audience] were flipping their wigs, and Walt said, "Get it out of here."

Joint interview with Preston Blair, 6 October 1988. The draft for sequence 8.1, marked "Final After Preview" and dated 19 January 1940, shows a large cut.

92. W. E. Garity and J. L. Ledeen, "The New Walt Disney Studio," *Journal of the Society of Motion Picture Engineers*, January 1941, 7–9.

93. *Bulletin*, 3 March 1939.

94. Disney, "Growing Pains," 38.

95. Walt Disney Productions, prospectus, 2 April 1940, 4.

96. Robert Carlson, interview with Gray, 29 January 1977.

97. Garity and Ledeen, "The New Walt Disney Studio," 12.

98. *Fantasia* meeting notes ("Dance of the Hours"), 16 November 1938. WDA.

99. Robert De Grasse, interview, 11 June 1991.

100. NLRB/Babbitt 984.

101. Babbitt, 1971 interview.

102. Hurtz, January 1977 interview. Babbitt, in a 13 December 1986 interview, confirmed the accuracy of Hurtz's account.

103. Hurtz, interview, 15 December 1986.

104. Letters, *Millimeter*, April 1976, 6.

105. Howard Swift, interview, 26 October 1976. Swift's exact words are from notes he added to the transcript.

106. Walt Disney to W. G. Van Schmus, 20 October 1939. WDA.

107. *New York Times*, 12 January 1940.

108. Walt Disney Productions' first annual report, for the fiscal year ended 28 September 1940, puts the figure at $2,595,379.66. The 29 March 1947 balance sheet shows a slightly higher figure: $2,604,641.57. RKO.

109. Disney, "Growing Pains," 39.

110. Sharpsteen's remark is part of the transcript of a development program lecture by T. Hee, 2 March 1939. WDA.

111. Frank Thomas, interview with Christopher Finch and Linda Rosenkrantz, 17 May 1972. WDA.

112. Luske, "Character Handling."

113. Meeting notes, "Studio Profit-Sharing Plan," 30 January 1940. WDA.

114. Joe Grant, 1986 interview.

115. 9 September 1939 meeting notes.

116. *Bambi* meeting notes, 1 September 1939. WDA.

117. *Bambi* meeting notes, 1 March 1940. WDA.

118. *Bambi* meeting notes, 27 February 1940. WDA.

119. *Bambi* meeting notes, 1 February 1940. WDA.

120. *Miami Daily News Rotomagazine*, 2 November 1941. "Mammal of the Year," *Time*, 29 December 1941, 27. The copyright registration for *Dumbo, the Flying Elephant* by Helen Pearl and Harold Pearl shows it as published in April 1939, by Roll-a-book Publishers of Syracuse, New York. Another edition of the original story, which contains little more than the germ of the film story, was published by Whitman in 1941, this time bearing a Disney copyright.

121. Disney's Standard Daily Journal, 1939, shows a 27 June meeting on *Dumbo* in the model department, and a 29 August meeting to see a *Dumbo* Leica reel in "Joe's room." WDA.

122. Adamson, "With Disney on Olympus," 42.

123. 27 February 1940 meeting notes.

124. *New York Times*, 21 July 1940.

125. NLRB/Babbitt, Lessing exhibit 29 (the text of a speech delivered by Disney to some of his employees on 11 February 1941). Lamb to Walt Disney, memorandum, 8 February 1941.

126. Prospectus, 11.

127. 1940 annual report, 3.

128. *Bulletin*, 18 October 1940.

129. 1940 annual report, 12.

130. Walt Disney to Sharpsteen, memorandum, 6 May 1940. WDA.

131. *Bambi* meeting notes, "First Bambi Showing With Walt—October 24, 1940." WDA.

132. A. P. Peck, "What Makes 'Fantasia' Click," *Scientific American*, January 1941, 29.

133. *Bulletin*, 15 November 1940.

134. Thor Putnam, interview, 1 December 1990.

135. *Fantasia* meeting notes (Toccata and Fugue), 8 November 1938. WDA.

136. Lee Blair, 1976 interview.

137. Huemer, 1973 interview.

138. *Bambi* meeting notes, 3 February 1940. WDA.

139. *Variety*, 21 August 1940.

140. *Variety*, 20 November 1940.

141. Walt Disney Productions, 1941 annual report, 4, 13.

142. The 1941 annual report puts the negative cost at $2,289,246.85. The 29 March 1947 balance sheet shows the negative cost as $2,277,969.40. According to the balance sheet, receipts to the studio on the film's initial release eventually totaled $1,423,046.78.

143. Disney, "Growing Pains," 39.

144. *New York Times*, 4 April 1939. *Daily Variety*, 13 and 18 February 1941.

145. NLRB/Babbitt 274 (testimony by Babbitt).

146. *Bulletin*, 4 April 1941.

147. Gunther Lessing to N. Peter Rathvon, 24 May 1946. RKO.

148. "BAMBI NOTES (Complete by Seq) OF REVISIONS Resulting from March showings '41." WDA. In a 15 March 1941 memorandum to Disney, Dave Hand detailed the cuts from each sequence, which totaled 1,067 feet.

149. NLRB/Babbitt 258 (testimony by Babbitt).

150. Campbell Grant interview. Joe Grant said of Disney: "When you were working for him, and you did get into conversation with him, you would be expecting to talk about pictures—that was it." 1986 interview.

151. 1 September 1939 meeting notes.

152. Frank Thomas, 1976 interview.

153. Hand, 1973 interview.

154. Zachary Schwartz to author, tape-recorded letter, circa February 1979.

155. Ralph Wright, interview with Gray, 1 February 1977.

156. For example, Dave Hilberman, when a layout man on *Bambi*, saw Disney only on such occasions. 1976 interview.

157. Hand, telephone interview, 17 August 1975.

158. Van Kaufman, interview, 23 February 1991.

159. Provensen interview.

160. "Studio Profit-Sharing Plan" meeting notes.

161. *Arthur Babbitt v. Walt Disney Productions*, Superior Court, Los Angeles County, No. 471865, filed 7 January 1942.

162. NLRB/Babbitt, Babbitt exhibit 14.

163. The total amount is mentioned in a 6 March 1939 memorandum from Oliver B. Johnston, the Disney comptroller, to Roy Disney; that memorandum, the list of "salary adjustments" (dated 29 April 1938), and an undated list bearing Walt Disney's modifications (each sheet signed "OK Walt") are in the Walt Disney Archives. Disney clearly distinguished such "salary adjustments" from a general bonus from the profits on *Snow White*, which many employees believed he had promised them; he said that those profits "are back in *Pinocchio*." "Studio Profit-Sharing Plan" meeting notes.

164. The inbetweener Bob McCrea, who was a supervisor during work on *Fantasia*, said that the studio's rapid growth meant that "junior management just was nonexistent.... You began to get irritated when management didn't have any idea what you were doing, good or bad." Interview with Bob Thomas, 30 September 1976. WDA.

165. Donald Christensen, interview, 12 August 1978.

166. NLRB/Babbitt 945.

167. NLRB/Babbitt, Lessing exhibit 29.

168. *In the Matter of Walt Disney Productions, Ltd., and Federation of Screen Cartoonists,* 13 NLRB 873, 875 (1939).

169. NLRB/Babbitt, Babbitt exhibit 21.

170. NLRB/Babbitt, Lessing exhibit 29. That version of Disney's talk was delivered to lower-ranking employees at the studio, particularly the women who worked as inkers and painters of the cels, on 11 February 1941. He delivered a different version to other members of the staff on 10 February, addressing some remarks specifically to the animators; a copy of that text is at the Walt Disney Archives.

171. The 1940 annual report says that the move was completed by the end of May 1940.

172. Commonly published were figures showing twenty-four employees, including nineteen union members, dismissed just before the strike; however, the studio released at least twenty-six employees in the animation, story, and effects departments between 16 and 23 May 1941. Hugh Presley to Walt Disney, memorandum, 27 June 1941. WDA. The dates when two other employees on Presley's list were laid off are not specified.

173. According to a memorandum by Gunther Lessing, the Disney payroll totaled 1,079 at the time of the strike; 294 employees within the Screen Cartoonists Guild's "proper" jurisdiction went out on strike, 352 stayed in. NLRB/Babbitt, Lessing exhibit 23.

Chapter 7

1. Robert Allen, interview with Gray, 13 January 1978.

2. Harman, 1973 interview.

3. Maxwell interview.

4. Allen interview. MGM, in the first issue of *MGM Shorts Story*, a promotional magazine aimed at exhibitors, said that Chertok had been "placed in charge of production" of the cartoons. *MGM Shorts Story*, October 1937.

5. *M-G-M Studio Club News*, 18 November 1937.

6. George Gordon, interview with Gray, 4 January 1977.

7. Freleng to author, tape-recorded letter, 3 August 1976.

8. Paul Sommer, interview with Gray, 30 March 1977.

9. Hanna interview.

10. Ising, 1971 interview.

11. Hanna interview.

12. Allen interview.

13. *Motion Picture Herald*, 30 October 1937.

14. *Variety*, 16 March 1938.

15. *Variety*, 4 May 1938.

16. Allen interview.

17. Gordon interview.

18. *Motion Picture News*, 11 March 1927.

19. "Notice to All Employees," 10 September 1937. HH.

20. As reflected in correspondence and draft contracts in Hugh Harman's papers. The story sketch book for the cartoon in the Walt Disney Archives includes sketches from many different hands, including some signed by members of the Disney staff (Riley Thomson, Ferdinand Horvath).

21. Ising, 1971 interview.

22. Harman, 31 October 1976 interview.

23. Harman and Ising, 31 October 1976 interview.

24. *The Animator*, 21 January 1938.

25. The figures are from the copies of the contracts in Harman's and Ising's papers.

26. Ising, 1986 interview.

27. Richard Bickenbach, interview with Gray, 25 February 1977.

28. Allen interview. Fred MacAlpin agreed with Allen that Harman showed some bitterness but Ising did not. MacAlpin, interview, 15 January 1979.

29. From a 1 February 1938 Associated Press dispatch clipped from an unidentified New York newspaper. Film Study Center, Museum of Modern Art.

30. Kneitel interview.

31. Fleischer/AAP, appendix to appellant's brief 95a.

32. Fleischer/AAP, appendix to appellant's brief 8a.

33. *Miami Herald*, 9 October 1938.

34. NLRB/Fleischer, "closed case report," 5 November 1938.

35. *Variety*, 2 March 1938.

36. Cal Howard, interview, 1 November 1976. Jack Mercer also recalled the redrawing of the storyboards.

37. From the souvenir program for the Miami premiere of *Gulliver's Travels*.

38. *Miami Daily News*, 13 February 1939.

39. Eugster interview.

40. *Miami Herald*, 2 July 1939.

41. Waldman interview.

42. Bemiller interview.

43. Ed Rehberg, interview with Gray, 14 December 1977.

44. "Flippers" program book, 15 December 1939 (published for the Fleischer studio's Christmas dinner dance). Nelson Demorest, interview with Gray, 4 February 1979.

45. That is the figure in a promotional booklet.

46. Ising, 1971 interview.

47. Irven Spence, interview, 22 February 1991.

48. William Littlejohn, interview with Gray, 11 December 1976.

49. That figure was provided by a confidential source who worked at MGM.

50. Pabian, 1977 interview.

51. Harman, 1973 interview.

52. Gordon interview.

53. Ising, 1971 interview.

54. Urbano, 1977 interview.

55. Ising's name was in fact spelled "Rudolph," but he thought "Rudolf" looked better on the screen.

56. Scott Bradley, "Music in Cartoons," *Film Music Notes*, December 1944.

57. Urbano, 1977 interview.

58. Ising, 1973 interview.

59. *Daily Variety*, 28 January 1941.

60. Roger L. Mayer (MGM's vice president, administration) to author, 4 February 1980.

61. *Daily Variety*, 2 May 1941.

62. Mayer, 4 February 1980.

63. A copy of Buchwald's memorandum, dated 17 March 1939, was in the papers of Tack Knight, who worked on stories at the Fleischers' Florida studio.

64. Adamson/Huemer.

65. Kneitel interview.

66. Sheehan interview.

67. Fleischer/AAP, appellant's brief 5–6, 13; appendix to appellant's brief 5a, 119a.

68. Fleischer/AAP, appendix to appellant's brief 37a.

69. *Fleischer v. W.P.I.X.*, 30 Misc. 2d 20, 213 N.Y.S. 636 (1961).

70. Lamb, 8 February 1941 memorandum.

71. Fleischer/AAP, appendix to appellant's brief 13a, 37a, 97a.

72. *Fleischer v. W.P.I.X.* 20. A copy of the contract, which was a plaintiff's exhibit in *Fleischer v. W.P.I.X.*, one of several suits by Dave Fleischer challenging the 1956 sale of Fleischer cartoons to television, is part of the National Archives' file for *Fleischer v. A.A.P., Inc. et al.*

73. Bemiller interview.

74. Paramount, in the 24 May 1941 agreement with the Fleischers, set a ceiling on

production costs of $50,000 for the first Superman cartoon, $30,000 each for subsequent cartoons in the series, and $16,500 each for Popeye cartoons.

75. Kneitel interview.

76. From an 8 July 1959 affidavit by Fred Koehner, Paramount's controller, filed in connection with *Fleischer v. N.T.A. Pictures et al.*, a companion case tried simultaneously with *Fleischer v. W.P.I.X.* The affadavit is part of a printed compilation of pleadings and affidavits submitted to the Appellate Division of the New York Supreme Court in that case (10 A.D. 2d 688, No. 8); a copy is at the New York State Library, Albany.

77. *Fleischer's Animated News*, February 1935.

78. *Fleischer's Animated News*, May 1935.

79. Kneitel interview.

80. *The Animator*, 2 November 1942.

81. John Walworth's papers included a 12 January 1943 receipt for his moving expenses.

82. Kneitel interview.

83. John Walworth, interview, 16 August 1981.

84. *Daily Variety*, 6 June 1941.

85. Lessing's associations with Villa and other Mexican politicians and revolutionaries were described in the Disney studio's *Bulletin*, 10 February 1939, and in a fifty-three-page autobiographical manuscript, "My Adventures During the Madero-Villa Mexican Revolution," written in 1963, that is now in the Walt Disney Archives.

86. NLRB/Babbitt, Disney exhibit 31.

87. De Grasse interview.

88. Ben Washam, interview with Gray, 15 December 1976.

89. Babbitt, 1973 interview.

90. Swift interview.

91. A photo of the "dragon" was published in the New York newspaper *PM*, 22 July 1941.

92. 29 March 1947 balance sheet.

93. House Committee on Un-American Activities, *Hearings Regarding the Communist Infiltration of the Motion Picture Industry*, 80th Congress, 1st session (Washington, 1947), 282. Disney testified on 24 October 1947.

94. Hilberman, interview, 24 November 1986.

95. *Daily Variety*, 29 and 31 July 1941.

96. According to a record of Disney's travels compiled by the Walt Disney Archives from his desk diaries.

97. Case File 196/2188, Subject and Dispute Files; Records of the Federal Mediation and Conciliation Service, Record Group 280, National Archives, Washington, D.C.

98. NLRB/Babbitt, Adelquist exhibit 2.

99. NLRB/Babbitt 944.

100. Walt Disney Productions, 1941 annual report, 12.

101. *Daily Variety*, 25 November 1941. 1941 annual report, 7.

102. NLRB/Babbitt 944.

103. Jackson, 1976 interview.

104. The "supervising animator" arrangement may actually have come into existence on the shorts that fell in between production of *Snow White* and *Pinocchio*. Sweatbox notes for *The Practical Pig*, on which Fred Moore and Norm Ferguson animated late in 1937, show Moore's name coupled with those of less experienced animators—Riley Thompson, Larry Clemmons, Claude Smith—as if he were in some kind of supervisory role.

105. Jackson, 1973 interview.

106. Swift interview.

107. Tytla, action-analysis lecture, December 10, 1936. WDA.

108. "Mammal of the Year," 27.

109. Tytla animated what Wilfred Jackson described as a few "pilot scenes" to estab-

lish the personalities of the elephants, before work on the rest of that sequence contin-
ued. Jackson to author, 31 December 1978. A 27 November 1940 memorandum from
Ben Sharpsteen to Walt Disney shows preparation for the sequence further along than
for almost any other, with animation about to begin. WDA.

110. Boleslavsky, *Acting: The First Six Lessons*, 47.

111. NLRB/Babbitt, Adelquist exhibit 2.

112. Carl Nater to Roy Disney, memorandum, 14 November 1941. WDA.

113. Roy Disney to Walt Disney, memorandum, 18 October 1941. WDA.

114. Thomas and Johnston, *Disney Animation*, 160.

115. Frank Thomas, 1987 interview.

116. Larson interview.

117. Frank Thomas, 1987 interview.

118. Thomas and Johnston, *Disney Animation*, 475.

119. Thomas was lecturing on 1 February 1978 at the Studio City, California, offices
of the Motion Picture Screen Cartoonists union.

120. Roy Disney, interview with Richard Hubler, 17 November 1967. WDA.

121. 29 March 1947 balance sheet.

122. There's no indication in the typewritten notes of the date of the interview or its
purpose, although it most likely was conducted by Bob Thomas for *Walt Disney: The Art
of Animation*.

Chapter 8

1. Don Williams, interview with Gray, 14 May 1977.

2. Bob Clampett, 1975 interview. Norman McCabe, interview with Gray, 8 December
1976.

3. Frank Tashlin, interview, 29 May 1971. Abbreviated versions of this interview were
published in Claire Johnston and Paul Willemen, eds., *Frank Tashlin* (Edinburgh, 1973)
and Roger Garcia and Bernard Eisenschitz, eds., *Frank Tashlin* (Locarno, 1994).

4. Bernard Brown, interview, 28 November 1973. Bob Clampett was also present.

5. Bob Clampett, telephone interview, 8 June 1979. Other members of the
Schlesinger staff remembered Brown as, in the animator Jim Pabian's words, "a very
genial person" (Pabian to author, 30 January 1990).

6. *Film Daily*, 10 June 1933.

7. Paul Fennell, interview with Gray, 7 December 1977.

8. Falk, *How to Make Animated Cartoons*, 30.

9. According to a Harman-Ising payroll list in Hugh Harman's papers, Freleng left the
staff as of 27 September 1933, and McKimson two days later.

10. Bob Clampett, 1975 interview.

11. Demorest interview.

12. McCabe, 1976 interview. Chuck Jones, interview, 3 December 1986. Pabian, type-
written notes prepared in advance of 1977 interview.

13. Tom Baron, in conversation with Gray, 21 June 1978.

14. Bernard Brown interview.

15. According to Clampett, it was Duvall, as a writer, who originated the character
Buddy. Michael Barrier and Milton Gray, "Bob Clampett: An Interview with a Master
Cartoon Maker and Puppeteer," *Funnyworld* 12 (Summer 1970), 14. The interview on
which the published interview was based was recorded on 6 June 1969.

16. McCabe, interview, 10 February 1990.

17. Letter agreement between Warner Bros. and Schlesinger, 8 February 1934.
USC/WB.

18. The 1979 compilation by David R. Smith shows the average cost of a Disney car-
toon rising from around seventeen thousand dollars in 1933 to around twenty-five thou-
sand dollars in 1934.

19. Letter agreement between Warner Bros. and Schlesinger, 10 July 1934. USC/WB.

20. Bob Clampett, 1975 interview.

21. Phil Monroe, interview, 29 October 1976.

22. Biographical information has been conflated from these sources: *Dallas Morning News*, 2 April 1933; a 1971 letter from Avery to Joe Adamson; remarks by Avery in a television interview recorded after a talk at Chapman College in Orange, California, on 17 August 1974; and an interview with Gray on 27 April 1977.

23. Joe Adamson, *Tex Avery: King of Cartoons* (New York, 1975), 157–58. Hastings was identified as the perpetrator by, among others, Cal Howard, Manuel Moreno, and Fred Kopietz. Kopietz said that Avery probably lost his eye late in 1931 or early in 1932.

24. Salkin interview.

25. Avery, interview with Gray, 18 February 1977. Avery never received screen credit as a Universal director.

26. According to Los Angeles County records, Avery married on 25 April 1935.

27. Avery, February 1977 interview.

28. That name may have originated with Bob Clampett, who by then was animating for Freleng and the other directors; Clampett said he proposed a team made up of "Porky and Beans" when Leon Schlesinger asked for candidates for an animal version of Our Gang. Barrier and Gray, "Bob Clampett," 15.

29. Adamson/Freleng.

30. The quotation is from an unidentified clipping in Joe Dougherty's papers.

31. Avery, 17 August 1974 at Chapman College.

32. Bob Clampett, 1975 interview.

33. King returned to the Disney payroll 27 April 1936.

34. *Film Daily*, 27 June 1936.

35. The Vitaphone Building is identified as such in a 27 February 1941 memorandum on Schlesinger's lease. USC/WB. The Schlesinger studio's employee newsletter, the *Exposure Sheet*, noted in its ninth issue, published in May 1939, that the move had taken place on 11 May 1936. The *Exposure Sheet* referred to the original studio as "Termite Terrace," a name that has also been applied to Avery's frame building and to the Schlesinger studio as a whole, regardless of its location. Avery, in the February 1977 interview, spoke of the frame building as "the little bungalow, the original Termite Terrace."

36. The reorganization of the Schlesinger staff into three "divisions," under Freleng, Avery, and Frank Tashlin, was announced in *Daily Variety*, 15 May 1936 (from a clipping in Tashlin's scrapbook).

37. Tashlin interview.

38. Barrier and Gray, "Bob Clampett," 16.

39. *Daily Variety*, 1 August 1936. *Film Daily*, 3 August 1936.

40. Barrier, Gray, and Spicer, "An Interview with Carl Stalling," 26.

41. Treg Brown, interview, 20 January 1979.

42. Avery, April 1977 interview.

43. *Daily Variety*, 22 January 1937, and *Film Daily*, 25 January 1937, reported that Schlesinger had, in *Film Daily*'s words, "started production" on *Uncle Tom's Bungalow*.

44. Avery, April 1977 interview.

45. *Daily Variety*, 22 January 1937, reported: "Leon Schlesinger...is going in for parodies on picture hits. He has about completed work on 'Clean Pastures' and has already started animators to work on 'Uncle Tom's Bungalow.' "

46. Joseph I. Breen to Schlesinger, 11 May 1937. USC/WB.

47. F. S. Harmon (of Breen's office) to A. S. Howson (of Warner Bros.), 21 October 1937. USC/WB.

48. *Hollywood Reporter*, 20 May 1937.

49. Schlesinger assigned his contract with John Carey, then an assistant animator, to Katz through a letter dated 21 June 1937—a reasonable starting date for what became known as the "Katz unit." JC.

50. Schlesinger told the National Labor Relations Board in 1939 that he was paying Katz sixty-five hundred dollars each for ten Looney Tunes that year, under an oral contract. NLRB/Lantz 68–69.

51. Monroe, interview, 10 October 1987.

52. Bob Clampett, 1975 interview; interview, 31 October 1976.

53. Bob Clampett, 1975 interview.

54. Jones, telephone interview, 13 September 1979.

55. For example, Norm McCabe said that "Chuck and Clampett were the directors" (1976 interview), and Jerry Hathcock said, "As far as I was concerned, they were co-directors" (interview, 29 November 1986).

56. Bob Clampett, 1976 interview.

57. John Carey, interview, 15 January 1979.

58. Bob Clampett, 1975 interview.

59. Bob Clampett, 1976 interview.

60. Sody Clampett (Bob Clampett's widow), interview, 13 July 1987.

61. Richard Thomas, interview, 23 February 1991.

62. Bob Clampett, telephone interview, 9 March 1980.

63. As witnessed by, among others, Mel Shaw: "If they would show him pictures of nude women, or anything like that, he would faint." Interview.

64. Richard Thomas interview.

65. Bob Clampett, 1976 interview.

66. Jones, telephone interview, 5 October 1976.

67. McCabe, 1990 interview.

68. Bob Clampett, interview, 30 April 1972.

69. Carey interview.

70. Jones, October 1976 interview.

71. David Monahan, interview with Gray, 28 March 1977.

72. From Avery's remarks at the ASIFA Hollywood "Annie" awards banquet, 21 November 1974.

73. *Hollywood Reporter*, 2 April 1938.

74. Tashlin interview.

75. According to *Warner Club News* (the Warner Bros. employee newsletter), September 1947, Jones started at Schlesinger's on 24 March 1933; in an 8 June 1979 telephone interview, he said he started directing on 23 March 1938. (*Warner Club News*, May 1958, says, however, that Jones started at Schlesinger's in May 1933, rather than March.)

76. Jay Cocks, "The World Jones Made," *Time*, 17 December 1973.

77. Mary Harrington Hall, "The Fantasy Makers: A Conversation with Ray Bradbury and Chuck Jones," *Psychology Today*, April 1968, 70.

78. *Exposure Sheet*, vol. 1, no. 4, undated but published in February 1939.

79. *Exposure Sheet*, vol. 1, no. 2, undated but published in January 1939.

80. Chuck Jones, "The Roadrunner and Other Characters," *Cinema Journal*, Spring 1969, 160.

81. Jones confirmed, in the September 1979 interview, that his first job at Schlesinger's was as Fennell's assistant.

82. Fennell interview.

83. Pabian, interview, 1 December 1986.

84. The senior Jones was described this way by both Pabian and Don Williams.

85. Jones, telephone interview, 14 July 1976.

86. Letter agreement between Warner Bros. and Schlesinger, 12 March 1938. USC/WB.

87. Jones, telephone interview, 11 October 1979. Other parts of *Old Glory* were roto-scoped, however.

88. Demorest interview.

89. Avery, February 1977 interview.

90. From a press release filed as a description of the film with the Copyright Office, Library of Congress.

91. Barrier and Gray, "Bob Clampett," 19. Hardaway may have worked with Avery on a Daffy Duck cartoon shortly before he directed *Hare Hunt*; he received screen credit for the story on Avery's second Daffy Duck cartoon, *Daffy Duck & Egghead*. Schlesinger had just begun giving screen credit to writers, though, starting with releases for the 1937–38 season, and it's not clear how soon the credits began reflecting actual contributions to the stories. In the late thirties, the Warner story men typically worked in groups, for one director and then for another, and at first, the credits rotated, without regard to how much the man receiving credit had contributed to the cartoon. "If you were next in line," Dave Monahan said, "your name went on it. If it was my turn, it didn't matter what story it was, when the film was completed, my name went on it." Interview.

92. *Exposure Sheet*, vol. 1, no. 1, undated but published in January 1939.

93. Blanc provided Woody's voice in only four cartoons, though, because Schlesinger signed him to an exclusive contract in April 1941. *Daily Variety*, 25 April 1941.

94. According to the *Exposure Sheet*, 25 August 1939, Jones was then timing a cartoon called *Mighty Hunters*, based on James Swinnerton's "Canyon Kiddies" comics page. The cartoon was released only five months later, on 27 January 1940.

95. Robert Givens to author, circa April 1980.

96. Avery, February 1977 interview.

97. Avery, April 1977 interview. Avery had lived for two years in El Paso, "and my first year in high school was in Dallas, and everything was 'doc.' "

98. Avery, April 1977 interview.

99. Robert McKimson, interview, 28 May 1971. The *Exposure Sheet* (vol. 1, no. 8, undated but published in April 1939) said that McKimson's output jumped from forty to seventy feet a week.

100. *Exposure Sheet*, 11 August 1939.

101. Phil Monroe said that McKimson "had to check your scenes before you had them pencil tested. And if he didn't like the way you drew it, you had to go back and draw it another way." But McKimson "only dealt with the standardized characters." 1976 interview.

102. McKimson interview.

103. Mark Nardone, "Robert McKimson Interviewed," in Gerald Peary and Danny Peary, eds., *The American Animated Cartoon* (New York, 1980), 148.

104. Avery, in a 13 August 1979 letter to author, said he never used the first Givens model sheet, of "Tex's rabbbit," in work on *A Wild Hare*, but instead used one that he roughed out and Bob McKimson cleaned up. It seems likely, though, that Avery was thinking of the two model sheets that McKimson drew after *A Wild Hare* was released. The Bugs of *A Wild Hare*—even in those scenes animated by McKimson—looks much more like the "Tex's rabbit" of the Givens model sheet than like the Bugs on the two McKimson sheets. The Givens sheet that Avery remembered not using was probably "Bugs Bunny Sheet #1," the one that Givens never finished.

105. Avery, February 1977 interview. Adamson, *Tex Avery*, 165–66. *Hollywood Reporter*, 2 July 1941, said that Avery walked out to protest Leon Schlesinger's order that forty feet be cut from "a recently completed 'Bugs' Bunny cartoon," presumably *The Heckling Hare*, which was released on 12 July 1941, but Avery himself mentioned no such incident. *The Heckling Hare* now ends with Bugs and his hound adversary plummeting toward earth from a high cliff and screaming in all-too-realistic terror for about forty seconds. They brake to a halt, and Bugs says to the camera, "Yeah! Fooled ya, didn't we?" An abrupt fade to black ends the cartoon, as the dog says, "Yeah... " A dialogue transcription in the United Artists collection at the State Historical Society of Wisconsin indicates that Bugs and the dog originally took *two* more long falls after the first one, with the cartoon finally coming to an end during the third fall. If Schlesinger did order the cut, he was not acting arbitrarily.

Chapter 9

1. Lundy, 1977 interview.

2. Walt Disney Productions, 1942 annual report, 2.

3. J. B. Kaufman, "Before Snow White," *Film History*, June 1993, 158-75.

4. Walt Disney to Aviation Film Committee, 10 April 1941. WDA.

5. Walt Disney to Kay Kamen, 3 December 1941. WDA.

6. A memorandum summarizing an oral agreement (misdated 8 December 1942) is in the Walt Disney Archives.

7. Johnston to author, 8 August 1977.

8. Roy Disney, "Memorandum re: South American Short Subjects," 7 October 1941. WDA.

9. Hal Adelquist to Walt Disney, memorandum, 1 April 1942. WDA.

10. G. J. Schaefer to Phil Reisman, 10 April 1942. RKO.

11. It was evidently skepticism at RKO about the theatrical viability of such a film in the United States, as indicated in Schaefer's letter to Reisman, that led to this unusual release pattern.

12. 29 March 1947 balance sheet.

13. A 16 July 1941 memorandum from John Rose to Norman Ferguson consists of a "list of South American short subject story possibilities and tentative assignments...set down in accordance with the production plan as discussed in Walt's office last Friday." The basic division is between a "gaucho series (Argentina)"—assigned to Ted Sears, Webb Smith, and John Miller—and "Pan-Am Symphonies"—assigned to Bill Cottrell, Lee Blair, and Jim Bodrero. Some of the shorts included in both *Saludos Amigos* and *The Three Caballeros* are recognizable on this list; there are, for instance, suggestions for a cartoon about a mail plane, to be set in Chile, and another on a "Carioca Carnival" theme, to be set in Brazil—ideas that materialized in *Saludos Amigos* as "Pedro" and "Aquarela do Brasil." WDA.

14. *Saludos Amigos* meeting notes, 3 June 1942. WDA.

15. Thornton Delahanty, "The Disney Studio at War," *Theatre Arts*, January 1943, 38.

16. A 9 April 1942 memorandum in RKO's files was apparently drafted by an RKO executive—no author or recipient is specified—to memorialize an informal oral agreement. The memo says in part that "we are asked to subordinate after all cost, but not more than $200,000"—that is, Disney would, in an unusual arrangement, recoup its production costs before RKO began collecting its distribution fees. RKO. Disney had been talking about such a feature for some months before his agreement with RKO was reduced to writing. Kenneth Macgowan, director of production for the motion picture division of the office of the coordinator of inter-American affairs—the government sponsor of his South American trip—wrote to Disney on 2 March 1942 that a sixteen-millimeter film a member of Macgowan's staff had seen "might be of interest to you in reference to your own film on aviation." WDA.

17. Walt Disney to Leo Samuels (a Disney representative in New York), telegram, 4 May 1942. WDA.

18. *Victory Through Air Power* meeting notes, 10 November 1942. WDA.

19. A copy of the contract is part of the O'Brien files, Box 155, Wisconsin/UA. The contract actually contemplated the distribution of *three* feature cartoons, although Disney's obligation to deliver the remaining two films was slight.

20. 29 March 1947 balance sheet.

21. Walt Disney Productions, 1943 annual report, 4.

22. As reported in *Dispatch from Disney's*, a booklet intended for former Disney staff members in the armed services and published in June 1943.

23. W. H. Clark to N. P. Rathvon et al., memorandum, 24 May 1943. RKO.

24. Joe Grant and Huemer to Walt Disney, memorandum, 10 June 1943. WDA.

25. Reports to Disney by Ralph Parker, his story editor, showed work on the storyboards under way in both May and September 1943. WDA. The storyboard drawings were part of the 1995 laserdisc release of *Alice in Wonderland*.

26. "How Disney Combines Living Actors With His Cartoon Characters," *Popular*

Science, September 1944, 110.

27. Kenneth Anderson, interview with Gray, 14 December 1976.

28. 29 March 1947 balance sheet.

29. *The Gremlins* meeting notes, 20 August 1943. WDA.

30. Joe Adamson, *The Walter Lantz Story* (New York, 1985), 99, puts the date of the transition as 16 November 1935.

31. Lantz interview.

32. Lantz interview. The payment came, the animator George Jorgensen (whose name appeared in screen credits as George Dane) recalled, in lump sums based on the footage each one had animated. Jorgensen, interview with Gray, 1 December 1977.

33. Walter P. Spreckels (NLRB regional director) to National Labor Relations Board, memorandum, 5 March 1941. NLRB/Lantz.

34. Lovy interview.

35. Lantz interview.

36. Lantz interview.

37. Hardaway joined the staff 12 August 1940, just three and a half months before the cartoon's release.

38. Shamus Culhane, *Animation from Script to Screen* (New York, 1988), 81.

39. Lundy, 1973 interview. Just such an increase in costs occurred in the forties: according to Adamson, *The Walter Lantz Story*, 129, 139, *Scrub Me Mama With a Boogie Beat*, the most expensive cartoon of the 1940–41 release year, cost $10,000; Culhane's *The Barber of Seville*, the most expensive cartoon of the 1943–44 release year, cost $16,717.

40. Lantz interview.

41. Culhane, *Talking Animals*, 278. Lantz may have chosen to lose Culhane rather than Lundy because Culhane was too expensive; Lundy's recollection was that Culhane asked Lantz for a raise, didn't get it, and quit. Lundy, 1973 interview. In later years, at least, Culhane believed, in his wife's words, that he was "let go by Walter Lantz because he believed in the union and Lundy didn't." Juana Culhane to author, 21 June 1995.

42. Lundy, 1973 interview.

43. Lundy, 1973 interview.

44. Schaffer interview.

45. The Lantz Collection at the University of California at Los Angeles, University Research Library, Department of Special Collections, includes the story sketches for many cartoons from the forties, and many of the sketches—presumably Schaffer's—are appealingly loose and expressive.

46. Copies of the contract are in the O'Brien files, Boxes 40 and 219, Wisconsin/UA.

47. *Variety*, 10 December 1947.

48. Dick Lundy left the payroll on 4 December 1948.

49. Lantz interview.

50. Columbia Pictures Corporation documents (Form 10-K for corporations), on file with the U.S. Securities and Exchange Commission in the early eighties, showed that Columbia owned 50 percent of Screen Gems in 1936 and acquired complete ownership on 15 September 1937; those documents have since been destroyed. Art Davis's 1932 contract was with Charles Mintz, his 1933 contract with Screen Gems, a change that probably coincided with Columbia's acquisition of half-ownership. Davis to author, 16 October 1979.

51. Harry Love, interview with Gray, 16 January 1977. Arthur Davis interview.

52. NLRB/Babbitt 876–77 (testimony by Hal Adelquist).

53. Tashlin interview.

54. *Daily Variety*, 29 October 1941.

55. Tashlin interview.

56. *Variety*, 8 April 1942.

57. *Daily Variety*, 23 April 1942. *Motion Picture Herald*, 25 April 1942. *The Animator*, 27 April 1942 and 22 June 1942.

58. John Hubley, interview, 26 November 1976.

59. "Evolution of a Cartoonist," *Sight and Sound,* Winter 1961–62, 17.

60. Schwartz to author, tape-recorded letter, circa February 1978.

61. Sommer interview.

62. *The Animator,* 24 December 1943.

63. Bob Clampett, 1976 interview.

64. Sommer interview.

65. *Variety,* 28 May 1947.

66. Jackson, 1976 interview.

67. Babbitt, 1973 interview.

68. Carlson, interview, 24 October 1976.

69. Tytla had bought the property, in East Lyme, while he worked at Disney's; his parents lived there while he was working in California.

70. The meetings were noted in Mrs. Terry's journal of the trip. PT.

71. Gentilella interview.

72. NLRB/Terry 23, 32, 41 (testimony by William Weiss).

73. NLRB/Terry 12, 43–44 (Weiss). A list of employees as of 10 April 1943 was an exhibit in that case.

74. Terrytoons Inc., financial statements, 30 June and 30 September 1944. PT.

75. NLRB/Terry 13 (Weiss).

76. Tytla's uncertain status when he came to Terrytoons was reflected in William Weiss's testimony before the National Labor Relations Board in April 1943; he said at first that there were only three directors, acknowledging only under questioning that Tytla, too, should be considered a director. NLRB/Terry 43–44.

77. Gentilella interview.

78. Silverman to author, 28 June 1980.

79. *In the Matter of Terrytoons, Inc.,* 50 NLRB 684.

80. A detailed chronology of negotiations with Terrytoons is part of the Screen Cartoonists Guild collection, California State University at Northridge.

81. Gentilella interview.

82. An excerpt from a 1979 interview of Klein by Harvey Deneroff—the exact date is uncertain—is part of the Canemaker Collection at New York University.

83. From Tytla's draft, dated 17 October 1944, for a letter to Jack Cutting, his former colleague at Disney's. NYU/JC. Photocopy.

84. Gentilella interview.

85. Bob Bawbell, memorandum, 24 May 1944. The memo is not addressed to Walt Disney specifically but is part of his interoffice files in the Walt Disney Archives.

86. *Variety,* 11 August 1943.

87. J. V. Sheehan to Walt Disney and Roy Disney, memorandum, 9 November 1944. WDA.

88. *Variety,* 7 June 1944.

89. Campbell Grant interview. J. V. Sheehan left the Disney staff on 29 September 1945.

90. Walt Disney Productions, 1946 annual report, 3.

91. Walt Disney Productions, 1945 and 1946 annual reports.

92. Walt Disney Productions, 1946 annual report, 4.

93. *New York Times,* 14 July 1946.

94. *Variety,* 31 July 1946.

95. John Reeder (the Disney studio's general manager) to Roy Disney, memorandum, 20 August 1946. WDA. The four features were *Song of the South, So Dear to My Heart, Fun and Fancy Free,* and what was then known as *All in Fun* but was eventually released as *Melody Time.*

96. The contract itself is not available to researchers, but its existence is noted in a 2 February 1993 memorandum by David R. Smith in the Walt Disney Archives' files on *Make Mine Music.*

97. A five-page treatment, dated 24 November 1939, is in the Walt Disney Archives' *Make Mine Music* files.

98. 29 March 1947 balance sheet. Freeman to Rathvon, memorandum, 12 May 1947. RKO.

99. Jackson, 1976 interview.

100. Jacques Roberts to Walt Disney, memorandum, 23 October 1944. Ken Peterson to Walt Disney, memorandum, 21 December 1944. WDA.

101. Thomas and Johnston, *Disney Animation*, 164.

102. 29 March 1947 balance sheet. Freeman, 12 May 1947 memorandum.

103. Surviving in the Walt Disney Archives are a partial treatment (dated 27 November 1945) and a partial script (dated 5 December 1945) by Huxley.

104. *Variety*, 18 December 1946.

105. Hal Adelquist, story inventory report, 28 May 1947. RKO.

106. Jonathan Bell Lovelace to Freeman, 29 April 1947. RKO.

107. *Variety*, 6 November 1946.

108. Jack Kinney, interview, 28 November 1973.

109. Walt Disney Productions, 1947 annual report, 8.

110. Putnam interview.

111. Carlson, 1976 interview.

112. Joe Grant, 1988 interview.

113. Hand, 1973 interview.

114. The first of Hand's cartoons for Rank were released in the fall of 1948, four years after Hand was hired, to prevailingly negative critical reaction. Production evidently ceased in the fall of 1949, when Rank began laying off some of the two hundred staff members. Nineteen cartoons were completed before the shutdown.

115. Joe Grant, 1986 interview.

116. Kimball interview.

117. Thomas and Johnston, *Disney Animation*, 159.

118. Kimball interview.

119. Thomas and Johnston, *Disney Animation*, 522.

120. Frank Thomas, 1976 interview.

121. Kahl interview.

122. Kimball interview.

123. Geronimi interview.

124. Those negotiations are reflected in the RKO file labeled "Disney/Special Negotiations." RKO.

125. Bill Peet, interview, 15 August 1978.

126. From a copy of the outline in the papers of Ben Sharpsteen.

127. "Notes on Cinderella as Taken in Walt's Office 9/2/43" are part of Disney's interoffice files in the Disney Archives. On 12 May 1944, Disney wrote to Charles Koerner, a Paramount executive, that he was "resum[ing] production" on *Cinderella*. RKO. He was acting to protect his studio's registration of the title with the film industry's clearinghouse, and that motive was undoubtedly behind some of the bursts of work not just on *Cinderella* but on other films, too. A studio could not register a title and then sit on it, but had to show that it was making some progress toward putting a film of that title on the screen.

128. *Cinderella* meeting notes, 26 March 1946 and 1 and 23 April 1946. WDA.

129. Disney story inventory report.

130. Walt Disney Productions, 1948 annual report, 2–3.

131. Thomas and Johnston, *Disney Animation*, 330.

132. Frank Thomas, 1987 interview.

133. Jackson to author, 30 September 1975.

134. Frank Thomas, 1987 interview.

135. Jackson to author, 30 September 1975 and 3 May 1977.

136. According to the record of Disney's travels compiled by the Walt Disney Archives, he was gone 11 June–29 August 1949.

137. Jackson, 30 September 1975.

138. Johnston, 1976 interview.

139. Huemer, 1973 interview.

Chapter 10

1. Hanna interview.

2. A very brief synopsis for *Puss Gets the Boot* (then called "The Mouse and Cat Story"), probably prepared for submission to Quimby early in the writing for the film, shows a start date for story work of 8 May 1939 (a Monday). USC/MGM.

3. Ising, 1971 interview.

4. Bob Allen and Jim Pabian both spoke of Ising's having turned over the story for *Puss Gets the Boot* to Hanna and Barbera in something close to finished form. "He had just written the first story of Tom and Jerry," Pabian said. "Rudy's story department had written it. To get them out of his hair, Rudy gave them this; it was intact, all it needed was timing, and Bill...had already learned how to do that." 1977 interview. Allen said, similarly, that "I designed the first model sheet for Rudy's unit and the storyboard and models were handed over to Bill and Joe incomplete—Bill and Joe finished the picture." Allen to author, 29 December 1989. Both men could only have had in mind the transfer of the story to the new Hanna and Barbera unit since there's no question but that Hanna and Barbera did most of the writing while they were still in Ising's unit; they were, in other words, "Rudy's story department," at least as far as *Puss Gets the Boot* was concerned.

5. Ising, 1976 interview.

6. *Motion Picture Herald*, 23 September 1939.

7. That is the date shown for the start of story work on a one-page synopsis like the one for *Puss Gets the Boot*. The synopsis itself is dated 9 October 1940. USC/MGM.

8. According to both Hanna and Barbera, one letter from a major exhibitor was the stimulus for the second cat-and-mouse cartoon. Bill Hanna, *A Cast of Friends* (Dallas, 1996), 43. Joe Barbera, *My Life in 'toons* (Atlanta, 1994), 76.

9. Hanna interview.

10. Gus Arriola, interview with Gray, 31 January 1977.

11. Zander interview.

12. Hanna interview.

13. Michael Lah, interview with Gray, 4 January 1977.

14. Barbera, *My Life in 'toons*, 73.

15. Barbera, *My Life in 'toons*, 75. Barbera's book is typical of such Hollywood autobiographies in that it includes anecdotes that are difficult to credit in their literal form—he has Quimby wanting Hanna and Barbera to drop Tom and Jerry entirely, after *Puss Gets the Boot* had been well received in the theaters—but that clearly have some basis in fact. For an MGM director to concentrate so heavily on one series was a sharp break with precedent (the failed Captain and the Kids series apart).

16. "Tips to Remember When Submitting Gags," 12 February 1937. WDA.

17. Bickenbach interview.

18. Mark Kausler, "Tom and Jerry," *Film Comment*, January–February 1975, 74–75.

19. Avery, February 1977 interview.

20. Ed Barge, interview with Gray, 26 November 1976.

21. Claude Smith, February 1991.

22. Avery, February 1977 interview.

23. Gordon interview. The animator Ed Love remembered only one pose reel, for Avery's first cartoon, *The Early Bird Dood It!* (interview with Gray, 18 January 1977). It seems likely that Gordon made a pose reel only for that first Avery cartoon, and that Avery abandoned the practice after Berny Wolf became his layout artist.

24. Wolf to author, 20 September 1982.

25. Wolf, interview with Gray, 8 April 1977.

26. Claude Smith to author, 9 July 1983.

27. Avery, February 1977 interview.

28. *M-G-M Studio Club News*, October and December 1942.

29. Avery, April 1977 interview.

30. Preston Blair, 1988 interview.

31. Preston Blair, telephone interview, 27 January 1990.

32. Preston Blair, 1988 interview.

33. Avery, February 1977 interview.

34. Jack Stevens, interview, 8 December 1990.

35. Detailed synopses were prepared when work on a cartoon story was substantially complete (as opposed to the much briefer synopses that were submitted to Quimby earlier in the process); these synopses were distributed to people within the cartoon studio and on MGM's main lot, apparently in an effort to head off any problems that might arise from a cartoon's content. There are a total of three copies of two different synopses for *Red Hot Riding Hood* in the USC/MGM collection; the earlier synopsis, which exists in two copies, reflects the story as Avery originally wrote it, with changes marked on one copy in his hand (the same changes have been inserted into the other copy on typewritten slips); it is these changes that toned down the wolf's reactions to Red. The second synopsis, which exists in a single copy, incorporates the changes marked on the other copies. The revisions reflect some concern about bestiality: they eliminated several scenes of the Grandma's kissing the wolf, and, most significantly, had the wolf pulling off his false face at the beginning of the film to reveal that he was really "a goof human in a wolf suit." Avery evidently thought better of that change: the wolf remains a wolf in the finished film.

36. Any correspondence between the PCA and MGM related to *Red Hot Riding Hood* no longer exists, but a file card that reflects the PCA's actions on the film shows that the PCA took an unusual amount of interest in it. A PCA staff member went to MGM for a preliminary screening on 28 October 1942, more than a week before a screening at the PCA offices on 6 November 1942. The PCA did not issue a certificate until 19 January 1943, presumably after changes were made in the version submitted in November, and even screened the film again on 19 March 1943 for reasons that are not clear. AMPAS.

37. *M-G-M Studio Club News* reported in its issues of October and November 1943 on the enthusiastic reception *Red Hot Riding Hood* was receiving.

38. Another self-defeating apology is in *The Screwy Truant* (1945): Screwy exclaims, "Oh, brother—now I've seen everything," after his canine foe Meathead opens the "trunk" in his rump to take out a spare foot; the effect is to ridicule the audience for laughing at the gag. In *The Shooting of Dan McGoo* (1945), the wolf after saying, "'Tain't funny, McGoo" to Droopy, turns toward the camera and says, "What corny dialogue."

39. Hames Ware, "Hearing Voices: Screwy and Sniffles Solved!," *Animato*, Spring 1995, 28.

40. *M-G-M Studio Club News*, November 1943.

41. Preston Blair, 1988 interview.

42. Spence, interview with Gray, 29 November 1976.

43. Bickenbach interview.

44. Barge interview.

45. Spence, 1976 interview.

46. Barge interview.

47. Scott Bradley, interview with Gray, 11 March 1979.

48. Avery, February 1977 interview.

49. Adamson, *Tex Avery*, 193.

50. *Poetics* 1460a26, trans. Ingram Bywater (New York, 1954).

51. Vincent Canby, "Gaffes and Gags of a Shy Dimwit," *New York Times*, 30 April 1993.

52. Gene Hazelton, interview, 6 January 1979.

53. Adamson, *Tex Avery*, 179.

54. Avery, February 1977 interview.

55. Avery, April 1977 interview.

56. Lah interview.

57. Avery, February 1977 interview.

58. Lundy, who kept careful records of his own work, said that he started at MGM on 15 May 1950, and that Avery was already gone by then. "Avery and Quimby had a fight, so I was more or less to put out a series in place of Avery. I said, 'Well, what would happen if Tex comes back?' He said, 'Tex isn't coming back.'" 1973 interview.

Chapter 11

1. Washam interview. Jack Bradbury, interview with Gray, 23 March 1977.

2. Schlesinger did talk with Warner Bros. executives in New York about making a feature, in January 1938, but it seems likely that the impetus for such a discussion came from Warners; a month later, Warners was talking about making *two* animated features, but Schlesinger was away on a cruise at the time. *Motion Picture Herald*, 29 January 1938. *Variety*, 23 February 1938.

3. Schlesinger put the figure at 200 in a 1939 interview (Watson, "He's the Father of Looney Tunes"), but the National Relations Board in a decision that year said that he employed only 128, and that Katz employed 34. *In the matter of Walter Lantz Productions et al.*, 16 NLRB 223 (1939).

4. Givens, interview with Gray, 3 April 1976.

5. Bill Melendez, interview with Gray, 20 November 1979. The story man Dave Monahan has added this detail: "You'd finish a Coke—and I've seen this happen many times—and you'd just punch a hole in the wall and drop the bottle in." Interview.

6. Washam interview.

7. Paul Julian, interview with Gray, 18 December 1976.

8. Christensen interview.

9. *Daily Variety*, 19-21 May and 28 May 1941.

10. According to McCabe, his unit moved to the main building after he had directed "maybe one picture." After the move, Katz no longer functioned as the unit's producer, but "became like just another assistant to Schlesinger." 1976 interview.

11. Warner Bros. Pictures, Inc., to Schlesinger, 5 February 1942. USC/WB.

12. NLRB/Babbitt 454 (testimony by Tashlin).

13. *The Animator*, 9 November 1942.

14. Tashlin interview.

15. Warner Bros. Pictures, Inc., to Schlesinger, 3 April 1943. USC/WB.

16. Bob Clampett, 1976 interview.

17. Melendez interview.

18. Bob Clampett, 1976 interview.

19. Melendez interview.

20. Bob Clampett, 1972 interview.

21. Bob Clampett, 1976 interview; telephone interview, 22 June 1979.

22. Bob Clampett, 1976 interview; 8 June 1979 interview. Virgil Ross recalled that "we even went over to the east side of town, in the black district, to go through the nightclubs and watch them dance. It was quite a lot of fun.... [Clampett's] idea was to get the atmosphere of it; but we had a lot of fun doing it, too." Interview, 29 November 1973.

23. Bob Clampett, 8 June 1979 interview.

24. Walter White (secretary of the NAACP) to Harry M. Warner, 28 April 1943. Library of Congress, Manuscript Division.

25. Melendez interview.

26. Washam interview.

27. Julian, 1976 interview. That team spirit looked like something else to people in other units, like the animator Dick Bickenbach, who said of Jones: "He had his own little group, and he dictated to them." Interview.

28. Jones, October 1979 interview.

29. Greg Ford and Richard Thompson, "Chuck Jones: Interview," *Film Comment*, January–February 1975, 27–28.

30. Ford and Thompson, "Chuck Jones," 28.

31. Michael Barrier, "An Interview with Chuck Jones," *Funnyworld* 13 (Spring 1971), 11. The interviews on which the published interview was based were recorded on 4 and

5 June 1969.

32. *Exposure Sheet*, 24 February 1941.

33. Julian, 1976 interview.

34. John McGrew, interview, 11 September 1995.

35. Jones, telephone conversation with author, 28 February 1977.

36. Hubley, "The Writer and the Cartoon," 111.

37. Barrier, "An Interview with Chuck Jones," 11.

38. Eugene Fleury, joint interview with Bernyce Polifka, with Gray, 27 March 1977. *Coal Black* also had an all-human cast, as did any number of prewar Schlesinger cartoons.

39. Jones, telephone interview, 14 January 1981.

40. Fleury interview.

41. *The Animator*, 12 October 1942.

42. *The Animator*, 26 April 1943.

43. *The Animator*, 4 January 1943.

44. Julian to author, 3 February 1980.

45. Fleury interview.

46. *The Animator*, 24 December 1943.

47. "New Approach to the Animated Cartoon," *California Arts & Architecture*, February 1944.

48. As evidenced by Chuck Jones, "Music and the Animated Cartoon," *Hollywood Quarterly*, July 1946.

49. Julian, 1976 interview.

50. Julian, 3 February 1980.

51. *Daily Variety*, 16 June 1941.

52. Ford and Thompson, "Chuck Jones," 23.

53. Earl Klein, telephone interview, 7 October 1990.

54. "That was a rare occasion, when Rod would devote that much time to doing layouts," Clampett said. Interview with Gray, 28 May 1979. He also said that *Coal Black* "was the first and last picture [where] Rod worked on the layouts." Clampett to author, circa November 1979.

55. Bob Clampett, 1972 interview.

56. Bob Clampett, recorded conversation with Gray, October 1979 (the exact date is uncertain).

57. Bob Clampett, interview with Gray, 7 March 1975.

58. McKimson interview.

59. Monroe, 1976 interview.

60. Melendez interview.

61. Monroe, 1976 interview.

62. McKimson interview.

63. Melendez interview.

64. Monroe, 1976 interview.

65. Bob Clampett, 1972 interview.

66. Melendez interview.

67. Jones, October 1976 interview.

68. McKimson interview.

69. Monahan interview.

70. Melendez interview.

71. Bob Clampett, October 1979.

72. Bob Clampett to author, 14 May 1979.

73. Bob Clampett to author, circa November 1979.

74. *The Animator*, 12 April 1943.

75. Bob Clampett, 1975 interview. In a 28 December 1979 letter to Clampett, Hugh Harman confirmed that the car-ad sequence was the genesis of the later magazines-coming-to-life cartoons. BC.

76. Tashlin interview.

Chapter 12

1. "Warner Bros. Cartoons, Inc.—Deal; Acquisition of Leon Schlesinger Productions." USC/WB.

2. *Warner Club News*, September 1948.

3. Tashlin interview. After directing three films for Sutherland, Tashlin worked for several years as a screenwriter and live-action gag man before becoming a director of feature films.

4. From a copy of the memorandum in Davis's papers.

5. *Warner Club News*, October 1944, noted that Clampett "very quietly has spent the past two years doing research in the new angles that will arise when the animated cartoon is televised." After a number of false starts, Clampett achieved success in television in 1949 not with cartoons but with a daily puppet show, *Time for Beany*.

6. McKimson interview.

7. Bob Clampett, 14 May 1979. Clampett was speaking specifically of McKimson's 1942 model sheet of Bugs Bunny, but the tendency he described was visible throughout McKimson's work.

8. The transition is reflected in the draft for *One Meat Brawl*. RMcK.

9. A chart titled "Footage for Animators" shows Scribner back at work the week ending 2 April 1948. RMcK.

10. McKimson interview.

11. Arthur Davis interview.

12. Bill Melendez: "It's surprising the influence the animators had on Artie Davis, as opposed to the animators' influence on Chuck Jones. Chuck Jones would very carefully pose out and draw every picture, and the guys had nowhere to go but to do it that way." Interview.

13. In interviews, Davis did not respond to opportunities to express any special esteem for Scott and Turner. Scott described Davis as "a badminton bird in a couple of political games being played at WB at that time. Worried, nervous, and not at all sure of himself or of the two fledgling writers foisted on him. But he was always nice to us." Scott to author, 15 June 1978.

14. Max Eastman, *Enjoyment of Laughter* (New York, 1939), 192. Also see Walter Blair and Hamlin Hill, *America's Humor From Poor Richard to Doonesbury* (New York, 1978), 66-68 and 128-32.

15. Freleng, July 1976 tape recording.

16. In an interview with Joe Adamson, Maltese said of Sam: "I patterned him more or less after Freleng.... A real red-haired, hot-tempered little guy! Oh, he was a little fire-brand." Adamson, "'Well, for Heaven's Sake! Grown Men!' Interviews," *Film Comment*, January–February 1975, 18.

17. Mel Blanc, interview, 3 June 1969.

18. Avery, February 1977 interview.

19. Tashlin interview.

20. *Warner Club News*, December 1944 and November 1947.

21. Mrs. Michael Maltese to author, 19 January 1988 and 29 February 1988.

22. *Fleischer's Animated News*, vol. 1, no. 10, undated but published in October 1935.

23. Michael Maltese, interview, 31 May 1971. Maltese and Foster became good friends then; Foster was best man at Maltese's wedding in 1936. *Fleischer's Animated News*, vol. 2, no. 5, undated but published in April 1936.

24. *Fleischer's Animated News*, vol. 2, no. 4, undated but published in March 1936.

25. Maltese, 1971 interview.

26. Bob Clampett, 1976 interview.

27. Maltese, 1971 interview.

28. Monahan interview.

29. Maltese, 1971 interview.

30. Bob Clampett, 1976 interview.

31. Jones, September 1979 interview.

32. Maltese, telephone interview, 8 June 1979. Maltese's imminent return to the studio after his surgery was reported in *Warner Club News*, August 1946.

33. McKimson interview.

34. *Warner Club News*, May 1949.

35. Mrs. Michael Maltese to author, 10 July 1990.

36. Paul Etcheverry, "Interview with William Scott, Part One," *Animania*, 30 November 1982, 27.

37. Lloyd Turner, interview, 13 May 1989.

38. Bob Clampett, 1976 interview.

39. Sheehan interview.

40. Christensen interview.

41. *Warner Club News*, August 1949. Of his Warner colleagues who spoke of his performances, only Bob Clampett, for whom Maltese worked on a few cartoons in the early forties, remembered Maltese as not much of an actor in front of a storyboard. Interview, 25 May 1971.

42. Maltese, interview, 1 November 1976.

43. Maltese, 1976 interview.

44. Jones confirmed in the October 1979 interview that Maltese wrote this story while still a "floater."

45. Jones, telephone interview, 6 July 1976.

46. Jones, October 1979 interview.

47. Maltese, 1976 interview.

48. Maltese, 1971 interview.

49. Jones, telephone interview, 9 July 1976.

50. Jones, October 1976 interview. In the early forties, when Jones was taking his animators, as a group, through a new story, he showed them the storyboard (Rudy Larriva to author, 24 November 1989). By the late forties, he was showing them his own character layout drawings instead (Monroe, 1987 interview). That change could reflect how extensively Jones revised the story as he received it from Maltese, or it could simply reflect how inadequate Maltese's story sketches were, as drawings, compared with the story sketches by Ted Pierce and Bob Givens.

51. From a copy of the original dialogue, with the Fala references. CJ.

52. Monroe, 1976 interview.

53. Jones, 9 July 1976 interview.

54. Jones made this statement during a 27 April 1975 appearance at the American Film Institute's theater in Washington, D.C.

55. Jones, 9 July 1976 interview.

56. Jones, October 1976 interview.

57. Jones, 6 July 1976 interview.

58. A model sheet for Colonel Shuffle is dated 13 February 1947; the cartoon was released 26 February 1949.

59. Barrier, "An Interview with Chuck Jones," 15.

60. The "jam session" notes for *Long-haired Hare* are dated 18 March 1947; the cartoon was released 25 June 1949. CJ.

61. See, for example, Jones's column "Cel Washer" in *Take One*, March 1977, 31, where he writes, "The Coyote is a history of my own frustration and war with all tools multiplied only slightly."

62. Jones was interviewed by Dick Cavett on the Public Broadcasting Service on 25 October 1979. Jones has spoken of the series' parody origins many times, as in Hall, "The Fantasy Makers," 31, where he said that *Fast and Furry-ous* "was intended as a parody of all the chase cartoons. You know, the baseboard pictures, where the camera is so low that all you see is the baseboard of the room, and cats chasing mice, and dogs chasing cats. But nobody accepted it as a parody, which was a disappointment to me."

63. Alex Ward, "Chuck Jones, Animated Man," *Washington Post*, Style section, 27 October 1974.

64. Maltese, 1971 interview.

65. Notes from a "jam session" on *Beep, Beep* bear the date 26 April 1950. CJ.

66. The "jam session" notes for *Operation: Rabbit* are dated 3 November 1949, probably too soon after the release of *Fast and Furry-ous* for there to be any connection. CJ.

67. Julian, 1976 interview. Jones, 8 June 1979. Despite the repeated use of "beep" in the titles of Road-Runner cartoons, the proper spelling of the noise Julian made was, according to its author, "hmeep-hmeep." Julian to author, 9 January 1990.

68. Barrier, "An Interview with Chuck Jones," 14.

69. Maltese, 1971 interview.

70. Barrier, "An Interview with Chuck Jones," 14.

71. Jones, September 1979 interview.

72. Walt Disney, 23 December 1935 memorandum.

Chapter 13

1. James Nevin Miller, "Army's Animated Cartoons Make Better Soldiers," *Popular Science*, June 1935, 30.

2. The unit's name was changed in 1944 to the Eighteenth Army Air Force Base Unit (Motion Picture Unit).

3. *The Animator*, 30 November 1942.

4. *The Animator*, 28 February 1943.

5. *Daily Variety*, 7 May 1943.

6. Ising, 1971 interview.

7. Givens interview.

8. Morris to O. B. Johnston, memorandum, 21 December 1942. WDA. "At 11:15 a.m. today," Morris wrote, "Major Sam Briskin called Roy [Disney] on the telephone and advised that they were rejecting our offer to produce [the Snafu cartoons] for the Army magazine reel, due to the fact that the Army had received a lower bid than ours, which they were accepting." Documents in the Defense Audiovisual Agency's "estimate envelopes" for each of the Snafu cartoons indicate that the Schlesinger studio had begun work on the first one by 31 December 1942.

9. Theodor Geisel to author, 12 June 1978.

10. Fleury interview.

11. Judith and Neil Morgan, *Dr. Seuss & Mr. Geisel* (New York, 1995), 110.

12. Ising, 1971 interview.

13. Clampett, telephone interview, 1 August 1977.

14. Hilberman, 1976 interview.

15. Fleury interview.

16. Hubley, "The Writer and the Cartoon," 111.

17. Schwartz, 1979 tape recording. Transcripts exist for several *Cydalise* meetings from the fall of 1938, before Disney decided to replace it with Beethoven's *Pastoral*. Schwartz would have been deep into work on *Sorcerer's Apprentice* by that time.

18. Hurtz, 1986 interview.

19. Stephen Bosustow to author, tape-recorded letter, circa August 1976.

20. The dates and titles of Bosustow's wartime jobs are listed in a government "personnel security questionnaire" that he filled out sometime in 1944. SB.

21. Schwartz, 1978 tape recording.

22. Hilberman, 1976 interview.

23. Novros interview.

24. Bosustow, interview, 30 November 1973.

25. Hilberman, 1976 interview. Hilberman's account is consistent with Bosustow's 28 July 1952 written answers to questions submitted on 14 May 1952 by an investigator for the House Committee on Un-American Activities. SB.

26. The dates are those in Bosustow's personnel security questionnaire. He said in 1973 that he started as the sole owner of the company, then sold one-third shares to Schwartz and Hilberman. Interview.

27. Schwartz, 1978 tape recording.

28. Hubley interview. Hurtz, January 1977 interview.

29. Hurtz, 1986 interview.

30. Hubley interview.

31. Hilberman, 1976 interview.

32. Novros interview.

33. Bosustow tape recording.

34. Hilberman, 1976 interview.

35. Bosustow made his remarks during a 5 May 1978 panel discussion at the Filmex film festival in Los Angeles.

36. Schwartz, 1978 tape recording.

37. Hilberman, 1976 interview.

38. Report dated 5 November 1951. FBI/UPA.

39. Copyright registration 15509, Class M. Copyright Office, Library of Congress.

40. Hilberman, 1976 interview.

41. Bosustow interview.

42. Schwartz, 1978 tape recording.

43. Schwartz, 1978 tape recording.

44. Hilberman, 1976 interview.

45. Novros interview.

46. Hubley enlisted in the army 23 November 1942 and was discharged as a staff sergeant 13 November 1945. Report dated 3 May 1947. FBI/Hubley.

47. Hubley interview.

48. Hurtz, interview with Gray, 26 February 1977.

49. Hurtz, January 1977 interview.

50. Hilberman, 1976 interview.

51. Shull, speaking during Graham, action-analysis lecture, 10 December 1936.

52. Andrew Sarris, "How Animated Are Cartoons (1)," *Village Voice*, 19 June 1969, 43.

53. John Canemaker, "David Hilberman," *Cartoonist Profiles*, December 1980, 19.

54. John Hubley and Zachary Schwartz, "Animation Learns a New Language," *Hollywood Quarterly*, July 1946, 362.

55. Hurtz, January 1977 interview.

56. Hilberman to author, 21 October 1995.

57. Gyorgy Kepes, *Language of Vision* (Chicago, 1944), 98, 107.

58. Kepes, *Language of Vision*, 201, 209.

59. Kepes, *Language of Vision*, 129.

60. Kepes, *Language of Vision*, 221.

61. Phil Eastman, "New Techniques and Uses," in *Writers' Congress: Proceedings of the Conference Held in October 1943 under the Sponsorship of the Hollywood Writers' Mobilization and the University of California* (Berkeley, 1944), 123.

62. Hubley interview.

63. *Boxoffice*, 20 April 1946.

64. Julian, 1976 interview.

65. Bosustow tape recording. Hilberman, 1976 interview.

66. Hubley interview.

67. According to a chronological list of board members and officers that accompanied Bosustow's 28 July 1952 reply to HUAC, Hubley was elected to UPA's board 12 August 1946 to take Schwartz's place. SB.

68. Bosustow tape recording.

69. Bosustow interview. According to Bosustow's 28 July 1952 reply to HUAC, Karen Morley bought fifteen shares of common stock on 18 September 1946. Bosustow said that he had "less than ten days to resell" Hilberman's and Schwartz's interest in the company, and Morley was among the possible buyers that he approached. Morley sold her stock to Hubley in 1950.

70. *Film Daily*, 3 October 1946.

71. Hilberman, 1976 interview.

72. Holly Allen and Michael Deming, "The Cartoonists' Front," *South Atlantic Quarterly*, Winter 1993, 113.

73. Report dated 15 August 1947. FBI/UPA. The list, part of the Federal Bureau of Investigation's file on UPA, is incomplete, but there's no question but that UPA was heavily dependent on government contracts.

74. Martin Gang to American Business Consultants, 29 September 1950. Gang, a UPA attorney, was responding to allegations in the newsletter *Counterattack* that UPA had communist connections. SB.

75. Hurtz, January and February 1977 interviews.

76. Bosustow interview.

77. Bosustow tape recording. The New York cartoonists' union newsletter *Top Cel* reported in its 8 February 1946 issue that Bosustow had arrived in New York "to complete negotiations for a release by a major distributor of a group of 12 cartoons."

78. Hurtz, February 1977 interview. Julian, 1976 interview.

79. From a September 1973 interview by John D. Ford in "Animation: A Creative Challenge—John & Faith Hubley," a booklet published by the Mid-America Film Center of the Kansas City Art Institute.

80. Scott, 15 June 1978.

81. Willis Pyle, interview, 17 June 1984.

82. Hurtz, 1986 interview.

83. Hubley, Ford interview.

84. Adrian Woolery, interview, 9 December 1986.

85. Hubley interview.

86. Scott, 15 June 1978.

87. Julian, 1976 interview.

88. Bosustow interview. Geisel himself put the figure at five hundred dollars. Morgan and Morgan, *Dr. Seuss & Mr. Geisel*, 131. The record, *Gerald McBoing Boing by Dr. Seuss*, was released in 1950 as Capitol CAS 3054. The story is told on the record, with musical accompaniment, by Harold Peary, the radio performer known as the Great Gildersleeve.

89. Hurtz, February 1977 interview.

90. That is the completion date shown on a list compiled by UPA and headed "Production No. for 50-XX—Columbia Cartoons—Burbank." The list, a copy of which Milton Gray obtained from UPA in 1971, begins with production number 50-7, *Giddyap*. It's not clear what the dates under the heading "completed" mean, although those dates' proximity to the release dates suggests that "completed" meant that a cartoon had been put through camera and possibly delivered to Columbia by then.

91. Morgan and Morgan, *Dr. Seuss & Mr. Geisel*, 129-30.

92. Hurtz, interview with Gray, 19 March 1977.

93. Hurtz, February 1977 interview.

94. Arthur Knight, "Up From Disney," *Theatre Arts*, August 1951, 92.

95. 5 November 1951 FBI report.

96. Knight, "Up from Disney," 92.

97. Hubley, Ford interview.

98. UPA's list of production numbers shows *The Wonder Gloves* completed on 30 April 1951, little more than a month after the award of the Oscar to *Gerald*, and too soon for Cannon to have begun work on it after he escaped Hubley's supervision.

99. Julian to author, circa January 1991.

100. Thornton Hee, interview with Gray, 20 April 1977.

101. Hurtz, March 1977 interview.

102. Hubley, Ford interview.

103. Hee, interview with Gray, 13 April 1977.

104. Pyle interview.

105. Howard Rieder, "Memories of Mr. Magoo," *Cinema Journal*, Spring 1969, 21.

106. Julian, January 1991.

107. Julian to author, circa October 1990.

108. W. R. Wilkerson, "Trade Views," *Hollywood Reporter*, 11 March 1952.

109. Hubley, Ford interview.

110. Norman McLaren, "'Begone Dull Care' and 'Fiddle-de-dee,'" in Robert Russett and Cecile Starr, eds., *Experimental Animation* (New York, 1976), 124.

Chapter 14

1. According to Bosustow's 28 July 1952 reply to HUAC, Eastman was laid off on 26 October 1951.

2. Scott, 15 June 1978. Scott worked again for UPA later; he has a writing credit on *The Tell-tale Heart*, among other things.

3. Bosustow tape recording.

4. Julian, interview, 12 February 1990. The letters are in Bosustow's papers.

5. Bosustow's 28 July 1952 reply to HUAC says that Hubley was removed from the UPA payroll on 31 May 1952 "by a Board of Directors' Committee elected by the Board." The board ratified the action of the committee, whose membership Bosustow did not specify, on 24 July 1952.

6. Bosustow tape recording.

7. Hurtz, February 1977 interview.

8. Bosustow interview.

9. *It*, Winter 1956, 46, 52. *It* was an amateur magazine, but this issue, devoted to UPA, was produced with a great deal of cooperation from the studio.

10. Hurtz, 1986 interview.

11. Novros interview.

12. Lew Keller, interview, 30 May 1989.

13. *Daily Variety*, 16 June 1953.

14. *Daily Variety*, 2 July 1953.

15. Jones to Maltese, 17 August 1953. Wyoming/Maltese. Jones was on the Disney payroll from 13 July 1953 to 13 November 1953.

16. McKimson to author, 10 September 1974.

17. Jones to Maltese, 30 November 1953 and undated from late 1953. Wyoming/Maltese.

18. *Daily Variety*, 15 June 1953.

19. Maltese, 1976 interview.

20. *Warner Club News*, November 1955.

21. Monroe, 1987 interview.

22. *Warner Club News*, December 1952. The two cartoons were assigned production numbers 1295 (*Goo Goo Goliath*) and 1296 (*From A to Z-z-z-z*), a strong indication that they went into production almost simultaneously.

23. Jones to Bhob Stewart, 14 March 1956.

24. Corny Cole, interview, 23 February 1991.

25. Maurice Noble, interview, 31 May 1989. *Warner Club News*, November 1946.

26. Noble, 1977 interview.

27. Noble, interview with Gray, 24 January 1977. Jones, October 1976 and January 1981 interviews.

28. Noble, 1977 interview.

29. Jones, October 1976 interview.

30. *Warner Club News*, August 1955.

31. Jones, September 1979 interview.

32. Jones, October 1976 interview.

33. Graham, *Composing Pictures*, 119.

34. Jones, telephone interview, 24 June 1976.

35. Lundy's record of his work showed him departing from MGM in October 1951 — after Avery had returned, he said in the 1973 interview.

36. *Daily Variety*, 16 June 1953.

37. Mayer, 4 February 1980.

38. *Hollywood Reporter*, 23 December 1953.

39. Avery, February 1977 interview.

40. Under a contract dated 28 June 1950 (evidenced by a contract brief), Lantz agreed to provide Universal with six Woody Woodpecker cartoons at a negative cost of not less than $20,000 or more than $25,000. USC/Universal.

41. Avery, February 1977 interview.

42. Paul Smith interview.

43. Avery, February 1977 interview.

44. Lantz interview.

45. Maltese, 1976 interview.

46. Avery, 21 November 1974 remarks.

47. From a conversation with Gray in the fall of 1976. Gray to author, 18 October 1976.

48. Lah interview.

49. The screen credit "Produced by Fred Quimby" did not appear on any MGM cartoons until after World War II, although it was added to earlier cartoons as they were reissued.

50. Hanna interview.

51. Bradley to Johnny Green, memorandum, 3 July 1957. USC/MGM.

52. Gene Deitch to author, 30 October 1971. CBS press release, 1956.

53. Deitch, 30 October 1971.

54. The only extensive consideration of Tyer's career has come in a paper by Mark Mayerson for a Society of Animation Studies conference in 1990; Mayerson revised and privately published that paper in 1995.

55. Deitch to Mark Kausler, 26 February 1975.

56. Al Kouzel to author, 12 March 1975.

57. Deitch to author, 15 September 1971.

58. John Canemaker, "Sincerely, Frank Thomas," *Millimeter*, January 1975, 18.

59. These dates are derived from the Disney Archives' record of Disney's travels, as well as *Daily Variety*, 24 June 1952, 4 September 1952, 18 February 1953, and 26 June 1953.

60. Frank Thomas, 13 July 1990.

61. *Daily Variety*, 22 September 1952.

62. Disneyland became a wholly owned subsidiary of Walt Disney Productions a few years later, when the company purchased ABC's 34.48 percent interest. Walt Disney Productions, 1960 annual report, 3.

63. *Daily Variety*, 6 April 1954.

64. *Daily Variety*, 20 June 1952.

65. *Daily Variety*, 22 April 1954.

66. Jackson, 31 December 1978.

67. For a full and highly sympathetic treatment of Blair's life and work, see John Canemaker, *Before the Animation Begins: The Art and Lives of Disney Inspirational Sketch Artists* (New York, 1996), 115–42.

68. Jackson, 31 December 1978.

69. Eyvind Earle, interview, 30 May 1983.

70. John Hench, interview with Gray, 9 May 1977.

71. Larson interview.

72. Earle interview.

73. Earle interview. Earle to author, circa September 1983.

74. Larson interview.

75. Frank Thomas, speaking at a seminar on 19 July 1973 during a retrospective series of Disney films at Lincoln Center in New York.

76. Earle interview.

77. Geronimi interview.

78. Earle interview.

79. 1960 annual report, 14–15.

80. Larson interview.

81. Bickenbach interview.

82. Hanna interview.

83. Maltese, 1976 interview.

84. Jerry Bails and Hames Ware, eds., *Who's Who in American Comic Books,* vol. 1 (Detroit, 1973), 63.

85. Jones to Maltese, 4 March 1960 (misdated 1959). Wyoming/Maltese.

86. *Warner Club News,* October 1957.

87. *Hollywood Reporter,* 21 January 1960. *Warner Club News,* March 1960.

88. *Warner Club News,* July 1959.

89. Noble, 1989 interview.

90. David DePatie, telephone interview, 20 June 1979. DePatie, in a Christmas 1962 message to the cartoon studio's staff in *Warner Club News,* January 1963, spoke of "our final holiday season together as a division of the company."

91. The relevant papers are part of the USC Warner Bros. Archive.

92. *Warner Club News,* January 1963. Freleng to author, tape-recorded letter, circa November 1976.

93. Bill Tytla, by then in the later stages of a long professional and physical decline, worked briefly on *Limpet* in 1962 and received screen credit as its animation director. (Jack Kinney was the first choice of the film's producer, John Rose, but Kinney and Rose could not agree on terms.) Other former Disney people were involved with the film at one time or another, but the final product was very much the work of the Warner Bros. cartoon studio. The film's tortured history is reflected in the production materials housed in the special collections of the San Diego State University Library.

94. Hanna interview.

95. *Hollywood Reporter,* 6 and 7 July 1960.

96. Bosustow interview.

97. *Daily Variety,* 9 June 1960 and 27 December 1960. *Hollywood Reporter,* 15 November 1960.

98. *The Peg-Board* (union newsletter), March 1960.

99. *Daily Variety,* 10 August 1959.

100. For a penetrating description of this later Disney, see Aubrey Menen, "Dazzled in Disneyland," *Holiday,* July 1963.

101. Gereon Zimmerman, "Walt Disney, Giant at the Fair," *Look,* 11 February 1964, 32.

102. Patent 2,130,541, issued 20 September 1938. U.S. Patent and Trademark Office.

103. *Daily Variety,* 24 April 1959. Herbert Klynn, interview with Gray, 15 March 1977.

104. Disney, "Growing Pains," 40.

105. Anderson interview.

106. Larson interview.

107. Thomas and Johnston, *Disney Animation,* 229.

108. Marc Davis, 1976 interview.

109. Peet to author, circa March 1979.

110. Kimball interview.

111. 1 September 1939 meeting notes. WDA.

112. Johnston, 1976 interview.

113. The *Jungle Book* meeting notes extend from 29 April 1963 to 22 September 1966. WDA.

114. "A Wonderful World: Growing Impact of the Disney Art," *Newsweek,* 18 April 1955, 60. "The Magic Kingdom," *Time,* 15 April 1966, 84.

115. Thomas, *Walt Disney,* 353-54. Disney died on 15 December 1966.

Index

A Note on the Design

Hollywood Cartoons is set in Veljović, a postmodern font with a
rationalist, or vertical, axis. The font was designed by Jovica
Veljović and was first issued digitally in 1984. The three
series of "flip book" illustrations were drawn by Milton
Gray. The ink bottles found on the chapter openers
and the space-breaking ink blotches were drawn
by Thomas Zummer. The text itself was
designed by Adam B. Bohannon.
And production was handled
by Joellyn M. Ausanka.